Vincent and Theo

A Dual Biography

Father wrote me once,

Do not forget the story of Icarus,
who wanted to fly to the sun,
and having arrived at a certain height,
lost his wings and dropped into the sea.

Vincent's letter to his brother Theo, 14 October 1875

Jan Hulsker

Vincent and Theo
VAN GOGH

A Dual Biography

James M. Miller, Editor

Fuller Publications
Ann Arbor

Based on *Lotgenoten* by Jan Hulsker,
published in Holland in 1985 by Agathon/Unieboek bv, Weesp

Translated and rewritten by the author,
edited by James M. Miller

Fuller Technical Publications, Bx 7995, Ann Arbor Michigan USA 48107
 Telephone (313) 662-9953 TeleFax (313) 747-9712

Library of Congress Cataloging-in-Publication Data

 Hulsker, Jan.
 [Lotgenoten. English]
 Vincent and Theo van Gogh : a dual biography /
 by Jan Hulsker ; [translated and rewritten by the author].
 p. cm.
 Translation of : Lotgenoten.
 Includes bibliographical references.
 ISBN 0-940537-05-2
 1. Gogh, Vincent van, 1853 - 1890. 2. Gogh, Theo van, 1857 - 1891.
 3. Painters--Netherlands--Biography. 4. Art Dealers--Netherlands-
 -Biography. I. Title.
 ND653.G7H79413 1990
 759.9492--dc20
 [B] 89-28907
 CIP

Some excerpts of letters are reprinted here with permission from the publishers of *The Complete Letters of Vincent van Gogh* (New York Graphic Society, Greenwich, Connecticut, 1958). It would have shown little appreciation for the tremendous task Jo van Gogh-Bonger undertook in translating Van Gogh's letters into English if in quoting material from the letters the author had tried to duplicate her important work by translating from the original letters. Dr. Hulsker has revised her text translations only where he found that it could be made more exact.

To Chris

Contents

Part IV *With Scorched Wings*

Preface

Every year the never-ending stream of books about Vincent van Gogh brings new ones. There probably is not a painter in the world about whom so much has been published, and likewise there will not be many painters about whom so much is known. Among all those books there are only a few that are really worthwhile. One of them is *Lotgenoten* (the book of which this is a translation and revision) written by the great Van Gogh expert Jan Hulsker.

The purpose of the present book, *Vincent and Theo Van Gogh: A Dual Biography*, is to provide us with a well documented biography of Vincent van Gogh and his brother Theo. That is something that I find particularly important. Without the moral and financial support of Theo, Vincent could not have produced his vast *oeuvre*. Yet Theo's role has often remained somewhat in the shadow, if only because no more than forty letters from him to Vincent have been preserved as compared to some 650 from Vincent to Theo. Dr. Hulsker has assembled countless exact data from other sources as well and has arranged them in chronological order, thus composing a fascinating life story of the two brothers.

As a grandson of Theo, I applaud the publication of an English translation of this book wholeheartedly. I do it also as President of the Vincent van Gogh Foundation.

The collection of paintings and drawings by Vincent which was owned by Theo and later by his widow Johanna G. van Gogh-Bonger, became the property of their son, Dr. V. W. van Gogh, when she died. It is now owned by the Vincent van Gogh Foundation. Also as a part of this property are the original manuscripts of the letters as well as paintings by contemporaries which were collected by Theo. All these treasures are housed in the National Museum Vincent van Gogh in Amsterdam.

I hope this new book, *Vincent and Theo van Gogh: A Dual Biography,* will attain the large distribution it deserves.

Johan van Gogh

President
Vincent van Gogh Foundation

Introduction

Details about the lives of artists are often unknown or, if known, such information may contribute little to our understanding and appreciation of their work. Vincent van Gogh, however, belongs to the category of artists whose life and work are intricately connected. Knowledge of the events in his life provides a great deal of insight into both his art and personality. Moreover, even *before* he decided, at a relatively advanced age, to devote himself entirely to art, his life had been so eventful and even dramatic that it would be worthy of a biography itself.

More than being an investigation of his art, this book has been written as a biographical study, more detailed than earlier biographies, and partly based on documents that were lesser known, or even completely unknown before the present publication. It is also in part a reaction to several books in which Van Gogh's life is reported as if the author were present at the events himself in which no statements are substantiated, no sources disclosed, and quotations given without even mentioning the accepted reference numbers provided in the editions of the Van Gogh letters. Even a century after Vincent's death not all of the facts can be reconstructed, but the many years I have devoted to the Van Gogh research have at least enabled me to fill in a number of gaps in our knowledge of Vincent's life and that of his brother, to clarify connections between the facts of their lives, and to reduce romantic anecdotes to their proper proportions.

The time has passed when one begins a book or article on Van Gogh in such ecstatic and picturesque terms such as these:

> Beneath skies that sometimes dazzle like faceted sapphires or turquoises, that sometimes are molded of infernal, hot, noxious and blinding sulfurs . . . there is the disquieting and disturbing display of a strange nature. . . . Such, without exaggeration, is the impression left upon the retina when it first views the strange, intense and feverish work of Vincent van Gogh (G. Albert Aurier, 1890).

> Van Gogh! These two simple syllables conjure up in our minds canvases of fire, burning visions, the flaming plains of the Provence, enormous suns above the fields as hallucinatory monstrances (Louis Piérard, 1913).

Today, every reader knows that Van Gogh is considered a great painter and that his work, like his life, has extravagant aspects. What is needed is a more matter-of-fact approach, an approach that concentrates on questions such as: How did Van Gogh *arrive* at these "canvases of fire" or these "enormous suns"? It is precisely because I admire Vincent Van Gogh no less than Aurier or Piérard that I have tried to tackle with a cer-

tain coolness the important questions which have puzzled many authors for so long. What influence—if any—did the still-born first child of his mother have on Vincent's psyche? What impact may be ascribed to the London girl who is always referred to as Vincent's first great love? What prompted Vincent to make two pictures of empty chairs while in Arles? What is the connection between Vincent's so-called madness and the development of his work? And finally, were the dramatic events in Vincent's life really caused by changes in his brother *Theo's* life? In this book I have tried to collect as much factual evidence as possible concerning these important recurring questions; others may use it to compare their opinions with mine.

This book has yet another goal. It is not overly risky to suppose that, if there were not a Theo, the artist Vincent would not have existed either. I probably am not the first to say so, and Theo has certainly often been mentioned with gratitude by others. Yet remarkably little has ever been published about him compared to what has been written about his famous brother. For this reason I have assembled as many details as possible about the life of this man who has unjustly remained in the shadows of art history. Understandably, I could not expect to end with as complete an image of his life story as I have of Vincent's. Of Theo's letters no more than some forty have been published against roughly 750 from Vincent, and even more important, no more than another fifty (unpublished) letters from Theo to members of his family have been preserved. Nevertheless, I hope that the chapters about him in this book will provide at least some compensation for the all too modest place which this important brother has thus far been assigned in Van Gogh literature.

I do not want to anticipate what the reader is about to discover in this book by trying to summarize in a few sentences the complicated relationship between the brothers. Just let me comment that it was a profound friendship, though one that was disturbed by several serious quarrels and estrangements. One of the few writers on the subject referred to their relationship as a *symbiosis*. With all respect for the insight of this author, Charles Mauron, it seems far from being the appropriate term. Their association was not a state of true "togetherness." Although their existences showed such great similarities and were connected in such a remarkable way, each lived his own life, separated from the other not only by physical distance, but also by his different character and ideas. When Vincent once described his brother and himself as *compagnons de sort* (companions in destiny) in a letter of July 1889 (letter 603), he could not possibly have suspected what life had in store for them and that destiny allotted them

an equally short lifespan and an equally tragic end. How much they meant to each other as long as their relationship lasted, I hope to make convincingly clear in the following pages.

For the factual details about their lives I have used primary sources only, the oldest available authentic documents. The starting point was of course the correspondence between the brothers. Another important source was the unpublished letters between other members of the Van Gogh family, especially the numerous letters to Theo from his parents. I have made extensive use of them, not only because they contain many concrete details about the lives of Vincent and Theo that could not have been obtained in any other way, but also because they reflect on the characters of the parents and their views in situations of conflict. The parents are surely entitled to a more objective judgment than they have received in the past. As only Vincent's letters and a few of Theo's have been published, the world has likely perceived their relationship with Vincent somewhat one-sidedly in Vincent's favor. The love they gave not only to Theo, but also to their less successful eldest son Vincent, the concern they always had for his future, and the sacrifices they constantly made for *all* their children, deserve to be given more attention than before.

I cannot write about the Van Gogh correspondence without gratefully acknowledging the work of those people to whom we owe its preservation. To begin with, Theo was a great keeper of things. But it is questionable that the world would have been able to enjoy those precious letters if, after Theo's untimely death, his widow, Jo van Gogh-Bonger, did not take upon herself the task of preserving the hundreds of letters that Theo had received in the course of many years, and especially those written by Vincent, of which she sensed the historic value. As most of these letters were not dated, she began with the difficult work of arranging them in chronological order. That done, she did not shrink before the gigantic effort of copying these thousands of handwritten pages and preparing them for the press. When her three volume edition of the letters was finally published in 1914, she accompanied it with an extensive Memoir in which she carefully composed a sketch of Vincent's life that for many years was to remain the principle source for other books on the subject. In the years 1952-53, her son, a former consulting engineer called Vincent Willem van Gogh after his uncle, continued the work of his mother by publishing a new, revised edition of the letters, enlarged with Vincent's letters to his sister Willemien and to friends such as Van Rappard and Emile Bernard, and also including some letters written by Theo. This important edition,

which has formed the basis for many translations, has been reprinted several times.

Although, like other authors on Van Gogh, I have constantly consulted Jo van Gogh's Memoir for this biography, one will see that I have not unreservedly accepted everything she wrote. My study of some of the sources she also used, such as the unpublished letters from other members of the family, has sometimes led me to different opinions, but one should not conclude from the critical views of her text which I have found necessary to express at several points that I do not have an enormous respect for the pioneering work she accomplished.

Theo's death left Jo van Gogh-Bonger to care not only for the letters and other documents he possessed, but also for the almost countless number of Vincent's drawings and paintings that had accumulated in his apartment. Here it was her task to not only *preserve* Vincent's art but also to arrange for it to be finally recognized by the world through exhibitions and sales. To accomplish this she again did everything she could, and so it was not long before his oeuvre became well-known in the Netherlands and in many other countries. An important part of the collection remained in the Van Gogh family and was later incorporated into the Vincent van Gogh Foundation, housed in the specially built Rijksmuseum (National Museum) Vincent van Gogh in Amsterdam. Owing to the fact that in the beginning of this century a number of important works were bought by an early admirer of the painter, Hélène Kröller-Müller, who had an unfailing taste herself and was assisted by the excellent advice of H. P. Bremmer, a second collection of outstanding quality has been preserved for the Netherlands. It is now owned by the Rijksmuseum Kröller-Müller in Otterlo near Arnhem. It would be a question of misguided nationalism if the Dutch regretted that hundreds of drawings and paintings by Vincent van Gogh have found their way to public and private collections in other parts of the world. Vincent already considered himself "a cosmopolitan" when he was working in London as a young man; Theo became a true Parisian, and it was the art trade, after all, which procured Theo a living and which through him made Vincent's great achievement possible.

I cannot end this introduction without expressing my gratitude to the many who helped make the appearance of this dual biography possible. In the first place I am indebted to the late Dr. Vincent van Gogh, Theo's son, who with great liberality first gave me access to the manuscripts of Vincent's letters many years ago. I am also grateful to the other members of the Van Gogh family, members of the Board of the Vincent van Gogh Foundation, and especially to Johan van Gogh, Theo's

eldest grandson and now President of that Board, who was kind enough to write the Preface to this book. I thank the Director of the Rijksmuseum Vincent van Gogh, Ronald de Leeuw, and the members of his staff, in particular Fieke Pabst, the museum documentalist, to whom I had to appeal numerous times for documents or information. Of the many others who have encouraged me in my research or helped me with information, I would like to mention at least these few: Ton de Brouwer (Nuenen), David Bruxner (London), Dr. J. J. Groen (Epe), Mrs. A. Karagheusian (New York), Dr. W. Lutjeharms (Horebeke, Belgium), Martha Op de Coul (Netherlands Institute for Art History, The Hague), F. J. Ph. Du Quesne van Bruchem, (Deux Montagnes, Quebec, Canada), Pierre Richard (Nîmes, France), A. Verkade-Bruining (Ellecom, Netherlands) and also Dr. Bogomila Welsh-Ovcharov (Toronto, Canada).

Finally, I am grateful to Dr. James M. Miller of the University of Michigan for his willingness to undertake the tasks of editing and publishing my book, and to the members of his staff, with special thanks to Susan Churinoff.

<div align="right">J.H.</div>

Notes to Reader:

The numbers in parentheses (such as letter 234) refer to Vincent's letters to his brother Theo, his sister Wil, and others, as published in *The Complete Letters of Vincent van Gogh* (New York Graphic Society, 1958). The numbers indicating works by Van Gogh (such as JH 1592) refer to the complete catalogue, published under the title *The Complete Van Gogh* and edited by Jan Hulsker (Harry N. Abrams and Phaidon, 1980).

In most books on Vincent van Gogh, his works are indicated by numbers referring to *The Works of Vincent van Gogh: His Paintings and Drawings*, edited by J. B. de la Faille, 3rd edition (Meulenhoff International Amsterdam, 1970, first published in 1928). There is a concordance of De la Faille and Hulsker numbers at the end of this book.

Part I

A Labyrinth

THE FIRST TO TAKE UP THE PEN

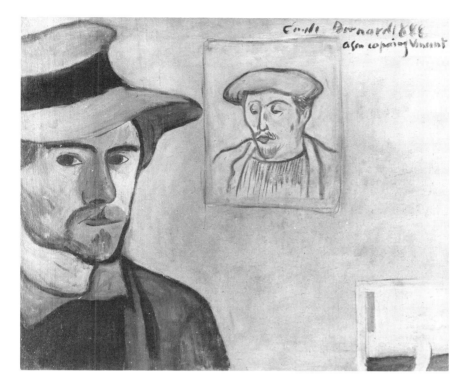

1
Emile Bernard. Self portrait made for Vincent van Gogh, with sketch of Paul Gauguin, 1888.
Vincent van Gogh Foundation / National Museum Vincent van Gogh, Amsterdam

The first biography ever to be published on Vincent van Gogh dates from immediately after his death. Its author was a young friend and colleague, the painter Emile Bernard, and it appeared in 1890 as an article in the series *Les Hommes d'Aujourd'hui*. Consisting of no more than three pages and a title page which included a self-portrait of Vincent copied by Bernard, it still gave a striking impression of the practically unknown artist who had died in Auvers-sur-Oise in that year. The paintings that were to be among his most famous, *The Potato-Eaters*, *The Sower*, *La Berceuse* and many others, are mentioned, as are the names of the artists whom he revered as great masters: Delacroix, Monticelli, and Millet. In his article Bernard devoted only one sentence to Vincent's generous character, but it was a telling one: "What desolated him was not that his work was not appreciated, but that Pissarro, Guillaumin and Gauguin had to cope with the want of money which is so frustrating in creative work and paralyzes all attempts." The final sentence of the essay describes the man to whom he was closest, ". . . his brother who loved him so much, who was so devoted to him, and whose name will forever be linked with his." This, of course, refers to Theo van Gogh, the brother who would play an important role in Vincent's artistic career.

Emile Bernard did not stop at this first attempt to call attention to his admired colleague. He possessed a number of letters, sent to him by Vincent, and in 1893 he published extensive fragments of them in the important monthly *Mercure de France*. Before the year was over he began to publish, also in *Mercure de France*, letters from Vincent to his brother Theo—letters made available to him by Theo's widow, Johanna (Jo) van Gogh-Bonger. Thus, by 1893, only three years after his

death, much was known about Vincent's life and ideas. The importance of his work had also become evident to larger groups through exhibitions in cities such as Paris, The Hague and Amsterdam. In 1911 Bernard concluded his series of important studies with the publication in book-form of the letters he had received from Vincent, including an insightful forty-three page introduction (*Lettres de Vincent van Gogh à Emile Bernard*).

In 1910, Vincent's sister Elisabeth Huberta du Quesne (*née* van Gogh) published a booklet called *Vincent van Gogh. Persoonlijke herinneringen aangaande een kunstenaar* (English edition: *Personal Recollections of Vincent van Gogh*, 1913). Unfortunately, this was a very incomplete story of Vincent's life, and it was marred by many factual errors. Elisabeth knew little about her brother's later years and had almost no contact with him after he left Holland except through the exchange of a few letters. Her main intent was to write a sort of poetic booklet rather than a biography; she had earlier published three volumes of poetry and considered herself a poetess. In the preface she admitted that she would have preferred not to mention the *name* of the artist whose life she described. In the end she did not conceal her subject, but she avoided mentioning the important geographical names of Zundert, Nuenen, Etten, Saint-Rémy and Auvers-sur-Oise. Other locations, such as Paris and Arles, were mentioned only in passing.

Elisabeth's booklet stimulated other contemporaries to record their memories of Vincent, not surprisingly, as in the meantime interest in his work and personality was strongly intensified by important exhibitions such as the one in the Municipal Museum in Amsterdam where more than four hundred of his paintings and drawings were displayed. In 1910 Dr. M. B. Mendes da Costa published a fascinating newspaper article about the time he had given Vincent lessons in Latin and Greek in Amsterdam,[1] and two years later the amateur painter Anton Kerssemakers published recollections of his work with Vincent in Eindhoven.[2] Both articles are of the utmost importance for their contributions to the knowledge of Vincent's life story and will be referred to frequently in this book. A third author who was inspired by Elisabeth du Quesne's booklet was Louis Piérard. Since the books and articles which had been published contained few details about Vincent's stay in the Borinage, Piérard, who was born and raised in that region and represented it as a *député*, felt prompted to investigate this period in Vincent's life more thoroughly. The result was a wealth of material that he used for an extensive article in the *Mercure de France* in 1913 under the title "Van Gogh au pays noir."[3]

In 1914 Vincent's letters to his brother Theo appeared in a three volume edition arranged by Jo van Gogh-Bonger, titled *Brieven aan zijn broeder*. Her sixty-four page introduction in the first edition was more extensive than the one Bernard had written in 1911 and gave many new details about Vincent's life, making it an invaluable contribution to the growing literature about Van Gogh. Numerous biographies published after 1914

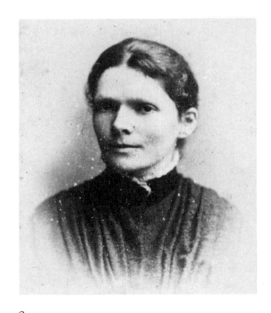

2
Elisabeth Huberta van Gogh.
Vincent van Gogh Foundation / National Museum Vincent van Gogh, Amsterdam

[1] *Algemeen Handelsblad* (30 November 1910).

[2] *De Amsterdammer* (14 and 21 April 1912).

[3] Later included in Louis Piérard, *La vie tragique de Vincent van Gogh* (1924).

are based upon her work, some of which quote her almost directly, often without citing her work as a source. She owed her knowledge to the careful reading of the letters she had prepared for the press, and her memories of the talks she had with Theo about Vincent, even though these had occurred some twenty years earlier. For several reasons she had little contact with Vincent's three sisters,[4] or with his younger brother Cor who had died in South Africa in 1900. That she had known Vincent personally could not have been very significant to her biography. She first met him a mere three months before his death, when he stayed with her and Theo in Paris for three days, and after that she met him only twice. For information about Vincent's earlier years her principal sources must have been his mother, who died in 1907 at the age of eighty-seven, and the family letters Jo and her mother-in-law kept.

The Van Gogh Family

Two facts are of conclusive importance in Vincent's life: first, that his father was a minister of the church, and second, that he grew up in a small village. Because of the former, religion dominated his life for many years; because of the latter, as an artist he remained a realist to whom the life of the farmers and the landscape were always inexhaustible sources of inspiration. Only in the last few years of his life did nature move him to the exalted, non-realistic renderings that are sometimes viewed as his most characteristic works.

Vincent Willem van Gogh was born on 30 March 1853 in the Brabant village of Zundert, near the Belgian border. He was the eldest child of Theodorus van Gogh, the village parson, and Anna Cornelia Carbentus. A curious coincidence about the date was that exactly one year earlier, on 30 March 1852, his mother had given birth to a still-born child, This child was buried in Zundert in the graveyard on the side of the small Protestant church. It has often been assumed that this fact made an indelible impression on Vincent. Jo van Gogh's son, Vincent W. van Gogh, who edited a revised edition of Vincent's letters in 1952 to 1954 titled *Verzamelde brieven van Vincent van Gogh*, wrote in the last volume of this edition, "Near the entrance to the little church at Zundert there is the grave of the little boy who was born precisely a year before Vincent, and who was also called Vincent; he lived for only a few weeks. Until he left his parent's home, Vincent saw this little grave at least once a week when he went to church, but he saw it too when he came home on weekends, holidays, etc. Besides, it is certain that he heard the little boy mentioned continually. This must have made a deep impression on the baby as well as on

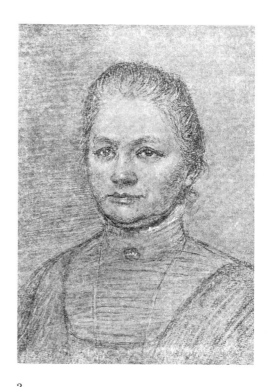

3
Jo van Gogh-Bonger, 1910 drawing by J. Cohen Gosschalk, her second husband. Vincent van Gogh Foundation / National Museum Vincent van Gogh, Amsterdam

[4] A serious controversy had arisen, especially between her and Elisabeth. Jo van Gogh-Bonger probably regretted that so shortly before the publication of her work, Elisabeth had come forward with her own booklet about her brother. Elisabeth did not like the way Jo was editing the publication of the letters. She believed that a biased image was being given because only Vincent's, and not Theo's letters were published, and she was of the opinion that too many family secrets were revealed (information received in 1983 and 1984 in letters from Elisabeth's son, Mr. Felix du Quesne van Bruchem). The "feud" between the two sisters-in-law seems to be the reason that Jo removed all traces of Elisabeth's existence from her edition. She wrote, for instance, *"la soeur"* (the sister) when the manuscript had *"les soeurs"* (the sisters), or even *"les deux soeurs"* (the two sisters). However, Jo must be given the benefit of the doubt that this was done at Elisabeth's own request.

the growing child." It was probably this passage that induced many authors to elaborate on the influence this death had on Vincent's personality. Psychoanalysts have often stressed how detrimental it can be for the emotional development of a person to be a "replacement child."[5] However, the facts in this passage are not altogether correct. The idea that the first child had lived for a few weeks was an error. The child was still-born, as is confirmed by the birth certificate and by Jo van Gogh-Bonger in her 1914 edition of the letters. In any case, it is doubtful that a young village boy would be overly affected by the sight of a gravestone with which he had been acquainted for years. It is also doubtful that in a parson's family, with all its numerous "taboos," the still-born first child would have been mentioned often, let alone "continually." Infantile deaths were surely not a rare phenomenon in nineteenth-century Holland.

Theodorus van Gogh, Vincent Willem's father, was born in Benschop, a little village near Utrecht, Holland on 8 February 1822. When they married, his wife, Anna Cornelia Carbentus, was thirty-three; she was born in The Hague on 10 September 1819. Theodorus himself was also the son of a minister. His parents were the Reverend Vincent van Gogh (1789-1874) and Elisabeth Huberta Vrijdag (1790-1857); his wife's parents were Willem Carbentus (1792-1845), whose profession is listed either as bookseller or bookbinder, and Anna Cornelia van der Gaag (1792-1835). Of his grandparents, Vincent could only have known the Van Gogh grandfather and grandmother; the latter only very shortly, as she died on 7 March 1857, shortly before his fourth birthday. Ancestors of earlier generations are of little importance for Vincent's life story, but many genealogical details may be found in Jo's famous Memoir to the *The Complete Letters of Vincent van Gogh* (New York Graphic Society, 1958) and in a more elaborate form in the last volume of *Verzamelde brieven*, which contains particulars from official archives and a family history written by Maria Johanna van Gogh, one of Vincent's aunts.[6]

Vincent's father studied theology in Utrecht after attending the Latin school in Breda, in the province of Brabant. His first appointment had been at Zundert, where he had been confirmed by his father on 1 April 1849. Jo van Gogh-Bonger's assessment would certainly have been accurate: "He was exceptionally good-looking (he was called the handsome parson by some), he had an amiable character and fine spiritual qualities, but as a preacher he had no special gifts, and so for twenty years lived unnoticed in the quiet village of Zundert

Both Vincent's father and his paternal grandfather were ministers.

[5] See, among others, Humberto Nagera's *Vincent van Gogh: A Psychological Study* (1967), pp. 13-14, and Albert Lubin's *Stranger on the Earth* (1972), pp. 77-102 (a whole chapter devoted to "The first Vincent and the sad mother"). In one of the latest biographies, Viviane Forrester's *Van Gogh ou l'enterrement dans les blés* (1983), a book that bristles with mistakes, Van Gogh's imaginary obsession with the still-born child for whom he was the unwanted "replacement" even became the main theme. Erroneously, the author assumed that the first-born was also called Vincent Willem (or Vincent Wilhelm as she persists in calling several members of the family). According to her, the gravestone not only shows that double name but the precise date of the birth: 30 March 1852. In reality, the stone has only 1852 as a date and *Vincent van Gogh* as a name. It is therefore quite possible, and even probable, that Vincent Willem van Gogh was never aware of the fact that "the first Vincent"—assuming that he knew of his existence—was born on the date of his own birthday.

[6] The latest scholarly genealogy of Vincent's ancestors was published in an article by Piet Sanders in *Genealogisch Tijdschrift voor Midden-en West-Brabant* (1981), entitled "Genealogie Van Gogh."

before he was called to other places, small Brabant villages like Helvoirt, Etten and Nuenen."

Two years after Vincent's birth a sister, named Anna Cornelia after her mother, was born (1855-1930). Another two years later, on 1 May 1857, a boy, who was given his father's name Theodorus, was born (1857-1891). Two girls followed, Elisabeth Huberta, nicknamed Lies (1859-1936), and Wilhelmina Jacoba or Willemien, often called Wil (1862-1941). The last child was Cornelis Vincent—"little brother Cor"—(1867-1900). When Cor was born, Mother Van Gogh was forty-seven.

On the subject of their children's education, it is surprising to discover that this village parson and his pious wife were far more broadminded than one might expect. It is certainly remarkable that the daughters were given such unusually good schooling. The eldest daughters, Anna and Elisabeth, were successively sent to the boarding-school of a Miss Plaat in Leeuwarden (in northern Holland) in order to study foreign languages. The girls were obviously successful; at the age of sixteen or seventeen it was not unusual for them to write to their brother Theo respectively in English and French. For the parents, this education must have meant a heavy financial burden. In a letter to Theo on 3 April 1875, his mother said in passing that Miss Plaat's school cost five hundred guilders a year, "and we have so much trouble getting it together."

Father Van Gogh made great sacrifices for his sons, too. In a letter dated 19 February 1873 he explained what he did to keep Vincent out of the military. "Last Saturday I went to Oisterwijk to draw lots for Vincent. He is 'in,' and I paid 625 guilders for a *remplaçant*." There was conscription in Holland at the time, but by drawing a high number in a kind of lottery, the person in question was exempt from his military duties. If the young man—or his father—drew a low number, it was still possible to avoid service by paying a considerable sum for a *remplaçant*, someone willing to take the place of the conscript. In this way, Father Van Gogh assured the same privilege for his other two sons. "If the law remains as it is now, then [Theo] and Cor will also be excused from military service." All this at a time when the clergyman's yearly income must be estimated at around one thousand guilders! There would be many conflicts between Vincent and his father—these two so widely divergent characters were bound to clash—but the father always did his utmost to help his eldest son. Father Van Gogh's letters seldom show resentment or anger toward Vincent—sometimes disappointment, but always great concern for his future.

The Van Goghs also attended to the education of their youngest son. Although not much is said about it in the letters, Cor was sent to a "Hogere Burgerschool," a type of grammar school which was new to the province of Brabant. This particular school was in Helmond. On 28 November 1882 Reverend Van Gogh wrote to Theo: "Cor is enjoying much friendship from the Carp family in Helmond, one of the most distinguished families in that town. Therefore on St. Nicholas Day Cor should give a present to Naud Carp who is at the H. B. school [Hogere Burgerschool] with him." On 19 July 1884 when Cor was seventeen, his father reported that his son had passed his final examination with good marks and that he was going to work as an apprentice at the factory of a Mr. Begemann in

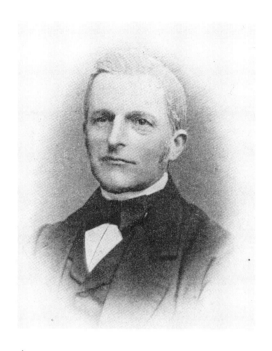

4
The Reverend Theodorus van Gogh.
Vincent van Gogh Foundation / National Museum Vincent van Gogh, Amsterdam

Helmond. The Reverend Van Gogh was required to pay for this apprenticeship, for lessons and for boarding—altogether more than eight hundred guilders. "It is certainly a terrible sum, but we must not hesitate and hope for the Lord's blessing."

As Vincent's father had ten brothers and sisters and his mother eight, he had many uncles and aunts. Several played important roles in Vincent's life. Most notable are his father's four brothers: Hendrik Vincent (Uncle Hein), Johannes (Uncle Jan), Vincent (Uncle Cent), and Cornelis Marinus (Uncle Cor, or C. M.).

Uncle Jan was a rear admiral and director of the navy yard in Amsterdam. Vincent went to live with him in 1877 and 1878 when he stayed in Amsterdam to study. The other brothers, Hein, Vincent and Cor, were art dealers, something which was of the utmost significance to both Vincent's and Theo's development and later life. In this respect, Uncle Vincent was the most important influence. At a young age he started a small business in paints and drawing materials in The Hague. Owing to his energy and insight, this modest shop soon grew into a prosperous art gallery. By 1858 Uncle Vincent had earned himself such a respected name in the art dealer's world that a well-known European firm, Goupil & Co. in Paris, invited him to become a partner in the business. He moved from Spuistraat to The Plaats (The Place) in The Hague, where a business was opened that he made very successful. Later he settled in Paris, first at 10, rue Chaptal above the Paris branch of Goupil, and subsequently in a suburb of Paris, le Vésinet. After his retirement in 1871, the letterhead for The Hague branch carried the heading: *Ancienne Maison Vincent van Gogh, Goupil & Cie., Successeurs*. In 1850 he married Cornelia Carbentus, and when they settled in the Brabant village of Prinsenhage, they had much contact with Vincent's parents. Prinsenhage was "near his old father at Breda and near his favorite brother at Zundert," Jo van Gogh-Bonger wrote in her Memoir. According to her, there was "a profound, cordial intercourse between the parsonage at Zundert and the childless home at Prinsenhage," and she concludes with the insightful question, "What could be more natural than that the rich art collector would destine his young nephew and namesake to be his successor in the firm—possibly even to become his heir?"

Uncle Hein first had a shop in Rotterdam, but he settled in Brussels in 1863 when Vincent was only ten. In 1855, he took a partner, Johan Oldenzeel, who had worked for him since 1851, and in 1858 he left him the management of the firm while he remained a partner himself. (The well-known firm of Oldenzeel was therefore the direct successor to the Dutch firm of H. W. van Gogh.) For health reasons, however, Hein gave up his business in Belgium in 1872 and took a house in Laeken near Brussels. When Vincent lived in Brussels for some months in 1880 and 1881, he sometimes went to see a Mr. Schmidt, who was the manager of the firm then, Uncle Hein having died in 1877. In the course of the years Vincent and his brother Theo had many contacts with their father's youngest brother, Uncle Cor. In 1862, he set up his own art firm in Amsterdam at Leidschestraat 190. The art business C. M. van Gogh (later at 449 Keizersgracht) developed a fine reputation and was later owned by Uncle Cor's son Vincent, who died in 1911.

5
Vincent van Gogh (Uncle Cent).
Vincent van Gogh Foundation/National Museum Vincent van Gogh, Amsterdam

Uncle Hein, 1814-1877.
Uncle Jan, 1817-1885.
Uncle Cent, 1818-1888.
Uncle Cor, or C. M., 1824-1908.

6
Birthplace of Vincent and Theo in Zundert.

When Vincent was born, Zundert was a fair-sized village of six thousand, mostly Roman Catholics. The Protestant parish, whose minister Vincent's father Theodorus became in 1849, consisted of only 120 to 130 members, scattered over a large municipality that also included the village of Wernhout.

The house where the six Van Gogh children grew up was very small; the first floor was two windows and a front door wide, and the second floor was only two windows wide. (The house no longer exists, but photographs of it have been preserved.) Any luxury in the lives of these children must have been out of the question, if only because of the extremely meager income of this village minister. But luxury would have been the last thing they desired, because, at least in the summer, the surroundings completely sufficed for their games and leisure. It was, of course, a blessing for them to be able to grow up in the quiet, pastoral atmosphere of this Brabant village that was surrounded by fields of heather and woods. Forty years later in the first words of her booklet, Elisabeth Huberta referred to them as "real village children." Her

description of Vincent's looks when he was about fifteen is in accordance with this picture.

> Rather broad-shouldered than tall, his back slightly bent by his bad habit of keeping his head down, the short-cut reddish-blond hair under a straw hat, shading a strange face; certainly not a boy's face! The forehead already wrinkled, the eyebrows pulled together in deep thoughts above a pair of eyes, small and deep-set, now of blue, now of greenish color according to the impression things around him made. Not handsome, ungraceful, he was remarkable at such an early age because of the profoundness that was expressed in his whole being. His brothers and sisters were strangers to him; he was a stranger to himself; he was a stranger to his own youth.

It would be interesting to know whether anyone noticed an early drawing talent in Vincent. When in 1926 Benno J. Stokvis investigated whether there were still people in Brabant who could remember anything about the artist, the result was meager, and among the people he interviewed there was no unanimity as to the question of his drawing talent.[7] Elisabeth du Quesne's recollections leave no doubt: Vincent did not show a conspicuous talent at all. She was not quite correct when she said that "there had not survived a single little pen drawing or pencil sketch" made by Vincent in those years. About a dozen, made when he was between the ages of eight and ten, have survived; Dr. J. G. van Gelder, who made a detailed study of Vincent's early work, believes these to be authentic.[8] One of them represents a small bouquet of flowers, strongly resembling the few decorative flower drawings that his mother had made, so it may be assumed that he copied it from one of her bouquets. The other drawings show landscapes with additions such as a little bridge, a farm or a barn. A few could be identified as copies after drawing models by V. Adam (a drawing of a barking dog shows an annotation with that name), and it is likely that most of the others, if not all of them, were copies as well.

Little is known about Vincent's schools, with the exception of the last. Evidently, Elisabeth du Quesne, who was six years his junior, did not remember anything about them (the only information she gives in passing is erroneous), and Jo van Gogh-Bonger did not know much either. The bit of information she knew probably came from her mother-in-law. "For a short time he attended the village school, but as his parents found that the daily company of peasant boys made him too rough, a governess was sought for the children of the parsonage, whose number had meanwhile increased to six." For Vincent, this kind of education would not last long. When he was only eleven his parents decided to send him to a boarding school in the village of Zevenbergen, directed by a man named Mr. Provily. His departure date from Zundert is given in the municipal archives as 1 October 1864, and he stayed at the boarding school until the summer of 1866, when he seemed sufficiently prepared to go to the secondary school his parents had chosen for him. That he had gone to a secondary school at all was unknown until as late as 1971, when the surprising discovery

[7] *Nasporingen omtrent Vincent van Gogh in Brabant* (1926).

[8] See De la Faille's 1970 catalogue under "Juvenilia," pp. 600-609.

was made that he had attended a school in Tilburg for almost two years. It was a fact which his sister Elisabeth had evidently forgotten completely, and which his mother does not seem to have told Jo van Gogh-Bonger. The information was published in a local periodical, *Brabantia*. The author, Dr. H. F. J. M. van den Eerenbeemt, professor of history of economics at the Tilburg School of Economics, was chiefly interested in the history of education in Brabant, but the discovery that Vincent van Gogh had been one of the first pupils of the newly founded institute in Tilburg gave his article an unexpected importance.

The school, called Rijks Hogere Burgerschool "Willem II" (State Secondary School King Willem II), occupied a building that had been the palace of the late King Willem II and had been donated by his heirs to the municipality of Tilburg. When Vincent arrived in April of 1866, the school had just opened. As the government offered good salaries, the school could boast of a good teaching staff, quantitatively and qualitatively. There were nine teachers and, at the beginning of the first school year in September 1866, thirty-six pupils. Since the school did not house its students, a boarding house had to be found in Tilburg for Vincent. According to Professor Van den Eerenbeemt: "an address 'for the placement of young gentlemen for board, lodgings and family conversation' was found in the Korvel quarter at number 57, at present St. Annaplein no. 18-19. At this address in the Korvel lived J. Hannik with his wife and a son five years older than Vincent. The young boarder was the only one the Hannik family had in their home."

Although a preparatory class had been formed, Vincent was at once admitted to the first class (seventh grade) because of his excellent primary training. The weekly program of lessons was duly impressive. "Dutch and German three hours a week; both French and English five hours; arithmetic, history and geography each three hours; geometry one hour; linear drawing one hour; free-hand drawing four hours; botany and zoology two hours; calligraphy two hours; gymnastics two hours." Several pupils of the preparatory and first class were not promoted to the next grade after the examinations in July 1867. It is, therefore, an important indication of Vincent's intelligence that he was among the five students out of ten who were promoted to the second class.

Vincent never finished the second school year. In March 1868, a few months before the end of the term, he left Tilburg to return to Zundert. The reason for this move is still unknown. If he had found a job, this would seem understandable, but Professor Van den Eerenbeemt found that "Vincent stayed in Zundert more than a year without having any occupation." Whatever the reasons for his leaving, Vincent's parents, by allowing him to attend this secondary school for even a short time, gave him the opportunity to enjoy an education which was of the greatest value to the formation of his personality.

In his letters to Theo, Vincent did not describe his departure from home to take up employment. Yet this must have been an important moment, because it signified the end of his boyhood and school years. This moment came at the end of July 1869 when he was sixteen. Evidently there was no question of prolonging his studies any longer; Vincent had to leave home and earn a living. His choice of profession, to become an art dealer, was not surprising given that three of his

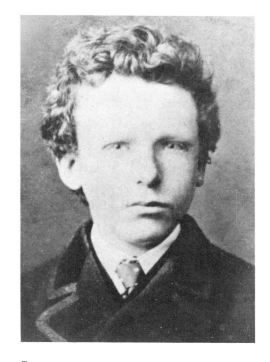

7
Vincent van Gogh, age 13.
Vincent van Gogh Foundation / National Museum Vincent van Gogh, Amsterdam

father's brothers were art dealers. Uncle Vincent's influence was particularly strong. Although he had lived in Paris since 1862, he was still a leading figure in the Goupil company (of which the branch in The Hague was now managed by H. G. Tersteeg).

Theodorus van Gogh was born in Zundert on 1 May 1857, a little more than four years after Vincent. While Vincent had been named after his two grandfathers—and perhaps also after his thirty-three-year-old uncle—the second son was honored with his father's name, as if the parents had foreseen that he was to become the pride and glory of the family. It could certainly not be said that Theo was a "replacement child"; from the beginning he had his own identity, and no dark cloud hovered over his youth as has been said about Vincent's. Yet his short life would be characterized by a melancholy that may have been even greater than his brother's. About his early years even less is known than about Vincent's. When their sister Elisabeth published her recollections in 1910, her hero was Vincent; Theo was only mentioned in passing as one of the playing children who was so different from the earnest, lonely boy of seventeen.

Theodorus van Gogh (Theo), born in Zundert, 1 May 1857.

From the Memoir to the *Complete Letters* it is known that Vincent had been at the village school, if only for a short time. Whether Theo attended this school is questionable. It is possible that he had his early lessons only from the governess, employed to protect the children from the roughening influence of the village boys. He later attended a boarding school for some time; not at Mr. Provily's boarding school at Zevenbergen where Vincent had been, but at a school in Oisterwijk, another village in Brabant. When the Van Gogh family moved to Helvoirt in January 1871, the Reverend Van Gogh having been called there, Theo walked to this school in Oisterwijk every day until the end of December. There is an echo of this in the first few letters from Vincent to his young brother. In August 1872 he wrote Theo, "What terrible weather! You must have suffered from the heat on your walks to Oisterwijk" (letter 1), and on 13 December he wrote sympathetically, "I pity your having to walk to Oisterwijk every day in this beastly weather" (letter 2).

At that moment, however, the end of Theo's school days was in sight. On 1 January 1873 he was to begin earning his own living, and, in the family tradition, it was in the art business. Theo was fifteen when he left school, younger than Vincent, who was sixteen when he began working for the art dealers at Goupil & Co. As Vincent was employed in The Hague branch of Goupil's, Theo was placed elsewhere. Evidently the firm did not like having two brothers in the same gallery. Theo was sent to the offices in Brussels, 58, rue de la Montagne de la Cour. His Uncle Hein had been the manager of this branch for many years before illness compelled him to stop working in 1872. On 19 February there is a reference in one of the Reverend Van Gogh's unpublished letters to the fact that Theo received thirty francs as his first earnings, and that this was welcome news. "So now you're helping us, too, and I have to pay only fifty francs a month instead of eighty."

Theo enters the art business, January 1873.

Vincent's letters from January 1873 show that Theo found a good boarding house and visited Uncle Hein and his wife regularly. He seemed to be on good terms with his employer V. Schmidt, Uncle Hein's successor, and even moved into his

house in June 1873. Vincent wrote to him: "I hear from home that you are staying with Mr. Schmidt now and that Father has been to see you. I certainly hope this will please you better than your former boarding house, and I'm sure it will."

8
The art gallery of Goupil in The Hague, where both Vincent and Theo van Gogh worked for some time.
Vincent van Gogh Foundation / National Museum Vincent van Gogh, Amsterdam

However, he did not stay in Brussels long. When Vincent was transferred to Goupil's London branch in May 1873, his father asked for Theo's replacement to The Hague. A letter from Vincent shows that Theo arrived there on 12 November and lodged at the same address where Vincent had lived (letter 12a). Theo's employer in Brussels gave him a very good written reference (included in the *Complete Letters* under T 43):

The undersigned declares that Mr. Theod. van Gogh had been employed by our house from 6 January of the current year until today, and that I have every reason to express my entire satisfaction with his behavior as well as with the zeal he has given evidence of during this period of time.

Brussels, 14 November 1873
H. V. van Gogh
V. Schmidt, successor.

Sixteen-year-old Theo could look upon the start of his career in the art business with contentment.

Amazingly little is known about Vincent's life and work while he was with the Goupil company in The Hague as not a single one of the letters he certainly must have written home has survived. It is only from the last nine months of that four year period that a few letters to Theo have been preserved. Vincent's father accompanied him to The Hague at the end of July 1869, so his work as a junior clerk at Goupil's must have begun around that date and ended when he was transferred to London in May 1873. As a whole it seems to have been a happy and fruitful time for him.

Vincent's relationship with Mr. Tersteeg, who was only eight years his senior, must have been very good. He also must have known his employer's family well, because in 1874, he sent their five-year-old daughter Betsy a small album with sketches he had made for her, accompanied by a very friendly note. It is only in a letter from the last half year of his stay in The Hague that he mentions something about his position at Goupil's. Not only does it state his salary, but it also shows that he was still full of enthusiasm for the art business and had worked to the satisfaction of his employers. "My new year began well," he wrote to Theo in January 1873. "My salary was raised ten guilders, so that I now earn fifty guilders a month, and in addition I got fifty guilders as a bonus. Isn't that splendid! I hope to be able to shift for myself now. . . . It is such a splendid firm; the longer you are in it, the more ambition it gives you" (letter 3).

Vincent must have spent much of his time in The Hague studying art. A visit to his Uncle Cornelis Marinus in Amsterdam also allowed him to look at paintings, in his uncle's home as well as in the museum. "Last Sunday I spent a very pleasant day at Uncle Cor's, as you can imagine, and saw so many beautiful things. As you know, Uncle just came back from Paris and brought some beautiful pictures and drawings with him. I stayed in Amsterdam till Monday morning and went to see the museums again. Do you know that they are going to build a large new museum in Amsterdam instead of the Trippenhuis [the later national museum]? I think it is right, for the Trippenhuis is small, and the way many pictures are hung, they can hardly be seen" (letter 4). The years Vincent spent at Goupil's in The Hague also developed his love for art considerably. The management of the firm undoubtedly wanted to further that love by giving him the opportunity to see as much as possible. It was in the interest of his training that when they sent him to London, it was via Paris, to enable him to get acquainted with the galleries the Goupil firm had in that city.

On 17 March 1873, Vincent informed Theo that he was being transferred to London. This letter confirms that by this time, studing paintings had become more important than ever. "A fortnight ago I was in Amsterdam to see an exhibition of the pictures that are going from here to Vienna. It was very interesting, and I am curious to know what impression the Dutch artists will make in Vienna. I am also curious to see the English painters; we see so little of them because almost everything remains in England" (letter 5).

Contemplating his upcoming stay in London he wrote: "It will be quite a different life for me in London, as I shall probably have to take a room and live by myself and therefore will have to take care of many things. I don't have to worry about that now. I am very much looking forward to seeing London, as you can imagine, but still I am sorry to leave here; now that it has been decided that I have to go away, I notice how strongly I am attached to The Hague. Well, it can't be helped, and I intend not to take things too hard. I am very glad, as it will be good for my English; I can understand it well, but don't speak it as well as I should wish." It is no wonder Vincent didn't speak English well, as he had never had an opportunity to practice. That he knew English as well as he did speaks for the excellent language education he received at the boarding school and at the grammar school. In August 1873 he wrote that he enjoyed reading the poems of John Keats, and a few years later he would teach English children and even preach in that language (letter 10a). A letter dated 5 May gives more details about his departure for London: "My time here is almost up. Next Saturday I go home [to Helvoirt] to say goodbye, and then on to Paris on Sunday, or, I'm afraid, on Monday, so that I shall have to stay over in Helvoirt on Sunday. I hope to write you in time when I'll be passing through Brussels, but I may not be able to do that, as I do not know for sure when I have to be in Paris at the latest" (letter 7).

9
Vincent van Gogh, age 18.

In a letter of 13 June from London he wrote to Theo: "In Paris I spent some very pleasant days, and you can well imagine how much I enjoyed all the beautiful things I saw at the exhibition and in the Louvre and the Luxembourg. The firm in Paris is splendid and much bigger than I had expected, especially the [gallery at the] place de l'Opéra" (Goupil had two galleries and a printing shop in Paris) (letter 9). How long Vincent stayed in Paris cannot be deduced from this letter, and so it cannot be determined exactly when he started his work in London. He can only have been in Paris a few weeks, because there is an unpublished letter from his father dated 31 May in which he tells Theo that he has already received a letter from Vincent in London. In any case, his first visit to Paris, however short, must have left unforgettable impressions.

VINCENT IN LONDON AND PARIS

There is a wealth of information about Vincent's stay in London, but many questions still remain unanswered. His first boarding house was in one of the comparatively quiet suburbs of London. Neither the name of the suburb nor the address of the house is mentioned in Vincent's letters, but he writes that the place where he stayed pleased him. He found the neighborhood "quite beautiful, and so very quiet and intimate that you almost forget you are in London. . . . In front of every house there is a small garden with flowers or a few trees, and many houses are built very tastefully in a sort of Gothic style." In the second half of July he wrote, still in the same vein, "I walk a lot and the neighborhood where I live is quiet, pleasant and fresh—I was really very lucky to find it." Nevertheless, a few weeks later he considered moving to a village outside London if he could find a cheap room, "but moving is so horrible that I shall stop here as long as possible, although everything is not so beautiful as it seemed to me in the beginning." The following month he did move to another room, though not outside of London as he had planned.

The London branch of Goupil & Co. was very different from the branch in The Hague and from the three Paris branches of the firm he visited on his way. In London, Goupil had no gallery, but sold directly to art dealers. Apart from paintings they sold mostly engravings, reproductions and photographs. The "good" engravings sold relatively well, and it was "a pleasure to see" how well the photographs sold, especially the colored ones, which were quite profitable. Vincent did not find the branch here as interesting as the one in The Hague. He had a rather critical opinion of it, talking like someone who already had some expertise. "Lately we have had many pictures and drawings here; we sold a great many, but not enough yet. It must become something more established and solid. I think there is still much work to do here in England, but it will not be successful at once. Of course, the first thing necessary is to have good pictures, and that will be quite difficult" (letter 12). It is rather amusing to read that he had such confidence in his future with the firm. "Later on, especially when the sale of pictures grows more important, I shall perhaps be of use. And then, I cannot tell you how interesting it is to see London and English business and the way of life, which differs so much from ours" (letter 12).

Vincent's employer was Charles Obach, with whom he evidently had a good rapport; in one of his first letters from London, Vincent described a long trip he made with him. "Last Sunday, I went to the country with Mr. Obach, my principal, to Box Hill; it is a high hill about six hours by road from London, partly of limestone and overgrown with periwinkle, and on one side a wood of high oak trees" (letter 9). For the time being, the correspondence address he gave in these letters was the address of the firm: "Messrs. Goupil & Co., 17 Southampton Street, Strand, London" (letter 9).

Apart from these facts that are found in Vincent's own letters, additional information can be obtained by studying the unpublished letters from his parents. The Reverend Van Gogh wrote to Theo on 31 May 1873: "We have a nice letter from Vincent. He is living in the outskirts of London and in the

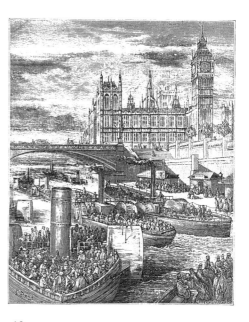

10
The Houses of Parliament and the Thames with the "penny steamers," London. Print by Gustave Doré.

morning at 8:30 he goes to the city in a little steamer, which takes him an hour, he eats in town and comes home at seven. His lodgings are quite expensive, but he doesn't know yet what his salary will be. So far he likes it very well, and Uncle Cent [Vincent] has seen to it that he met some people." In her part of the same letter, Mother Van Gogh had special praise for sixteen-year-old Theo, who was doing very well in Brussels by now, but she was also proud of Vincent. Commenting on Theo's responsibilities at work she wrote: "Let that be your greatest joy and care, then you will become clever and reliable and make yourself indispensable, and this way you will have chosen the best way to be spared temptations that you will certainly meet just like any other boy, and you remain our crown and our honor and our joy, just like Vincent, who had great satisfaction [from his work]. Aren't you glad he does so well; he had so much pleasure in Paris, he had dinner with the Cailloux family, and he found the interior of the gallery splendid. Who knows if you may not work there too, some time in the future."[9] A few months later, on 2 July, Father Van Gogh wrote more about Vincent's salary. "He gets ninety pounds, 1,080 guilders a year [almost twice as much as in The Hague], yet he has to be economical because of the high cost of living there; his boarding house and his dinner cost him 890 guilders a year. He is very happy with the firm. He is not quite used to his work yet, but the tone of his letters is one of satisfaction."

All the same, Vincent moved a month later. His father wrote Theo on 25 August: "Vincent is doing well in London. We get cheerful letters. He has moved in order to live more economically, as his former boarding house became too expensive, and he had found a good one for 180 guilders a year less." The only thing Vincent himself wrote about this second address was in a letter of 13 September 1873: "Oh, boy, I should like to have you here to show you my new lodgings, of which you will certainly have heard. I now have a room such as I always longed for, without a slanting ceiling and without blue wall paper with a green border. I live with a very amusing family now; they keep a school for little boys."

Jo van Gogh-Bonger's Memoir gives more details about Vincent's stay at the Loyers' and about his controversial first love story, which, for lack of other information about the subject, has been repeated in most books on Van Gogh. She begins her long passage: "Here he spent maybe the happiest year of his life. Ursula made a deep impression upon him." In Jo van Gogh-Bonger's opinion, his feelings for Ursula had a strong effect on Vincent's mood and even on the development of his character. "He did not write it to his parents, for he had not even confessed his love to Ursula herself, but his letters home were radiant with happiness. He wrote that he enjoyed so many good things, 'I have a very nice home,' and in the fullness of his heart he exclaims, 'such a rich life, your gift O God.'" In the beginning everything seems to have gone well: "In January [1874] his salary was raised, and until spring his letters remained cheerful and happy. He intended to go to Holland in July, and before that time he apparently spoke to Ursula about

Vincent's new house was the boarding house mentioned in the Memoir, "the house of Mrs. Loyer, a curate's widow from the south of France, who with her daughter Ursula ran a day school for little children."

[9] This letter also contains the remark, found in the Memoir of the *Complete Letters* and later repeated in several books about Vincent, "Our Vincent wrote that he had bought a top hat; you cannot be in London without one."

his love. Alas, it turned out that she was already engaged to someone who boarded with them before Vincent came. He tried to make her break this engagement, but he did not succeed, and with this first great sorrow his character changed; when he came home for the holidays he was thin, silent, dejected—a different being."

In the last few years some new facts have been discovered about the Loyers which complicate the story. After much research, a postman named Paul Chalcroft, whose hobby was painting copies of Vincent's pictures, succeeded in finding out where the Loyers had lived. The address was 87 Hackford Road, a street in the London district of North Brixton. This led to the discovery that the girl was not called Ursula but Eugénie (the *mother* was named Sarah Ursula Loyer).

An unpublished letter from Anna van Gogh, sent to Theo from Leeuwarden on 6 January 1874, introduces some of the confusion connected with this episode. As Anna was studying languages at Miss Plaat's school in Leeuwarden, the letter was written in English.

> Monday morning at breakfast I found a letter from London, which contained a letter from Vincent and one from Ursula Loyer, both were very kind and amiable. She asks me to write her and Vincent wished very much we should be friends. I'll tell what he writes about her: [The next three sentences are in Dutch.] "Ursula Loyer is a girl with whom I have agreed that we should consider ourselves each other's brother and sister. You should consider her as a sister too and write to her, and I think you will then soon find out what kind of a girl she is. I'll say nothing more than that I never heard or dreamed of anything like the love between her and her mother. . . . Old girl, don't think there is more behind it than I wrote just now, but don't tell them at home; I must do that myself. But again: Love her for my sake." I suppose there will be a love between those two as between Agnes and David Copperfield. Although I must say that I believe there is more than a brother's love between them, I send you here Ursula's letter and so you can judge for yourself. I hope you will send it back very soon with a long epistle of yourself.

This letter must have been one of the sources Jo van Gogh-Bonger used when relating the Ursula Loyer episode in her Memoir; she did not use the name Ursula by mistake, but had found it in Anna's letter. The question, then, is why did Anna use this mistaken name? She could have found it only in Vincent's own letters; she even uses it in a direct quotation from him. Could he have imagined that this was her real name? Was she perhaps really called Ursula sometimes? In accordance with the customs of those days, Vincent surely addressed her as "Miss Loyer," but wouldn't he have heard her mother call her Eugénie? This is a mystery that has not yet been solved. However, when Anna wrote again on 24 February 1874, she used the name *Eugénie*, which shows that somehow or other between the three of them the error had been corrected. "I got too a very kind letter from Eugénie; she seems to be a natural and amiable girl. Vincent wrote that she was engaged, with a good natured youth who would know to appreciate her. . . . We two are just [like] old people who try to know all about persons who are in love. But I am very glad for Vincent that he found such a kind family to live [with], you

know yourself how agreeable it is. He seems to be always in good spirits."

It is quite probable that Vincent really did fall in love with Eugénie Loyer, considering the fact that he was a young man of twenty living under the same roof with a nineteen-year-old girl who, according to Anna, was "natural and amiable." This conclusion seems to be confirmed by Vincent himself. In connection with his love for Kee Vos, a woman he met in 1877, he wrote: "I made a similar mistake once; I gave up a girl and she married another, and I went away, far from her, but kept her in my thoughts. Fatal." As he had asked himself earlier in the same letter, "What kind of love was it that I felt when I was twenty?" it is certain that he was thinking of something that had happened in London (letter 157).

The final conclusion can only be that the episode has been somewhat exaggerated and over-dramatized by other biographers, especially since many contradictions exist in the letters. In the beginning of January 1874, Vincent wrote that he and Eugénie looked upon each other as brother and sister, and he assured Anna that she should not think there was more behind the relation, though this caution did not prevent Anna—herself a girl of eighteen—from imagining that he might feel more than brotherly love. Vincent knew in February (not June or July as is stated in the Memoir) that she was engaged, but that did not stop him from being "always in good spirits"; nothing in the letter indicates that Vincent came home "silent, dejected—a different being." He wrote to Carolien van Stockum-Haanebeek, an acquaintances from The Hague: "I live a rich life here, 'having nothing, yet possessing all.'" (letter 13a). When he sent Theo congratulations for his birthday on 30 April 1874, he sounded quite cheerful, although he had known for three months that Eugénie was engaged to someone else. Because of these contradictions and ambiguities, there is little evidence to truly support or reject the entire story of Vincent's first love that has put so many biographers' pens in motion.

When Vincent visited his parents in Holland at the end of June 1874, he had the pleasant opportunity of not having to return to England alone, and the letter he wrote to his friends Carolien and Willem van Stockum in March shows how much he enjoyed the idea. "Now I have something new to tell you; perhaps our Anna will come here. You can well imagine how wonderful this would be for me. It is almost too good to be true. Well, we'll have to wait and see. If she comes, it will probably be in May; and perhaps it might be arranged for me to go and bring her back. I am longing to be closer to her than I am now. We have hardly seen each other once these last few years, and we only half know each other" (letter 14a). Anna, now nineteen, did venture to England to look for a job—she had a certificate in French—but the journey was postponed until July. It was after Vincent had spent two weeks in Helvoirt that they left together for London, where they arrived on 15 July 1874. On 21 July Vincent informed Theo: "Anna and I arrived safely in London and hope we shall find something for her here. I do not say it will be easy, but every day she is here she learns something, and at all events I think there is more chance for her to find something *here* than in Holland. It is a great pleasure for me to walk with her through the streets in the

Vincent's first love, Eugénie Loyer.

20

evening. I find everything again as beautiful as when I saw it the first time" (letter 19).

Upon his return Vincent rented his room at the Loyers' again, and Anna found lodgings there, too. At the end of July he wrote home optimistically about their being together. "Anna is in good spirits; we take beautiful walks together. It is so beautiful here, if only one has an open mind and an eye without many beams in it. But if one has that, it is beautiful everywhere" (letter 20). They must have stayed together for more than a month, because when there was talk of moving in August, it meant moving together. Vincent gave no reason for the move when he wrote: "A[nna] and I take walks every evening. Autumn is coming fast and that makes nature more serious and more intimate still. We are going to move to a house quite covered with ivy; we shall soon write more from there" (letter 21). Unfortunately there are no letters from Vincent which provide more information about this period; in the published correspondence there is a gap of no less than half a year. An unpublished letter from his parents gives some insight into the course of events. On 15 August Father Van Gogh wrote to Theo: ". . . they have moved and live no more *en famille* [with the family], but have rented rooms. Their address is Ivy Cottage, 395 Kennington New Road, London. At the Loyers it appeared not to be too satisfactory. I am glad; I did not trust it too well."

In the same letter he gave more information about Anna's plans: "Yesterday afternoon there was a letter from Vincent and Anna. . . . Anna found a job at a school (dayschool) in a small but very nice village some five hours from London. Salary twelve pounds a year, so that is not much yet; . . . She is free at four in the afternoon and lives with the lady, a little, shy person, she writes." A few of the sentences his wife added were: "How strange it will be for them when they part company. On the 24th of August Anna must start her job; may she have the courage and strength to go on with it. . . ."

The village where Anna was to work was named Welwyn, less than twenty miles north of Kennington Road. The "little, shy lady" was Miss Caroline Applegarth, and her school was located in a house that coincidentally had the same name as the house on Kennington Road, Ivy Cottage.[10] There is a plaque on the wall of the school building which reads: "In this house dating from c. 1452 and formerly 'Miss Applegarth's school,' ANNE VAN GOGH taught French in 1875 and 1876. Her brother VINCENT VAN GOGH walked all the way from Ramsgate [the village where he worked after leaving London] to visit her at Rose Cottage, Church Street, where she lived at the time." The fact that Vincent visited her in Welwyn is confirmed by his own letter of 17 June 1876 (letter 69).

Van Gogh biographers have generally assumed that Anna lived in Ivy Cottage in Welwyn, when in actuality she worked

Vincent and Anna stayed together at their new address for only a few weeks, as she had to begin work on the twenty-fourth of August.

[10] In the Memoir to the *Complete Letters* Jo van Gogh-Bonger gives the name of the street as *Hensington New Road*. Alan Bowness, in his catalogue of the Van Gogh exhibition in the Hayward Gallery, 1968, was the first to notice the error of Hensington for Kennington. David Bruxner, who did extensive research on Vincent's stay in England, established that the official name of the street was *Kennington Road* (Kennington *New* Road may have been what the inhabitants called the street for some time), and that Vincent's landlord was John Parker, a "publican" (information obtained in letters from David Bruxner). In Vincent's letters, Parker is mentioned only once, in letter 117 from 1878.

there and lived at Rose Cottage. This house, too, has a plaque on its wall which reads, "ANNE VAN GOGH a sister of the painter lived here in 1875-1876. Employed as an usher at a school in Ramsgate at the time, he visited Anne on more than one occasion, poverty compelling him to walk all the way from London." These plaques are not very reliable sources in themselves, but they are based on the information of a local historian, W. Branch Johnson, who found among the parish records of Welwyn Church an old list of donors or subscribers to a church fund; an entry showed that the sum of five shillings a year in 1875 and 1876 was contributed by Anna van Gogh, then living at the Rose Cottage.[11]

Another curious fact that has so far remained undiscovered is that not only Anna, but also her younger sister Willemien, then only thirteen, stayed in Welwyn. She had been sent to England by her parents for her education and entrusted to Anna's care. These facts are confirmed in the family letters, including a letter to Theo from his father dated 11 August 1875: "The time is near that Anna and Willemien are going to leave us." From the letters it also becomes clear that Willemien stayed in Welwyn only about a year. Father Van Gogh wrote to Theo on 8 March 1876, "It is just as I wrote you, it is certain that Willemien is not going to stay in England," and on 15 March: "Anna suggests that she will come home with Willemien in the beginning of May and stay with us until August. Up to that time she is willing to remain Willemien's governess." (Later letters show that Willemien came home *by herself* in the second half of May, while Anna stayed on much longer.)

Willemien's stay in Welwyn, 1875-1876.

Transferred to Paris

In October 1874, Vincent was transferred to Paris for a short time, though not quite with his full approval, and he wrote unpleasant things home about the move, assuming that his father had arranged it. It is telling that Vincent did not object to the transfer in itself—according to his mother, in any case—but he could not bear his father's interference in his affairs. In turn, his parents were unhappy about the events. In a letter to Theo of 28 October, his mother wrote:

Paris, October-December 1874.

> Don't you think it very sad that Vincent does not write to us, during such important days. Oh Theo, you don't know how it distresses us and how we long to go to him and say, "Boy, how is it? Isn't it true we can't live without each other and love each too dearly to be estranged from each other and not open our hearts?" He thought that Father had brought about his transfer, which in itself he was pleased with, he wrote in his last unfriendly note. We later heard from Anna that he had sent her a postcard asking for his suitcase. She was also longing to hear something from him. After that letter from Vincent, Father assured him immediately that he had not spoken about Paris with Uncle [Vincent], but Uncle with him. Uncle had said he wished

[11] This information was published by W. Branch Johnson in the booklet *Welwyn, By and Large* (1967). I owe the information about Anna's stay in Rose Cottage to David Bruxner who also did research on the schools in Ramsgate and Isleworth where Vincent taught. The list of subscribers which formed the basis of W. Branch Johnson's discovery has been lost, but there is no reason to doubt the story.

the transfer for Vincent's sake; he wanted to give him a better insight into the business, especially in connection with the later enlargement of the London branch.

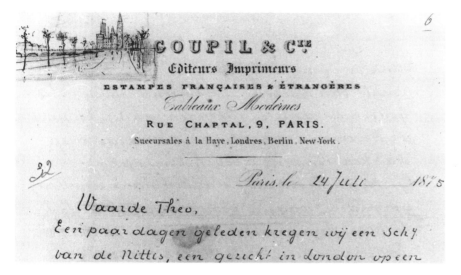

The beginning of a letter Vincent sent to Theo from Paris in 1875. It shows a sketch of Westminster Bridge after a painting by G. de Nittis (letter 32).

Vincent's first stay in Paris, arranged by Uncle Vincent with his best interests in mind, lasted from October until December 1874. Little is known about it, however, since not a single one of his letters to Theo from those months has survived. It follows from his parents' letters that Vincent spent Christmas in Helvoirt with the other children. Anna alone remained in Welwyn, but she spent some days with Vincent at Kennington Road when he returned to London. "I am glad she is still together with Vincent," the Reverend Van Gogh wrote to Theo on 7 January 1875, and when Lies returned to school his wife added, "We are still enjoying the memories of those nice days together. Those were very good days that we won't forget easily, and Vincent being with us that cold evening, and Anna's nice letter arriving when we were all sitting together around the stove." On 1 February Father Van Gogh wrote that there had again been a letter from Anna about her stay in London. "Together with Vincent she had seen *Hamlet* there and seems to have well enjoyed it all."

After reading this it is surprising to discover that the relation between brother and sister was not as agreeable as their parents must have believed. In a letter from Anna herself written to Theo a few months later on 28 April 1875, she gives a curious image of Vincent (this time she wrote in Dutch):

> Do you sometimes hear from Vincent? I never do. It seems to me he has illusions about people and judges them before he knows them, and then, when he finds out how they really are and that they don't come up to the expectations he had formed *too soon* about them, he is so disappointed that he throws them away like a bouquet of wilted flowers without looking whether among those wilted flowers there would not be some that are not "quite rubbish" [in English in the text] if only they would be treated with some care. I am really sorry I went to stay with him during the school holidays and was a burden to him. If I would have had any reason to foresee that that would be the case I certainly would have found some way to arrange things differently. I did not tell this to the people at home; they think he is a great support to me and that seems to give Father and Mother a

great sense of relief. Well, the sun shines into my little room too beautifully and joyfully to think about unpleasant things and still less to write about them; if, however, you know why he is like that to me, I should be very glad if you would tell me.

Although she probably felt that in Vincent's eyes she was one of those "wilted flowers," Anna was too independent to have much need of his support. She liked her job in Welwyn, and she felt herself quite at home there. In her father's words: "She is happy and feels well placed, she likes her work and gets satisfaction out of it. She is really becoming a very capable person and she blesses the opportunity of being surrounded by such beautiful nature; she says it gives her courage and force to work and struggle on, and serenity and peace in the heart" (11 February 1875). She also had a very good rapport with her employer, Miss Applegarth; together they visited Anna's parents in Holland during the summer of 1876.

Exactly a month after Anna's letter of May 1875, Theo received one from his sister Lies with the opposite opinion of Vincent. Shortly after her sixteenth birthday she wrote him on 30 May 1875 (in not quite faultless, yet admirable French): "Oh, if only Anna wanted to, how much she would be able to do for him. I don't understand she has changed so much; I used to think she loved him so much." Reminding Theo of a peaceful evening they had spent together at home, probably at Christmas, she continued: "I have never had the opportunity of really getting to know Vincent well, but during that holiday and at that moment I realized what he is and what it meant to have such a brother. Theo, I for one, I think we should be proud of him and should follow his example instead of going against him. If only Father could hear but once how he talked to us then and could realize the purity of his thoughts, how differently he would think of him." Lies was certainly not uncritical of Vincent. In one of her letters to Theo from 18 August 1876, at a time when Vincent's letters overflowed with texts from the Bible, she wrote: "How much worry that boy gives Father and Mother. Looking at them one could not fail to notice it. It is a pity he doesn't have a little more energy. He becomes dull with piety, I believe."

Vincent stayed in London another five months (January to May 1876), and he did not write again about his work in the four letters known from that period. He was still preoccupied with literature and art. His preferred authors were Michelet and Ernest Renan (he especially admired Renan's *La Vie de Jésus*). When he was again transferred to Paris in May, he ended his last letter to Theo from London with a quotation from Renan which must have expressed his deepest thoughts and which foretold his attitude toward life in the coming years. Nothing could better express the essence of his later artistic convictions than Renan's words: "Man is not on this earth merely to be happy, nor even to be simply honest. He is there to realize great things for humanity, to attain nobility and to surmount the vulgarity of nearly every individual."

When Vincent continued his correspondence with Theo from Paris, the tone of his letters at first did not change. There were few signs of dejection, although Jo van Gogh-Bonger wrote that "his letters home were melancholy." In his letters to Theo, Vincent described a Corot exhibition and the paintings in the

Jules Michelet, 1798-1874.
Ernest Renan, 1823-1892.

Louvre and the Luxembourg with obvious enthusiasm (letter 27). A sale of drawings by Millet was mentioned with the somewhat exalted words, "When I entered the hall of the Hôtel Drouot, where they were exhibited, I felt like saying, 'Take off your shoes, for the place where you are standing is holy ground' " (letter 29). He further tells about the prints he had on the walls of his little room; it must have been quite a large display, for he describes twenty—significantly all with profane subjects.

After 13 August 1875 (beginning with letter 33), his letters to Theo have a distinctly different tone, as he became more and more dominated by religious thoughts. He now wrote about attending church, something he never mentioned in earlier letters. "Last Sunday and Sunday fortnight I went to church to hear the Reverend Bercier, and his text was 'All things work together for good to them that love God,' and, 'God created man in his own image.' It was beautiful and grand" (letter 33). The following letter also contains information about the Reverend Bercier and his text, and is filled with quotations (in French) of biblical texts that Vincent admired. For his mother's birthday (on 10 September) he picked out two engravings with religious themes, *Good Friday* and *St. Augustine*, which he intended to send "in the next box" (i.e. in the box of goods that went from the Paris firm to the one in The Hague). He hoped that Theo would agree on the plan: "I should like it to be a present from both of us, so will you pay 2.50 toward the frames?" (letter 34).

Vincent did have interests other than church-going; in a letter of 1 September 1875 he wrote, "Last Sunday I was at the Louvre (on Sundays I generally go there or to the Luxembourg)," Occasionally he also wrote about paintings or books, but even this stopped after a while, his letters consisting almost entirely of edifying thoughts and religious admonitions. Sometimes his longing for spiritual flights was so strong that he simply had to tell Theo; a short note from September begins with the emotional exclamation: " 'Wings, wings over life! Wings over grave and death!'[12] That is what we want and I am beginning to understand that we can get them. Don't you think Father has them? And you know how he got them, by prayer and the fruit thereof—patience and faith—and from the Bible that was a light unto his path and a lamp unto his feet" (letter 37).

Fortunately there is from this period at least one letter among the many to Theo that gives concrete information about Vincent's life. He must have realized that the subjects of his letters had become something unusual, and began a letter dated 11 October 1875, "This time I will write you in a way I seldom do; that is, I will tell you in more detail how I spend my time" (letter 42). Vincent wrote that a fellow employee lived in the house in Montmartre where he had a room. He was the eighteen-year-old son of a London art dealer, and Vincent gave a lively description of the way they spent their free time. He seemingly found in young Harry Gladwell a true disciple, in religious as well as in artistic matters.

For his mother's birthday (on 10 September) Vincent picked out two engravings with religious themes, Good Friday *and* St. Augustine.

A new friend, Harry Gladwell.

[12] In German in the Dutch text.

At first everybody laughed at this young chap, even I. Later on I grew to like him, and now, I assure you, I am very glad to have his company in the evening. He has a wholly ingenuous, unspoiled heart and is very good at his work. Every evening we go home together and eat something in my room; the rest of the evening I read aloud, generally from the Bible. We intend to read it all the way through. In the morning, usually between five and six, he comes to wake me. We breakfast in my room, and about eight o'clock we go to the office. Lately he has been less greedy at his meals and has begun to collect prints, in which I help him. Yesterday we went to the Luxembourg together, and I showed him the pictures I liked best, and indeed, the simple-minded know many things the wise do not. [A list of some twenty paintings follows.]

Another bit of news was much more important. On 10 January 1876 Vincent informed Theo that his employment with Goupil & Co. was coming to an end. He wrote the news quite unemotionally, but it must have meant a heavy blow to him and also to his parents. Unpublished letters give a better idea of what took place. The Reverend Van Gogh, who had been transferred to the village of Etten at the end of October, wrote Theo on 14 December 1875 that Vincent had asked Mr. Boussod's permission "to leave a few days earlier" to be able to be with his parents at Christmas. During his stay in Etten Vincent had a conversation with his father about his job. A few days later, on 31 December, the Reverend wrote Theo:

1876: His employment with Goupil & Co. comes to an end.

How Vincent is going to go on, we don't know yet—he certainly is *not* happy. I believe it is not the right place for him there. We talked quite openly and discussed possibilities. Yesterday he went to Uncle Cor to consult him too; he is also a businessman. I tend to believe that I must advise Vincent to ask for his resignation in two or three months. (I tell you this *confidentially*!) Don't think I act hastily; I have noticed the signs of the times, seriously noticed them! In the meantime, these are only deliberations; it is not a definite decision. We also keep an eye on God in this matter. May his light give us wisdom and courage to act, when we see it necessary. . . . There is so much good in Vincent. That is why it may be necessary to make a change in his position.

Reverend van Gogh was not the one to make the "definite decision"; however, Vincent's letter to Theo of 10 January shows that it came sooner than expected:

I have not written to you since we saw each other; in the meantime something happened to me that did not come quite unexpectedly. When I saw Mr. Boussod again, I asked him if he approved of my being employed in the house for another year, and said that I hoped he had no serious complaints against me. But the latter was indeed the case, and in the end he forced me, as it were, to say that I would leave on the first of April, thanking the gentlemen for all that I might have learned in the house.

When the apple is ripe, a soft breeze makes it fall from the tree; such was the case here, in the sense that I have done things that have been very wrong, and therefore I have but little to say. And now, boy, I am not yet sure what I should do, but we will try to keep hope and courage. Be so kind as to show this note to Mr. Tersteeg—he may

26

know—but for the rest, I think it best to speak to nobody about it and to act as if nothing has happened (letter 50).

It will probably never be known what things Vincent had done that were so "very wrong." The only thing Jo van Gogh-Bonger wrote in her Memoir is, "One of the grievances against him was that he had gone home to Holland for Christmas and New Year's, the busiest time for business in Paris." At first sight this seems hardly probable; how could Vincent have gone to Etten without the consent of his superiors? Yet the proof is in an unpublished letter of 12 January 1876 from Father Van Gogh to Theo (which must have been Jo van Gogh-Bonger's source). "Vincent's problems keep giving us great concern. On the fourth of this month he wrote that he had had a very unpleasant encounter with Mr. Boussod at the moment of the New Year's wishes. He had been especially blamed for going home at the end of the year. He certainly should not have done it, but he appears to have stubbornly stuck to his point. After this encounter there is no other way open to him, he feels, than to say that he will leave the first of April." Vincent, therefore, did have Mr. Boussod's consent, but he had more or less forced that consent with his persistence, and that is why later in his letter, Father Van Gogh repeated that Vincent should not have left "when it appeared that he was needed." With a large staff, he said, there should be discipline.

Descriptions of the clashes between father and son have often shown Reverend Van Gogh in a less than favorable light. How considerate and caring a father he was at heart, however, is apparent in this letter. "We have not had any news from him since. I sent him a registered letter with forty guilders so he will not be inconvenienced if need be. I wrote again, but there was no answer. I have written again now, but just like before, without any reproaches, yet trying to open his eyes to his own faults. Will it be of any use? We are bitterly sad. In fact we are tired and exhausted by sorrow and grief."

It was many years later that Vincent wrote about his dismissal in a bit more detail. He maintained that he left of his own free will and was dismissed at the same time. In a letter of August 1883, Vincent explained to Theo that he would have preferred to stay at Goupil's, but not in a capacity that forced him to have much contact with the public. He must have already gotten the idea that he made a strange impression on other people—the same feeling that later would make it difficult for him to find an outlet for his drawings. Vincent explained: "You must not let my conduct when I left Goupil's deceive you. If business would have meant to me then what art does now, I would have acted more resolutely. But then I was in doubt whether it was my career or not, and I was more passive. When they said to me, 'Hadn't you better go,' I replied, 'You think I had better go, so I shall go'—no more. At the time more things were left unspoken than said aloud" (letter 315).

In the weeks after his meeting with Mr. Boussod, Vincent immediately began to look for another job. He apparently thought only of possibilities in England where he felt more at home than he did in Paris. In January he said: "I am reading the advertisements in the English papers and have already answered some. Let us hope for success" (letter 52). But success was not forthcoming, and as late as 23 March he told Theo:

Was he dismissed, or did he leave of his own accord?

27

"Today I answered two advertisements again. I continue to do it, though I get hardly any answers" (letter 57). On 1 April he planned to return to Holland, and just before he left there was finally some relief. "On the morning before I left Paris, I received a letter from a schoolmaster at Ramsgate. He proposed that I go there for a month (without salary). At the end of that time he will decide whether I am fit for the position. You can imagine I am glad to have found something. At all events I have board and lodgings free" (letter 59). Not a word was said about his feelings toward Mr. Boussod and Mr. Valadon or about his departure from Paris. Vincent should not be considered introverted, but there were times when he was extremely reticent, even toward his beloved younger brother.

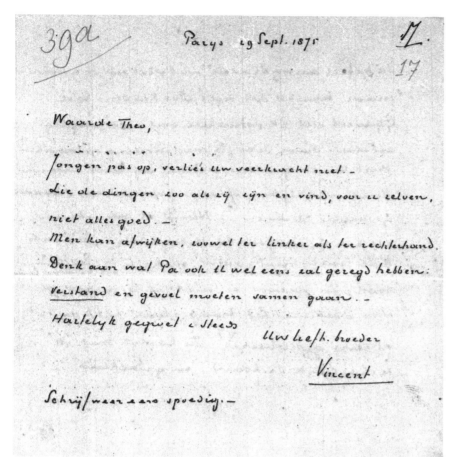

12
Letter from Vincent to Theo, written in Paris (letter 39a), 1875. The letter begins with the words "Boy, be careful, do not lose your resilience. See things as they are and don't approve of everything yourself."

Before describing how Vincent fared in his new post, some attention must be paid to the younger brother. Theo had been transferred from Brussels to The Hague in November 1873, more or less taking up the position that Vincent had held in the Goupil firm for four years, and Vincent hastened to send him a letter of welcome. On 19 November he wrote from London: "I want to be sure you hear from me soon after your arrival in The Hague. I am eager to hear your first impressions of your new position and home. I heard that Mr. Schmidt gave you such a beautiful souvenir. That proves you have been satisfactory in every respect" (letter 12).

As an elder and more experienced brother he often inserted in his letters pieces of advice which sometimes seem pedantic, but one must recall that Theo at that time was a boy of only sixteen. In a letter of November, for instance, Vincent wrote: "Go to the museum as often as you can; it is a good thing to know the old painters, too. If you have the opportunity, read about art, especially the art magazines, *Gazette des Beaux-Arts*, etc. As soon as I have the opportunity, I will send you a book by Burger about the museums at The Hague and Amsterdam.[13] Please send it back when you have read it" (letter 12). When he sent Theo New Year's greetings, he wrote in the same fatherly

[13] Théophile Thoré (1807-1869) wrote under the pseudonym W. Bürger. The book meant here was *Musées de la Hollande*, 1858.

29

manner, revealing some of his own preferences in art, a combination of names that today seems somewhat curious. "From your letter I see that you take a great interest in art; that is a good thing, boy. I am glad you like Millet, Jacque, Schreyer, Lambinet, Frans Hals, etc., for as Mauve says, 'That is *it*.' Yes, that picture by Millet, *The Angelus*, that is *it*—that is beauty, that is poetry. How I should like to talk with you about art; instead, we must write about it often. *Admire* as much as you can; *most people do not admire enough*" (letter 13).

In July, when he returned to London from a holiday with the family in Helvoirt, Vincent took up the correspondence again, this time writing about books as well as art. He had given (or lent) Theo Michelet's *L'Amour*, and Theo had profited from it. "I am glad you have read Michelet and that you understand it so well. Such a book teaches us that there is much more in love than people generally suppose. To me that book has been both a revelation and a Gospel" (letter 20). This book—or this letter—seems to have incited Theo, who was seventeen at this time, to make a confession, as he evidently was struggling with some sort of sexual problem. As always in this period his brother reacted with aphorisms from the Bible. His letter of 10 August even opens with them: " 'Ye judge after the flesh; I judge no man.' 'He that is without sin among you, let him cast a stone at her.' So keep to your own ideas, and if you doubt whether they are right, test them with those of Him who dared to say, 'I am the truth,' or with those of some very human person, Michelet, for instance. Virginity of the soul and impurity of body can go together. You know the *Margaret at the Fountain*, by Ary Scheffer, is there a purer being than that girl 'who had loved so much'?" (letter 21).

Vincent kept working at his self-imposed task of mentor to his younger brother, giving advice and sending him books. In the same letter he wrote, for instance: "With the money I gave you, you must buy Alphonse Karr's *Voyage autour de mon jardin*. Be sure you do that, I want you to read it." After his first stay in Paris, he filled a notebook with poems he admired, and in March 1875 he sent it to Theo, together with a print and books he found useful for him. "Today we are sending a box [to The Hague] in which I have included the little book of poetry I spoke of, *Jésus* by Renan, *Jeanne d'Arc* by Michelet, and a portrait of Corot from the *London News*, which hangs in my room, too" (letter 23). He also sent him photographs after paintings, etchings and lithographs from admired artists, a book of poetry by Jules Breton, a book on the French painter Michel with etchings after his paintings, etc., in an attempt to improve Theo's modest knowledge of art and literature. It was also in this period that he started to feel responsible for Theo's *religious* education, as he himself went through an inner crisis and was rapidly developing in an ultra-religious direction. Theo broke away from the church even earlier than Vincent, and the latter tried to stop this process. Sending him books such as Renan's *Jésus* cannot have been of much help, however.

From his parents' letter of 28 October 1874 (already quoted) it becomes clear that Theo had asked them "whether it was not sufficient for someone that there is nature." This had caused his mother to reply with a long letter, patiently explaining that even though he meant "nature without the Church but at least with the Bible," it was certainly not sufficient because "nature

13
Title page of Jésus *by Ernest Renan (1823-1892). Photograph of the original book that Vincent sent to Theo in 1875. The book is now housed in the National Museum Vincent van Gogh in Amsterdam.*

does not speak of Jesus." Theo seems to have admitted that he did not find it necessary to go to church, and his mother admonished: "Theo, do not stop going to church; very often you will hear words there about the things you have been thinking about, words that you need to bear happily the difficulties you meet or to be consoled in your sorrows. There is so much in life, and you will often come back from church with satisfaction and admit that, even if you don't think it *necessary*, it is useful to be reminded of those things in a world that is so full of distractions and worries."

Vincent did his best, too. In July 1875 he wrote, "As soon as there is a chance I shall send you a French bible and *l'Imitation de Jésus Christ*" (letter 35), and in August, after having told about his latest visits to the church, he prompted Theo to follow his example. "You too must go to church every Sunday if you can; even if the sermon is not so good, it is better to go; you will not regret it" (letter 33). When Vincent had heard that Uncle Jan Carbentus, one of his mother's brothers, had died, he responded immediately with religious thoughts. "Such a thing makes us say, 'Unite us, O Lord, close together, and may the love of Thee strengthen that bond,' and, 'Fear God, and keep his commandments: for this is the whole duty of man'" (letter 35).

His father must have noticed that Theo was much too melancholy for his age. In a letter dated 9 July 1875 he tackled this problem with fatherly and pastoral words of advice, although the opening sentences reveal his feelings about his eldest son, as well:

Theo's melancholy moods.

> If with regard to Vincent, we sometimes were worried about something strange in him, this does not mean—you do know that, don't you?—that we overlooked all the good qualities he has!
>
> There is a kind of naturalness that is blamable. Someone who yields to low passions, follows *nature*, that is to say bestial nature, but *human nature* teaches him to dominate those passions.
>
> Now don't misunderstand me; I don't want to say that I suspect you or Vincent of yielding to those ignoble passions, indeed, no!
>
> But this is the course of my reasoning: a person can sometimes be *not natural enough*. Youth is allowed to be lively, gay, cheerful; a youthful person is allowed to enjoy meeting people who are also youthful, gay and cheerful. In those years it is even a good thing if one doesn't go against one's nature, for there is in a cheerful mood a beneficial force. Melancholy can be harmful, and to indulge in melancholy does not help to produce energy.
>
> My dear Theo! You should really think about that; I see that recently your liveliness has diminished, your cheerfulness is no longer what is was before.

And at the end of the letter he wondered whether the melancholy mood prevailing in the Haanebeek family during the fatal illness of their daughter Annet did not have a bad influence on Theo.[14]

Vincent's letters to Theo, which are full of moralizing and religious admonitions and which follow each other in quick succession, did not help to cheer him up. A letter of 25 September 1875, for instance, begins with the sentences: "The

14 The Haanebeeks were friends of the Roos family where Theo boarded.

path is narrow, therefore we must be careful. You know how others have arrived where we want to go; let us take that simple road, too. *Ora et labora.*" The same letter shows that he intended to put his theories to practice himself. "I am going to destroy all my books by Michelet, etc. I wish you would do the same" (letter 39). Theo must certainly have found it rather inconsistent that Vincent, in a letter of October 1875, in which he inquired whether Theo had followed the advice about doing away with all his books, at the same time mentioned a few new titles. "Have you done as I suggested and destroyed your books by Michelet, Renan, etc.? I think that will give you rest. . . . Do you know Erckmann-Chatrian's *Conscrit, Waterloo* and especially *L'Ami Fritz,* also *Madame Thérèse?* You should read them if you can get them" (letter 42).

It is refreshing to see that Vincent's letters are not wholly devoted to philosophical questions; he also wrote about more mundane matters. In the postscript of a letter from mid-September devoted to the prayer: "Let us ask that our part in life should be to become the poor in the kingdom of God, God's servants," Vincent asked his eighteen-year-old brother: "Is your appetite good? Eat especially as much bread as you like. Good night. I must go and give my boots a shine for tomorrow" (letter 38).

The tone of Theo's letters gave Vincent (and his father) just cause to worry about his dejected moods. In a letter from September 1875, Vincent encouraged his brother not to give in to his melancholy . "Don't take things that do not really concern you very closely *too* much to heart, and don't let them hit you too hard." Similar examples are found in his next few letters:

> I know quite well that your life is not easy just now, boy, but stay firm and keep up your courage; it is sometimes necessary "not to dream and not to sigh." You know that "thou art not alone, but thy Father is with thee" (letter 40).

> Keep courage, lad, sunshine follows after rain; keep hoping for that. Always recall to your mind the words, "This also will pass away" [in English in the Dutch text] (letter 41).

> I hope that you will pardon my telling you these things. I know you are intelligent enough to find them out for yourself. Don't find *everything* all right. Learn to distinguish for yourself between what is relatively good and *evil,* and let that feeling show you the way under God's guidance, for boy, we need God's guidance so much. Look for light and freedom, and *do not ponder too deeply over the evils of the world* (letter 42).

In the next few years, there were no important changes in Theo's position at Goupil's or in his personal life. Apparently his zeal was appreciated, because he was commissioned to make a long journey for the firm during which he visited many Dutch towns. This is known from unpublished letters, written by his parents and his sister Lies, which show much satisfaction with this success. Lies wrote: "How nice for you to be allowed to make the trade journey for the spring season. I am sure that will be a big change for you" (27 February 1876). And Father Van Gogh wrote: "I find it a marvelous thing for you and hope you will be successful. You are going to visit some

interesting towns" (31 March 1876). He had already told Theo that Vincent considered it "such a good thing" that Mr. Tersteeg had decided to give Theo the commission (6 March). The letters from Father and Mother Van Gogh to Theo usually ended with good wishes, religious thoughts and good advice, and the ones about his journey did so even more than the others. Shortly before the start of the trip, Mother Van Gogh wrote: "And now, dear Theo, live happily. Look for the good things in life in all respects. Avoid what is not good. Control yourself in the things which you don't need but were recommended to you in well-meant advice" (15 March 1876).

In spite of his apparent success at work, Theo was not happy, and Vincent, to whom he certainly wrote more openly than to his parents, knew much better than they that it was not just "shyness" that bothered him. Theo worried about the errors he had made in what he called his "worldly" life. This follows more clearly from a letter that Vincent sent him on 8 July 1876. "God is righteous, and He will lead all who err onto the right path; you were thinking of that when you wrote, 'May this happen, I am erring in many ways, but there is still hope.' Do not be unhappy about your worldly life, as you call it; go quietly on your way. You are more simple-hearted than I am, and probably you will succeed sooner and to a greater extent" (letter 71). Theo certainly did not experience the serious religious crises that plagued Vincent, but the fact that he had such melancholy contemplations when he was nineteen proves that he had not yet broken from the oppressing influence of his religious education.

Whether it had anything to do with his state of mind or only with his physical condition is still a mystery, but Theo became seriously ill in the fall of 1876. This fact has gone unnoticed by the biographers of the Van Gogh brothers, and yet it seems significant as a foreshadowing of Theo's poor health in later years and his death at an early age. The first sign in the published letters of what had happened comes unexpectedly in a letter from Vincent to Theo of 3 October 1876 which begins: "I heard from home that you are ill. Poor boy, how I should like to be with you. Yesterday evening I walked to Richmond; it was a beautiful gray evening, and I was thinking of you all the way."

In Vincent's next letters—even in quite long ones—there are only short references to Theo's illness, mostly in the form of good wishes for a speedy recovery, but nothing that would alarm an unprepared reader. Yet there is more in his letters that reflects the sympathy he felt for his sick brother than appears at first sight. It is typical that he tried to comfort him more with quotations from literature and from the Bible than with his own words. On 7 October he wrote a long quotation from the novel *Le Conscrit* by Henri Conscience, starting with the words, "I had been ill; my mind was tired; my soul, disillusioned; and my body, suffering," words that may well have precisely described Theo's own condition (letter 76). In his next letter, on 13 October, he quoted in full two poems by a popular preacher-poet De Genestet titled, "On the Mountains of Sorrow" and "When I was a Boy," both clearly meant to console Theo (letter 77). The poems, however, are omitted from the printed edition of the letters, along with an entire page of religious texts, introduced by the words, "And now I'll copy some more for my brother."

14
Portrait of Jules Michelet (1798-1874), one of Vincent's favorite authors.

In the next letter, which is undated, he again turned to religion. Theo seems to have written that even though he was ill, there was a good side to it. "My illness is no misfortune." "No," Vincent replied, "when God supports us, illness is no misfortune, especially when we get new ideas and new intentions in those days of illness that would not have come to us if we had not been ill, and when we achieve clearer faith and stronger trust in God" (letter 78). But apart from these words, there are three long deleted passages of religious thoughts— together some eighty lines—that were meant to reinforce the idea that life is full of hardship and that consolation can be found only in God. "Has not man a struggle on earth? When you were ill, you must have felt that. No victory without struggle, no struggle without suffering. 'There must be much struggle, / There must be much suffering, / There must be much prayer, / And then the end will be bliss.' "

Details about Theo's illness can only be deduced from unpublished letters from members of the family, and even in these the exact nature of the malady is never mentioned. A high fever made him very weak in September and he was unable to work for almost two months. The beginning of the story can be found in a letter from Father van Gogh of 29 September which mentions that fever had forced Theo to stay at home from work on 26 September. A short time later he left Etten to be with his son in The Hague for a few days, soon relieved by his wife who stayed at Theo's sickbed until 23 October—about two weeks. (This explains why Vincent's letter of 13 October was addressed "Dear Mother and Theo.") When he was well enough to travel, Theo joined his parents in Etten and stayed with them until he was fully recovered, which was around 16 November.

Theo's illness, September-November 1876.

The extent of his illness can be read in many of the unpublished letters. His sister Anna wrote him on 12 October from England that she had been very worried, but that "father had written that the crisis was over," and in a letter of 19 October his father wrote to Theo, "Let us be grateful that so far you are getting somewhat better and let us thank God who has spared your life." A confirmation of the fact that his parents had been extremely worried during Theo's illness is found in their New Year's letters to Theo, both written in the same vein; his father wrote, "we wish you all the best, dear child, now that the good Lord has spared you for us when you were so dangerously ill and weak."

Compared to these words, Vincent's simple references to Theo's illness, "try to get well soon" or even "thank God you are recovering," seem rather mild, but it is almost certain that his parents never told him that the situation was so serious. Moreover, at this stage of their lives, Vincent was still too much obsessed by his role as his brother's mentor in spiritual affairs—a role that he would soon abandon—to be very much concerned about his physical well-being.

VINCENT IN RAMSGATE AND ISLEWORTH

15
Ramsgate, view from the school windows.
Sketch by Vincent.
Vincent van Gogh Foundation / National
Museum Vincent van Gogh, Amsterdam

In the middle of the nineteenth century Ramsgate was still a small seaside resort with a population of about twelve thousand. It is situated on the east coast of England, seventy-five miles from London, and the school where Vincent was to be employed looks out onto the sea. The address was 6 Royal Road, and the location is known from two almost identical little drawings that Vincent made representing the view from the school windows. One had been sent with a letter to Theo in May 1876 (letter 67); the origin of the other is not known, but it was probably sent with a letter to his parents or another member of the family. The view had awakened memories of his own sad farewell from home, and for a sensitive young man like Vincent it was not difficult for him to realize that the boys who lived here experienced the same feelings. This gives the somewhat naïve sketch he sent Theo a special emotional value. "Enclosed is a little drawing of the view from the school window through which the boys wave goodbye to their parents when they are going back to the station after a visit. Most of them will never forget the view from that window." His sympathy for the boys is also apparent when he described how they sometimes went without their bread and tea in the evening because they had made too much noise. "At such occasions you should have seen them looking out that window, it really was melancholy; they have so little else except their meals to look forward to and help them get through the days. I should also like you to see them going from the dark stairs and passage to the dining room. But there a friendly sun is shining" (letter 67).

More objective information about the school appears in a letter to his parents (letter 60) and the letters to Theo (letters 61-67) The school was a small one: twenty-four boys aging from ten to fourteen. Vincent was only one of the assistant teachers; the one other was seventeen years old. Vincent's sleeping quarters were in another building which looked out on the same square. Four of the boys and the other assistant teacher also slept in this building. The school itself was old; the boys had to wash in a room with rotten floorboards where "a dim light filters onto the washstand through a window with broken panes." Some time later Vincent remembered, "there were many bugs at Mr. Stokes', but the view from the school window made one forget them" (letter 72).

Mr. William Port Stokes was apparently a painter or drawing master, but Vincent probably did not know this as he does not mention anything of it in his letters. One gets the impression that the school meant everything to Mr. Stokes, although financially he seems to have had a hard time with it; he told Vincent that he "definitely" could not give him any salary, because he could "get teachers enough for just board and lodging" (letter 70).

Less than a fortnight after Vincent had arrived in Ramsgate, he wrote to Theo that Mr. Stokes was planning to move the whole school "after the holidays," which was in a month or two. They would be relocating "to a village on the Thames about three hours from London." There he would "organize his school somewhat differently and perhaps enlarge it" (letter 63). The village was Isleworth, now part of greater London, and Stokes knew it well having been brought up there. Around the middle of June the boys must have gone home and Stokes started the move. This gave Vincent the opportunity both of going to London for a few days and of visiting his sister Anna in Welwyn.

From Welwyn on 17 June 1876 he sent Theo a description of his trip—a letter that gives an interesting insight into the character of this remarkably tenacious, but also idealistic and sensitive young man. "Last Monday I started from Ramsgate to London. That is quite a stroll." Even for an Englishman "quite a stroll" would have been an enormous understatement; it was a distance of almost eighty miles. When he left it was very hot, and it stayed so into the evening when he arrived in Canterbury. He continued a little further until he arrived at a spot where there were large beech and elm trees near a little pond. There he "rested for a while," which meant that he spent the night outdoors, until at half past three in the morning the birds began to sing and he set off again. In the afternoon he was at Chatham and started on the last stage of his two-day trip. "I met a cart which took me a few miles farther, but then the driver went into an inn and I thought that he would stay a long time, so I continued on my way. I arrived in the familiar suburbs of London toward evening, and walked to the city along the long, long roads" (letter 69).

Later letters show that by that time Vincent had already decided to look for another job, which must have been the main reason for his going to London. Not only was there no future for him whatsoever at Mr. Stokes' school, he also wanted a change in his type of work. His stated preference was "a position between clergyman and missionary among the working people

"Last Monday I started from Ramsgate to London. That is quite a stroll."

36

in the suburbs of London" (letter 69), and he wrote on 5 July, "Last week I went to London two or three times to find out if there was a chance of becoming one of them" (letter 70). He was told that he must be at least twenty-four years old, "and at all events I shall have to wait another year." Much later letters show that Vincent had not only tried to become a preacher among the working people of London, but that he had also considered the possibility of becoming an evangelist among the *miners*—something he actually succeeded in doing two years later in the Borinage. In November 1878 he wrote, "When I was in England, I applied for a position as evangelist among the coal miners, but they put me off, saying I had to be at least twenty-five years old" (letter 126).

Energetic as always, Vincent used his time in London to find a new position, which meant that his walking trip had not ended. "I stayed two days in London and have been running from one part to the other to see different persons, including a clergyman whom I had written to" (letter 69). He sent Theo a translation of the request he had handed the clergyman on that occasion—a document that is a succinct autobiography—the only one Vincent ever wrote. Factually there is nothing new in this short piece, but his motives for looking for a new kind of work are worth reading:

A short autobiography.

> Though I have not been educated for the church, perhaps my travels, my experiences in different countries, of mixing with various people, poor and rich, religious and irreligious, of different kinds of work— manual labor and office work—perhaps also my speaking a number of languages, may partly make up for the fact that I have not studied at college. But the reason which I would rather give for introducing myself to you is my innate love for the Church and everything connected with it. It may have slumbered now and then, but is always aroused again. Also, if I may say so, though with a feeling of great insufficiency and shortcoming, 'the Love of God and man' (letter 69).

His father was not very happy with Vincent's attempts to become an evangelist; in spite of the time it would take, he believed the study to become a clergyman would be preferable. Father told this to Theo in a letter of 1 July 1876, and also listed a few alternatives of his own. "If he *really* has such a love of the Church or the Evangelization and is really serious about it, I would think that he could start the study for it in this country, and we might try to find the necessary resources. But at least eight years would be needed. On the other hand, it might be better if he tried to find over there or in this country— perhaps better in this country—some position as bookkeeper or as assistant in an office or shop."

Teaching was another possibility. "If he wants to teach, then he should start the study to be an assistant schoolmaster and try to improve himself later by his own exercise and study of languages. Alas, we begin to become more and more worried about him. Of course, the lack of finances is also a problem; he doesn't want us to send him anything, but this morning I enclosed twenty-five guilders in my letter to him."

In London, at least, there was no need for Vincent to spend the night outdoors. He stayed at the house of the art dealer Reid, whom he must have known well from the time he was employed by the London branch of Goupil & Co. The second night he spent with the parents of his Paris friend and housemate Harry Gladwell. Here "they were very, very kind," he wrote and continued: "Mr. Gladwell kissed me goodnight that evening and it did me good; may it be given to me in the future to prove my friendship for his son now and then. I wanted to go on to Welwyn that very evening, but they kept me back literally by force because of the pouring rain. However, when it began to let up a little about four o'clock in the morning, I set off for Welwyn. First a long walk from one end of the city to the other, about ten miles (of twenty minutes' walk each). In the afternoon at five o'clock I was with our sister and was very glad to see her" (letter 69). In the letter Anna wrote to Theo on this occasion there is not much more than in the one from Vincent, but in any case it is clear that she enjoyed his visit. "You can well imagine how delightful it was meeting Vincent again. I am so glad he is meeting all the people here, too, for no one can imagine what a happy life I lead here, surrounded by so much love. It will be extremely hard to say goodbye to them all. Perhaps I shall stay here until Christmas" (letter 69a).

Neither Vincent nor Anna mentioned their younger sister Willemien. Yet that was only natural; the girl, now fourteen, had left Welwyn about a month earlier and had gone back to Holland. Her parents wanted her home on 21 May, the day they celebrated their silver wedding anniversary. It was this festive occasion that Vincent had in mind when he wrote Theo: "W. will perhaps be there already on 21 May. From your letter I see you also consider going. By all means, boy, do so if it is possible" (letter 66). His next letter proves that Theo had indeed gone: "Bravo on going to Etten on 21 May; fortunately four of the six [children] were home then.[15] Father wrote me in detail how everything went on that day" (letter 67).

Isleworth

After his visit to Anna, Vincent returned to his school. He may have gone to Ramsgate first, or possibly directly to Isleworth, which was nearer but still some twenty-five miles from Welwyn, on the opposite side of London. It is not known whether he went all the way on foot, but it is certain that, if necessary, he would not have hesitated to do so. He must have written home with his new address, because his father forwarded it to Theo in a letter dated 1 July as: "c/o W. P. Stokes Esq., Linkfield House, Isleworth (near London)." The Linkfield house, originally at 183 Twickenham Road, was renamed Somerset House around 1921 and later demolished. Vincent was to stay here only a few weeks because he soon found a job in another school run by a man named Jones. His main motive for leaving Mr. Stokes' school for another one was that it improved his chances of finding a position "related to the

Alexander Reid's son, also called Alexander, was one of Vincent's friends and was painted by him twice in his later Paris period.

15 The four children present were Theo, Lies, Willemien and Cor.

Church," since Mr. Jones was the minister of a little chapel in Turnham Green, some three and one half miles from Isleworth.

Another reason must have been that Mr. Jones was ready to give him a small salary, and Mr. Stokes was not. In a letter of 6 July, Father Van Gogh told Theo that once Vincent received another offer, Mr. Stokes was suddenly willing to give him twenty-five shillings a month, and paid him one month in advance. As his father had just sent him twenty-five guilders, Vincent sent the money back to be saved for his travel expenses at Christmas. It was not the only time that he had sent money home. In 1873, for instance, he sent his parents "a half gold piece" (about six guilders), as "a Christmas present," and in a letter from 7 January 1874 his father wrote that Vincent had sent "a marvelous letter" in which were enclosed two and one half pounds, something which clearly showed "his good heart." On another occasion in 1874 Vincent had enclosed "a note of twenty francs."

Vincent's new position was at Holme Court. It still exists under the name of Garvin House, and was on the same road that Mr. Stokes' school was. In many respects it was an improvement over the school in Ramsgate. It was a stately Queen Anne house which offered splendid walks in the parks along the Thames, but Vincent would certainly have missed the fascinating sea view of the Ramsgate school.[16]

16
The little chapels at Petersham and Turnham Green. Sketch by Vincent, who taught Sunday school and held Bible classes there.
Vincent van Gogh Foundation / National Museum Vincent van Gogh, Amsterdam

In his letters to Theo he wrote little of the subjects he taught, mentioning only the religious lessons he gave. "I often teach the boys Bible history, and last Sunday I read the Bible with them" (letter 73). The pupils were "twenty-one boys from the London markets and streets," to whom Vincent read the Bible, singing and praying with them every morning and evening. In the room where they slept he used to read to them from the Bible or tell them stories. "I often tell them stories in the evening, for instance: *The Conscript* by Conscience, and *Madame Thérèse* by Erckmann-Chatrian, and *New Year's Eve* by Jean Paul, which I am sending you at the same time, and Andersen's *Fairy Tales*, such as the 'Story of a Mother,' the 'Red Shoes,' and the 'Little Matchseller'; also *King Robert of Sicily* by Longfellow, etc. Sometimes I also tell them episodes from Dutch history."

It is touching to read how he told them the story of John and Theoganes, which he had studied in the daytime, walking

16 I owe details about Vincent's addresses in Ramsgate and Isleworth to letters from David Bruxner (London).

between the hedges in the neighborhood of the school with the book in his hands. "I have just been telling the story of John and Theoganes, first in the room where most of the boys sleep, and then in the upper room where there are four more; I told it in the dark, and they had gradually all fallen asleep by the time I had finished. No wonder, for they have raced about a great deal today on the playground, and then, you see, I do not speak without difficulty; how it sounds to English ears, I do not know, but 'practice makes perfect.' I think the Lord has taken me as I am, with all my faults, though I am still hoping for more profound acceptance."

The last words indicate that at this time Vincent was again experiencing a strong religious inclination. This had started as soon as he had arrived in Holme Court. Practically every letter written to Theo from there made some religious reference. "No day passes without praying to God and without speaking about God," he said triumphantly in his letter of 26 August (letter 74). His education as the son of a parson and the letters he regularly received from home may well have contributed to keeping his religious feelings awake. A letter he wrote to Theo in September 1876 (letter 82a) consists of many pages filled with nothing but Bible texts and pious exhortations. There is little logical coherence, and one wonders what Theo could have thought of his brother's state of mind when he read the letter.

Vincent's religious exaltation.

Theo himself was brought up in the same religious atmosphere. When he sent Vincent a couple of prints in July, he also chose religious subjects: *Christus Consolator* and *Christus Remunerator*, engravings which Vincent immediately hung above the desk in his room. The prints represented paintings by Ary Scheffer, whom Vincent greatly admired, although the pathos of his work now seems unbearable. He was to mention the prints many times in later letters, and when he saw the paintings themselves in the Dordrecht museum two years later, he called them "unforgettable" (letter 80).

Ary Scheffer, 1795-1858.

Curiously enough, an unpublished letter from the Reverend Van Gogh shows that Vincent's ultra-religious way of expressing himself during these months became too much even for his own father. On 8 September 1876 he wrote Theo: "Just now a letter from Vincent. We have not yet been able to read it completely due to the wriggly writing. But in any case it is not a letter that gives us pleasure, alas! If only he learned to remain simple as a child, and would not always go on filling his letter with Bible texts in such an exaggerated and overwrought manner. It makes us worry more and more, and I fear that he becomes altogether unfit for practical life; it is bitterly disappointing. How are his letters to you? If he wants to become an Evangelist, he should be ready to start the *preparation* and necessary *studies*; I would then have more confidence."

It was in the beginning of October that the fulfillment of Vincent's dream seemed to draw near, as the Reverend Jones started to give him the work of an assistant preacher. "Mr. Jones has promised me that I shall not have to teach so much in the future, but may work more in his parish, visiting the people, talking with them, etc. May God give it His blessing" (letter 76). It was not a vain promise, for a month later he was able to write, "A new assistant has come to the school, for in the

future I shall work more at Turnham Green" (letter 80).[17] At the same time, however, Mr. Jones appointed a completely different kind of task to Vincent. In the letter of 7 October in which Vincent informed Theo of the happy change in his position, he also said, "While I was writing to you, I was called to Mr. Jones, who asked me if I would walk to London to collect some money for him" (letter 76). Vincent has described in detail this trip, which from now on was to be a regular part of his job. His letter indicates the distances he had to walk, and shows that he had not altogether lost his interest in worldly affairs. As soon as he had returned from his first trip he continued his letter to Theo:

> Now I am going to tell you about my walk to London. I left here at twelve o'clock in the morning and reached my destination between five and six. When I came into the part of town where most of the picture galleries are, around the Strand, I met many acquaintances; it was dinnertime, so many were in the street, leaving the office or going back there. . . .
> In the City I went to see Mr. Gladwell and to St. Paul's Church, and then from the City to the other end of London, where I visited a boy who had left Mr. Stokes' school because of illness; I found him quite well, playing in the street. Then to the place where I had to collect the money for Mr. Jones. The suburbs of London have a peculiar charm; between the little houses and gardens there are open spots covered with grass and generally with a church or school or workhouse in the middle among the trees and shrubs. It can be so beautiful there when the sun is setting red in the thin evening mist.

It had grown dark for the return trip, so he caught a bus near the Strand, and we easily believe him when he added, "It was already pretty late."

These excursions and the work for the church did not exempt him altogether from teaching. Until one o'clock in the afternoon he was busy teaching the boys; after one o'clock he had to go out for Mr. Jones, or sometimes he would teach either boys who resided in town or Mr. Jones's own children. For instance, a letter from mid-October tells us, "Just now I gave a German lesson to Mr. Jones's daughters, and after the lesson I told them the story of Andersen's 'The Snow Queen'" (letter 77). His work as assistant preacher kept him quite occupied. Every Monday evening he went to the Methodist church in Richmond, a few miles from Isleworth, where he gave a short lecture, probably in the room used for Sunday school. Sometimes he had to prepare the interior of the little church in Turnham Green for a lecture in the evening (letter 78). And between lectures and at night would write in his sermon book if he wasn't already writing letters (letter 81).

After Vincent had been allowed to give his first real sermon in the church at Richmond, he wrote to Theo how much this moment had meant to him:

29 October 1876: Vincent's first Sunday sermon.

> Theo, your brother has preached for the first time, last Sunday, in God's dwelling, of which is written, "In this place, I will give peace." Enclosed a copy of what I said. [In the *Complete Letters*, the text is given after letter 83; it is based upon Psalm 119:19, "I am a stranger

[17] A village near Isleworth where there was a small chapel.

41

on the earth, hide not Thy commandments from me."] May it be the first of many. . . .

When I was standing in the pulpit, I felt like somebody who, emerging from a dark cave underground, comes back to the friendly daylight. It is a delightful thought that in the future wherever I go, I shall preach the Gospel; to do that *well*, one must have the Gospel in one's heart. May the Lord give it to me (letter 79).

Whether this was the only time he was allowed to preach in Richmond remains uncertain. In any case, he also had to read or preach in Petersham. In the middle of November he wrote: "Next Sunday evening I have to go to a Methodist chapel in Petersham. This is a village on the Thames, twenty minutes beyond Richmond" (letter 81). His next letter gives an indication of all the efforts connected with the kind of clerical work he had to do, on top of the preparation of the sermon itself:

Last Sunday evening I was in Petersham, a village on the Thames. In the morning I had been at the Sunday school in Turnham Green, and after sunset I went from there to Richmond and then to Petersham. Soon it became dark, and I did not know the way very well. It was a terribly muddy road, on top of a sort of dike, the slope of which was covered with gnarled elm trees and bushes. At last I saw a light in a little house somewhere below the dike, and climbed and waded through the mud to reach it; there they showed me the right way. But, boy, there was a beautiful little wooden church with a kindly light at the end of that dark road. I read Acts 5:14-16 and Acts 12:15-17, Peter in prison; and then I told the story of John and Theoganes once more. A harmonium in the church was played by a young lady from a boarding school, the pupils of which were all there (letter 82).

In spite of his busy life Vincent was in fact lonely and longing for home and for the family life he had missed for such a long time. "You will have delightful days at home," he wrote to Theo, who was in Etten during an illness, "I almost envy you, my boy. . . . How I should like to be with A[nna]; therefore I wrote her today once more" (letter 80). To his father and mother he wrote, "Thank God that Theo has almost recovered, and bravo that he has already walked with Father in the snow to the Heike [a hamlet near Etten]; how I wish I could have been together with you both" (letter 81), and to Theo, "I am looking forward to Christmas; two years ago we took a walk in the snow in the evening, do you remember? and saw the moon rise over the Marienhof" (letter 82a). To Theo again he wrote: "How delightful it will be to sail down the Thames and across the sea, and see those friendly Dutch dunes and the church spire that is visible from so very far away. . . . How little we see of each other, boy, and how little we see of our parents, and yet the family feeling and our love for each other is so strong that the heart is uplifted and the eye turns to God and prays, 'Do not let me stray too far from them, not too long, O Lord' " (letter 78).

How strong his feelings were is clear from a passage he wrote at the end of the year. "How often have we longed to be together, and how dreadful the feeling of being far from each other is in times of illness or care—as we felt it, for instance,

Vincent longs for home.

during your illness—and then the feeling that want of money might be an obstacle to coming together if it would be necessary" (letter 83). Vincent wrote this from Etten on 31 December 1876, after he had met Theo at their parents' home, but the circumstances had apparently been very different from those he had expected.

Vincent knew before the end of December that he was not to go back from Etten to Isleworth, for there was already talk of a job in Dordrecht (letter 83). In a letter to Theo of 21 January 1877, he said, "Last Sunday I wrote to Mr. Jones and his wife, telling them that I was not coming back, and unintentionally the letter became rather long—out of the fullness of my heart— I wished them to remember me and asked them 'to wrap my recollections in the cloak of charity.'" It is obvious that Vincent did not leave Isleworth because he was no longer on friendly terms with the Reverend Jones and his family, although what exactly had happened will probably always remain unknown.

When summarizing the three and one half years Vincent spent in Paris and England, it becomes clear that it was a valuable period. He experienced some difficult moments, the worst being the dismissal from Goupil's, but was able to greatly improve his knowledge of art and the art trade—and especially of English painting and prints. As he would say much later, there had been an unhappy experience with love when he was twenty (letter 157), but its importance seems to have been vastly overemphasized. The most significant development in these years, especially during the second half of his stay in England, was his preoccupation with religion. Sometimes it was so exalted as to become a real obsession, and it led to a change in his career plans. In his letters of this period he already spoke of his wish to find "a position in connection with the Church," and it is clear that the veneration he felt for his father would sooner or later lead him to try to follow in his footsteps by becoming a parson himself, an ideal that so far had always seemed unattainable.

During these years, his character was distinguished by warmth, sensitivity and faithfulness. Such qualities are illustrated by his correspondence with a brother who was four years his junior; his treatment of the boarding school boys, playing on the beach with them, taking walks with them, telling them fairy tales and other stories in the evening; and the naïve drawings and friendly letter he composed for young Betsy Tersteeg. At this time he was completely unselfish, and it is remarkable to see his self-denial and perseverance; he did not utter a single complaint as he fulfilled the heavy tasks imposed upon him by Reverend Jones.

Equally amazing is the extensive knowledge he acquired in spite of the fact that he had left school when he was not quite fifteen. It is not surprising that he would acquaint himself well with the art trade after having worked at an art dealer's business for seven years, but what is astonishing is the extent of his knowledge of literature. He must have been an avid reader, especially of French and English prose writers. But he also read German poets, such as Heine and Rückert. Reading poetry was a joy for him, and he never tired of copying the

Summary of the years spent in London, Paris, Ramsgate and Isleworth, 1873-1876.

poems he liked best in his letters to Theo or to his sisters; he even filled whole booklets with copied poetry for Theo.[18]

His knowledge of the Bible was also amazing. Although he had no formal training in this field, he was asked to teach the Bible and biblical history at the Sunday school in Turnham Green, to give short religious talks in Richmond on Mondays, and even to give a sermon there on a Sunday, all in a language that was not his mother tongue. There is no doubt that he was intelligent, with an ear for languages and a talent for literature. Such capabilities were evidenced in his preparation of religious texts and in his numerous and often extremely long letters.

It was not until 1975, when a kind of visitor's book or autograph album was discovered in which Vincent had filled at least seven large pages, that one could fully appreciate his knowledge of languages and the subjects that interested him during this period. In that year the album was offered for sale and was deposited for some time at the Tate Gallery in London. The owner had been Ann Slade Jones, the wife of the minister at Isleworth. Evidently she had liked Vincent enough to let him write in her book without limits. Strangely, there is neither a dedication nor even a single personal line addressed to her, but page after page is filled with quotations from mostly religious texts written in a minuscule, extremely careful handwriting. One would almost think that he did it more for his own sake than for hers, because the whole of the first page is written in Dutch, a language she almost certainly could not read. This page is filled with Psalm 91 and other hymns. The second page begins with a text from the Bible written in English and continues with English religious songs. The following page is in German, a language Vincent knew well enough to teach to Mr. Jones's daughters. Here he copied a long poem by Rückert, called "Abendfeier" (Evening Celebration), and also the short Psalms 121, 133, and 126. Vincent had not made it any easier for the girls and their mother by using German script, although it caused him no trouble at all to write. The following three pages are in French. They consist of half a page of Michelet, one and one half pages from *Le Conscrit* by Hendrik Conscience (a translation from the Flemish novel *De Loteling*), some more prose fragments, and finally, all forty-three verses of Psalm 107. On the seventh page an engraving has been pasted, which shows Christ praying in the garden of Gethseman. It probably can be assumed that this picure was a gift from Vincent to pay homage to the wife of his employer, who in a sense was also his hostess.

This is indeed a fascinating document in which the remarkable young man inadvertently reveals much of himself. The endless patience and devotion with which these thousands of words were written in very small, but clearly legible letters, without a single crossed-out word, reflect the care and perseverance he put into the fulfillment of his tasks. It is as if he also wished to express with this unusually long entry in Anne Jones's autograph album that nothing was too much for him when the cause was good. His obsession with religion,

Ann Slade Jones's autograph album.

[18] These booklets have now been published by the Rijksmuseum Vincent van Gogh: *Vincent van Gogh's Poetry Albums*, edited by Fieke Pabst, vol. 1 of *Cahier Vincent* (1988).

44

which the letters from these years show so clearly, is once more confirmed by these texts. The use of four different languages and the choice of the texts bear witness to the level of his intellect and the scope of his reading. It is not difficult to guess why he copied three or four pages from the novel *Le Conscrit*. It is the fragment that begins with the words, "The hour of leave-taking has struck!" and continues, "A young man stands in front of the cottage, the traveling stick on his shoulder, a sack on his back. His eyes, always so lively, look slowly around him, his face is calm, and everything in him seems to express a great calmness of the soul; and yet, his heart beats violently, and his oppressed chest rises and falls with difficulty."

This image of the heartbreaking farewell of a young man leaving home clearly represents Vincent's own past departure from his home and relatives. It may also be seen as a symbolic forecast of the farewell he would soon take of the Jones family. And if this is so, his extensive entry in Ann Slade Jones's autograph book is more than the friendly gesture of a guest. Rather, it has the deep emotional meaning of a last farewell.

During Vincent's stay in London, Paris, Ramsgate and Isleworth, he progressed little as a draftsman, although the Memoir to the *Complete Letters* reports that his mother wrote about "many a nice drawing" and his "delightful talent." A sentence in a short letter to Theo from June 1874 also arouses one's curiosity: "Lately I took up drawing again" (letter 17). In 1874 Vincent had sent a booklet with sketches to the young daughter of his employer H. G. Tersteeg. That booklet and two similar ones have been preserved and are now in the National Museum Vincent van Gogh in Amsterdam. They have been studied thoroughly by the art historian Anna Szymanska (her book appeared in German in 1968) and are therefore easily accessible in both the original and in reproduction. Moreover, a number of these sketches—not all of them—were reproduced in the oeuvre catalogue of 1970 in the chapter *Juvenilia* and were commented on by Professor J. G. van Gelder.

The short note to Betsy Tersteeg which accompanied the third booklet is of some importance for establishing the date of the four drawings it contains. "My dear Betsy, I had wanted to fill the whole of this booklet, but today Theo is leaving and therefore there is no time for it anymore. Just take it as it is, and when I come back next year, I will make a new one. Next Monday I go back to London with my sister Anna, to the house I have drawn for you, and then I go again in the little steamboat I have drawn here. Well, Betsy, adieu, till next year, Vincent." Since Vincent and Anna arrived in London on Wednesday, 15 July 1874, the drawings must have been made shortly before then in Helvoirt. All four are landscapes; one of them includes a small portrait that may have represented Anna, and was probably made after a photograph. The other two booklets, one with twenty-four pencil drawings and one with fifteen, may have been made a year earlier. They almost exclusively represent birds and insects. But there are also scenes such as a boy on a goat-driven carriage, a church with over-sized birds on the roof, a woman knitting at the window, and a hunter with a small dog.

These drawings shed little positive light on the artistic proficiency that Vincent possessed at the time. Even if the

Vincent's attempts at drawing.

sketches in the first two booklets were intentionally drawn in a naïve sort of style, since they were made for a girl of four or five, it is work that does not surpass the artistic ability of an inexperienced schoolboy.[19]

Vincent's lack of artistic skill is not surprising. Although he wrote in a letter during June of 1874, "Lately I took up drawing again" (letter 17), he was not practicing regularly. Later in the summer of 1874, back from a holiday in Helvoirt, he wrote, "Since I have been back in England, my love for drawing has stopped, but perhaps I will take it up again some day or other" (letter 20). Vincent made drawings as if they were diary notes; he did it as a hobby, certainly not as a professional artist, nor even as an artist-to-be. Just as a diary is sometimes interrupted, so also was his enthusiasm for drawing. He was surely conscious of his ineptitude in drawing. It is significant that after an interval of almost ten years he dismissed his sketches in practically identical words: "Lately I took up drawing again, *but it did not amount to much*" (letter 17), and, "In London how often I stood drawing on the Thames Embankment on my way home from Southampton Street in the evening . . . *and it came to nothing*" (letter 332) [author's italics]. This later letter shows that he regretted not having had an education in art. His early drawing lessons under master E. E. Huysmans at the school in Tilburg seemed not to have borne much fruit. Almost pleadingly Vincent proclaimed: "If there had been someone then to tell me what perspective was, how much misery I should have been spared, how much further I should be now!"

[19] It is somewhat surprising that even two years later, Vincent doesn't seem to have made much progress. Some of the published drawings that show more skill, such as the one used as an illustration in the 1953 edition of the collected letters with letter 70 from Isleworth, may have been copied from postcards or other illustrations.

BACK IN HOLLAND: DORDRECHT

17
Vincent's letter 89, sent to Theo from Dordrecht in March, 1877. "I want you to have a letter from me on your journey. What a pleasant day we had together in Amsterdam; I kept watching your train until it was out of sight."

After spending Christmas 1876 in Etten with the family, Theo returned to his work in The Hague and Vincent sought a new job. Almost by chance he found it in a bookshop. Writing to Theo on New Year's Eve, Vincent told him how this had happened. "A few days ago Mr. Braat from Dordrecht came to visit Uncle Vincent, and they talked about me; Uncle asked Mr. Br. if he had a place for me in his business, should I want one. Mr. Br. thought so, and said that I should just come and talk it over" (letter 83). Mr. Braat was one of the owners of a bookshop in Dordrecht, the firm Blussé and Van Braam. Vincent was immediately interested in this opportunity; he could earn a little more than he was making with Reverend Jones, and thus it was decided that he would come for the first week of January to try it out.

The trial period went well, and Vincent worked in the bookshop in Dordrecht for about four months. This is a period about which there is more information than almost any other period of his eventful young life. He wrote eleven letters to Theo alone in those four months. There are also trustworthy reports by contemporaries, something quite exceptional in Vincent van Gogh's life story. The most important information from a third party was an extensive letter written after the fact in 1890 by P. C. Görlitz, Vincent's roommate during the time he worked in Dordrecht. His letter was addressed to Frederik van Eeden, the author of a laudatory article about Vincent van Gogh in the monthly *De Nieuwe Gids* of 1 December 1890. In 1890 Görlitz was a history teacher at a secondary school, an educated man whose profession more or less guaranteed that his rendering of events of the past would be careful and objective.

The second important outside document dates from a later time, but it also reflects the impressions of people who had known Vincent well during these four months: his landlord P. Rijken, who was a grain handler, and Mr. Rijken's wife. They told their story to a reporter, M. J. Brusse, whose lively interviews were quite famous at the time. The testimony is

thus less direct, but it may be assumed that the interview approximates very closely the pronouncements of Rijkens and his wife.

In the following description of the months in Dordrecht, four sources were used: Vincent's letters, Görlitz's letter of 1890, a letter Görlitz wrote to Brusse in 1914[20], and Brusse's interview with people like Braat and Rijkens.

The bookshop of Blussé and Van Braam, where Vincent was employed, was located in a stately patrician house on Voorstraat with a view of Voorstraat harbor, near the imposing medieval Grote Kerk (Big Church). The boarding house he found was in a narrow little street, called Tolbrugstraatje (Tollbridge Alley). The address did not sound impressive, but Vincent was not a man to complain; to him, the house had a particular charm. "The window of my room looks out on a garden with pine trees and poplars, and the backs of old houses, etc., one of them has a gutter covered with ivy. 'A strange old plant is the ivygreen,' says Dickens. The view from my window can be solemn and gloomy, but you ought to see it in the morning sun" (letter 84). He shared his room with the twenty-five-year-old Görlitz who worked in Dordrecht as an assistant teacher. When Vincent applied for lodgings, Mr. Rijken asked Görlitz: " 'Would you object to sharing your room with Mr. Van Gogh, sir? Otherwise I have no room for him, and I should very much like to take him in.' 'Oh yes, provided he is a decent fellow.' So it came about that Mr. V. W. v. G. and I became fellow boarders and roommates."

In the bookshop Vincent had to work hard from the very first moment. The beginning of the year was always a busy time there, so it took three weeks before he found a moment to write to Theo. "You probably expected a letter from me sooner. I am getting along pretty well at the store and am very busy; I go there at eight o'clock in the morning and leave at one o'clock at night." With his usual optimism he added, " but I like it that way" (letter 84). The length of the working day seems almost incredible, but there can be no doubt about it, as in three other letters (85, 87 and 87a) he also says in passing that he came home from the shop after midnight, even at one o'clock. Yet on some days he went home earlier, because Görlitz recalled that "when he came back from his office at nine o'clock in the evening, he would immediately light a little wooden pipe" and sit down to read.

In the beginning his job was bookkeeping. That is what Vincent himself wrote in his first letter from Dordrecht, and Görlitz also called him a bookkeeper in his memories from 1890. Vincent does not mention selling books in any of his letters from Dordrecht, which suggests that he was not entrusted to do so. An amusing anecdote from Görlitz makes it clear that not having him sell was only reasonable. "It is clear as daylight that his were not the qualities of a businessman. It was his job not only to keep the books but also to attend to the sale of artistic prints in the shop. For instance he once advised some ladies to buy a cheaper engraving, rather than a more expensive one, which was less beautiful according to him, but

"The view from my window can be solemn and gloomy, but you ought to see it in the morning sun."

[20] Brusse approached Görlitz for information on Vincent and published Görlitz's reply, which contained roughly the same material as his letter of 1890, in *De Nieuwe Rotterdamsche Courant*, 26 May and 2 June 1914. Brusse's article was partly reproduced in the *Complete Letters* under letter 94a.

for which the ladies showed a preference." Mr. Braat would later comment that "his behavior had been beyond reproach"; he also expressed his admiration for the qualities of Vincent's character and for the physical strength he showed when "one of those frequent floods" occurred in Dordrecht and the basement of the warehouse became flooded. "Without hesitating for a moment, Van Gogh rushed out of the house and waded through the water to his employer's house in order to warn him. The whole morning he was lifting those heavy wet sacks of paper and carrying them upstairs." The only thing Vincent said about it himself was, "Working with one's hands for a day is a rather agreeable diversion—if only it had been for another reason" (letter 85).

As an employee, Vincent had certain shortcomings, about which the various testimonies are in complete agreement. His zeal was undeniable, but his religious fervor was even greater. In Mr. Braat's words, ". . . whenever anyone looked at what he was doing, it was found that instead of working, he was translating the Bible into French, German and English, in four columns, with the Dutch text in addition." "In the midst of his bookkeeping a beautiful text or a pious thought would occur to him, and he would write it down; he could not resist the impulse, *ce fut plus fort que lui*." "While bookkeeping he would write sermons or read them, and psalms or texts from the Bible; he struggled against it, but it was too much for him." In Vincent's defense however, it seems extremely unreasonable that his employers did not allow him these moments of relaxation during a working day which was usually sixteen or seventeen hours long.

Bookkeeping and similar work in the bookshop must have bored Vincent immensely. This explains why he never mentioned in his letters the kind of work he was doing, with the exception of a few lines in the first. What really occupied his mind was religion, certainly not much less than in Isleworth. Late at night, Görlitz recalled, "He would take down a big Bible, and sit down to read assiduously, to copy texts and to learn them by heart; he would also write all kinds of religious compositions. When I said to him on such occasions, 'Van Gogh, my boy, you're working yourself too hard, you had better go rest for a while,' he would answer with a peculiar smile, half melancholy, half humorous, which made his sharp features so attractive, so beautiful, 'Oh dear, G., the Bible is my comfort, the staff of my life. It is the finest book I know, and to follow what Jesus taught mankind will be the purpose of my life.' " Görlitz recalls that when Vincent's trunk arrived, he modestly asked Görlitz's permission to paste some biblical pictures on the wall. "Of course I immediately acceded to this request, and he went to work with feverish haste. And within half an hour the whole room was decorated with biblical scenes and ecce-homos, and Van Gogh had written under each Head of Christ, 'sorrowful, but always rejoicing.' "

Görlitz also reports that one day—probably at Easter— Vincent had framed every picture in palm branches, and he adds, "I am not a religious man, but I was deeply touched by his religious devoutness." According to his roommate, Vincent went to church on Sundays three times; he not only went to the Reformed Church, but also to the Roman Catholic Church and the Old Episcopal Church, which was then commonly called the

"Sorrowful, but always rejoicing" was one of the biblical quotations Vincent used most often (II Corinthians, 6:10).

Jansenist Church. "When once we made the remark, 'But, my dear Van Gogh, how is it possible that you can go to three churches of such different creeds?' he said, 'Well, in every church I see God, and it's all the same to me whether a Protestant pastor or a Roman Catholic priest preaches; it is not really a matter of dogma, but of the spirit of the Gospel, and I find this spirit in all churches.' " It should not to be expected that Vincent himself would often mention his church-going in his letters, yet there is one passage which shows that Görlitz had not exaggerated. In a letter from the end of April 1877 he wrote that on a Sunday morning he had attended a sermon in "the little French church," whereupon he had been to the big Reformed Church in the afternoon and to yet another Protestant church in the evening (letter 94).

Church-going was not his only pastime on his free Sundays. In his first letter from Dordrecht he mentioned a visit to the museum, where he reiterated how he was especially impressed by the religious paintings of Ary Scheffer (such as *Christ in Gethsemane*). He returned to the museum several times, always "to see the Scheffers." In February, when Theo had come to visit him, they went together. Some time later, when his father came to see him in Dordrecht, he took him also, and he went to the museum again shortly before he left Dordrecht, this time with Görlitz and the other boarders. He also repeatedly described the long walks he took on Sundays. If Vincent's landlord did not approve of these walks, it was because he was so good-hearted; he could not endure the thought that Vincent sometimes missed his dinner as a result of his outings. Görlitz described this side of Vincent's character even more clearly. "He lived as a saint, and was as frugal as a hermit. In the afternoon, at the table, the three of us would eat with the appetite of famished wolves; not he, he would not eat meat, only a little morsel on Sundays, and then only after being urged by our landlady for a long time. Four potatoes with a suspicion of gravy and a mouthful of vegetables constituted his whole dinner. To our insistence that he make a hearty dinner and eat meat, he would answer, 'To a human being physical life ought to be a paltry detail; vegetable food is sufficient, all the rest is luxury.' "

Another anecdote about Vincent's Dordrecht months illustrates his character and the circumstances of his life in those days. It is Görlitz's story of how Vincent once went from Dordrecht to Zundert to visit some people there:

It was again on a Saturday that he came to me with his peculiar smile and said: "G., I need you, perhaps you can help me; I'm in a bad fix. I just got word from home that an old peasant I've known for years, and who had always been a faithful follower of my father, is dying. I'm so fond of that man, and I should like so much to see him once more; I want to close his eyes, but I can't pay for the journey to Breda. I haven't got any money left. Should you think it queer, G., to advance me the money for such a purpose? I don't dare ask our landlord for it."

"Do I think it queer, Van Gogh?—not on your life, but I shall not be able to manage the whole; here is something; the 'boss' will lend you the rest; I'll ask him to put it down on my bill, then we'll settle our account in due time, for instance on the Day of the Atonement."

Visits from Theo and from his father.

50

Vincent's own letter, written from Etten in the beginning of April, where he had gone on foot from Zundert to visit his parents, tells the rest of the story:

Vincent walks to Zundert to visit the dying Aerssen.

> Saturday night I took the last train from Dordrecht to Oudenbosch, and walked from there to Zundert. It was so beautiful on the heath; though it was dark, one could distinguish the heath and the pine woods and moors extending far and wide—it reminded me of the Bodmer print hanging in Father's study. The sky was overcast, but the evening star was shining through the clouds, and now and then more stars appeared. It was very early when I arrived at the churchyard in Zundert; everything was so quiet. I went over all the dear old spots, and the little paths, and waited for the sunrise there. You know the story of the Resurrection—everything reminded me of it that morning in the quiet graveyard.
> Having arrived at Aerssen's house, I heard from young Aerssen and Mientje, as soon as they had got up, that their father had died that night. . . . I shall never forget that noble head lying on the pillow: the face showed signs of suffering, but wore an expression of peace and a certain holiness. Oh! it was so beautiful, to me it was characteristic of all the peculiar charm of the country and the life of the Brabant people. And they were all talking about Father, how good he had always been, and how much these two had loved each other (letter 191).

To realize how much certain human ties meant to Vincent, one must remember that he could not have had any contact with this farmer Aerssen for years. Vincent left Zundert when he was sixteen and could have met him only sporadically since then. In order to be present at the deathbed of the old man and to bring consolation to the members of his family, Vincent had not only traveled by train to Oudenbosch, but had also made long walks from one place to the next, and even spent the night outdoors, evidently in that quiet churchyard in Zundert.

Vincent had not yet written to Theo that he wished to become a clergyman, but this longing could not be kept a secret much longer. He may have mentioned it at the end of February, when Theo spent a day in Dordrecht. There is an echo of their conversation in the letter he sent Theo in Amsterdam, where they had planned to visit their Uncle Cor together. "I hope and believe that my life will be changed somehow, and that this longing for Him will be satisfied; I too am sometimes sad and lonely, especially when I walk around a church or parsonage" (letter 88).

The difficulties of Vincent's theological study.

In order to talk about the difficult problems of Vincent's theological study, Uncle Cor, the art dealer, had taken him to the more experienced Uncle Stricker, the minister. "In the morning I went with Uncle Cor to Uncle Stricker's and they had a long conversation on the subject you know. In the evening at half past six Uncle Cor saw me off to the station; it was a beautiful evening and everything seemed so full of expression—it was quiet and there was a little fog hanging in the streets, as it usually is in London" (letter 89). After the visit Vincent felt prompted to confide in Theo and explain as clearly as possible what he was thinking in these decisive moments.

As far as one can remember, in our family, which is a Christian family in every sense, there had always been, from generation to generation, one who preached the Gospel. Why shouldn't a member of that family feel himself called to that service now, and why shouldn't he have reason to believe that he may and must declare his intentions and look for the means to reach that goal? It is my fervent prayer and desire that the spirit of my father and grandfather may rest upon me, that it may be given me to become a Christian and a Christian laborer, and that my life may resemble more and more the lives of those named above; for behold, the old wine is good, and I do not desire a new one (letter 89).

Uncle Stricker probably did not doubt that the spirit of his father and grandfather also rested upon Vincent, but he must have pointed out that having been at a secondary school for only a year and a half, Vincent would have at least another seven years of study before him if he wished to go on with his plan; he would also have to sit for a state examination, and in order to do that he would first have to learn Latin and Greek. It is no wonder that Vincent's letter ended with a sigh: "Theo, my boy, brother whom I love, I have such a fervent longing for it, but how can I reach it? This long and difficult work to become a servant of the Gospel, how I wish I were already through with it."

Uncle Vincent had also been approached, but he wrote that in this case he was not prepared to help his nephew, and even "that he did not think that carrying on the correspondence served any purpose" (letter 90). As was his habit, the gentle Vincent passed on this news to Theo without one word of comment or complaint. The reaction of his well-to-do uncle did not increase the chances of Vincent's plans being realized, for what had been expected of him had probably been not only moral, but also financial assistance. Vincent was certainly correct in writing to Theo, "Humanly speaking, one would say it cannot happen," yet he did not lose courage. "When I think seriously about it and penetrate the surface of what is impossible to man, then my soul is in communion with God, for it is possible to Him Who speaketh, and it is, Who commandeth, and it stands firmly" (letter 92). And in an emotional closing sentence, he wrote something which up to now he had never pronounced (at least in the published letters)—just a few words in passing, but enough to understand what reproaches he had endured from his family and other people about all his "failures," and how much it must have distressed him all those years. "Oh, Theo, Theo boy, if only I might succeed in this! if I only might be freed from that terrible depression and from that torrent of reproaches that I had to endure because everything I have undertaken has failed; and if there might be given to me both the necessary opportunity and the strength to develop fully and to persevere in that course for which my father and I would thank the Lord so fervently."

According to his letter of 1890, P. C. Görlitz appears to have had a share in inducing Vincent's parents to agree with the plan to send Vincent to school in Amsterdam. He had been in Etten to see the Reverend Van Gogh about a vacant teaching post in the village of Leur, near Etten, and had used the opportunity to put in a word for his friend. This is what he remembered about it:

Uncle Vincent's negative response.

In those days I stayed for a night at his father's, the clergyman at Etten and Leur. His mama asked me, "Mr. G., how are things going with Vincent, please tell me everything you know about him—is he happy?—do tell me the truth."

To this I replied, "Madam, to tell you the absolute truth, Vincent is unfit for his job; his ideal calls him elsewhere; it is religion."

Not long afterward, and probably as a result of this conversation, Vincent confessed to his parents that he could not stand it any longer; he longed ardently to teach the Gospel, and he might have added with a clear conscience: to the poor and oppressed in society— at least this was the essence of what he had often told me.

In April 1877 the preparations for Vincent's new endeavor and his departure from Dordrecht were in full swing. On 23 April Vincent wrote Theo: "Uncle Jan has been to Etten, and says that my little room is already waiting for me. Mr. Braat has somebody in mind for my place, so in May I shall probably be able to put my hand to the plow" (letter 93). It had been arranged that during his theological study Vincent would stay in Amsterdam with Uncle Jan who lived in a house near the navy yard where he was the director. Such arrangements would diminish the cost of his study considerably. The last day of the month Vincent wrote once more, congratulating Theo on his birthday, which was on 1 May, and announced that he would be back in Etten in two days to spend a few days before beginning his new life in Amsterdam. He had in fact already started with the study. "Between times I have worked through the whole story of Christ from a catechism book of Uncle Stricker's and copied the texts" (letter 94).

Vincent prepares to depart for Amsterdam.

Though he knew there was much he still had to learn, he was confident that he was not unprepared for the kind of work he saw as his vocation; "the acquaintance with cities such as London and Paris," "life in schools like those at Ramsgate and Isleworth," "knowledge of and love for the work and life of men like Jules Breton, Millet, Jacque, Rembrandt, Bosboom and so many others" (letter 94), all these things of his past experience, he knew, might help. And with this optimistic note ended the series of Vincent's letters to Theo from Dordrecht—the last halting place before he could put his life entirely in the service of the Gospel.

VINCENT IN AMSTERDAM

Vincent stayed in Amsterdam from May 1877 until July 1878, when, in spite of the enthusiasm with which he had started, he had to abandon his studies. All that time he kept Theo informed about his experiences and meditations, sometimes in very long letters. Some thirty of them have survived, enough to give a detailed picture of his life. There are also a number of letters from his father and mother to Theo, which show how deeply the parents were involved in the problems of Vincent's studies. Finally there is the more direct testimony of Vincent's teacher, Dr. M. B. Mendes da Costa, whose memories were originally published in a 1910 newspaper article and reprinted under letter 122a in the *Complete Letters*.

With respect to Vincent's parents, there is a letter from the Reverend Van Gogh to Theo, dated 7 May 1877, that in spite of the light-hearted tone clearly shows the love and care they felt for their eldest son.

> We are having an agreeable time with Vincent, it is very cozy. On Monday morning [14 May] he will leave us. This morning again a nice letter from Uncle Jan; very kind and friendly also from Uncle Stricker; he has found a capable teacher, so that we now start the undertaking with courage, hoping for God's blessing.
> We have improved his appearance a little bit with the help of the best tailor from Breda. Would you be so kind as to do another work of mercy and have his *chevelure* metamorphosed by a clever hairdresser—here in Etten we don't have such people. I suppose a barber of The Hague might be able to do something about it, therefore try to coax him into coming with you to one.
> It is not clear how we will manage; the teacher costs 1.50 guilders per lesson, and every day a lesson makes nine guilders per week, and lessons in other subjects will probably also be necessary. We insist that Vincent pays visits to Tersteeg, Haanebeek and Mauve. Please collaborate! We hope Mrs. Tersteeg will be all right. Vincent hopes to arrive in The Hague on Monday afternoon around six o'clock. We wish him all the best!

Vincent's letters to Theo from Amsterdam, the first being from 19 May, soon make it obvious that his life had undergone a radical change. Now he could devote the whole day to his studies instead of being occupied from early morning until late at night with the work at Mr. Braat's store which did not interest him in the least. During the day Dr. Mendes da Costa taught him Latin and Greek for a few hours, and he spent the rest of the time studying other subjects such as general history, and especially the Bible and biblical history. As he did this with his usual fanaticism, it meant that he often worked far into the night, making excerpts and copying texts.

It can be inferred that living in Uncle Jan's quiet house was much to Vincent's liking, even if he hardly talks about it in his letters to Theo. Uncle Jan probably had very little time for Vincent, and Vincent still less for his uncle. The latter was sometimes out of town, sometimes even for a week, but in general he was the house companion whose presence was taken for granted in the evenings and with whom Vincent for more than a year shared meals and the few moments of leisure that were left him. After supper he often studied in his uncle's living

May 1877-July 1878, a year spent in study.

55

room. This, in any case, is suggested by the fact that one evening in September when his uncle had visitors, Vincent wrote, "I am sitting upstairs by the lamp, for there are visitors downstairs, and I cannot sit there with my books" (letter 108).

Uncle Jan's position as director of the shipyards had many attractive aspects for a young man with a lively interest and a great power of observation. The house, at 3 Grote Kattenburgerstraat, was next to the yard, and Vincent's letters often contain passages showing how much he liked watching the goings-on at the yard. "This morning I got up very early. It had been raining overnight, but very soon the sun broke through the clouds; the ground and the piles of wood and beams in the yard were drenched, and in the pools the sky's reflection was quite golden from the rising sun. At five o'clock I saw those hundreds of workmen scatter like little black figures."

Sometimes Vincent was allowed to visit the yard; this happened once in August, when a Reverend Meijes came with two of his sons to see Uncle Jan, and Uncle gave them permission to visit the yard and the workshops while the forges were in full swing. Uncle Jan even let Vincent accompany him one evening on the watch ship Wassenaar when a cargo boat had caught fire in the harbor. There were other pleasant interruptions in Vincent's busy life. He mentions several times that he had paid an evening visit to Uncle Stricker's family, where he enjoyed the cozy atmosphere and contributed to the pleasure by telling about London and Paris (letters 96 and 100). He sometimes was invited to dinner (letter 112), and was allowed to make use of Uncle Stricker's study in the daytime (letter 97).

The Reverend Stricker's daughter Kee (pronounced "Kay")—her full name was Cornelia Adriana—had been married for five years. Her husband, Christoffel Martinus Vos, had studied theology and had been a pastor for a few years, but poor health had forced him to give up his post; he worked for a newspaper now. Vincent sometimes met these young people during his visits to Uncle Stricker's; he did so, for instance, on 21 May, shortly after he had arrived in Amsterdam.[21] He also visited them in their house on 158 Prinsengracht (letters 105 and 116). One need not attach much importance to these visits, but as four years later Vincent would fall passionately in love with Kee—who had since become a widow—it is very possible that she had already made a deep impression on him in 1877. There certainly is an emotional undertone in his description of the visit he paid them in September: "I spent Monday evening with Vos and Kee; they love each other truly, and one can easily perceive that where love dwells, God commands his blessing. It is a nice home, though it is a great pity that he could not remain a preacher. When one sees them side by side in the evening, in the kindly lamplight of the little living room, quite close to the bedroom of their boy, who wakes up every now and then and asks his mother for something, it is an idyll. On the other hand, they have known days of anxiety and sleepless nights and fears and troubles, too" (letter 110).

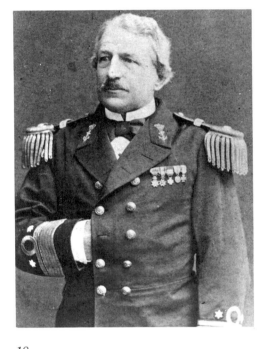

18
Uncle Jan, one of the most influential men in Vincent's life in Amsterdam.

21 The visit is related in the manuscript of letter 96, but in the printed editions of the letters the passage referring to Kee Vos and her husband has been left out.

At times Vincent also went in the evenings to see Uncle Cor, the art dealer, and his wife Johanna, and while these visits gave him the opportunity of "looking over old books, including volumes of *l'Illustration*"—one of his great pleasures—they were especially useful to him because here he could study paintings and art journals, and hear the latest news from the art world.

Paintings still meant a lot to Vincent., and again he filled the walls of his small room with prints and sent many prints to Theo, whom he had persuaded to start a collection. He sometimes brought prints to his teacher Mendes, but—Mendes wrote in 1910—"always completely spoilt, because he had literally covered the white borders of the prints with quotations from Thomas à Kempis and the Bible, more or less connected with the subject." He repeatedly went to see the Trippenhuis (the predecessor of the later Rijksmuseum), where he never tired of studying the Rembrandts (letters 96, 101a, 109, etc.). And in every letter from this period he mentions the names of painters and paintings in connection with things which struck him or persons whom he met.

Even more numerous are his references to the landscapes he observed on the way to his lesson or during his long walks out of town. They reminded him of painters and paintings, and sometimes of authors and books. "Everything was full of Matthijs Maris and Andersen" (letter 110), he said of a nightly walk on the outskirts of the town. When on an early Sunday morning he was walking through old streets, he thought of Daubigny's painting *Le Pont Marie* (letter 105). The Jewish quarter and other old districts reminded him of Charles de Groux, a Belgian painter he much admired, and, of course, there were in old Amsterdam many sights and scenes that made him think of Rembrandt (letter 108). The following is a fragment of one of his early letters from Amsterdam, a remarkable example of his talent for expressively describing a landscape; the association with painting is not lacking:

19
Uncle Cor, one of the three men who supervised Vincent's study and well-being in Amsterdam.

> This morning at a quarter to five there was a terrible thunderstorm here; shortly after, the first gang of workmen came through the gates of the yard in the pouring rain. I got up and went out into the yard, taking a few copybooks with me to the summerhouse. I have been sitting reading there, looking out over the whole yard and dock; the poplars and elderberry and other shrubs were bowed down by the heavy storm, and the rain poured down on the piles of wood and on the decks of the ships. Boats and a little steamer were sailing back and forth, and in the distance, near the village across the IJ,[22] one saw swift-moving brown sails and the houses and the trees on Buitenkant and the more vividly-colored churches. Again and again one heard the thunder and saw the lightning; the sky could have been from a picture by Ruysdael, and the seagulls were skimming the water. It was a grand sight and a real relief after the oppressive heat of yesterday. It has quite refreshed me, for I felt very tired when I went upstairs last night (letter 101).

While he was in Dordrecht, Sundays were mainly devoted to church-going and then walking. All letters describing a

[22] The large inlet from the (former) Zuiderzee, now called Ysselmeer, on which Amsterdam is situated.

Sunday indicate that on such days he had attended a church service at least twice. Usually he listened to "an early morning sermon" first and then attended a regular morning service conducted by Uncle Stricker. This was either in the Amstel Church, the Easter Church, or in the Eland Church, and it was often also in the Oudezijds Kapel, a small chapel in the picturesque quarter between Zeedijk and Enge Kapelsteeg (Narrow Chapel Alley), where very few people came "except the boys and girls from the orphanage in their red and black clothes," but then, "they filled a great part of the little old church" (letter 102). Vincent had real admiration for "that good Uncle Stricker." "I often hear Uncle Stricker; what he says is very good, and he preaches with much warmth and true feeling" (letter 101a). It was with evident pleasure that he wrote in February, "I have lessons from Uncle Stricker twice a week now. I profit a great deal from it, as Uncle is very clever, and I am glad he has found time for it" (letter 118).

Religious meditations dominate Vincent's letters to Theo from these months as much as those from Dordrecht. He rarely neglected to comment upon the sermons he heard, he copied long passages from biblical stories or from sermons (letters 99 and 100), and he shared his religious thoughts with Theo or told him about the pious books he received or bought. On one occasion he gave his teacher Mendes da Costa a copy of the *Imitatio Christi* in Latin, with a dedication alluding to the fact that Mendes was a Jew. "In him there is neither Jew nor Greek, nor servant nor master, nor man nor woman, but Christ is all and in all" (letter 116). It was a book that he cherished most next to the Bible. In September, when he had not even mastered Latin enough to read it without difficulty, he had received a copy in Latin from "Vos" (Dr. C. M. Vos). In March 1878 he could not refrain from promising Theo a copy of the book in a Dutch translation, *De Navolging van Christus*, calling it "a small book which can easily be carried in the pocket"—an edition he had probably found in a bookstall (letter 120).

What occupied Vincent most was, of course, his study, which filled six long days of every week. In his first letter from Amsterdam he wrote that it wasn't easy, but with a typical descriptive metaphor, he added: "patience will help me through. I hope to remember the ivy 'which stealeth on though he wears no wings'; as the ivy creeps along the walls, so the pen must crawl over the paper" (letter 95). Only a few weeks later he sounded less hopeful. "My head is sometimes heavy, and often it burns and my thoughts are confused—I don't see how I shall ever get that difficult and extensive study into it; to get used to and persevere in simple regular study after all those emotional years is not always easy" (letter 98). A letter from July sounds a little more hopeful:

> The other day I met a young man who had just passed his entrance examination for Leyden University. It is not easy—he told what they had asked him. But I must keep courage; with God's help I will pass, and the other examinations, too. Mendes had given me hope that at the end of three months we shall have accomplished what he had planned we should if everything went well. But Greek lessons in the heart of Amsterdam, in the heart of the Jewish quarter, on a very close and sultry summer afternoon, with the feeling that many difficult examinations await you, arranged by very learned and

The Imitation of Christ, by fifteenth-century Augustinian priest Thomas à Kempis, was one of Vincent's most cherished religious texts.

shrewd professors—I can tell you they can be more oppressive than the Brabant cornfields, which are beautiful on such a day (letter 103).

In October Vincent admitted to Uncle Stricker, his mentor, that he was disappointed with his studies. Mendes da Costa had delivered a report about his pupil, about which Vincent said, "I am glad to say he did not make an unfavorable report about me, but Uncle asked me if I did not find it very difficult, and I acknowledged that I did indeed, and that I tried my best, in every possible way, to remain strong and keep myself alert in all possible ways" (letter 112). Uncle Stricker encouraged him, but Vincent sighed, ". . . now that terrible algebra and mathematics still remain; well, we must see—after Christmas I must have lessons in those also, it is necessary." Yet he was not completely desperate. In the beginning of January, back in Amsterdam from a short holiday in Etten, he wrote: "Tuesday morning I began my lessons again. I intend to do the exercises I have already done all over again—at least as much as I have time for in addition to my other work. Father advised this, for once one is well grounded in grammar and the verbs, translation comes easier" (letter 117). Despite such assurances, gradually a frightful feeling of doubt must have come over Vincent; "a terrible sense of fear" he called it when he wrote to Theo in the second half of February (letter 119).

An article by Mendes da Costa provides background for the change in Vincent's attitude toward his studies as it contains much information that does not appear in Vincent's letters. First, it is interesting to see how da Costa described Vincent's appearance.

October 1877: The disappointment begins.

> Our first meeting, of so much importance to the relationship between master and pupil, was very pleasant indeed. The seemingly reticent young man—our ages differed by little, for I was twenty-six then and he was undoubtedly over twenty [Vincent was twenty-four]—immediately felt at home, and notwithstanding his lank reddish hair and his many freckles, his appearance was far from unattractive to me. In passing, let me say that it is not very clear to me why his sister speaks of his "more or less rough exterior"; it is possible that, since the time when I knew him, because of his untidiness and his growing a beard, his outward appearance lost something of its charming quaintness; but most decidedly it can never have been rough, neither his nervous hands, nor his face, which might have been considered homely, but which expressed so much and hid even more.
> I succeeded in winning his confidence and friendship very soon, which was so essential in this case; and as his studies were prompted by the best of intentions, we made comparatively good progress in the beginning—I was soon able to let him translate an easy Latin author. Needless to say, he, who was so fanatically devout in those days, at once started using this little bit of Latin knowledge to read Thomas à Kempis in the original.

The following passage from the article illustrates that the program Vincent was supposed to master in such a short time was very concentrated indeed. But it must be pointed out that the main reason for his inability to finish his studies was his impatience to begin what he knew was his calling.

So far everything went well, including mathematics, which he had begun studying with another master in the meantime [this was a cousin of Mendes da Costa, called Teixeira de Mattos]; but after a short time the Greek verbs became too much for him. However I might set about it, whatever trick I might invent to enliven the lessons, it was no use. "Mendes," he would say—we did not "mister" each other any more—"Mendes, do you seriously believe that such horrors are indispensable to a man who wants to do what I want to do: give peace to poor creatures and reconcile them to their existence here on earth?" And I, who as his master naturally was not supposed to agree, but who felt in my heart of hearts that he—mind, I say *he*, Vincent van Gogh!—was quite right, I put up the most formidable defense I was capable of, but it was to no avail. "John Bunyan's *Pilgrim's Progress* is of much more use to me, and Thomas à Kempis and a translation of the Bible; and I don't want anything more." I really do not know how many times he told me this, nor how many times I went to the Reverend Mr. Stricker to discuss the matter, after which it was decided again and again that Vincent ought to have another try.

He did try it again for many months, and he did it with the utmost exertion. Yet it must have been in the spring of 1878 that Mendes da Costa began to question seriously whether Vincent would be able to persevere.

Reverend Van Gogh began to lose all hope, too. A few letters from him and his wife to Theo, written in 1878, have been preserved, and some of them clearly show how worried they were. On 2 March Father Van Gogh wrote:

> The concern about Vincent oppresses us heavily, I foresee that again a bomb is going to burst. It is apparent that the beginning of his studies are disappointing to him, and his heart seems to be torn by conflicting forces. He has now tied up connections with English and French clergymen of ultra-orthodox views—and as a result the number of faults in his work has increased again. I am afraid he has no idea what studying means, and now I fear the remedy he will choose will be again a proposal for a change, for instance to become a catechist! but that doesn't bring in any bread! We sit and wait, and it is like the calm before the storm.

The most important information this letter provides is that already in March 1878 Vincent's parents knew that he feared not being able to finish his studies and that he thought of "a change" as a remedy. The change meant beginning a profession that was far beneath the status of a clergyman: teaching catechism in a Sunday school or work of that kind. Father Van Gogh used an exclamation mark to express his abhorrence.

His parents had been informed—not by Vincent himself, but by one of his uncles or by Mendes da Costa—that Vincent now wished for "a position with the church but without study." This appears in a letter that Mother Van Gogh had written to Theo on 2 March, at the same time as her husband; speaking of Vincent she wrote: "You know, he is always a faithful writer, and now we haven't had a letter for a fortnight. You will remember that Pa was not quite reassured when he had seen him; Pa wrote him about it once more, and then we received such a strange conflicting reply. . . . But how unhappy he must

Vincent desires "a position with the church but without study."

be, poor boy, you can well imagine how it worries us. He probably doesn't want anything else but a position with the church but without study; what a prospect for his living and his honor!"

It is worthwhile to see how the pious father reacted to the news, for it gives a good idea of the spirit in which Vincent had been brought up: "To us, it is a vexation of our souls, and yet we believe in relief that God can accomplish. He creates light in the darkness! but also, there is a close relation between human errors and sad results. Does this happen also under God's guidance?—and is it amazing that we experience pain and sorrow when he always goes his way as with bowed head, while we have done everything we could to lead him to an honorable goal? It is as if he purposely chooses the ways that lead to difficulties."

Vincent knew much more joy than his father assumed, even if he began to hate his studies more and more in these months. He found joy in paintings, prints, and books; also in the visits he made to his uncles. He enjoyed his long walks in and around the town, during which he certainly did not go around "with bowed head," but was all eyes for characteristic details and for the beauty of the landscape. Finally, there can be no doubt that the many hours he spent on religion were a source of delight rather than sorrow, considering the intensity with which he was engrossed in his religious reading as well as in his church-going. His parents, however, saw only his growing aversion from the study for which they had made so many sacrifices. That is why his father wrote to Theo a month later: "I am afraid he is very unhappy, but what can we do about it? We encourage him and give him the opportunity of continuing his studies, although we hardly know how to manage. It is a sickly existence he has chosen, I'm afraid, and how much he will still have to endure, and we together with him." The term "sickly existence" appears excessive, even for the somewhat pompous style of the Reverend Van Gogh; but it must be admitted that his parents had made great sacrifices for him, and his impossible wish to become a clergyman at his age and with his background caused them continual concern.

He found joy in paintings, prints, and books; also in the visits he made to his uncles.

Abandoned Studies

How or when he made the decision to abandon his studies is difficult to say, because only one more of Vincent's letters from Amsterdam has been preserved. It is a letter dated rather roughly May 1878. There is, however, a much later letter from Vincent, which throws a curious light on the event. In September 1883 he wrote Theo, saying he had been very skeptical then about the plan of studying, not knowing whether his parents' promise to carry it through—namely to provide for sufficient financial help—was sincere and well considered.

> I then thought that they had made the plan rashly and that I had approved of it rashly. And in my opinion it always remains an excellent thing that a stop was put to it then, which I brought about on purpose and arranged so that the shame of giving it up fell on me, and on nobody else. You understand that I, who have learned other languages, might have managed also to master that miserable little

61

bit of Latin—which I declared, however, to be too much for me. This was a blind, because I then preferred not to explain to my protectors that the whole university, the theological faculty at least, is, in my eyes, an inexpressible mess, a breeding place of Pharisaism.

That I did not lack courage, I tried to prove by going to the Borinage, where life was certainly much harder than it would have been for me if I had become a student (letter 326).

One might ask how much value should be attached to these words, for he certainly may be deluding himself in this passage. However surprising his story may sound, though, it tallies more with the facts than appears at first sight. His opinions about religion must have started to become more unorthodox in the Amsterdam period; the decision two years later to break off all ties with the Church did not come out of the blue. And it was indeed impossible for him to let his "protectors" know— especially clergymen like Uncle Stricker and his father—that he was developing a conception of academic theology as "a breeding place of Pharisaism"!

Even with Vincent's skepticism about studying, there must have been some sort of crisis in the beginning of June 1878 that prompted him to change course. There are hints of this in a letter from Father Van Gogh to Theo, in which he wrote that he was trying to find work for Vincent as an evangelist in Belgium. Discussions must have been held among Mendes da Costa, Reverend Van Gogh, Uncle Stricker and perhaps other uncles, resulting in the decision that Vincent's preparations for academic examinations should be abandoned. "We don't know yet," the Reverend Van Gogh wrote to Theo on 7 June 1878, "where this crisis will lead to. . . . Because I did not want to rush things, I told him that for the time being he should go on with his lessons for three months, giving me time to think things over. In the meantime I have written to the Reverend Van den Brink, who is now a parson at Roesselaere in Belgium, asking him whether he might be used in that country. The Reverend Van den Brink thinks it not impossible that a post as evangelist might become available for which knowledge of English and French would be an asset. He will keep me informed and try to help."

The crisis of June 1878.

In later years, there were to be many conflicts between Vincent and his father, with rights and wrongs occurring on both sides. It is true that Reverend Van Gogh rarely showed much insight into the peculiarities and qualities of his son; yet it is only just to admit that in these years he did everything possible to try to help Vincent find a job, even though his son was twenty-five and the jobs he was after, such as Sunday school teacher or evangelist, were far below his own ideals. One must respect his feelings when reading his conclusion to the passage above: "Perhaps we should risk this experiment as a last resort, but everything is still so uncertain. It is a problem that worries us seriously, but let us not lose courage. You have always said: who knows whether he will not pull through some day and succeed. May God grant it."

To become an evangelist was the only remaining possibility for Vincent. It would take two more years of study to become a catechism master, which was out of the question. It was a solution that suited Vincent well, for it meant practical work and it met his desire to help the unfortunate, a desire by which

he was "consumed," as Mendes da Costa put it. The decision to end his studies in Amsterdam could now be made quickly. Theo encouraged his parents to decide accordingly, and no more than two weeks later all the necessary measures had been taken, as appears from a letter his mother wrote to Theo on 23 June.

> To begin with I must tell you that your letter was very good; we feel you were right, and your words helped more than much reasoning about the question itself would have done. We should leave things as they are, for nothing can be done about them, and we should not despair but hope. Vincent admits that he is glad it is so far, and he is looking forward to the future with more courage than when he hopelessly devoted himself to his studies. Pa received a reply from Mr. Van den Brink; there will soon be a meeting in which Vincent's case will be discussed, and we shall hear from him.
>
> Till the end of this month Vincent will continue his lessons. He has asked Mr. Jones for references and received a very satisfactory one. Of course both he and we were pleased with it, and now we have to wait; sometimes that is easy, sometimes not. He writes many letters, also quite long ones, and when one reads them one is inclined to think: how could one expect him to become a simple clergyman, but at other times: there is some good in him also. May God grant that his common sense prevails and may the good in him prepare him for the fulfillment of his wish.

What happened next can also be reconstructed from the letters of his parents. His father wrote on 8 July that Vincent had come home from Amsterdam "last Friday evening"—which was 5 July. The idea of having him continue his lessons for another three months appears to have been abandoned. Vincent had written to the parson in Belgium that he wished to travel to Brussels in order to discuss matters there himself. His father had written a letter of recommendation for him to another parson, the Reverend A. van der Waeyen Pieterszen in Mechlin (Malines). On 16 and 17 July he accompanied his son to Brussels for the important meeting with the gentlemen who had the authority to make the appointments of evangelists. The episode as related by Jo van Gogh-Bonger in her Memoir is the version that is repeated in most of the books on Vincent van Gogh's life. "He would remain 'humble,' and now wanted to become an evangelist in Belgium; for there no certificates were required, no Latin or Greek—only three months at the School of Evangelization at Brussels. There the lessons were free, the only charges being board and lodging, and he could get his nomination."

A few corrections are necessary. It is not quite true that Vincent "now wanted to become an evangelist" (the original Dutch text even has "wanted the most"); what he wanted the most was to become a "catechism-master," which, however, would take another two years of study, and it was only because of the efforts of his father that something else was found in Brussels that might be within Vincent's reach. Furthermore, the duration of the course at the School of Evangelization was not three months, but three years, as is clearly stated in one of Vincent's own letters, even though the course did not have to be completely finished. He wrote:

Back in Etten, 5 July 1878.

63

We saw the Flemish training school; it has a three-year course, while, as you know, in Holland the study would last for six years more at the least. And they do not even require that you quite finish the course before you can apply for a place as evangelist. . . .
Ces messieurs in Brussels wanted me to come for three months to become better acquainted, but that would again cause too much expense, and this must be avoided as much as possible. Therefore I am staying in Etten for the present, doing some preparatory work; from here I can occasionally visit both the Reverend Mr. Pietersen [that is how Vincent spelled Pieterszen's name] in Malines and the Reverend Mr. De Jong in Brussels, and in that way become mutually better acquainted. How long this will take depends entirely on what they will say over there (letter 123).

About Vincent's visit to Brussels, the Reverend Van Gogh wrote to Theo on 28 July 1878:

The School of Evangelization in Brussels.

It was last Tuesday and Wednesday that we were there, and we have seen a lot of people. What we have decided now is that we will arrange for a try-out period of three months—against payment for board on our side—to see whether he would have a chance in succeeding. Vincent spoke perfectly well and made a good impression as far as I know. After all, his staying abroad has not been completely fruitless, nor has the year spent in Amsterdam; when he is called upon he is able to prove that he has learned and observed a lot in the school of life.
However, the cause of evangelization in Belgium cannot boast of a solid monetary base; it is started and continued in faith. But most of the time, if money was necessary, there was no lack of it. The Reverend Pietersen from Malines joined us and led us to the Reverend De Jong in Brussels, who had asked us to stay with him.

He also reported that the evangelists in Belgium did not have to have any certain grade or diploma, but could be appointed on a "proof of suitability," continuing:

Vincent is complimented on his English.

It was a pleasant coincidence that the Reverend Jones, with whom Vincent had been in England, could accompany us. He had arrived the preceding Saturday, and stayed till Tuesday, when he went to Brussels with us. He is a nice human being, who had made a good impression upon all of us. In Brussels he spoke well of Vincent, and his presence caused the discussion to be held mostly in English; this gave Vincent the opportunity to show that he could speak it quickly and correctly, for which they gave him a compliment. We now wait for further instructions about when and how he will start work.

In spite of these efforts it remained uncertain whether this new direction for Vincent would be successful, but he set to work diligently in order to prepare himself well. "Now I will try to write some compositions which will prove useful to me later; I am writing one now on Rembrandt's picture *The House of the Carpenter* in the Louvre." His father still had his doubts about the decision, and he was also worried about the financial side of the project. To Theo he wrote on 31 July: "I am under no illusions about Vincent—often I even feel the fear coming over me that we shall again be disappointed, and then, very, very much will be needed. And however much one is ready to cut down expenses, there is always a following up of things that

increase the worries. However, it is written: the Lord is my shepherd, I shall not want."

On 5 August Vincent himself wrote Theo about his trip to Brussels. "I just received a postcard from the Reverend Mr. Pietersen; about the middle of August I shall have to go to Brussels. But as no date has been fixed and as Father and Mother think it better for me to stay until Anna's wedding, I shall wait until all that is over and then start for Brussels" (letter 124).

Anna, Vincent's eldest sister, was going to marry Joan Marius van Houten, a lime-burner from Leyden, on 22 August, and as Theo could not attend the marriage (he had been transferred to the Paris branch of Goupil & Co. in the meantime) it was only natural that the parents wanted their eldest son to be present. It was decided accordingly, and a letter from his father to Theo shows that Vincent finally departed for Brussels on 24 August. His mother added on the same day—the day before the wedding: "May everything go well with Vincent, but o Theo, it isn't clear yet, he is more absent-minded than ever. Probably also because he really concentrates on his thoughts on his sermons, of which he is making a whole stock. On Saturday he will go, and so will Lies, and then it will be very quiet here."

Marriage of Anna van Gogh to Joan Marius van Houten, 22 August 1878.

20
President Macmahon opens the World's Fair in Paris, May, 1878. It was at this fair that Theo had a job.

Not much in Theo's life had changed in 1877 and 1878. He remained with the Roos family in The Hague; in the spring of 1877 he was allowed to make the sales journey for Goupil's, and at regular intervals he visited his parents and other family members.

In one respect there was a difference from 1876. Although nothing can be found about it in the family letters that have been saved, there is no doubt that in the beginning of 1877 Theo had shocked the family with some kind of a love affair. There is a rather obscure passage in one of Vincent's letters from Dordrecht, written on 26 February 1877, that must be connected with this event. "Thanks for coming this way yesterday. Let us have as few secrets from each other as is possible. That is what brothers are for" (letter 86). That Theo had worries is evident in a letter from March: " 'I am so sad and lonely,' you say." In response, Vincent characteristically consoled him with a text from the Bible: "And yet I am not alone for the Father is with me" (letter 88).

A few days later, when the brothers had met in Amsterdam to visit one of their uncles, Vincent took the opportunity to

stress how much Theo's friendship meant to him. "I want you to have a letter from me on your journey. What a pleasant day we spent in Amsterdam; I stood watching your train until it was out of sight. We are such old friends already—how many walks have we taken together since the time at Zundert in the black fields with the young green wheat, where walking with Father at this time of year, we heard the lark singing?" (letter 89). And in a letter written only a few days later, he repeated his appeal that they have faith in each other. "It is an old truth that the love between brothers is a strong support through life; let us seek that support. May experience strengthen the bond between us, let us be true and outspoken toward each other, and let us not have any secrets—just as it is now."

What had happened in Theo's life can only be reconstructed with the help of one of Vincent's much later letters, and then only if one consults the original manuscripts, for the passage in question had been omitted by Jo van Gogh-Bonger from her 1914 edition of the letters and was not restored in later editions. In this letter, which dates from five years later in 1882, Vincent wrote:

> You speak of something that happened to yourself. I seem to remember it vaguely, as in a mist. If I remember well, you were acquainted with a lower class girl. You loved her and had slept with her. Now I don't know who that person was, but I do know that you had consulted Pa, and had also talked to me about her. And also that Pa made you promise something about marrying her; I don't quite know what—but probably that you would not do that without his consent during your minority. As long as you were under age, Pa really had the right to interfere, and I can understand his standpoint (letter 198).

The point Vincent was trying to make was that Father Van Gogh did *not* have that right in his own case (i.e., his living with Sien Hoornik), for he was much older and did not have to think about a position in society or about class distinctions. He came back to the subject once more in July 1882:

Theo's plan to marry a "lower class" girl.

> Theo, I am now obliged to touch upon a subject which will perhaps be painful to you, but which will possibly make you understand what I mean. In the past you also had an "illusion," as Father and Mother call it, about a woman of the people; and it was not because you *could* not have chosen that path in life that nothing came of it after all, but because things took another turn and you adapted yourself to life in another social station and are now solidly situated. If you should want to marry a girl of your own station, for *you* it would not mean a new illusion. You would not be admonished; and though nothing came of the first affair, something would certainly come of a new love affair (letter 212).

Only by reading this does it become clear what was meant in the following passage from the letter of March 1877—suppressed in previous printed editions—which follows the sentence saying that brothers should have no secrets from each other: " 'It is not over yet,' you say. No, it could not be over yet. Your heart will feel the need for confidence in itself and for unburdening itself; you will be hesitating between two roads: she or my father. As far as I am concerned, I believe that

Father loves you more than she does—that his love is more valuable." Yet the last sentence of this passage is, "Do go there, whenever it becomes too much for you," something which may probably be read as, "Do go *to her*, whenever it becomes too much for you." One must assume that Theo listened to the wise words of his father (and those of Vincent), though it will have strengthened his feeling of dejection. How drastically he sometimes gave vent to these feelings is apparent in a few sentences from Theo's letters, quoted by Vincent in one of his own. "A phrase in your letter struck me: 'I wish I could go far away from everything; I am the cause of it all, and bring only sorrow to everybody; I alone have brought all this misery on myself and others.' These words struck me because that same feeling, neither more nor less, is also on my conscience" (letter 98).

It was at this point in time—and probably because of what had happened—that Theo considered going to another city (London or Paris) and had already talked it over at home. Vincent encouraged him and hoped that Theo would be able to go to London before Paris. "I have loved so many things in these two cities; I often recall them with a feeling of melancholy, and I almost wish to go back there with you." Yet it was a long time before Theo really did go out into the world, and in the next nine months in The Hague he probably followed his accustomed routine.

In 1878 he was again commissioned to make the yearly business trip for the firm, but then—evidently as a surprise for himself and the family—he was sent to Paris. Although this was only for a limited time, he must have been very pleased to comply with the wishes of his employers. Shortly before 1 May 1878 he traveled to Paris, where he was assigned to work at Goupil's stand at the World's Fair. His father wrote him on 11 May, as soon as he heard about it, "So your work will be of a somewhat different kind from what we had thought, and you will have to be at the exhibition most of the time." In the same letter his mother added: "Our whole heart traveled after you and keeps following you and praying for the Lord's blessing. Do not start a single day without the good Lord, my child. In that big world full of distraction and temptation you can't do without Him, just as little as we in our quiet spot in Etten; and whatever the circumstances, don't forget life is earnest, then you will increase not only in knowledge, but also in firmness, which is the basis and source of a happy life—something we wish you above all."

But his father, who had spent his whole life in small Brabant villages and who must have had a terrifying idea of life in the big city, followed up with serious warnings of a more practical kind:

> You say that among the young people there they do not understand why you have been picked for that job. Is it possible that they are somewhat jealous? Then take care, do not trust *unconditionally* every friendship that is being offered. Think of intrigues! which are somehow ascribed to that metropolis! If one should tempt you to any spending beyond your means: be *doubly* on you guard! When one plans someone's downfall, the system of making him *run up debts* is fairly customary to throw a net over his head! But do not think I look at things too darkly. Only watch out. I do know that you do not

1878: Theo is sent to Paris.

intend anything else, we trust you! But is it surprising that we—who know what disappointment is—also think a little further ahead?

Naturally, that disappointment was primarily caused by Vincent, who had just made it clear that he would not finish his studies in Amsterdam. A few days later, they were informed by Lies, who had entered for examinations in French and English, that she had not passed, much to the disappointment of her parents, even though she was allowed to take them again some months later. "Dear Theo," his mother wrote on 12 May when she had forwarded this bit of news, "do remain the crown for us old ones, which is shaken so often." No wonder the "old ones" enjoyed Theo's letters about the important personalities he saw go past at the exhibition. His father wrote: "You evidently enjoy life and are well able to overcome your difficulties. It is really a stroke of luck to be able to look at that colossal world around you and observe representatives of all nations and people behaving at their best and less than best, and then with so much art around you . . . and far, very far away so many who think of you with love and interest and confidence, and already look forward to receiving a word or two from you."

Theo's star is rising; Vincent's is descending.

Theo's star was rising at the same rate that Vincent's was descending. This did not go unnoticed by the influential Uncle Vincent in Prinsenhage. That he had lost all confidence in his namesake was obvious already in March 1877 when he wrote that he did not think that carrying on a correspondence with Vincent would serve any purpose. In contrast, Mother Van Gogh, who had been to Prinsenhage on 7 June wrote: "Theo, Uncle loves you so much, I believe that after the disappointment with Vincent, the thought that you may succeed in his old favorite trade gives him a hope in life, something that is so important to him. Write him from time to time; that will give him pleasure, and tell him about everything; he is so nice to us that we should cooperate as far as we can to give him some joy in life."

When Theo's activity at the World's Fair ended is not certain, but he did not stay in Paris. Vincent's letter of 26 December ended again with the words, "Best regards to everyone at Roos's" (letter 127), indicating that Theo was back at his old address in The Hague. It is safe to suppose that he returned around the middle of November, as Vincent wrote from Laken near Brussels on 15 November that they had spent the day together (letter 126). That meeting could only have been while Theo was on his way back from Paris, for he would never have made the journey from The Hague to Brussels just to be with his brother for a day. With this visit their paths crossed once again; it was an important moment for both brothers, especially for Vincent, whose life story was to be connected with Belgium for the next two and one half years.

Vincent's and Theo's paths cross again.

The Evangelist

There is a gap in the published letters from Vincent to Theo between 15 August—shortly before he left for the School of Evangelization in Brussels—and 15 November 1878, although he must have written to Theo from Brussels more than once. The long letter of 15 November, however, written at the end of

his three-month "testing" period at the training school, is one of extraordinary importance, as it provides a clear picture of the maturity Vincent had developed when, at age twenty-five, he started his work as an evangelist. Theo had recently spent a day with Vincent in Laken, and the emotional tone of the first sentences shows how much the meeting with his beloved brother had meant to him. "On the evening of the day we spent together, which went by only too quickly for me, I want to write you again. It was a great joy for me to see you again and to talk with you, and it is a blessing that such a day, which passes in a moment, and such short-lived joy, yet stays in our memory, never to be forgotten" (letter 126).

21
A view of the Borinage.

The most striking side of the letter may be that it shows Vincent much more as an artist—at least an artist-to-be—than as a preacher of the Gospel. In the three printed pages of the letter, only a few sentences refer to religion, and in general his thoughts appear to be more occupied with paintings and prints than with the study of the Bible. After a few friendly words he begins the letter with an evocative description, combining—as was his habit—realistic observation with the memory of a work of art:

When we had said goodbye, I walked back, not the shortest way but along the towpath. Here are workshops of all kinds; they are picturesque-looking, especially in the evening with the lights. To us who are also laborers and workmen—each in his own sphere, doing the work to which he is called—they speak in their own way if only

we listen, for they say, "Work while it is day; the night cometh, when no man can work."

It was just when the street cleaners were coming home with their carts drawn by the old white horses. A long row of these carts was standing at the so-called Terme des boues[23] at the beginning of the towpath. Some of these old white horses resemble a certain old aquatint which you perhaps know, an engraving of no great artistic value, it is true, but which struck me and made a deep impression on me. I am referring to the last of that series of prints called *The Life of a Horse*. It represents an old white horse, lean and emaciated and tired to death by a long life of heavy labor—work which was too much and too hard. The poor animal is standing on a spot utterly lonely and desolate, a plain scantily covered with withered dry grass, and here and there a gnarled old tree, broken and bent by storms. On the ground lies a skull; and at a distance in the background, the bleached skeleton of a horse near a hut where a horse-knacker lives. The sky above is stormy; the day, cold and bleak; the weather, gloomy and dark.

It is a sad and very melancholy scene, which must affect everyone who knows and feels that one day we too have to pass through the valley of the shadow of death, and *"que la fin de la vie humaine, ce sont des larmes ou des cheveux blancs"* [that the end of human life is tears or white hair]. What lies beyond is a great mystery which only God comprehends, but He has revealed irrefutably that there is a resurrection of the dead.

The poor horse, the old, faithful servant, is standing patiently and meekly yet bravely and unflinchingly; like the old guard who said, *"la garde meurt mais elle ne se rend pas"* [the guard dies but does not surrender], it awaits its last hour. Involuntarily I was reminded of that engraving when I saw those ash-cart horses tonight (letter 126).

Vincent's painter's eye and his amazingly sharp visual memory enabled him to call to mind with such precision an engraving that he had probably seen quite a long time before. Some five years later he made an impressive drawing of just such an "an old white horse, lean and emaciated" (JH 368) which he had seen at the garbage dump in The Hague ("a splendid subject," he called the dump) (letter 292). How striking it is that there was so much inner unity and continuity in his life, in spite of all the fluctuation.

This long passage is only one of several examples of Vincent's descriptive talent that could be quoted from the same letter. The following sentence about an earlier walk in the surroundings of Brussels also bears witness to his acute sense of observation: "Here and there are places where stone is found, so there are small quarries through which pass sunken roads with deep wagon ruts; along them one can see the little white horses decorated with red tassels and the drivers with their blue blouses; the inevitable shepherd is not lacking, nor the women in black dresses and white caps who remind one of those of De Groux."[24] Finally, there is this evocation of a landscape, which Vincent again connected to the work of yet another painter: "That day I walked on past Forest and took a side path leading to a little old ivy-covered church. I saw many

23 The name of a road, literally, "end of the mud."

24 Charles de Groux (1825-1870), a Belgian painter, is often mentioned with much admiration in Vincent's letters.

linden trees there, even more interwoven and more Gothic, so to speak, than those we saw in the park; and at the side of the sunken road leading to the churchyard were twisted and gnarled stumps and tree roots, fantastic, like those Albert Dürer etched in *Ritter, Tod und Teufel.*"

It is no wonder that one of the last sentences of this letter reads, "How much beauty there is in art; if one can only remember what one has seen, one is never empty or truly lonely, never alone." And it is only natural that Vincent did not want to leave it at words alone, but try his hand at drawing himself in order to depict what he saw.

As no letters from these months have survived, nothing is known from Vincent himself about his schooling in Brussels. Up until a short time ago the only document that contained information about the first months that Vincent spent in Brussels was a short article in the Protestant monthly *Ons Tijdschrift* from 1912, thirty years later.[25] Here an unidentified fellow student reminisces about "Master Bokma," the man who directed the Training School for Evangelists.[26]

It is not difficult to trace the fellow pupil who had told this story to one of the contributors to *Ons Tijdschrift*. It was Pieter Jozef Chrispeels (1858-1939), who after his study years became pastor in Maria Horebeke and later in Laken. When in 1927 a Van Gogh exhibition was held in Brussels, he published a similar story in his own weekly, called *Christelijk Volksblad*, a periodical devoted to evangelization in Holland and Belgium. When Chrispeels finished his studies, he became a soldier. Still, Vincent did not forget his fellow pupil. "In the meantime I had become a soldier [Chrispeel's military service lasted from 1879 to 1881]. Once when we were exercising on the parade ground the sergeant called me, saying, 'There is a man to see you.' The man came to me. . . . It was Van Gogh, with a big portfolio under his arm. He showed me drawings, representing miners. How queer these stiff little figures looked. But that is how Van Gogh saw them with his artist's eye."

Jo van Gogh-Bonger summed up the end of Vincent's training period in her Memoir as follows: ". . . and when the three months had elapsed, he did not get his nomination." This, however, does not give a true picture of the situation. The three months were meant as a testing period, necessary to find out whether he would be able to continue with the training, not whether he could be given a nomination. Understandably, Vincent himself gave a different explanation in his letter to Theo in November. "November 15 had passed, so the three months have elapsed. I spoke with the Reverend Mr. de Jong and Master Bokma: they told me that I cannot attend the school on the same conditions as the native Flemish pupils—I can follow the lessons free of charge if necessary, but this is the only privilege. To stay here longer, I ought to have greater financial resources than I have, which are nonexistent. So perhaps I shall soon try the Borinage plan. Once in the country, I shall not soon go back to a big town" (letter 126).

What happened next has only become clear since the 1978 publication of a booklet about the Training School for Evangelists, written by a professor of the Brussels School of

Reminiscences of a fellow student, Pieter Jozef Chrispeels.

[25] Quoted in *The Complete Letters* under letter 126a.

[26] Dirk Rochus Bokma (1831-1911) had died the year before.

Theology, W. Lutjeharms.[27] In it, many unknown facts about Vincent van Gogh and his three months' stay in Belgium came to light. Most of the lessons were given by D. R. Bokma, who was also headmaster of the Protestant primary school at Kathelijneplaats (a classroom was used adjoining this school); and theology and philosophy lessons were given by the Reverend Nicolaas de Jong and Dr. G. F. C. Herfst respectively. The booklet confirms that Vincent was permitted to go on following the lessons. "Although Vincent had not shown signs of being a diligent student, he was allowed to stay on; De Jonge and Bokma were very accommodating in this respect. But it was only natural that he did not get a grant for free boarding and pocket money. He was a Dutchman who did not speak a Flemish dialect, his main interest was the French-speaking population of the mining district, and there was no hope that he would become one of the pupils who could persevere till the final diploma. In spite of all this he was certainly not rejected."

Vincent's main reason for quitting was that he did not want to be a burden to his father any longer. During his studies, Vincent lived in Laken with a family called Plugge. According to Professor Lutjeharms, "He had a good bedroom in the house of the Plugge family, 6 Trekweg, but as a penance he often slept on the mat in front of his bed." The house was not a boarding house, but was found accidentally; P. J. Plugge was a member of the council of the church at Kathelijneplaats and of the board of the Protestant primary school there. He evidently considered it his duty to inform Vincent's father of his concern about his boarder, as follows from Father Van Gogh's letter to Theo on 24 November: "I am on the point of going to Brussels. Mr. Plugge wrote me about Vincent. He is weak and thin—it seems he was not given any prospects, and I am worried. According to Mr. Plugge's letter, he cannot sleep and seems to be in a nervous condition. Therefore I want to go and see for myself what we should do." Mother Van Gogh, who called Mr. Plugge's letter "terribly sad," added: "Tomorrow is the end of the three months' period; we are almost sure he will not be accepted. We don't talk about it to anybody, don't do that either. We say to the people who know that Father will go on a journey, that Vincent is ill. You can well imagine what a sad journey. Mr. Plugge asked us to come and take him home. What is going to become of all this?"

In the Memoir to the *Complete Letters*, a short description of Vincent's state of health and mind that must have been based on this letter is followed by the sentence, "He [Mr. Van Gogh] immediately traveled to Brussels and succeeded in arranging everything." There can be no doubt that Jo van Gogh-Bonger had misunderstood what had happened. In fact, Reverend Van Gogh's journey never even took place, because in the meantime Vincent had taken his affairs into his own hands. The booklet on the training school reports that in the same days at the end of November, Vincent had set out for Dour, a far-off place in the south of Belgium where he wanted to go to see the Reverend Pierre Péron, who was not only the secretary of the synod but also of the Committee for Evangelization. This

Fall 1878: Vincent lives in Laken, Belgium with the Plugge family.

[27] It is number 6 in the series *Historische Studies* of the *Vereniging voor de Geschiedenis van het Belgisch Protestantisme* (Historical Studies of the Society for the History of Protestantism in Belgium), entitled "De Vlaamse Opleidingsschool" (1978).

74

is confirmed by a letter from Father Van Gogh, published in Professor Lutjeharms' booklet.

Not surprisingly, the Reverend Péron had asked for more information about the young man who had visited him, and it was at Vincent's request that on 5 December 1878 his father wrote the following letter to "Mr. Péron, Protestant Minister at Dour" (translated from the French): "Dear Sir, Having received a letter from my son Vincent, who wrote that he had addressed himself to you to ask for some work, and who said that you, Sir, wished to have some more information about him from me, his father, I hasten to comply with your request by telling you: That it is really my son who, having been looking for a place as evangelist in Belgium for three months now, came to see you in the hope that you might give him some light, giving him the advice and information which he needs." The letter ends with recommendations and the prayer "May God grant him to find with you the possibility of gaining his daily bread by practical work of an honest kind."

Acting on his own account, Vincent anticipated events by moving to the Borinage, Belgium in December 1878. His arrival there was a very important moment in his career. He now had his schooling behind him, and this was the start of a period of almost two years that was to become one to the most emotional and eventful phases in his life. The surroundings differed completely from anything he had experienced in his earlier wanderings. Here that he could listen freely to what his heart told him to do and could put into deeds the sympathy he felt with the fate of the less fortunate; here he chose the path of the arts instead of religion to vent his almost fanatical urge for self-expression .

December 1878: Vincent moves to the Borinage.

Some factual information may be useful to the reader who is not familiar with this part of Belgium. The Borinage is a region in the province of Henegouwen (Hainaut) south of the town of Bergen (Mons). There were many coal mines—all closed now. The villages where Vincent stayed—Pâturages, Wasmes and Cuesmes (nowadays more or less one urban area)—are located southwest of Mons, within ten kilometers of the French border. "Everywhere around one sees big chimneys and immense heaps of coal at the entrances to the mines, the so-called *charbonnages*" (letter 127). Vincent would not have been Vincent if he had not found something to praise, even here. "It has been thawing tonight; I cannot tell you how picturesque the hilly country is in the thaw, now that the snow is melting and the black fields with the green winter wheat are visible again." Again he made associations with art. "At every moment I am reminded here of the work of Thijs Maris or of Albrecht Dürer. There are sunken roads, overgrown with thornbushes, and old gnarled trees with their fantastic roots, which perfectly resemble that road on the etching by Dürer, *Le chevalier et la mort.*"

Thijs Maris, 1839-1917.
Albrecht Dürer, 1471-1528.

In the same connection he also described the people he saw around him. "So, a few days ago, it was an intriguing sight to see the miners going home in the white snow in the evening at twilight. Those people are quite black when they come out of the dark mines into daylight; they look exactly like chimney sweeps." In a later letter he gave a more complete picture of the people, after he had visited the mine at Marcasse, "one of the oldest and most dangerous mines in the neighborhood." About

the mine he wrote: "It had a bad reputation because many perish in it, either going down or coming up, or through poisoned air, explosion, water seepage, cave-ins, etc. It is a gloomy spot, and at first everything around looks gloomy and desolate" (letter 129). He described the miners and their surroundings as follows: "Most of the miners are thin and pale from fever; they look tired and emaciated, weather-beaten and aged before their time. On the whole the women are faded and worn. Around the mine are poor miners' huts, a few dead trees black from smoke, thorn hedges, dunghills, ash dumps, heaps of useless coal, etc." (letter 129).[28]

When Vincent wrote to Theo on 26 December, his letter was headed "Petit-Wasmes," a village in the Borinage, and it shows that he had been there for some time, had given religious speeches and visited sick people (letter 127). The seeming contradiction in the address he gave at the end of the letter—"M. van der Haegen, [the correct spelling was Vander Haeghen] *colporteur à* Pâturages" (a village close to Petit-Wasmes)—can be explained with the help of an unpublished letter to Theo from his mother, dated 27 February 1879, which contains the words, "Verhaegen, a *colporteur*, to whom Pa also sent his letters in the beginning, where Vincent had been lovingly received during the first eight days; he was the one who had found that good boarding house at Denis." Vincent therefore had been in Pâturages only for a short time. Théodore Vander Haeghen's house, therefore, was only a temporary shelter before a definite address was found for him in Petit-Wasmes in the house of Jean-Baptiste Denis, a baker. How he had found this first residence is not difficult to guess; his landlord in Pâturages must have been the father of Willem Vander Haeghen, one of his five fellow pupils.

Vincent must have found his work as an evangelist to be satisfying, for he told Theo: "I wrote today to the President of the Committee of Evangelization, asking him if my case could be brought up at the next meeting of the committee." By writing some particulars to his parents, he also reassured them a good deal, as seen in the letter the Reverend Van Gogh wrote to Theo on 20 December 1878:

Vincent starts work as an evangelist at Petit-Wasmes.

> Eight days ago we received a rather nice letter from Vincent; nice in so far as he seems to have found a good boarding house with farmers in Pâturages for thirty francs a month, the reason that it is not much being that he teaches the children in the evening. He was soon accepted by many people with goodwill, and working with those people seems to give him satisfaction. Furthermore, the Reverend Péron has promised him his cooperation. In the middle of January there will be another meeting of the committee of which Mr. Péron is the secretary, and he promised him that he would try to do something for him.
>
> In the meantime, he spends his free moments drawing big maps of Palestine which can be used for talks and catechism, and with which he tries to make some money. I received one and ordered him to make four more copies for which I gave him ten francs each.

[28] Louis Piérard gave important details about Vincent's stay in the Borinage in an article in *Mercure de France* in 1913 (later used for his book *La vie tragique de Vincent van Gogh*, published in 1924). In 1977 further interesting details were published by Pierre Secrétan-Rollier, who had been pastor in Petit-Wasmes from 1922 until 1926. His booklet, however, contains more news about the Borinage than about Van Gogh.

A month later, on 20 January 1879, he related to Theo with great satisfaction: "We are glad to be able to tell you that Vincent has been accepted for the evangelization in the Borinage—provisionally for six months. He gets fifty francs a month—surely not much, but his boarding house costs him [only] thirty francs. It seems he works there with success and ambition, and his letters are really interesting. He devotes himself to that job with all his heart and has a heart and an eye for the needs of those people. It is certainly remarkable what he writes; he went down, for instance, in a mine, 635 meters."[29] The place where Vincent had been appointed was Wasmes, where at that time a small community of Protestants had been founded.

One of Vincent's tasks as an evangelist, besides delivering sermons in "le Salon du Bébé" (a room in the Denis' house), was to visit the sick and other people who needed his help, and references in his letters indicate that this kept him very busy. A letter in March, for instance, ends quite abruptly with the words, "I must go out to visit some sick people, and some healthy as well" (letter 128). The postscript of another letter describes such a visit in a few sentences. "I have just visited a little old woman in a miner's family. She is very ill, but full of faith. I read a chapter with her and prayed with them all" (letter 127).

The frequent mine gas explosions and other disasters, combined with the general unhealthiness of the region, must often have made his help indispensable. This is shown in a letter of April: "Did I tell you about the miner who was so badly hurt by a fire-damp explosion? Thank God, he has recovered and is going out again, and is beginning to walk some distance just for exercise; his hands are still weak and it will be some time before he can use them for his work, but he is out of danger" (letter 129). Vincent's preoccupation with the wounded worried his parents. Although his mother justly remarked in their letter to Theo of 12 February 1879 that such work was part of his activities, his father found it necessary to write: "We are beginning to worry about him again. I am afraid he is wholly absorbed by the care for the sick and the wounded and by sitting up with them." In other words, he was neglecting his religious tasks!

All reliable reports about Vincent's stay in the Borinage praise him for the devotion he showed, although some of the stories exaggerate the extent of his self-denial. His face may sometimes have been as black as those of the miners, but it is doubtful that he blackened it on purpose. At a certain time he did start to live on his own, but not necessarily in a pigsty, as some have reported. It is true, however, that his conduct was characterized by humbleness if not by self-deprecation. An objective report by an eye-witness is quoted in Louis Piérard's 1913 article. His research in the Borinage had brought him into contact with an old pastor, Mr. Bonte, who in 1878 was posted in Warquignies, a village bordering on Wasmes. Mr. Bonte therefore had known Vincent personally thirty-five years earlier. These are the main passages from a letter the Reverend Bonte had sent to Piérard:

Vincent's preoccupation with the wounded worried his parents.

[29] This is confirmed in Vincent's own letter 129.

Our young man found lodging in a farm at Petit-Wasmes; the house was relatively nice; it distinguished itself notably from its surroundings where there were only small miners' cottages.

The family that lodged Vincent van Gogh had very simple manners; they lived like working people.

But very soon our evangelist manifested toward his dwelling the particular sentiments that had taken hold of him; he found it too luxurious; it shocked his Christian humility, he could no longer stand to live so differently from the miners. He then left the people who surrounded him with so much sympathy and went to live in a little cabin. He lived there all by himself; he had no furniture and it was said that he slept crouching down in a corner near the hearth.[30]

Mr. Bonte's reminiscences are confirmed by letters from the Reverend Van Gogh and from Vincent himself. A letter from his parents dated 12 February indicates that: "He also spoke about a plan of renting a workman's house and living there alone. We have tried to dissuade him from it. We are afraid he would not keep it in good shape and it would again lead to eccentricities." However, it was certainly not the "miserable hut" that Jo Van Gogh-Bonger described in her Memoir. Vincent himself described the use of the house in March. "I have rented a small house where I should like to go and live altogether, but which now serves only as a workshop or study, for Father (and I, too) thinks it better that I board with Denis. I have all kinds of things there and some prints on the wall" (letter 128).

Mr. Bonte's reminiscences provide a lively picture of Vincent's self-denying lifestyle at that time:

Vincent rents a small house.

> In view of all the misery he met at his visits, his pity had prompted him to give away almost all his clothes; his money had gone to the poor too, and, by way of speaking, he had kept nothing for himself. His religious feelings were strong, and he wanted to obey the words of Christ as absolutely as possible. He saw it as his duty to follow the first Christians, to sacrifice everything he could spare, and he wished to be even more destitute than most of the miners to which he preached the Gospel.
>
> I must add that the Dutch cleanliness had been abandoned just as well; soap had been abolished as a reprehensible luxury, and our evangelist's face ordinarily was even dirtier than that of the miner's, if not entirely covered with coal. That was an exterior detail which did not bother him; he was absorbed by his ideal of renunciation; he clearly showed, by the way, that his behavior did not arise from negligence, but from consciously practicing the ideas that governed his mind. And if he did no longer care for his own well-being, his heart went out to the needs of the others.

According to Jo van Gogh-Bonger, Vincent's father was worried by the accounts that reached him concerning the fanatical conduct of his son. He thus went to see him and "succeeded in stilling the storm." Letters from his mother give a more detailed image of what had happened. On 27 February she wrote Theo: "And now I have to tell you that Pa has gone to Vincent this week. We were worried about all the bad weather

[30]It seems more likely that he slept on a straw mattress, as is stated further on in Piérard's article.

he had, and especially because while I was away, there had been a very unpleasant letter from him, confirming what we had already suspected, that he had no bed, and that there was nobody to watch his things, but far from complaining he said that that was nobody's concern, etc. We were preparing a parcel for him, but we both thought that it would be so much better if Pa himself would take it to him." Her husband had already left, she said, when she received a letter from "Verhaegen," as she called Vander Haeghen, and a very disturbing one from Vincent. Vander Haeghen warned the Van Goghs that it had been decided that Vincent "would lose his post if he did not want to listen to good advice," but he added that he hoped "his fatherly advice would yet lead him back from his wrong ways." About a letter from Vincent she wrote: "It informed us that one of these days we should probably receive a negative opinion about him as a result of the visit of the Reverend Rochelieu from Brussels—I suppose it was an inspection—which had caused the church council of Wasmes to have a meeting about him with people of the neighborhood—and, Vincent wrote, what are we to do now? Jesus was also calm during the storm, and evil can turn into good, and perhaps it must grow worse before it grows better."

In letter 128, Vincent wrote about his father's visit: "I am very glad Father came. Together we visited the three clergymen of the Borinage, and walked through the snow, and visited a miner's family, and saw the coal brought up from a mine called 'Les trois Diefs' (The Three Mounds); Father attended also two Bible classes, so we did a great deal in those few days. I think Father had been impressed with the Borinage and that he will not easily forget it; no one who visits this curious, remarkable and picturesque region can."

After his father's visit, Vincent decided to use the little house he had rented only as a "workshop" and for a study, but that is as far as his father's influence went. It certainly is not true that Father Van Gogh brought his son back to Etten, as Piérard said in his book; he had copied that from Elisabeth van Gogh's *Recollections*, but she was not well informed about this episode.

There was an important change in Vincent's circumstances; at the end of the six months' period for which he was engaged, he was not reappointed. What is said about this change in the Memoir to the *Complete Letters* stems from a letter from the Reverend Van Gogh to Theo of 19 July 1879. "You know, don't you? that Vincent's situation in Wasmes does not become any clearer. They have given him three months to look for something else. He does not comply with the wishes of the Committee and it seems that nothing can be done about it. It is a bitter trial for us. We literally don't know what to do. There is so much good in him, but he simply doesn't want to cooperate." In Vincent's own letters there is not a word about this matter. Piérard's research, however, produced an important document that gives a completely reliable and objective image of the opinions his clerical superiors had of Vincent. It is the report of the *Union des Eglises protestantes de Belgique*, 1879-1880, chapter Wasmes, from which Piérard quoted the following:

The experiment that has been tried by accepting the services of a young Dutchman, Mr. Vincent van Gogh, who believed his calling

The Reverend Theodorus van Gogh visits his son in the Borinage.

was to preach the Gospel in the Borinage, has not given the results we had expected. Mr. Van Gogh has certainly shown admirable qualities in his care for the sick and the wounded; many times he has shown devotion and a sense of sacrifice; he has kept night watches with people who needed it, and even gave the best part of his clothes and linen away.

If he had also had the gift of the word, which is indispensable to anyone who is placed at the head of a congregation, Mr. Van Gogh would surely have been an accomplished evangelist. It would certainly not have been reasonable to demand extraordinary talents. But it is a fact that the lack of certain qualities can render the principal activity of an evangelist insufficient.

Unfortunately that was the case with Mr. Van Gogh. That is why we had to give up the thought of employing him any longer, now that the testing period of some months is finished.

The present evangelist, Mr. Hutton, has started his work on 1 October 1879.

It is unclear what Vincent did during the months following the unfavorable decision of the Committee. By giving him "three months to look for something else," the Committee probably gave him another three months' pay, but he was not permitted to continue his work in the same way. After July there is not a word in his letters about giving Bible readings or nursing sick people—the regular subjects of his earlier reports to Theo. If he had indeed not given up this kind of activity, it must have become much less important to him. On 2 July his mother, who had just paid him a short visit when she was returning from a trip to her brother-in-law in Paris, wrote about Vincent to Theo; her words may sound somewhat clumsy, but they show great affection for her eldest son:

> This week a letter from Vincent; we are always thinking about him with anxiety; poor boy, shortly after my visit to him he wrote that he had had such a melancholy feeling when we had said goodbye, as if it could have been for the first, but also for the last time; but now, there had been a meeting, but they hadn't said anything to him; before, they had always found fault with him. We have the idea they still want to wait and see for some time, but if he doesn't suit himself to their wishes and adopt the behavior they demand from him, they can't accept him. He could still achieve so much, if only he knew how to control himself. Poor boy, what a difficult, unrewarding, much missing young life, and what is he going to do next?

Vincent left Wasmes in August and moved to the nearby village of Cuesmes, and this certainly is a sign that he stopped working in Wasmes. In his father's words from a letter to Theo of August, "He can no longer work in the service of the Committee, that is impossible—can he go on working as an evangelist on his own accord? that, [Pieterszen] thinks, would be the best, but where would the money come from?" Assessing the situation in the Borinage, his mother said in a letter of 19 August that "there was nothing for him to do there."

July 1899: Vincent's work as an evangelist ends; he moves to Cuesmes, another village near Mons.

80

THE EVANGELIST BECOMES A DRAFTSMAN

22
"The Bearers of the Burden" was the symbolic title Vincent gave this drawing. A subject first done in Brussels in 1880, only this more finished version from 1881 has survived.
National Museum Kröller-Müller, Otterlo, The Netherlands

As the themes which had occupied Vincent as an evangelist disappeared from his letters, a new subject came to the foreground. A letter from his mother to Theo as early as May 1879 contains the surprising sentence, "Vincent wrote that he would do his best to draw costumes and tools." By August 1879, drawing became the main theme of the letters. In a letter of 5 August, when he was awaiting a visit from Theo, he wrote, "If you have time to stay a day, or more or less, I should be very happy; I should have some drawings to show you, types from here," and also, "Often I draw far into the night, to keep some souvenir and to strengthen the thoughts raised involuntarily by the aspect of things here" (letter 131). More remarkable is the information that he had written to Mr. Tersteeg "to thank him for the box of paints he sent me, and the sketchbook, which is almost half full already," for why would Mr. Tersteeg have sent him a sketchbook and a box of paints unless Vincent had asked for it? Vincent also reported in the letter that "I went to Brussels recently, and to Maria Hoorebeeke and Tournay, partly on foot." The fact that "in Brussels I bought from a Jewish book dealer another big sketchbook of old Dutch paper," is another sign that around the middle of August of 1879 drawing, and not evangelism, had become Vincent's main activity.

An unpublished letter from Father Van Gogh to Theo, dated 7 August 1879, explains that Vincent, who was now living in Cuesmes, had gone on foot to Maria Horebeke in Flanders to see the Reverend Pieterszen; however, as the latter happened to be in Brussels, Vincent had gone on to visit him in that city. Being one of the members of the board of the Flemish School for Evangelists in Brussels, the Reverend Pieterszen had to be there often, although he lived in Maria Horebeke where he was the Protestant minister. Formerly he had been an artist and an evangelist in Mechlin, but Vincent must have known that he was now working in Maria Horebeke and had his studio there.

The distance between Maria Horebeke and Cuesmes is some fifty kilometers as the crow flies and some eighty kilometers if Vincent had gone via Tournay, as suggested by

On foot from Cuesmes to Brussels.

one of the letters; moreover, it is another fifty kilometers from Maria Horebeke to Brussels. It is no wonder that at the end of the trip Vincent was very tired-looking. The Memoir to the *Complete Letters* contains this anecdote, repeated in many books about Van Gogh: "He arrived tired and hot, exhausted and in a nervous condition; his appearance was so neglected that the daughter of the house who opened the door was frightened, called for her father and ran away."

Jo van Gogh-Bonger assumed that this scene had happened at the house of the Reverend Pieterszen, but the booklet by Professor Lutjeharms about the School for Evangelists establishes that it was at the home of the architect Otto J. Geerling, whose daughter later married the Reverend J. Chrispeels. Geerling belonged to the circle of Protestants connected with the School for Evangelists, and was a member of the board for many years. The students often visited the hospitable family, and it seems to have been his daughter, Joanna Geerling herself, who first told the story. Reverend Van Gogh's letter of 7 August confirms these facts.

> Last Friday [25 July], Vincent writes, he started on a trip to Maria Hoorebeeke in Flanders; he arrived there—on foot—on Sunday afternoon, intending to meet the Reverend Pietersen, who [however] was in Brussels. Thereupon he went to that city, and he met him on Monday morning [this suggests that he had arrived at another family's home on Sunday afternoon]. After consultation with him, he is now in Cuesmes again, where he has found shelter; he hopes to find a small room there to stay for the time being. At present his address is: *Chez* M. Frank, Evangéliste *à* Cuesmes (*près de* Mons) *au* Marais. In Brussels, he visited the families he had met there earlier—what impression will he have made?

Despite missing him the first time, Vincent did succeed in visiting the Reverend Pieterszen at his studio—perhaps on the way back. "Lately I have been at a studio again, namely at the Reverend Pietersen's, who paints in the manner of Schelfhout or Hoppenbrouwers, and has good ideas about art. He asked me for one of my sketches, a miner type" (letter 131). It is most probable that he had wanted to see Mr. Pieterszen to know his opinion about his possibilities as an artist rather than because he wanted to consult him about his work as an evangelist. His path as a teacher of religion had been cut off for good now, and it was in this period—and not in the summer of 1880 as has mostly been assumed—that the thought of completely turning to art as a profession must have ripened in Vincent's mind.

Vincent had not seen Theo since November of the previous year, but he finally met him again in August 1879. He had heard that Theo was going to work in Paris, and asked whether they could meet at the station. His following letter, also from August,[31] shows that the meeting had actually taken place. The visit had done him good. "When I saw you again and walked with you, I had the same feeling which I used to have more often than I do now—as if life were something good and precious which one must value, and I felt more cheerful than I have for a long time."

Meeting Theo again, August 1879.

[31] The date given to it in the *Complete Letters*, 15 Oct. 1879, was a mistake.

Yet the letter makes it clear that the meeting was not altogether pleasant. From what Vincent says about it, Theo—supported by the family and especially by their eldest sister Anna—was of the opinion that Vincent should finally start doing something "useful" and practical instead of "spending his days in idleness." The occupations they had suggested to him—all in earnest—in order to make a living were summed up in Vincent's answer, the tone of which gradually changed from quiet reasoning to sarcasm and indignation. He realized that something had to be done: "To improve my life—do you think I am not longing for it, or don't need it?" He assured Theo that he did not doubt his intentions. "On the other hand you would also be mistaken if you thought that I would do well literally to follow your advice to become an engraver of bill headings and visiting cards, or a bookkeeper or a carpenter's apprentice—or else to follow the advice of my very dear sister Anna[32] to devote myself to being a baker—or many similar things (curiously different and hard to combine) that other people advise me. But you say, 'I do not expect you to take that advice literally; I was just afraid you were too fond of spending your days in idleness, and I thought you should put an end to it' " (letter 132).

Vincent was not only indignant—and rightly so—but also said, "If I have to believe in earnest that I am troublesome to you or the people at home, of no good to anyone, and have to feel like an intruder or a superfluous person, so that it were better I did not exist, and if I am obliged to try to keep out of the way of other people more and more—when I think that this really is the case, a feeling of anguish overwhelms me, and I have to struggle against despair." These were the feelings that made him overcome—following Theo's advice—his aversion of trying to strengthen the bond with his parents. "Perhaps the fault is mine, and you may be right that I do not see matters clearly; so it may be that, notwithstanding my strong repugnance and that it will be hard for me to do, I will go to Etten for at least a few days" (letter 132). A letter from his mother to Theo on 19 August 1879 shows that Vincent did indeed go to Etten almost immediately, but also that the attempt at kindness was less his than his parents'.

Vincent returns to his parents' home in Etten.

But now I must tell you something new, which is that Vincent, after much pressure from our side to visit us at home because we were worrying so much about him and he had nothing to do there, suddenly stood before us last Friday [15 August]. The girls were boating with the Gezink family, and all at once we heard, "hello father, hello mother," and there he was. We were glad; although seeing him again we found he looked thin; that is over now; it must have been the walking and bad food, etc.—things, by the way, he doesn't talk about, but he looks well, except for his clothes. Pa immediately gave him his cherished new jacket. We bought a pair of boots, and he now wears the little summer coat I made for Pa's birthday every day. Some of your old underwear came in useful, too, and as far as stockings, etc., are concerned, I had prepared them in advance, so that now he is quite well taken care of. He is reading books by Dickens all day long, and doesn't speak apart from giving answers—sometimes correct, sometimes strange ones; if only he

[32] The sarcastic words about his "dear sister Anna" were left out in the printed editions.

adopted the good things from those books. For the rest, about his work, about the past or the future, not a word. . . . Tomorrow, he and Pa will go to Prinsenhage, where CM's boys [Uncle Cornelis Marinus' sons] will come to see the paintings; they are going by train. Pa and Vincent will go on foot, maybe he will talk a little bit then.

Theo's attitude toward Vincent probably became cooler when he heard about Vincent's painful visit to his parents. At this point there is a great gap in their correspondence—at least in what has been published—the greatest that ever occurred between the two. There are no letters from Vincent between August 1879 and July 1880, and as no letters from his parents to Theo during these months are available either, not much is known about this period in Vincent's life. One certainty is that in March 1880 he made a long journey on foot to Courrières, a village in the north of France, south of Lille. The journey, full of hardships, betrays his almost desperate longing for human contact, but speaks of an iron will and perseverance. Vincent wrote about it in a letter from September 1880 and referred to it once more in a letter of September 1883, in which he mentioned that the journey had taken place "in the beginning of March" (letter 136). His reason for going to Courrières was that Jules Breton, a painter he admired very much, lived there, but that was not all; in the first letter of 1880 he said: "I had undertaken the trip hoping to find some kind of work there. I would have accepted anything."

The account of his journey was prompted by a letter from Theo in which he had written something about the famous painters' town of Barbizon in the forest of Fontainebleau. With the wry sort of humor that often characterized his letters, Vincent replied, "I have not seen Barbizon, but though I have not seen it, last winter I saw Courrières." Once he broached the subject, it became a long dramatic story. "I had only ten francs in my pocket, and having started by taking the train, I had a long, weary walk of it." This is again one of his great understatements; he had taken the train only for the stretch between Mons and Valenciennes, which means that he must have traveled almost eighty-five miles on foot.

A few passages from this story should be quoted, beginning with the sad statement that the journey had been for nothing: "Anyhow, I saw Courrières, and the outside of Mr. Jules Breton's studio. The outside of the studio was rather disappointing, as it is new and built of brick with a Methodist regularity, an inhospitable, chilly and irritating aspect. . . . I lacked the courage to enter and introduce myself. I looked elsewhere in Courrières for traces of Jules Breton or some other artist; the only thing I was able to discover was his picture at a photographer's, and in a dark corner of the old church a copy of Titian's *Burial of Christ*, which in the shadow seemed to me to be beautiful and of wonderful tone" (letter 136).

It was not Vincent's habit to complain, but he did provide a glimpse of the abominable circumstances he had to cope with during that week.

Though this trip almost killed me and I came back overcome with fatigue, with sore feet, and in a quite melancholy mood, I do not regret it, for I have seen interesting things, and when one

Vincent travels on foot to Courrières in the north of France, February-March 1880.

84

experiences the hardships of real misery oneself, one learns to look at it with different eyes. Along the road I occasionally earned a few crusts of bread in exchange for some drawings which I had in my valise. But when the ten francs were all gone, I had to spend the last nights in the open air, once in an abandoned coach, which was white with frost the next morning—rather a bad resting place; once in a pile of faggots, and once—and that was a little better—in a haystack, where I succeeded in making a rather more comfortable berth, but then a drizzling rain did not exactly further my well-being (letter 136).

After this adventurous trip, Vincent must have decided to go back to his parents' in Etten. The only document that mentions something about this second stay in Etten is an unpublished letter from his father to Theo of 11 March 1880. "Vincent is still here—but alas! it is nothing but worry. Now he is talking about going to London in order to speak with the Reverend Jones. If he sticks to that plan, I'll enable him to go, but it is hopeless." How long Vincent stayed in Etten is not known, although there are indications that the stay was quite lengthy. When Vincent wrote to Theo in July 1880—for the first time in almost a year—he said, "As you perhaps know, I am back in the Borinage. . . . My address is: *chez* Charles Decrucq, Rue du Pavilion, Cuesmes" (letter 133). This suggests that he had been in Etten since March.

Vincent returns to Etten.

Vincent resumed correspondence with Theo because Theo sent him fifty francs. He accepted the money, "reluctantly, it is true, . . . but I am up against a wall and in a sort of a mess; how could I do otherwise?" (letter 133). The letter also explains why he had gone back to the Borinage: "Father would rather I stay in the neighborhood of Etten; I refused, and in this I acted for the best. Involuntarily, I have become more or less an impossible and suspect person in the eyes of the family, somebody at least in which they have no confidence; how could I in any way be of use to anybody?"

A passage written by the Reverend Van Gogh on 5 July 1880 after he received a letter from Vincent (forwarded to him by Theo)—which may have been the important one quoted above (letter 133)—shows how impossible the twenty-seven-year-old son was in the eyes of the family "Indeed that letter Vincent wrote you gave me some pleasure. But oh! what will become of him, and isn't it insane to choose a life of poverty and let time pass by without looking for an occasion of earning one's own bread—yes, that really is insane. But we have to put up with it. *None* of all the things we tried has helped in any way. Maybe you should write him back; in the last days of June I sent him sixty francs, which he acknowledged; some time later we sent him some clothes. Thinking of him always hurts, and we do think so continuously of him."

A few sentences added by his mother make it clear how divergent Vincent's views were from his parents'. During his second visit to Etten, he had again made it difficult for them, and a book he had sent them—probably *Les Misérables*—had not made a favorable impression.

We can agree with what you write about Vincent, but if reading books gives such practical results, can it then be called right? and for the rest, what kind of ideas his reading gives him. He sent us a book

by Victor Hugo, but that man takes the side of the criminals and doesn't call bad what really is bad. What would the world look like if one calls the evil good? Even with the best of intentions that cannot be accepted. Did you answer him? If not, do so in any case; we were so glad that he thought of you, and we were so sad that he didn't want to have anything to do with anybody when he was here. We haven't heard from him for a long time now and shall write him again.

The letter that Vincent had written to Theo in July 1880 was probably prompted by his need for self-questioning and meditation rather than by a desire to justify his conduct. He started with a sort of apology—a passage that is especially important because it shows how acutely he could observe and judge himself:

"I am a man of passions."

> I am a man of passions, capable of and subject to doing more or less foolish things, which I happen to repent, more or less, afterward. Now and then I act and speak too hastily, when it would have been better to wait patiently. I think other people sometimes make the same mistakes. Well, this being the case, what's to be done? Must I consider myself a dangerous man, incapable of anything? I don't think so. But the problem is to try every means of putting those passions to good use. For instance, to name but one of my many passions, I have a more or less irresistible passion for books, and I continually want to instruct myself, to study, if you like, just as much as I want to eat my bread. You certainly will be able to understand this. When I was in other surroundings, in the surroundings of paintings and works of art, you know what a violent passion I had for them, a real ecstasy. And I don't regret this, for even now, *far from my country, I am often homesick for the land of the paintings* (letter 133).

If he had "sinned" against social conventions, those "sins" were minor. "You know that I have often neglected my clothes; I admit it, and I admit that it is shocking. But look here, poverty and want have their share in the cause, and profound discouragement also has something to do with it. And then it is sometimes a good way to assure the solitude necessary for concentrating on whatever study preoccupies one."

Vincent then concentrated on the question of "doing nothing" in a long and eloquent passage. He repeatedly used the word *fainéant* (idler), which probably was what Theo had called him, and left it to him to decide what kind of idler he might be.

> There are idlers and idlers, contrasting forms of them. There is the man who is idle from laziness and from lack of character, from the baseness of his nature. If you like, you may take me for such a one.
>
> On the other hand, there is the idler who is idle in spite of himself, who is inwardly consumed by a great longing for action but does nothing, because it is impossible for him to do anything, because he seems to be imprisoned in some cage, because he does not possess what he needs to be productive, because the fatality of circumstances bring him inevitably to that point. Such a man does not always know what he could do, but he instinctively feels, I am good for something, my life has a purpose after all, I know that I could be quite a

86

different man! How can I be useful, of what service can I be? This is a different kind of idler; if you like, you may take me for such a one!

In order to emphasize these words Vincent used a metaphor which in later writings would often be quoted; he compared the man who is doomed to idleness with a caged bird which knocks its head against the bars of the cage when other birds make their nests and bring up their little ones.

He gave an even more impressive picture of his own situation when he wrote: "Well, what shall I say? Is it ever visible what goes on within us? Someone may have a great fire in his soul, yet no one ever comes to warm himself at it, and the passers-by see only a wisp of smoke coming through the chimney, and go on along their ways. Now tell me, what can be done about it, should one tend that inner fire, have salt in oneself, wait patiently, yet with how much impatience, for the hour when somebody will come and sit down by it—maybe to stay? Let him who believes in God wait for the hour that will come sooner or later."

For a year Vincent did not fill his letters with the biblical texts and pious meditations they contained in the past. His faith gradually took on a different character, but he had not become an unbeliever altogether. The ecclesiastical form of devotion in which he had been brought up no longer appealed to him, although he had been dedicated to it only a few years before. The letter of July 1880 contains a passage that, for the first time, gives an idea of the somewhat vague form his religious feelings had assumed.

Vincent's religious beliefs begin to change.

> I think that everything which is really good and beautiful—of inner, spiritual and sublime beauty—in men and their works, comes from God, and that all which is bad and wrong in men and their works is not of God, and God does not approve it. Yet I always think that the best way to know God is to love many things. Love a friend, a wife, something—whatever you like—and you will be on the way to know more about Him; that is what I say to myself. But one must love with a lofty and serious intimate sympathy, with strength, with intelligence; and one must always try to know deeper, better and more. That leads to God, that leads to unwavering faith.
>
> To give you an example: someone loves Rembrandt, and seriously—that man will know there is a God, he will surely believe it. Someone studies the history of the French Revolution—he will not be unbelieving; he will see that in great things, too, there is a sovereign power manifesting itself.
>
> Maybe for the short time some person takes a free course at the great university of misery, and pays attention to the things he sees with his eyes and hears with his ears, and thinks them over; this person too, will end up believing, and he will perhaps have learned more than he can tell. To try to understand the real significance of what the great artists, the real masters, tell us in their masterpieces, that leads us to God. One man has written or told it in a book; another, in a picture (letter 133).

How far Vincent had drifted from the point at which five years earlier he had advised Theo to dispose of Michelet and of all his other books except the Bible! In these past few years, though, he had frequent occasion to acquaint himself with the "free

course at the great university of misery," which explains many of his new insights.

Most authors consider this letter to mark the onset of the great change in Vincent's life, and usually they quote the words of Jo van Gogh-Bonger who, after referring to this letter, wrote in her Memoir: "Now, in the days of deepest discouragement and darkness, at last the light began to dawn. Not in books would he find satisfaction, nor find his work in literature, as his letters sometimes suggested; he turned back to his old love: 'I said to myself, I will take up my pencil again, I will go on with my drawing, and from then on everything has seemed transformed for me.' It sounds like a cry of deliverance, and once more, 'do not fear for me. If I can only continue to work, it will set me right again.' "33

Contrary to this interpretation, books and literature would always retain a very important place in Vincent's life and would give him satisfaction to the end of his days, even if he did not try "to find his work in them." In letter 133 he had written that one could find God in literature as well as in Rembrandt: "one man has written or told it in a book; another, in a picture." Secondly, he had already apparently made drawing his main occupation in the middle of 1879, as shown earlier. The words, "I will take up my pencil again, I will go on with my drawing," etc., must be placed in context. They were taken from letter 136, written in September 1880, but they refer to his trip to Courrières in March of that year and of the hardships it had caused him. "Well, and yet it was in that deep misery that I felt my energy revive and I said to myself: In spite of everything I shall rise again; I shall take up my pencil again which I have forsaken in my great discouragement, and start drawing again; and from that moment it seemed to me everything had changed for me; and now I am on my way and my pencil has already become obedient, and seems to become more so every day" (letter 136).34

The passage as a whole indicates that Vincent's decision to become an artist had not been made at that moment in March 1880, but much earlier. The truth is that he had interrupted his work because of his disappointment with the initial results; after the journey to Courrières he had taken it up again and had been more successful. It is not certain whether Theo replied to the *cri de coeur* which letter 133 had been, but it must be assumed that he did, for from now on Vincent started to write to him again once or twice a month.

That Theo was informed about Vincent's turning to art is clearly shown by Vincent's letter of 20 August 1880 which begins: "If I am not mistaken, you must still have *Les Travaux des champs* by Millet. Would you be so kind as to lend them to me for a short time, and send them by mail? I must tell you that I am busy sketching large drawings after Millet, and that I have already finished *The Four Hours of the Day* as well as *The Sower*" (letter 134). He asked Theo to lend him still more prints which he could copy, and in a long postscript he told him that he had asked his former employer Mr. Tersteeg to lend him a copy of the *Exercices au fusain* by Bargue, a book with drawing

A mistaken conclusion.

Vincent and Theo's correspondence continues.

33 The first quotation was taken from letter 136 (September 1880), the second from letter 134 (August 1880).

34 This is a more literal translation than the published one.

drawing examples published by Goupil & Co. He realized that he had to do everything possible to get more experience in drawing the human figure, and copying the much-admired Millet and the drawings by Bargue, specially made for study purposes, seemed the best way to begin.

Within a few weeks, Vincent had made copies of the ten sheets with the *Travaux des champs* by Millet, which Theo had sent him, and of the whole series of *sixty* sheets of the *Cours de dessin* by Bargue, which he had requested from Tersteeg. All this work on figure studies must have helped him considerably. He was not yet satisfied with his achievements, but he saw some possibilities, and in his September letter he wrote, in all modesty, "I hope that after having copied the other two series by Bargue, I shall be able to draw miners, male and female, more or less reasonably, if by chance I can have a model with some character—and as to that, there are plenty of them here" (letter 135). Just two weeks later on 24 September he was to thank Theo for sending a new collection of etchings and other prints; he was especially grateful for the "masterly" etching by Daubigny after a work by Ruysdael, called *Le Buisson*. He also seized the opportunity to give a more or less complete report of his plans.

Copying Millet and Bargue.

> I intend to make two drawings, either in sepia or in something else: one after that etching, the other after *Le Four dans les landes* by Th. Rouseau. It is true that I have already done a sepia after the latter, but you will understand it lacks power compared with the etching by Daubigny, though the sepia itself may have some tone and sentiment. I must take it up again and work on it.
> I work regularly on the *Cours de dessin Bargue*, and intend to finish it before I undertake anything else, for each day makes my hand as well as my mind more supple and strong. I cannot be grateful enough to Mr. Tersteeg for having lent it to me so generously. The studies are excellent. Between times I am reading a book on anatomy and another on perspective which Mr. Tersteeg also sent me. The style is very dry, and at times those books are terribly irritating, but still I think I do well to study them (letter 136).

Vincent had now seriously begun his career as an artist— or, to put it more exactly, his schooling to become an artist. Art was the only subject of the ten letters he sent Theo from August 1880 until his departure from Etten in April 1881; not a word was mentioned about religion or nursing the sick or wounded. He worked at his drawing with the same fanaticism he had shown as an evangelist or when he wrote about religion from London and Isleworth. His life did not become easier by his change of occupation, and certainly not when he decided to settle down in Brussels in October 1880.

Working in Brussels

There were several reasons for Vincent's move back to Brussels; one of the main ones was a lack of space, which hampered his work. Theo had "vaguely" written about the possibility of Vincent coming to Paris in the near future (letter 136), but that was not feasible. It was his "great and ardent wish" to go to Paris or Barbizon, but as he did not earn a penny

it would be a long time before he could even think of such a thing. By the end of September he wrote to Theo: "Nevertheless it is a fact that I cannot remain very much longer in the little room where I am now [in Cuesmes]. It is a small room anyway, and then there are two beds, one for the children and one for me. And now that I draw those rather large-sized Bargues, I cannot tell you how inconvenient it is. I don't want to upset the people's household arrangements, and they have already told me that I could by no means have another room, even if I paid more, for the woman needs it for her washing, which has to be done almost every day in a miner's house" (letter 136).

He thought of renting a small workman's house, which would cost about nine francs a month, but he didn't do so, probably because his growing longing to have contact with good artists (which was the motive for undertaking the terrible journey to Courrières) was important enough to make him leave Cuesmes for good. Without asking anyone's advice he made one of those sudden decisions that characterized so many of the moves he made during the course of his life. When he wrote to Theo again, hardly three weeks later, he began his letter with the surprising news, "As you see, I am writing from Brussels."

A sudden decision.

In order to make a somewhat more radical start with his plans he had gone to see one of the few people he knew in Brussels: Mr. Schmidt, the man who in 1872 had taken over the Goupil branch in Brussels from Uncle Hein. "I went to see Mr. Schmidt here in Brussels and told him about the affair, that is, I asked him if he could help me make an arrangement with some artist so that I could continue my study in a good studio. For I feel that it is absolutely necessary to have good things to look at and also to see artists at work. Then I am more aware of what I lack, and at the same time I learn how to do better. It had already been a long time since I have seen enough pictures or drawings, etc., and the very sight of some good things here in Brussels has given me new inspiration and has strengthened my desire to make good things myself."

The room Vincent found was much more suitable than his former primitive lodgings. It was at a small inn, at 72, boulevard du Midi, where he immediately resumed copying the third volume of Bargue. Mr. Schmidt had suggested that he register at the Brussels academy, the Ecole des Beaux-Arts, but Vincent told him frankly that in his particular case it would be better to work with an artist. He had not quite dismissed the idea; he thought he might go there in the evening if the tuition was free or inexpensive. All this was in accordance with the goal he now formulated clearly for the first time: "For the moment my aim must be to learn to make drawings that are presentable and salable as soon as possible, so that I can begin to earn something directly through my work. Because that is the necessity which is forced upon me." Little could he know then how often in the coming years he would have to repeat the statement that it was an urgent necessity to earn some money with his work!

"For the moment my aim must be to learn to make drawings that are presentable and salable as soon as possible."

Vincent's following letter shows that Theo did not seem to object to his brother's surprising move, but warned him that Mr. Schmidt was involved in a money question with the Van Gogh family, probably as a result of his transaction with Uncle Hein. Vincent concluded that it would probably be wise not to

see him too often, but he did not see the necessity of avoiding him altogether. It was of more positive help to Vincent that Theo reminded him that Willem Roelofs, an important Dutch painter, lived in Brussels. Writing in Dutch (which was probably a sign that everything was now as of old), Vincent told Theo on 1 November: "I went to see Mr. Roelofs the day after receiving your letter. He told me that in his opinion from now on I must draw principally from nature, that is from either plaster cast or model, but not without the guidance of someone who knows it well. He—and others too—have advised me so earnestly to go and work at the academy, either here or in Antwerp or wherever I can, that I felt obliged to try to get admitted at the said academy, though I don't think it so very pleasant" (letter 138). The cost was no problem, as he found in the meantime. "Here in Brussels the teaching is free of charge"; in order to be admitted, however, one had to have the mayor's permission, so "I am waiting for the answer to my request."

In his 1969 biography of Van Gogh, M. E. Tralbaut reproduced a fragment of the Brussels academy register, which shows the name "Van Gogh, Vincent Guillaume." As subject it mentions *Dessin d'après l'antique, torse et fragments*, that is drawings after plaster casts, something which Vincent was also to practice later in Antwerp and Paris. Whether he really followed the lessons at the academy, however, is another matter. It is not very probable, since he does not mention a word about them in any of his following letters. It must be assumed that he really wanted to try but did not get the mayor's permission. The document produced by Tralbaut can therefore only have been the list of the *requests* for admission, not the list of students who were admitted. There is another problem with this document. After Van Gogh's name, in the second column, is the date 15 7br 1880 (15 September 1880). This can not refer to the date his request arrived, for Vincent was living in Cuesmes at that date, and had not yet considered studying at the academy in Brussels. It is probable that 15 September was nothing but an indication of the date this particular course started.

While he was still awaiting the reply to his request, Vincent continued undaunted, trying to improve his technique. He informed Theo that he was making progress with the Bargues and that he had drawn a skeleton on five large sheets of Ingres paper, working after a book called *Esquisses anatomiques à l'usage des artistes* (Sketches of the anatomy for artists' use). His next project, a further study of the anatomy of the human body, was to draw the muscles of the torso and the legs. He also began to make the difficult drawings after Holbein in Bargue's *Modèles d'après les maîtres*, and said that he had read "with great pleasure" an extract from the work of Lavater and Gall, *Physiognomie et phrénologie*.

Vincent found friendship and expert advice in the young Dutch painter Anthon van Rappard, who also lived in Brussels, although in the beginning their contact seems to have been somewhat hesitant, probably on both sides. He wrote: "Have also been to see Mr. Van Rappard, who now lives at Rue Traversière 6a, and had a talk with him. He is a fine-looking man; of his work I saw only a few pen-and-ink drawings of landscapes. But judging from the way he lives he must be quite wealthy, and I do not know whether he is the person with

Vincent applies at the Brussels academy, the Ecole des Beaux-Arts; his request for admittance, however, is not granted.

91

whom someone like me could live and work, for financial reasons. But I certainly shall go and see him again some time. He impressed me as one who takes things seriously" (letter 138).

Anthon van Rappard was twenty-two, five years younger than Vincent. He had studied at the Academy of Art in Amsterdam from October 1876 to March 1879, and had worked in the studio of the then-famous history painter Léon Gérôme. He had entered the Brussels academy in September 1880. Van Rappard, therefore, was exactly the kind of man Vincent was looking for in Brussels: a more experienced artist who could give him some hints and whom he could observe working. A letter of April shows that he worked at Van Rappard's regularly. Van Rappard was about to return to Holland, and this was a reason for Vincent to go to Brussels himself. "I can continue to work with Van Rappard for a few weeks, but then he will probably leave here. My bedroom is too small, and the light is not good, and the people would object to my partly shutting out the light from the window; I am not even allowed to put my etchings or my drawings up on the wall. So when Rappard leaves in May, I shall have to move, and I should then like to work a while in the country" (letter 142).

For some time that winter Vincent took lessons with another painter, probably because the contacts with Van Rappard were then only sporadic. This other teacher is briefly described in a letter to his parents of 16 February 1881 (published as letter 141 together with Vincent's letters to his brother): "The painter who gives me lessons now is making a very good picture of a Blankenberg fisherman." Jo van Gogh-Bonger writes in her Memoir, "From a letter to his father it appears that he took lessons in perspective from a poor painter for 1.50 francs for a two-hour lesson. I have not been able to ascertain the name of the painter; he probably was called Madiol." This supposition may have been based on a sentence in a letter from Vincent to Theo, written in April: "If you can recommend at the Salon the picture by Madiol, do so, for there is much that is beautiful in that work, and the man is hard up and has many little children" (letter 142). Apparently Vincent knew Madiol personally and admired certain aspects of his work, though Vincent himself would turn in a completely different, less romantic direction. Adriaan Johannes Madiol (1845-1927) was born in Groningen in the north of Holland, but he had studied for six years at the Antwerp academy before settling down in Brussels. While at that moment he may have been really "hard up," he was already a painter of some renown. His entries into exhibitions in different countries met with much success, even in London, where he had received a gold medal in 1873.

Little is known about the circumstances of Vincent's six month stay in Brussels since he never elaborates about them in his letters. From the few details that are known, one can imagine how precarious life must have been. A few such telling details are to be found in his second letter from Brussels. "In Cuesmes, boy, I should have fallen ill with misery, if I had stayed a month longer. You must not imagine that I live richly here, for my chief food is dry bread or some potatoes or chestnuts which people sell here on the street corners, but by having a somewhat better room and by occasionally taking a somewhat

Anthon Gerard Alexander, Ridder van Rappard, 1858-1892.

Lessons in perspective.

92

better meal in a restaurant whenever I can afford it, I shall get on very well" (letter 138).

Living in bitter poverty.

What else could it have been but bitter poverty. Vincent's father had written to him that for the time being Vincent could count on sixty francs a month. His expenses would certainly amount to more than sixty francs, as drawing materials, studies to copy, etc., cost money, too, and some time later there would be expenses for models as well. It was only to be expected, therefore, that in Vincent's letter to his parents he would ask for something extra, as he had bought some second-hand clothes. He hoped they would not consider such purchases an "extravagance." With humility and respect he further advised them that they should send him something only if they could do it without depriving themselves (letter 141). It gave the Reverend Van Gogh great satisfaction that just at this point in time Theo was given a promotion. This enabled him not only to live on his own salary, but also to help support Vincent. This is shown by his father's 14 February 1881 letter to Theo:

> It seems as if the melancholy mood caused by our worries about Vincent has much diminished since we heard that good news about your promotion. . . . It is very kind of you that you are willing to assist us a little in those expenses for Vincent. I can assure you that it will not be a negligible relief to us, for the months fly by and every time the necessary sum has to be available. I sent him forty guilders in the beginning of January, twenty guilders on 22 January, thirty-five guilders on 7 February. Yet, it should not get you into any troubles yourself. For the moment he is cared for, but in the beginning of March he will need something again. Does it suit you to take care of it already then, or shall I do it; tell me frankly.

In the winter of 1881, it became more and more necessary for Vincent to look for a better living situation, for his existence in Brussels was miserable. He indicated to Theo in January that there had been talk of his coming to Paris; he said that he wished to do so, provided he could be sure of finding work that would give him a salary of at least one hundred francs a month (letter 140). Since Van Rappard would soon leave Brussels, it would be difficult for him to continue his studies there; he wrote to his parents in February: "You will not be surprised when I tell you that I am eager to hear what Theo's proposition might be, or to hear something from Mr. Tersteeg.[35] For one way or the other, before the month of March I must know what I can expect and how and where I shall be able to work during the spring and summer."

Near the end of March or the beginning of April, Father Van Gogh made an important visit to his son in Brussels. This occasion led Vincent to write a long letter to Theo. One of the subjects he discussed was the attitude of his family and especially of Mr. Tersteeg. He did not understand why Uncle Cor, who so often helped other draftsmen, refused to do anything for him. He mentioned the point to his father. "I noticed that people talked about the strange and unaccountable fact that I was so hard up, although I belonged to such and

[35] He had written to Tersteeg from Brussels, "Wouldn't it be possible for me to work in The Hague awhile?" (letter 191).

such a family" (letter 142). He also wrote something about it to Mr. Tersteeg and received a very unpleasant response. "He seems to have misunderstood my intention, as he got the impression that I planned to live on the bounty of my uncles; this being his opinion, he wrote me a very discouraging letter, and said I had no right to do such a thing."

This was probably the beginning of the tense relationship that would exist between Vincent and his former employer. When Vincent returned to Holland, Tersteeg had no use for him any longer, even though Vincent tried to explain his earlier letter: "I wrote back that I was not at all astonished at his misconstruing my letter in this way because you yourself had spoken one time of my 'living on my rents.' And as I now gather from the tone of your letter that you no longer see my difficult position in that miserable light and as I infer it from your strong assistance, so I hope that Mr. Tersteeg's opinion will also change eventually. The more so because he was the first to help me with those Bargues, for which I shall always be grateful to him" (letter 142).

Problems with Tersteeg.

It was in this same letter to Theo, written after Vincent's father had visited him in Brussels in April 1881, that Vincent came to acknowledge the important role Theo had taken on. It was a role that would result in Vincent's rapid growth as an artist. Vincent wrote: "I heard from Father that without my knowing it you had been sending me money for a long time, in this way effectively helping me to get on. Accept my heartfelt thanks, I firmly believe that you will not regret it" (letter 142).

Time began to press. Vincent had often thought of working "in the country," and he now enumerated several possibilities: "Heyst, Calmthout, Etten, Scheveningen, Katwijk, anyplace, even nearer here, as Schaerbeek, Haeren, Groenendael." The curious thing is that he mentions Etten here only as one of many possibilities. It seems that it became clear to Vincent only while writing that moving to his parents' home was the best solution, but it took him several pages before he came to the conclusion: "The cheapest way would perhaps be for me to spend this summer in Etten; I can find subjects enough there. If you think this right, you may write to Father about it. I am willing to give in about dress or anything else to suit them, and perhaps would come across C. M. some day this summer" (letter 142).

Vincent's departure from Brussels was ultimately accelerated. He had been informed by his father that Theo was expected to come to Etten on Sunday 17 April and that it would be desirable for Vincent to be present—evidently in order to discuss the plans. Nothing could please Vincent more, and on 12 April 1881 he wrote that he was looking forward to seeing Theo "with a great longing. So I leave today and am letting you know, so that you will not look for me in Brussels. I should like to make a few sketches of the heath at Etten, which is why I start a few days earlier" (letter 143).

Vincent leaves Brussels, April 1881.

However much Vincent may have longed to meet Theo again, he was apparently apprehensive of his brother's opinion about the progress he had made in Brussels. The reason for his plan to make a few landscapes sketches in Etten before Theo's arrival was his hope that these would give a better indication of his technical ability than the work he had done in Brussels. His uneasiness is clearly shown by the postscript he added to his

short letter of 12 April, in which he apologized in advance for the work that Theo was going to see. "I am sending you three sketches[36] which are clumsy as yet, but from which you will see, I hope, that I am gradually improving. You should take into account that it is only a short time since I started drawing, although I made little sketches when a boy. And during this winter I thought it most important to make rigidly accurate anatomical studies, not my own compositions" (letter 143).

After discussions with his family in Etten, it was decided that Vincent could live with his parents. He returned briefly to Brussels to retrieve his modest belongings, but shortly before the end of April he left Brussels for good. Before he departed he visited an exhibition of watercolors, studying it so thoroughly that he could give Theo a detailed description of the works he had seen (letter 144). In this letter, written around 30 April to congratulate Theo on his birthday, he commented, "I have been here a few days now," which gives a rough idea of the date of his arrival in Etten. The letter does not say anything about Theo's reaction to his work, but the meeting had been a pleasant one in any case. "I often think of your visit; I am glad that we saw each other again, and hope you will come back this summer." Thus it was in April 1881 that a new and important phase in Vincent's life began. It was the phase in which he would develop in a very short time from a laboriously struggling beginner and pupil into a budding artist.

As for Theo, the great change in his own life took place a year earlier in 1880. It was during the course of that year that he joined the French branch of Goupil's and settled down in Paris for good. This must have been the main reason for Vincent to write his long letter from July 1880 in French (letter 133), and it also explains a sentence in his next letter, written in August, "If sooner or later you should make a trip to Holland, I hope you will not pass by here without coming to see my sketches." Brussels was easy to visit from Holland.

Much had changed in the relationship between the two brothers by 1880. In a reversal of roles it was now the younger, twenty-two-year-old Theo who used his newly gained experience to advise his older brother, even to lecture him, as when he had tried to induce Vincent to choose a more practical profession during a visit in the summer of 1879. The fact that Theo now had a permanent and well-salaried position in Paris made it possible for him to put money aside for Vincent, and this, too, was decisive for their relationship; from now on Theo became the man who enabled Vincent to live and work.

Although it doesn't reveal in detail what had happened, a letter from Vincent shows that in January 1881 Theo again saw his position strengthened at Goupil's, while other employees had been dismissed. "You told me of a change in the staff of the house G. & Co., and also of another change in your own position. I congratulate you, and as to these gentlemen G. & Co., I am inclined to believe that they, too, are to be congratulated on having got rid of some of the staff" (letter 140).

The extent of the authority Theo had gained with the family this year is shown not only by financial support of Vincent or by his elder brother's humble requests for advice and support,

Theo settles in Paris, 1880.

[36] The Dutch word he used was *krabbelingen*, a very depreciative word for sketches, something like "scrawls."

but also by his father's leaving Theo to care in part for the "lost sheep." When the question arose where Vincent was to seek shelter in the beginning of 1881, his father said, "Just write to Theo, and arrange with him what is best, and what will be the cheapest way" (letter 142). Theo's status in the Van Gogh family had changed dramatically—from the young and inexperienced boy to the family supporter and advisor—and this was a role that he would play throughout the rest of his life.

Part II

On The Wing

ETTEN: VINCENT'S START AS AN ARTIST

23
The parsonage in Etten, drawing by Vincent from 1875.

After the miserable years he spent in the Borinage and Brussels, life at the parsonage in Etten during 1881 must have seemed like paradise to Vincent. For the first time in three years he had a home and regular meals without having to be concerned about the cost; for the first time he could devote all his time and attention to his drawing. The parsonage (replaced by a new one on the same spot in 1904) could not have offered much luxury, but that was probably the last thing he wanted. It was, however, a large, comfortable, two-story house with seven windows on the first floor. The difference between this house and his poor quarters at the inn in Brussels or the room in Cuesmes that he had to share with the children was enormous. These were ideal surroundings for a draftsman, a quiet, rural village in the beloved Brabant of his youth![37] Yet Vincent did not write a word about his new quarters in his letters. In the first few months of his stay in Etten, he wrote about nothing but his work. The only sentence he devoted to his living arrangements (unenthusiastic as it is) can be found in the first of the more than twenty letters he wrote from Etten, "I am very glad things have been arranged so that I shall be able to work here quietly for a while."

The parsonage is known from two small drawings Vincent did, one of which includes the large local church. This might be taken for a sign that Vincent was impressed by his new home, but it must be assumed that the drawings had been made some five years earlier, when Vincent had visited Etten after his stay in England and saw the parsonage for the first time. Anthon van Rappard also made a small pen drawing of it, much freer and more expressive than Vincent's naïve sketches. Van Rappard annotated his sheet with the words: *Etten, 14 juni '81,* which proves that he had made the drawing when he stayed with the Van Gogh family that year; the parsonage was new to him then, as it was to Vincent in 1875.[38]

[37] Etten was a village of some 5,700 inhabitants. Only about 125 of these were Protestants, but they were allowed to use the big medieval church. This and other historical particulars can be found in an article by Anieta van Geertruy in *Jaarboek van de geschied- en oudheidkundige kring van Stad en Land van Breda "De Oranjeboom,"* 6/1983 (a historical yearbook of the region).

[38] See the catalogue *Anthon van Rappard, his life and all his works* (1974).

Van Rappard's visit must have meant a great deal to Vincent. It gave him the opportunity to spend time with his friend during one of the most beautiful months of the year, and he could make sketches daily and compare his abilities with his more advanced colleague. Theo, of course, was immediately informed:

> You must know that Rappard has been here for about twelve days, and now he has gone. Of course he sends you his best regards. We have taken many long walks together—have been, for instance, several times to the heath, near Seppe, to the so-called Passievaart, a big swamp. There Rappard painted a large study (1 meter by 50 cm.), in which there was much that was good. Besides that, he did about ten small sepias, also in the Liesbosch. While he was painting, I made a drawing in pen and ink of another spot in the swamp, where all the water lilies grow (near the road to Roozendaal). We also went to Prinsenhage together, but Uncle [Vincent] was ill in bed again (letter 146).

Surprising progress in landscapes.

Vincent's drawing of the swamp with the water lilies must therefore have been done at the same time, around mid-June. It is a surprising fact that so shortly after his arrival in Etten he would have been able to produce such an excellent piece of work. It is certainly not inferior to Van Rappard's drawings of the Passievaart of the same month. Vincent's treatment of the water lilies and other plants in the foreground, drawn in great detail and with an impression of depth, is especially noteworthy. This shows amazing progress compared with the rather primitive landscape drawings he did at the beginning of his stay in Etten in April. In many ways this drawing foreshadows the type of landscape that was frequent in Van Gogh's later years: the high horizon, long foreground, and detailed rendering of nearby elements. (His famous painting of an Arles meadow and big purple irises in the foreground, JH 1416, is one of the best examples.)

While Vincent was in Etten he was almost completely occupied with his drawing study. "Every day that it does not rain, I go out in the fields, generally to the heath," he wrote from Etten in his second letter to Theo (letter 145). In a booklet about his research in Brabant, Benno J. Stokvis wrote: "The maid-servant the Van Goghs had at that time said that Vincent was sometimes painting the whole night [drawing was, of course, what she must have meant]; and when his mother came down in the morning she would sometimes find him still at work. He often did not even allow himself the time for coffee; when she kept calling him at such occasions, he would answer, 'Yes, I'm coming,' but did not appear at all or more than an hour later." Stokvis had heard these particulars not from the maid, but from Piet Kauffmann, the seventeen-year-old gardener. The source of the story is therefore indirect, but it has an authentic ring; one can easily recognize in it Vincent's fanatical tendencies.

Vincent continued with the work that had kept him busy in Brussels: making copies of engravings and other reproductions after Millet. At the end of April 1881 he wrote Theo: "The *Semeur* is finished and I have sketched the *Quatre heures de la journée*. And now I still have to do *les Travaux des champs*" (letter 144). These were studies he had already copied in

Brussels, but with characteristic perseverance he had started again, trying to improve them. He did the same with the models of the *Cours de dessin Bargue*, which, incredibly, he copied three times. When it became very hot in July, "too hot to sit on the heath by day" (letter 147), he copied the drawings by Holbein and Bargue. He found it difficult to persevere in this work because he much preferred drawing from nature, but, he wrote, "I set myself the task of copying them once more, and then for the last time" (letter 148). His next letter shows that he actually fulfilled that task. He wrote that during a visit to The Hague he had been able to show Tersteeg (who had lent him the Bargue books) the entire series of sixty sheets from the *Exercices au fusain*.

Shortly after his trip to The Hague, he engaged with great enthusiasm in drawing the human form after a live model, something which he had done only sporadically in Etten, and which Anton Mauve, whom he had also visited in The Hague, had advised him to do. Vincent found several people who were willing to pose for him, including Piet Kauffmann, the young gardener. In a letter written in September he told Theo: "Studying the *Exercices au fusain* by Bargue carefully and copying them over and over have given me a better insight into drawing the figure. I have learned to measure and to observe and to look for broad lines. So what seemed to be impossible before is gradually becoming possible now, thank God" (letter 150).

Anton Mauve, Dutch painter, 1838-1888.

On close inspection of the few dozen surviving drawings from this time, it becomes evident that, in spite of his confidence, Vincent's technical skill in rendering the human figure was developing much more slowly than his ability to realistically represent a landscape. Most of the figures from Etten look somewhat clumsy, and the proportions are often still awkward. They do, however, contain the quality of ruggedness and honesty which would remain typical of his later drawings. Anthon van Rappard gave a good characterization of a sketch that Vincent had sent him; he said that the figure was "not a man who is sowing, but one who is posing as a sower." Vincent admitted this readily, but he remarked that his drawings were studies of the model and did not pretend to be anything else; after a year or two he thought he would be able to paint a real sower at work. Among Vincent's studies from September, a few were remarkable; they are detailed, well-proportioned drawings with an unmistakably personal touch. Most notable is his *Peasant Sitting by the Fireplace* (JH 34), which he had annotated with the words "Worn Out" (it was a motif he would repeat several times later). Other examples of surprisingly good drawings are *Boy Cutting Grass with a Sickle* (JH 61), for which Piet Kauffmann must have been the model, *Farmer Sitting by the Fireside, Reading* (JH 63), *Woman Peeling Potatoes* (JH 66), and *Girl Kneeling in front of a Bucket* (JH 76).

Besides landscapes and peasant drawings, Vincent also drew portraits during the summer of his stay in Etten. He wrote to Theo, "Remembering what you told me once, I have tried to draw a few portraits after photographs, and I think this is good practice" (letter 147). One surviving drawing gives the impression of having been carefully drawn after a photograph, the oval portrait of a girl (JH 11). It is generally supposed that this represents Willemien van Gogh, the sister who, Vincent

said, "posed so well." The only other portrait that is ascribed to this period represents an elderly man in profile, wearing a sort of skull cap (JH 14). According to most authors it represents the Reverend Van Gogh, and was also done after a photograph. That the sitter was Vincent's father does not seem impossible, but there is hardly any resemblance to existing photographic portraits. It is doubtful, in any case, that Vincent's drawing was made after a photograph; an almost caricature-like portrait in profile like this one could hardly be expected from photographers of the late nineteenth century. Why would Vincent, who saw his father daily, have done his portrait from a photograph rather than from real life? In any case, it is an interesting study, which shows Vincent as a draftsman at his best.

Vincent probably did not have such a pleasant and carefree time in years as he had during the first six months in Etten. From morning to night his days were filled with drawing, but there were also many interruptions of the daily routine and distractions, mostly related to his work, that benefited his development as an artist. After Van Rappard's twelve days' visit in June, when Vincent collaborated with him so fruitfully, Theo made an important, though short, visit. Around the beginning of September 1881 Vincent made a four day trip to The Hague and Dordrecht, and at the end of October Van Rappard came again for a quick visit on his way to Brussels. And finally, there was in the summer of 1881—probably in August—the exciting visit of Kee Vos.

Van Rappard's visit to Etten in October was short, but Vincent wrote, "We all enjoyed your visit very much; I am so glad to have seen your watercolors, you have made progress indeed" (letter R 3). In a sense it had been a farewell visit, for Van Rappard was going to stay in Brussels where he wanted to work at the academy making nude studies until Christmas. They would not see each other for half a year, but they continued to write. The letters from Vincent have survived, and it is quite amusing to see how much "free rein" he allowed his imagination in them (letter R 6). In order to discourage his friend Van Rappard from making nude studies, he suggested that he should concentrate on "reality"—which to Vincent meant "ordinary people with their clothes on" (letter R 3). Staying in Brussels, Vincent felt, was also a mistake. In this connection he made a statement which is significant in illustrating his own artistic ideal in these years. "As I see it, both you and I cannot do better than work after nature in Holland (figure and landscape). There we are ourselves, there we feel at home, there we are in our element. The more we know of what is happening abroad, the better, but we must never forget that we have our roots in Dutch soil" (letter R 2).

More inspiring than the visit from Van Rappard was Vincent's own trip at the end of the summer. He told Theo that he had first gone to The Hague, had spent a few days there, and had stopped at Dordrecht on the way back. "I spent an afternoon and part of an evening with Mauve, and saw many beautiful things in his studio. My own drawings seemed to interest Mauve more [more than the copies he had shown Tersteeg]. He gave me a great many hints which I was glad to get, and I have arranged to come back to see him in a relatively short time when I have some new studies. He showed me a

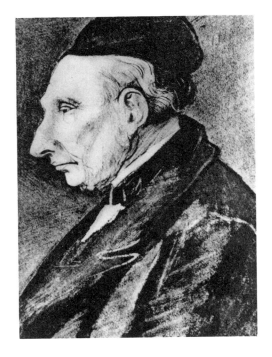

24
The Reverend Theodorus van Gogh (?),
drawing by Vincent, 1881. Pencil, black ink
washed, heightened with white, JH 14,
F 876, 33 x 25 cm.
Collection Mrs. A. R. W. Nieuwenhuizen
Segaar-Aarse, The Hague

whole lot of his studies and explained them to me—not sketches for drawings or pictures, but real studies, things that seemed of little importance. He thinks I should start painting now" (letter 149).

The visit to The Hague also offered Vincent the chance to profit from other, more advanced artists such as Théophile de Bock. "I enjoyed meeting De Bock; I was at his studio. He is painting a large picture of the dunes which has much that is fine in it. But in my opinion the fellow must practice drawing figures in order to produce even finer things. It seems to me he has a real artist's temperament and that we have not heard the last of him. He raves about Millet and Corot, but didn't these two work hard on figures—yes or no?"

Though Vincent hardly talks about it in this letter, visiting the *Panorama* in The Hague must have made a great impression on him (he had seen so very little painting in the last few years). The enormous circular painting (later called *Panorama Mesdag*), which represents a view of Scheveningen seen from a high vantage point, had been finished that year, 1881. Though it was meant to be a tourist attraction, it certainly had its artistic merits; it demonstrated the great and versatile talents of the painters of the Hague School. The Panorama was not only the work of H. W. Mesdag, who had painted the sea and the skies. His wife, Sina Mesdag-van Houten, painted the view of the village and the harbor; George Hendrik Breitner painted the splendid hussars, riding at full speed across the beach; and Théophile de Bock did the landscape of the dunes. "Then I went to see Mesdag's *Panorama* with [De Bock]; it is a work that deserves all respect. It reminded me of a remark, I think by Burger (or Thoré) about *The Anatomy Lesson* by Rembrandt: *le seul défaut de ce tableau est de ne pas avoir de défaut*" (this picture's only fault is that is has no fault) (letter 149).

De Bock told Vincent that some painters looked down upon this kind of work, but that was certainly not the case with Vincent; he was pleased to quote the anecdote which De Bock used to illustrate his remark, and he also repeated it to Van Rappard (in his letter R 2). "He said an extremely nice thing about the *Panorama* which made me feel very warmly toward him. You know the painter Destreé? The latter came to De Bock with a pedantic air, and said—of course in a very haughty, yet bland and intolerably condescending tone, 'De Bock, they asked me to paint that Panorama, too; as it is such an inartistic thing I felt I had to refuse it.' To which De Bock answered: 'Mr. Destreé, what is easier—to paint a Panorama, or to refuse to paint a Panorama? What is more artistic—to do it or not to do it?' " (letter 152).

Vincent's many contacts in The Hague left him little time for drawing, but he did not come back empty handed. "I stayed in The Hague until Thursday morning, then I went to Dordrecht because from the train I had seen a spot I wanted to draw—a row of windmills. Though it was raining, I managed to finish it, and so at least I have a souvenir from my little trip" (letter 149). The drawing of the meadows with some eight windmills under a rainy sky (JH 15) has survived. The rather gloomy landscape is a good example of the more elaborate drawings in mixed media (pencil, pen and watercolor) that Vincent had learned to make at this stage. Only in passing in

Théophile de Bock, 1851-1904.

that letter did he mention that he had also been in Rotterdam, probably on his return, which proves how thoroughly he had used the occasion to gather artistic impressions. When a short time later Theo wrote to Vincent about a painting by Carel Fabritius, Vincent answered, "I went to see that picture by Fabritius at Rotterdam on my last trip."

Rejected Love

Vincent had been in Etten some four months when an event took place that completely changed his active, but relatively unproblematic life under his parents' roof. He fell in love. This can hardly be seen as an unexpected or startling occurrence, but, as so often with Vincent, it developed with unusual passion. His exaltation shows itself clearly in the torrent of words he poured out to Theo once he took his brother into his confidence. In two months he wrote no fewer than twelve long letters about his problems; they fill some thirty-six printed pages in the *Complete Letters*.

In early biographies, Vincent's love affair was treated with some secrecy. When Jo van Gogh-Bonger wrote an introduction for the *Brieven aan zijn broeder* in 1914 (the first edition of the Van Gogh letters), she began her description of this episode with the words, "Among the guests who spent that summer at the vicarage in Etten was a cousin from Amsterdam—a young widow with her little four-year-old son." As the "cousin" was still alive when she wrote this, it is understandable that Jo did not mention her name; copying the letters, she changed that name to *K*. Although much was added to the definitive edition of 1953, the proper name was still not restored. The result is that for many years in books about Van Gogh, the name *K*. continued to make its ghostly appearance.

It was his cousin Kee Vos-Stricker (1846-1918), the second daughter of the Reverend J. P. Stricker, with whom Vincent had fallen hopelessly in love in the summer of 1881. She was not a stranger to him; in 1877 and 1878 when her husband, Christoffel Martinus Vos, was still alive, Vincent had visited the couple at their home more than once. Vos had died on 27 October 1878, leaving Kee with their young son, Johannes Paulus, who was born on 13 April 1873 (which meant he was eight in 1881, not four, as Jo van Gogh-Bonger believed).

Vincent would only write to Theo about the events of the summer many weeks later. The first letter mentioning the situation is dated 3 November. Unfortunately, as a result of this long delay, he refrained from recounting the facts of Kee's stay in Etten; instead, his long letters are filled with deliberations about what had to be done in the aftermath of the events. The one concrete fact that can be found in the letters— and it is an extremely important one—is that there was no question of casual meetings taking place, but that Vincent and Kee had experienced prolonged contacts.

His father had reacted nervously and with surprise when Vincent told him about his love; it was, Vincent wrote, as if he had not expected it, "and yet it was under his very eyes, so to speak, that she and I had walked together and spoken together for days and weeks" (letter 157). It is not known what they talked about during those walks, or whether Kee Vos left

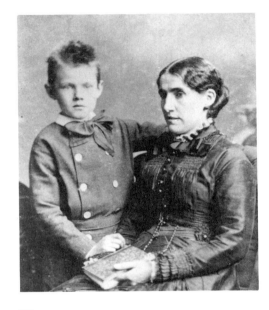

25
Kee Vos and her eight-year-old son.

104

immediately after Vincent's declaration of love. The only thing Vincent ever told Theo about his advances was that her reaction had been a decisive "never, no, never."

The letters reveal Vincent's curious, obstinate personality. The letter from 3 November begins with the revelation of Vincent's "secret"—which was probably no secret to Theo any longer as there was such a constant flow of letters between Theo and his parents. "There is something in my heart that I must tell you; perhaps you know about it already and it is not new to you. I want to tell you that this summer such a deep love has grown in my heart for Kee Vos that I cannot find other words for it than: it is as if Kee Vos is my nearest and I the nearest of Kee Vos, and—I have told it her in these words. But when I said this, she replied that to her, past and future remained one, so that she could never return my feelings." Before actually telling Theo, Vincent had revealed his feelings for Kee to his father and mother, Kee's parents, and even his Uncle Vincent and his wife. They all were against the relationship—except Uncle Vincent, who treated the question light-heartedly.

The second letter on the subject, dated 7 November, is not much more than an extension of the first. Vincent asked whether Theo agreed that there could be a love "serious and passionate enough not to be chilled by many 'never, no, never[s]' " (letter 154). He respected that her thoughts were always in the past, but he wanted to try "something new." Against her "never, no, never" he put his "she and no other."

A few days later he wrote again. He asked Theo to put in a good word for him with his parents, who could not appreciate the depth of his feelings, and who had called his love "untimely and indelicate." "An energetic word from you to Father and Mother," Vincent said, "would be of great help to me" (letter 155).

With his fourth and fifth letters, written barely a week after the first, Vincent reacted to a reply he had received from Theo, whose advice had been: "Don't believe in too many illusions before you are certain it is not all in vain." To hedge, however, was not in Vincent's character. "Since the beginning of this love," he said, "I have felt that unless I gave myself up to it entirely, without any second thoughts, without any restriction, with all my heart, entirely and forever, there was no chance for me whatever" (letter 156). He knew his chances were slight, but he wanted to risk one more attempt to make her change her mind by going to Amsterdam to talk with her. To make this possible he asked Theo for some money for the trip. He added, "Father and Mother have promised not to oppose this if only I leave them out of the matter, as it were."

The next two letters, both dated 18 November, mention the first serious conflict with his parents. Apart from calling his love "untimely and indelicate," they had strongly criticized him for persisting in writing letters to Kee Vos. He took his revenge by not speaking to them for several days, with the result that his father—quite understandably!—grew very angry and told him to leave the house and live elsewhere. Again Vincent asked Theo to intervene, for nothing could be more inconvenient for him than to have to leave the house and his work because of what he called "the prejudices of an old man."

"There is something in my heart that I must tell you; perhaps you know about it already and it is not new to you. I want to tell you that this summer such a deep love has grown in my heart for Kee Vos . . ."

Theo sent the money for Vincent's trip and spoke to their parents, which at least temporarily cleared the air. Vincent continued to fill his letters with philosophical thoughts about love (partly inspired by Michelet's books *l'Amour* and *la Femme*), but he also mentioned a fact that shows his stubborn perseverance; he had "risked an attack" on Kee's father, the Reverend Mr. Stricker, by sending a registered letter, an undiplomatic way of asking for attention.

He demanded that attention when, later in the month, he visited the Strickers in Amsterdam. Vincent did not write much about this visit except that Stricker had been "rather angry." He sent Theo a report of this dramatic visit to Amsterdam only after he returned to Etten (letter 164), and even then he did not tell everything; some details he revealed only in a letter of five months later (letter 193). With telling details he described how he had fared when he had tried to see Kee Vos:

A dramatic report of his visit to Amsterdam.

> And on a certain evening I strolled along the Keizersgracht looking for the house, and I found it. I rang the bell and heard that the family was still at dinner. Yet I was asked to come in. But they were all there except Kee. And they all had a plate before them, but here was not one too many, and this little detail struck me. They wanted me to believe that Kee was out, and had taken away her plate, but I knew that she was there, and I thought this rather like a play or a farce. After some time I asked (after the usual greeting and small talk), "But where is Kee?"
> Then J. P. S[tricker] repeated my question, saying to his wife, "Mother, where is Kee?"
> And Mother answered, "Kee is out."

After Vincent's repeated question about Kee, Uncle Stricker finally admitted, "Kee left the house as soon as she heard that you were here." He then began to read a letter that was ready to be sent to Vincent (undoubtedly a reply to the registered letter Vincent had sent him). Vincent succeeded in remaining very calm. "Let me hear the letter, or not, I said; I don't care. Then came the letter. It was very 'reverend' and very 'learned'; there was really nothing in it, except that I was requested to stop my correspondence and was advised to make energetic efforts to put the thing out of my mind. At last the reading of the letter was finished. I just felt as if I were in church, and after the clergyman's voice had pranced up and down, had heard him say, amen; it left me just as cool as an ordinary sermon." The end of the emotional evening is described in the same lively and somewhat ironic manner, and it is to Vincent's credit that he does not show any hard feelings toward his uncle and aunt, in spite of their rejection of his attempts to see Kee. It was clear, nevertheless, that the visit to Amsterdam, through which he had hoped to achieve something with regard to Kee Vos, had resulted in disillusion. "I felt quite lonely and forlorn during those three days in Amsterdam; I felt absolutely miserable, and that sort of semi-friendliness of Uncle and Aunt, and all those discussions—it was all so dull. Till at last I began to find myself dull, and I said to myself, You don't want to get melancholy again, do you?"

He characterized his mood with a splendid metaphor as "a feeling as if I had been standing too long against a cold, hard, whitewashed church wall," and it was in this mood that he

106

sought consolation from a prostitute. The description of this adventure is formulated with a great intensity of feeling.

> I still felt chilled through and through, to the depths of my soul, by the above-mentioned real or imaginary church wall. And I did not want to be beaten by that feeling. Then I thought, I should like to be with a woman—I cannot live without love, without a woman. I would not give a dime for life at all, if there were not something infinite, something deep, something real. . . .
> And, dear me, I hadn't far to look. I found a woman, not young, not beautiful, nothing remarkable, if you like, but perhaps you are somewhat curious. Well, she was rather tall and strongly built; she did not have a lady's hands like Kee, but the hands of one who works much; but she was not coarse or common, and had something very womanlike about her. She reminded me of some nice figure by Chardin or Frère, or perhaps Jan Steen. Well, what the French call *une ouvrière*. She had had many cares, one could see that, and she knew what life was; oh, she was not distinguished, nothing extraordinary, nothing unusual. "Every woman at every age, if she loves and is a good woman, can give a man not the infinity of the moment, but a moment of infinity."[39]
> Theo, to me there is such a wonderful charm in that slight fadedness, that something over which life has passed. Oh, she had a charm for me, I even saw in her something of Feyen Perrin or Perugino. You see, I am not quite an innocent greenhorn or a baby in a cradle. It is not the first time I was unable to resist that feeling of affection, really affection and love, for those women who are so damned and condemned and despised by the clergymen from the height of their pulpit. I am almost thirty years old—would you think that I have never felt the need of love? . . .
> The clergymen call us sinners, conceived and born in sin, bah! What dreadful nonsense that is. Is it a *sin* to love, to need love, not to be able to live without love? I think a life without love a sinful and immoral condition. If I repent anything, it is the time when mystical and theological subtleties lured me to lead too secluded a life.

All this led Vincent to talk of the completely different kind of love he felt for Kee Vos, and it becomes clear that after the discussions he had held with his Uncle Stricker, he had come to the conclusion that there was more that separated them than her protestation "never, no, never." Although in the letter he repeated that he had not given up, it is evident that he began to let go, and a feeling of compassion began to take the place of his former passionate love.

> But my love for Kee is something quite new and quite different. Without realizing it, she is in a kind of prison. She too is poor and cannot do as she wishes, but look, she feels a sort of resignation; and I think that the Jesuitism of clergymen and pious ladies often makes more impression on her than on me—they have no hold on me any longer, just because I now know some of the *dessous de cartes* [40] but she believes in them and would not be able to bear it if the system of resignation, and sin, and God, and heaven knows what else, proved to be idleness.

[39] *"Toute, à tout âge, si elle aime et si elle est bonne, peut donner à l'homme non l'infini du moment, mais le moment de l'infini."*
[40] "The hidden side."

And she never realizes, I fear, that God perhaps really begins when we say the words with which Multatuli[41] finishes his *Prayer of an Unbeliever*: "O God, there is no God!" For me that God of the clergymen is as dead as a doornail. But am I an atheist for all that? The clergymen consider me so—so be it—but I love, and how could I feel love if I did not live and others did not live; and then if we live, there is something mysterious in that. Now call it God, or human nature or whatever you like, but there is something which I cannot define in a system though it is very much alive and very real, and see that is God, or just as good as God.

He explained that he understood Kee's beliefs about God and religion, for he too once shared them. He would be patient with her, "but while she holds on and clings to the old things, I must work and keep my mind clear for painting and drawing and business" (letter 164).

Lessons With Mauve

The money Theo sent for Vincent's visit to the Strickers' was not used solely for that purpose. Instead of going directly to Amsterdam, Vincent first visited his cousin, the artist Anton Mauve, in The Hague. He explained to Theo:

You know that Mauve had planned to come and stay in Etten for a few days. I was afraid that something would prevent it or that the visit would be too short, and I thought, I will try it in another, and possibly more radical way. I said to Mauve, Do you approve of my coming [to The Hague] for a month or so, and occasionally troubling you for some help or advice? After that I shall have overcome the first misery of painting, and then I shall return to 't Heike.[42] Well, Mauve at once sat me down before a still life with a pair of old wooden shoes and some other objects, and so I could set to work. And I also go to him for drawing in the evening.
I am staying in a little inn near Mauve, where I pay thirty guilders a month for a room and breakfast. So if I may count on the 100 fr. from you, I can manage (letter 162).

Theo could hardly have foreseen that his "money for the ticket" to Amsterdam would be used this way, although Vincent did use some of the money for the purpose for which Theo had intended it. Vincent proved once more to be a man of sudden, unexpected, and as he called it, "radical" decisions. For his future as an artist, this particular decision was of far-reaching importance, for not only was he greatly helped by Mauve's lessons, but the contact with him would eventually lead to his settling in The Hague.

When Vincent wrote to Theo again, more than two weeks had passed in which he worked daily under Mauve's supervision, and he could summarize his production as follows: "I have now painted five studies and two watercolors and made, of course, a few more sketches." The main reason for this letter was that Vincent had now been away for almost a month and had a great many expenses. "When I wrote to Father this week

[41] Famous Dutch author (1820-1887); pseudonym for Edward Douwes Dekker.

[42]A hamlet near Etten; the name is jokingly used for Etten here.

for money, he thought it so very excessive that I had spent ninety guilders." He had learned much from Mauve and wanted to stay in The Hague a little longer, but he had no money to stay and no money to go back. "I shall wait a few more days for your answer. But if it does not come within three or four days, I shall ask Father for money to go back at once."

Apparently Theo had been unwilling or unable to help Vincent with the money to stay in The Hague, for Vincent's next letter, the one in which he revealed his changing feelings for Kee Vos, came from Etten. Vincent was extremely grateful for Mauve's help, but he had agreed with him that he would now struggle on a few months by himself. In telling Theo about his activity at Mauve's, Vincent opposed it to the difficult situation with his parents at home. To characterize their narrow-mindedness, Vincent gave an amusing example. He had once told Theo what their reaction had been to his reading Michelet: "They had brought up the story of a great-uncle who was infected with French ideas and took to drink" (letter 159). This time they reacted to Goethe. "Since the Reverend Mr. Ten Kate translated Goethe's *Faust*, Father and Mother have read that book, for now that a clergyman has translated it, it cannot be so very immoral (*??? qu'est-ce que c'est que ça*) [what is that?]. But they consider it nothing but the fatal consequences of an ill-timed love." Vincent had other reservations about living with his parents. His father had said that he did not have to worry about expenses (Reverend Van Gogh was happy with Mauve's opinion about his son and liked the studies he had brought back from The Hague), but Vincent felt he could not possibly accept his father's offer.

> As I told you before, I hate not being entirely free, and though I do not literally have to account to Father for every cent, he always knows exactly how much I spend, and on what. I may have no secrets, but I don't like to show my hand to everybody, and even my secrets are no secrets to people with whom I am in sympathy. But Father is not a man for whom I can feel what I feel for you or for Mauve, for instance. I do love Father, but it is quite a different kind of sympathy from what I feel for you or Mauve.
> Father cannot understand me or sympathize with me, and I cannot be reconciled to Father's systems—it oppresses me, it would choke me (letter 164).

There followed from Etten just one more short letter to Theo, written a few days later, and then came the catastrophe that he had feared: he had to leave his parents' home. One should not be persuaded by the explanation of Vincent's move in the Memoir to the *Complete Letters*: "He could not bear to stay in Etten any longer. He had become irritable and nervous, his relations with his parents became strained, and in December, after a violent altercation with his father, he left suddenly for The Hague." This is perhaps what Vincent's mother had told Jo van Gogh-Bonger, but it is clearly biased and even partly erroneous. Vincent did suddenly move to The Hague, but that was because his father had turned him out— had thrown him out of the house, as Vincent himself put it. To argue that Vincent "could not bear to stay in Etten any longer" is especially inaccurate. Vincent had just decided to stay on for at least another three months (Mauve had told him to come

Without money to stay in The Hague, Vincent returns to Etten.

back to The Hague perhaps in March) (letter 164). He had even written in the same letter that he feared being "thrown out of the house" on or shortly after the Strickers' silver wedding party. (There are no further particulars about this celebration that took place on 8 December, but what he feared indeed became a reality.) Fortunately, Vincent's own explanation of what had happened exists. From The Hague he wrote on 29 December:

> Thanks for your letter and the enclosed. I was back in Etten when I received it; as I told you, I had arranged this with Mauve. But now you see I am back again in The Hague. On Christmas Day I had a rather violent scene with Father, and it went so far that Father told me I had better leave the house. Well, he said it so decidedly that I actually left the same day.
>
> The real reason was that I did not go to church, and I said that if going to church was compulsory and if I was *forced* to go, I certainly would never go again out of courtesy, as I had done rather regularly all the time I was in Etten. But oh, in truth there was much more behind it, including the whole story of what happened this summer between Kee and me (letter 166).

It is interesting to see how Theo reacted to these dramatic events; it was not the reaction Vincent anticipated.

THE STUDIO IN THE HAGUE

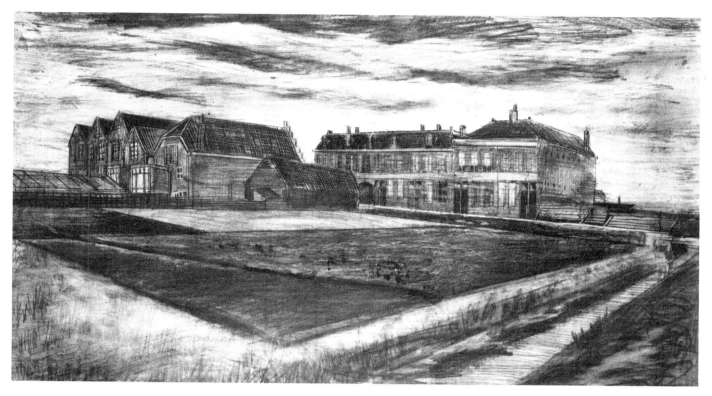

26
Nursery on the Schenkweg, *drawing by Vincent. He first lived on the block on the far right of the drawing (second floor, left side). Later he moved to the second floor of the adjoining house. 1882. Pencil, heightened with chalk and sepia, JH 122, F 915, 40 x 69 cm. Collection Mrs. A. R. W. Nieuwenhuizen Segaar-Aarse, The Hague*

There is no uncertainty about Theo's reaction to Vincent's sudden move to The Hague and the events that led to it, because the letter he wrote about it has been preserved. This was because Vincent returned it to him, not, he said, "with the intent of insulting him," but because he had placed some numbers in the text as a short way of clarifying his response. Theo's letter was dated "Paris 5 January 1882":

I received your two letters and thank you for keeping me informed as to how things are going. Your settling in The Hague is something I entirely agree with, and I hope to be able to help you as much as I can until you can earn your own money, but what I cannot approve of is the manner in which you contrived to leave Father and Mother. That you could not bear it there any longer is possible, and that you differ in opinion with people who have lived all their lives in the country and have not come into contact with modern life is not unnatural; but, confound it, what made you so childish and impudent as to embitter and spoil Father's and Mother's lives in that way. It is not difficult to fight against someone who is already tired. When Father wrote to me about it, I thought it might be a misunderstanding, but you yourself say in your letter: it will not be redressed so easily. Don't you know him then, and don't you feel that Father cannot live as long as there is a quarrel between you two? *Coûte que coûte* [at all costs] you must put the matter straight, and I

111

am sure that someday you will deeply regret having been so heartless in this matter. (letter 169).

This letter reveals one of the best qualities of the twenty-four-year-old Theo: the great love and appreciation he had for his parents, although he was fully aware of their intellectual shortcomings and short-sightedness, which he justly ascribed to their rural upbringing. The letter also shows to what extent he had become a leading figure in the family, a family member who could address Vincent with authority.

But his criticism was biased and for the most part unjust; he had taken sides with his father without knowing the entire story, and Vincent did not hesitate to tell him so in the strongest terms. He began by explaining that he had not "contrived" to leave his father and mother. On the contrary, when his father was in The Hague, he and Mauve had discussed the possibility of Vincent's renting a studio in Etten and staying there in the winter; Vincent had even written about such a studio earlier, a shed in which only a few repairs had to be made. He also reminded Theo of earlier letters in which he had pointed out how useful working in Etten was for him and what a pity it would be to put an abrupt end to the kind of work he had been doing for months.

Another point of discussion was Vincent's relationship with his father. In his letters from Etten he had always written about him in moderate terms, even if he had not left any doubt that he found his father's ideas narrow-minded and obsolete, and sometimes spoken of clergymen in general in a very negative way. But now that Theo had accused him of having "embittered and spoiled" his parents' lives, Vincent could not refrain from telling him more clearly than ever before what the situation in Etten had really been. "Father is excessively touchy and irritable and full of waywardness in his home life, and he is used to always getting his own way. He would sometimes fly into a frightful rage and be surprised if one did not give way to his anger. . . . Because Father is a tired old man I have spared him a hundred times, and tolerated things which are little short of intolerable." But, he concluded his apology, "When somebody says deliberately and resolutely to me, 'Get out of my house, the sooner the better, and rather in half and hour than an hour,' well, my dear fellow, it won't be a matter of an hour before I shall be gone, and I shall never return, either."

It must be admitted that Theo was certainly correct when he stated that Vincent must have deeply offended his father with his remarks about religion. Vincent cannot be blamed for not renouncing his convictions about ecclesiastical religion—convictions which had undoubtedly cost him years of inner struggle. But there is no doubt that he did not realize how grievous his words must have been to a man whose whole life had been devoted to the service of the church. When Vincent said that the morality and religious system of clergymen and their academic opinions "were not worth a fig" to him since he had come to know so much of the *dessous de cartes*," he ruthlessly attacked the cornerstone of his father's existence. He meant it when he said he was not his father's enemy, but for the Reverend Van Gogh to feel the same way was asking from him an almost superhuman broad-mindedness and forgiveness. It speaks for his parents' love and compassion that they did not

"Because Father is a tired old man I have spared him a hundred times, and tolerated things which are little short of intolerable."

112

ostracize their rebellious son altogether, and even took him into the house two years later.

To build a new, independent existence as an artist in The Hague must have seemed possible only under the guidance of his cousin Mauve who was so well-disposed toward Vincent. Vincent packed his modest belongings—his portfolio with drawings, his watercolor box, his new painter's tools, his prints, and some clothes. He had just enough money for the journey and was able to manage for a few days, but outside help would soon be indispensable.

27
The beginning of the letter that Theo wrote from Paris in 1882 (letter 169), and the few lines that Vincent added when he returned the letter with an extensive defense of his actions.

He wrote this to Theo shortly after he had arrived in The Hague and had made sure he could rely on Mauve. He found an inn, but at the same time looked for a few rooms where he could continue to work, a "studio" as he euphemistically called it. On 29 December, he wrote that he had found "a room and an alcove which can be arranged for the purpose." Because it was an old house on the outskirts of town, the apartment cost only seven guilders a month. The low price and the splendid view were its main assets, but it also had the advantage of being situated no more than ten minutes from Anton Mauve. Vincent could move into the house on 1 January 1882, but had, of course, no furniture whatsoever. Mauve helped him solve the problem. He lent him one hundred guilders—quite a considerable sum when one realizes that the monthly allowance Vincent received from Theo amounted to fifty guilders. It was enough to buy some kitchen chairs and "a real strong kitchen table," Vincent wrote with satisfaction (letter 167). Of course there had to be a bed, too, and this caused some discussion: "I would be satisfied with a blanket on the floor instead of a bed. But Mauve wants me to get a bed, and will lend me the money if necessary" (letter 166). It is clear that even with the bed, Vincent's "studio" must have appeared quite

empty. He was happy with it, however, and a few days later, when he had decorated the walls with his own drawings and some of his prints, he wrote Theo (not without a touch of irony) that he enjoyed life again in spite of the bad weather and other hardships of the winter. "Especially my having a studio of my own is inexpressibly delightful. When will you come to have lunch with me, or tea? You can even stay overnight; that will be fine, and you will be quite comfortable. And I have some flowers, too, a few bulbs in pots" (letter 169). In one of the first drawings of The Hague period, *An Old Woman at the Window, Knitting* (JH 90), and some other sketches, one can see those "flowers"; meagre blades in flowerpots, but they represent a sign of newly developing life.

The address he mentioned in one of his first letters, 138 Schenkweg, has for many years had something mysterious about it, because the house at that address did not fit Vincent's description. Only in recent years has it been discovered that his house was not on Schenkweg itself, but on a side street, called Schenkstraat, indicated on maps from Vincent's time as "third street of Schenkweg."[43] The story he rented belonged to a block of two houses, which stood completely isolated in the meadows near Rijswijk. Building for the expansion of the town was already in full swing at that time. The Schenkweg itself could hardly be called a road; it was a narrow path through the meadows, bordered by ditches and rows of trees; in letter 238, he called it *een kolenweg* (a cinder path). In several of his drawings and sketches, made from the back window of his studio (JH 93, 95, 150, etc.), one can see this country road clearly. The railroad to Utrecht ran along the Schenkweg, and the house looked out on a complex of buildings which was later pulled down, including a locomotive depot and a shed. Vincent drew the view of the meadows, the railroad and the railroad buildings many times (JH 99, 150, 156, etc.) and he also described it enthusiastically. One of his best descriptions, remarkable for its precise observation, is given in letter 138, written in October 1882, some ten months after his arrival. It is typical for the realistic artist he had become in the meantime, who saw as beautiful, or at least as fascinating, much that in his time was certainly not considered "picturesque":

The view from the Schenkweg, or Schenkstraat, house.

> In the foreground, the cinder path with the poplars, which are beginning to lose their leaves; then the ditch full of duckweed, with a high bank covered with faded grass and rushes; then the gray or brown-gray soil of spaded potato fields, or plots planted with greenish-purple red cabbage; here and there the very fresh green of newly sprouted autumn weeds, above which rise bean stalks with faded stems and the reddish or green or black bean pods; behind this stretch of ground, the red-rusted or black rails in yellow sand; stacks of old timber—heaps of coal—discarded railway carriages; higher up to the right, a few roofs and the freight depot—to the left, a far-reaching view of the damp green meadows, shut off far away at the horizon by a grayish streak, in which one can still distinguish trees, red roofs and black factory chimneys.

[43] For particulars see my articles "The Houses where Van Gogh Lived in The Hague," and "Van Gogh's Studio in The Hague Identified," in *Vincent, Bulletin of the Rijksmuseum Vincent van Gogh*, vol. I, nrs. 1 and 2 (1970-71).

All this has long since vanished. The houses in which Vincent lived fell victim to the bombardment of that quarter of The Hague in 1945, but fortunately a memory of them is preserved in Vincent's meticulous drawings of 1882 (JH 122).

The first weeks of Vincent's stay in The Hague must have been exceptionally hard. When Theo did not reply to his first two letters about his move to The Hague until 5 January, Vincent became nervous, if only because he had been penniless for days. "Of course," he said, "I had counted positively on your sending me at least a hundred francs for the month of January" (letter 168). Being hungry was not as bad to Vincent as being unable to work, and the latter was now the case. "The worst is that I cannot work with a model until I have some money in my pocket again, so I can hardly do anything, as the weather is too bad to sit outside, though I tried it several times." He did not know that Theo's letter was already on its way, so "in desperation" he had gone to Goupil's to borrow money, but was told that his friend Tersteeg was out of town. A day or two later Tersteeg did lend him twenty-five guilders to last him until he received Theo's letter. The hundred francs he finally received from Theo was not enough to cover all his needs, especially as he sometimes allowed himself expenses that were not absolutely necessary, although of great importance for his work. For instance, immediately after receiving the money he wrote: "I have another decoration for my studio—I made an exceptionally good buy; some splendid wood engravings from the *Graphic*, in part prints not from the cliché but from the blocks themselves. Just what I've been wanting for years, drawings by Herkomer, Frank Holl, Walker, and others. I bought them from Block, the Jewish book dealer, and for five guilders I chose the best from an enormous pile of *Graphics* and *London News*" (letter 169).

Theo sent him another hundred francs before the end of the month, but when Vincent acknowledged the receipt, he was obliged to add: "What I had already feared when I wrote you last had really happened, meaning that I have not been well, and have been in bed for almost three days with fever and nervousness, now and then accompanied by headache and toothache. It is a miserable condition, which is caused by over-exertion" (letter 173).

With all this worrying about money and staying healthy, there was one bright spot: Vincent's good relationship with his cousin Anton Mauve. It was to be short-lived, but while it lasted it was of the greatest importance to Vincent, in the material as well as in the moral and artistic sense. Anton Mauve had been born in 1838 and was therefore fifteen years older than Vincent. By 1882 he was a renowned painter and an influential man in the art world. Curiously enough, he too was the son of a parson. In 1874 he had married Ariëtte (or Jet) Carbentus, a daughter of Arie Carbentus, a brother of Vincent's mother. As Mauve was a parson's son and a cousin by marriage, Vincent's parents trusted and esteemed him. Vincent himself admired him immensely and was most grateful for the kindness and support his cousin gave him at this difficult moment (letter 169).

It is remarkable to see how much Mauve did to help a beginner like Vincent, especially since he was a rather inaccessible figure who otherwise refused to have pupils. "Mauve has

"The worst is that I cannot work with a model until I have some money in my pocket again. . . ."

115

now shown me a new way to make things, that is, how to make watercolors," Vincent wrote in the middle of January (letter 170). "Well, I am quite absorbed in this now and sit daubing and washing out again; in short, I am trying to find a way." Mauve's help in making watercolors should not be underestimated, for he was a very good artist in this field; Dr. W. J. de Gruyter, an expert on the Hague School, even called him one of the most refined of all the Dutch nineteenth-century watercolorists.[44] He wrote, "Mauve's influence on Van Gogh is greater than is generally assumed. The reason is that Van Gogh possessed an enormous power of assimilation and an astonishing alertness of mind, which enabled him to take in many things in a short time and to learn from others. Some of his watercolors (such as *De la Faille* 870) are very close to Mauve's."[45] The watercolor referred to represents a knitting Scheveningen woman, done under Mauve's supervision (JH 84). "Certain subjects such as diggers, potato-diggers, and lumber sellers he took over from Mauve. Nevertheless he soon found his own, very personal style, in which much stress was laid upon the structural drawing."

Opposed by Mauve and Tersteeg

On 4 February 1882 Vincent had good news and bad news to report to Theo (letter 175). The good news was that he had been encouraged about his work. He proudly reported to Theo that he had been visited by J. H. Weissenbruch—the great painter and masterly watercolorist—who had shown a friendly interest in his work:

> I have already told you in a previous letter that I had a visit from Weissenbruch. At present Weissenbruch is the only one allowed to see Mauve, and I thought I would go and have a talk with him. So today I went to his studio, the attic which you know, too. As soon as he saw me, he began to laugh and said, "I am sure you have to come to talk about Mauve"; he knew at once why I came, and I did not have to explain. Then he told me that the reason for his visiting me was really that Mauve, who was doubtful about me, had sent him to get his opinion about my work.
> And Weissenbruch had then told Mauve, "He draws confoundedly well, I could draw from his studies myself."
> And he added to me, "They call me 'the merciless sword,' and I am; I would not have said that to Mauve if I had found no good in your studies (letter 175).

The favorable opinion of an artist as competent as Weissenbruch must have boosted Vincent's self-confidence, and on the same day he had another pleasant experience. When he went to see Tersteeg to show him a few of his drawings, he was told that they were better than the previous ones he had shown him and that he should make more small watercolors (letter 176). More important still, Tersteeg even bought one of his drawings for ten guilders. The money was extremely welcome;

J. H. Weissenbruch, 1824-1903.

[44] *De Haagse School* (1969), vol. II, p. 62.

[45] Ibid., pp. 68-69.

Vincent wrote that it was only because of this that he was able to manage those weeks.

The bad news in the February letter was that Vincent began to have difficulties with Mauve. He wrote that Mauve had treated him very unkindly "of late" (letter 175). He added that at first it had "worried him exceedingly," but he was now reassured because he understood that it was not because Mauve thought badly of his work, but because he was "far from well," which was "of course the usual thing." He was referring to the fact that Mauve was very depressive, something Theo also undoubtedly knew. It was understandable that Vincent ascribed Mauve's unfriendliness to one of his moods of melancholy and irritability. He wrote that lately Mauve had done very little for him, and had even once said, "I am not always in a mood to show you things; sometimes I am too tired, and then you will damn well have to wait for the right moment" (letter 175). Yet it was not only his depression that made Mauve turn away from Vincent; there were motives of a completely different kind.

Bad news about Mauve.

Vincent did not tell Theo what these motives were until some months later. He probably did not want to give Theo too much cause for alarm in the beginning of his independent life as an artist. But it appears that it was Tersteeg, and not Mauve, who had been the first to develop some mistrust in Vincent. The account Vincent gave of it in the first half of March was a sad story: "In your letter of 18 February you said, " 'When Tersteeg was here, we of course spoke about you and he told me that whenever you wanted anything, you could always go to him.' Then why is it that when I asked Tersteeg some days ago for ten guilders, he gave them to me, but accompanied by so many reproaches—I might also say insults—that I could hardly control myself, though I did. I would have thrown the ten guilders in his face if the money had been for myself, but I had to pay the model, a poor sick woman whom I cannot keep waiting" (letter 179).

Insults from Tersteeg.

Tersteeg's reproaches were so offensive that Vincent ended his letter by saying that he would rather obtain money by going without dinner for six months than occasionally getting ten guilders from him accompanied by comments such as "Of one thing I am sure, you are no artist," and "this is my main objective: you started too late." Tersteeg also thought that Vincent should try to make "salable" things, by which he meant small drawings, not in black and white but in watercolor and of pleasant subjects. Vincent said repeatedly that this was something which he could not immediately succeed in doing, but he also felt instinctively that artistically it would lead him onto the wrong track.

Theo probably heard about the conflict when Tersteeg had visited him in Paris or from Tersteeg's letters. Perhaps he may even have felt some reservations himself without Tersteeg's allusions and suggestions. When Vincent wrote to him in March, Theo must have asked himself whether Vincent had not gone a bit far hiring models, considering his limited means .

Since I received your letter and the money, I have had a model every day, and I am up to my ears in work.

I have a new model now, though I drew her superficially once before, or rather, it is more than one model, for I have already had three

117

persons from the same family: a woman of some forty-five, who is just like a figure of Ed. Frère,[46] then her daughter of about thirty, and a younger child of ten or twelve. They are poor people, and I must say they are more than willing. I got them to pose, but not without difficulty, and only on condition that I promise them regular work. Well, that was exactly what I wanted so much myself, and I think it a good arrangement (letter 178).

Although it was only the beginning of the month, the arrangement seemed financially risky. "Up to now I have paid them regularly, but next week I should not be able to do so. But I can get the model anyhow, either the old woman, the younger one, or the child" (letter 178). When he wrote again a week later he would admit, "I hope your letter will come soon—I spent my last penny on a stamp for this letter" (letter 180).

It was not until the second half of April 1882 that Vincent began to write to Theo in more detail about Mauve's changed attitude. Reminiscing about the events that occurred in January, he wrote: "Near the end of January, I think a fortnight after my arrival here, Mauve's attitude toward me changed suddenly—became as unfriendly as it had been friendly before. I ascribed it to his not being satisfied with my work, and I was so anxious and worried over it that it quite upset me and made me ill, as I wrote you at the time" (letter 189).

Mauve's attitude explained.

Mauve had said a number of spiteful things, which, Vincent thought, might have been suggested to him by Tersteeg. Vincent went to see Mauve occasionally, but always found him moody and rather unkind. The incident that finally caused the crisis was almost unavoidable because it was a clash of two obstinate artistic personalities.

A few times I was told he was not at home—in short, there were all the signs of a decided estrangement. I went to see him less and less, and Mauve never came to my house again, though it is not far away. His talk also became as narrow-minded, if I may call it so, as it used to be broad-minded. I had to draw from casts, that was the principal thing, he said. I hate drawing from casts, but I had a few plaster hands and feet hanging in my studio, though not for drawing purposes. Once he spoke to me about drawing from casts in a way such as the worst teacher at the academy would not have spoken; I kept quiet, but when I got home I was so angry that I threw those poor plaster casts into the coal bin, and smashed them to pieces. And I thought, I will draw from those casts only when they become whole and white again, and when there are no more hands and feet of living beings to draw from.
Then I said to Mauve: Man, don't mention plaster to me again, because I can't stand it. Thereupon I got a note from Mauve, telling me that he would not have anything to do with me for two months (letter 189).

When Vincent wrote about the incident in April, those months had long passed, and two things had happened which understandably had made a strong impression upon him. Tersteeg had threatened that he would see to it that Theo no

[46] Edouard Frère (1819-1886), French genre painter whom Vincent mentioned repeatedly in his letters.

longer sent Vincent money. "Mauve and I," he had said, "will see to it that there is an end to this." This confirmed Vincent's suspicion that Tersteeg was scheming against him, and, utterly shaken, Vincent wrote Theo, "I am a man with faults and errors and passions, but I don't think I ever tried to deprive anyone of his bread and his friends." The second blow Vincent had to endure was that his effort to become reconciled with Mauve had been ignored. After the bitter experience with Tersteeg, he had written a note to Mauve in which he said something like, "Let us shake hands, and then each go his own way, rather than have a quarrel between you and me," but Mauve had given neither word nor sign, leaving Vincent with a feeling of being "choked" (letter 190).

The events of the last two weeks of April 1882 belong to the most decisive of his whole stay in The Hague. They caused him to write ten lengthy and very emotional letters in quick succession. Unfortunately the editor of the *Brieven aan zijn broeder* has not succeeded in placing this group of letters in the correct sequence, with the result that they make an extremely confusing impression. The order of the letters was not changed in the revised and expanded editions which formed the basis for the translations into French, English, German and other languages. It is true that Vincent's emotional state of mind while writing these letters caused him to be repetitive and sometimes even a bit rambling, but when they are placed in the correct order there is much more logic, more intelligent reasoning in them than the unsuspecting reader of the printed editions would suppose. The following summary of the occurrences of these weeks is based on a restored sequence of letters 191 to 199.[47]

In his disappointment, Vincent devoted one long letter especially to the subject of Mauve and Tersteeg and his strained relations with them. Because Theo had advised him, "Tersteeg has been almost like an older brother to us, try to stay friends with him," Vincent thought it necessary to explain that in reality Tersteeg had done extremely little for him. In the years of his hardship, he said, referring to the years in England and the Borinage, Tersteeg had never given him "a piece of bread," and never encouraged him. "Did he ever help me in any way? No, except when he sent me the Bargues after I had literally implored him four times. When I sent him my first drawings, he sent me a paintbox, but not a cent of money. I readily believe those first drawings were not worth any money; but you see, a man like Tersteeg might have argued, 'I know him of old, and I will help him get on,' and he might have known I needed it so badly in order to live" (letter 191). Mauve had helped him when Vincent moved to The Hague early in 1882, but under the influence of Tersteeg this had changed. "Mauve's sympathy, which was like water to a parched plant to me, is running dry."

In his next letter (195, not 192), it is found that Theo had immediately tried to convince Vincent that his gloomy ideas of Tersteeg and Mauve were the result of a misunderstanding, and Vincent was only too glad to believe him. He assured Theo that it was apparent that the change in Mauve and Tersteeg had been in part "only imaginary." "I do not see clearly in such

During the last two weeks of April 1882, Vincent wrote ten long letters to Theo about his estrangement from Mauve and Tersteeg.

"Mauve's sympathy, which was like water to a parched plant to me, is running dry."

[47] The correct order of the letters is: 190, 191, 195, 196, 192, 194, 197, 198, 193, 199.

things, but your letter showed me distinctly that there is no reason for me to worry if only I work on."

Only a few days later, an unexpected event unsettled everything again, and invalidated the soothing words Theo had written. After a casual encounter with Mauve Vincent wrote: "Today I met Mauve and had a very painful conversation with him, which made it clear to me that Mauve and I are separated forever. Mauve has gone so far that he cannot retract, at least he certainly wouldn't want to. I had asked him to come and see my work and then talk things over. Mauve refused point-blank: 'I will certainly not come to see you, that's all over.' At last he said, 'You have a vicious character.' At this I turned around—it was in the dunes—and walked home alone" (letter 192). There is no doubt that Vincent felt that his good friend and comrade, Anton Mauve, had deserted him for good.

THE BROTHERS AND THEIR LIAISONS

After Vincent's confrontation with Mauve he returned to his house "with a heavy heart." This time he did not need to ask Theo for an explanation; he knew only too well why his friend behaved like this, and he finally decided to disclose his "secret" to Theo, hoping that a long exposition would at least give him a better insight into his actions. His story took on the unique dramatic form that is characteristic of Vincent's most emotional letters:

> They suspect me of something—it is in the air—I am keeping something back. Vincent is hiding something that cannot stand the light.
>
> Well, gentlemen, I will tell you, you who prize good manners and culture, and rightly so if only it be the true kind: Which is the more delicate, refined, manly—to desert a woman or to take an interest in a deserted woman?
>
> Last winter I met a pregnant woman, deserted by the man whose child she carried.
>
> A pregnant woman who had to walk the streets in winter, had to earn her bread, you understand how.
>
> I took this woman for a model, and have worked with her all winter. I could not pay her the full wages of a model, but that did not prevent my paying her rent, and thank God, so far I have been able to protect her and her child from hunger and cold by sharing my own bread with her (letter 192).

The truth had finally been admitted. It was his relation with his model that had estranged Tersteeg and Mauve from him, and there can be no mistake about the nature of that relationship, for Vincent had cared for the woman like a husband and had also said in all simplicity that he could do nothing better than to marry her. He knew that his confession meant taking a great risk, and so he ended this part of his letter with a few sentences that left no doubt about what was at stake for him: "I thought I would be understood without words. I had not forgotten another woman [Kee Vos] for whom my heart was beating, but she was far away and refused to see me; and this one walked the streets in winter, sick, pregnant, hungry—I couldn't do otherwise. Mauve, Theo, Tersteeg, you have my bread in your hands, will you take it from me, or turn your back on me? I have spoken now, and await whatever will be said to me next."

It is questionable whether all this came as a surprise to Theo. Tersteeg and Mauve could easily have reported to him that the model frequented Vincent's house, and even Vincent's own communications about his "regular models" would have given Theo every reason for some suspicion. The dangerous game with words Vincent had played in his letter of 1 May 1882 (before his confession in letter 192) must have been enough for Theo to see through the smoke screen Vincent had laid around his life in The Hague. "Last year I wrote you a great many letters full of reflections on love. Now I no longer do so because I am too busy putting those same things into practice. She for whom I felt what I wrote you about is not in my path, she is out of my reach in spite of all my passionate longing. Would it have been better to keep thinking of her

always and to have overlooked what came my way?" (letter 195). Theo himself may have had a liaison with a model at the time, but it is certain that he had one a year later. It must have been startling, however, to learn that his brother was earnestly considering *marrying* his model, and not unexpectedly it was this step Theo would object to with all his power.

Before discussing Theo's reaction to the letter and Vincent's own opinions about the situation, some information must be given about the woman who was the center of the discussion. Though Vincent never revealed more than her first name in his letters (he first called her Christien, in later letters, Sien) gradually enough has become known about her to form a reasonably clear image of her personality and background. In the letter of the beginning of March 1882, quoted earlier, Vincent had described his models as follows: ". . . I have already had three persons from the same family: a woman of some forty-five, who is just like a figure of Ed. Frère, then her daughter of about thirty, and a younger child of ten or twelve." It was the thirty-year-old woman to whom Vincent referred when he spoke about a pregnant woman he had taken into his care. Her name was Clasina Maria Hoornik.[48] She was born in The Hague on 22 February 1850 and therefore, at thirty-two, was three years older than Vincent. Her father, Pieter Hoornik, had died in 1875, but her mother, Maria Wilhelmina Pellers, was still alive, although she was somewhat older than Vincent had estimated. Clasina Maria—Sien as she will be called from now on—had a young daughter, though not the "younger child of ten or twelve" whom Vincent mentioned as his third model; this must have been Sien's youngest sister, Maria Wilhelmina, who was born on 11 October 1872. Sien's daughter, who, like her ten-year-old aunt, was also called Maria Wilhelmina, was born on 7 May 1877, and was therefore not yet five.

Sien was indeed pregnant and, as Vincent said, she was "deserted by the man whose child she carried." The father of her daughter had also refused to marry her (letters 192 and 198). Something Vincent probably did not know was that before he met her, she had already had two other illegitimate children, who had died early. She cannot be blamed for clinging to Vincent when she found that here was a man who really was good to her. It is just as understandable that Vincent, who was still bowed down by the humiliation he had experienced in his love for Kee Vos and was suffering from misery and loneliness, clung to the woman in whom he hoped to find some warmth and human feelings. He did not idealize her—nor himself—when he wrote in May: "Perhaps I can understand her better than anyone else because she has a few peculiarities which would have been repulsive to many others. First, her speech, which is very ugly and is a result of her illness [she had a throat disease]; then her temper, caused by a nervous disposition, so that she has fits of anger which would be unbearable to most people. I understand these things, they don't bother me, and until now I have been able to manage them. On her side she understands my own temper, and it is a sort of tacit understanding between us not to find fault with each other" (letter 194).

Clasina Maria Hoornik (Sien), born 1850, drowned herself in 1904.

[48] I have published many biographical details about her in the monthly *Maatstaf*, September 1958, later reprinted in translation in *Vincent*, vol. 1, nr. 2 (1971).

28
Sorrow, *lithograph after the drawing
Vincent did of the pregnant Sien Hoornik
in 1882. Pencil, washed, JH 259, F 929,
38.5 x 29 cm.
Various collections*

He did not idealize her either in the dozens of drawings he made of her, nor when, a few weeks later, he said a few things about her looks. "She is slightly pock-marked, so she is no longer beautiful, but the lines of her figure are simple and not ungraceful" (letter 201). He found other things more important. She put herself out to help him and came every week to clean the studio in order to save money for a cleaning woman, showing that she had patience and good will—at least that is what he thought at that time.

When some days passed in which Vincent did not hear from Theo, the tension became too strong for him. He sent him another long letter and some sketches and drawings, declaring, "What I want to show you first of all is that the situation I told you about does not keep me from my work; on the contrary, I am literally absorbed in my work and enjoy it, and have good courage" (letter 197). Vincent hoped that Theo would not be angry that he was so anxious to have a reply. He certainly did not believe that Theo would completely desert him because of his "being with Christien," as he put it, mentioning this name for the first time. "I wish that those who are not my enemies would understand that my actions stem from a deep feeling of

love and from need of love; that recklessness and pride and indifference are not the springs which move the machine, and that this step is proof of my taking root in a lowly station on the road of life. I do not think I should do well to aim for a higher station or try to change my character. I must have much more experience, I must learn still more before I shall be ripe, but that is a question of time and perseverance" (letter 197).

He did not exclude the possibility that Theo would indeed stop his financial assistance; if that happened, he said in the postscript, he begged him not to do it without warning. "Theo, I do intend to marry this woman, to whom I am attached and who is attached to me. If unfortunately this would bring about a change in your feelings for me, I hope you will not withdraw your help without giving me warning some time in advance, and that you will always tell me frankly and openly what you think. Of course, I hope that your help and sympathy will in no way be withdrawn, but that we shall continue to join hands like brothers, notwithstanding things which 'the world' opposes" (letter 197).

Risking the loss of Theo's financial support.

Theo's response caused Vincent to change the tone of his later letters, for the answer was negative. One of the things Theo had written was somewhat reassuring: the difference in class was not the main reason for his objections, and this, of course, was something Vincent eagerly tried to hold on to. He mentioned in his next letter to Theo, "I certainly appreciate many things in your letter, for instance that you write: 'One must be narrow-minded or prejudiced to give absolute preference to one class over another' " (letter 198). Another positive element of Theo's answer was that he had said nothing about canceling Vincent's allowance; he had even included fifty francs in the letter. On the main points, however, he had not given hope for any agreement, for he had written that he was completely opposed to the idea of Vincent's marriage.

Vincent was short and determined in his answer. "I will not desert a woman for anybody's sake; I am attached to her by a bond of mutual help and respect" (letter 198). He tried to express as clearly as possible *why* he thought of marriage; it was more for worldly reasons than for a deep-felt inner necessity. "That is what Christien and I think: we both long for home life, close together. We need each other daily in our work and we are together daily. We do not want anything crooked in our position, and think marriage the only radical way to quiet the gossip and to prevent being reproached for our living together illegally. If we do *not* marry, people can say there is something wrong—if we do marry, we shall be very poor and give up all pretense of social standing, but our actions will be straight and honest. I think you will understand this" (letter 198).

"I will not desert a woman for anybody's sake; I am attached to her by a bond of mutual help and respect."

Probably because of something that Theo had said in his letter, Vincent mentioned in a postscript[49] that he was even prepared to leave The Hague if it would make it easier for people to accept his living with Christien. Less than a month later, he understood that he might have to make this sacrifice, and he wrote: "You will find me very compliant in anything I can do without being unfaithful to Christien. I shall be very

[49] In the printed editions the postscript is inserted in the body of the letter, where another passage had been removed.

124

glad to hear your opinion, for instance, in the matter of where I shall live, or such things. If there is any objection to my staying in The Hague, I am not bound to stay in The Hague. And I can find a field of action wherever you like, either in a village or in a town."

It is surprising that Vincent thought it necessary, after the clear and definite letter in which he wrote all this, to follow up *on the same day* with a second letter, even longer than the first (it contains no less than sixteen pages), and why he should have come back to the events of December in Amsterdam. The main reason was his extreme anxiety, betraying itself both in the almost pathological length of the letter and in the emotional handwriting. But there was also a more rational motive. One of the arguments used by Theo to oppose Vincent's marriage to Sien was his contention that if Vincent had really loved Kee Vos, he would not do what he was doing. He therefore tried to convince his brother by making him realize that his liaison with Sien was connected with the "inhuman" way he had been received in Amsterdam. "If I succeed in making you understand what I think you don't yet understand," Vincent responded, "then Christien, her child, and myself have a chance. And in order to accomplish this, I must risk saying what I am going to say." Although what he now revealed about the visit to the Strickers was in essence the same as what he had written in December, this time he did not hide the fact that the reception in Amsterdam had so terribly shaken him that his love for Kee had ended. He even disclosed what her brother had said at that occasion, something that was considered so shameful for the family that it was suppressed in Jo van Gogh-Bonger's edition of the letters in 1914, and was never restored in the later editions.

> They told me: "When you are in the house, Kee leaves it. To your 'she, and no other,' her answer is 'Certainly not him'; your persistence is *disgusting*" . . .
> I put my fingers in the flame of the lamp and said, "Let me see her for as long as I hold my hand in the flame," and no wonder that later H. G. T[ersteeg] may have looked at my hand. But they blew out the lamp, I believe, and said, *"You shall not see her."*
> And thereafter I also had a discussion with her brother who said— officially or unofficially—that only money would be able to achieve something here. Officially or unofficially—I find it mean in both cases, and when I left Amsterdam, I had a feeling as if I had been on a slave market (letter 193).

It was after these experiences that he felt his love for Kee die, and in a passage that is characteristic of Van Gogh as a man and an artist, he described what, at least, could make him overcome his grief. "To forget, I lie down in the sand by an old tree trunk and make a drawing of it. In a linen smock, smoking a pipe and looking at the deep blue sky—or at the moss or the grass. This soothes me. And I feel just as calm, for instance, when Christien or her mother is posing, and I estimate the proportions, and try to suggest the body with its undulating lines under the folds of a black dress. Then I am a thousand miles away from C. M. [Uncle Cor], J. P. S[tricker], and H. G. T., and much happier. But—alas, the worries come, and I must

More revelations about his visit to the Strickers' in Amsterdam.

125

either talk or write about money, and then it all begins anew" (letter 193).

He felt that he also had to explain in this letter why he had hidden his liaison with Sien from Theo, and he honestly admitted: "Until now I have always thought it probable that you would drop me as soon as you knew everything. So I have lived from day to day, but with a dark fear of the worst, which I don't dare think myself free of yet." However, he had meant his silence only as a *delay*. "I always thought, I can no longer expect anything from Mauve and Tersteeg, and I shall thank God if Theo will continue to send me what is necessary until I can bring Christien safely to Leyden. Then I shall explain it to him, and say, Stop, this is what I have done."

Nevertheless, he felt that if in this whole affair one could speak of guilt, his only guilt had been in his silence, not in his actions, and in a very emotional last page (suppressed in the printed editions) he exclaimed, "Gentlemen, here is my neck—I plead guilty in so far that I have hidden something from you, something that has cost money, but a human life was at stake, and I did not want to talk about it and yet wanted to save it, but now . . . if you declare me guilty I shall not protest; for your money I shall deliver work, but if it's not sufficient, then I'll owe you something and have nothing to pay you back" (letter 193).

Theo's reaction was not altogether favorable. He did not "drop him," as Vincent had put it, but he did something that must have caused his brother great anxiety: he simply did not reply to Vincent's letters. It was a full two weeks before Vincent heard something from him (around 1 June), and only after Vincent had sent another three letters and a postcard. It was thanks to Vincent's iron constitution and the firmness of his character that these weeks of uncertainty had not caused him a serious mental breakdown; according to one of his letters from the end of May, it had cost him at least fever, nervousness and several sleepless nights.

Theo's Mistress

Although he was strongly opposed to Vincent's marriage plans, Theo was familiar enough with the art world in Paris not to be shocked by the idea of a painter living with his model; as a matter of fact, he himself had taken a mistress around the same time. He must have written about it to Vincent for the first time in January of 1883, and all that is known about Theo's "secret" stems from a series of letters written by Vincent in reply. Theo had entered a relationship with a rather sick woman, "a woman with a severely tried constitution" as Vincent put it, and, just like his brother a year earlier, Theo was struggling with the problem of whether or not he should marry her.

Along with Vincent's first letter about the subject (letter 259), Jo van Gogh-Bonger wrote a note saying, "Theo had met a young woman who was sick and alone in Paris and had interested himself in her behalf." This was representing the situation in the most innocent way, but it can easily be forgiven, as she wrote this around 1914 and was speaking of her late husband. It is, however, abundantly clear that the

woman Jo referred to was Theo's mistress, a hardly surprising situation for a twenty-five-year-old bachelor in Paris at that time. It is no wonder that Vincent at once assured him, "You have my full sympathy in this matter," (letter 259), and in his next letter, "So if you should stick to your opinion that this person is the woman to whom you want to devote your life, I consider it a fortunate thing for you." In many other letters he simply called her "your wife," or "the woman with whom you are," and from the beginning he used the word "love"to describe their feelings for one another: "Perseverance is the great thing in love, once it has taken hold of us." Even if Theo had not talked about love in plain words, Vincent could not have doubted what he meant.

Comparisons with his own situation were of course bound to appear. In a letter from the same month of January 1883, there is this passage in Vincent's inimitable dramatic style: "Left aside the difference between the two persons in question, one can say that to you and to me there appeared on the cold, cruel pavement a sad, pitiful woman's figure, and neither you nor I passed it by—we both stopped and followed the human impulse of our hearts" (letter 262). A short time later he was already dreaming of future happiness for Theo: "Certainly you will be doubly, doubly happy when she recovers. And I wish from the bottom of my heart that she might become your wife, for a woman turns life into something so very different" (letter 267). A whole letter had been devoted to considerations of what would be best for the woman, for now a reversal of roles had occurred in the brothers' lives; it was *Vincent* who would give advice to *Theo*. "It would be desirable for her to be elsewhere than in a dreary hotel room—she ought to have more home-like surroundings," he thought. "Certainly, if you could take her into your house at once—I should not mention it. But I am afraid it is impossible, and you yourself could not approve of doing so all at once" (letter 260).

Who was this woman who so unexpectedly had entered Theo's life? The numerous references to her in Vincent's letters provide a fairly clear picture. Her family name is not known, but in the letters she was referred to as *Marie*. One of the letters states that she "would like to return to her own country" (letter 269), but the statement should not lead to false conclusions; she was a French woman, and her native soil was "that old coast of Brittany" (letter 264). She had no children (letter 260), but she still had a certain relation with her mother (letter 281), something that gave Vincent, who had had bad experiences with Sien's mother, reason to say, "be on the *qui vive*" (letter 281). She was a "decent woman of a middle class family" (letter 288), yet what Father Van Gogh would call "a woman of a lower station in life" (letter 290). There was "something intellectual about her and she was not without culture" (letter 290). Although she was a Roman Catholic, Vincent did not believe that this would be the greatest obstacle to Theo's marrying her, even though he came from a parson's family (letter 291). She had "encountered a series of calamities" (letter 268a), one of which was that she had been deceived by a man, and Vincent called it "really noble" of her that she nevertheless had "paid his debts" (letter 263).

Theo's most urgent problem at the moment of their meeting was that she had to undergo an operation. In Vincent's words,

29
Theo van Gogh.

127

"That operation will be a hard time—if I were you I shouldn't say too much to her about finding a situation later, as the future is so undecided because of her foot—better leave it undecided" (letter 264). In this sentence Jo van Gogh-Bonger placed the following note with the word *foot*: "The patient had to be operated on for a tumor on the foot." There is reason to believe that Jo downplayed the seriousness of the situation; soon after the operation Vincent wrote, "I congratulate you especially on the operation's being over. Such things as you describe make one shudder! May the worst be over now, at least the crisis is past!" (letter 265). His next few letters also suggest a serious illness; for a long time Vincent sent good wishes and inquired about the condition of "the patient," and in March, a month after the operation, he still wrote: "I find the news about your patient favorable. Congratulations, the recovery from that anemia is decidedly a result of renewed hope and joy in life, brought about by sympathy and kindness" (letter 270). In April he told Theo, "I am glad your patient is progressing, though slowly"; one is surprised to then read the question, "Is she up already?" (letter 278). All this makes it clear that, while this woman who had entered Theo's life in 1882 or 1883 may have somewhat brightened his rather lonely existence in those years, she also must have caused him much sorrow in the first four or five months of their relationship.

It is no wonder that Vincent continued to speak of marriage as the normal consequence of the step that Theo had taken, for this is what he had always maintained in his own relationship with Sien. Vincent's views became even more radical; regardless of whether Theo married her or not, he bluntly told his brother, "I think it desirable that there be a child." It is more surprising that Theo himself was thinking of a permanent relationship. Around the end of April 1883 he must have written that he was going to inform his father and mother of his decision, for around 2 May Vincent answered, "That you have written our parents about it, or rather, that you are going to, is something which will set your mind at rest, and it is the right thing to do" (letter 282). Theo's plans had taken such a definite form that a date for the marriage had already been fixed, as follows from what Vincent wrote in the same letter: "Well, from the bottom of my heart I hope that things will turn out the way you planned them, toward October, and I am glad things have been carried so far, heartily glad for *your* sake as well as for *hers*." This time Vincent was not the only one who had been overly optimistic. The letter home had a completely unexpected effect, and when Vincent heard about his parents' reaction to it, he burst out in extreme indignation.

Theo considers marrying Marie, April 1883.

> If in my own case—considering my small income—Father and Mother should raise objections to my marrying on account of my having no money, I could approve of it to a certain extent, at least understand why they talked this way and give in.[50] But, Theo, now that in *your* case—knowing that you have a permanent position and a good salary (*nota bene*, considerably more than their own)—they raise the same objection, I can only say that I think it unutterably pretentious and downright ungodly" (letter 288).

[50] Erroneously, the American edition of the letters has here "although I should *not* give in . . ."

128

And in his anger he repeated in only slightly different words what he once had written in Etten: "In point of fact, clergymen are among the most unbelieving people in society and dry materialists."ß[51]

How Theo reacted to the letter from his parents is unknown. It is certain that he "took things calmly" (letter 292); he did not marry Marie, but he did not worry about his parents' disapproval either. In a letter from July, months after his parents had objected to his affair, Vincent wrote, "Recently I have not asked for particulars about the woman, as I myself feel assured that you love each other, which is the main thing, for as long as one knows this one thing, there is no need to ask for particulars" (letter 297). Rather surprising, considering the "illegal" character of Theo's liaison, are the sentences in one of Vincent's next letters, written when Theo had announced a trip to Holland in August. "Do you intend to bring the woman with you to Holland, or don't you think this advisable yet? I should like it if you did" (letter 299). Theo did not, but his relationship with Marie continued. As a result, it again became more difficult to support Vincent financially, for, as he once stated himself, he now divided his income between no less than six people: himself and Marie, his parents, his sister Wil, and Vincent (letter 304). Vincent was not overly impressed with this sacrifice and reacted rather sarcastically: ". . . the division of my 150 francs among four living creatures, while all the expenses for models, materials for drawing and painting, and the rent also have to be deducted, makes you wonder too, doesn't it?"

Theo's liaison continued until the spring of 1884, as indicated in the letters. Theo had spoken about his *amour traînant* (lingering love)—using a term from one of Zola's books—in a letter of March, and Vincent called the break-up "a manly action" (letter 362); in an earlier letter he also had mentioned Theo's "parting" from the woman he had loved (letter 359). There are no more references to Theo's liaison in any of the following letters, except in one of the end of the year in which Vincent mentioned the affair as something of the past. When in letters from 1886 and later there is again mention of a love affair with regard to Theo, the woman in question is always indicated as *S* (letter 386a).

[51] In letter 160 Vincent had written, "There really are no more unbelieving and hard-hearted and worldly people than clergymen and especially clergymen's wives" (in the printed edition the words have been transferred to letter 161).

VINCENT'S LIFE WITH SIEN

Although Vincent's good relationship with Theo had been more or less restored in June of 1882, his worries were far from over. The money Theo sent had enabled him to pay for his rent, so the immediate danger of being kicked out of the house had been diverted; moreover, Vincent had welcomed his proposal to pay the allowance in three installments of fifty francs from now on, but as far as Sien was concerned there was no question of Theo's agreeing with everything Vincent had written. Once more he had declared himself radically opposed to Vincent's plan of marrying her, and Vincent's response shows how drastically Theo had expressed himself: "I am glad you told me frankly what your thoughts were about Sien, namely that she intrigues, and that I let myself be fooled by her" (letter 204). Vincent argued, of course, that this was not true, but was a little more flexible about the marriage, carefully explaining the reasons for the slight change in his attitude. "Now you understand quite well that, provided I remained faithful to her, I should not care much for the formality of marriage if the family didn't. But I know for sure that Father attaches great importance to it; and though he will not approve of my marrying her, he would think it even worse if I lived with her without being married."

He responded at great length to another important passage from Theo's letter. Theo had warned him that the family might take steps to put him under guardianship, as they certainly considered his actions irresponsible. Vincent firmly denied the possibility of such a measure. "What you seem to be afraid of, namely the possibility that the family might put me under guardianship—this is what I want to say to all that. When you say, *'Only a few witnesses (and even false ones) would have to declare that you are unable to manage you own financial affairs*; this would be sufficient to entitle Father to take away your civil rights and put you under guardianship'—if, I say, you really mean this, and think that nowadays this might be an easy thing to do, I take the liberty to doubt it (letter 204)." He said that he knew the law about guardianship, and mentioned a few cases in which "even the lawyers" had failed to put persons under guardianship against their will. He did not feel quite at ease, though, and said he hoped that Theo would warn him if he noticed the family planning to do something of the kind. "If you ask me, I do not think the family would do a thing like that, but you may counter that in the case of Gheel, they already tried. Alas, yes—Father is capable of it—but I tell you, if he dares to attempt anything of the sort, I shall fight him to the limit. Let him think twice before he attacks me, but once again I doubt whether they will have the courage to do it."

The expression "in the case of Gheel" requires some explanation. It refers to a very sad affair that has almost been obliterated from the letters and other documents, so that it is no longer possible to reconstruct exactly what happened. A few casual remarks in some of the letters that have been preserved make it impossible to doubt the main fact: at one time, the Reverend Van Gogh had planned to place his eldest son "at Gheel," which means that he considered Vincent insane, or at least feeble-minded. Gheel is a village in Belgium, some thirty-

30
Sien with her baby, drawing by Vincent from 1882. Pencil, sepia, washed, China ink, JH 216, F 1062, 43.5 x 27 cm. National Museum Kröller-Müller, Otterlo, The Netherlands

five kilometers east of Antwerp, which traditionally housed (and still houses) a great number of the insane.

In a letter of November 1881, as well as in two others of May 1882 (letters 193 and 198), Vincent reminded Theo that his father had wanted to put him in an asylum, but said that he had firmly resisted that plan.[52] The passage in the letter of 1881 is as follows: ". . . Father grew very angry, ordered me out of the room with a curse, at least it sounded exactly like one! Now this causes me much pain and sorrow, *but I can't believe*

[52] All three passages were omitted from the first edition of the letters and have not been restored in any of the later Dutch or translated editions. The memory of the attempt to have him declared insane haunted Vincent for many years. In 1888, he must have told the story to his friend Paul Gauguin when they were together in Arles. This is how Gauguin retold Vincent's story in his reminiscences: "One day, as a young pastor, without warning my family, I left for Belgium to preach the gospel in the factories, not how I had been taught it myself, but the way I had understood it. . . . My words taught wisdom, obedience to the laws of reason and conscience, and also the duties of a free man. It was seen as a rebellion against the Church. My father assembled the family council to have me locked up like a madman; thanks to my oldest brother, that good Theodore, they left me alone, but, of course, I had to leave the Protestant Church."

that a father is right who curses his son and (think of last year) wants to send him to a madhouse (something which I oppose with all my might), and calls the love of his son untimely and indelicate" (letter 158).

As Vincent speaks of "last year" here, it seems likely that it had happened in the spring of 1880, when Vincent, whose conduct in the Borinage was so objectionable to the family, saw reason to flee back to Cuesmes. Whether or not the danger was real is unknown; it may simply have been an attempt to induce Vincent to give up his marriage plans. In any case, it was not the only thing Vincent had to worry about, because totally unexpected problems arose.

On 8 or 9 June 1882 Vincent wrote Theo a letter from the Municipal Hospital at Brouwersgracht in The Hague, which began: "If you come here toward the end of June, you will find me at work again, I hope; for the time being I am in the hospital, where I shall stay only a fortnight, however. For three weeks I have been suffering from insomnia and low fever, and passing water was painful. And now it seems that I really have what they call the 'clap,' but only a mild case" (letter 206).

Vincent is hospitalized for three weeks, June 1882.

The three letters that Vincent wrote to Theo in the course of the three weeks he stayed in the hospital sound quite cheerful, though he described the treatment as being very painful. Even here his optimism did not fail him. One of the reasons why he saw some good in his forced rest was pathetic: "I am the less sorry to be lying quietly here for a few days, seeing that in case I should need to, I should be able to get an official statement from the doctor here to the effect that I am not the person to be sent to Gheel or to be put under guardianship" (letter 206).

A more positive side of his stay in the hospital was that there was so much to see—that is if one had Vincent's peculiar painter's eye. To him, the doctor looked "like some heads by Rembrandt, a splendid forehead and a very sympathetic expression" (letter 208). And among the patients in his ward there were some very characteristic types, too. "There is one old man who would have been a superb St. Jerome—a thin, long, sinewy, brown wrinkled body with such very distinct and expressive joints that it makes one melancholy not to be able to have him for a model."

When he received a letter from his parents he explained it as a sign of improvement in their feelings toward him, though he realized that he should not be overly optimistic, as they were not yet aware of his liaison with Sien. "Few things have given me so much pleasure recently as hearing things from home which to a certain extent set my mind at ease about their feelings toward me. Sien came to tell me that a parcel had been delivered to the studio, and I told her to go and open it and see what was in it, and in case there was a letter, to bring it with her; so I learned that they had sent a whole package of things, underwear and outer clothing and cigars, and there were also ten guilders enclosed in the letter" (letter 207). In his next letter he reported another unexpected event that occurred while he was in the hospital: "I still have to tell you that Father came to visit me during my first days here, though it was only a short and very hurried visit, and I was not able to speak about anything that mattered. I would have preferred his visiting me another time, when on both sides we could have enjoyed it more. This way it was very strange to me, and seemed more or

133

less like a dream, as does this whole business of lying here ill" (letter 208).

In an unpublished letter to Theo of 14 June 1882, Father Van Gogh himself gave a more detailed account of the visit: "Vincent was somewhat surprised to see me, he was a little irritated, but I succeeded in bringing him back to a more normal mood, and promised to come back the next day. He does not look bad, his pulse is calm, and he is quite normal. He nursed grievances against Uncle Cor because he has not been very enthusiastic about his drawings. Van Rappard, who had seen them, had called them good. This Van Rappard remains faithful to him; he has written Vincent again to encourage him."

Father Van Gogh's suspicions were aroused when he realized that Vincent had heard from his model about the parcel they had sent, and he asked Theo, "I hope that there could not be any danger in that so-called model, could there?" Continuing with this subject, Theo's father wrote, "He always remains strange, and my expectations are not great; if only he does not go down more and more, and if only he does not throw himself away on an unworthy creature. . . . Don't say I am too suspicious; I say these things to no one but you, and you will understand only too well what I fear. He has always had a penchant for people of lower classes, and out of sheer cursedness and a feeling of loneliness a man might get entangled in the wrong sort of ties."

When, months later, Vincent finally told his parents about the nature of his relationship with his model, he described his father's reaction to his friend Anthon van Rappard. "I must add that, when my father heard of all these happenings, he was far from pleased—as you may well understand—or rather, not having expected such a thing of me, he did not know what to make of it. But after a while we saw each other again, which had not happened since I came here, as I left home after a lot of trouble. And he changed his original position when he knew more about it. . . . And then, even though I was still living with her, my father came to see me once [at the end of September 1882]" (letter R 20).

Although Vincent was glad to see his father in his own house, the visit had not been pleasant in every respect. In June of 1883 he told Theo: "When Father was here, he spoke disapprovingly of my being with the woman, and I told him I did not refuse to marry her. Then he evaded the point, and started talking in generalities. He did not want to tell me directly that I ought to desert her, but he did regret that I had relations with her" (letter 288). During the fall of 1882, however, his parents seem to have more or less accepted the situation. It is to their credit that they even enclosed something for Sien in a package for Vincent. "Just imagine, this week to my great surprise I received a parcel from home with a winter coat, a warm pair of trousers, and a warm woman's coat," Vincent wrote in the beginning of October, and he had every reason to add, "It touched me very much."

During these weeks, Vincent's greatest worry must have been Sien's condition; he had been admitted to the hospital in The Hague at the exact moment that she had to go to the maternity clinic; she left for Leyden on 14 June (her confinement was expected around the middle of that month). The

Vincent's father pays a visit, September 1882.

following lines reveal much about their relationship at that time: "She came to visit me regularly until the last day she was here [in The Hague], and used to bring me some smoked beef and sugar or bread, things I have to do without now, which makes me feel very faint. But now I am so sorry that I in turn cannot go to Leyden to bring her some extra tidbits, for it is weak and tasteless food one gets there. It gives me such a strange feeling not to be able to do anything, and see the days pass by so idly" (letter 208).

On Saturday 1 July Vincent was allowed to return home on the condition that after a few days he would come back to the hospital for a checkup. On Sunday he visited Sien, and he was surprised to hear that the baby had been born just the night before. The same afternoon he wrote Theo, and the words he used leave no doubt about the depth of the emotion he felt on the occasion:

Sien's baby is born, 2 July 1882.

> I have been to Leyden, as I wrote you yesterday. Sien delivered last night; she had a very difficult time, but thank God, her life has been saved and that of a very nice little boy, too.
> Her mother and little girl and I went there together; you can imagine how anxious we were, not knowing what we should hear when we asked the nurse about her at the hospital. And how extremely glad we were when we heard: "Delivered last night . . . but you may not speak with her long." I shall never forget that "you may not speak with her long"; it meant "you can still speak with her," and it might have been, "you will never speak to her again." Theo, I was so happy when I saw her again.
> She was lying near a window overlooking a garden full of sunshine and green, and she was in a kind of exhausted doze; and then she looked up and saw us all. Oh, boy, she looked at us so, and was so happy to see us, and wasn't it good luck that we were there exactly twelve hours after it happened?—there is only one hour a week when visitors are allowed. And she brightened so much, and in a moment she was wide awake, and asked about everything.

Vincent explained that it had been a critical case; the doctors had been obliged to use forceps, but Sien forgot all her worries when she saw her visitors. She was even convinced that she and Vincent would soon be together again. In his characteristic manner he concluded this part of the letter with the words, "Only the gloomy shadow is threatening still—master Dürer knew it well enough when he placed Death behind the young couple, in that beautiful etching you know."

A New Phase

Sien's confinement prompted Vincent to reach a final decision regarding a new apartment. He had mentioned it to Theo several times, but had not received his unequivocal consent. The house in which he rented the second floor was in bad repair due to a large storm around 1 May 1882 which had caused extensive damage. At that time he had immediately reported to Theo what had happened. "It has been very stormy for three nights. Last Saturday night the window of my studio gave way (the house is very shaky); four large window panes broke and the frame was torn loose" (letter 195). When his

135

neighbor, the carpenter who often helped him with little jobs, said, "Why don't you go and live next door?" (letter 211), Vincent was understandably interested. Adjoining the block of two old houses in which he had his studio were a few new houses that had been built recently, and one of them seemed very appropriate. With the help of a little floor plan he drew in his letter, Vincent explained why he wanted the second floor of the house next door. "The studio is larger than mine, the light very good. There is an attic which is completely furnished with planks so that you don't see the tiles of the roof. It is very large and can be divided into as many rooms as you like (I have the partitions for it). The rent is 12.50 guilders a month for a strong, well-built house; it is cheap because it is 'only on the Schenkweg,' and the people whom the owner expected to get do not want to live there" (letter 195).

The new house—136 Schenkweg—is clearly depicted with the old one in the drawing of the site (JH 122). It was expected that Sien would be permitted to leave the maternity clinic two weeks after her confinement and would then come and live with Vincent, and so he wrote, "This persuaded me to take the new house, so that she may find a warm little nest when she returns after so much pain" (letter 211). As Vincent was not yet allowed to lift heavy things, the owner of the house lent him a few men from the carpenter's yard to carry his furniture over. The house was not quite finished when he rented it; it was "full of plaster" and had to be scrubbed, but Sien's mother was helping him.

When it was almost ready on 6 July, he wrote Theo with undisguised pride in a mood of great anticipation about the new situation. He expected Theo to be at peace with it if only he would now come and see for himself. He characterized his apartment as "a studio, rooted in real life, a studio with a cradle and a baby's chair." If anyone should come and tell him that he was a poor financier (he was still thinking of the threat of guardianship, it seems), he would now be able to point to his established household.

The new house at 136 Schenkweg—". . . a studio, rooted in real life, a studio with a cradle and a baby's chair."

> This winter we had the woman's pregnancy, my expenses for getting settled; now the woman has been confined, I have been ill for four weeks and am not yet well. Notwithstanding all this, the house is neat and bright and clean and well kept, and I have most of my furniture, beds and painting materials. It has cost what it has cost—indeed, I shall not minimize it—but then your money has not been thrown away. It is the start of a new studio which cannot do without your help even now, but which is going to produce more and more drawings, and which is full of furniture and working materials that are necessary and retain their value (letter 212).

When he was alone in the silence of the room, sitting near the iron cradle which he had carried home on his shoulders from the second hand shop, he emotionally described his new surroundings.

> The studio looks so real, I think—plain grayish-brown wallpaper, a scrubbed wooden floor, white muslin curtains at the windows, everything clean. And, of course, studies on the wall, an easel on both sides, and a wooden working table. . . . Then the little living room with a table, a few kitchen chairs, an oil stove, a large wicker chair

for the woman in the corner, near the window that overlooks the wharf and the meadows, which you know from the drawing. And beside it a small iron cradle with a green cover.

I cannot look at this last piece of furniture without emotion, f or it is a strong and powerful emotion which grips a man when he sits beside the woman he loves with a baby in a cradle near them. And though it was only a hospital where she was lying and where I sat near her, it is always the eternal poetry of the Christmas night with the baby in the stable—as the old Dutch painters saw it, and Millet and Breton—a light in the darkness, a shine in the dark night. So I hung the great etching by Rembrandt over it, the two women by the cradle, one of whom is reading from the Bible by the light of a candle, while great shadows cast a deep chiaroscuro all over the room (letter 213).

Though this passage may seem overly sentimental, it can easily be explained by Vincent's longing for life with a family. He expressed his melancholy feelings in the same letter. "I know how only a short time ago I came home to a house that was not a real home with all the emotions connected with it now, where two great voids stared at me night and day. There was no wife, there was no child. I do not think there were fewer cares for all that, but certainly there was less love. And those two voids accompanied me, one on either side, in the street and at work, everywhere and always. There was no wife, there was no child" (letter 213). Now that Sien and her two children filled those voids, Vincent did the utmost to make it clear to Theo what he felt for her. "I have a feeling of being at home when I am with her, as though with her I have 'my own hearth,' a feeling that our lives are interwoven. It is a heartfelt, deep feeling, serious and not without the dark shadow of her gloomy past and mine, a shadow which I have already written you about—as if something evil were threatening us which we would have to struggle against continuously all our lives. At the same time, however, I feel a great calm and brightness and cheerfulness at the thought of her and the straight path lying before me" (letter 212).

There can be no doubt that this new phase in Vincent's life, the possibility of being together with a woman and children in a better, more comfortable house, had a strong and positive influence upon his development as an artist. Even in his letters the satisfaction about a new existence, devoted to observation and expression, makes itself clearly heard. In an evocative piece of prose from July he wrote:

Just picture me sitting at my attic window as early as four in the morning, busily studying the meadows and the carpenter's yard with my perspective frame when they are lighting the fires inside to make coffee and the first workman comes sauntering into the yard. Over the red tile roofs a flock of white pigeons comes cruising along between the black smoking chimneys. But behind it all, a wide stretch of soft, tender green, miles and miles of flat meadow; and over it a gray sky, as calm, as peaceful as Corot or Van Goyen.

That view over the ridges of the roofs where the grass has taken root, very early in the morning, and those first signs of life and awakening, the small figure far below sauntering along, that then is the subject of my watercolor. I hope you will like it (letter 219).

32
Sien's two children, drawing by Vincent from 1883. Black chalk, pencil, heightened with white, JH 336, F 1024, 48 x 32 cm. Vincent van Gogh Foundation / National Museum Vincent van Gogh, Amsterdam

The watercolor that fits this description is a fascinating drawing, daring in its surprising composition of an enormous pink tiled roof, seen in close-up against the soft green meadows. The resulting perspective seems exaggerated, but is very effective. Fortunately, the drawing (JH 156) which for a long time belonged to a private owner, is now in a public collection, the Musée d'Orsay in Paris. The sketch that Vincent sent to Theo (reproduced with letter 220 in the Dutch edition of the letters) gives one a good idea of the composition, though not of the vigorous color contrasts.

During July of 1882, Vincent was able to devote himself completely to drawing again. He lost much time due to his illness, and so he said, "Well or not, I shall start drawing again, regularly from morning until night." What he wanted to achieve was "confoundedly difficult," yet his program could be expressed in a few words: "I want to do drawings that *touch* some people." He mentioned his drawing *Sorrow* as "a small beginning," but the other examples he mentioned—landscapes such as *Carpenter's Yard and Laundry* (JH 150 or 153) and the *Fish-Drying Barn* (JH 154, one of the drawings made for Uncle Cor)—prove that he was not thinking only of drawings with a sentimental *subject*. Elaborating on his thoughts, he arrived at a declaration that gives a surprising insight into his innermost feelings. His words do not betray any self-pity, but they do reveal that he knew himself well. "I want to progress so far that people will say of my work, 'He feels deeply, he feels tenderly'—notwithstanding my so-called roughness, perhaps even because of it. It seems pretentious to talk this way now, but this is the reason why I want to push on with all my strength. What am I in most people's eyes? A nonentity, or an eccentric and disagreeable man—somebody who has no position in society and never will have; in short, the lowest of the low. Very well, even if this were true, then I should want my work to show what is in the heart of such an eccentric, of such a nobody" (letter 218).

One of the people who considered Vincent an eccentric and who had no idea of what was in the heart of such a "nobody," was H. G. Tersteeg; it was, in fact, an unpleasant experience with Tersteeg that had made Vincent write as he did in this letter, and it was this incident that had convinced him to devote himself entirely to drawing. One morning Tersteeg had dropped in at Vincent's, had seen Sien and the children, and had, in their presence, verbally attacked Vincent in the roughest possible way, asking him how he could think of living with a woman, and children besides (letter 216). For the woman's sake, Vincent had restrained himself, but the event prompted him to talk it over with Theo, and again explain his relationship with Sien. To the family, he said, the civil marriage was probably the most important question, but to him it was subordinate to the essence of the matter, the love and faith between them. And so he could now meet Theo, who had always been against the marriage, halfway. "I am ready to propose to you letting the whole question of civil marriage rest for an indefinite time and, for instance, postponing it until I earn 150 francs a month by selling my work, at which time your help will no longer be necessary. With you, but only with you, I will thus agree that for the time being I shall not enter

"I want to do drawings that touch *some people."*

138

into a civil marriage, not until my drawing has progressed so far that I am independent" (letter 217).

With or without marriage in mind, Vincent's feelings for Sien remained the same. Since he had gone to Leyden to bring her home from the maternity clinic, he had written a number of letters to Theo in rapid succession, all filled with particulars about her treatment in the hospital, her state of health, her talks with the professor who treated her and appeared to be well-disposed toward her, etc. One such detail, which gives some information about Sien's way of life, must be quoted here: "I was greatly amused by what Sien told about her conversations with the professor; it was really funny. He seems to be very jovial with his patients; for instance, he said, 'By the way, do you like to drink a gin and bitters, and can you smoke cigars?' 'Yes,' she answered. 'I only asked,' he said, 'to tell you that you need not give them up.' But on the other hand, he vehemently forbade her to use vinegar, mustard and pepper. On days when, as often happens, she is more thirsty than hungry, she must take a gin and bitters as a medicine, to give her an appetite" (letter 215).

It is a curious and sad fact that these few sentences, scribbled down by Vincent without any malice or disapproval, have caused many biographers of Van Gogh to represent Sien as an alcoholic; apart from this passage there is not a single bit of information in the letters or other documents about her that could refer to her drinking habits. Following the example of the doctors Victor Doiteau and Edgar Leroy in their book *La folie de Van Gogh* (1928), Michel Florisoone, in his book *Van Gogh* (1937), called her "une ignoble ivrognesse" (a vile woman, addicted to alcohol); many subsequent authors have used similar terms to describe her.

Some authors have also suggested that she was the prostitute with whom Vincent had an encounter in the beginning of December 1881, after his unpleasant visit to the Strickers'. It is true that his description of the woman, put in very general terms, could have referred to Sien, at least in part: a working woman, "no longer young, perhaps as old as Kee, and she had a child, yes, and she knew what life was" (letter 164). What speaks against the assumption that the two women were one and the same is Vincent's outright declaration that he had met Sien at the end of January 1882, not around 1 December 1881: "Then toward the end of January, after I had been let down by Mauve and had been ill for a few days, I met Christien" (letter 193). Furthermore, Vincent's encounter with the prostitute in December most probably took place in Amsterdam, not in The Hague.

This issue is only relevant because the possibility has often been suggested that Vincent was the father of Sien's baby. It is obvious that a baby born on 2 July 1882 could not have been his if he did not meet the mother until the end of January. That is why the statement from letter 193 has been doubted by some authors or even called a lie. Probably the worst is that this opinion is also shared by the editor of the magnificent French edition of the letters, *Correspondance complète de Vincent van Gogh* (1960). The editor who was responsible for the short introductions to each period, Georges Charensol, said about Vincent's move to The Hague, "But there was another reason for it which he does not reveal, namely that during his first

Suppositions about Sien.

139

stay in The Hague he had met there a woman, pregnant, drunk, and whom he admits was neither pretty, nor sweet, nor young."[53] Some authors have gone still farther. A journalist, Ken Wilkie, published a book in which he states as fact that Vincent was the father of Sien's baby.[54] This, Wilkie argues, is something Sien herself had told the child, when he was a little older and she herself had meanwhile married a man named Van Wijk. In his turn, Willem van Wijk, as Sien's son was then called, was supposed to have revealed this in his old age to the Dutch author Ed Hoornik and his wife.

It can be said with absolute certainty that Wilkie's premise is wrong. To doubt Vincent's statement that he had met Sien only late in January would mean to deny completely his honesty and frankness; it would also mean that he spoke in an extremely unsympathetic and hypocritical way when he described Sien as "a pregnant woman, deserted by the man whose child she carried" (letter 192). However, there is proof of a more objective nature that Willem van Wijk was not Vincent van Gogh's child. Even if one accepts for a moment that Vincent met Sien around 1 December 1881, and that the child had been conceived at that time, the child would have been two months premature at its birth in July. In reality, the child that Sien gave birth to on 2 July 1882 was a mature baby weighing roughly seven and a half pounds.[55] Given all this, Vincent could not possibly have been the father.

[53] "Mais il est une autre raison qu'il ne révèle pas, c'est qu'il a connu, lors d'un premier séjour à La Haye, une femme, enceinte, ivre et dont il convient lui-même qu'elle n'a ni beauté, ni douceur, ni jeunesse" (vol. 1), p. 293.

[54] Het Dossier Van Gogh (1978); title of the English edition: The Van Gogh Assignment (1978).

[55] This information was received from the Academic Hospital in Leyden. A photocopy of the pages from a register contains an extensive report about the delivery of Christina Hoornik, as she is called there, on 2 July 1882. More details appear in my article in Nieuwe Rotterdamse Courant/Handelsblad of 7 July 1978.

33

In letter 222 from August, 1882, Vincent showed Theo how he could use his perspective frame even on uneven ground. "Sand, sea, and sky," he said, was what they had seen together in Scheveningen.

Vincent's optimism often seemed boundless; sometimes fate happened to be favorably disposed toward him—mostly in little things, for which he always appeared extremely grateful. In March 1882 fate turned his way. *"Theo, it is almost miraculous!!! . . .* C. M. van Gogh asks me to make twelve small pen drawings for him, views of The Hague, apropos of some that were ready. (The Paddemoes, the Geest, and the Vleersteeg were finished)[56] At 2.50 guilders a piece, price fixed by me, with the promise that if they suit him, he will take twelve more at his own price, which will be higher than mine. [And] I just met Mauve, happily delivered of his large picture, and he promised to come and see me soon. So, 'It's all right, we are on the way, we'll keep going!' "[57]

[56] The Paddemoes, the Geest and the Vleersteeg were streets in the oldest part of The Hague.
[57] *"Ca va, ça marche, ça ira encore!"*

In reaction to Uncle Cor's commission, Vincent produced a significant amount of work during the early and difficult months of his stay in The Hague. That he received the commission is a clear indication that his drawings had already reached an respectable level of proficiency, for otherwise the shrewd art dealer would certainly not have ordered the drawings, even for very little money. The pen drawing of the Paddemoes (a setting near the New Church in The Hague), which led to the commission, is indeed a well-represented characteristic view of the town, done with a firm hand showing neither traces of the naïveté of the drawings from Brussels nor the stiffness of most of those from Etten. Vincent said that he had once sketched it "at twelve o'clock at night while strolling around with Breitner" and had worked on it with his pen the next morning. *The Paddemoes* concludes a series of drawings he made in the months of January, February and March of 1882. A few were landscapes, such as the charming watercolor view of the Schenkweg and a painting of the meadows (JH 99). Most were figure studies, such as the old woman at the window (the drawing he had sold for ten guilders to Tersteeg), and drawings of Sien and her young daughter. This child was probably also the model he used for two splendid pencil drawings of a knitting girl (JH 107 and 108).

34
A sketch from letter 231, September, 1882.

On 24 March, no more than two weeks after Uncle Cor's visit, Vincent wrote that he had finished and dispatched the twelve small town-views that were expected from him. It seems that Uncle Cor was not dissatisfied with them, for when he paid for them—thirty guilders for the twelve drawings—he ordered Vincent to make six more.

This first group of drawings does not belong to the most successful part of his early production in The Hague. However, *The Paddemoes* (JH 111) is certainly not surpassed in its intimacy and atmosphere by any of the other eleven; a landscape, the Schenkweg with the canal and the meadows (JH 116), stands out by the rendering of perspective and space; and a street scene (JH 126) clearly shows that Vincent had made much progress in a very short time in drawing groups of figures as well as the buildings in the background. Several of the others, however, are rather "dry" sketches, atypical of Vincent's talent as a realistic draftsman in his Dutch years.

To do him justice, it must be added that he succeeded far better in his second series for his uncle. This series took him quite a long time and caused many worries because he had to work on it during the emotional weeks of April and May, during which time he was dealing with Theo over his situation with Sien and problems with Mauve. There were several moments when he considered giving up altogether (letter 188). He had started the series immediately, in spite of the cold and windy weather, but he had to write on 14 May that work was difficult because he was so depressed by the change in Mauve's attitude (letter 189). He wrote in even more concrete terms in his second letter of 14 May; here it becomes clear how heartlessly Mauve had hit him in a spot where he was most vulnerable. "Mauve said to me, 'That uncle of yours only gave this order because he was at your studio once; but you must understand that it doesn't mean anything; it will be the first and last, and then nobody will take an interest in you.' You must know, Theo, *that I cannot stand such things*; if such

142

things are said to me—my hand drops as if paralyzed" (letter 193).

Yet after receiving an encouraging letter from Theo, Vincent finished the drawings, and at the end of May he sent off a series of seven. The reception to them was not exactly friendly. "I have had news from C. M. in the form of a postal order for twenty guilders but without one written word. So I do not know as yet whether he will give me a new order, or whether the drawings are to his liking" (letter 205). Considering the price he paid for the series—there were two large drawings and four medium-sized ones—he assumed that Uncle C. M. was not in a good mood when he received them, or else that they did not please him. The latter appears to be the case, for a few days later he received an answer, but one "with a scolding in the bargain," as he wrote in a letter to Van Rappard, "did I happen to think that such drawings had the slightest commercial value?" (letter R 9).

Looking at them today, it is clear that they belong to the best drawings Vincent made in his Dutch period. The drawings of the nursery at the Schenkweg—especially the smaller one (JH 125)—and those of the house and back garden of Sien's mother (JH 146 and 147) are much more interesting than any of the first series, and there is at least one that is simply a masterpiece: the drawing of the carpenter's yard and laundry, seen from Vincent's back window (JH 150). It is almost unbelievable that hardly a year after he began his career as an artist by drawing from nature in Etten, Vincent could have produced such highly sophisticated work, perfect in all details of the complicated composition.

35
Carpenter's Yard and Laundry, *the view from Vincent's window. Drawing from June, 1882. Pencil, pen, brush, heightened with white, JH 150, F 939, 28.5 x 47 cm. National Museum Kröller-Müller, Otterlo, The Netherlands*

Of the other drawings done in these months, there are some quite successful figures of women, for which Sien's mother was the model (JH 140), or Sien herself (JH 143, 144, 145). It must have been these large drawings that Vincent had in mind when, writing about all his problems, he said that he could only feel happy when he was working with his models trying "to suggest the body with its undulating lines under the folds of a black dress."

Still more impressive than these "objective" studies is the large drawing representing Sien sitting by the stove (JH 141). This drawing, showing Sien in the intimacy of the "studio,"

sitting on the ground in her underclothes or nightgown, is a far more personal work—materially and psychologically a complete portrait, a splendid complement to the descriptions of Sien in his letters. The carefully drawn angular profile, the worried expression with which she is staring at the stove, the easy attitude of a woman who feels at home in this corner of a bare room, the barely stressed detail of the cigar she holds between her fingers, all result in a penetrating image of the beloved, but problematic, partner with whom Vincent shared his life in these years.

The most important and most famous drawing of these months—and of Vincent's Hague years in general—is a drawing for which Sien posed nude (JH 129). He drew her in profile again, but in a bent position, hiding her face in her arms, which rest on her knees. It is obvious that the woman is pregnant, and her whole attitude expresses melancholy or even despair, something which Vincent underlined by annotating the drawing with the word *Sorrow*. His mastery in creating in a few simple lines this imposing image of a woman's tragedy is amazing considering that it was done in the very beginning of his career as an artist. Vincent must have been aware of the fact that he had produced something exceptional, and at once sent the drawing to Theo, saying that in his opinion it was the best figure he had drawn so far. Significantly, it was the first example of the work done in The Hague that Theo was permitted to see, except for a few small sketches in letters. "Today I mailed you a drawing which I send to show my gratitude for all you have done for me during what would otherwise have been a hard winter. Last summer when you brought with you Millet's large woodcut *The Shepherdess*, I thought, 'How much can be done with one single line.' Of course I don't pretend to be able to express as much as Millet in a single contour. But in any case I tried to put some sentiment into this figure. I only hope this drawing will please you" (letter 186).

Vincent also made different versions of the subject, as he explained in the same letter: "This is not the study from the model, and yet it is done directly after the model. You should know that I had two underlayers beneath my paper. I worked hard to get the right contour; when I took the drawing from the board, it had been imprinted quite correctly on the two underlayers, and I finished this one immediately according to the first study. So this one is even fresher than the first. I am keeping the other two for myself; I wouldn't like to part with them."

So it was this "finished" drawing he sent to Theo. He decorated the ground on which the woman sat with snowdrops, lilies of the valley and other little flowers, and indicated a landscape behind the figure; at the extreme left added a small, wintry looking tree, with a few flowers and buds. Was it his way of saying that, in spite of all the worries, the budding new life would bring some hope? At the bottom of this copy of the drawing he had placed not only the word *Sorrow*, but also a motto, a quotation from Michelet, which forcefully expressed his feelings of pity for Sien: "How could there be [even] one lonely, abandoned woman in the world?"[58] Apologizing for his

Vincent's famous drawing of Sien, titled Sorrow.

58 *"Comment se fait-il qu'il y ait sur la terre une femme seule—délaissée."*

unusual outburst of sentiment, he wrote, using another quote from the much-admired Michelet: "Of course I don't always draw this way, but I am very fond of the English drawings done in this style, so no wonder I tried it just this once; and as it was for you, and you understand these things, I didn't hesitate to be rather melancholy. I wanted to say something like 'But there remains the void in the heart that nothing will fill,'[59] as in Michelet's book."

36
A view from Vincent's attic window; sketch from letter 220, July 1882.

It may be that Vincent was inspired by English drawings as he was by Millet's *la Bergère*; yet there can be no doubt that Bargue's *Exercices au fusain*, which he had copied so often, also influenced the style of *Sorrow*. Just like the original copy of Vincent's drawing (not the "decorated" one), Bargue's *Exercices* show figures in simple contours on a white background. Involuntarily Vincent confirmed this assumption when he wrote, a short time before sending Theo the drawing: "I haven't many studies after the nude yet, but there are some which greatly resemble the Bargues; are they less original for that? Perhaps it is more because I have learned to understand nature from the Bargues" (letter 185). Finally, there is still a third version of *Sorrow*.

In November he did lithographs after some of his studies; *Sorrow* was one of them, and of that lithograph three copies have been preserved (two are in the Rijksmuseum Vincent van Gogh in Amsterdam, and one is in the Museum of Modern Art in New York).

Some months later, after settling into the new apartment at 136 Schenkweg, Vincent entered a long, relatively carefree working period. August started with a short visit from Theo, something Vincent had eagerly awaited. He thanked Theo profusely in a letter written immediately after he had left. "I

59 *"Mais reste le vide du coeur que rien ne remplira."*

145

am so grateful you have been here; I think it a delightful prospect to be able to work a whole year without anxiety, and a new horizon has been opened to me in painting through what you gave me. I think I am privileged over thousands of others because you removed so many barriers for me" (letter 222).

It is clear that Theo had somehow reconciled himself completely with Vincent's situation, even if the letter does not reveal how Theo had reacted to meeting Sien and her children; on the contrary, in Vincent's letters of the next half year not a word is to be found about her, which seems to suggest that an agreement about this subject had been made at Theo's request. A more concrete gesture was that he had given Vincent a considerable sum of money, enabling him to work on in a somewhat less restricted manner. In his letter Vincent mentioned several useful things he had immediately started to purchase: a large watercolor box, new brushes, and a number of tubes of oil paints; he had also ordered the blacksmith to make a new and better perspective frame.[60] The new purchases and Theo's promise of continuing help caused Vincent to begin painting again, something he had not done in half a year. He threw himself into his work with his usual energy, and he was able to write after a little more than a week that he had already finished seven painted studies. "I simply couldn't restrain myself or keep my hands off it or allow myself any rest" (letter 225).

The studies were only early attempts, but he was not dissatisfied with them. "To tell you the truth, it surprises me a little. I had expected the first things to be a failure, though I supposed they would improve later on; but though I say so myself, they are not bad at all" (letter 225). After this he continued painting for some time with great enthusiasm. He made some studies in the woods, one of Scheveningen women repairing nets in the dunes with a few small boats while he was at the beach in stormy weather. Another was of a girl in white standing near a large tree (JH 182). This canvas is undoubtedly the best of the series. Vincent had been successful here in suggesting light and space, or, to use his own words, "to make it so that one can breathe and walk around in it, and smell the wood" (letter 227). Yet he must have painfully felt that he was a much better draftsman than an oil painter, and he probably resolved to improve his drawing talent a year longer before going on with painting. In his letters he repeatedly complained about the high cost of using oils, but it is difficult to believe that this was his only reason for giving up painting. It is significant that after the series of studies he made in the first month following Theo's visit, there is not a single mention of work in oils in the letters until July of the next year.

60 The perspective frame, already in use in Dürer's time, consisted of a rectangular frame, divided by wires in triangular partitions, making it easier to compare the proportions of the objects seen through it in perspective. Vincent had used it in his drawings of the carpenter's yard and of the meadows.

146

Concentrating on People

In September he made several good watercolors, including *Bench with Four Persons* (JH 197), and *The State Lottery Office* (JH 222). Although he occasionally worked in watercolor in the following months, his main activity in the autumn and winter of 1882 was drawing in black and white. One of the reasons was that Sien had gradually become strong enough to resume posing. In this period he did a series of drawings in which she is the model, either alone (as in the marvelous profile study, JH 291), or with the baby (as in JH 216 and 221). Vincent made splendid large drawings of her young daughter (JH 299-301). These are moving evocations of a poor man's child, and can be considered the most outstanding drawings of Vincent's Dutch period. The sensitive drawing of the same little girl, kneeling by the cradle with the baby, done a few months later (JH 336), is equally impressive.

The most numerous and most characteristic group of drawings were done when Vincent began to use models from one of the local almshouses, belonging to the parish of the Reformed Church. Once he had established this contact in September, he made at least fifty or sixty drawings during the next five or six months. Vincent called these subjects "very expressively *orphan men* and *orphan women*" (letter 235). One of these "orphan men," who, according to Vincent, had "a very nice bald head, large (*nota bene* deaf) ears and white whiskers," became his most beloved model. This curious old fellow appears in most drawings from these months, usually wearing a long overcoat and top hat, although occasionally he sports a little black cap, and in several drawings he wears a decoration, indicating that he had participated in the military operations against the Belgians in 1830.[61] He depicts this man and other models from the almshouse in all kinds of poses: standing with walking sticks, sitting with cups of coffee, sitting on chairs with their heads in their hands, reading, etc. The drawings are done in black chalk or pencil, mostly with sharp contours and forceful hatchings, and usually without any indication of a background. The jauntiness of some of the figures gives them a touch of humor, but they never become caricatures; on the contrary, most of the drawings betray respect for the dignity of these poor old people, and even a deep insight into the reality of old age.

Apart from these figure studies, there is a smaller group of drawings from the same period that includes only heads or busts. The models are the "orphan men," Sien and her mother. With these large heads, Vincent was following a tradition from the wood engravings he collected from English magazines, such as *The Graphic*. During Vincent's time, this magazine published a series of half-figures under the title "Heads of the People": a miner, a coastguardsman, a farmer, etc. Vincent was disappointed that *The Graphic* had announced they would soon publish a series, "Types of Beauty." He was provoked to write: "Look here, Theo boy, I cannot make 'Types of Beauty'; I do try my best to make 'Heads of the People.' You know, I would like

37
Orphan Man with Long Overcoat, Glass, and a Handkerchief, *drawing from 1882. Pencil, JH 244, F 959, 49 x 25 cm. National Museum Kröller-Müller, Otterlo, The Netherlands*

[61] Many interesting particulars about this "orphan man" and other matters concerning The Hague have been assembled by Dr. W. J. A. Visser in the yearbook of *"Die Haghe"* (1973), pp. 1-125.

to do the kind of work those who started the *Graphic* did, though I do not count myself their equal: I would take a fellow or woman or child from the street, and draw them in my studio" (letter 252). Or, as he said in his next letter, "I want to make types of the people for the people" (letter 253).

Even if he remained faithful to the realism he had recognized from the very beginning of his artistic path, he was not afraid to let sentiment enter his work. Just as he said months before that he wanted to make drawings that "touched" some people, he would now admit without any sense of shame that with some of his figures, however objectively rendered, he wanted to express a particular kind of feeling or sentiment (letter 218). Two excellent drawings, done shortly before Christmas 1882 (JH 278 and 281), may serve as an example: "I have two new drawings, one of a man reading his Bible, and the other of a man saying grace before his meal. Both are certainly done in what you may call an old-fashioned sentiment—they are figures like the little old man with his head in his hands. . . . My intention in these two, and in the first old man, is one and the same, namely to express the peculiar sentiment of Christmas and New Year's Eve" (letter 253).

Some attention should also be given to Vincent's collection of prints, which he valued greatly. In England he had decorated his room with prints by admired artists, and these prints accompanied him to Amsterdam and his subsequent dwelling places. His began collecting again when he discovered that he could find a good supply of prints in the bookstalls in The Hague, where there were plenty of old periodicals. He wrote Theo enthusiastically when "an exceptionally good buy" of wood engravings had come his way: "There are things among them that are superb, for instance, *The Houseless and Homeless* by Fildes (poor people waiting in front of an overnight shelter); and two large Herkomers, and many small ones; and *The Irish Emigrants* by Frank Holl; and *The Old Gate* by Walker; and especially *A Girls' School* by Frank Holl; and another large Herkomer, *The Invalids*. In short, that is just the stuff I need" (letter 169).

The titles of these works reflect Vincent's interest in prints with a narrative element, or even a social "message," and he was so strongly convinced of their importance that he even defended them against his admired teacher Anton Mauve, who, as one of the Hague School painters, was not particularly fond of art which depended on the quality of the subject. "It is a pity," Vincent told Van Rappard, "that the artists here know so little of their English colleagues. Mauve, for instance, was quite thrilled when he saw Millais' landscape *Chill October*, but for all that they don't believe in English art, and they look upon it in too superficial a manner, I think. Over and over again Mauve says, 'This is literary art' " (letter R 8).

Anthon van Rappard had a collection of wood engravings, and he and Vincent constantly exchanged double prints. In January 1883, Vincent's collection was extended enormously by his purchase of more than twenty volumes of *The Graphic* (the years 1870 to 1880). Naturally, this caused a series of enthusiastic letters to Van Rappard. Curiously, he did not write about it to Theo, at least in the beginning, perhaps because he was afraid that Theo would suspect him of being

Vincent was particularly interested in prints with a narrative element.

extravagant. Yet he had only paid one guilder per volume, something which in a way he thought a shame; it made him melancholy to realize that there were hardly any bidders for such marvelous books. The collection became so dear to him that he succeeded in preserving it from loss and destruction through all his travels in the following years.[62]

When in the beginning of November 1882 Theo had written Vincent about a type of paper which made it easier to transfer drawings to a lithographic stone, Vincent's interest was strongly aroused. He suddenly saw the possibility of realizing one of his ideals: making a number of copies of drawings "for the people," and distributing them inexpensively. For this reason, he immediately asked Theo for samples of the paper and for more information about the procedure, but even before he had an answer, he managed to make his first lithograph. He found that Smulders, a printer he knew, sold a similar kind of copying paper, and he could not resist the temptation to experiment with it.

The first lithograph was done after the drawing of the orphan man standing in his long coat with a walking stick (JH 256), and in the following three weeks he made five more prints, two with the orphan man, one each of a spitter and a sitting man, and one after the important drawing *Sorrow*. Not only did he think of the editors of magazines, to whom he could show copies of his lithographs if he should ever apply for a job, but he also had more far-reaching ideas: he was already dreaming of a coherent series of sheets with which something could be done commercially. He knew of a series of twenty-four lithographs which was being used in primary schools, but he found their quality "deplorable" (letter 242). When he made his fifth lithograph—the old man with his head in his hands (JH 268)—something became clear to him: the relatively low costs of this kind of graphic work made it especially suitable for "a popular publication, which is so very, very necessary, here in Holland even more than anywhere else" (letter 249). He wondered, however, whether he should drag Theo and others into an enterprise whose success was so doubtful: "the drawing and printing of a series of, for instance, thirty sheets of workmen types—a sower, a digger, a woodcutter, a plowman, a washerwoman, then also a child's cradle or a man from the almshouse—well, the whole immeasurable field lies open, there are plenty of beautiful subjects." The enterprise in itself seemed of great value to him. His lively imagination had already worked out a detailed program whose main points were that the prints, destined "for workmen's houses and for farms, in a word for every working man," should be made and distributed by a combination of artists, and that "the price of the prints must not be more than ten, at the most fifteen, cents."

Theo's reaction to these ideas is unknown, but he certainly did not encourage his brother to go ahead with the plan, and Vincent soon stopped writing about the subject. In his later letters Vincent often mentioned the idea of a cooperation between artists, but it never resulted in a concrete plan. In a way, however, his ideal, to distribute widely cheap prints of works of art, was realized after his death. Color reproductions

38
Girl with Shawl, Half-Figure, *drawing from 1883. Pencil, black lithographic chalk, JH 301, F 1008, 50.5 x 31 cm.*
Vincent van Gogh Foundation / National Museum Vincent van Gogh, Amsterdam

[62] It is now in the National Museum Vincent van Gogh in Amsterdam.

are now sold on a very large scale—reproductions of his own works being among the most numerous—and these can be found all over the world in all kinds of circles, including, as was Vincent's wish, "in workmen's houses and farms."

In spite of his social ideals and his longing for friendship, Vincent remained a lonely worker. His was not an easy character to deal with, and he often repelled his colleagues by the force of his convictions and his stubbornness. In addition, he called himself a laborer and wanted to be one; he felt more at ease among workmen and peasants than in "salons" or among artists. Moreover, in his opinion there was not a friendly atmosphere between the artists in The Hague. "Here in The Hague there are clever great men, I readily admit it; but in many respects what a miserable state of affairs—what intrigues, what quarrels, what jealousy. And in the personality of the successful artists who, with Mesdag at their head, set the tone, material grandeur is unmistakably substituted for moral grandeur" (letter 252).

The result was that he felt he had no other desire than to go on in the same way, "without mixing with anybody else." In the year that had just begun, 1883, he had indeed hardly any contact with other artists except the landscape painters H. J. van der Weele and Théophile de Bock, whom he met a few times. He had worked together with G. H. Breitner for a short time at the beginning of his stay in The Hague, but he did not hear from him after Breitner became a teacher at a secondary school in Rotterdam. He did maintain a lively correspondence with Anthon van Rappard, but as Van Rappard lived in Utrecht, traveled extensively and was ill for a long time, he rarely came to The Hague—only once in May 1882, once in May 1883, and again in August 1883. As a consequence, there was not much to distract Vincent from the task he had set for himself, which simply was "to try [his] very best at drawings."

He did not ask for recognition by other artists or art experts, but it was a joy for him to see that his work was appreciated by simple working people, which happened when he made his first lithographs in Smulder's printing office. Theo was immediately informed: "Smulder's workmen at the other store on the Laan saw the stone of the old man from the almshouse, and asked the printer if they could have a copy to hang on the wall. No result of my work could please me more than when ordinary working people hang such prints in their room or workshop" (letter 245).

During the first six months of 1883, Vincent's material circumstances improved. However, his development as an artist seemed to stay at a plateau; there was no sign of the same rapid development seen in the first months of 1882. He realized that he was involved in a long-lasting process and could count on some success only with the help of much perseverance and patience. At the end of October 1882, he had already written in his inimitable manner: "What is drawing? How does one learn it? It is working through an invisible iron wall that seems to stand between what one *feels* and what one *can do*. How is one to get through the wall—since pounding against it is of no use? One must undermine the wall and drill through it slowly and patiently, in my opinion. And, look here, how can one continue such work without being disturbed or

H. J. van der Weele, 1852-1930.

150

distracted from it—unless one reflects and regulates one's life according to principles" (letter 237).

In 1883, he went patiently on with what he saw as his main task: mastering the human figure—not "to pay homage to the form," but to instill "some sentiment and expression" (letter 253). He continued with the series of orphan men and large heads and made many more drawings of Sien, her mother, and the children. A few times he also tried to depict them as a small group in action. He was familiar with the places where poor people could get a bowl of soup for little money—he often must have been forced to get food there himself—and tried to imitate the atmosphere of such a "soup kitchen" in his studio. For that purpose he had the carpenter make shutters for the big windows, of which both the upper and lower halves could be opened or closed at will, allowing him to work in a sort of Rembrandt-like tempered light—technical questions about which he reported to Theo in a series of letters (letters 268-273).

On at least one occasion he attained an excellent result; it is the large drawing of Sien, her mother, her youngest sister, and the two children in front of the counter in the soup kitchen (JH 330). He never tried to draw surroundings other than the ones in which he felt at home, but these he rendered with undeniable talent. Again he was a true realist, fascinated by the beauty of the ordinary. This went so far that in June his enthusiasm was aroused by what he had seen at the *garbage dump*! Most of the drawings he did at that site have not been preserved, but he mentioned a few of the sketches in his letters, and twice described the "splendid" scene (letters 289 and 292). "It is somewhat like the scratch I made here; everything, even the women in the foreground and the white horses in the background, must stand out in chiaroscuro against the little bit of green, with a streak of sky above it. So that all those gloomy sheds, gliding away, one after the other, and all that dirt and

those gray figures are in contrast to something pure and fresh" (letter 289).

Few painters of his time would have found worthwhile the subjects that fascinated Vincent. "In the foreground, all kinds of broken and discarded objects, bits of old baskets, a rusty street lamp, broken pots, etc" (letter 289); a century later, artists were to call them *objets trouvés*. At least one of the drawings of the garbage dump survived, and it is an impressive one. It is the drawing of an old white horse (JH 368, recently acquired by the Vincent van Gogh Museum in Amsterdam). Here the sentiment was certainly much more important to Vincent than the technique. The misery of this emaciated animal is rendered with such intensity that expressionism rather than realism describes the style of the drawing.

It was near the end of his stay in The Hague that he again did some drawings and watercolors of landscapes. In July 1883 he wrote, "For a change, this week I have done a few watercolors outdoors, a little cornfield and a potato field, and I have also drawn a few landscapes as studies for the background of some figure drawings" (letter 299). One of the few landscapes that have survived is a scene with a potato field in the dunes. Two little figures are almost lost in the shadows of the field which opens toward the horizon with striking perspective (JH 390). It is a beautiful, somewhat impressionistic drawing, which suggests the direction of Vincent's future artistic development.

It is significant that during the second year of his stay in The Hague he also took up *painting* again. In July, the letters speak of his contacts with the landscape painters H. J. van der Weele, Théophile de Bock, and B. J. Blommers, whose studios he visited, and who came to see him in turn. Even Breitner, with whom all contact appeared to have been disrupted, had unexpectedly dropped in. All these encounters may have contributed to his decision to try oil painting again after a year's concentration on drawing. It was also encouraging that De Bock, after seeing several studies from the previous year, expressed his approval; Vincent himself said that his own paintings pleased him less and less, but that he now hoped to be able to make better ones (letter 300).

There are references in the letters to an increasing number of paintings done in the summer of 1883, such as "a view of the sea, a potato field, a field with net menders, a fellow planting cabbage"; and somewhat later "two small boats," and "a boy in a potato field," etc. Few of these paintings have survived. Twenty-five studies in oils are known from the entire Hague period, some only in reproduction, and less than half of this number date from 1883. That he had done even more studies than he mentioned in his letters to Theo is proven by a letter Vincent wrote after he left The Hague: "In The Hague I have left behind more than seventy painted studies" (letter 329).

Beginning to paint again.

152

40
Sien with Cigar Sitting on the Floor near a Stove, *drawing from 1882. Pencil, black chalk,*
pen, brush, sepia, heightened with white, JH 1882, F 898, 45.5 x 56 cm.
National Museum Kröller-Müller, Otterlo, The Netherlands

Although Vincent remained productive in 1883, darker and darker clouds accumulated above his head. The time that he could devote to his work without worry was much shorter than he had expected, and the 150 francs he received monthly from Theo was insufficient, especially during the periods when he was obliged to buy the more expensive materials necessary for painting. In June 1883 he asked Theo, whose business was rather slow, not to fall behind in sending money. "To me it means models, studio, bread; cutting it down would be something like choking or drowning me. I mean, I can do as little without it now as I can do without air" (letter 288). Three weeks later he wrote: "I do not know how to keep things going; the expenses increase beyond my power, though I economize on everything, and the woman, too" (letter 295).

When Theo sent an allowance a month later, he wrote, "I can give you little hope for the future" (letter 301), and for a moment it seemed that Vincent would succumb to the blow.

> The weeks went by—many, many weeks and months of late—when the expenses were repeatedly heavier than I could afford, notwithstanding all my worrying and economizing and however much I racked my brain. As soon as your money arrives, I must not only manage to live ten days on it, but I have so many things to pay for at once that from the start those ten days which are ahead are bound to mean starvation. And the woman has to nurse the baby, and the baby is strong and growing, and it often happens that she has no milk for it. . . . Well, I should not care, Theo, if I could only stick to the thought, It will come out right, we must go on. But now your saying, "I can give you little hope for the future," is like the straw that breaks the camel's back at last (letter 301).

He had hoped that of the last ten or twelve drawings a few could be sold, but nobody had shown any interest, neither Tersteeg nor Uncle Cor nor Theo, and so "this too had come to nothing" (letter 303). Pulling himself together, he concluded with a striking image, "Well, whatever may happen, I'll try to keep courage, and I hope that perhaps a certain frenzy and rage for work may carry me through, like a ship is sometimes thrown over a cliff or sandbank by a wave, and can make use of a storm to save herself from wrecking" (letter 303).[63]

The situation was worsened by other serious worries. Living with Sien had become more difficult. For many months Vincent had not mentioned her to Theo, but in a letter at the end of April 1883 there are a few words about "the difficulties [he] had with the woman" (letter 281). A short time later he wrote about it in more detail (letter 284). In Leyden, the professor who cared for Sien had told him that her complete recovery could take years, and therefore Vincent was most understanding of her irritability; but he knew that the great danger for her was what he euphemistically called "her falling back into former errors." It worried him "continually and seriously," and in spite his lenient character, which is obvious even from this letter, he could not refrain from writing, "At times her temper is such that it is almost unbearable even for me—violent, mischievous—I am sometimes in despair." When Theo showed that he was worried, Vincent more or less took it all back. "It has redressed once again, and I hope the time will come when things go much better still" (letter 286). He asked Theo not to speak about it with others, and added with his usual kindness, "In no case think ill of her—there are awfully good traits in her character which, with some luck, are worth fostering."

There was no such luck. Hardly two weeks later he had to admit that difficulties with Sien continued, and that he was seriously worried. This time he decided to tell Theo more.

> The family proposed that she, with her mother, should keep house for a brother of hers who divorced his wife and is rather an infamous scoundrel. The reason why the family advised her to leave me was

Vincent worries about Sien "falling back into former errors."

63 He sometimes used drawings to make payments. His landlord, the architect M. A. de Zwart, owned no less than eighteen drawings by Van Gogh, which had probably been used to pay for part of the rent or for the shutters that were installed in February 1883 (see Dr. J. G. van Gelder in *Vincent*, vol. I, nr. 4, pp. 18-27).

that I earned too little, and I was not good to her, and did it only for the posing, but would certainly leave her in the lurch. *Nota bene*, she has hardly been able to pose the whole year because of the baby. Well, you can judge for yourself just how far these suspicions of me have any foundations. But all these things were secretly discussed behind my back, and at last the woman told me. I said to her, "Do just as you like, but I shall never leave you unless you turn back to your former life" (letter 288).

The tragic side was that one problem led to the other. If Vincent had not been so poor, it would not have been so easy for her brother to convince Sien that prostitution would be more advantageous than living with Vincent. Under these circumstances it is understandable that he sometimes thought of moving to the country, not only because life there seemed to be cheaper, but because it was a means of removing Sien from the influence of her family (letter 297). Moving would involve numerous expenses, however, and he would not do it before first marrying her. He sometimes thought vaguely of London as a possibility, as he might find a position there as an illustrator at one of the magazines (letter 297). On 22 July, however, after receiving Theo's message that he could not give him much hope for the future, Vincent spoke only about staying in a small village where the rent would be lower and there would be better food for Sien and the children (letters 301, 302). He felt responsible for the children, those "poor creatures," and Sien had "been doing well recently," or so he made himself believe (letter 302). He thought he knew her well enough, and his own good-heartedness made it possible for him, even now, to assure Theo "how pure she [was], notwithstanding her depravity. As if, deep in the ruin of her soul and heart and mind, something had been saved" (letter 314).

Vincent's plans really began to take shape after Van Rappard visited him. After hearing of the area from Van Rappard, Vincent felt that the province of Drenthe in the northeast of the Netherlands, where Van Rappard had been working for some time, seemed the best spot to take refuge both because of the low prices and the fascinating landscape there. Van der Weele, whom he visited the next day, encouraged him to go there, too (letter 319). However, he now was not as certain that Sien would come along, for despite her promise to avoid seeing her mother, she had again consulted with her. "I told her that if she could not keep such a promise for even three days, how could she expect me to think her capable of keeping a promise of faith forever" (letter 317). He realized that the decision was no longer his alone. "Whether the woman goes with me or not depends on herself—*I know* she is deliberating with her mother. I do not know *what*. I do not ask, either." He was still ready to take her with him, exactly as she was; "leaving her," he said, "would mean driving her back to prostitution—how could this be done by the same hand that tried to save her?" Vincent was not the man to condemn another human being. "When I think of that neglected character of hers, half or rather entirely spoiled—one might almost call it dragged through the gutter—then I say to myself: 'After all she cannot be different than she is,' and I should think myself stupid and conceited if I condemned her in big solemn words" (letter 317).

Drenthe as a place of refuge.

155

Soon everything was decided: Vincent would leave The Hague *alone*. Curiously enough, this decision was not the result of a new crisis; rather, as he told Theo on 2 September, he had spent a quiet day with Sien and talked over the problem with her from all sides (letter 318). He had made it clear that it was necessary for him and for his work to have a year with "few expenses and some earnings," and also that it would be better for her and her children if she and Vincent separated as friends—"for a short time or forever, depending on how things would turn out." She should get her family to take the children and look for a job herself. The only thing that kept him from leaving immediately was that he had to wait for money for the journey, which he could expect from Theo on 10 September.

That Sien and the children could not accompany him to Drenthe was not Vincent's fault. "If she had really wanted to struggle on with me in such a way that it had been more than mere words, but an avoidance of those faults that have made things unbearable, I believe—however many cares we might have had, however poor we might have been—it would have been a better fate for her than what she may now expect. But I have come to think of her as something of a sphinx, incapable of saying Yes or No" (letter 321). Finally he came to realize that Sien was not honest. "These last days I have seen clearly that her going out to look for a job was only make-believe, and that she is probably waiting till I am gone before beginning something they do not mention to me." This realization made it easier for him to leave her behind, and yet, as he said, referring to the tragic parting of Alfred de Musset and George Sand, "these things bring so much agony of the soul, and make hearts shrivel up with pain—more than anybody suspects."

Thus it was not with a light heart that Vincent left Sien and her children when he departed The Hague on 11 September 1883, immediately after he had received a letter from Theo with a hundred francs. One can read his sorrow in the first letter he wrote from Drenthe: "Of course the woman and her children were with me to the last, and when I left, the parting was not very easy. I have provided her with all kinds of things as well as I could, but she will have a hard time" (letter 323). In a letter of some time later, he said in even more striking words, "As I told you, the little boy was very fond of me, and when I was already on the train, I still had him on my lap, and so I think we parted from both sides with inexpressible sadness, but not more than that" (letter 326).

What had upset him for days before he decided to leave Drenthe was a visit from Theo—the first in a year, and one he had been looking forward to with great expectations. The visit can only have lasted a very short time, because Theo arrived from Nuenen late in the afternoon of 17 August 1883 and returned the same day. It was disappointing in any case, in complete contrast to his visit of August 1882 for which Vincent had been so grateful. This time he also wrote Theo a long letter after his visit, even on the same day, but it was not only to thank him. He wanted to go more deeply into a number of points about which Theo had reproved him, and in another three subsequent letters he nervously wrote about the emotions the talks with his brother had aroused.

17 August 1883: An upsetting visit from Theo.

156

The question of what to do with Sien was the main topic of the letters. Vincent was referring to *her*—without mentioning her name—when in the first sentence after Theo's visit he requested, "do not hurry me in the various things we could not settle at once, for I need some time to decide" (letter 312). Theo had exerted strong pressure on him to break away from Sien completely, as is obvious from a much later letter, written at the end of December, when Vincent had met with Sien again; it was one of the most bitter letters he had ever written to Theo. "Know then that I look back on your visit of last summer, on our conversations at the time, and on what resulted from them with deep regret" (letter 350). Though he saw the decision to leave Sien as his own responsibility, he could not forgive Theo for having influenced that decision. "You have this much in common with Father, who often acts in the same way, that you are *cruel* in your worldly wisdom" (letter 350a).

Theo criticized Vincent on at least four other topics: his coolness toward his father, the quality of his work, his lack of diligence in earning a living with it, and his sloppy appearance, and Vincent felt he could not let these remarks pass without comment. He explained that when his father had visited him for the first time in The Hague, Vincent had proposed to stay away from the family since he understood that they could not approve of his way of life. Instead of trying to dissuade him from this proposal, his father had cooly answered, "Well, you must do as you think best," leading Vincent to conclude that his parents were more or less ashamed of him. For this reason he had not been overly anxious to correspond with them, and neither his nor their letters had been very intimate.

For the quality of his work, Vincent felt the need to apologize. He thought that "the dryness of the execution [was] the natural consequence of the great strain of overcoming the initial difficulties," or, in other words, the weaknesses in his work could be overcome with more practice. Theo's criticism of Vincent's diligence must have been quite painful, but his assertion that Vincent had not tried hard enough to find buyers for his own work must have been even more upsetting, considering the poor reception he had gotten from Uncle C.M. and Tersteeg. Vincent was afraid that if he took further steps to introduce his work, it would do more harm than good. "It is always painful for me to speak to other people," he lamented, and he felt that even if it were not, he still preferred to leave the sales to Theo. These reflections gradually led Vincent to think that something might indeed be wrong with him; he recognized the "strangeness" that Theo found in him. He foresaw that his lack of self-confidence might remain a lasting source of difficulties with people, and he could only hope for a little more understanding.

Finally is the question of his appearance, which Theo seems also to have criticized strongly. Theo had undoubtedly heard rumors about the clothes Vincent was wearing, and he had brought him a suit—probably one that he had worn himself. His unusual way of dressing was, however, a sore point with Vincent, connected with his fear about contact with the public, and he could not refrain from repeatedly coming back to the point. Not without a grim sort of humor, he said:

157

As to my clothes, dear brother, I put on what was given me, without wanting more, without asking for more. I have worn clothes I got from Father and you, which sometimes do not fit me the way they ought to because of the difference in our sizes. If you will drop the matter of defects in my attire, I shall remain content with what I have, and even be grateful for little, though of course later I hope to remind you of it and say, "Theo, do you remember the time when I walked about in a long clergyman's coat of Father's?" etc. It seems to me that it is infinitely better to take things as they are *now*, and laugh over them together later, when we have made our way, rather than quarrel about them (letter 315).

After having extensively discussed all the points on which Theo had criticized him, Vincent could simply conclude: "let me quietly go on with my work, be as liberal as you can about the money, and my drawings will become good." He remained extremely grateful for the relation with Theo, so grateful that he assured him he would be content with every condition and resigned to put up with everything. The only thing he asked in exchange was that Theo should not doubt his good will and his zeal, and credit him with some common sense.

To be at peace with the decision to leave Sien behind remained very difficult for Vincent. More than a month later, when he had been in Drenthe more than two weeks and was in a despondent mood, he remembered how much had remained unspoken between himself and Theo. "You know yourself how we were not exactly in a mood to say more during your visit" (letter 328). He now declared that rather than part from her, he would have risked marrying her and going to live in the country with her. He would not have done it without consulting Theo, but there was no doubt in his mind. "I felt sure that this was the straight way, notwithstanding temporary financial objections; not only might it have saved her, but it would also have put an end to my own anguish, which has now unfortunately been doubled." Reality had been different, though, and he did not hold Theo or the family responsible for the decision; he had decided himself, because he was in debt and had no confidence in the future. He knew he was forced to change the circumstances of his life, but he also knew that life would not become much easier by it. He accepted his destiny, and, just for once adopting the language of the Bible again, he expressed his decision in the sublime words: "My own future is a cup that will not pass from me unless I drink it. So, *Fiat voluntas* " (Thy will be done) (letter 313).

Worried about leaving Sien.

To Drenthe Alone

Vincent was to spend two and one half months in Drenthe. After leaving, he reflected in a letter to Theo upon the extremely gloomy and sorrowful time it had been for him. In the first place there was the constant shortage of money and, therefore, a lack of painting material. Vincent wrote, ". . . I had to put my material in order, I had to get a supply of colors, I had to make some trips, I had to pay my board and lodging, to send something to the woman, to pay off some debts" (letter 343). And then there was "that particular torture, loneliness." The loneliness he felt was worse than being alone, because it

158

stemmed from the animosity of the people there. "I say loneliness, and not solitude, but that loneliness which a painter has to bear, whom everybody in such isolated areas regards as a lunatic, a murderer, a tramp, etc. etc." It worried him that he did not get on better with people in general, and he often thought of the people he had left behind. "The fate of the woman, the fate of my dear, poor little one and the other child—I feel strongly about them. I would like to help them still, and I cannot."

41
Plowman with Two Women; *sketch from Drenthe in letter 333.*

Vincent's few outbursts of despair are to be found in the early letters from his stay in Drenthe, when he began to realize that the few things he had taken from The Hague were insufficient for the work he wanted to do. As early as the end of September he had to confess that he was "overcome by a feeling of great anxiety, of depression, a *je ne sais quoi* of discouragement and despair" (letter 328). His working conditions were so miserable that he saw the bitter humor of them. "We have gloomy rainy days here, and when I come to the corner of the garret where I have settled down, it is curiously melancholy; through one single glass pane the light falls on an empty color box, on a bundle of worn-out brushes; in short, it is so melancholy that fortunately it also has a comical aspect, enough not to make one weep over it, but to take it gaily" (letter 328).

Once Vincent had decided "to drink the cup to the end," he did it with admirable resignation and courage. The aspect of the country had not disappointed him, and in almost every letter the statement how beautiful it was comes as a constant refrain. After a few days he noticed, "Everything is beautiful here, wherever one goes" (letter 325). In subsequent letters he wrote: "I think it is more and more beautiful here" (letter 327); "What tranquility, what expanse, what calmness in this nature" (letter 330); "[There are] so many extremely different things [in] this apparently monotonous country" (letter 332). And in one of the last letters from Drenthe, dating from the second half of November, he still stated, "this country had an influence of calm, of faith, of courage on me" (letter 341).

When Vincent arrived in Hoogeveen, a town in the western part of Drenthe, on the evening of 11 September 1883, he found the inn of A. Hartsuiker, who was willing to put him up for one guilder a day. Vincent found out that in order to work in a region with vast heaths he had to travel to the east as far as possible, something that had to be done in a canal boat (letter 329). To risk going further inland, however, without sufficient money and materials would be foolish because he had not yet found anything in the way of drawing materials even in Hoogeveen—which could hardly be called a town, he said. He therefore kept working near Hoogeveen, waiting to receive money from Theo so that he could order paints from The Hague. In this region, too, there were enough things to see which he found characteristic: cottages made of sods of turf, sheepfolds, and peat barges in the very middle of the heath, drawn not only by black or white horses, but also by men, women or children (letter 324). During his working trips he often thought "with much melancholy" of Sien and her children. "Theo, when I meet on the heath such a poor woman with a child on her arm, or at her breast, my eyes get moist. It reminds me of her; her weakness, her untidiness, too, contribute to make the likeness stronger" (letter 324). He knew he must not get weak and should concentrate on his work, but so strong was his feeling for Sien that he wrote, "there are moments when one only finds rest in the conviction: Misfortune will not spare me either" (letter 324).

In Hoogeveen, 11 September 1883.

Despite his lack of good materials, Vincent was able to paint some studies: cottages on the heath, a cemetery, a sunset, and as soon as they were dry he sent them to Theo (letter 327). He had more difficulties with figure studies. "At first I had some bad luck with my models on the heath; they laughed at me, and made fun of me, and I could not finish what I had started because of the unwillingness of the models, notwithstanding that I had paid them well, at least by local standards" (letter 326).

One of the problems Vincent mentioned repeatedly in the first few weeks of his stay in Drenthe was Uncle Cor's lack of cooperation. The help Vincent expected from him before he left The Hague had not yet arrived, and the letters Vincent wrote him had not been answered. At first Vincent wrote about the issue in quiet and resigned words, "It is a pity you have not heard anything from C. M. Of course he need not do anything, but I think it rather rude never to send a word in reply" (letter 325). However, when Uncle Cor did not react even after Vincent sent him a bundle of studies, Vincent did not conceal his anger. "I have never pretended that he was obliged to do something, nor do I now. I consider what he did or might do a favor, for which I have always thanked him; and for my part, I have given him studies for it, at least fifty in all, with the right to exchange them later. This being so, I certainly need not put up with insults, and it is a decided insult that he did not acknowledge the receipt of the past package of studies. Not a syllable" (letter 326). However desirable it might be to get financial help, Vincent stressed that this was far from being the principal aim. In his opinion, Uncle Cor went too far by treating him as a stranger or a scoundrel, and losing sight of Vincent's "rights as a human being" (not to speak of his rights as a relative, which he would never use as an argument).

Critical of Uncle Cor's lack of cooperation.

160

In the meantime, Theo must have sent Vincent money and written that he could count on his lasting assistance. Because of Theo's assistance, Vincent undertook the delayed trip to the inland at the beginning of October. He immediately sent Theo an enthusiastic report from a place called Nieuw-Amsterdam in the east of the province. "This one I write to you from the most remote part of Drenthe where I arrived after an endless expedition on a barge through the moors. I see no possibility of describing the country as it ought to be done; words fail me, but imagine the banks of the canal as miles and miles of Michels or Th. Rousseaus, Van Goyens or Ph. de Konincks" (letter 330). In a somewhat later letter he wrote about the inn where he stayed: "Downstairs there is the inn, and a farmer's kitchen with a peat fire on the hearth, very cozy in the evening. Such a fireplace with a cradle beside it is an excellent place for meditation. When I am feeling melancholy or worried about something, I just run downstairs for a while" (letter 332).

In Nieuw-Amsterdam, October 1883.

42
A canal in Drenthe; pen drawing, 1883.
Pen, pencil, washed, JH 424, F 1104,
28 x 40 cm.
Vincent van Gogh Foundation / National
Museum Vincent van Gogh, Amsterdam

This is virtually everything that he said about the inn and its occupants in all the letters from this period. To Vincent, however, it became the center point for his trips in the surrounding areas, about which he could talk endlessly. He especially described the rest and peace he felt everywhere, but once in a while he was also struck by a more dramatic effect. "Yesterday I drew some decayed oak roots, so-called bog trunks (that is, oak trees which have perhaps been buried for a century under the bog, from which new peat had been formed; when digging the peat up, these bog trunks come to light). . . . That pool in the mud with those rotten roots was completely melancholy and dramatic, just like Ruysdael, just like Jules Dupré" (letter 331). The drawing of this curious subject has been preserved (JH 406). To be reminded of the work of artists when he was fascinated by landscapes or other aspects of reality was still characteristic of Vincent. It happened most frequently with the vast and quiet scenes he admired most.

I saw an effect exactly like Ruysdael's bleaching fields at Overveen: in the foreground a high road overshadowed by clouds, then a barren meadow, on which the light fell, and down below two houses (one with a slated roof, the other with red tiles). Behind it a canal and mounds of peat, varying in size according to the plane on which they stand; far away a silhouette of a small row of huts, and a little church spire, little black figures spreading linen out to bleach, a single mast of a barge sticking up between the mounds of peat. A gray stormy sky over all. I often think of Van Goyen on these misty mornings, the cottages are just like his, they have that same peaceful and naïve aspect (letter 331).

Such splendid little descriptions of rural scenes are not uncommon in Vincent's letters from these months, but they are all surpassed by the extensive account he gave of a trip to Zweelo, a village three hours from Nieuw-Amsterdam, where he knew that Max Liebermann and several Dutch painters had worked. This long letter is well worth reading in its entirety as it is one of the highlights of his descriptive talents, but two short passages from it must suffice here.

Max Liebermann, 1847-1935.

Imagine a trip across the heath at three o'clock in the morning, in an open cart (I went with the landlord, who had to go to the market in Assen), along a road or *diek* as they call it here, which had been banked up with mud instead of sand. It was even more curious than going by barge. At the first glimpse of dawn, when everywhere the cocks began to crow near the cottages scattered all over the heath—it all, all became exactly like the most beautiful Corot: the few cottages we passed, surrounded by thin poplars whose yellow leaves one could hear drop to earth—an old stumpy tower in a churchyard, with earthen wall and beech hedge—the flat landscapes of heath or cornfields. A quietness, a mystery, a peace, as only he has painted it (letter 340).

And when on his way back that evening he came across a flock of sheep returning to the sheepfold, it was to him like "the finale of the symphony" he had heard that day.

And on that muddy road a rough figure—the shepherd—a heap of oval masses, half wool, half mud, jostling each other, pushing each other—the flock. You see them coming—you find yourself in the midst of them—you turn around and follow them. Slowly and reluctantly they trudge along the muddy path. However, the farm looms in the distance—a few mossy roofs and piles of straw and peat between the poplars. The sheepfold, too, is a dark triangular silhouette. The door is wide open like the entrance to a dark cave. Through the chinks of the board behind it gleams the light of the sky. The whole caravan of masses of wool and mud disappear into the cave—the shepherd and a woman with a lantern shut the doors behind them.

Apart from the trip to Zweelo, Vincent must have had very few distractions in those months. All his days followed the same monotonous pattern, the only change being that the weather gradually became colder and more gloomy, until it finally became impossible to work outside. The good side of his stay in Nieuw-Amsterdam and its environs was that he could enjoy a completely unspoiled countryside—something that to

him was simply a necessity now and then; he also felt most at home with the simplest forms of human life. "For a month now I have been breathing the air of the heath; I needed it absolutely—I have sat down by a peasant's fire with a cradle beside it. Now I speak calmly—I think calmly" (letter 333).

Nowhere in his letters did Vincent state so clearly as in the ones from Drenthe what a deep-rooted need being in and with nature was. It was the source of his creativity, the source, too, of his moral forces and of his belief—a belief in something that in these years he preferred to name with the cautious term of *quelque chose là-haut* (something up there). Nature was everything which was the opposite of "the street and the office and the care and the nerves" (letter 332), because those were the reasons that he sometimes could not see "the beauty in the most beautiful landscape." That is why he cautioned Theo not to tie himself "irrevocably to the city and the affairs of the city" (letter 339a). When he advised him to come to Drenthe, he did it in these words: "In order to grow, one must be rooted in the earth. So I tell you, take root in the soil of Drenthe—you will germinate there—don't wither on the sidewalk. You will say there are plants that grow in the city—that may be, but you are corn, and your place is in the cornfield" (letter 336). And so it was with deep conviction that he assured Theo, "What life I think best, oh, without the least shadow of a doubt, is a life consisting of long years of intercourse with nature in the country—and with the *quelque chose là-haut*—inconceivable, 'awfully unnameable,' for it is impossible to find a name for that which is higher than nature" (letter 339a).

Much of the work Vincent produced in this period must have been lost. Nine painted studies, seven watercolors, nine drawings, and some sketches in letters are known from Drenthe—not very much for a period of two and one half months. Paintings that are mentioned in his letters but that have not been preserved are a landscape with "a red sun between the little birches in a marshy meadow" (mentioned in letter 325), a study with a plowman and two women (letter 333), and two painted studies of a drawbridge (letter 342). The few that are known, however, are sufficient to give an idea of the landscapes he admired so much and of the artistic level he had reached in the meantime. By reducing everything to a few large planes and closed forms in very dark browns and greens, he succeeded in a striking expression of the gloomy character and the vast expanses of the land; an example is the melancholy landscape with a few cottages (JH 395). It is only in some watercolors such as the *Drawbridge* (JH 425) that he used some lighter grayish-blue and yellowish-brown colors and went into much more detail.

One of the most fascinating of the drawings was sent with a letter to Theo. It is a sheet with several small pen sketches (JH 405), which he must have done during the "endless expedition on a barge through the moors" of which he wrote in letter 330. Here one sees the horse which pulled the barge, the woman "with crêpe around her gold head-plates because she was in mourning," and the evening effect of low cottages against the evening sky. What remains of Vincent's work in Drenthe has a touch that is certainly characteristic and distinguishes it from the rest of his work, but its importance cannot be compared

Much of the work Vincent produced in this period must have been lost.

163

with that of the written memory he left of that period in the numerous letters he wrote to his brother Theo.

Theo in Trouble

The time that Vincent spent in Drenthe coincided with a crisis in Theo's life. Theo, although socially much more successful than his brother, was also struggling with grave difficulties. Not only was he inclined to moods of despondency, but he lived in a state of armed peace with his superiors Boussod and Valadon, Goupil's successors—a state that was sometimes interrupted by sword-rattling. At such moments, unsure about his future, he wrote nervous letters to Vincent, who reacted with equally nervous answers, some with encouragement, and some with well-meant but often unpractical advice.

This was one of those moments. What Theo wrote is quoted literally in Vincent's own letter: "The gentlemen have made things almost impossible for me since I spoke to them this week" (letter 332). It follows from a later letter that Theo had even added, "... and I even believe they *would rather dismiss me than let me resign*" (letter 343). The situation was dangerous enough for Vincent to warn Theo more than once not to let his nerves take over. "You have gone through a period of terrible mental strain; in fact, you are right in the midst of it" (letter 333). Theo had even threatened to run away from his problems. One of Vincent's letters quotes a sentence Theo had written in this respect (it can be read in the manuscript of letter 343, but was omitted from the printed editions): "And you said, 'Sometimes I think I should rather disappear.'" This statement was so distressing that Vincent found it necessary to react strongly: "... making oneself scarce or disappearing, neither you nor I should *ever* do that, no more than commit suicide. I too have my moments of deep melancholy, but I say again, both you and I should regard the idea of disappearing or making oneself scarce as not becoming you nor me. Taking the risk of going on even when one feels that it is *impossible*—going on with the desperate feeling that it will end in disappearing— our conscience tells us 'beware!!!'" (letter 337).

Whatever Theo really had in mind, the possibility of his being dismissed or having to resign was real, and Vincent tried to encourage him. "Now, stick to your point, and don't let your grief let you lose your head; if the gentlemen behave like that, then stand on your honor, and do not accept your dismissal except on conditions which guarantee your getting a new situation" (letter 332). If Theo was thinking of joining another firm, Vincent was not against the idea. "I think your idea of changing your employer is a sound one" (letter 335). What he could not accept was that Theo considered moving to America. In an early reaction Vincent called it the impulse of a despondent moment, comparable to the moments of despair he sometimes experienced himself. "At times—like those moments when you think of going to America—I think of enlisting in the East Indian army; but those moments when one is overwhelmed, things are miserable and gloomy, and I would wish you could see these silent moors, which I see here from my

Would Theo be dismissed? "They would rather dismiss me than let me resign."

164

window, for they are soothing, and inspire more faith, resignation, steady work" (letter 330).

Against the background of these considerations, Vincent's proposed solution to Theo's problems, which at first seems utterly foolish, becomes somewhat more understandable: he wanted Theo to give up his situation in the art trade and to become a painter. This was not a completely new thought; when he was still in The Hague he had once suggested it. The difference was that now, after having raised the idea, he stuck to it with stubborn perseverance and tried to convince Theo in letter after letter that this was the best solution. Theo seems to have replied that, although he had made some drawings in his youth, they did not show any talent; this, however, only made Vincent more adamant. Had he not himself had a period of almost desperate struggle against such difficulties? "In London, how often I stood drawing on the Thames Embankment, on my way home from Southampton Street in the evening, and it came to nothing. If there had been somebody then to tell me what perspective was, how much further I should be now" (letter 332). In his enthusiasm he sometimes exaggerated excessively. "I am so deeply convinced of your artistic talent that to me you will be an artist as soon as you take up a brush or a piece of crayon and, adroitly or maladroitly, make something" (letter 339a).

Theo pointed out that he could not simply give up his position, since many people depended on his income. That Vincent disagreed is the best proof of his recklessness, since he would be the first victim if Theo followed his advice. "Theo, understand clearly what I mean at this moment: Father, Mother, Wil, Marie and particularly I myself are all assisted by you; you think you will have to stick it out for all our sakes, and believe me, I quite enter into your feelings about this, at least I can sympathize with them to a great extent. But think it over. What is the purpose—your own purpose and Father's, Mother's, Wil's, Marie's and mine? What do we all want? We want to pull through, acting righteously; we all want to arrive at a clear position, not a false position, don't we? This is what we want unanimously and earnestly, however much or little we may differ" (letter 332). Without awaiting Theo's reaction Vincent decided to ask his parents about the possibilities. "And today I shall simply write Father this: In case Theo considers it advisable that my expenses be reduced to a minimum and I should have to live at home for a while, I hope, for myself as much as for you, that we shall possess the wisdom *not* to make a mess of things by discord, and that, ignoring the past, we shall resign ourselves to what the new circumstances may bring" (letter 332).

It is not necessary to follow in detail the discussions that took place between Vincent and Theo in the following weeks. Vincent kept pressing him and Theo kept resisting, even though he initially seemed to welcome his brother's advice. With many variations Vincent admonished Theo: thirty years is not too old to start anew (letter 335); it is possible "to free oneself from a world of conventions and speculation" (letter 336); it is nonsense to speak of a "gift," to say "I am not an artist"—it is a question of patience, of "growing"; and he summarized all with the exclamation, "So, boy, do come and paint with me on the heath, in the potato field, come and walk

Vincent's advice: become a painter too!

Theo resists Vincent's pressure.

with me behind the plow and the shepherd—come and sit with me, looking into the fire—let the storm that blows across the heath blow through you" (letter 339).

Selfishness or sacrifice? Vincent causes a conflict.

Working together with his beloved brother and no longer being alone in Drenthe was immensely attractive to Vincent. Yet there was in his proposal much more heartiness and readiness for sacrifice than selfishness, as he was certainly aware that it would undermine the basis of his own existence if Theo were to act on it. Theo's objections, on the other hand, though mainly caused by his feeling of responsibility toward his family and Marie, must also be explained by his attachment to his trade. Vincent understood this perfectly, but kept pointing to the unreasonable demands made on his brother. "Your heart is partly with the firm of G[oupil] & Co., but in their presumption G. & Co. demand unreasonable things" (letter 336). When, after several letters, Theo had progressed no further than to a hesitating "Will you think it over whether there isn't also much to be said for my staying at G. & Co.," it became too much for Vincent; he exclaimed that this was something he had been thinking over for such a long time that there could be no doubt about the answer. He ended by writing that he would refuse financial help if Theo was going to bind himself for good to Goupil & Co. He himself could try to get a job as an illustrator for an illustrated magazine or in a printer's office, "in short, anything, *n'importe quoi*," to be independent of his present source of income.

This was a fatal decision because it almost caused a complete break in the brothers' relationship. Already irritated by the constant pressure Vincent had exerted on him with his interminable stream of letters (nine long letters in three weeks), Theo saw in Vincent's final arguments a sort of ultimatum for which he had no use. Instead of writing this he "punished" Vincent in the same way as he had once done in The Hague: he postponed sending an answer. When his letter finally arrived, Vincent immediately tried to straighten out the "misunderstanding," as he euphemistically called it. His declaration that in the future he would refuse the usual allowance if Theo was going to stay with Goupil had been seen as an "ultimatum," and he hastened to try to take away that impression. "I simply meant, 'I wouldn't want to thrive if you were the loser by it,' I would not want to develop the artist in me if you had to suppress your artistic talent for my sake. I would never approve of your repressing the artist in yourself, no matter whose sake it were for, for the sake of either father, mother, brother or wife. That was my meaning—perhaps nervously expressed, and in wrong terms—but I most decidedly meant no more, or nothing else."

As was typical, Vincent took the initiative independent of Theo's reply. Only a few days later did he conclude that something drastic had to be done and that the only solution was to leave Drenthe and go to Nuenen. He wrote this in a letter of 1 December 1883—his last from Drenthe. Curiously enough, the important decision was mentioned only in the postscript, and in an indirect way; the only words that refer to it are, "I shall be able to write you more calmly from home."

If for Theo everything remained as it was, for Vincent a whole new phase of his life began. Because of Theo's silence he wrote a note to his father begging for money (letter 343). A

later letter reports that his father lent him fourteen guilders for the train fare home (a sum he paid back a few weeks later). The money must have arrived shortly after 1 December, so it was on 3 or 4 December 1883 that Vincent could make the journey to his parents' home. This was not so simple from Nieuw-Amsterdam because it meant that he first had to go back to Hoogeveen, where he could take the train. The departure from Drenthe therefore started "with a good six hours' walk across the heath" (letter 344). He did not mention that he was loaded with his painter's materials and his luggage, but he did add that it was "on a stormy afternoon in rain and snow."

Vincent was not the man, however, to complain about such trifles; on the contrary, "That walk cheered me greatly, or rather my feelings were so much in sympathy with nature that it calmed me more than anything." He intended to stay in Nuenen some eight days; he cannot possibly have expected that he would remain there for two years.

Leaving Drenthe, December 1883.

A REFUGE IN NUENEN

43
The parsonage at Nuenen.

The house in Nuenen where Vincent's parents lived is well known, not only because he drew and painted it several times, but also because it has been preserved (unlike the parsonage in Etten) and remains in very good condition, thanks to a restoration in the 1950s. It is a little smaller than the house in Etten had been, but only twenty-two-year-old Wil and seventeen-year-old Cor were still at home so that the family did not need much room. According to a letter from Vincent to Van Rappard, Lies was "usually in Soesterberg" with the Du Quesne family (she was to marry J. P. T. du Quesne in 1891) (letter R 39). There was a low extension at the back of the Nuenen house, used as a laundry room, that would serve Vincent as a studio. The long back garden looked out on cornfields. Even before his parents had gone to live in the house, Vincent had dreamed of eventually being able to paint the old church with the small cemetery which could also be seen from the garden. In July 1883 he wrote Theo: "I wish I could go to Brabant some time in the autumn and make some studies there. Above all, I should like to make studies of a Brabant plow, of a weaver, and of that village churchyard in Nuenen" (letter 299). It is no wonder that the church and the cemetery were the first things Vincent drew when he arrived in Nuenen, and that the weavers were to become one of his first and favorite themes.

Nuenen is in the vicinity of a large town, Eindhoven, but in the late nineteenth century it was much like Etten; a small, mainly Roman Catholic village where the Protestants formed a minority. Several authors have shown some surprise that the inhabitants of Nuenen were unaware of the existence of this son who came to live with the pastor and his wife, but there seems to be nothing mysterious about it. The parents had only been living in Nuenen for four months—since August 1883—when Vincent arrived, and in that time, unlike Theo, he had never visited them. That the eccentric, strangely-dressed painter caused something of a sensation when he arrived in the village is another matter, and it is not difficult to agree with Jo

van Gogh-Bonger's comment in her Memoir to the *Complete Letters*: "In a small village vicarage, where nothing can happen without everybody's knowing it, a painter was obviously an anomaly; how much more a painter like Vincent, who had so completely broken with all formalities, conventionalities, and with all religion, and who was the last person in the world to conform himself to other people."

Soon after Vincent arrived in Nuenen on 3 or 4 December, he started writing to Theo, his first letter being of 5 December or shortly after (letter 344). A day after his arrival he was already complaining that after writing that letter he had been lying awake half the night, worrying about his parents' attitude. "I am sick at heart about the fact that, coming back after two years' absence, the welcome home was kind and cordial in every respect, but basically there had been no change whatever, not the slightest, in what I must call the most extreme blindness and ignorance as to the insight in our mutual position" (letter 345). There was in his father's mind, he believed, not "the faintest shadow of a doubt" about turning him out of the house two years before.

44
The back of the parsonage with Vincent's studio.

Approximately a week later, when Vincent had been home for almost a fortnight, the situation had not improved, and he wrote about it in bitter terms. The imagery he used was grim: his parents, he said, felt the same dread of taking him in the house as they would about taking in a big rough dog. "He would run into the room with wet paws—and he is so rough. He will be in everybody's way. *And he barks so loud.*" How little it meant to him that his parents had received him "with so much love" is clearly shown by his outcry: "The dog is only sorry that he did not stay away, for it was less lonely on the heath than in this house, notwithstanding all the kindness." He did not deny the kindness, but the complete reconciliation for which he had hoped had not occurred.

While he was writing all this, a letter from Theo arrived, but instead of bringing him some consolation, it made things worse by giving him "a good scolding." Theo accused him of

hurting his father, and rather sarcastically, Vincent answered that he thought it noble of Theo to take his father's part.

Although he could raise many objections to Theo's remarks, Vincent decided to leave Nuenen as soon as possible (letter 346). He thought of going to Van Rappard, and from Van Rappard perhaps to Mauve. He only asked Theo to send "the usual" by return of mail; this would make it possible for him to go away without asking his father for anything. He simply had to ask this because all he had in his pocket at this moment was "a quarter and a few cents"; the rest of the money he had received in the last few weeks (one hundred francs) he had spent on returning the money he had borrowed from his father and Van Rappard. It was a kind of farewell letter he was now writing, and he did not fail to express emphatically how grateful he was for Theo's continued support. "You know, don't you, that I consider you to have saved my life. I shall never forget that; though we put an end to relations which I am afraid would bring us into a false position, I am not only your brother, your friend, but at the same time, I am infinitely grateful to you for the fact that you lent me a helping hand at the time, and have continued to help me. Money can be repaid, not kindness such as yours" (letter 346).

All this sounds very definite, and if they had parted, probably not much would have become of the painter Vincent van Gogh. Fate had decided differently, however. At a moment when his decision to leave seemed firm, he again had a talk with his father which apparently caused him to change his plans completely. Without giving details about their discussion he wrote: "The result is that the little room at home where the mangle stands will be at my disposal to put away my things—to use as a studio too, in case this might be necessary. And they have now begun to clear out the room, which had been put off while things were still undecided" (letter 347). Vincent's version can be compared with an unpublished letter his father wrote to Theo dated 20 December. "We undertake this experiment with real confidence, and we intend to leave him perfectly free in his peculiarities of dress, etc. The people here have seen him anyhow, and though it is a pity he is so reserved, we cannot change the fact of his being eccentric."

It was the promising start of a new and fruitful working period, but unfortunately it also became the cause of a new impassioned discussion between Theo and Vincent. When it had been decided that he was going to use the mangling room as his studio, he immediately traveled to The Hague to get his studies, prints and other belongings that he had stored in the carpenter's attic at the time of his departure for Drenthe in September 1883. He used the occasion to contact Sien and the children, and this proved to be a very disturbing experience, which brought back to his conscience the full range of grief that the separation had caused on both sides. Vincent gave his first reaction to meeting with Sien in a short letter from The Hague. "I have seen the woman again, a thing I had greatly longed for. I feel that it would indeed be difficult to begin anew. But for all that, I do not want to act as if I had forgotten her entirely. And I wished that Father and Mother would realize that pity is not limited in the way the world thinks. You were the one to understand me in this matter. She has behaved bravely under the circumstances, a reason for me to forget the difficulties I

45
The parsonage garden with snow as Vincent found it in December 1883. Pen drawing, JH 426, F 1127, 29 x 21 cm. Vincent van Gogh Foundation / National Museum Vincent van Gogh, Amsterdam

171

had with her at times. And just because I can hardly do anything for her now, I must at least try to encourage and fortify her" (letter 349).

Back in Nuenen a few days later, he wrote more extensively. He looked back "with deep regret" on Theo's visit of the preceding summer and on the result of that visit, namely his departure to Drenthe (letter 350). It was, of course, his own decision, but he also held Theo more or less responsible. Sien worked "as a washerwoman to earn a living for herself and the children," and he now gave more details about her situation. "There was anemia, and perhaps the beginning of consumption; well, as long as I was with her, she did not grow worse, but in many respects stronger, so that several ugly symptoms disappeared. But now everything has changed for the worse, and I fear for her life; and the poor little baby too, whom I cared for as if he were my own, is no longer what he was. Brother, I found her in great misery, and I am in great sorrow over her. I know, of course, that it is more my own fault than anyone else's, but you too might have spoken differently" (letter 350).

He appreciated that Theo had helped him keep her alive at a time when others had deserted her. He was nevertheless beginning to see Theo with different eyes, and he said, "Our friendship, brother, has received a bad shock from this, and if you were to say we certainly did not make a mistake, and if it should appear to me that you are still in the same frame of mind [of last summer]—then I should not be able to respect you as much as in the past." In a letter that was erroneously given the number 193a, but that must have been written at this time, he defiantly said: "So you have me at your mercy, you particularly, along with many others, none of whom can agree with me. *And yet you will not be able to force me to renounce her*, whatever your financial power. And because I shall make no concessions in the matter of the woman—and I will clearly declare it, loud enough for even ears that are most hard of hearing—I announce in advance that I have resolved to share with her all that is my property and I do not wish to accept any money from you, except that I may regard as my property without *arrière pensée*."

Despite this pledge, there is no indication that he gave Sien any money, and after his visit to The Hague, Sien and her children are not mentioned once in any of his letters. The conclusion must be that he had really given up the relationship with her altogether. Vincent never disclosed his reasons, but because of his strong determination to keep assisting her, it seems reasonable to suppose that she had been responsible for the final split. When he left The Hague in September of 1883, Vincent had made one reservation: "I shall be ready to help, even after I am gone, provided I see some willingness and energy." In whatever way he found out—whether he went to The Hague again after his trip in December, or whether there had been an exchange of letters which made him change his mind, or whether he heard things from other people—he informed Theo that same month that she no longer "behaved so well" (letter 350).

What is known about Vincent's character would indicate that there must have been a substantial motive for him to break so completely with her and her little family. One circumstance that may have made it easier for Vincent to stop

Vincent breaks completely with Sien, 1884.

worrying about Sien was that another woman was beginning to play a part in his life: his neighbor Margot Begemann. Their contact dates from January 1884, when his mother broke her thigh while getting off a train in Helmond. ". . . It is a fact that she and I became attached to each other during Mother's illness" (letter 385). The daily contact with the good-hearted, helpful and intelligent Margot Begemann must certainly have made him see in a different light the woman with whom he had led such a difficult life for almost two years.

In Revolt Against Theo

When Theo sent him his allowance shortly after their mother's accident, in view of the difficult circumstances Vincent gave this money to his father instead of paying bills for paints as he had planned to do. When, however, Theo again sent an amount (this time of one hundred francs) around 1 February, Vincent used it to pay some of his debts, and he could now come forward with a plan that would put his relationship with Theo on a new and different basis. "Now I want to make a proposal for the future. Let me send you my work, and keep what you like for yourself, but I insist on considering the money I receive from you after March as money I have earned" (letter 360).

He realized that there remained a great debt he owed Theo and assured him that if possible he would pay him back. On 13 February he informed Theo that he had sent a parcel with three little panels and nine watercolors (letter 356). It was a friendly letter this time, partly filled with poems by François Coppée. It was not just the poetry he admired; the three poems he had copied for Theo were melancholy pieces, describing a lost love, which must have reminded Vincent of his own situation. He may also have thought of Theo, who was in the process of breaking away from Marie. The first stanza of the poem "Désir dans le spleen," is:

> Tout vit, tout aime, et moi, triste et seul, je me dresse
> Ainsi qu'un arbre mort sur le ciel de printemps,
> Je ne peux plus aimer, moi qui n'ai que trente ans,
> Et je viens de quitter sans regret ma maîtresse.[64]

The other titles, "Douleur bercée" and "Blessure rouverte" ("Sorrow Assuaged" and "Reopened Wound") must certainly also have had meaning for Theo.

A week passed and Vincent had not received any reaction to the parcel he had sent. He could not refrain from mentioning this. When he finally did receive an answer at the end of February, it put an end to his friendliness. In a letter of many written sheets (eight pages in print), he launched the fiercest attack on Theo he had so far attempted. The reason was clear: Theo had not appreciated the work at all. It is not difficult to guess what Theo had written, and it came at a moment when Vincent greatly needed a few words of encouragement. In Theo's opinion, Vincent's work ought to become "much better"; "almost suitable" he seems to have written, and this remark

[64] In essence: "All is love around me in spring, and I being only thirty, cannot love anymore, having left—without regrets—my mistress."

was precisely what made Vincent so angry. "I must make my own way too, Theo, and with you I am exactly as far as I was a few years ago; what you say about my work now, '*it is almost salable, but*'—*is literally the same as what you wrote me when I sent you my first Brabant sketches from Etten.*"

Vincent knew only too well how much progress he had made to accept such a comment. It hurt him especially that Theo had suggested, "Aren't you too much preoccupied with Michel?," something which he also could have said of the old church Vincent had painted in Nuenen. Vincent responded: "And yet neither before the churchyard nor before the sod huts did I think of Michel, I thought only of the subject I had before me. A subject which, I think, would have stopped Michel if he had passed, and would have struck him. I do not put myself at all on the same line with Master Michel, but *imitate* Michel is what I decidedly do not do" (letter 358). The result was that he haughtily wrote, "I do not feel greatly inclined to send you the painted studies from here, no, we shall just leave them where they are—you can see them when you perhaps come here in spring." From the defensive Vincent moved forcefully to the attack. "For my part I will also tell you frankly that I think it is true what you say, that my work must become much better, but at the same time, that your energy to do something with it might become much stronger too. You have *never sold a single one from me*—neither for much or for little—and in fact *have not even tried.*"

It is evident that many feelings are revealed here that Vincent had hidden within himself for a long time, the most notable being his annoyance that none of his work was ever sold. He talks about the fact in this letter more than once and quite spitefully. "I now understand that my doings are indifferent to you, but if you are indifferent to certain things that will hardly fail to present themselves—I for my part find it very unpleasant, for instance, when they ask me, How queer, don't you do business with your brother or with Goupil? Well, in that case I shall say, 'It is beneath the dignity of *ces Messieurs* G. & Co.—Van Gogh & Co.' That will probably make a bad impression as far as I am concerned—something I am prepared for by this time—yet I foresee I shall get colder and colder in my feelings toward you too" (letter 358).

As he wanted to be able to say that he did sell his work, namely to Theo van Gogh, he decidedly wrote, "*If you do not do anything with my work, I do not cherish your protection.*" He felt that he had to regard Theo's help as "protection" if he were not entirely free to do what he wanted with the money he received. When he wanted to set up a household with Sien, Theo had stopped him from doing so "with a little tug at the financial bridle" (letter 358). All these considerations resulted in the famous lines: "A *wife* you cannot give me, a *child* you cannot give me, *work* you cannot give me. Money—yes. But what good is it to me, if I must do without the rest?"

His conclusion was that their collaboration had to come to an end. Even if it seemed absurd that his career, which had begun with Theo's "help and assistance," had to be broken off abruptly, there was no other way. It was a hard thing for him to say, but he felt that "the way to remain good friends is to part company." The only thing known about Theo's reaction to all this is that he reproached Vincent about speaking "in haste

Georges Michel, 1763-1843.

"A wife *you cannot give me, a* child *you cannot give me,* work *you cannot give me. Money—yes. But what good is it to me, if I must do without the rest?"*

174

and rashly," to which Vincent answered coolly, "That very idea of yours is sufficient proof to me that we have come to the point where more words won't do any good, and I think it better to let this question rest" (letter 361).

In the meantime, however, Theo had sent 250 francs (undoubtedly meant for the whole month of April, but it does not become clear why he sent more than the usual 150 francs), so that there was still no question of "parting company," and the whole matter was reduced to the question of whether or not Vincent was completely free to do with the money what he wanted. Theo cannot be blamed for replying that this entitled him to the same freedom, in other words, that he could do as he pleased with Vincent's work. Vincent could hardly do anything else but agree:

> Of course I will send you my work every month. As you say, that work will be your property then, and I perfectly agree with you that you have every right to do anything with it; even I couldn't make any objection if you should want to tear it to pieces.
>
> I, for my part, needing money, am obliged to accept it, even if somebody said to me, "I want to put that drawing of yours away, or, I want to throw it into the fire, you can get so much money for it"; under the circumstances I should say, "All right, give me the money, there is my work, I want to get on." I must have money, in order to get on; I try to get it, and therefore—even if you were completely indifferent to me—as long as I get your monthly allowance, without conditions forbidding me to do certain things, I will not break with you, and I agree to everything if need be (letter 364).

Theo continued sending money, but it is clear that the relationship between the brothers had cooled considerably. The letters that Vincent sent in April and the following months were much shorter and more businesslike than they had been for a long time, though the tone was not unfriendly, and this remained the case until the controversy flared up again in the autumn.

Vincent's Work in 1884

When Vincent had arrived in Nuenen in December 1883, he immediately started making small pen drawings of the landscape he had so longed to see: the fields behind the parsonage with the little old church tower and the cemetery that surrounded it. There are some eight little drawings in the same style, together giving a very characteristic picture of the wintry surroundings. According to the Memoir to the *Complete Letters*, Father Van Gogh was referring to these drawings when he wrote to Theo, "Do you not like the pen drawings of the old tower that Vincent sent you? It seems to come to him so easily."

Vincent also began working on a subject that was to occupy him for a long time. Around 1 February 1884 he wrote, "Since I have been here, not a day has passed, I think, when I have not been working from morning till night on the weavers or the peasants" (letter 360). There clearly is some enthusiastic exaggeration in these words, but it is also true that he devoted a great number of drawings, watercolors and paintings to these subjects alone. While some of the watercolors and pen drawings

are certainly equal in precision and expressive force to the best of the drawings from The Hague, most of the painted studies display an artistic level he had not reached before. He evidently took a great liking to the subject of the looms and "their rather complicated machinery with a little figure sitting in the middle" (letter 355). He represented them in very precise, almost technical drawings, often *after* he had already made a less detailed painted study of them. To his friend Van Rappard he explained that the drawings were made from start to finish at the spot, which was an awkward task since he sat so close to the looms that it was hard to take measurements.

Vincent expressively described the scene at the weaver's to his friend Van Rappard. "When that monstrous black thing of grimed oak with all those sticks is seen in such sharp contrast to the grayish atmosphere in which it stands, then there in the center of it sits a black ape or goblin or spook that clatters with those sticks from early morning till later at night" (letter R 44). He described the weavers in the somewhat irreverent, boyish manner more often found in his letters to Van Rappard than in those to Theo, yet he also understood for their dignity. When he was in the Borinage and had come through villages with weavers on his trip to Courrières, he had written that the miners and the weavers constituted a race apart from other laborers and artisans for which he felt a great sympathy. "The man from the depth of the abyss, *de profundis*—that is the miner; the other, with his dreamy air, somewhat absent-minded, almost a somnambulist—that is the weaver" (letter 136). Now, six years later, he had succeeded in fixing forever the image of these laborers with their "dreamy air" in drawings, watercolors and paintings. Meyer Schapiro, the author of the well-known book *Vincent van Gogh* (1950), was also struck by the serious figure of the weaver (JH 439). This drawing, one of only three of the Dutch period which Schapiro discusses, elicited this observation: "Van Gogh gave to the image of the worker at the machine a high solemnity and power. In the earnest skilful labour of the weaver, he felt, no doubt, a kinship with his own artistic work."

Vincent, too, saw himself as a laborer and felt a strong relationship with the weavers and farmers he depicted so often. It is therefore not surprising that he was appalled by their social circumstances. In one of his letters he told Theo something of their poverty: "A weaver who works steadily, weaves, say, a piece of sixty yards a week. While he weaves, a woman must spool for him, that is supply the shuttles with yarn, so there are two who work and have to live on it. On that piece of cloth he makes a net profit, for instance, of 4.50 guilders a week, and nowadays when he takes it to the manufacturer, he is often told that he cannot come with another piece for one or two weeks" (letter 392).

If the weaver's interior was enlivened by the presence of a child, Vincent observed the scene with heart-felt interest. "I am painting a loom of old, greenish, browned oak, in which the date 1730 is cut. Near that loom, in front of a little window which looks out on a green plot, there is a baby chair, and a baby sits in it, looking for hours at the shuttle flying to and fro. I have painted that thing exactly as it was in reality, the loom with the little weaver, the little window and the baby chair in the miserable little room with the loam floor" (letter 355).

"The man from the depth of the abyss, de profundis—that is the miner; the other, with his dreamy air, somewhat absent-minded, almost a somnambulist—that is the weaver."

176

Farther from home he did a few simple, but pleasant pictures of the fields with the old tower and the little cemetery; one is a winter effect with some snow (JH 458), the other a little more spring-like (JH 459). These probably date from the end of February 1884, when there were "mild days" (letter R 40). A third one, with the heavy tower pictured close-up against a gray, cloudy sky (JH 490) must have been painted later in spring, and a fourth, with a very successful moonlight effect, was done as late as the beginning of August.

He arrived at much more elaborate compositions in the drawings of the vicarage garden and surroundings. These were the drawings he specifically mentioned when he was trying to convince Theo that their collaboration had a business-like character. Striking examples are the pen drawings *Behind the Hedges* (JH 461) and *Landscape with Willows* (JH 467) in which the panoramas are seen against the light. In the second the sun itself is visible in the picture—one of Vincent's daring innovations in his later paintings—though only just breaking through the clouds. Another drawing shows the vicarage itself, seen from the side of the garden, including Vincent's "studio" (JH 475). There is a blossoming sapling in the foreground, making it probable that it was done in early spring.

There are several excellent pen-and-ink drawings of the vicarage garden, some of which suggest a grim, wintery scene. The maze of twisted, angular trees in these drawings is reminiscent of the touched-up drawings of *Sorrow*, done two years earlier (JH 130), and also of a drawing of tree roots (JH 142). In both drawings he attempted to convey "the grim tenacity and passionate intensity with which they hold onto the earth although they are half uprooted by the gales." One might perhaps say the same of Vincent himself; it certainly is an appropriate characterization of his artistic development: from realist, firmly rooted in his rural native soil, to cosmopolitan expressionist.

By May of 1884, Vincent decided that the improvised studio in the dark little mangle room was no longer adequate for the scope and variety of the work he was undertaking. Around the first of May he rented rooms elsewhere, and it was not before the middle of the month that he told Theo about them, completely in accordance with his view that he now could do what he wanted with his money. "I have waited too long to answer your last letter, and I will tell you why. Let me begin by thanking you for you letter and the 200 francs enclosed. And then I want to tell you that today I just finished arranging a spacious new studio I have rented. Two rooms—a big one and a smaller one adjoining" (letter 368). More or less as a friendly afterthought, not as a request for permission, he added: "I think I shall be able to work much better there than in the little room at home. And I hope you will approve of the step I have taken when you see it."

The rooms he had rented were in the house of Johannes Schafrat, the sexton of the Roman Catholic church. Vincent's father, whose position as the pastor of the small Protestant community in a Roman Catholic village was not an easy one, could not have been very pleased with the choice. To Vincent, however, the new situation had many advantages. He had much more room for his activities and was no longer under the watchful eye of his parents, who were much too meddlesome for

May 1884: Vincent rents a new studio.

177

his taste. He went home only in the early afternoon for his warm meals to keep his expenses down. For some time he slept at home, but after being with his parents for five months he must have felt that in any case the move meant an important first step toward the independent position which was his dream.

During the summer months he worked with undiminished energy at his drawings and painted studies of landscapes and weavers. There was little time left for writing long letters to Theo, and certainly none for making caustic digressions about their mutual rights and duties, the less so because of the many events that took up most of his time and attention. There was a visit from Anthon van Rappard just when Vincent had more or less finished settling into his new studio. Theo, of course, was immediately informed of the visit. "I want to tell you that Rappard has been here some ten days, and that he sends you his best regards. As you can imagine, we paid many a visit to the weavers, and took many a trip to all kinds of beautiful spots. He was greatly pleased with the scenery here, which I too am beginning to like more and more" (letter 369). Vincent also wrote a friendly postscript to Van Rappard about this occasion, "I think of your visit here with great pleasure, and I don't doubt that the more you come the more you will feel attracted to nature here" (letter R 50).

They had gone together to look at two water mills in the neighborhood and in the meantime Vincent had discovered still another water mill, one with two red roofs which he had started to paint. The friends had discussed books about painting, and after his return Van Rappard sent Vincent two of those books on loan. It follows from other letters that these books, which were to become very important to Vincent, were *Les artistes de mon temps* by Charles Blanc and *Les maîtres d'autrefois* by Fromentin, both from 1876. In the first he found details about Eugène Delacroix which fascinated him as he happened to be studying color theories at that particular moment. As he informed Van Rappard in August, the book had induced him to buy another book by Blanc, *Grammaire des dessins*.

Van Rappard had hardly left when there was another distraction in Vincent's rather monotonous life. At Whitsun[65] (this year on 1 June), Theo came from Paris for a short visit with his parents. He did not seem to object to Vincent's renting a new and larger studio, for in his next letter the only thing Vincent wrote about the visit was, "I still think of your pleasant visit very often, which I hope will soon be repeated and then for a somewhat longer time." The rest of the letter, written in the same friendly manner, was almost exclusively devoted to color theory. Despite the cordiality between the brothers at this time, letters to Theo were becoming more and more scarce. There were five in both March and April, two in both May and June, and only one in July. Theo continued sending money once a month, but certainly did not write often either.

Vincent's July letter shows that although he was still working on two large studies of weavers' interiors, his primary interest had gradually become the characteristic beauty of this rural area at the height of summer. What attracted his

Charles Blanc, 1813-1882.
Eugène Fromentin, 1820-1876.
Eugène Delacroix, 1798-1863.

[65] The fiftieth day after Easter commemorating the descent of the Holy Ghost on the Apostles.

178

painter's eye were, of course, the summer colors, especially now that color theories had become his daily study. "The half-ripe cornfields are at present of a dark golden tone, ruddy or gold bronze. This is raised to a maximum of effect by the contrast with the broken cobalt tone of the sky" (letter 372). This color combination was to become a favorite. Five years later it dominated many of his paintings, including a whole series, the small copies after Millet. But his heart went out even more to the peasants he saw working in the fields whom he would have loved to paint if only he could find the right models. "Imagine against such a background women's figures, very rough, very energetic, with sun-bronzed faces and arms and feet, with dusty, course indigo clothes and a black bonnet in the form of a barrette on their short-cut hair; while on the way to their work they pass through the corn along a dusty path of reddish-violet, with some green weeds, carrying weeding hoes on their shoulders, or a loaf of black bread under the arm—a pitcher or a brass coffee kettle" (letter 372).

46
Harvest Time, *sketch in a letter to Theo from 1884 (letter 374).*
Vincent van Gogh Foundation / National Museum Vincent van Gogh, Amsterdam

His production from July and August was limited, but he remained, nevertheless, very busy. He was working on a "commission," and that was yet another interruption in his normal routine. In nearby Eindhoven he had made the acquaintance of Antoon Hermans, a former goldsmith who had made a fortune collecting and selling antiques. The man was an amateur painter and was decorating his ceilings and walls himself—"really well sometimes," according to Vincent—with panels of flowers. There were six panels left in the dining room which he wanted to fill with compositions of a Last Supper and saints. Vincent, who was so full of admiration for what he saw outside every day, could not let this opportunity pass. "I begged him to consider whether the appetite of the worthy people who would have to sit down at that table would not be more stimulated by six illustrations from peasant life in the Meierij [a Brabant region], at the same time symbolizing the four seasons, than by these mystical personages. And now, after a

visit to my studio, the man became quite enthusiastic about it" (letter 374).

Hermans wanted to paint the panels himself, after canvases done by Vincent, who had given him preliminary sketches of the subjects, ". . . on condition that I paint the six canvases *for myself*, and that I bear his dining room in mind, for instance with regard to their size. He will pay the expenses of models and paint, whereas the canvases remain my property, and will be returned to me after he has copied them." It was not a very lucrative commission, for rich Mr. Hermans in fact did not pay anything for Vincent's designs, nor for his work. It is not surprising that Vincent grumbled a little when he wrote again about the affair in October, relating how much trouble it had cost him to get twenty-five guilders from Hermans while he had lost at least twenty guilders' worth of expenses. In any case, during the summer of 1884 the work for Hermans had made it possible, he told Van Rappard, "to do things that would get too expensive if [he] had to pay for everything" (letter R 47).

During the harvest at the beginning of August, Vincent was in the fields every day, and the sketch of the "compositions" he made of the harvest—men and women busy mowing the wheat and loading it onto a cart—shows no fewer than seven people. Four more small sketches of subjects represent a sower, a man and a woman digging potatoes, an ox wagon in the snow, and a plowman with an ox pulling the plow. Of the large panels that Vincent had painted as models for Hermans, four have been preserved. They show that Vincent had changed the subjects quite substantially in the process of working. He added a shepherd with a flock of sheep (JH 517), the oxcart in the snow had been substituted for wood gatherers in the snow (JH 516), and there are seven instead of two potato diggers (JH 513). The work occupied Vincent for some time. It was not before the second half of September that he could write, "Last week I made the last of the six pictures for Hermans, *Wood Gatherers in the Snow*, so he has all six of them to copy; when he has finished with them and they become thoroughly dry in the meantime, I shall work them up into pictures."

Just before he had to devote all his attention to the work for Hermans, he had finished two large canvases, exceptional in his oeuvre as to the subject. In both an oxcart fills almost the whole surface of the picture (JH 504 and 505). One pair of oxen is black and white, the other red and white. When he enumerated the subjects of his designs for Hermans in the beginning of August, one of them was an *Oxcart in the Snow*, and a small sketch that happens to have been preserved (JH 511) shows that he had carefully copied his own painting with the black and white oxen and therefore must have been planning to use it for a large painted study. In a somewhat earlier letter he explained that "one could paint a picture which very well expresses the mood of the seasons in each of the contrasts of the complementary colors (red and green, blue and orange, yellow and violet, white and black)" (letter 372). Of winter he had said, "Winter is the snow with the black silhouettes." As he had proposed to Hermans to symbolize the four seasons with his panels, he could put his own theory into practice. The painting with the black and white oxen lent itself for the winter landscape, much more so than the one with the

Antoon Hermans, born 1820 and therefore more than thirty years older than Vincent.

180

red and white oxen, which above all was a study in carefully balanced, muted, but warm colors.

It is in Vincent's letters about color theories that he mentions for the first time the new trends in painting of that moment. However isolated his life had been in the last few years, some rumors about these trends must have reached him. His ignorance about the things that went on in France, however, is surprising, though not completely inexplicable. The following naïve but significant passage proves that for the time being Jozef Israëls remained an ideal whom he looked upon with admiration: "When I hear you mention so many new names, it is not always easy for me to understand because I have seen absolutely *nothing* of them. And from what you told me about 'impressionism,' I have indeed concluded that it is different from what I thought, but it's not quite clear to me what it really is. But for my part, I find Israëls, for instance, so enormously great that I am little curious about or desirous for other or newer things" (letter 371).

The last time Vincent had been in Paris he had left the city at the end of March, just a little too early to have been able to visit the second exhibition of the impressionists in April 1876. Yet during his stay in Paris there must have been opportunities to see works by several participants of that exhibition. That he could have remained so completely ignorant of their existence in spite of the fact that he had worked in an art dealer's firm in Paris for eleven months in the years 1875 and 1876 is a significant indication of the position of the impressionists at that time: a small group of isolated avant-garde artists who were not accepted in the official art world to which the conservative Goupil firm belonged. It is also a fascinating thought that less than two years after Vincent wrote this to Theo, he was to play an active part in a group of Paris painters who were already leaving impressionism behind.

Jozef Israëls, 1824-1911.

47
Still Life with Pottery and Bottles, a
painting by Vincent from November, 1884.
Canvas on panel, JH 538, F 53,
39.5 x 56 cm.
Vincent van Gogh Foundation / National
Museum Vincent van Gogh, Amsterdam

In the fall of 1884 a very personal matter dominated Vincent's letters: a dramatic affair with Margot Begemann. Margot Begemann, or Miss X, as she is mysteriously called even in the later Dutch and French editions of the *Complete Letters*, was the youngest of three sisters who lived in Villa Nuneville, next to the vicarage in Nuenen. At the time of Vincent's mother's accident in January and during the following months, the young neighbor had come often to help and had befriended him.

Margot Begemann was a woman of remarkable qualities. "It cannot be denied," Vincent wrote in a later letter, "that at various times she did good turns for almost all the people in the surroundings, either in case of sickness or when they were in some trouble or other" (letter 385). She must also have been intelligent and businesslike, because she was a partner in the firm of her brother Louis (Jacobus Lodewijk Begemann), a linen manufacturer in Nuenen.[66] As the daughter of a clergyman, she must have had a good education. (Her father, Willem Lodewijk Begemann, who died in 1876 at the age of seventy-two, had been the pastor of Nuenen for many years.) Vincent certainly held her in high esteem; if he sometimes wrote about her with some reserve, it was because in his opinion she was "damaged" by the people around her and had not been able to develop her mind in the freedom of thought which he valued so highly. He had seen "something grand in her from the very beginning," but he blamed the narrow-minded ecclesiastical circle in which she had been educated for suppressing her brilliant qualities (letter 378).

There can be no doubt that Vincent and Margot loved each other, and this must have caused the scorn (and perhaps the subconscious jealousy) of her sisters. Vincent's relationship with his brother had been so strained that he had not breathed

[66] Some factual details about the Begemann family are based on M. E. Tralbaut's article on Margot Begemann in *Van Goghiana IX* (1974).

a word about his love to Theo, in complete contrast to the numerous long letters he had devoted to his love for Kee Vos during the Etten period. But in an otherwise unfriendly letter from November 1884, he said in passing: "The simple fact is that if she and I choose to love each other, if we are attached to each other, *which we have been for a long time for that matter* [author's italics], we are doing no *harm* which people have a right to reproach either one of us with. And in my eyes it is absurd that people should feel obliged to bother their heads about it—with the idea that it is in my interest or hers" (letter 385).

In an earlier letter he had written: "I certainly believe, or know for sure, that she loves me. I certainly believe, or know for sure, that I love her, it has been sincere" (letter 378). He therefore could write with firm conviction, "Both she and I have sorrow enough, and worries enough, but neither of us feels regret." Their love was so strong that they planned to get married, evidently not seeing the difference in their ages as a hindrance; Margaretha Carolina Begemann was born in Nuenen on 17 March 1841 and was therefore twelve years older than Vincent. Vincent realized that such a marriage might not be very sensible. Speaking of his love for Margot he said: "Was it foolish, etc.? Perhaps so, *if you like*, but the *wise* people who never do a foolish thing, aren't they more foolish in my eyes than I in theirs?"

In the first half of September, Vincent acted unpredictably toward Theo: he did not answer a letter he had received, not even to thank him for the 150 francs that were enclosed. When Theo enquired, Vincent told him that he had started a letter but had simply not been able to find the right words to finish it. "Something terrible has happened, Theo, which hardly anybody here knows, or suspects, or may ever know, so for heaven's sake keep it to yourself. To tell you everything, I should have to write a book—I can't. Miss Begemann took poison in a moment of despair after she had had a discussion with her family and they slandered her and me; she became so upset that she did it (in a moment of decided *mania*, I think)" (letter 375). What had led to this catastrophe one learns only in bits and pieces, and even then only partially.

In this first letter about the suicide attempt he strongly denounced the religious ideas of the sisters who had driven Margot to her act of despair. "But for heaven's sake, what should we think of that standing and of that religion which the respectable people believe in—oh, they are absolutely *absurd*, making society a kind of lunatic asylum, a perfectly topsy-turvy world—oh, that mysticism!" Shortly after the dramatic event, he described her using words that, however surprising and to the point they may be, seem rather cold and aloof. "It is a pity that I didn't meet her *before*, for instance, ten years ago. Now she gives me the impression of a Cremona violin which has been spoiled by bad, bungling repairers. And the condition she was in when I met her proved to be rather too damaged. But originally, it was a rare specimen of great value" (letter 377).

Before the tragic incident there certainly must have been harsh words between Margot and her two sisters and sister-in-law about her contact with a man whom they could only see as an eccentric. Vincent, however, foresaw a crisis when he noticed that Margot's sisters' reproaches had completely

Margot Begemann's suicide attempt.

184

thrown her off balance. "Theo, I had already consulted a doctor once about certain symptoms of hers; three days before I had secretly warned her brother that I was afraid she would get brain fever, and that I was sorry to state that, in my eyes, the Begemann family acted extremely imprudently in speaking to her the way they did" (letter 375). Vincent's warnings had been to no avail; she became "desperate and over-melancholy" and acted in a moment of utter desperation. Vincent's precise and drastic description proves once more that he could have been a naturalistic novelist if he had not become a painter.

> When we were quietly walking together, she had often said, "I wish I could die now"—I had never paid any attention to it. One morning, however, she slipped to the ground. At first I thought it was just a weakness. But it got worse and worse. Spasms, she lost her power of speech, and mumbled all kinds of things that were only half intelligible. She collapsed completely with many jerks and convulsions, and so on. It was different from an epileptic fit, though there was a great similarity, and suddenly I grew suspicious, and said, "Did you happen to swallow something?" She screamed "Yes!" Well, then I took matters in hand—she insisted on my swearing that I should never tell anybody—I said, "That's all right, I'll swear anything you like, but only on condition that you throw that stuff up immediately—so put your finger down your throat until you vomit, or else I'll call the others." Well, you understand the rest. That vomiting succeeded only partially, so I went to her brother Louis and told him what the matter was, and got her an emetic, and I went immediately to Eindhoven, to Dr. Van der Loo.
>
> It was strychnine she took, but the dose must have been too small, or perhaps she took chloroform or laudanum with it as a narcotic, which would be the very counter-poison against strychnine. But in short, she took the counter-poison which the doctor prescribed in time. She was at once sent off to a doctor in Utrecht, and is said to have gone on a journey (letter 375).

Although it had given Vincent "a terrible fright" because they were alone in the fields when it happened, it is typical of the way his mind worked that he could immediately connect Margot's desperate act with a parallel in literature: "Do you remember," he asked Theo, "the first Madame Bovary who died in a nervous attack?" It is surprising, for that matter, that he was thinking of the *first* Madame Bovary and not of the *second* who was the main character of Flaubert's book and who had also tried to take her life by taking poison. Yet, he had a good reason for stressing which of the two women he meant. He repeated the question to Theo in his next letter in somewhat clearer terms, though still using careful nineteenth-century euphemisms. "With much forethought *I have always respected her* on a certain point that would have dishonored her socially (though if I had wanted it, I had her in my power), so that socially she can maintain her position perfectly, and *if* she *understood it well*, she would have a splendid opportunity to take her revenge and get satisfaction from those very women who defeated her" (letter 377). Nevertheless, he said, the reproaches she had to endure made her feel "she had done something frightful" and "without having done anything she ought not to have done, she took it so much to heart that she felt deserted by everybody and everything."

A parallel in literature.

It becomes clear from these passages why the drama with Margot had reminded him of the first Madame Bovary. Clearly there could be no question of a love affair such as the one that led the second Madame Bovary to taking poison. "You do understand, don't you, that, although I wrote you it reminded me of a passage in *Madame Bovary*, there is nothing here that had anything to do with the second Mme. Bovary, who is really the heroine of the book, but only of the first Mme. Bovary, of whom there is little more than how and why she died on hearing bad news about her fortune. Here the cause of the desperation was not bad news concerning her fortune, but the way in which they reproached her, telling her that she was too old and that sort of thing" (letter 376).

Yet he felt the need to justify his actions, both to Theo and possibly to himself. There were people who said, "Why did you meddle with *her?*" while there were also people who said to her, "Why did you meddle with *him?*" (letter 378). Vincent reasoned that it might be salutary to wake up a woman from the state of lethargy to which someone like Margot had fallen. "Disturbing the tranquility of a woman, as theological people call it (sometimes theologians *sans le savoir*), is sometimes *the breaking of stagnation or melancholy*, which steals over many people and is *worse* than *death itself*" (letter 377). Yet some people find this terrible, he realized—hurling them back into life, into feeling—and he realized that he must consider carefully how far he should go in this respect with Margot.

His conscience was clear, and he called it "damned touching" that Margot, when she had been led to her desperate act, had cried out "almost triumphantly and as if she had found *rest*, 'I too have loved at last.' In that respect she had always beaten about the bush, so far."

After Margot's suicide attempt Vincent had not quite abandoned the idea of a marriage but had consulted the doctor who had taken her into his house. "I wanted to get his advice as to what I must or must not do, for the sake of the patient's health and future, *i.e.* either continue our relation or break it off" (letter 377). It is interesting to read the opinion of the physician, who may be considered an objective judge of the situation. He told Vincent: ". . . she had *always* had a very frail constitution and will always have; that for the moment there are *two* dangerous things, that she is too weak to marry, at least for the moment, but that at the same time a separation would be dangerous, too. So some time will have to pass, and then I shall receive a definite hint of what will be best for her, separation or not" (letter 377).

"She is too weak to marry, at least for the moment, but . . . at the same time a separation would be dangerous, too."

Vincent as Art Teacher

The dramatic events with Margot Begemann and his worsening relationship with Theo must have made it doubly welcome for Vincent that his friend Anthon van Rappard again came to visit the Van Gogh family in the second half of October. In letters from September and October Vincent does not mention much new work; until late in October he was occupied with finishing the panels for Hermans. Now he naturally became inspired to do a different kind of work. "Rappard and I have made long excursions, and visited house after house; we

have seen the most beautiful things, just because of the splendid autumn effects. And we have discovered new models" (letter 383). He noticed that he was animated by Van Rappard's presence. "His visit has given me new ideas for my own work again." A landscape mentioned a few days later gives a good impression of the level of the work from this period. "The last thing I made is a rather large study of an avenue with poplars, with yellow autumn leaves, the sun casting sparkling spots on the leaves on the ground, alternating with the long shadows of the stems" (letter 382). This is an impressive picture, showing a striking color contrast between the yellowish and reddish-brown autumn tints and the blue sky above a farmer's cottage at the end of the lane (JH 522). In the same weeks, Vincent did more landscapes and studies of the water mill at Gennep (JH 523-526) while it had been freezing "pretty hard." Eventually, it became too cold to work outside, and so during the rest of the winter his main subjects became still lifes and "heads."

That Vincent produced a series of still lifes in November and December was not only the result of the necessity of staying indoors. While working on the study of the water mill at Gennep, near Eindhoven, he found "a new friend" from that town. That new friend, a tanner named Anton Kerssemakers, later published his recollections of his contact with Vincent in the newspaper *De Amsterdammer* (14 and 21 April 1912). He wrote: "At the time, instead of having the walls of my office covered with wallpaper, I was engaged in painting a number of landscapes on them, and my house painter, who furnished me with colors, thought this so nice that one day he brought Van Gogh along to show him my work. [This house painter happened to be the owner of the shop where Vincent bought part of his paints.] Van Gogh was of the opinion that I could draw reasonably well, and kind-heartedly, as was his way, he at once showed himself willing to help me on with my painting." Vincent advised Kerssemakers first to do a number of still lifes instead of landscapes. He explained that there was a lot he also had to learn himself, and he was prepared to work on the same subject as Kerssemakers. The result was that he not only tried to help his pupil "for days and even weeks on end and with the utmost patience," as Kerssemakers remembered it, but produced almost an entire series of still lifes himself.

Kerssemakers was not the only one for whom Vincent acted as teacher. In the letter preceding the one in which he mentioned a "new friend," he wrote, "I now have three people in Eindhoven who want to learn to paint, and whom I am teaching to make still lifes" (letter 385). One of the three students was the ex-goldsmith Hermans, who sometimes lent from his rich collection of antiques objects for the still lifes. The third was Willem van de Wakker, whom Dr. Benno J. Stokvis quoted extensively in an article written after the publication of his Brabant researches in 1926.[67] Evidently Vincent wanted to make some money, but this was not his main goal: "I intend to make these people gradually pay, not in money, but by telling them, You must give me *tubes of paint*. For I want to paint a lot—continually, and I want to manage so that I no longer need work at *half speed*, but can paint from morning till night"

Anton Kerssemakers, 1846-1924.

[67] Published in *Opgang* under the title "Nieuwe nasporingen omtrent Vincent van Gogh in Brabant" (January 1927).

(letter 386). The expense for paint was Vincent's greatest burden in this period of continual production. It is not astonishing that Van de Wakker asked him one day, "How is it, do you really always pay this fellow Baaiens for his paint?" and was answered, "Up till now I do, but when it would not be possible for me anymore I would not mind stopping; the fellow has made enough money on me." That, in any case, is the story Benno Stokvis heard from Van de Wakker.

Van de Wakker's recollections tell much about Vincent's working methods, even more than his article does. According to Van de Wakker, Vincent was not an easy teacher. Stokvis quotes him as saying, "He was sarcastic and did not hesitate to use strong language when errors were made or the pupil had not brought enough material." His pupils, however, admired both his enormous love of work and inexhaustible readiness to help. "He did not like unnecessary talk. Once he had started working he did not stop before he had finished what he had in mind. He worked very fast, with forceful, wide brush strokes. He never corrected anything or came back to the same spot of the canvas."

Willem van de Wakker's recollections.

While Vincent still felt himself to be a pupil of the great masters, he was well aware of his independent status as an artist. Van de Wakker wrote:

> When his pupils pointed out to him that what he did was contrary to academic techniques, he became hot-tempered and shouted, "I scoff at your technique!" What counted most for him were tone and relations of tone. He never drew his subjects first, but immediately grabbed his brush, by preference a wide one, and put directly onto the canvas what he wanted to render. He often worked with his nails and fingers. But he always used to take measurements carefully, because he considered that a first necessity. He often said: "I have my whole elementary knowledge from my pocket knife. That I have put down in all kinds of ways and that teaches you things."

He sometimes took his pupils outside, and they learned from his intensive observation of nature. Kerssemaker draws an amusing portrait of the young painter, his unintentional originality, his unorthodox form of religiousness, and his total indifference to the opinion the villagers expressed about his eccentric behavior.

> Whenever he saw a beautiful evening sky, he went into ecstasies. . . Once, when we were tramping from Nuenen to Eindhoven, he suddenly stood stock-still before a glorious sunset, and using his two hands as if to screen it off a little, and with eyes half-closed, he exclaimed: "God bless me, how does that fellow—or God, or whatever name you give him—how does he do it? We ought to be able to do that too. My God, my God, how beautiful that is! What a pity we haven't got a prepared palette ready, for it will be gone in a moment. Do let us sit down for a minute. Take care you never forget to half-shut your eyes when you are painting in the open air. Once in a while those clodhoppers in Nuenen say that I am mad when they see me shuffling about over the moor, or stopping to crouch down in a half-sitting position, every now and then screwing my eyes half-shut, holding up my hands by my eyes, now in this way, now in that, in order to screen things off. But I don't give a damn about that, I just go my own way."

188

All of Vincent's students agreed that he was extremely frugal. "In those days he lived like a true poor Bohemian," Kerssemakers wrote, "and more than once it happened that he did not see meat for six weeks on end, always just dry bread with a chunk of cheese." When Van de Wakker's mother invited Vincent for dinner, he looked at the laid table and heatedly asked: "What's the meaning of that? Has this food been put out for me? The only thing I always eat is a chunk of bread. I don't eat that nice food."

While working with his pupils Vincent produced a good number of pictures. Thirteen still lifes are known that he must have done in this period, all showing simple objects such as bottles, stone jars, beer jugs, pots, white earthen bowls, etc., placed in different groups. When Vincent made another series of still lifes a year later, he arrived at more interesting compositions, but in this first group one is struck by the loving care with which he rendered the simple objects and their dull or shining surfaces. Most of these studies are quite dark, their main colors are reddish-brown, dark green or gray, with sometimes only a small white bowl fringed with yellowish-green as a lighter note. Although 1884 still lifes certainly do not belong to Vincent's most important work, they are a distinct expression of his personality: his stubborn devotion to one subject in a series of attempts, his deep absorption in the simplest objects, and his rejection of aesthetic effects.

In the months that Vincent concentrated on a series of still lifes with his pupils, he began another group of studies which was to become even larger than the last. At the end of October 1884, he conceived the plan to go to Antwerp, hoping to have some success with portraits. He had drawn heads of people in The Hague, "But," he wrote to Theo, "if I paint some thirty studies of heads here first I shall be able to get more out of Antwerp," and with his usual spirit of enterprise he added, "and I am starting on those thirty heads now, or rather I have already done so by painting a large bust of a shepherd" (letter 383). By the time he wrote his next letter, the number had increased. "To get more experience I must paint fifty heads, because right now I am hitting my stride. As soon as possible, and one after the other" (letter 384). Such a goal would seem impossible, but not for Vincent. By the end of winter, he had painted at least forty-five heads (not including ones that have disappeared such as the "bust of a shepherd") and drawn many others. A small sketchbook of this period has been preserved which contains a number of preliminary studies of heads.

The Quarrel with Theo Flares Again

Vincent's relentless productivity also had its drawbacks; it cost a great deal of money, a fact which caused great tension between the Theo and Vincent. A short passage in a letter of November 1884 aptly expresses Vincent's worries: "Do you realize that at present my expenses amount to two guilders a day; take one guilder for models and one for canvas, colors, etc.—I cannot do it cheaper—I still have some bills to pay and—I have to go to Antwerp" (letter 386b). It is not difficult to see that he could not possibly manage with the 150 francs a

"In those days he lived like a true poor Bohemian," Kerssemakers wrote, "and more than once it happened that he did not see meat for six weeks on end, always just dry bread with a chunk of cheese."

month from Theo, which amounted to two and one half guilders a day. He was ready to leave Nuenen, but that was simply impossible, because there at least he could save a little on his food and his lodging. Yet he hated to take advantage of his parents. "At home—even though there are no rows—they do not think the prospect of my staying here *too* long very cheerful. Which I can well understand" (letter 386b).

Lack of money was not the only and probably not even the main reason for the polemics with Theo. In letters from September and October Vincent examined the differences that existed between them from a more fundamental side. He came to the conclusion, and rightly so, that the difference between them was a "tragic" one rather than one for which they were themselves alone to blame. In his characteristic way he used a metaphor based on a work of art. He reminded Theo of the painting by Delacroix, sometimes referred to as *la Barricade*, to make him realize that they were in different camps, on opposite sides of a (mental) barricade, just like the parties of 1848 who fought with a real barricade between them. (The painting by Delacroix he had in mind, however, referred to the revolution of 1830, not 1848.) The opponents of those days, he said, were Guizot (the Protestant historian-minister, who had fought against democracy) and Louis Philippe on the one hand, and Michelet and Quinet (both democratic historians) on the other. Vincent's judgment was probably not incorrect when he wrote: "Much has happened since then. But my opinion is, if you and I had lived then, you would have been on the Guizot side, and I on the Michelet side. And both remaining consistent, with a certain melancholy, we might have confronted each other as direct enemies, for instance on such a barricade, you before it as a soldier of the government, I behind it as a revolutionary or rebel" (letter 379).

Vincent hoped that what he said in a figurative sense would be understood as such."Try to know for yourself where you really belong, as I try to know for myself." When Theo treated it all as "exaggerated" and wrote that what Vincent had called a barricade was nothing but a narrow ditch, Vincent did not relent. "As to what I call barricade and you call ditch, it can't be helped, but there is an old civilization that, in my opinion, is declining through its own fault—there is a new civilization that has been born, and is growing and will grow more. In short, there are *revolutionary* and *anti-revolutionary* principles. Now I ask you whether you yourself have not often noticed that the policy of wavering between the old and the new isn't tenable? . . . Sooner or later it ends with one's standing frankly either on the right or on the left" (letter 381).

Their paths seemed to diverge more and more. Vincent may have been especially grieved because Theo had said that his art had not improved; this, at any rate, is what may be deduced from a passage in a letter, which dates from the end of September: "You are stuck with G[oupil] & Co. G. & Co. will certainly not do anything with my work for years to come. In the meantime, I ask you, is it possible for me to reconcile myself to making absolutely no progress, which is what you want to make me believe?" (letter 380).

"We might have confronted each other as direct enemies, for instance on such a barricade, you before it as a soldier of the government, I behind it as a revolutionary or rebel."

As Vincent now believed that Theo only wished to be view his work as a "protector"—in other words that he was not willing to fight for it, though ready to give him money—he concluded that it was in both their interests to part as good friends. He said so in plain, though rather bitter words:

December 1884: The situation between the brothers becomes explosive.

> Your position—isn't this true?—does not admit of our association with each other intimately, frequently, cordially. Your position—to mention only one thing by way of example—would not admit of my going to live at your house in Paris, let's say, either with the intention of studying or for financial reasons. . . . For—against my person, my manners, clothes, words, you, like so many others, seem to think it necessary to raise so many objections . . . that they have caused our personal, brotherly intercourse to wither and die off gradually in the course of the years. To this must be added my past, and that at G. & Co. you are much in favor and I am the black sheep and a *mauvais coucheur* (letter 386a).

Speaking of "parting" was easy, but parting without any form of income was impossible; therefore, Vincent made one proviso: "Separate, but in peace, and *without forcing things too much*" (letter 388). Money remained the all-important issue, and he protested emphatically when Theo pressed him to leave Nuenen. "For pity's sake, how is it possible that you do not seem to be able or willing to understand that by fixing up my studio here and keeping it here for the present, I have made it possible to have money enough for painting, and if I had done otherwise, it would have been a failure for myself as well as for others. If I had not done so, I should have had to drudge at least three more years before I had definitely overcome the difficulties of color and tone, just because of the expenses."

Theo's generosity is verified by his response to this urgent appeal; he sent money. Vincent showed his gratitude, stressing that much depended on his working hard during the winter months when it was easier to get models. Yet in a letter from January of 1885, Vincent summed up his hardships in clear terms: "I've hardly ever begun a year with a gloomier aspect, in a gloomier mood, and I do not expect any future of success, but a future of strife. It is dreary outside, the fields a mass of lumps of black earth and some snow, with mostly days of mist and mire in between, the red sun in the evening and in the morning, crows, withered grass, and faded, rotting green, black shrubs, and the branches of the poplars and willows rigid, like wire, against the dismal sky" (letter 392). Despite his financial problems Vincent finished 125 or 150 drawings and paintings in 1884. Although he probably was unaware of the actual number he completed, his self-esteem must have been considerably strengthened by his achievement. This may explain how the revolt against Theo grew to such dangerous proportions.

The first months of 1885 brought little change in his living circumstances or his work. He went on with his series of heads, and expanded this field of study somewhat by concentrating equally on *hands*. "I am working at various heads and hands all the time," he wrote at the end of January, "I have drawn a number again" (letter 393). His persisted with the same theme because "whether people approve or do not approve of what I do and how I do it, I personally know no other way than to wrestle with nature long enough for her to tell me her secret."

"Whether people approve or do not approve of what I do and how I do it, I personally know no other way than to wrestle with nature long enough for her to tell me her secret."

Early in 1885, a tragic occurrence brought the brothers nearer for a moment, literally and figuratively. It was the sudden death of their father. Jo van Gogh-Bonger's Memoir to the *Complete Letters* describes what happened. After quoting from the Reverend Van Gogh's letter of 25 March, Jo wrote, "Two days later, coming home from a long walk across the heath, he fell down on the threshold of his home and was carried lifeless into the house." She made a mistake in the date (he died on 26 March, not on 27), but there can be no doubt about her description of the occurrence itself. Although the Reverend Van Gogh had turned sixty-three in March 1884, he had not been ill, and so his death must have come quite unexpectedly. Theo came from Paris, meeting his brother for the first time since the previous August. It gave him the opportunity to see the numerous studies that Vincent had made since that time. The letters do not say what he thought about them, but his impressions cannot have been unfavorable as he took several of the studies back to Paris.

Vincent's letters do not contain any sentimental meditations about their father and his death, not only because in the last few years the relationship with his father had left much to be desired (he was not used to writing in a sentimental way in any case!), but also because the brothers had ample opportunity to talk about their father in the days around the funeral. That the death affected Vincent is suggested by the fact that one of the first studies he did after the funeral was a still life of honesty in an earthenware pot. "In the foreground are Father's tobacco pouch and his pipe," he wrote to Theo. "If you care to have it, you may of course" (letter 398). Unfortunately the painting has not been preserved, but the sketch reproduced in the *Complete Letters* shows its general composition.

To Vincent's mother the blow was very hard. She was allowed to remain in the parsonage for another year, but the period of forty-four years in which her husband had been the center of her existence came to an abrupt end. To Vincent the death of his father also meant an important change. It made him decide to leave his parents' home in Nuenen altogether. However, moving to his studio in Mr. Schafrat's house also caused new problems. "Of course you will understand that it isn't for my own pleasure that I shall go and live in the studio. It makes things more complicated for me again, but I am quite sure that it is better for the others if I leave. Especially in view of Mother's intention to take in as a boarder somebody who wants to stay in the country for his or her health, if it can be done—or, if this should not prove so easy, they will at all events be freer in the matter of receiving guests, etc" (letter 398). It was not only for his Mother's sake that he decided to move, as he frankly admitted in a following letter: "I think I shall move by the first of May. Though, of course, I am on good terms with Mother and the sisters—yet I see and feel it is better so, for in the long run it would hardly be possible to live together. For which I can blame neither them nor myself personally, but rather the incongruity of ideas between persons who want to maintain a certain rank and a peasant-painter who does not think of such things" (letter 400).

In 1886 Vincent's mother moved to Breda with her unmarried daughter Wil. In 1889 she moved from there to Leyden—again with Wil—where she died in 1907.

192

THE PEASANT-PAINTER

48
Farmers at a Meal, *first sketch for*
The Potato-Eaters, *early 1885. Black chalk,
JH 666, F 1168.*
*Vincent van Gogh Foundation / National
Museum Vincent van Gogh, Amsterdam*

At the same time Vincent was considering the move to Mr. Schafrat's house, he was engaged with his usual energy in the study which is always described as the main work of his Dutch years, if not as one of the main works of Dutch nineteenth-century art in general: *The Potato-Eaters.* The idea for the picture must have occurred to him while he was working on his series of heads of peasants, probably in February 1885, when he wrote, "Just now I paint not only as long as there is daylight, but even in the evening by the lamp in the cottages, when I can hardly distinguish anything on my palette, so as to catch, if possible, something of the curious effects of lamplight in the evening, with, for instance, a large shadow cast on the wall."

The precise history of this canvas has been extensively documented before; here only the main facts will be given. After an experiment with a group of four persons of which he did a pencil sketch, Vincent turned to oils and did a first sketchy version of the composition with five people (JH 734, in the Rijksmuseum Kröller-Müller in Otterlo); on another canvas he repeated this composition in a more carefully finished form (JH 764, now in the Rijksmuseum Vincent van Gogh in Amsterdam), all of this preceded by numerous pencil sketches of details and of the whole. The last version, which he did in his studio, "and for the greater part from memory," was practically finished at the end of April 1885 and was sent to Theo on 6 May (letter 404). It was an incredible achievement, considering the short time he spent on the whole exercise and especially on the final version, and it is interesting to see how he summarized the process in a letter dated the end of April: "Though the ultimate picture will have been painted in a relatively short time and for the greater part from memory, it has taken a whole winter of painting studies of heads and hands. And as to those few days in which I have painted it now, it has been a real battle, but one for which I feel great enthusiasm" (letter 404).

His own commentaries on the picture—certainly of great importance—have been quoted so often that the temptation is great to ignore them here. Yet there is one passage that cannot be missed as it illustrates his now strongly developed self-assurance. "I have tried to emphasize that those people, eating their potatoes in the lamplight, have dug the earth with those very hands they put in the dish, and so it speaks of manual labor, and how they have honestly earned their food. I have wanted to give the impression of a way of life quite different from that of us civilized people. Therefore I am not at all anxious for everyone to like it or to admire it at once" (letter 404).

49
Sketch in letter 399 after the painting of The Potato-Eaters, *April 1885.*

If these words already reveal the pride that he had developed his own unconventional style, the splendid metaphor he used as an introduction to the next paragraph is an even stronger declaration of self-confidence: "All winter long I have had the threads of this tissue in my hands, and have sought for the ultimate pattern; and if it has become a tissue of rough, coarse aspect, nevertheless the threads have been chosen carefully and according to certain rules. And it might prove to be a real peasant picture. I know it is. But he who prefers to see the peasants in a sentimental way may do as he likes. I personally am convinced one gets better results by painting them in their roughness than by giving them a conventional charm."

There is an incident in connection with the history of *The Potato-Eaters* which is important enough to be related here, because it had such a serious effect on his friendship with Anthon van Rappard. Even before he started on the last, definitive version of *The Potato-Eaters*, Vincent realized that he could give his brother an idea of the composition by making a lithograph of it. He had already elaborated on the thought when he wrote Theo on 13 April: "Today I went to Eindhoven to order a small lithographic stone, as this must become the first of a series of lithographs, which I intend to start again. . . . I intend to make a series of scenes from rural life, in short—*les paysans chez eux*" (peasants at home) (letter 400). Dimmen Gestel, a man to whom he had given painting lessons and who had a factory in Eindhoven that made cigar labels, lent him the stone for *The Potato-Eaters* (the plan for a whole series was

194

soon dropped). After having copied the composition onto the stone with lithographic chalk, which took only a short time, Vincent went back to Gestel's printing office to make a number of prints (JH 737). All his hope was now set upon a new relation with the art dealer Alphonse Portier, someone Theo knew well. (Portier lived in the same building at 54, rue Lepic where Theo was to move a year later.) Encouraged by Theo's first reaction to the lithograph, he wrote on 21 April: "By the same mail you receive a number of copies. Please give Mr. Portier as many as he wants" (letter 402).

Portier's opinion about the lithograph is not known, but Vincent's friend Anthon van Rappard, who had also received a copy, wrote an opinion so critical that Vincent was deeply offended and returned Van Rappard's letter immediately with these few words: "Amice Rappard, I just received your letter— to my surprise. You are herewith getting it back. Greetings, Vincent" (letter R 51). The quarrel was later resolved, but the friendship between the two men was never restored completely, and the correspondence probably ceased altogether not long after this incident. No letters from Vincent to his friend are known after September 1885.

Alphonse Portier, 1841-1902.

It is interesting to know what Van Rappard wrote, as the words had such radical consequences for the relationship:

> I hope I was mistaken in my opinion of your manner of working, and I hope so still; but for this very reason I was deeply sorry to see such a complete confirmation of my opinion in what you sent me that I myself was terrified by it. You will agree with me that such work is not meant seriously. Fortunately you can do better than that, but why then did you see and treat everything so superficially? Why didn't you study the movements? Now they are only posing. How far from true that coquettish little hand of the woman in the background is—and what connection is there between the coffee kettle, the table and that hand that is lying on top of the handle? (letter R 51a).

In the second half of his argument Van Rappard became quite unreasonable, for instance when he said that the man to the right had arms that were "a yard too long." Some of his remarks, however, such as the one about the coffee kettle, were valid points, something which is not surprising; after all, Van Rappard was a good painter and an excellent draftsman. It is true that the hastily done lithograph is far beneath the level of the definitive painting, but on the other hand, the "expressive" qualities for which Van Rappard had no understanding (strict realism being his highest ideal) had been strengthened rather than diminished in the final version of *The Potato-Eaters*.

Some of the changes Vincent made in the final version are difficult to explain. Of the two female figures, the woman behind the table seems to be the older in the sketch (JH 734); in the final version (JH 764) it is the woman with the coffee kettle who looks unmistakably older. The other woman seems to be more or less "idealized"—if one might use the term in connection with Van Gogh. He gave her the features of a young woman whose portrait he had done several times before, the thirty-year-old Gordina de Groot, generally called Stien de Groot (Vincent called her Sien). The painting was done in the little cottage of her mother, Cornelia de Groot; her father had died in 1883 and is not represented in the picture. As to the

young peasant's features, they had been made even uglier than in the lithograph, and certainly uglier than in the preparatory study Vincent had made of him, showing him sitting without the others at the table in the same posture (JH 689).

That Vincent aimed more at expression than at realism is also shown by his use of color. He first tried to render the color of the flesh by using yellow ocher, red ocher and white. But, he wrote Theo: "That was much, much *too light* and was decidedly wrong. What was to be done? All the heads were finished, and even finished with great care, but I immediately repainted them, inexorably, and the color they are painted in now is like *the color of a very dusty potato, unpeeled of course.*"

Vincent's enthusiasm in representing peasants had not yet been exhausted by painting and repainting *The Potato-Eaters*. No more than a week after sending the painted version to Theo he had another seven heads ready, and adding to his letter a sketch of one of them, a peasant woman with a white cap, he wrote, "I haven't yet made a head so much *peint avec de la terre*, and more will follow" (letter 409). "*Peint avec de la terre*" (painted with earth) was an expression he had found in A. Sensier's biography of Millet, one of his favorite books. Sensier had written about Millet's work, "*Son paysan semble peint avec la terre qu'il ensemence*" (roughly translated: With him, a peasant seems to have been painted with the earth in which he has sowed).

Vincent's thoughts were occupied at this moment by Emile Zola's novel about the miners, *Germinal*, a book that had just appeared and that Theo had sent to him (at his request). In a letter of mid-May he wrote: "I just received *Germinal*, and started to read it at once. I have read about fifty pages, which I think splendid; I once traveled through those same regions [in the North of France] on foot" (letter 409). When he announced a dozen new painted studies two weeks later, he added, "Among the latter you will find a head which I simply had to paint after reading *Germinal*" (letter 410). His description shows that he referred to a head in profile against a dark background (JH 785), a scene which in the book is described as "the flat plain of sugar-beet fields under that starless night, dark and thick like ink."[68] "Standing out against this," he went on, "the head of a *hercheuse* or a *sclôneuse* [a woman working in the mines] with an expression of a lowing cow."

One sees how far he had left "conventional sweetness" behind. The head is done accordingly, with heavy brushstrokes in very dark colors with bright stripes of light along the profile and on the cheek. The model was a girl with a bony, hollow face, whom he had painted several times before, but this time many features were sacrificed to expressiveness so that one might easily see in the painting the face of a *man*—an error that was in fact made in a catalogue some time ago. Other heads in this group were also done with heavy strokes of paint in dark brown, sea-green, dark red and white, for the most part left unmixed and rough. A typical example is the head of an older peasant woman with a white cap (JH 782). Zola's *La Terre* (Earth) had not yet been published—it appeared in 1887—but one could say that with the expressionistic stress

Alfred Sensier, La vie et l'oeuvre de J. F. Millet, *Paris, 1881.*

[68] In French: "*la plaine rase des champs de betteraves, sous la nuit sans étoiles, d'une obscurité et d'une épaisseur d'encre.*"

196

upon the "earthen" character of his models, Vincent anticipated the fierce accents of that novel.

His work did not prevent him from having an open eye for a different, more idyllic side of farm life. This is shown by some of the landscapes he did during these months. With the same shipment that included the Zola-inspired head, Theo received a study which Vincent indicated as *La Chaumière* (the hut), a small farmer's cottage with thatched roof in dark colors, but seen against an evening sky with bright stripes of light (JH 777). There are about ten other studies of this type of cottage, half hidden in the green—"human nests" as he called them—in which the stillness and strong bonds with nature.were expressed. Another painting, sent at the same time, represents the old tower in the fields behind the parsonage (JH 772) and expresses nothing but quiet and peacefulness. Vincent himself referred to it as *The Old Churchyard*. However imposing the picture plane is, filled by the heavy tower, to Vincent the real subject of the painting was the little churchyard at its foot. The poetic meditation he devoted to this study when writing to Theo is worth quoting, both for its sensitive wording and for the characteristic view on life and death it contains;

> I have omitted some details—I wanted to express how this ruin shows that for ages the peasants have been laid to rest in the very fields which they dug up when alive—I wanted to express what a simple thing death and burial is, just as simple as the falling of an autumn leaf—just a bit of earth dug up—a wooden cross. The fields around, where the grass of the churchyard ends, beyond the little wall, form a last line against the horizon—like the horizon of the sea. And now this ruin tells me how a faith and a religion moldered away—strongly founded though they were—but how the life and the death of the peasants remain forever the same, budding and withering regularly, like the grass and the flowers growing there in that churchyard.
>
> "*Les religions passent, Dieu demeure*" [Religions pass away, God remains], is a saying of Victor Hugo whom they also brought to rest recently (letter 411).

There are not many passages in the letters where Vincent so clearly formulated his thoughts about the "moldering away" of religion. He had developed these convictions within a couple of years, no doubt under the influence of his intensive reading of authors such as Jules Michelet, Thomas Carlyle (whom he often mentioned in one breath with Michelet), Ernest Renan, Victor Hugo and others. To his friend Van Rappard he sometimes wrote about these thoughts, as in a letter of March 1883. "At the moment I am reading [Carlyle's] *Sartor Resartus*—the philosophy of old clothes. Among the 'old clothes' he includes all kinds of forms and in the matter of religion all dogmas; it is beautiful—and faithful to reality—and humane. There had been a lot of grumbling about this book, as about his other books. . . . He has learned much from Goethe—but still more, I believe, from a certain man who did not write books, but whose words, though he did not write them down himself, have endured—namely Jesus" (letter R 30).

In the passage quoted above, Vincent spoke of the old tower as "that ruin." This was not only because the heavy tower was all that remained of a medieval church, but also because the

Jules Michelet, 1798-1874.
Thomas Carlyle, 1795-1881.
Ernest Renan, 1823-1892.

197

tower itself was in the process of being torn down. "The old tower in the fields will be pulled down next week. The spire had already gone. I'm working on a picture of it" (letter 408). This was painting JH 772, in which one sees the tower, in fact, without the spire. The demolition resulted in several pictures. There had been an auction of wood and slate and old iron, including the cross that had crowned the spire, and all this activity had inspired Vincent to do a watercolor (JH 770) and a number of fascinating drawings in black chalk, made as preliminary studies.

In June 1885 Vincent started on a series of drawings of the harvest. In the second half of that month he wrote Theo, "Recently I have been very busy drawing figures; I will send them especially for Serret's sake to show him that I am far from indifferent to the total aspect of a figure and its form" (letter 413). Charles E. Serret was a Paris painter who was now—next to the art dealer, Portier—the man of whom Vincent had the greatest expectations since he had heard from his parents that Serret had ventured a favorable opinion about his work.

Vincent's studies and efforts in the fields had been going on for some time, and in July he wrote Theo a long letter, putting down all the thoughts that had arisen in him as a result of this kind of activity. He contrasted his work to the historic or exotic-romantic genre which at the time was so popular. In every town of some importance, he joked, there seems to be an academy "with a choice of models for historic, Arabic, Louis XV, in short, all *really non-existent figures*" (letter 418). But, he said, an academy "where one learns to draw and paint a digger, a sower, a woman putting the kettle over the fire or a seamstress" does not exist. And clearly in defense of his own preferences, he continued, "Nothing seems simpler than painting peasants, rag pickers and laborers of all kinds, but no subjects in painting are so difficult as these commonplace figures!"

Most important in this letter is his attempt to forestall the expected objections to his work due to his disregard for "academic correctness;" on the contrary, he did not consider this to be "the essential quality of modern art." Serret, the far-away, unknown, but favorably-inclined critic, he thought, should now be influenced and convinced. "When I send you and Serret some studies of diggers or peasant women weeding, gleaning, etc., as the beginning of a series of all kinds of labor in the fields, then it may be that you or Serret will discover faults which will be useful for me to know, and which I may easily admit myself." But he continued to stress that faultlessly drawing figures was not the main thing. Figures by a Millet, a Régamey, a Daumier, may have been well put together, "but, after all, in a different way than the academy teaches." What really mattered was life, was action. And so, writing on in an attempt to clarify things for himself, he ended up by putting all his cards on the table in defense of the non-academic, the incorrect, as part of the ideal that he vaguely had in mind. He did this in a passionate passage which may not have impressed Theo or people like Portier and Serret, but which certainly is of great importance to later readers. Vincent's own commentary to the splendid drawings of the summer of 1885 was:

"Nothing seems simpler than painting peasants, rag pickers and laborers of all kinds, but no subjects in painting are so difficult as these commonplace figures!"

It is not yet well expressed. Tell Serret that *I should be desperate if my figures were correct,* tell him that I do not want them to be academically correct, tell him that I mean: If one photographed a digger, *he certainly would not be digging then.* Tell him that I adore the figures by Michelangelo though the legs are undoubtedly too long, the hips and the backsides too large. Tell him that, for me, Millet and Lhermitte are the real artists for the very reason that they do not paint things as they are, explored in a dry analytical way, but as they—Millet, Lhermitte, Michelangelo—feel them. Tell him that my great longing is to learn to make those very incorrectnesses, those deviations, remodelings, changes in reality, so that they may become, yes, lies if you like—but truer than the literal truth.

The numerous drawings of peasants in action Vincent produced that summer (about seventy have survived) can be said to surpass almost everything he had done as a draftsman so far. Most of them show peasant women bending deep down while gleaning or pulling out carrots, and they are characterized by a monumentality and a sureness of line and of a depiction of light and shade that is new in his work. This thought that Theo might show the drawings to Portier and Serret (or that he might send them to Serret directly) must have caused him to annotate some in French. He did this, for instance, in June, when he considered sending Serret some of his work. Two drawings are annotated "*planteuse de betteraves Juin*" (woman planting beets, June), others "*planteuse de pommes de terre*" or "*arracheuse de pommes de terre*" (woman planting potatoes and woman digging up potatoes). Serret's reaction had probably not been especially favorable; in any case, there is no echo of it in Vincent's letters. Worse is that Theo did not seem to have had much appreciation for Vincent's work of this summer either. Although Theo had written to his parents in June that Serret had found "much that was good" in Vincent's studies (up to then Serret can only have seen *The Potato-Eaters* and a few other painted studies). Theo did not mention his own opinion.

It is unfortunate that the facts lead to the conclusion that at this point Theo lacked an appreciation for and insight into Vincent's work and its possibilities. This becomes especially evident in the passages in the letters regarding Theo's visit to Nuenen in August 1885. Just as in previous years, Theo made a business trip to The Netherlands that month and visited his parents' home, this time also spending a few moments at Vincent's studio at the Schafrats'. Immediately after this visit, which took place on 6 August, Vincent wrote him a long letter, trying to come to grips with the things they had discussed. Their talk, he said, had left him "utterly disconsolate," and even though this may principally refer to the fact that he could not be sure of sufficient financial help from Theo for the future, it also suggests that Theo did not have a very high opinion of his progress.

The main purpose of Vincent's letter was urgently to repeat the appeal he had made to Theo that afternoon, namely, not to stop providing him with the financial backing for his work, even though Theo himself was expecting to have a difficult year ahead of him. "With this letter," he explained, "I cry out to you once more that my request for reinforcement may prove to be in

August 1885: Theo visits his brother.

199

both our interests and that I do not make it out of selfishness as you suppose." With one of his curious Homeric comparisons he conjured up the image of two ships, a large one and a small one, both of which were vulnerable:

> The hint I wanted to give you was this: don't consider this painting business of mine a burden, and don't treat it in a stepmotherly way, because the little boat may prove to be a lifeboat when the big ship is wrecked. My hint is now, and will be in the future: let's try to keep the little boat trim and seaworthy, whether the tempest comes, or my uneasiness proves unfounded. At present I am a tiny vessel that you have in tow, and which at times will seem to you so much ballast. But this—I mean the ballast—you may leave behind by cutting the towrope, if you like. But I, who am the skipper of the tiny vessel, ask in this case that—far from having the towrope cut—my little boat be kept trim and well-provisioned, in order that it may do better service in times of need (letter 419b).

The request had little effect. Theo was apparently not willing, or able, to increase his subsidy. In any case he did not send more than the usual 150 francs either in September or October; the November amount is not mentioned in the letters. The only sum he sent over and above the normal monthly payment was twenty francs, when Vincent had asked him three times to send something extra (see letters 415, 420 and 421). This extra amount was needed to pay for the cost of sending a number of studies to The Hague, where one of his paint dealers, a Mr. Leurs in Molenstraat, had offered to display them in his windows.

Although Vincent's financial situation was close to disastrous, it had little adverse influence on his productivity. He had already finished a great number of drawings of the wheat harvest and other activities in the fields. However, a new obstacle threatened to bring his work to a halt altogether. In a letter of early September he mentions something about a comic, but to Vincent utterly disagreeable, entanglement. "These last two weeks I have been worried by the Roman Catholic priests, who told me, evidently with the best intentions and feeling obliged like all the others to meddle with it, that I ought not to get too familiar with people below my rank; expressing themselves to *me* in these terms, but using quite a different tone toward "the people of lower rank," namely threatening them that they should not have themselves painted" (letter 423).

This story would be less surprising if Vincent had ever asked the peasants to pose nude, but from what is known, he never thought of making nude studies during the Nuenen years. The impossibility of doing such a thing in this Brabant village was one of the reasons he eventually thought of moving to Antwerp. In this predominantly Roman Catholic community, the small Protestant group occupied a very distinct place, and the priests must have been quite suspicious of the strange parson's son with his unconventional behavior. Moreover, there now was a concrete reason for their attack. "A girl I had often painted was with child, and they suspected me, though I was innocent. But I had heard the real state of affairs from the girl herself, and as it was a case in which a member of the priest's congregation at Nuenen had played a very ugly part, they cannot, at least for this once, get at me" (letter 423).

According to other sources, the pregnant peasant's daughter was Gordina de Groot, whom Vincent had indeed portrayed more than anyone else, and this fact could not have passed unnoticed in the village. Vincent reminisces on the incident in one of his later letters, in which he even mentions her name. In the letter to his sister Wil, written in 1887 when he was in Paris, he asked her: "You would please me greatly by letting me know how Margot Begemann is, and how things are with the De Groots; how did that affair turn out—did Sien [Gordina] marry that cousin of hers? And did her child live?" (letter W 1). It is evident that this cousin was the father of the child she expected in September 1885, and Vincent did everything he could to defend himself against the accusation that he was the father. "I simply told the Burgomaster at once, and pointed out to him that it was a thing that did not concern the priests at all, who have to keep to their own territory or more abstract things. At all events, they stopped their opposition for the moment and I hope it will remain so" (letter 423).

Yet the suspicion hampered him seriously in his work, for he wrote, "But I could by no means get anybody to pose for me in the fields these days," even though not all the farmers let themselves be intimidated so easily. "The priest even went so

far as to promise the people money if they refused to be painted; but they answered quite spiritedly that they would rather earn money from me than beg some from him." Considering the potential for a scandal, in September Vincent wisely turned back to still lifes. They must have kept him busy the whole month, for there are at least twenty that must date from this period. Some are composed of simple domestic objects resembling the still lifes of the year before—earthenware jugs, a ginger pot, a copper kettle, combined with a few onions or potatoes. An entire group, however, represents subjects exclusively connected with peasant life—bowls or baskets filled with vegetables, fruits, and above all, potatoes. While in a few of the still lifes the aim seems to have been a more or less "aesthetic" composition, like the one with two small jars and two pumpkins (JH 921) or the one with the big copper kettle and one jar (JH 925), the others do not pretend to be anything but the modest subjects belonging to the rural life of which he wished to be the interpreter. As far as the pictorial side of this group is concerned, he gives an indication of his aim in a letter of October. "You will receive a big still life of potatoes, in which I tried to get *corps*, I mean, to express the material in such a way that they become heavy, solid lumps—which would hurt you if they were thrown at you, for example" (letter 425). Curiously enough, his endeavor to give "solidity" to his objects paralleled what Paul Cézanne was doing at that moment in the south of France.

In the same letter Vincent reported that he was working on still lifes of birds' nests, of which he had finished four (there are five canvases altogether of this subject). "I believe," he wrote, "that because of the colors of the moss, the dry leaves and the grasses some people who are good observers of nature might like them"; however, it was probably personal interest rather than sales that caused him to paint this subject. He had a large collection of nests and had just sent some to Van Rappard, probably as a friendly gesture, now that their quarrel had been settled. In the last letter of their correspondence to be preserved, he wrote: "I sent a basket containing birds' nests to your address today. I have some in my studio too, quite a collection, and I am sending some of which I have doubles. They are nests of the thrush, the blackbird, the golden oriole, the wren and the finch. I hope they will arrive safe and sound" (letter R 58). Most of his pictures of nests are of a very dark color. In the course of time they have probably become much darker as a result of his use of bitumen and bistre,[69] colors of which Vincent was fond, but in any case he had deliberately made the backgrounds very dark. He explained to Theo, "Well, the birds' nests were also purposely painted against a black background, because I want it to be obvious that the objects do not appear in their natural surroundings, but against a conventional background" (letter 425).

In a book that reveals an intimate understanding of Vincent's inner life, *The Symbolic Language of Vincent van Gogh* (1963), H. R. Graetz comments on the deeper meaning of these still lifes. "His keen interest in such nests, with their deep dark holes, is another intimation of his somber mood at

September 1885: A second series of still lifes.

[69] Bitumen is a sort of asphalt, formerly used in painting. Bistre is a yellowish brown to dark brown pigment.

the time he chose them as a subject. Indeed, deep in his heart, he always looked for a nest—a home, and never really found one." It is not difficult to agree; in letter 425, Vincent himself said that the nests made him think of the "human nests—the huts on the moor and their inhabitants."

Farewell to Nuenen

In October 1885, a most welcome interruption occurred in Vincent's daily life, something which would occupy his thoughts for a long time: with his friend from Eindhoven, Anton Kerssemakers, he made a trip to Amsterdam. It did not happen totally unexpectedly; plans for it had been made long before, but on account of the expenses he had put the trip "off and off," he said. Now, about 10 October, he could write Theo: "This week I have been to Amsterdam. I barely had time to see anything but the museum. The trip lasted three days; I went on Tuesday and came back on Thursday [from 6 to 8 October]. The result is that I am *very glad* that I went in spite of the costs, and I made up my mind not to go so long without seeing pictures" (letter 426).

The recollections that Anton Kerssemakers published in 1912 are well worth quoting, especially because they tell more about the trip than does Vincent's own letter to Theo, which is almost exclusively devoted to the paintings he saw. About the trip, Kerssemakers recalled:

October 1885: An excursion to the new museum in Amsterdam.

> As I was unable to spend the night away from home for domestic reasons, he went the day before and made an appointment to meet me the next day in the third-class waiting room of the Central Station in Amsterdam.
>
> When I came into this waiting room I saw quite a crowd of people of all sorts, railway guards, workmen, travelers, and so on and so forth, gathered near the front windows, and there he was sitting, surrounded by this mob, in all tranquillity, dressed in his shaggy ulster and his inevitable fur cap, industriously making a few little city views (he had taken a small tin paintbox with him) without paying the slightest attention to the loud disrespectful observations and critical remarks of the esteemed (?) public. As soon as he caught sight of me, he packed up his things calmly, and we started for the museum. Seeing that the rain was coming down in torrents, and Van Gogh in his fur cap and shaggy ulster soon looked like a drowned tomcat, I took a cab, at which he grumbled considerably, saying, "What do I care about the opinion of all Amsterdam, I prefer walking; well, never mind, have it your way."
>
> In the museum he knew where to find what interested him most; he spent the longest time in front of *The Jewish Bride*; I could not tear him away from the spot. He went and sat down there at his ease, while I myself went on to look at some other things. "You will find me here when you come back," he told me.
>
> When I came back after a pretty long time and asked him whether we should not get a move on, he gave me a surprised look and said, "Would you believe it—and I honestly mean what I say—I should be happy to give ten years of my life if I could go on sitting here in front of this picture for a fortnight, with only a crust of dry bread for food?" At last he got up. "Well, never mind," he said, "we can't stay here forever, can we?"

After that we went to Van Gogh's Fine Art Establishment, where at his recommendation I bought two books, *Musées de Hollande* and *Trésors d'art en Angleterre* by W. Burger (Thoré); when I asked him if he would go inside with me, he replied, "No, I must not be seen on the premises of such a genteel, rich family." He still seemed to be on bad terms with his family; he remained standing in the street, waiting for me.

In his next letter to Theo, Vincent described the studies he brought from Amsterdam: "The two small panels I did in Amsterdam were done in a very great hurry. One even in the waiting room of the station, when I was too early for the train, the other in the morning, before I went to the museum at ten o'clock. I will still send them to you; look upon them as 'Dutch tiles,' on which something is dashed off in a few strokes" (letter 426). More important is the passage in which he wrote about his admiration for the picture that had become his favorite among Rembrandt's paintings, *The Jewish Bride*: "*The Syndics* is perfect, is the most beautiful Rembrandt; but *The Jewish Bride*—not ranked so high—what an intimate, what an infinitely sympathetic picture it is, painted *d'une main de feu* [with a hand of fire]. You see, in *The Syndics* Rembrandt is true to reality, though *even there*, and always, he soars aloft, to the very highest height, the infinite; but Rembrandt could do more than that—if he did not have to be *literally* true as in a portrait, when he was free to be *poet*, which means creator. That's what he is in *The Jewish Bride*" (letter 426).

Next to Rembrandt, Vincent was especially fascinated by Frans Hals. Of a piece by Frans Hals and Pieter Codde he gave an extensive description, saying that it alone was worth the trip to Amsterdam, "especially for a colorist." He particularly admired the figure of the flag-bearer with its variations of gray, combined with the soft colors of the flag. ". . . That orange blanc blue fellow in the left corner. . . I seldom saw a more divinely beautiful figure. It is something unique. Delacroix would have raved about it, absolutely raved. I was literally rooted to the spot" (letter 426). It must have given him immense satisfaction to see that the seventeenth-century masters of the Rijksmuseum confirmed that he was not on the wrong track with the quick and heavy brushstrokes he had been using the last few months. "What struck me most on seeing the old Dutch pictures again is that most of them were painted quickly, that these great masters, such as a Frans Hals, a Rembrandt, a Ruysdael and so many others—dash off a thing as much as possible *de premier coup* [from the first stroke] and did not retouch it so very much. . . . To paint in one rush, as much as possible in one rush. What joy to see such a Frans Hals, how different it is from those pictures—there are so many of them— where everything has been smoothed down in the same way" (letter 427).

It is typical that Vincent, with his almost monomaniacal preoccupation with painting, wrote nothing in his letters about the new national museum building (the Rijksmuseum). Vincent knew well most of the pictures in the museum's collection from the days they were still to be seen in the Trippenhuis on Kloveniersburgwal, but only a few months before, on 13 July, the colossal new building on Stadhouderskade, designed by Pierre Cuypers, had been inaugurated with great ceremony.

"What struck me most on seeing the old Dutch pictures again is that most of them were painted quickly, that these great masters, such as Frans Hals, a Rembrandt, a Ruysdael and so many others—dash off a thing as much as possible de premier coup" *(from the first stroke).*

204

Neither the building, which had created such a stir in Amsterdam, nor the interior, seems to have made any impression on Vincent; the only thing he had an eye for was the paintings.

51
Wheatfield with Sheaves and a Windmill, *one of the last drawings Vincent did in Nuenen. 1885. Black chalk, JH 911, F 1319, 44.5 x 56.5 cm. Vincent van Gogh Foundation / National Museum Vincent van Gogh, Amsterdam*

The short period Vincent was still to spend in Nuenen—less than two months—was one of intense study of color problems, not one of extensive production, although the few paintings known from these weeks are among the most important of the Dutch years. In long letters to Theo he discussed ideas about color he had gradually developed under the influence of books like *Les artistes de mon temps* by Charles Blanc, and in October he sent him the still life that was the last and, for many reasons, the most important of the Nuenen still lifes (JH 946). It was announced in these words: "In answer to your description of a study by Manet, I send you a still life of an open—so a broken white—Bible bound in leather, against a black background, with yellow-brown foreground, with a touch of citron yellow" (letter 429).

Theo must have guessed that the study represented his father's Bible, a thought which was confirmed when Vincent used the words "a Bible which the people at home gave me for you" in his next letter. It must, however, have been a surprise to him when he unpacked the painting to discover that the "touch of citron yellow" was a book, too, namely Zola's *Joie de vivre*. The symbolism of this choice will not have been lost on him, and neither will the symbolism of the candlestick with the burned-out candle, as this was a well-known *memento mori* in seventeenth-century painting. Opposite the mighty open Bible, which represented the world of his late father, Vincent had placed the small book with the yellow cover and the defiant title, read so frequently that it was almost in pieces, as a telling symbol of his own preferred sphere.

Apart from its message, the aim of the picture was also to prove Vincent's ability as an artist at the moment he was planning to leave Nuenen; he clearly said so himself when writing about his latest work. "I painted this in one rush, in one

day. This to show you that when I say that I have perhaps not plodded entirely in vain, I dare say this because at present I find it quite easy to paint a given subject unhesitatingly, whatever its form or color may be" (letter 429).

Vincent cannot have realized that the yellow book was also a premonition of his own future, both because of the color and because of the connection with Paris. Whether he was conscious of the fact that the title of the French novel, although indicating a proud sort of program, also had an ironic and sarcastic ring to it (for how little joy of living had he experienced so far, and how little was the future going to have in store for him?)—is something that can only be guessed. What he probably did realize was that the picture announced a departure, though he did not know exactly when he was going to leave Nuenen. In any case, the decision was made some time in November. "Now is just the moment to break free for a while, as I have had those difficulties with my models and was going to move in any case" (letter 433). In spite of all his optimism, the influence of the gossip in the village was too strong to neglect altogether. "In this studio, just next door to the priest and the sexton, the trouble would never end, that is clear, so I am going to move."

His plan was to go to Antwerp, where he hoped to paint and sell views of the town. He also thought of the possibility of painting from the nude there, something he felt was absolutely necessary to improve his technique. "They would not want me at the Academy, nor would I want to go there—but—perhaps a sculptor, for instance (there surely must be a few living there), might be sympathetic." Theo was helpful; more than a week before the end of the month he sent part of the usual sum, and Vincent replied immediately: "Very many thanks for the fifty francs and your letter. You will easily understand that I shall leave next Tuesday, if you consider, first, that I am simply longing for it, second, that I risk getting stuck here with my work through lack of models, while working out-of-doors has stopped because of the cold" (letter 435). "Tuesday" was 24 November, so this is the date of his departure from Nuenen and of his arrival in Antwerp, which was only a few hours away by train.

The last pictures Vincent did in Nuenen were large autumn landscapes. Again, they were primarily color studies, as follows from Vincent's letter: "I am completely absorbed in the laws of colors. If only they had been taught to us in our youth!" (letter 430). And when he announced two of them, he described them accordingly in terms of color. "Shortly you will receive two studies of the autumn leaves, one in yellow—*poplars*—the other in orange—*oaks*." When writing about the next autumn study (JH 962), he stressed this side of his endeavors even more, and his words show a degree of satisfaction rare in Vincent's letters "Never before was I so convinced that I shall make things that are all right, that I shall succeed in calculating my colors, so that I have it in my power to make the right effect. This was havana, soft green and white (gray), even pure white, direct from the tube" (letter 431). It is worthwhile to read in Vincent's own words what happened with the painting as a result of his kind-heartedness and spontaneity.

Last evening something happened to me which I will tell you as minutely as I can. You know those three pollard oaks at the bottom of the garden at home: I have plodded on them for the fourth time. I had been at them for three days with a canvas the size of, let's say, that cottage and the country churchyard which you have. The difficulty was the three tufts of havana leaves, to model them and give them form, color, tone. Then in the evening I took it to that acquaintance of mine in Eindhoven, who had a rather stylish drawing room, where we put it on the wall (gray paper, furniture black with gold). . . .

Now, though that man had money, though he took a fancy to it, I felt such a glow of courage when I saw that it was satisfying, that, as it hung there, it created an atmosphere by the soft, melancholy harmony of that combination of colors, *that I could not sell*. But as he had a fancy for it, I *gave* it to him, and he accepted it just as I had intended, without many words, namely little more than, "The thing is damn good" (letter 431).

Anton Kerssemakers—because he was that "acquaintance from Eindhoven"—did not fail to acknowledge gratefully Vincent's gesture in his recollections, and referring to the talk they had at that occasion, he quoted a few words which show the confidence that Vincent had developed in his work at the end of his Dutch years. The words were certainly prophetic. "When I remarked that he had not yet signed it, he said he might do so some time or other, 'I suppose I shall come back someday, but actually it isn't necessary; they will surely recognize my work later on, and write about me when I am dead and gone. I shall take care of that, if I can keep alive for some little time.'" Later, the important canvas went from Kerssemakers' possession to the Rijksmuseum Kröller-Müller in Otterlo, Holland.

In his last letters from Nuenen, Vincent mentioned a large canvas which he described as "a view of the village behind a row of poplars with yellow leaves" (JH 959) (letter 434). It is an imposing painting, very colorful in spite of the fact that it represents an evening scene. "The horizon is a dark streak against a light streak of sky in white and blue. In that dark streak are little patches of red, bluish and green or brown, forming the silhouette of the rooks and orchards, the field greenish" (letter 434). It was a worthy farewell to the village he was leaving, and where he thought he would return to after spending a few winter months elsewhere. He was, however, never to see Nuenen again.

COLORPLATE 1. *Woman Sewing,* 1881. Charcoal, black chalk, watercolor, JH 70, F 1220, 44 x 30 cm.
National Museum Kröller-Müller, Otterlo, The Netherlands

COLORPLATE 2. *Peasant Woman*, 1885. Canvas on panel, JH 692, F 130, 45 x 36 cm.
Vincent van Gogh Foundation/National Museum Vincent van Gogh, Amsterdam

COLORPLATE 3. *Woman at a Table in the Café du Tambourin*, 1887. Oil on canvas, JH 1208, F 370, 55.5 x 46.5 cm.
Vincent van Gogh Foundation/National Museum Vincent van Gogh, Amsterdam

COLORPLATE 4. *Vase with Daisies and Anemones*, 1887. Oil on canvas, JH 1295, F 323, 61 x 38 cm.
National Museum Kröller-Müller, Otterlo, The Netherlands

COLORPLATE 5. *Portrait of a Woman with Carnations*, 1887. Oil on canvas, JH 1355, F 381, 81 x 60 cm.
Musée d'Orsay, Paris

COLORPLATE 6. *Pink Peach Trees, Souvenir de Mauve*, 1888. Oil on canvas, JH 1379, F 394, 73 x 59.5 cm.
National Museum Kröller-Müller, Otterlo, The Netherlands

COLORPLATE 7. *View of the Saintes-Maries,* 1888. Oil on canvas, JH 1447, F 416, 64 x 53 cm.
National Museum Kröller-Müller, Otterlo, The Netherlands

COLORPLATE 8. *Joseph Roulin, Sitting in a Cane Chair*, 1888. Oil on canvas, JH 1522, F 432, 81 x 65 cm.
Museum of Fine Arts, Boston

COLORPLATE 9. *Augustine Roulin (La Berceuse)*, 1888. Oil on canvas, JH 1655, F 504, 92 x 73 cm.
National Museum Kröller-Müller, Otterlo, The Netherlands

COLORPLATE 10. *Vase with Fourteen Sunflowers*, 1889. Oil on canvas, JH 1667, F 458, 95 x 73 cm.
Vincent van Gogh Foundation/National Museum Vincent van Gogh, Amsterdam

COLORPLATE 11. *Self-Portrait*, 1889. Oil on canvas, JH 1770, F 626, 57 x 43.5 cm.
John Hay Whitney Collection, New York

COLORPLATE 12. *Self-Portrait*, 1889. Oil on canvas, JH 1772, F 627, 65 x 54 cm.
Musée d'Orsay, Paris

COLORPLATE 13. *Portrait of a Farmer*, 1889. Oil on canvas, JH 1779, F 531, 61 x 50 cm.
The Peggy Guggenheim Collection, Venice

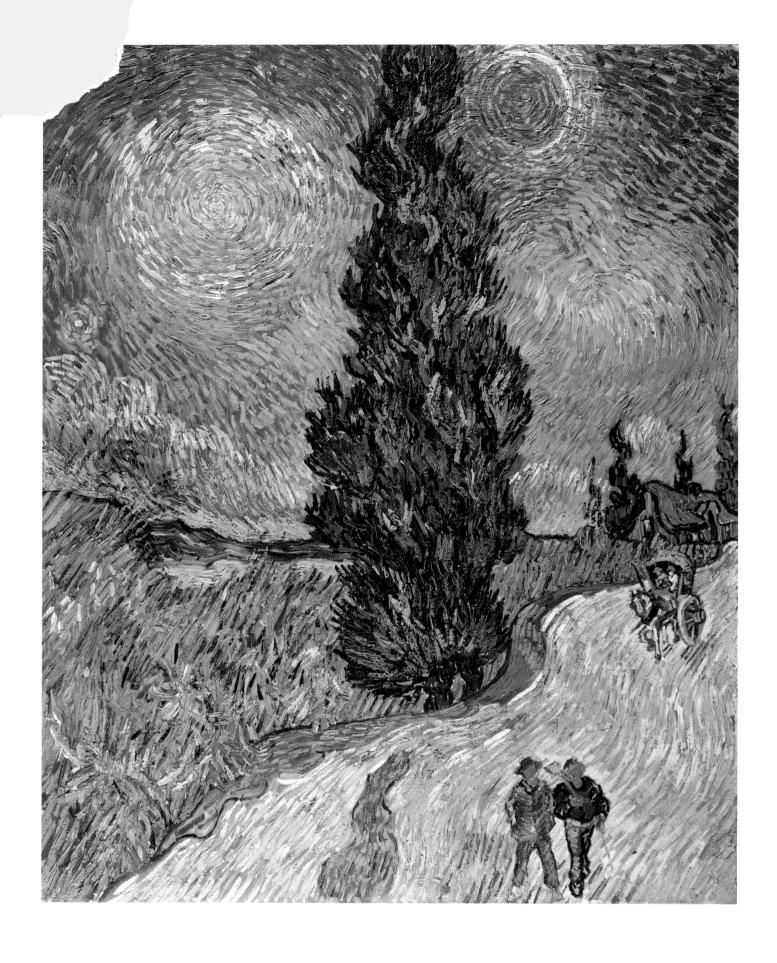

COLORPLATE 14. *Road with Men Walking*, 1890. Oil on canvas, JH 1982, F 683, 92 x 73 cm.
National Museum Kröller-Müller, Otterlo, The Netherlands

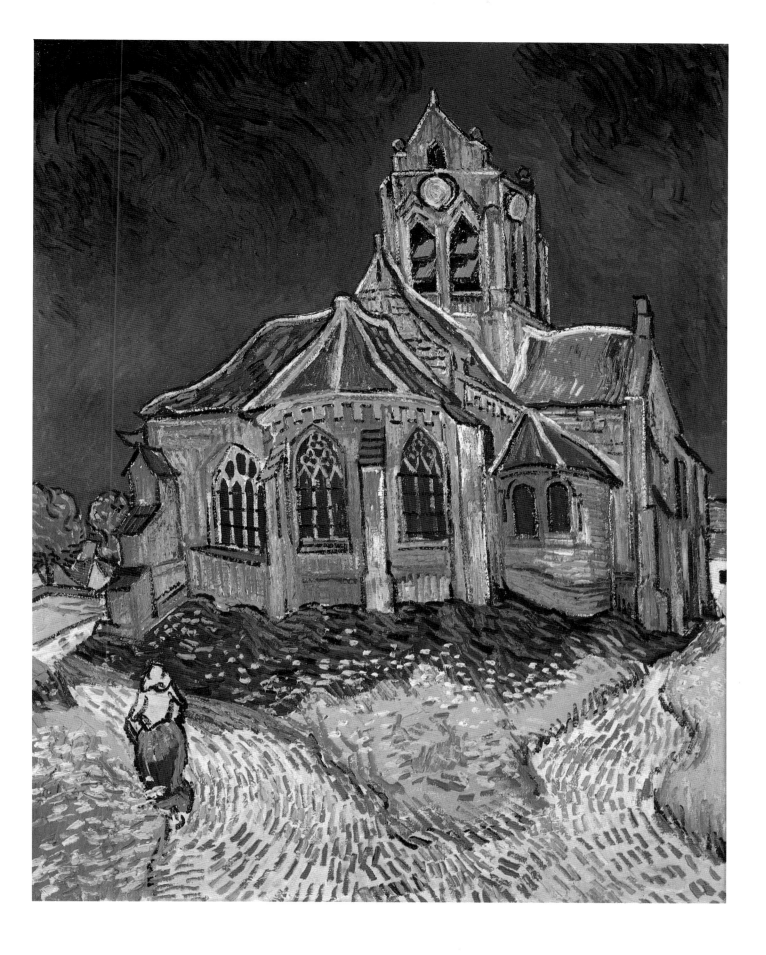

COLORPLATE 15. *Church in Auvers-sur-Oise,* 1890. Oil on canvas, JH 2006, F 789, 94 x 74 cm.
Musée d'Orsay, Paris

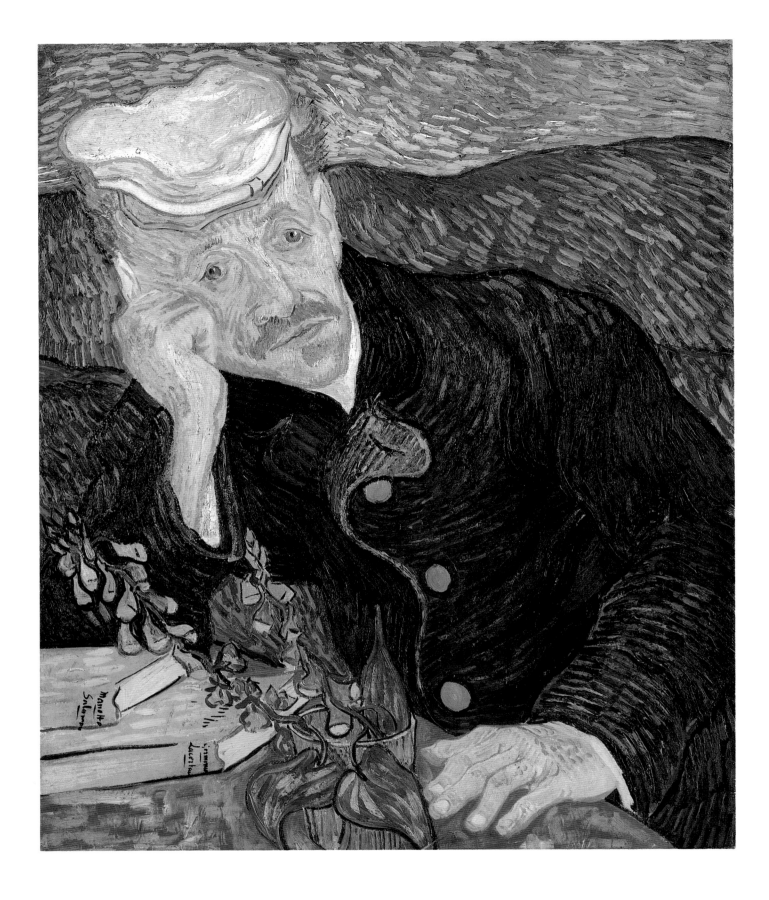

COLORPLATE 16. *Portrait of Dr. Gachet,* 1890. Oil on canvas, JH 2007, F 753, 66 x 57 cm.
Private Collection, New York

VINCENT IN ANTWERP

52
Houses in Antwerp, Seen from the Back;
*painting from 1885. Oil on canvas,
JH 970, F 260, 44 x 33.5 cm.
Vincent van Gogh Foundation / National
Museum Vincent van Gogh, Amsterdam*

Many details from Vincent's stay in Antwerp are known thanks to the numerous, long letters he wrote to Theo—no less than twenty-three in the short period of three months. It was an eventful time, very different from the quiet village life to which he had grown accustomed during the last few years. Upon leaving Antwerp, he would reflect that "after all" he had enjoyed life there and hoped to come back some time, "for life is rather free and artistic here, if one looks for it, more than anywhere else perhaps" (letter 458).

It was also a time of many hardships and great physical problems. It is evident that Vincent could not make ends meet with the 150 francs that Theo sent him monthly, and nowhere in the correspondence are the pleas for extra money as urgent as during these three months. About the middle of December he wrote that he had already started on his last five-franc piece, and it was a good thing that he had adopted the system of depositing some money with the baker at the beginning of each month in order not to be without food in the second half.

Yet in his next letter, around 19 December, he was obliged to write, "I must tell you that I am at the end of my rope; with my last remaining five francs I had to buy two canvases . . ., and the laundry woman had just brought me my clean linen, so that for the moment I have only a few centimes left" (letter 441). Before the end of December—that is between payment times— Theo sent his brother fifty francs, and he also sent an extra twenty-five francs in February 1886. Yet the need was great and frequent. In the second half of January Vincent wrote, "Therefore try, as I asked you, to send me another fifty francs, then I can keep going till the end of the month, and could buy a new pair of trousers and a waistcoat at once, and the coat in February" (letter 445).

The situation became critical around 18 February. "If you can send anything, even if it's only five francs, do so. There are still ten days left in the month, and how am I to get through them? For I have absolutely *nothing* left. Even at the baker's, *nothing*" (letter 456). Theo probably did what he could, but he evidently had financial problems himself. "You keep telling me that you have no money; all right, so that's a fact," Vincent concluded, using the fact as an argument to end his stay in Antwerp and come to Paris at an earlier date than Theo found desirable (letter 454). In the meantime, Vincent's state of health had become terribly impaired by these circumstances. His body was well trained by his daily work in the open, but, of course, it could not stand systematic undernourishment. "For you must realize that in the whole time I have been here now, I've only had three warm meals, and for the rest nothing but bread. In this way one becomes vegetarian more than is good for one" (letter 440).

Of course, there was no question of remedying the situation, as his fanatical urge for creative work was too strong. "Perhaps you will not be able to understand, but it is true that when I receive the money my greatest appetite is not for food, though I have fasted, but the appetite for painting is even stronger, and I at once set out to hunt for models, and continue until all the money is gone. While all I hold onto is my breakfast served by the people I live with, and in the evening for supper a cup of coffee and some bread in the dairy, or else a loaf of rye bread that I have in my trunk" (letter 442).

In the beginning of February his condition became so bad that it worried him excessively, and he concluded that the incessant coughing and crumbling of his teeth were caused by his stomach "having deteriorated to such a degree" (letter 448). He now also became aware of the unpleasantness of his appearance, which had worsened in the last few months. "I am having my teeth seen to, for instance; there are no less than ten teeth that I have either lost or may lose, and that is too many and too troublesome, and besides, it makes me look over forty, which is not to my advantage. So I must have that taken care of. It will cost me a hundred francs, but it can be done better now while I am drawing than at any other time, and I have had the bad teeth cut off and have just paid half the money in advance. They told me at the same time that I ought to take care of my stomach, for it is in a bad state. And since I have been here this has far from improved" (letter 448).

Unfortunately, the time for taking better care of himself and living a healthier life was short-lived, as he would leave

"If you can send anything, even if it's only five francs, do so. There are still ten days left in the month, and how am I to get through them? For I have absolutely nothing left."

town by the end of the month. In his last letter from Antwerp he could announce only a slight improvement. "I guess my health is improving a little, at least in that I can digest my food a little better. But it always remains unsteady, and it varies from one day to the next" (letter 458).

It is not surprising that, when compared to the rest of his oeuvre, the work produced in the short Antwerp period is neither extensive nor very impressive. When he assessed the situation in mid-February, he was not satisfied himself. "My impression of the time I have spent here does not change either; in a certain sense I am very much disappointed by what I have done here" (letter 452). Yet, what he added as the positive side of the balance sheet was certainly no less important: "But my ideas have been modified and refreshed, and that was the real object of my coming here."

His first letter from Antwerp, written a few days after his arrival, shows with what eager interest Vincent had "explored the city in every direction" (letter 436). Hungry for art, he immediately visited the museum of old pictures as well as the modern museum, and he also digressed on a visit to "Leys' dining room" (a large room decorated with murals painted by Henri Leys, a painter he much admired). Emotionally, this time the town seems to have impressed him even more than art. He saw the fantastic little world of wharfs and quays as "a remarkable *Japonaiserie*" (the word, owed to his reading of the Goncourt brothers, is here used in his letters for the first time). "Especially when one comes from the sand and the heath and the quiet of a peasant village, and had been in none but quiet surroundings for a long time, the contrast is curious" (letter 437).

He soon discovered that for a painter there were all kinds of subjects in such a town, and he said he would like to walk here with Theo, just to know whether they would see all those interesting sights and contrasts in the same way. Only an extended quotation can show with what keen observation and remarkable literary talent he described his impressions:

Henri Leys, 1815-1869.

> A white horse in the mud, in a corner where heaps of merchandise are lying covered with oilcloth—against the old smoky black walls of the warehouse. Quite simple, but an effect of Black and White.
> Through the window of an elegant English bar, one will look out on the dirtiest mud, and on a ship from which, for instance, attractive merchandise like hides and buffalo horns is being unloaded by hideous dock hands or exotic sailors; a very dainty, very fair young English girl is standing at the window looking at it, or at something else. The interior with the figure altogether in tone, and for light— the silvery sky above that mud, and the buffalo horns: again a series of rather sharp contrasts.
> There will be Flemish sailors, with almost exaggeratedly healthy faces, with broad shoulders, strong and plump, and thoroughly Antwerpish, eating mussels, or drinking beer, and all this will happen with a lot of noise and bustle—and by way of contrast: a tiny figure in black with her little hands pressed against her body comes stealing noiselessly along the gray walls. Framed by raven-black hair—a small oval face, brown? orange-yellow? I don't know. For a moment she lifts her eyelids, and looks with a slanting glance out of a pair of jet black eyes. It is a Chinese girl, mysterious, quiet like a

mouse—small, bedbug-like in character. What a contrast to that group of Flemish mussel-eaters (letter 437).

Vincent immediately recorded many of the things he saw. His letters mention two drawings and two paintings done in the park which, however, seem to have been lost (letters 437 and 438). The first painting that has been preserved represents the view from his window; it shows the rear side of some houses, observed with ruthless realism in all their disorder and ugliness. He was even more interested in people, and here again, it was not conventional beauty he was after, but character. The problem was, of course, that he had little money available for models, and it occurred to him that he might do portraits "and have them paid for by posing"; in other words, he would give the portraits to his models if they would pose for him again (letter 437). In the second half of December he wrote that he had pursued this idea and had done two relatively large heads, "by way of trying for a portrait." One was the head of an old man who reminded him of Victor Hugo (undoubtedly JH 971), and the other was a study of a woman (JH 972).

Drawing or painting city views seemed to Vincent another way of making money. "It is just the thing for foreigners who want to have a souvenir of Antwerp, and for that reason I shall make even more city views of that kind" (letter 441). He wrote this after having made a detailed picture of the Antwerp castle, Het Steen, a picture that seems to have been lost, but of which there exist a couple of the preliminary studies in black and colored chalk. He also made a few drawings of the cathedral tower, probably also as preliminary studies for paintings that could bring in money; writing about it to Theo, he made the characteristic remark, "Yet I prefer painting people's eyes to cathedrals, for there is something in the eyes that is not in the cathedral, however solemn and imposing the latter may be—a human soul, be it that of a poor beggar or of a streetwalker, is more interesting to me" (letter 441).

"I prefer painting people's eyes to cathedrals."

One side of life in the city became a very unusual pastime for Vincent: visiting the *cafés-concerts*. The main attraction for him was observing and drawing the visitors. He wrote about them in his third letter from Antwerp: "Yesterday I was at the Café-concert Scala, something like the Folies Bergères; I found it very dull, and of course insipid—but the public amused me. There were splendid women's heads, really extraordinarily fine, among the good middle-class folks on the back seats, and on the whole I think what is said about Antwerp true, that the women are handsome" (letter 438).

He also described rather paradoxically a popular sailors' ball he had attended one evening somewhere at the docks, remarking that there were several handsome girls, "the most beautiful of whom was [yet] plain-faced. I mean, a figure that struck me as a splendid Jordaens or Velasquez or Goya—was one in black silk, most likely some barmaid or such, with an ugly and irregular face, but lively and piquant *à la* Frans Hals. She danced perfectly in an old-fashioned style. Once she danced with a well-to-do little farmer who carried a big green umbrella under his arm, even when he waltzed very quickly. Other girls wore ordinary jackets and skirts and red scarves; sailors and cabin boys, etc. the funniest types of pensioned sea captains, who came to take a look, quite striking. It does one good to see

212

folks actually enjoying themselves" (letter 438). A few of the impressions Vincent made at the sailors' ball can be found in the small sketchbooks which now belong to the collections of the Van Gogh museum. One is a sketch of two ladies in a box (it may also be two sketches of the same lady); two others represent dancing couples (JH 967-969).

The second influence on Vincent's work in Antwerp was the opportunity to see other artists' paintings. Besides those in the two Antwerp museums, he mentioned paintings that had attracted his attention at auctions. His interest in Antwerp painters such as Henri de Braekeleer, Charles Mertens and Piet Verhaert shows that he did not lack an eye for his contemporaries. Yet Peter Paul Rubens, whom he had never been able to study as well as he could here, made the deepest impression. "I am quite carried away by his way of drawing the lines in a face with streaks of pure red, or of modeling the fingers of the hands by the same kind of streaks. I go to the museum fairly often, and then I look at little else but a few heads and hands of his and of Jordaens'. I know he is not as intimate as Hals and Rembrandt, but in themselves those heads are so alive. Probably I don't look at those which are generally admired most. I look for fragments like, for instance, those blonde heads in *Ste. Thérèse au Purgatoire*" (letter 439).

Rubens' influence has often been overrated in writings about Van Gogh. Rembrandt and Frans Hals were painters he valued infinitely more. By the end of December he wrote, "My thoughts are full of Rembrandt and Hals these days, not so much because I see so many of their pictures, but because among the people here I see so many types that remind me of that time" (letter 442). After the first shock Rubens had given him, he hardly mentioned him anymore, and when he came back to the subject in January 1886, when he had seen the two large paintings by Rubens in the Onze Lieve Vrouwekerk (Church of the Holy Mary), the *Deposition from the Cross* and the *Elevation of the Cross*, he was again full of admiration, but also very critical of the pathetic character of Rubens' baroque art, especially in the *Elevation of the Cross*.

Yet, that first shock had been strong enough to bring about a further move in the direction of a lighter and more colorful palette which had already started in the last part of his stay in Nuenen. Describing the first woman's head he had done in Antwerp, he used this terminology: "In the woman's portrait I have brought lighter tones into the flesh, white tinted with carmine, vermillion, yellow, and a light background of gray-yellow, from which the face is separated only by the black hair. Lilac tones in the dress" (letter 439). He had never before used such bright colors as in this picture (JH 972), and he risked still fiercer color contrasts when he permitted himself to employ a female model again a few weeks later. "As soon as I received the money, I took a beautiful woman and painted her head life-size. It is all light, except for the black hair" (letter 442).

The head he described has not been preserved; it may have been given to the model, although this time Vincent had paid for the sitting. One can get a good idea of what it looked like, however, because there is a second portrait of the same model (JH 979). This is a portrait which corresponds with the words in the same letter: "I began a second study of the same model in

Moving toward a more colorful palette.

profile." The carmine brushstrokes in the bows, on the model's lips, and—less extreme—in the coloring of the cheek, exemplify the daring renewal of Vincent's palette.

Student at the Academy

The third factor that had "modified and refreshed" Vincent's ideas—the Antwerp academy of art—is less easy to ascertain. He did not go to Antwerp because of the academy; his main purpose was to work in the town and try to make some money. "I brought together six addresses of art dealers [in Antwerp], so I shall take some things with me; and further, as soon as I get there I intend to paint a few city views, rather large size, and to exhibit them at once," he wrote in November 1885. He did consider the possibility of painting after the nude, but not at that academy, where he thought "they would not want him." He hoped to profit from the contacts with other artists in Antwerp, and he wrote prophetically, "As I have been working absolutely alone for years, I imagine that although I want to learn from others and can, I shall always see with *my own eyes*, and render things originally" (letter 434).

It was not before the beginning of January 1886, when he had had ample time to find out how difficult life in Antwerp was, that the thought of working at the academy became a little more attractive. "Because of the models I think I shall go and see Verlat who is the director of the academy here—and I shall see what rules they have, and if one could work there from the nude. I shall take a portrait and some drawings with me then" (letter 443). He did so, but not before the middle of January, and he was still awaiting the results when he wrote to Theo: "I should still like to work sometime either at Verlat's or in some other studio, besides working for myself as much as possible from the model. For the moment I have deposited five pictures—two portraits, two landscapes and one still life—at the academy in Verlat's painting class. I have just been there again, but he wasn't in either time. But I shall soon be able to tell you the result, and I hope that I shall be allowed to paint from the model all day at the academy, which will make things easier for me, as the models are so awfully expensive that my purse cannot stand the strain."

A few days later he could report that he had been accepted. He was to join Verlat's painting class. Immediately he began by drawing from plaster casts of antique sculptures under the direction of the drawing teacher Frans Vinck. He raved about the plaster models. "I, who for years had not seen any good casts of ancient sculptures—and those they have here are very good—and who during all these years have always had the living model before me, on looking at them carefully again, I am amazed at the ancients' wonderful knowledge and the correctness of their sentiment." He was less enthusiastic about the work he saw being done around him, and it is quite amusing to notice with what complete independence and critical sense he talked about the training and the results of the students. "In my opinion the drawings that I see here are all hopelessly bad and absolutely wrong, and I know for sure that mine are totally different. Time must show who is right. The

"As I have been working absolutely alone for years, I imagine that although I want to learn from others and can, I shall always see with my own eyes, *and render things originally"*

feeling of what ancient sculpture is, damn it, *not one of them has it*" (letter 445).

Vincent's attitude toward the teachers was equally independent, objective and critical. About Verlat, the director of the institution, for example, he wrote with quiet self-assurance: "I wish I could make some progress with Verlat. I think many of the things he makes both harsh and wrong in color and paint, but *I know that he also has his good days*, for instance, that he paints a better portrait than most of the others" (letter 445). He knew he was in danger of getting in trouble with the teachers because it was not easy for them to accept, let alone appreciate, his already advanced style of drawing and painting, but he had the good sense avoid an open quarrel.

The teacher of the drawing class from the live model and ancient sculpture, Eugène Siberdt, had been somewhat sympathetic in the beginning and gave him a little more freedom than the other students. Gradually, however, the situation must have become more tense, for a few weeks later, Vincent reported to Theo: "Sibert [as Vincent spelled Siberdt], the drawing-class teacher who at first spoke to me in the way I wrote you about, definitely picked a fight with me today, perhaps to get rid of me, but he did not succeed because I told him, 'Why do you pick a quarrel with me, I don't want to quarrel, and in any case I don't desire the least bit to contradict you, only you pick a quarrel with me on purpose' " (letter 450).[70] In one of his following letters he told Theo that the "nagging of those fellows at the academy" (he meant, of course, the teachers) was almost unbearable, but he added, "I try systematically to avoid all quarrels, and go my own way." The result was that there were no further problems (letter 452).

Apart from the details which Vincent himself gave about life at the academy, several anecdotes have become known and found their way into the biographies of the painter. They stem from the recollections of a fellow pupil, Victor Hageman, who was seventeen at the time, but were written down only when Vincent had become a famous painter. They were undoubtedly stimulated by the publication of Elisabeth du Quesne-van Gogh's booklet from 1910. The earliest version of Hageman's recollections appeared in a 1914 article by Louis Piérard in *Les Marges* entitled "Van Gogh à Auvers." This is part of what Piérard had to say about Vincent's experiences at the academy (translated from *Les Marges*):

> Van Gogh's arrival at the Antwerp Academy was told me by Victor Hageman in the following words:
> "At the time I was a pupil in the drawing class. He stayed there only a few weeks. I remember quite well that unpolished, nervous man who crashed like a bombshell into the Antwerp academy, upsetting the director, the drawing master and the pupils."
> Van Gogh, who was then thirty-one years old, first entered the painting class by Verlat, the perfect type of official painter, whose duty it was to transmit to posterity, by means of the art of painting, the memory of a great patriotic past. One morning Van Gogh came into the class, in which there were about sixty pupils, at least fifteen of whom were German or English; he was dressed in a kind of blue

53
Plaster Torso, *a page from a small sketchbook Vincent used in Antwerp; he must have done this kind of drawing at the academy, 1886. Pencil, JH 1002, F 1693, 11.5 x 9 cm.*
Vincent van Gogh Foundation / National Museum Vincent van Gogh, Amsterdam

70 *"Pourquoi vous cherchez dispute avec moi, je ne veux pas me disputer, et en tout cas je n'y tiens aucunement à vous contredire, seulement vous me cherchez dispute exprès."*

blouse, of the type usually worn by the Flemish cattle-dealers, and he wore a fur cap. In place of a regular palette he used board torn from a packing case that had contained sugar or yeast. On that day the pupils had to paint two wrestlers, who were posed on the platform, stripped to the waist. Van Gogh started painting, feverishly, furiously, with a rapidity that stupefied his fellow students. "He laid on his paint so thickly," Mr. Hageman told us, "that his colors literally dripped from his canvas onto the floor."

When Verlat saw this work and its extraordinary creator, he asked in Flemish, more or less dumbfounded, "Who are you?" Whereupon Van Gogh quietly replied, "Well, I am Vincent, Dutchman."

Then the very academic director proclaimed contemptuously, while pointing at the newcomer's canvas, "I won't correct such putrefied dogs. My boy, go to the drawing class quickly."

Van Gogh, whose cheeks had gone purple, restrained his anger, and fled to the course of good Mr. Siberdt, who also loathed novelties, but who had a less irascible temperament than his director.

On Monday 18 January 1886 Vincent had started work in the painting class of Karel Verlat. Though the anecdote above suggests that Verlat had immediately sent him away, it is certain that he remained in the class. In the course of that week he wrote: "I have now been painting there for a few days, and I like it pretty well. Especially because there are all kinds of painters there, and I see them work in the most varied ways, something I have never experienced before—I mean seeing others work" (letter 446). And he intended to go on with it. "Next Monday we shall get new models; in fact, then I shall begin in earnest," although there was the usual problem of needing a large canvas and new brushes without having the money to buy them (letter 446).

In the course of that second week he again mentioned the painting class: "This week I painted a large thing with two nude torsos—two wrestlers posed by Verlat, and I liked that very much" (letter 447). These were the wrestlers who, according to Victor Hageman, had been Vincent's first models, although it is not confirmed here that Verlat had rejected his work with the epithet *"chiens pourris"* (putrefied dogs). The most Vincent said about the work was, "What Verlat tells me is very severe," and he mentioned the fact without showing any hard feelings. That the situation did not lead to a real conflict is certain, if only because time was too short. In his next letter, written hardly a week later, in the beginning of February, Vincent reported, "The painting class ended last week, because at the end of the course a competition is held for those who have gone through the whole course, among whom I do not belong" (letter 448). All in all, working with the painting teacher Verlat had therefore lasted only about two weeks and cannot have carried much weight in Vincent's development as an artist.

The only picture that may have been done at the time represents the upper part of a skeleton (JH 999). As Vincent certainly did not possess a skeleton himself, he may well have painted it at the academy. As a macabre joke, however, he put a cigarette between the teeth of the skull, which makes it improbable that he did the picture during one of Verlat's lessons; if he did, he may have added the cigarette later as a kind of student-like revenge.

In connection with this short period of training at the academy, no painted work is known to exist.

216

On the other hand, a small number of drawings made at the academy have been preserved, which Vincent had either sent to Theo or kept in portfolio and taken with him when he departed for Paris. A better idea of his drawing activity can also be formed from the many references in the letters. The most surprising conclusion that can be drawn from these references is that at the academy he had no opportunity to make drawings (or paint) from the nude. Earlier biographers had always said— or silently suggested—that working from the nude was what had made the enrollment at the Antwerp academy so useful to Vincent. That in reality the academy had not given him that opportunity at all must have been a great disappointment for Vincent, for the first thing he had written to Theo about his study plans had been, "I shall see what rules they have and if one could work there from the nude" (letter 443).

The day class for antiques (apart from the "*concours*" the only activity going on at the academy in the second half of February) did not satisfy Vincent's urge for practice, and he looked for a way to work from the nude for some time. Even if he had been allowed to participate in the nude class, it would not have suited him. "They hardly ever use nude female models. At least not at all in the class, and only exceptionally individually. Even in the antiquities class there are ten men's figures to one woman's figure" (letter 452). However this may be, he soon found a way out. By the end of January he wrote: "I have been tremendously busy this week, for besides the painting class, I go and draw in the evening too, and after that, from half past nine till half past eleven, I work from the model at a club. For I have become a member of not less than two of these clubs" (letter 447). It is the first and, unfortunately, practically the last reference to these sketching clubs in the letters, but it is certain that he had gone on with this activity for some time. About ten drawings after male and female nudes, ascribed to the Antwerp period, must have been done at the sketching clubs.

Van Gogh oeuvre catalogues give a somewhat deceiving impression of the work he achieved at the academy; at first sight quite a few drawings that could have been done at the academy seem to have been preserved, but in reality the opposite is true. The drawings that represent a plaster torso, a hand, a foot, a knee, and such, are all done on sheets of a very small format (11.5 x 9 cm., 10 x 13.5 cm., etc.) which belonged to some of the small sketchbooks Vincent carried in his pockets during his months in Nuenen, Antwerp and Paris. The only drawings that may have been done at the academy, because they are of a larger format, are the ones representing an arm (JH 1004 and 1005, front and back of one sheet of paper). The ten studies of nudes must have been done at the sketching clubs, except one that may also be on the sheet of a sketch book (JH 1016). The other nudes, all quite large, clearly show Vincent's lack of skill in this field; most of them are quite clumsily done and not well proportioned, especially compared to the masterly drawings of peasants he had produced in Nuenen. The most "beautiful" among them (JH 1015), the only one in a very large format (73.5 x 59 cm.), seems to have been done by someone other than Vincent, or at least to have been intensely corrected by a more skillful hand; the flowing outlines do not look like Vincent's drawing style at all.

54
Portrait of Vincent, done by one of his fellow students, H. M. Livens, in the beginning of 1886.

A separate case is formed by two drawings in large format, both representing a clad model, a sitting man (JH 1017 and 1018). These figures make a much stronger and more characteristic impression than all the other drawings of the Antwerp period (in quality, maybe only the remarkable portrait of a woman, done in charcoal and red chalk, JH 981, is comparable). It is understandable that De la Faille ascribed the drawings to the Paris period; yet the board of editors of the revised edition of the oeuvre catalogue of 1970 preferred to place them in the Antwerp period. If this decision was correct, it again proves that Vincent was more successful with clothed figures than with nudes.

The conclusion must be that by sheer lack of material it is impossible to get a firm grasp of the work Vincent achieved in the two drawing classes at the academy. Vincent, at least in the beginning, did not think much of it himself. When he wrote to Theo in the middle of February that he was going to send him the drawings from the plaster casts, he apologized in advance, saying "that is unusual work for me, and I shall make better ones" (letter 456).

The drawing lessons at the Antwerp academy may have had an important influence on Vincent's development as an artist. Already in the spring of 1885 in Nuenen he had been intrigued by a line from Delacroix that he had read in a book by the painter J. F. Gigoux. Delacroix is quoted in this book as having said, approximately, "the ancients did not tackle it from the contour but from the center." In Antwerp Vincent became more and more convinced of the importance of that pronouncement for the technique of painting—not because this was the spirit in which he was taught at the academy, but because it was an attitude he already possessed. In one of his letters he devoted a long passage to this question, of which this is only the beginning:

The academy's influence.

> That method—Millet too draws in the same way, more than anybody else—is perhaps the root of all figure painting. It depends enormously on drawing the modeling directly with the brush, quite a different conception from that of Bouguereau and others who lack interior modeling, who are *flat* compared with Géricault and Delacroix, and do not emerge from the paint. With the latter—Géricault, etc.—the figures have backs even when one sees them from the front, there is airiness around the figures—*they do emerge from the paint*. It is to find this that I am working. I would not care to speak about it with Verlat, nor with Vinck; no fear they would teach me this, for the fault of both of them is in the color, which, as you know, isn't right in either's work (letter 447).

In the middle of February he returned to the subject, saying he would rather have worked without teachers, and once more he gave a characteristic reflection, culminating in sarcastic words:

> I feel that I am on the track of what I am seeking, and perhaps I should find it sooner if I could go completely my own way when drawing from the plaster casts. After all I am glad I went to the academy, for the very reason that I have abundant opportunity to observe the results of *prendre par le contour*. For that is what they do systematically, and this is why they nag me. "First make a contour,

218

your contour isn't right; I won't correct it if you do your modeling before having seriously fixed your contour."[71] You see that it always comes to the same. And now you ought to see!!! how flat, how lifeless and how insipid the results of that system are; I am very glad to be able to see it close up. It's like David, or even worse, like Pieneman in full bloom. I wanted to say at least twenty-five times, "*Votre contour est un truc*, etc." [your contour is a joke] but I have not thought it worth while to quarrel (letter 452).

It is this conscious striving for an individual style, this critical opposition to academic conventions, that must have been particularly fruitful to the development of Vincent's art; not only did it affect the development of his drawing, but it also indirectly influenced his painting. In reaction to his experience at the Antwerp academy, he decided that he might profit from a study period at Cormon's studio in Paris, where he could practice what he now had come to see as the right direction for his drawing and painting.

It is difficult to say who had mentioned the name Cormon first, but in the beginning of January Vincent wrote, "What pleases me enormously is that now you yourself propose the plan of going to Cormon's" (letter 448), and in one of his next letters he repeated, "I am very glad that you rather like the idea of my coming to Paris" (letter 450). There was no getting away from the necessity of a year's drawing, he had concluded. "For speaking of Cormon, I now think he would tell me much the same thing as Verlat, namely that I must draw from the nude or plaster casts for a year, just because I have always been drawing from life" (letter 449).

In spite of the fact that in principle he had Theo's permission to come to Paris, it was not so easy to agree upon a *date*. It was Theo who had proposed that they might live together in Paris, and one would think that Vincent would have jumped at the chance, but for some uncertain reason, he preferred to postpone this big step. "As to the plan of taking an apartment and rather good studio together where one can receive people if need be, keep it in mind, and let me keep it in mind too," Vincent wrote Theo (letter 448). Did he have a secret fear that they would not get along very well together? In Nuenen, and even more recently, he had sometimes written in strong words about Theo's lack of cordiality. In February he said cautiously, "Founding a studio together would perhaps be a good thing, but we must feel sure that we can carry it through—and we must know very well what we do and what we want, and once we begin it, we must have a certain confidence after all, left us after a long series of lost illusions" (letter 448). In his next letter—a letter in which he confessed to being "literally worn out and overworked"—he repeated the same objections; it certainly seemed best to try to find a way of living in the same city, if only temporarily, he said, "but the more I think about it, the more certain I am that it would perhaps be better not to spend too much on a studio the first year, because I shall mainly have to draw" (letter 449).

There was, however, a second problem. The winter term at the Antwerp academy ended on 31 March, and the painting

Planning to work at Fernand Cormon's studio in Paris.

[71] "*Faites d'abord un contour, votre contour n'est pas juste, je ne corrigerai pas ça si vous modelez avant d'avoir sérieusement arrêté votre contour.*"

course had stopped even before the end of January because of the *"concours"*; as there remained nothing to do for Vincent other than some drawing from plaster casts, he wanted to go to Paris as soon as possible. Theo, on the other hand, had written that he was planning to move to another apartment in a few months' time, so for the time being Vincent was not welcome at the small apartment on rue Laval. Yet, he was not easily put off. "As for me, if I come to Paris, I shall be perfectly contented with a cheap little room in some remote quarter (Montmartre) or a garret in a hotel" (letter 447). Theo had other ideas. In his opinion, it was all right for Vincent to come to Paris in June, but he wanted him to go back to Nuenen first. He could then help his mother with packing, as she was going to move with Wil to Breda on 31 March.

Being so dependent on his brother, Vincent could only do what he was told, but he did not spare Theo his objections. "As to what you wrote about the folks at home, in this matter I shall do what you think best. If necessary, I can leave here whenever I like, let's say in the first days of March. But—let's consider if the help I might be able to give would be worth the journey there and back, for I would also approve of staying here without going back, and from here straight to Cormon, whenever you like. The fare for the journey is not negligible when I reckon that the luggage costs me more than my own fare" (letter 448). Vincent continued using the argument of the extra usage in following letters; a few weeks later he wrote, "And as to my going straight to Paris, I tell you it will be less expensive for you, for what with traveling to and from, and starting relatively expensive work in Brabant, we should not be able to manage with the usual allowance, and in Paris we can" (letter 456).

In his next letter, he stressed the difficulties he had experienced in his work in Nuenen. "Further, as you tell me that your lease is not up till the end of June, perhaps it might be better, after all, if I went back to Nuenen in March; but if I should have to meet with the same opposition and scenes like the ones before I left, I should lose time there" (letter 450). Somewhat later he mentioned his health; it would probably take about six months before he would be completely recovered, he wrote, but "it would certainly take a much longer time if between March and June I had to go through the same things in Brabant as I have had to go through these last months—and probably it wouldn't be any different." It is almost pathetic to see that he ends this passage with an urgent appeal not to make him go to Nuenen: "Now, just at this moment, I am feeling terribly weak, even worse than that; it is the reaction after over-exertion, which is the natural course of things and nothing extraordinary. But as it is now a question of trying to live a healthier kind of life—well, in Brabant I would again spend my last penny on models; it would be the same story all over again, and I do not think that could be right. In that way we stray from our path. So please, permit me to come sooner, yes, I should almost say at once if possible" (letter 452).

In the last letter he wrote from Antwerp, Vincent commented that working outdoors would be possible with the slightest change in the weather, and so "if it must be, and you decidedly wish it, my being in Brabant would not be quite futile" (letter 458). This was clearly not what he wanted

Vincent resists returning to Nuenen.

himself, however, and he ended his letter with the repeated request, put in friendly, but urgent, terms. "Think it over carefully again, whether we can't find a combination that would render it possible for me to come to Paris before June. I should like it so much, because I believe it would be better for so many reasons, which I have already mentioned to you. To which I may add that I think we can discuss taking a studio by June so much better if we are both in Paris beforehand, and can investigate the pros and cons. Well, write me soon" (letter 458).

It is improbable that Theo gave Vincent permission to come to Paris immediately. Instead, Vincent took a dramatic step to end the dragging discussion about his immediate future: he simply took the train, again without asking for Theo's permission, and arrived in Paris the next morning. Vincent had done what he had written to Theo a year and a half before in a rebellious, but prophetic, mood: "I want to add that I am not going to ask you whether you approve or disapprove of anything I do or not do, I shall not hesitate, and if I should feel like going to Paris, for instance, I shall not ask whether you like it or not" (letter 378). Vincent had once again taken his fate into his own hands.

Part III

Flight to the Sun

55
View of Paris with the Opéra, *the roofs of Paris as Vincent and Theo saw them from their rue Lepic apartment; sketch by Vincent from 1886. Black, white, and brownish-red chalk, JH 1097, F 1390, 22.5 x 30 cm.*
Vincent van Gogh Foundation/National Museum Vincent van Gogh, Amsterdam

When Vincent arrived in Paris by night train, he did not go to Theo's apartment at 25, rue de Laval. Theo certainly would have left for his office (the branch of Goupil & Co. at 19, boulevard Montmartre) early in the morning, and one would expect Vincent to try to meet him there, but he did not do that either; he probably did not want to be confronted with either of his former employers, Mr. Boussod or Mr. Valadon, nor with members of the staff. Instead he sent Theo a note by means of a *commissionnaire*, one of the errand boys who were easy to find anywhere in Paris at that time and who more or less fulfilled the role of a telephone. A scrap of paper torn from a sketch book with a few sentences scribbled in black crayon was sufficient, and thanks to Theo, who seems to have kept every letter or note he received, however insignificant, the note still exists. It is a curious little document. This translation is what Vincent wrote; he switched from Dutch to French the moment he arrived in France: "My dear Theo, Do not be cross with me

225

for having come all at once like this; I have thought about it so much, and I believe that in this way we shall save time. Shall be at the Louvre from midday on or sooner if you like. Please let me know at what time you could come to the Salle Carrée. As for the expenses, I tell you again, this comes to the same thing. I have some money left, of course, and I want to speak to you before I spend any of it. We'll fix things up, you'll see. So, come as soon as possible. With a handshake, Ever yours, Vincent."

Evidently Vincent wanted to reassure Theo that he still had money left from his last "allowance" which he had partly used for his train-fare. It is an amusing surprise when one reads in a much later letter to learn how he had managed to save some money: he had simply left Antwerp without paying his bills! This was revealed in a letter of June 1888 in which he expressed the opinion that Paul Gauguin, who was in such financial straits in Brittany, should make it possible to come to Arles by not paying his debts in Brittany, and he added, "I was obliged to do the same thing to get to Paris, and though I lost a lot of things, it cannot be helped in a case like this, and it is better to get going no matter how than to rack and ruin where you are" (letter 496).

The exact date of Vincent's arrival in Paris is not known, but it was around 1 March 1886, immediately after he received Theo's allowance. There is a curious indication that he arrived before 6 March, in any case. On the back of the scrap of paper with which he had announced his arrival, Theo had scribbled a short laundry list, adding the date, "6/3/86."

Theo's apartment on rue de Laval (now rue Victor Massé) was on a side street of rue Pigalle, ten minutes' walk from the Galerie Goupil & Co. at 19 boulevard Montmartre. The rue Lepic, where they settled in June, was in Montmartre itself. At the foot of the hill was the famous Butte Montmartre. Both addresses were convenient, not only for Theo (they were near his office), but also for Vincent (they were only minutes away from Cormon's studio, where he soon started work). At the small apartment in rue de Laval Vincent did not have a room of his own large enough to be used as a studio, but it was not necessary for him to rent an attic room as he had suggested while in Antwerp. After the move in June the situation improved. Jo van Gogh-Bonger, who knew the apartment at 54, rue Lepic from personal experience, wrote in her Memoir: "The new apartment, on the third floor, had three large rooms, a small side-room, and a kitchen. The living room was comfortable and cozy with Theo's beautiful old cabinet, a sofa and a big stove, for both the brothers were sensitive to the cold. Vincent slept in the small side-room, and behind that was the studio, an ordinary-sized room with one not very large window."

In the second half of June, Theo wrote to his mother: "Fortunately we're doing well in our new apartment. You would not recognize Vincent, he has changed so much, and it strikes other people even more than it does me. He has undergone an important operation in his mouth, for he had lost almost all his teeth through the bad condition of his stomach. The doctor says that he has now quite recovered." Vincent had changed not only because of his dental operation; he also had adjusted to the new life by changing his style of dress, which can be seen in the self-

56
Drawing of a plaster statuette of a discus thrower, made at the Cormon studio in 1886. Black chalk, JH 1080, F 1364e, 56 x 44 cm.
Vincent van Gogh Foundation / National Museum Vincent van Gogh, Amsterdam

portraits he began to make in Paris. While he was described in Antwerp as wearing a blue blouse like a cattle-trader with a fur cap on his head, he looks quite distinguished in the first few self-portraits that are known (JH 1089 and 1090), which show him wearing a suit and a dark felt hat.

Paris was not new to him in 1886. He knew the city from three previous stays. The first was when, at twenty years old, he had made a short visit on his way to London in May 1873; he was temporarily transferred from the London to the Paris branch of Goupil's from October to December 1874, and he had even stayed in Paris for ten months, from May 1875 to March 1876—a long enough period to get to know the city quite thoroughly. This must have made it easy for him to feel at home when he returned in 1886, ten years later, the more so because instead of only visiting the museums, he now could live here as an artist, frequenting the circles of artists and art dealers.

As he was to live with his brother for two years it is important to look at the position Theo held in the world of the Paris art business. The first source on that position is again Jo van Gogh-Bonger's Memoir in the *Complete Letters*: "His own work was very strenuous and exhausting, he had made the gallery on the boulevard Montmartre a center of the impressionists; they were Monet, Sisley, Pissarro and Raffaelli, Degas (who exhibited nowhere else), Seurat, etc. But to introduce that work to the public, which filled the small *entresol* or mezzanine every afternoon from five until seven, what discussions, what endless debates, had to be held. On the other hand, how he had to defend the rights of the young painters against *ces messieurs*, as Vincent always called the heads of the firm."

It is a colorful story, but it could not have been based on Jo's own experience. She did not settle in Paris until April 1889 and must have relied chiefly on things she had heard from her husband. Theo's activities were undoubtedly "strenuous and exhausting," and it is generally acknowledged that they were beneficial to the cause of the impressionists; yet—even if Jo van Gogh-Bonger did not realize it—the image she gives of Theo as a fighter for "the young painters," whose gallery was "a center of the impressionists," is not in accordance with the situation in 1886 when Vincent arrived in Paris. In fact, for some time there would be more reason to call Vincent a propagandist of the new trends in painting rather than Theo.

John Rewald has given an admirable, completely objective description of Theo's position with regard to the impressionist movement in his extensive study, "Theo van Gogh, Goupil and the Impressionists," in the *Gazette des Beaux-Arts* (1973). He shows that in those years, Theo was obliged to concentrate on the sale of paintings that were popular. The only impressionist picture he sold in 1884 was a landscape by Pissarro. His second transaction in this field was a year later—concerning a work by Sisley—and in the same year, 1885, he succeeded in selling a painting by Monet and one by Renoir. According to Rewald, in the whole of the year in which Vincent had joined Theo, the registers of Boussod & Valadon[72] mention only one sale by

57
A sheet of paper with studies, from the same period as the discus thrower, 1886. Black chalk, JH 1048, F 1710v, 46 x 35 cm. Vincent van Gogh Foundation / National Museum Vincent van Gogh, Amsterdam

[72] Goupil and Co. was taken over in 1884 by Boussod & Valadon.

Theo of an impressionist picture, a marine by Edouard Manet, who died in 1883 and had already become quite famous.

It was only during the course of 1887 that the mezzanine on the boulevard Montmartre really became something like "a show-place for avant-garde pictures," as Rewald called it. In that year, Theo succeeded in acquiring one or more pictures by Degas, Monet, Sisley, Pissarro, Gauguin and Guillaumin with the object of seeking buyers for them. Generally, the prices received for such paintings were still extremely low, mostly a few hundred francs. Only the Monets belonged to a more lucrative category; in 1887, Theo bought no less than fourteen paintings by Monet for a total sum of more than 20,000 francs. How many of those paintings he succeeded in selling that same year, Rewald's study does not say; it does mention that he sold at least one Gauguin, two Pissarros, and four or five Sisleys in 1887. The Sisleys, in particular, yielded so little that the painter was undoubtedly less well-off than Pissarro; he was less well-off than Vincent, too, who could at least count on his monthly allowance.

In 1888 there is more reason to call Theo's mezzanine on boulevard Montmartre "a center of the impressionists," certainly after Monet sold ten of his Antibes landscapes to Boussod & Valadon via Theo that June. Vincent, too, considered Theo's role as dealer of impressionist and neo-impressionist pictures to be fundamental at that time. In June he wrote his sister Wil, "What I wanted to make you understand is this, that it is rather important that Theo has succeeded in inducing the business he manages to have a permanent exhibition of the impressionists now" (letter W 4). And in a postscript he added, "Theo is doing his best for all the impressionists; he has done something, or sold something, for every one of them, and he will certainly go on doing so."

It speaks for Vincent's modesty—and for his esteem for his brother—that he did not even make an allusion to the share he had in that development. Fortunately Theo's testimony provides an objective view of the situation. He wrote about it to his sister Wil and made no secret of it to his own brother. Vincent had already stayed in Arles for some months when Theo, writing to him about the problems of the art business, admitted to Vincent, "You may do something for me if you like—that is, go on as in the past, creating a circle of artists and friends for us, and which *you* have really more or less created ever since you came to France" (letter T 3).

Vincent and Impressionism

In 1886 the hill of Montmartre was still a surprisingly rural area. Building had started on the cathedral of Sacré-Coeur in 1876, but not much had progressed; there were no other buildings on the "Butte," which was still covered with small vegetable gardens. There were several quarries and even some windmills (paintings by Vincent show three). At least one of them had already become part of modern life, as it contained a restaurant and a dance hall, with a garden in the back which could also be used for dancing, as is shown in paintings like the famous Renoir from 1876, *Le Moulin de la Galette*.

Camille Pissarro, 1830-1903.
Edgar Degas, 1834-1917.
Alfred Sisley, 1839-1899.
Claude Monet, 1840-1919.
Auguste Renoir, 1841-1919.
Armand Guillaumin, 1841-1927.
Paul Gauguin, 1848-1927.

Theo was thoroughly occupied by his job, so most of the day, except for his working hours at Cormon's, Vincent could loiter through the town, make sketches, and look at paintings in galleries and museums. There was much for him to see in Paris in 1886, for destiny had brought him here at a very propitious moment. John Rewald, in the first chapter of his book *Post-Impressionism* (1978), mentioned the official May "Salon," the eighth and last exhibition of the impressionistic group (mid-May to mid-June), the fifth "Exposition Internationale" at the gallery of George Petit (June), and the "Salon des Indépendants" in August. In her book, *Vincent van Gogh, his Paris Period* (1976), Bogomila Welsh-Ovcharov extended this list; for the first half of 1886 alone, she mentioned the exhibition of watercolors by Gustave Moreau (in March), and the exhibition "Maîtres du Siècle" (April-May), which contained about 200 works by "masters," many of whom Vincent greatly admired, like Delacroix, Jongkind, and Millet. Finally there was the exhibition of the "Société des Aquarellistes Français" (in April), to name only a few. Vincent, who had always shown an eager interest in the field of art, presumably visited and studied all, or practically all, of these important exhibitions.

58
Self-Portrait with Dark Felt Hat, *one of the first done by Vincent in Paris in 1886. Oil on canvas, JH 1089, F 208a, 41 x 32.5 cm. Vincent van Gogh Foundation / National Museum Vincent van Gogh, Amsterdam*

In any case, it is certain that two months after his arrival in Paris he had already been confronted with a movement he knew practically nothing about when in Holland: impressionism. It had not made much difference to him that the eighth "Exposition de peinture impressionniste" did not represent impressionism in its definitive stage, some of the "true" impressionists like Monet, Renoir and Sisley having refused to participate. He may have hardly realized that some of the painters who exhibited their pointillistic experiments here had already outgrown impressionism; their work will have made the show all the more fascinating for him. For years to come he was to use the word "impressionists" to indicate the progressive painters of his time in general, including figures like Seurat, Signac, and Gauguin, who certainly cannot be considered impressionists. If one knows that Paul Gauguin exhibited about twenty paintings in his early, still impressionist style, and that "true" impressionists such as Berthe Morisot and Armand Guillaumin were also represented with an important selection, it becomes clear that in this exhibition alone he could have made himself acquainted with the new movement through at least fifty paintings.

He must also have developed a strong impression from the daring realism of the work by Edgar Degas, who had exhibited a number of pastels at the eighth impressionist exhibition, the first of the famous series of women washing, bathing, combing their hair, etc., with which Degas had shocked most of his contemporaries. While these did not shock Vincent, he probably was shocked—in a different sense—by the completely new way of painting shown by Georges Seurat and Paul Signac with their pointillistic or stippling technique, and to a lesser degree by the work of Camille Pissarro, who was represented in the exhibition with about twenty works in the pointillistic style he had lately adopted from younger friends. The enormous canvas by Georges Seurat, *La Grande-Jatte*, or more precisely *Un Dimanche après-midi à l'île de la Grande-Jatte* ("A Sunday afternoon on the island of La Grande-Jatte"), must have made an overwhelming impression on him, not only by its size (81 x 120 3/8"), but certainly no less by the almost scientific severity of its technique. By the use of unmixed dots of color and rigorous stylization of the figures, this was a form of painting of which Vincent could not even have dreamed (he was able to see the canvas again at the exhibition of the Indépendants in August and September of that same year).

It was quite a long time before he felt inclined to try to follow the new trends himself. Not only had he already acquired a style of his own in the Nuenen years, but he was not immediately convinced of the superiority of what he saw in Paris. It is interesting to see what he wrote two years later (in 1888), when he had long since digested it all and had already left impressionism behind. Looking back, he told his sister Wil: "... it is invariably the same thing all over again. One has heard talk about the impressionists, one expects a whole lot from them, and ... when one sees them for the first time one is bitterly, bitterly disappointed, and thinks them slovenly, ugly, badly painted, badly drawn, bad in color, everything that's miserable. This was my own first impression, too, when I came to Paris, dominated as I was by the ideas of Mauve and Israëls and other clever painters" (letter W 4).

230

Georges Seurat, 1859-1891.
Paul Signac, 1863-1935.
Berthe Morisot, 1841-1895.

Vincent had not come to Paris solely to find new modes of expression as a painter; he had come to improve his figure drawing and to draw from the nude, although he led a sheltered life with his brother. He had come to work at Cormon's and it was at Cormon's that he registered.

Fernand Cormon (1845-1924) was at that time a famous painter of historical scenes and was also well known as a portrait painter. He was a professor at the Ecole des Beaux-Arts and—what was considered an even greater honor in France—a "Membre de l'Institut." For years his studio was frequented by painters who later became famous; Toulouse-Lautrec and Emile Bernard are good examples. One of Cormon's students, the English painter A. S. Hartrick (1864-1950), described him in his book *A Painter's Pilgrimage Through Fifty Years* (1939). This is a small fragment of his recollections:

> Cormon was a sharp-featured little man, dark-haired, with the quick movements of a small bird, which he somehow resembled. He painted enormous pictures of prehistoric man, with titles such as *La chasse de l'Ours, l'Age de pierre,* or *La famille de Caïn* fleeing through a wilderness: the latter is, or was, in the Luxembourg Gallery. In spite of the abuse which has been showered on him for failing to recognize genius in his studio—a failing common to his contemporaries—I should say that he had excellent brains, was an admirable teacher, more sympathetic to novelties than most of his kind. No doubt he was particular about drawing, and especially construction, as a true Frenchman and a member of the Institute. In my time he was respected as an artist and as a teacher. I believe even Gauguin spoke of him with regard and worked for a short time in his atelier when in Montmartre in 1889. The crown of his reputation in the studio, however, was that he kept three mistresses at one time![73]

After the Paris years, all that Vincent ever said about his stay at Cormon's were a few casual words in a letter to an English friend from the Antwerp academy, H. A. Livens. That he never came back in later letters to his work at Cormon's, of which he had such great expectations while he was still in Antwerp, seems to suggest that his stay there had been a serious disappointment. This is the mild criticism he made to Livens: "I have been in Cormon's studio for three or four months but I did not find that as useful as I had expected it to be. It may be my fault however, anyhow I left there, too, as I left Antwerp and since I worked alone, and fancy that since I feel my own self more" (letter 459a).

In spite of his silence about his experience at Cormon's, one can learn a great deal about this study-period from the works he did there that have been preserved. Proof is evident by the work done at Cormon's that has been preserved: some fifty drawings and sketches and also some paintings. For the most part they are drawings after classical plaster casts and studies after anatomical drawing models. Only a few are studies from a live model, one of these being a painted study of a nude child. Vincent must certainly have learned something from this kind of work, especially by his endless repetition of classical plaster

Henri de Toulouse-Lautrec, 1864-1901.
Emile Bernard, 1868-1941.

[73] In Hartrick's book *A Painter's Pilgrimage*, p. 50.

casts. He worked mainly with female torsos, producing forms more harmonious than the awkward, badly proportioned nudes of the Antwerp period. Whether the experience was of great importance for his development as an artist is another matter. Except for a few instances in Paris, he was never to draw or paint nudes again. Next to portraits, landscapes were to remain the principal subject in the whole of his oeuvre.

From a biographical standpoint, it is fascinating to see the passion he directed toward this kind of academic work. In the introduction to a collection of letters the painter Emile Bernard received from Vincent, Bernard wrote, "I see him at Cormon's, in the afternoon, while the students have gone and the studio had become a kind of cell for him; sitting in front of a cast from the antique, he is copying its beautiful lines with angelic patience. He wants to master those contours, those masses, those reliefs. He corrects himself, starts again with passion, rubs out, until at last with his eraser he makes a hole in the paper."

It is unlikely that Vincent would have waited to start a different kind of work until he had definitely left Cormon's; that would not have been in accordance with his impetuous character, in spite of the angelic patience with which Bernard had seen him copying plaster models. He must already have begun to draw street scenes and paint flowers—a subject that was to remain one of his main occupations of his first half year in Paris. This is documented convincingly in an unpublished letter Theo wrote to his mother. It was shortly after they had settled down in the new apartment, probably in July 1886, that Theo wrote about his brother:

Street scenes and flower paintings.

> He is progressing tremendously in his work and this is proved by the fact that he is becoming successful. He has not yet sold paintings for money, but is exchanging his work for other pictures. In that way we obtain a fine collection, which, of course, also has a certain value. There is a dealer in pictures who has now taken four of his paintings [taken on consignment is probably what was meant here] and has promised to arrange for an exhibition of his work next year. He is mainly painting flowers—with the object to put a more lively color into his next set of pictures. He is also more cheerful than in the past and people like him here. To give you proof: hardly a day passes that he is not asked to go to the studios of well-known painters, or they come to see him. He also has acquaintances who give him a bunch of flowers every week which may serve him as models. If we are able to keep it up, I think his difficult times are over and he will be able to make it by himself.

It might at first seem odd that Vincent had not yet sold paintings "for money," but life was difficult for most of the progressive Paris painters of that time. In fact, Theo did not show any irritation about the fact until February 1887 when he wrote his mother: "He has painted a few portraits which have turned out well, but he always does them for no payment. It is a pity that he does not seem to want to earn something, for if he did he could make some money here; well, you can't change a person."

Theo's letter from the summer of 1886 does not tell more than that Vincent used flowers "as a model." More details are to be found in Vincent's letter to Livens, which is not dated but

cannot have been written later than summer of 1886. About his work he wrote (in English):

And now for what regards what I myself have been doing, I have lacked money for paying models, else I had entirely given myself to figure painting. But I have made a series of color studies in painting, simply flowers, red poppies, blue corn flowers and myosotys, white and rose roses, yellow chrysanthemums—seeking oppositions of blue with orange, red and green, yellow and violet, seeking *les tons rompus et neutres* to harmonize brutal extremes. Trying to render intense *colour* and not a *grey* harmony. Now after these gymnastics I lately did two heads which I daresay are better in light and colour than those I did before. So as we said at the time: in *colour* seeking *life* the true drawing is modeling with colour. I did a dozen landscapes too, frankly *green* frankly *blue*. And so I am struggling for life and progress in art (letter 459a).[74]

59
Portrait of Vincent van Gogh, by Toulouse-Lautrec from early 1887. Colored crayon on paper. The drawing clearly shows how close they must have been.

It is particularly interesting to see confirmed that the flower still lifes were in essence color studies. Vincent's confrontation with impressionism had at least given him the conviction that he had to aim at more and stronger color effects. Flowers gave him the opportunity to attempt color

[74] Some changes in punctuation have been made here.

233

combinations in endless variations—something which he did not only during the first months of his stay in Paris, but kept doing long after he had written to Livens, even far into the following year. No less than fifty studies of flowers of the Paris period are known, flowers in vases and pots of all kinds of colors and compositions, from very simple subjects such as a single plant in a pot to the most luxurious bouquets. Vincent clearly wanted to free himself from the dark and earthy colors of his Brabant years or, as the letter put it, from the "grey harmony."

Vincent's Work in 1886

In the summer of 1886, Vincent was producing painting after painting. Working toward a more colorful palette, he could experiment freely with the "laws of color" he had found through reading Charles Blanc. He did not yet permit himself important deviations from the colors the objects had in reality, but arranged his flowers in such a way that complementary colors dominated. In his own words, he was "seeking opposition of blue with orange, red and green, yellow and violet," and he took care to add broken and neutral tints to avoid overly strong color contrasts. Only when compared to the work done in Brabant can the early flower still lifes be called colorful or even loud. They make a harmonious impression and remind one more of the flower pieces of Fantin-Latour or of early Renoir than of his own daring still lifes of 1887 or 1888.

Henri Fantin-Latour, 1836-1904.

In the case of the early pictures, Vincent emulated not so much the paintings of the impressionists, but the work of Adolphe Monticelli, a Marseilles painter whom he admired and whom his brother also seems to have loved very much. Already in 1886 Theo possessed some paintings by Monticelli, among which was a flower still life (they are still in the Theo van Gogh collection in the Van Gogh museum in Amsterdam). A. Sheon, an expert on Monticelli, has suggested that Vincent may have known Monticelli's work when he lived in Paris in 1874 and 1875. At that time there was an art dealer in Paris, Joseph Delarebeyrette, who dealt in Monticelli's paintings.[75] To Sheon, the relation between Vincent's and Monticelli's flower still lifes is beyond doubt. "In Paris Van Gogh started a series of flower still lifes which for a large part are based on the compositions of Monticelli of the period 1875-1883 and which are certainly related to Monticelli's flower piece in the Theo van Gogh collection." Monticelli died in Marseilles on 29 June 1886, something that cannot have escaped Vincent and Theo van Gogh's attention. They would also have been aware of the fact that Monticelli had been invited to exhibit his work that year by the famous Belgian group "Les XX" (The Twenty), and that he was posthumously represented with five paintings at their July 1886 exhibition in Brussels.

Adolphe Monticelli, 1824-1886.

In the first few letters Vincent wrote from Paris, Monticelli is not mentioned, but in his later letters he clearly demonstrates his almost fanatical admiration. Monticelli's work is characterized by the brilliant coloration of precious stones and thick layers of paint, applied with a palette knife,

[75] A. Sheon, "Monticelli and Van Gogh," *Apollo* (1967), pp. 444-48.

234

forming a kind of mosaic of small patches of color. In some of Vincent's flower still lifes, he appears to have tried similar effects. There is more than a vague influence here; when he later wrote that he hoped to "continue" the work of the Marseillan, he made it clear that he would certainly not have been ashamed of the similarity between some of his paintings and the work of his great precursor (letters 541 and W 8). When in 1890 the art critic Albert Aurier published a flattering article about him, Vincent even went so far as to attempt to divert Aurier's praise onto Monticelli. In a grateful letter to the critic he wrote, "Saying as you do [namely about Van Gogh], 'As far as I know, he is the only painter to perceive the chromatism of things with such intensity, with such a metallic, gemlike luster,' be so kind as to go and see a certain bouquet by Monticelli at my brother's—a bouquet in white, forget-me-not blue and orange—then you will feel what I say" (letter 626a).

60
A Pair of Old Boots, *painting by Vincent from 1886. Oil on canvas, JH 1124, F 255, 37.5 x 45.5 cm. Vincent van Gogh Foundation/National Museum Vincent van Gogh, Amsterdam*

Apart from still lifes of flowers, Vincent did many still lifes in 1886 with other subjects. These were not the typically rural objects such as the baskets with potatoes and the birds' nests of the Nuenen days, but simple objects from daily life like a plate with a slice of cheese, flanked by two glasses of red wine and a bottle (JH 1121), red herrings, pieces of meat, etc., which still show the rather somber colors from the Dutch period. Undoubtedly the most important piece from this series is the one representing a pair of old boots (JH 1124). For obvious reasons it has also become the best known one; Vincent was developing into an extremely personal artist, and this picture is perhaps the most characteristic of the independence of his work in this period. The color is not the new element, for the canvas is still completely done in gray-brown with yellowish-green tints which Vincent himself called his "green-soap colors." But what artist before him would ever have chosen a pair of worn-out boots as the subject for a still life? It is not surprising that the unusual theme, so discordant with what was then

considered "picturesque," has inspired many authors to elaborate on the symbolic meaning that may have attracted Vincent to the subject. Some writers have simply considered the boots to be a recollection of his endless travels on foot, and others have seen them in a broader perspective, as the image of every human being who has experienced many hardships on the path of his life.

In spite of all his color experiments with flowers, Vincent could not shed his dark palette easily, as shown by the series of still lifes with "domestic" objects of the first half year of his stay in Paris. His landscapes, too, were all but "frankly green, frankly blue" as he described them to Livens. There are several small pictures, representing the hill of Montmartre with the windmills, seen from the rear of the Moulin de la Galette in which soft green and brown tints predominate and which show hardly a glimpse of sunshine (JH 1175-1177); one of them (JH 1177) has in fact been done under heavy clouds. The effects of light and atmosphere, representative of impressionism, do not yet seem to have had any influence here.

Landscapes.

Four views of the rooftops of Paris (JH 1099-1102), seen partly from Theo's apartment on the third floor and partly from another high vantage point at Montmartre, must also have been done earlier in 1886. The largest of the group is also the most attractive (JH 1101); here one sees the houses in the foreground and some green trees standing out in clear contrast against the rooftops and the silhouettes of some large buildings such as Notre Dame and the Pantheon. Here, perhaps, there is already some influence of the landscapes of the impressionists, but muted and cool colors still predominate.

Vincent's earlier painting style is even more prominent in the first of the self-portraits that are ascribed to the Paris period (JH 1089 and 1090). Of these two, JH 1090 is the more important picture as Vincent has depicted himself here as a half-figure, standing in front of the easel holding his palette in his hand. Most writers have placed it in the Nuenen period because of the dark greenish-brown and reddish tints; however, the dark felt hat and the more urbane clothes he wears instead of the fur cap and the workman's blouse—for which he was renowned in his Antwerp days and before—seem to leave no doubt that the origin of these two paintings was in the Paris period.

Self-portraits.

Among the numerous works of 1886 in muted tints, there is one curious exception. It is a small, very sketchy canvas, showing a Paris street on the national day, covered on both sides with red, white and blue flags, filling the picture plane almost completely with their brilliant colors (JH 1108). Even more than the Monticelli-like flower pieces he had done, this *Quatorze Juillet* painting is an example not only of the influence of contemporary painting, but can almost be seen as a conscious imitation. There can be no doubt that Vincent had seen Monet's picture *Rue Montorgueil* from 1878 (there is a similar, smaller piece Monet painted of the same subject, known as *Rue Saint-Denis*), which also gives an impression of the dazzling colors of a street decked with the red, white and blue flags of the national celebration.[76] It seems that Vincent,

A colorful Quatorze Juillet.

[76] In the year 1878 it took place on 30 June.

236

somewhat ironically, had wanted to outdo Monet in the exuberance of his colors.

Little is known about the personal contacts Vincent made with the Paris artists in 1886. It is certain that he met Toulouse-Lautrec and Emile Bernard, who had also been working at Cormon's. From a note about a possible exchange of paintings with the artists Frank Boggs and Charles Angrand it follows that he also knew these painters. And finally there is A. S. Hartrick who wrote in his book of recollections that he had met and befriended Vincent in the studio of the Australian painter John P. Russell. These artists were certainly not the only ones with whom Vincent was acquainted. Two anecdotes give contradictory images of Vincent: the first, ascribed to the painter Suzanne Valadon, describes him as taciturn and reticent; the other comes from the painter Armand Guillaumin, who found Vincent "aggressive". Valadon is quoted by Gustave Coquiot, the author of several superficial and anecdotal biographies of artists. His book *Vincent van Gogh* appeared in 1923, but Valadon's story can also be found in Florent Fels's *Vincent van Gogh* of 1928 and his *Utrillo* of 1930 (Suzanne Valadon was Utrillo's mother), and in many later books.

What Suzanne Valadon observed was that for some time Vincent made regular appearances at the weekly gatherings in Toulouse-Lautrec's studio, carrying one of his canvases under his arm. This he would put down in a corner and wait for some attention to be shown to it. He seldom joined in the conversation, and as no one took notice, he would leave, only to be back the next week with his latest work, and the performance would repeat itself. "What a heartless bunch!" Suzanne Valadon concluded.

The other anecdote is again related by Coquiot. Here, he refers to the painter Armand Guillaumin, whose work Vincent knew well (Guillaumin had shown about twenty paintings at the eighth Impressionist exhibition in 1886) and who had become a good friend. Vincent regularly visited Guillaumin's studio, 13, quai d'Anjou, the former studio of Charles François Daubigny. Guillaumin seemed apprehensive about those visits because of Vincent's excitability. According to Coquiot, "Vincent would tear off his clothes and fall on his knees to make a point clearer, and nothing would calm him down. So Guillaumin was always on the alert. One day in Guillaumin's studio Vincent noticed some canvases of *Men Unloading Sand*; suddenly he went wild, shouting that the movements were all wrong, and began jumping about the studio, wielding an imaginary spade, waving his arms, making what he considered to be the appropriate gestures." It made Guillaumin think of Delacroix's painting *Tasso in the Madhouse*.

In 1886, Vincent must have had important contacts with both artists and art dealers. In his letter to Livens, he spoke of "four dealers who had exhibited studies" of his. At least three of these were the art dealers Delarebeyrette, Portier and Thomas. At the shop of Gabriel Delarebeyrette, who succeeded his father Joseph Delarebeyrette in 1886, Vincent could study the work of Monticelli. The dealer Alphonse Portier lived on the second floor of the same building as the Van Gogh brothers, 54, rue Lepic, and George Thomas, mentioned repeatedly by Vincent in later letters, was a dealer with whom Theo certainly did some business.

Vincent's contacts with art dealers.

237

By far the most interesting figure of this small group was Julien Tanguy (1825-1894), a paint and art dealer who has earned a much greater reputation than the others, because of both his curious personality and his importance to the Paris avant-garde. Vincent's three portraits of this man greatly helped to make him widely known. For later writers the principal source on Tanguy was the extensive article of 1908 by Emile Bernard in *Mercure de France*,[77] which contained many unknown particulars about his life and gave a striking image of his character. Tanguy, who had come to Paris in 1860 and had earned his living for many years as a color grinder, had finally opened his own little paint shop in the rue Clauzel, a small street in the immediate neighborhood of the rue de Laval. This address was not more than ten minutes from the rue Lepic, the address to which Vincent and Theo had moved in June 1886. Vincent became one of the most faithful visitors of the little shop, a meeting place for the most progressive painters who came to discuss art, to exhibit their work, and to see the works of Cézanne, of which Tanguy had a monopoly.

[77] "Julien Tanguy," *Mercure de France* (1908), pp. 600-616.

THEO AND HIS HOUSEMATE

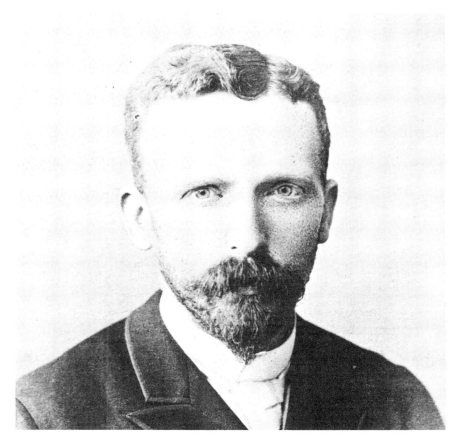

61
Photograph of Theo from the time he lived with Vincent in Paris.

Sharing an apartment with Vincent was not always easy for Theo. In her Memoir, Jo van Gogh-Bonger says, "Of all that Theo did for his brother, perhaps nothing entailed a greater sacrifice than his having endured living with him for two years." For an objective judgment of the situation, however, it is essential to examine the way Theo himself saw the problems. Fortunately, several of Theo's letters from these years have been preserved—letters to his mother, to two of his sisters, and to his brother Cor, which contain many particulars about his life in Paris and Vincent's stay with him.

In the cordial letters he wrote his mother and sisters, Theo rarely mentions his daily work at Boussod & Valadon's, at least not in those that have been preserved. As a result, it is not known when exactly he became the manager of the branch on boulevard Montmartre; in any case, that was his position when Vincent came to Paris. There is much to learn from the letters about his character and mood in these years. They make it very clear that he was not happy in Paris and was still suffering from fits of melancholia. One of the reasons must have been that he had not become accustomed to the city. Theo seemed most cheerful when he spent time in the country, which suggests that Vincent had shown a good insight when he wrote that Theo would have felt at home in Drenthe. In a letter to his mother of 22 April 1885, for instance, Theo wrote: "Last Saturday, Frans Braat, who lives at Ville d'Avray, one of the nicest spots around Paris, took me home with him and I stayed there. The fruit trees were in full bloom and the early greenery is so beautiful. It was a marvelous day."

And in a letter of 1 June of that same year, when his companion had probably been André Bonger, he wrote: "Last Sunday I was in a beautiful region. We had gone so far into the woods that we definitely lost our way, and it was late in the evening before we arrived in a village, where we bought a piece of meat from a butcher and had it prepared by a farmer. I assure you that it tasted good. It is so refreshing to feel the city far behind you. If one is born a countryman, one remains it his whole life, I believe, even if circumstances do not permit one to do exactly what one would like."

Theo was lonely in Paris, doubtless because he himself was so withdrawn. To his sister Lies, to whom he used to write more frankly than to his mother, he more than once complained that he had little contact with other people. On 13 October 1885 he wrote: "The more people one meets, the more one sees that they hide behind conventional forms of conversation, and that what they say when they pretend to be honest, is often so empty and so false. [André] Bonger, who is a good friend, is different, and we often say to each other that although we meet many people, we meet so few people whom we find sympathetic."

In a way, he secretly admired Vincent's lifestyle and would probably have preferred it had it been possible. He also showed more appreciation for Vincent's work—perhaps under Bonger's influence—than he would have admitted to Vincent himself, although at this moment he did not yet find it really "good." "You ask me about Vincent. He is one of those people who has seen the world from nearby and has retreated from it. We shall now have to wait and see whether he has genius. I do believe it and a few others with me, amongst them Bonger. Once his work becomes good he will become a great man. As to success, it may go with him as with Heyerdahl,[78] valued by some but not understood by the great masses. Those, however, who really care whether there is actually something in an artist or whether it is just tinsel, will respect him and in my opinion, that will be sufficient revenge for the displeasure expressed by so many."

One wonders whether Theo was happy that Vincent wanted to share an apartment. The Antwerp letters indicate that he had tried to postpone Vincent's arrival, but this may have been because he preferred him to come after he had moved to a bigger apartment. It will probably never be known for sure, as the letters to his mother and sisters from the first months of their shared life have been lost (the first to his mother from this period that has survived is from July 1886). The best guess would be that Theo received his brother with mixed feelings, certainly irritated by his unexpected arrival, and yet pleased— be it perhaps only in secret—with the fascinating companion who could now help fill the emptiness of his existence.

As it is only fair to take into account *all* available data, letters from Theo's friend André (or Andries) Bonger to his parents, which strike a somewhat different note, should therefore not be overlooked. The second volume of the *Complete Letters* includes a few short fragments of these letters.[79] Bonger had met Vincent only once before, in August 1885,

"It is so refreshing to feel the city far behind you. If one is born a countryman, one remains it his whole life."

Lonely in Paris.

[78] Hans O. Heyerdahl (1857-1913), a Norwegian painter.

[79] Under letter 462a on pp. 523-24.

240

when he had accompanied Theo during his short visit to Nuenen. He must have thought highly of Vincent as an artist after that visit. According to what Theo wrote to his sister Lies, Bonger saw "genius" in him (this was in October, only a few months after he had met him). In a fragment dated 23 June 1886, Bonger wrote: "Did I tell you that Van Gogh has moved to Montmartre? They now have a big, spacious apartment (big by Parisian standards) and their own household. They are now keeping a cook *in optima forma*. Theo is still looking frightfully ill; he literally has no face left at all. The poor fellow has many cares. On top of everything, his brother is making life rather a burden to him, and reproaches him with all kinds of things of which he is quite innocent."

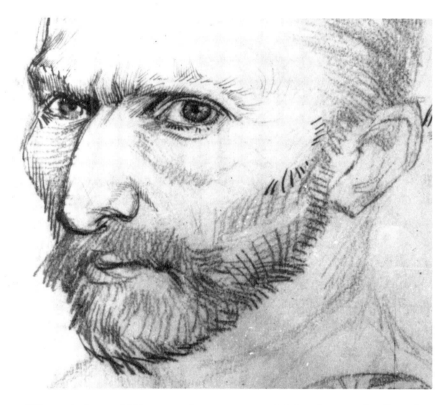

62
Self-portrait by Vincent, done when he lived with Theo in Paris, 1886. Pencil, pen, JH 1197, F 178v, 39.5 x 29.5 cm. Vincent van Gogh Foundation / National Museum Vincent van Gogh, Amsterdam

His opinion of Vincent, however, quickly changed when he came to know him better. This follows from a letter they wrote together to Theo in August, when Theo had gone to Holland and André Bonger had joined Vincent in the rue Lepic apartment during his absence. This letter gives the general impression of friendly unanimity, and Vincent noted that at times they were "almighty gay and light-hearted." All this leads to the conclusion that during the first months Vincent's irritability and obstinacy were indeed burdensome—something which annoyed Bonger more than Theo—but that there had been no serious clashes between the two brothers.

In 1886, Theo again had a mistress—a woman about whom even less is known than about "Marie," his former mistress. In their letter to Theo (letter 460), Vincent and Bonger indicated her only as *S*. There had been serious tensions between Theo

and her, bringing her almost to a nervous collapse, and Theo definitely wanted to end the relationship.

The main reason must have been that he longed to marry someone else. This was no secret to Vincent, and Theo certainly would have told him that the woman he had in mind was Jo Bonger, his friend André's sister.[80] Theo was attracted to her as early as 1886, but they did not marry until 1889. A few details about his secret marriage plans can be found in an unpublished letter, written a year later on 19 April 1887 to his sister Lies, who was the first (after Vincent) whom he took into his confidence. "I don't remember when I wrote you last and if I have already told you my secret. To go straight to the point, if you don't know yet: I am planning at one time or another to ask for Jo Bonger's hand. I surely don't know her enough to be able to tell you much about her. As you know, I have only seen her a few times, but the things I know about her appeal to me. She gave me the impression that I could trust her in a completely undefinable way, more than anyone else. I think I could talk with her about anything and I believe that if she wanted it, she could mean very much to me."

He admitted, of course, that it was extremely doubtful whether Johanna "would want him." "However, I can't stop thinking of her. She is always with me and very often I curse the terrible distance that lies between us. Why can't I see her more often and get to know her better, in order to know what she would wish and what she thinks of all kinds of things? How could I possibly get in contact with her in another way than I do now, being in Amsterdam once a year for one or two days, and then: *finished*? I have thought of beginning to write to her, but that is not possible either at the moment, as I was stupid enough last year not to ask her if she wanted to correspond with me."

These were the problems that occupied Theo's thoughts even as early as 1886, and it certainly was the relationship with S. which in his eyes was the principal hindrance to an official engagement. S. did not live with Theo in his apartment, something which would have made Vincent's arrival all the more problematic. Nonetheless, Theo had come to the conclusion that the affair could not be continued, and curiously enough, it was during his trip to Holland that, probably in a desperate mood, he had proposed a rather extreme solution to friends in Paris. The letter Vincent and Bonger wrote immediately after the receipt of Theo's cry of distress shows that they agreed on the seriousness of the situation but not on the solution.

Vincent's part of the letter begins with a comment about Theo's attempt to get support from his uncles in Holland to start his own business. Before Theo's journey, Vincent had tried to convince him that the discussions with the uncles would not be difficult, something which, however, had proven overly optimistic. This time it had not gone *à la vapeur*, as he expressed it (in Vincent's usage this meant it had not been "plain sailing"). This is what he wrote about the subject:

Theo's marriage plans.

Breaking from S.

[80] Johanna Gezina Bonger was born in Amsterdam on 4 October 1862, the daughter of Hendrik Christiaan Bonger and Hermine Louise Weissman; her father was an insurance broker.

242

This morning we got your letter. We think that it is already something that you have broached the subject—and broken the ice as you have spoken about it with the gentlemen in Holland, etc. And I do not think that my *"elle sera à la vapeur"*[81] was wrong; I myself see that *"à la vapeur"* in the future, and at this moment only insofar as our energy should be *"à la vapeur."* I do see it in the future. And as to the immediate present, you will remember that I said to you: meet with a refusal this time if necessary, but then in any case the subject is broached—and then there will have to follow a second trip to Holland by Bonger and you together. For the time being there is every reason to say with Father Pangloss: *tout est pour le mieux dans le meilleur des mondes* (letter 460).[82]

As said before, André Bonger had come to stay at rue Lepic when Theo was in Holland. On 27 August he mentioned it to his parents in these words: "During [Theo's] absence, I slept in his apartment as Vincent was alone." However, S. stayed with them for part of that time; even the fastidious Theo would allow a woman to stay in his apartment if that were convenient. Vincent was not secretive about it. "Do you know," he wrote Theo, "that Bonger is sleeping here as well as S., and these are queer days; at times we are very afraid of her, and at other times we are almighty gay and light-hearted. But S. is seriously deranged, and she is not cured yet by a long shot." André Bonger agreed: "Morally she is seriously ill," and maybe the explanation for their having taken her into the apartment lies in the sentences that followed: "It goes without saying that we could not leave her to her fate in this condition. On the contrary, we have been as kind as possible to her."

Vincent reacted to Theo's declaration that he wanted to get rid of her as follows: "But, old fellow, the solution to the S. problem which you mention in today's letter, namely 'either she gets out or I will,' would be very succinct and efficacious—if it were practical. But you will run your head against the same difficulties Bonger and I had to face the last few days, and which we are taking the utmost trouble to clear away" (letter 460). After this, Vincent proposed a solution to Theo which appears completely unexpected, if not bewildering.

> Well, I told Bonger what I told you, namely that you should try and pass her on to somebody else, and I told him more explicitly what my feelings on the subject are—that an amicable arrangement, which would seem obvious, could be reached by your passing her on to me. So it is certain that, if you could reconcile yourself to it, and S. too, I am ready to take S. off your hands, preferably *without* having to marry her, but if the worst comes to the worst even agreeing to a *marriage de raison*. I am writing this in a few short words in order that you may have time to think things over before your return. . . . If you could agree with this arrangement, the first consequence, as I see it, would be that you would feel a free man, and your own engagement would come *à la vapeur*. Keep courage and be calm!

"S. is seriously deranged, and she is not cured yet by a long shot."

[81] "It will be plain sailing." In using the pronoun *elle,* Vincent probably had in mind the word *l'affaire* (the business).

[82] Written in French in the Dutch text: "Everything is for the best in the best of worlds" (from Voltaire's *Candide,* one of Vincent's favorite sayings).

The heartless way in which he wrote about the woman is, of course, inexcusable, but should be seen in relation to the morals of Parisian society of that time. It is not only Vincent who appears heartless at this point, for it is clear that Theo was looking for a means of getting rid of her. His brother and his friend were in complete agreement, and were only cautioning him not to act too hastily.

Bonger appears to have agreed with Vincent in general, but not with the idea of "passing S." to him. He wrote to Theo:

"Morally she is seriously ill."

> The basis of V.'s reasoning corresponds with my own conviction. The problem is that S.'s eyes must be opened. She is not the least bit in love with you, but it is as if you have cast a spell on her. Morally she is seriously ill. It goes without saying that we could not leave her to her fate in this condition. On the contrary, we have been as kind as possible to her. If we hadn't, she would have gone mad. What makes me optimistic about her recovery is something she said last night: *"que je suis bête de ne pouvoir me faire un raisonnement"*.[83] So it seems she feels what is the matter with her. The great difficulty is her obstinacy, which we have repeatedly bumped our heads against. Nothing is to be gained by harsh treatment. For the time being it is extremely difficult to make a plan (Vincent's is impracticable, as far as I can see), but I hope you are fully convinced that your handling of her has been wrong; during the past year your relations have had no other result than getting her hopelessly muddled. Perhaps it would have been better to live together completely; then she would have seen of her own accord that you are not at all well matched (letter 460).

The end of this minor drama probably was as Vincent wrote: "The moment you meet again, you will both feel that the liaison between S. and you is definitely *off,* and so you need not be afraid of getting tied to her again. But you must talk a lot with her, and try to get her settled down. Please think it over in the interval between now and your return, and remember: *aux grand maux les grands remèdes"* (letter 460).[84]

Serious Problems

The end of 1886 was a period in which difficulties between Theo and his brother seriously threatened to disrupt their relationship. While late in the summer of 1886 there was still an atmosphere of great unity and even heartiness between them, great tensions developed later in the year. In one of his so far unpublished letters, André Bonger wrote that all was not well with Theo himself: "He has serious nervous afflictions, so bad that he could not move. To my great astonishment I found him back yesterday exactly as he was before; he seemed to be still stiff as after a fall, but there were no other after effects" (31 December 1886). Theo had not recovered even as of February 1887. "Van Gogh, too, is in need of a renewal.[85] He is still looking ill and thin and feels very weak. If he would not

[83] "How stupid of me that I can't make up my mind."

[84] A well-known saying in French: "serious diseases demand serious remedies."

[85] *Van Gogh lui aussi a grand besoin d' être remis à neuf.*

244

have been so terribly stubborn, he would have gone to see [doctor] Gruby[86] long ago."

A few of Theo's letters of a short time later show that relations between the brothers really did not go well. The earliest passage in which he wrote about problems with Vincent is in a letter to his younger brother Cor of 11 March 1887—one of the few to Cor that has been preserved. Theo wanted to congratulate his brother, who was now 19, for receiving his first salary.[87] He wrote about Vincent: "Vincent continues his studies and he works with talent. But it is a pity that he has so much difficulty with his character, for in the long run it is quite impossible to get on with him. When he came here last year he was difficult, it is true, but I thought I could see some progress. But now he is his old self again and he won't listen to reason. That does not make it too pleasant here at home and I hope for a change. That change will come, but it is a pity for him, for if we had worked together it would have been better for both of us."

A few days later Theo wrote to Wil in even stronger terms. Evidently her advice had been that Theo should stop supporting Vincent, or at least stop living with him. This was something that Theo was not willing to do, although he did write very critically about Vincent and even expressed the hope—and not in a friendly way—that Vincent would find another place to live. What follows is the most important fragment of Theo's letter of 14 March 1887, written in a mood when, he said, "the difficulties seemed insurmountable":

63
54, rue Lepic, where Theo had his apartment on the third floor.

I cannot tell you how much good your latest letter has done me. In difficult days it is so much to know that there is someone who wants to help bring things to a good end and I am often ungrateful enough to imagine that I stand all alone and then the difficulties seem insurmountable and it seems that there is no way out. Your letter proves to me that I am wrong. This is such a special case. If he was someone who had a different kind of job, I would certainly have done what you advised me a long time ago, and I have often asked myself whether it was not wrong always to help him; I have often been on the verge of letting him muddle along by himself.

After getting your letter I again seriously thought about it and I feel that in the circumstances I cannot do anything but continue. It is certain that he is an artist and what he makes now may sometimes not be beautiful, but it will surely be of use to him later and then it may possibly be sublime, and it would be a shame if one kept him from his regular studies. However impractical he may be, when he becomes more skilful the day will undoubtedly come when he will start selling.

You should not think that it is the money side that worries me the most. It is mostly the idea that we sympathize so little anymore. There was a time when I loved Vincent a lot and he was my best friend but that is over now. It seems to be even worse from his side,

[86] Gruby was at that time a well-known promoter of natural health care.

[87] As Cor was a metal worker, Theo could not refrain from telling him something which at the moment was the talk of the day in Paris, and the rather naïve way in which he formulated it is too curious not to quote it here: "Have you heard they are going to make an iron tower 300 meters high here? That must mean a lot of work. It seems it has been terribly difficult to figure out in what way it would be possible to keep it standing, and the designer tells us that ten years ago it would not have been possible to make that calculation."

for he never loses an opportunity to show me that he despises me and that I revolt him. That makes the situation at home almost unbearable. Nobody wants to come and see me, for that always leads to reproaches and he is also so dirty and untidy that the household looks far from attractive. All I hope is that he will go and live by himself, and he has talked about this for a long time, but if I told him to leave that would only give him a reason to stay on. Since I cannot do any good for him I only ask for one thing and that is that he won't do any harm to me and that is what he does by staying, for it weighs heavily on me.

It appears as if there are two different beings in him, the one marvelously gifted, fine and delicate, and the other selfish and heartless. They appear alternately so that one hears him talk now this way and then that way and always with arguments to prove pro and contra. It is a pity he is his own enemy, for he makes life difficult not only for others but also for himself.

I have firmly decided to continue as I have done up to now, but I hope that for some reason or other he will move to other quarters, and I will do my best for that.

It was the melancholy and even neurotic Theo who wrote these lines, for in him there were two different beings as well. Enough is known about Vincent's character for one to be convinced that words like "he never loses an opportunity to show me that he despises me and that I revolt him" could only have been written in anger and should not be taken too literally. While Theo still expresses the vague hope that Vincent "will move to other quarters," he also tells Wil that he has decided never to fail him. In the next few weeks his *examen de conscience* brought Theo to the conclusion that if mistakes had been made, they were not only Vincent's. This is especially evident in a letter of 19 April to his sister Lies, whom he had not bothered with his problems until now. "Don't think that when I don't go into details it is all other people's fault. No, the main reason was that I was ill, especially mentally, and that I had a hard struggle with myself."

On 26 April, hardly six weeks after his desperate outcry about the "unbearable" situation, he wrote to Wil that peace had been made. "A lot has changed since I wrote you last. We have made peace, for it did not do anybody any good to continue in that way, I hope it will last. So there will be no change and I am glad. It would have been strange for me to live alone again and he would not have gained anything either. I asked him to stay. That will seem strange after all I wrote you recently, but it is no weakness on my side and as I feel much stronger than this winter, I am confident that I will be able to create an improvement in our relationship. We have drifted apart enough than that it would not serve any purpose to make the rift any larger."

Theo's changed attitude toward his brother is confirmed in a letter he wrote to Lies on 15 May 1887. "Vincent is working hard as always and keeps progressing. His paintings are becoming lighter and he is trying very hard to put more sunlight in them. He is a curious chap, but what a head he has got, most enviable." There probably were no further frictions between the two, for three quarters of a year later, immediately after Vincent's departure for Arles, Theo confessed to Wil that he had not thought he would get so attached to his brother.

Vincent and Theo make peace.

64
Vegetable Gardens in Montmartre, *a pointillistic painting by
Vincent from 1887. Oil on canvas, JH 1245, F 350, 96 x 120 cm.
Stedelijk Museum, Amsterdam*

When Vincent did his portrait of the paint-dealer Tanguy,
he placed a precise date on the canvas, *Janvier 87* (January
1887), something exceptional in his oeuvre. With that date, the
threshold of 1887 was crossed—a year that would prove to be
one of the most decisive for Vincent's development as an artist.
During this year the outside influences on his work became
obvious, but he would also enter completely new paths,
unrelated to these influences.

While he formed strong artistic convictions in Brabant, he
could no longer resist the influence of the neo-impressionists,
as the group of artists such as Seurat and Signac was called
after the critic F. Fénéon had used the term in an article of
1887.[88] Vincent had made the acquaintance of one of their most
conspicuous technical renewals, pointillism (or divisionism, as
Signac, the theoretician of the group, preferred to call it),
shortly after his arrival in Paris, when, for instance, Seurat's

[88] "Le Néo-Impressionnisme," *L'Art moderne* (1887).

large picture *La Grande-Jatte* had been on show. However, it was not until 1887 that he began to experiment with pointillism, gradually developing a unique style comprised of heavy, unconnected brush strokes instead of the small dots of unmixed colors as pure pointillistic theory would require.

It is well known that in the spring of 1887 he often worked with the twenty-four-year-old Paul Signac, who was a follower and friend of Seurat and one of the champions of divisionism.[89] They painted landscapes along the Seine and in Asnières and Saint-Ouen (suburbs of Paris); on these occasions, according to Coquiot, Vincent carried all his material with him and sometimes came home with one or two canvases covered with a series of small landscapes, evidently sketches for larger pictures, to be worked out in the studio. The story sounds apocryphal, but was based on a letter by Signac, who had been asked for his recollections. According to Coquiot, Signac had written him: "Yes, I made the acquaintance of Van Gogh at père Tanguy's. At other times I met him in Asnières and in Saint-Ouen; we had lunch in a café and walked all the way back to Paris, through the streets of Saint-Ouen and Clichy. Van Gogh, dressed in a blue workman's blouse, had painted little dots of colors on his sleeves. Sticking close to me, he shouted and gesticulated, brandishing his large (size 30), freshly painted canvas, polychroming himself as well as passers-by with it."[90]

Working with Paul Signac.

As Signac had left for the South sometime in May and stayed away until November, this incident must have taken place in the spring, but Vincent continued to do these divisionist landscapes into the summer. In the fall of 1887 he wrote to his sister Wil: "Last year I painted anything hardly but flowers in order to get accustomed to using colors other than gray—namely pink, soft and vivid green, light blue, violet, yellow, orange, rich red. And when I was painting landscapes in Asnières last summer, I saw more color in it than before" (letter W 1). One has only to compare a few landscapes of this year with the landscapes with windmills or the views of Paris of 1886 to see how much they have gained in brightness of color. Typical spring landscapes, as the one with two rowing boats near a bridge (JH 1270), or the one with simply the banks of the Seine and the trees on them (JH 1269), might be called still more correctly "frankly green, frankly blue" than his work of the year before. They are closely related to the river views in the "pure" impressionist style he knew from Monet or Sisley. But at the same time he did many landscapes in the stippling technique which he had now begun to appreciate, no doubt particularly due to the influence of his friend Signac. Moreover, from the end of April until the beginning of May of 1887, there had again been an exhibition of the Indépendants, which had given him the opportunity to see a great number of pictures in pointillist style—about ten each from Seurat and Signac alone.

Divisionist landscapes.

Compared to the work of Seurat, Signac, and many of their followers, Vincent's pointillistic pictures are distinguished by a less consistent application of their system. In a landscape that was principally constructed with color dots, for instance, he did

[89] Already in 1899 he published a book in which the theoretical background of this movement is discussed in detail: *D'Eugène Delacroix au Néo-Impressionnisme*.
[90] Gustave Coquiot, *Vincent van Gogh* (1923), p.140.

248

not object to doing the sky in a more even, more impressionistic manner (an example is the Montmartre landscape, JH 1244). For some time, he seems to have considered color dots and little color stripes equally well suited for portraits; and so, from the first half of 1887 a whole series of important self-portraits as well as portraits of a few other models exist which clearly show the influence of pointillism.

It is possible to notice a certain evolution here. In the beginning, the dots and stripes are only conspicuous in the clothing of the figures and in the background, a good example being the refined portrait of a lady at the cradle (JH 1206). This portrait is still more impressionistic than pointillistic. At a later stage, the hair and the beard and even the face of the model are done in forceful little stripes of bright color, for instance in the portrait of Vincent's friend, the Scottish art dealer Alexander Reid (JH 1250). Several of the self-portraits from the middle of 1887 show the stippling technique in the same emphatic way, often with flamboyant backgrounds encircling the model with a halo of orange, dark green and brown color dots (JH 1248 and JH 1249, for instance).

The self-portraits of 1887.

Before these paintings were made—probably in the beginning of 1887—Vincent's self-portraits are distinguished by soft and light colors, in accordance with the palette of impressionism and without a trace of pointillism. A typical example of this group is the very small self-portrait against a soft blue background, in which Vincent has depicted himself more or less as a dandy with a light gray felt hat and a sky blue bow tie (JH 1210), every inch a Parisian. Stylistically, after these first attempts, he must have covered a great distance in a very short time, and this becomes clear when one compares this little picture with the important self-portrait in which he rendered himself with the same grey felt hat against a different light blue background; in the latter he has a much more forceful and tense expression (JH 1211). Although the dark brown jacket has been done with distinct strokes of color, the picture cannot be described as pointillistic. Apart from the style of execution of the jacket, the face is daringly modelled with paint strokes that are no more smoothed out than the brush strokes on the brown and reddish beard, the border and the dark blue ribbon of the hat! Here one clearly sees the beginning of the extremely personal painting style that distinguishes many of Van Gogh's masterly portraits of the next three years.

Vincent's friendship with Emile Bernard.

In 1887, Vincent had much contact not only with Signac, but also with the young Emile Bernard, whom he had probably met either at Cormon's studio in 1886 or at Tanguy's shop a short time later. Bernard was only eighteen when Vincent met him (he was born 28 April 1868); despite his youth he was already an artist with a style of his own, and his work may even have had some influence on the older Vincent. Bernard also had a literary talent—he wrote poetry and articles about modern art at this early age, and was the only one of Vincent's many friends from the Paris period who honored the man and his work many times in all kinds of periodicals.

Even the first sentence of Bernard's commemorative article of 1890 is sufficient to show how strongly they were attached; it is an error, Bernard wrote, that people sometimes have no confidence in the opinion of friends, about a deceased, for "whom do we know better than the ones we love, particularly in

art, where all friends are based on comparable endeavors, on similar insights?" Also in this, the earliest of his articles about Vincent, Bernard wrote: "I met Vincent van Gogh for the first time at Cormon's studio; and what laughter behind his back, while he did not condescend to notice anything. Afterwards at Tanguy's, that little chapel of rest, whose old priest showed the nice smile of unsuspected honesty. When Vincent emerged from the back shop, with his high large brow, I was almost afraid, so much was he in flames; but we became friends soon, and then the files of Holland and the portfolios with studies were opened."

The more elaborate piece Bernard wrote in 1911 as an introduction to an edition of the letters he had received from Vincent[91] gives a lively portrait of his colleague at work. There are curious similarities with the things Signac had written to Coquiot, but Coquiot's book dates from long after 1911 and cannot have influenced Bernard; inversely, Signac will certainly have known Bernard's recollections, and they may very well have influenced his own recollections of Vincent. "Vincent often came to see me in the wooden studio that had been constructed in my parents' garden. It is there that we painted together a portrait of Tanguy; he even began one of me; but, having picked a quarrel with my father who refused to give in to his advice about my future, he flew into such a rage that he abandoned my portrait and carried away the one of Tanguy, unfinished, having swung it under his arm, disregarding the fresh paint. Then he went off, without turning around once, and never put a foot again at our place. From that moment on I therefore frequented the apartment at 54, rue Lepic, which the brothers Van Gogh then occupied."

Bernard, who had been dismissed from Cormon's in the spring of 1886 because of his independent opinions, had followed a path which led him away from impressionism and from the kind of neo-impressionism that was propagated by artists such as Seurat and Signac. Although he too had experimented for a short time with pointillism in 1886 and at the beginning of 1887, like Vincent he sought an individual direction. By 1887 he had arrived at an extreme simplification of forms and flat colors in clearly outlined planes—a style which is generally described as "cloisonism" since the publication of Edouard Dujardin's article *Aux XX et aux Indépendants —Le Cloisonnisme*, in *La Revue Indépendante*, March 1888. At the same time, Vincent also began to develop a more synthetic style. There is no doubt that this development in the work of artists like Bernard, Van Gogh, and Gauguin was due largely to the admiration they had for the art of Japan, whose popularity was quickly rising in France—particularly in Paris—in these years.

Bernard's "cloisonism."

Since the middle of the nineteenth century, Japanese products, which had been completely closed off from the outside world, started to pour into the West. They were causing a great interest, particularly in Paris, and were called "Japonaiseries" (by analogy of "Chinoiseries" which had been popular for centuries). One can already notice Japonaiseries in paintings by impressionists from the sixties and seventies—in Manet's 1867-68 portrait of Zola, Zola is depicted sitting in front of a

The influence of Japanese art.

[91] *Lettres de Vincent van Gogh à Emile Bernard* (1911).

Japanese screen with a Japanese print on the wall, and in Manet's portrait of Nina de Callias (1874), the wall is full of Japanese fans—and these are just a few examples. At the same time, much was being written about Japanese art by literary authors. That Zola was interested in this trend is shown by Manet's portrait, but the brothers Jules and Edmond de Goncourt were still greater propagandists for everything Japanese. They even boasted to have been the first in France to have an eye for the art of Japan.

In the preface to his novel *Chérie* (a book that Vincent knew and admired), Edmond de Goncourt wrote that his brother Jules had stated a few months before his death in 1870 that the two of them had created the three great literary and artistic revolutions of the second half of the nineteenth century: the search for *truth* in literature, the renaissance of eighteenth century art, and the triumph of "Japonism." Jules had said: ". . . [our] discovery at the Porte Chinoise [a shop where oriental products were sold] of the first "album japonais" to become known in Paris, at least in the world of writers and painters, and the pages, devoted to things Japanese in [our] *Manette Salomon* [a novel that Vincent knew, as well] and in *Idées et sensations* —does all that not give us the right to call ourselves the first propagandists of that art, an art which is imperceptibly beginning to change the way of seeing of the Western world?"

Vincent was one of the artists on whom the impact of Japanese art had been particularly great, and he used all of his power of persuasion to make his friends share his enthusiasm. His influence on young painters such as Emile Bernard and Anquetin was certainly not less than theirs on him. It is not known when Vincent first became acquainted with Japanese art, but he did call his little room in Antwerp "quite tolerable," adding, "especially as I have pinned a number of little Japanese prints on the wall, which I enjoy very much" (letter 437). The only certainties, therefore, are that he possessed a number of Japanese prints already in November 1885 and that he read about Oriental art in books by the Goncourt brothers; he owed to them the term "Japonaiserie."

In Paris, he had every opportunity to improve his knowledge in this field. In 1886, several important publications on Japanese art appeared, such as a reprint of Louis Gonse's *L'art japonais* from 1883, one of the main sources of information on the subject. On 1 May, *Paris Illustré* came out with a double issue, solely devoted to "Le Japon." Vincent owned this issue, and he used the illustration on the cover for one of his paintings. He became a regular visitor at the shop of the main dealer in Japanese art, S. Bing, and it was here that he started the collection of the 400 or so Japanese prints which is still one of the great treasures of the Vincent van Gogh Museum in Amsterdam.

In letters to Theo from Arles, he strongly advised his brother to go on buying *crépons*, as they were generally called, and also to try to improve the quality of the collection by exchanging inferior prints for better ones. He wrote, for instance: "There is an attic at Bing's with a heap of ten

Van Gogh's collection of Japanese prints.

thousand crépons,[92] landscapes, figures, very old ones too. He will let you choose for yourself some Sunday, so take plenty of old prints as well" (letter 510). It was probably Vincent who had seen to it that they could enjoy the beauty and charm of the colorful prints daily. He wrote Theo, "Your rooms would not be what they are without the japonaiseries always there" (letter 510).

65
Self-portrait with pointillistic background from 1887. Oil on canvas, JH 1248, F 356, 41 x 33 cm. Vincent van Gogh Foundation / National Museum Vincent van Gogh, Amsterdam

His admiration for Japanese art is clearly shown by three paintings in which he had simply copied Japanese wood cuts, at an enlarged scale. They are *A Flowering Plumtree*, as the painting is mostly called (which is in fact the silhouette of part of the stem and a few branches); *Bridge with Pedestrians in the Rain*; and *Oiran* (a Japanese courtesan). The first two were done after prints by Hiroshige, the third one after the reproduction on the cover of *Paris Illustré*. This last illustration has been identified as a print by Kesai Eisen. On the sides of the first painting Vincent placed a decorative border with Japanese characters; on the second he did it on all four sides; but on the third, which is the largest and most original of the

[92] The original edition of the letters had "*100 mille crépons*," which was a printing error for "*10 mille*"; this became "millions of prints" in the English translation.

three, he surrounded the elongated figure—in itself already so decoratively attired—with all kinds of characteristic images (reeds, waterlilies, frogs, etc.) borrowed from other Japanese prints. That the three paintings were really meant to be exact copies is clearly shown by the fact that he carefully traced the contours of his models on transparent paper, which he divided in squares, enabling him to enlarge the subject. Two of the three preliminary drawings or "cartoons" still exist.[93]

Much has been written about these copies, but none of the commentators has succeeded in giving a definitive answer to the question of what really moved Vincent to undertake the complicated work involved in these slavish imitations. In his letters there is not a word about these paintings which gives a clue. The most acceptable explanation is that he did them for study purposes, not with the aim of producing attractive and salable pictures. By copying them he must have wanted to make himself familiar in detail with the composition technique of the admired Japanese artists: their stress on the linear instead of the three-dimensional, their crossing lines, their flat colors, and their gracefully decorative, but completely unrealistic figures, especially the geisha with the almost abstract patterned costume.

Another instance of his use of the Japonaiseries that were dear to him are the two portraits of père Tanguy he did by the end of 1887 (JH 1351 and JH 1352). In these portraits he portrayed his friend from the knees up, wearing a blue jacket and a wide-rimmed straw hat, sitting against a wall covered with Japanese prints. No one has ever been able to explain the curious composition, for as far as is known, Tanguy did not sell Japanese prints, and so the background cannot represent the wall of his shop with a display of wares. One might assume that Tanguy posed in the rue Lepic apartment. There is some foundation on which to base such an assumption, because on one of the portraits (JH 1352) there is a corner of a painting with an orange and yellow striped frame which probably represents one of Vincent's own pictures.[94] Even then it would have been a whimsical fantasy to change the background into a sort of draft-board of Japanese prints, for this was certainly not the way in which they were hung in Theo's rooms. There seems to be no logical relation between the model and the background decoration; it is possible that Vincent had simply wanted to obtain a fascinating and colorful composition.

In any case, he succeeded in paying a very original tribute to his beloved Tanguy, and expressing, even more convincingly than with his three copies, his admiration for the endless variety of the Japanese prints. Grouped together as he has presented them here, with their intriguing female figures, their charming spring landscapes, their hamlets in the snow, and the mighty Mount Fuji as a crowning background, they give the synthesis of a world as different from Paris as was possible. As to good old Tanguy, Vincent certainly did not try to flatter him. On the contrary, he shows him in his bulky simplicity as he

The portraits of père Tanguy, a synthesis of his love for the art of Japan.

[93] M.E. Tralbaut was the first to describe these copies in detail. His lecture, "Van Gogh's Japonisme," held at the Van Gogh symposium in The Hague in 1953, was published in *Mededelingen van de gemeente's-Gravenhage*, (1954), pp. 6-40.

[94] Identified by Fred Orton as still life JH 1339 (F 383). This had been dedicated to Theo and certainly would have hung in the apartment.

must have seen him sitting in his little shop countless times: hands crossed, waiting for customers and for the painters who brought him their unsalable canvases.

One of the portraits must have been made for the sitter, and Tanguy was very pleased with his curious image. This fact is known from the memoirs of the art dealer Ambroise Vollard who had never met Vincent, but who did know Tanguy. Vollard wrote about the portrait, which is now in the Musée Rodin in Paris: "If someone wanted to buy it from him, Tanguy coolly asked five hundred francs for it, and if one protested indignantly against the 'enormity' of the price, he would add, 'It is because I don't want to sell my portrait.' And indeed it remained in his possession for the rest of his life; after his death it was sold to Rodin."[95]

One could argue that there is a touch of the Japanese in some of the landscapes he painted or drew in the spring and summer of 1887, especially in a small group of watercolors he completed in the same year. This is suggested in a series of landscapes done from different places on the outskirts of the city where the surrounding walls had been partially levelled, resulting in sights which must have attracted Vincent's attention by their curious geometrical structure (see drawings JH 1280, 1283 and 1284). With their sharply drawn contours and their bright, flat colors they are a far cry from the atmospheric landscapes of the impressionists, and also from the more experimental pictures of the divisionists. One of these drawings, which shows part of the walls ending at a street with a horse-drawn tram and people walking (JH 1284), reminds one of Japanese prints if for no other reason than the quantity of little figures.

The most successful example of this narrative, linear style is the watercolor in which one of the suburbs of Paris— probably Asnières—is shown from a high vantage point with an imposing part of the walls partially levelled in the foreground (JH 1286). Such drawings are clearly related to the wood cuts of Hiroshige without being imitations.

Vincent's enthusiasm for Japanese art must have influenced his young friends like Anquetin and Bernard. He seems to have taken them to the attic at Bing's, for he wrote Theo, "I learned there myself, and I made Anquetin and Bernard learn there too" (letter 511). It is significant that during Vincent's stay in Paris he organized an exhibition of Japanese prints himself. Though there is no information available about it from contemporaries, there can be no doubt about the enterprise itself, for in a letter to Theo from Arles he wrote, "The exhibition of *crépons* that I had at the Tambourin influenced Anquetin and Bernard a good deal" (letter 510). The exhibition in the Tambourin was mentioned again in a still later letter to Theo (letter 595).

His relationship with the Tambourin did not only involve an exhibition of Japanese prints. Early information on the Tambourin establishment, located on the boulevard de Clichy, can be found in Bernard's above-mentioned 1908 article on Tanguy:

Vincent's exhibition of Japanese prints at Le Tambourin.

[95] Ambroise Vollard, *Souvenirs d'un marchand de tableaux* (1937), p. 36.

It was in this period [namely when Vincent frequented Tanguy] that he was a regular customer in a café called Le Tambourin. The manageress was a beautiful Italian woman, a former model, who displayed her healthy and imposing charms in her own little office. Vincent used to take Tanguy to this establishment, something which caused the honest mother Tanguy a lot of uneasiness; she could not imagine the innocent and even childish reasons for his . . . escapades. Vincent's arrangement with the Tambourin was that he could dine there on the basis of a few pictures per week, with the result that finally the walls of the café were covered with his paintings. Most of them were flower pieces, of which he made some splendid ones.[96] This lasted several months; but then the establishment went bankrupt. It was sold, all those pictures were thrown on a heap and dispensed for a ridiculous sum.

Many books about Van Gogh assume that he was Agostina Segatori's lover, the "beautiful Italian woman." This conclusion, however, is based only on a few sentences which Vincent had devoted to her in two letters he wrote to Theo during the latter's stay in Holland. He did write: "You can be sure about one thing, that I will not try to do any more work for the Tambourin. Besides, it seems that it is going into other hands, and I certainly shall not try to stop that" (letter 462). From this, it is clear that he had worked for the Tambourin, but not what the nature of his relationship with La Segatori was. It should not be concluded from the rather innocent words, *"j'ai encore de l'affection pour elle"* ("I still have some affection for her"), that she was his mistress. On the other hand, the conclusion might have been based upon one of the escapades he mentioned in a letter to his sister Wil the same summer, "As far as I myself am concerned, I still go on having the most impossible, and not very seemly, love affairs, from which as a rule I emerge damaged and shamed and little else" (letter W 1).

However this may be, we owe to Vincent's acquaintance with Le Tambourin an important picture, the portrait of a woman (JH 1208). It must be assumed that the portrait represents La Segatori, for whom else would he have been permitted to paint in such an imposing position in the otherwise empty restaurant? It is one of the most attractive portraits from Vincent's Paris years, not only because of the exotic decor, the barely sketched Japanese painting of a female figure with the Japanese umbrella in the foreground, but also because of the composition as a whole with its clear color combination, and particularly because of the model's somewhat mysterious, pensive expression.

That Vincent distanced himself even farther from reality and arrived at a still greater simplification of forms was perhaps also due to the influence of the young Bernard. Bernard's picture of the Seine with the railway bridge in the foreground is a good example of his synthetic procedure, in which elements of reality, such as the piers of the bridge, a train, or an upside down boat, have been reduced to almost geometrical, flat colored forms. One of Vincent's paintings, most often referred to as *The Italian Woman* (JH 1355), shows

Agostina Segatori.

[96] One early still life with pansies (JH 1093) must even have been painted for the Tambourin, or maybe in the café itself, for the flowers are on a little table in the form of a tambourine.

255

still more simplification than the portrait of La Segatori. In *The Italian Woman*, one of the most important portraits of his last months in Paris, the figure is not placed like La Segatori in a large, clearly delineated room in which one notices chairs and stools in the form of tambourines, but against an abstract, even-colored yellow background. And in the case of several of the splendid, brightly colored fruit still lifes dating from these months, the objects are placed in an abstract space, in which there is no indication whatsoever of a table top or a similar realistic support. In the simple but charming still life which Vincent had dedicated to his friend Lucien Pissarro (1863-1944), Camille's son, the apples are at least placed in a basket, even though it is indicated with only a few summary brush-strokes (JH 1340); in other canvases, such as the still lifes with apples, pears, lemons, and grapes (JH 1337 and 1339), the pieces of fruit seem to float in an indistinct vacuum, surrounded, in the first picture, by shafts of light blue, and in the other, by rays of golden yellow.

In spite of the individuals and circumstances that influenced the development of his Paris oeuvre, Vincent created a number of completely original compositions. The well-known still life with a number of French novels on a table (JH 1332) is a good example. It is difficult to find parallels to this unusual composition in contemporary or earlier painting. Vincent had already used the motif of a book lying on a table in 1885 in his famous still life with the Bible, but here the main subject of the picture is the *number* of books. One is struck by the arbitrariness with which they are spread out in little heaps—a chaos that is contrary to tradition. Vincent's aim was clearly not to master the chaotic by a "picturesque" arrangement, but he did harmonize the painting by making it into a mosaic of colors, using the yellow, orange and pink book covers as well as the colored stripes of the background.

A chapter about Vincent's stay in Paris cannot be closed without a few words about another important exhibition he organized there—the second exhibition after the one at Le Tambourin—for there is no better proof of the stimulating effect he caused in Paris once he was acclimatized. The earliest description of the second exhibition, held at the Grand Bouillon-Restaurant du Chalet, was given by Emile Bernard in his "Notes sur l'école dite de Pont-Aven" from 1903.[97] It is short and wonderfully concise. "1887. On the avenue de Clichy a new restaurant was opened. Vincent used to eat there. He proposed to the manager that an exhibition be held there. The walls were very high, the light was excellent. Canvases by Anquetin, by Lautrec, by Koning . . ., and by me, supplemented by an innumerable number of studies by Van Gogh, filled the hall. It really had the impact of something new; it was more modern than anything that was made in Paris at that moment."

It must have been a very important event—at least for Vincent and the other participating artists! For the first time Vincent's colleagues were able to acquaint themselves with the full extent of his talent—a talent that demanded recognition and respect. There is little authenticated information about the du Chalet exhibition, yet there is enough to know that it was not a failure, in contrast to what Vincent himself called his

Vincent's second exhibition.

97 *Mercure de France* (1903), p. 678.

exhibition in Le Tambourin: "The exhibition of crépons that I had at the Tambourin influenced Anquetin and Bernard a good deal, but what a disaster it was" (letter 510). His second exhibition, he thought, at least had some good results. "As for the trouble we took over the second exhibition in the room on boulevard de Clichy, I regret it even less: Bernard sold his first picture there, Anquetin sold a study, and I made an exchange with Gauguin; we all got something out of it" (letter 510).

It may seem strange that Vincent, who exhibited paintings at Le Tambourin and in the Restaurant du Chalet, did not participate in the exhibition of the Société des Artistes Indépendants, where his work certainly would not have been out of place and since his friend Paul Signac was "the soul" of the Indépendants.[98] The reason for Vincent's absence probably lay in his lack of self-confidence. It was not until later in the same year, 1887, that he showed signs of being aware of his own originality. In that year the exhibition of the Indépendants was held in the Pavillon de la Ville de Paris on the Champs-Elysées from 26 March to 3 May, and Vincent may not have felt that he was a match for the other exhibitors such as Angrand, Cross, Dubois-Pillet, Lucien Pissarro, Odilon Redon, Seurat and Signac himself. When there was another exhibition of the Indépendants in Paris in 1888, he had no objection to participating, and he was also represented at their exhibitions in 1889 and 1890.

The last few months of Vincent's stay in Paris were characterized by a series of masterly pictures in which he appears to have completely freed himself from the many influences on his work. He developed an original way of expressing himself in bright colors and a daring technique of unmixed, clearly divided brushstrokes. This is evident in his still lifes of fruit, in the still life with the books and the plaster model (JH 1349), in the portraits of Tanguy and the *Italian Woman*, in the self-portrait with gray felt hat (JH 1353)—perhaps the highlight of the long series of twenty-eight—and finally, in the well-known self-portrait in front of the easel (JH 1356). The painting is the only one that is annotated with the date 1888, but it could not have been the only work Vincent did between 1 January and his departure from Paris, around 19 February 1888. Whether it was the last of the Paris paintings or not, it is a repetition of the theme with which Vincent had begun his work in France.

One of the very first self-portraits Vincent completed upon his arrival in Paris was completely done in the "green-soap colors" that he called typical of his Brabant period. The 1888 self-portrait, however, though not even one of the most brightly colored works of these months, was done completely in divided brush strokes in mostly unmixed primary colors. Vincent did not hesitate to paint the facial features in short strokes of yellow, red and green—the brightest and clearest patches of color on his palette. What remained unchanged was the composition; the figure is in the same position (only without a hat this time), with the palette, brushes and part of the canvas on the easel filling the right hand corner of the painting. It has been suggested that the picture was influenced by Cézanne's well-known self-portrait in front of the easel, but for this

Vincent's farewell to Paris: A series of masterly pictures.

98 Gustave Coquiot, *Les Indépendants* (1920), p. 54.

composition Vincent had only to look at his own picture of 1886, which hung in his studio. This is what he did, but he must have had the feeling that he was copying the work of a predecessor of long ago—himself.

66
Drawbridge in Arles with Walking Couple, *sketch in a letter from Vincent to his friend Emile Bernard, 1888. Sketch in letter B 2, JH 1370.*
Private collection, Paris

When Vincent left Paris in February 1888, it was probably not because he was discontent with the work he did there; there must have been several other reasons for him to leave. A passage in a letter from Theo to his fiancee Jo Bonger, written in 1889 and quoted in her *Complete Letters*, gives some indication. "In Paris he [Vincent] saw so many things which he liked to paint, but again and again it was made impossible for him to do so. Models would not pose for him and he was forbidden to paint in the streets; with his irascible temper this caused many unpleasant scenes which excited him so much that he became completely unapproachable and at last he developed a great aversion for Paris." [99] Vincent himself never wrote that he had developed "a great aversion for Paris." In his first letter after his departure he did write, "It seems almost impossible to work in Paris unless one has some place of retreat where one can recuperate and get one's tranquility and poise back" (letter 463). The climate must certainly have been a factor in his decision to leave. The winters of 1887 and 1888 had been extremely severe. He wrote Theo a few weeks later, "If the weather is milder in Paris too, it will do you good. What

[99] If he was forbidden to paint in the street, this probably was a rule that also applied to other painters. Most street scenes by impressionists such as Camille Pissarro or Claude Monet were painted from their apartment windows. Vincent's only comment on the subject was that in Paris, "you can't sit down wherever you want" (letter 474).

a winter!" (letter 467). As late as 18 March he had read in *L'Intransigeant* that there had been "an abundance of snow" (letter 470) in Paris, and when he wrote in April that some days he felt "pretty bad," he added, "but don't worry about it in the least, as it is nothing but the reaction from last winter, which was out of the ordinary" (letter 474).

Vincent's reasons for leaving Paris.

Yet there are reasons of a much more serious nature. In one way or another, life in Paris had undoubtedly hurt him mentally as well as physically. He partly ascribed it to drinking, although he did not mention absinthe, as many biographers have (without being able to substantiate). "If my stomach has become very weak, it's a trouble I picked up there and most likely due to the bad wine, which I drank too much of " (letter 480). Even as late as September 1888, he reminded Gauguin of the bad shape he had been in. "When I left Paris, [I was] very, very distressed, quite sick, and nearly an alcoholic, because I wanted to give myself a boost [by drinking] when my strength failed me—then I shut myself up with myself, without having the courage to hope" (letter 553a, also referred to as 544a).

Theo discussed with his sister Wil Vincent's motives for going to the south: "The young school of painting concentrates particularly on getting sunshine into their pictures and you will easily understand that the gray days we were having offer few subjects for painting. Moreover, the cold made him ill. After the years of so much worry and adversity he has not become any stronger and he really felt the need to be in a softer climate" (unpublished letter to Wil of 24 February 1888).

Vincent did not want to leave Paris without undertaking something which he had never been able to bring himself to do, perhaps simply out of respect: in the company of Theo he paid a visit to the much-admired Seurat. He later wrote to Gauguin, "I visited his studio only a few hours before my departure." Understandably, it left a deep impression on Vincent. When in October he had finished a great number of paintings as decoration for his house in Arles, he asked Theo to report this to Seurat, for, he said, "it is often the memory of his personality and of the visit we made to his studio to see his beautiful great canvases that encourages me in this task" (letters 553).

Bernard's recollection of Vincent's departure.

In her Memoir included with the *Complete Letters*, Jo van Gogh-Bonger mentions still another remarkable detail in relation to Vincent's departure from Paris, something which she had found in one of Bernard's writings. Unfortunately, she reduced it to a simple sentence, making it hard to understand: "And Bernard tells how busy Vincent was that last day in Paris arranging the studio, 'so that my brother will think me still here.' " To do Bernard justice, one must again refer to the striking recollection written in his introduction to Vincent's letters. Here it is in its entirety:

> One evening Vincent said to me: "I am leaving tomorrow, let us arrange the studio together in such a way that my brother will think me still here." He nailed Japanese prints against the wall and put canvases on the easels, leaving others in a heap on the floor. For me he had prepared a roll which I unpack: it's Chinese paintings, saved from the hands of a junk dealer, who used them for packing the purchases done in his shop; then he announces that he leaves for the Midi, for Arles, and that he hopes I will join him there; for, he says,

"it is now in the Midi that the studio of the future should be created."
I accompany him as far as the avenue de Clichy—so aptly called by
him the *petit boulevard*—I shake his hand; and it is forever over, I
won't see him again, we shall not again be together until death is
between us.

It is true that Bernard's story can easily be misunderstood.
It was, of course, not Vincent's intention to lead Theo to believe
that he was still there,. He did not leave the house without
warning Theo, for Theo accompanied him to Seurat's studio
and finally to the station. Vincent's relation with his brother at
the moment that he left Paris was so strong that the last thing
Vincent wished to do was to hurt him. Bernard's help was
invoked to prevent Theo from being left in a vacuum. "Let us
arrange the studio in such a way that for him it would be as if I
were still here," was his thought at the moment he left the
apartment after having enjoyed his brother's hospitality for two
years. Vincent was a difficult, but certainly not an ungrateful,
housemate.

Arrival in Arles

It was Monday 20 February 1888 when Vincent arrived in
Arles. His first letter to his brother described what a splendid
impression the landscape made upon him when he neared
Tarascon at daybreak after a tiring journey (letter 463). He
could discern huge yellow rocks, piled up in the strangest and
most imposing forms. In the valleys he saw rows of small round
trees with olive-green and gray-green leaves which he imagined
to be lemon trees. Nearer to Arles the country became flatter;
he noticed extensive vineyards, the vines planted in red soil,
and in the distance mountains of the most delicate lilac.
Something he certainly had not expected was that the snow
extended so far south; the fields around Arles were covered
with a thick blanket. It was a disappointment, but on the other
hand, the white hills against the luminous sky—what a sight!
It reminded him of the snow landscapes he knew so well from
his Japanese prints.

Either the snow or his voluminous luggage must have made
him decide to look for an inn as soon as possible. He found one
near the station at the entrance to the town, the Restaurant
Carrel at 30, rue Cavalerie. He spent the rest of the day
exploring the curious town that had been the destination of his
long journey. As he explained in his letters to Theo, the
remnants of antiquity, such as the Roman arena and the
ancient theater, left him cold. He was horrified by the odd
museum; thinking of *Tartarin de Tarascon*, the humorous novel
by Daudet, he wrote that in his opinion it looked as though it
belonged in Tarascon (letter 464). In accordance with their
reputation, he found the women of Arles to be beautiful, and it
must have been an immense pleasure for him to be able to chat
about his beloved Monticelli with an antique dealer in the same
street where he lived.

He wrote to Theo the day after his arrival: "During the
journey I thought of you at least as much as I did of the new
country I was seeing" (letter 463). He was almost ashamed that

Alphonse Daudet, 1840-1897.

he was alone to enjoy this happiness, and consoled himself with the thought that perhaps Theo would often visit him there.

He spent the first few days searching for motifs to paint. Working outside was difficult because of the thick layer of snow, but Vincent could not resist the temptation to paint the snowy fields with Arles in the background (JH 1358). He was lucky enough to find an old woman willing to pose for him in the picturesque costume of Arles. A third subject, although not particularly picturesque, was also typical of the provincial atmosphere. This subject he found in the front of a butcher's shop, seen from the window of the building opposite, and it yielded an unusual composition. Vincent's production in Arles thus started with three completely divergent subjects: a landscape, a portrait, and a street scene. He can hardly have suspected that it would be months before he would again have the opportunity to concentrate on a portrait, his favorite subject. In any case, his working pace was rapid from the beginning, for on 25 or 26 February Theo received the letter in which Vincent stated, with some satisfaction, that he had finished these studies, meaning that the three paintings had taken only three or four days to complete (letter 464).

Because of the weather conditions, Vincent thought more about the art business than painting. Theo had written that their friend, the Scottish art dealer Alexander Reid, was upset with Vincent and Theo's art dealings. Vincent, because of his previous experience in the art business, immediately found a solution. In order to show good faith toward Reid, he proposed that he and Theo not interfere with Reid's buying Monticellis in Marseilles if Reid would agree to give them free rein to introduce the impressionists into England (letter 464).

Vincent's interest in business is a side of his personality that should not be ignored. He tried to enlist Theo's support in bringing Gauguin to Arles by proposing the arrangement as a business venture. He wrote in May: "You can't send him what will keep him going in Brittany and me what keeps me going in Provence. But you may think it a good idea for us to share, and fix a sum—say 250 a month—if every month you get a Gauguin besides and in addition to my work. Provided that we did not exceed this sum, wouldn't it even mean a profit?" (letter 493). With his typical optimism—though it was without foundation— he imagined a stream of modern paintings flowing into the Netherlands. ". . . In view of the low prices compared to the interest the pictures offer, Tersteeg could easily dispose of fifty or so for us in Holland; besides, he *will be obliged* to have some in stock, because if they are already being talked about in Antwerp and Brussels, they will likewise be talked about in Amsterdam and The Hague before long" (letter 465).

Curiously enough, Vincent's influence was so strong that the businesslike Theo did not try to convince him of the hopelessness of his ideas; he forwarded Vincent's letter to Tersteeg and added a recommendation. Tersteeg's reply was slow in coming, and Vincent's following letters began to show signs of his growing anxiety. When Tersteeg's answer finally arrived, it must have been formulated in such diplomatic terms (although he surely had no appreciation at all for these plans) that the brothers were perfectly happy with it. One interesting sentence from Tersteeg's reply is known, because it was quoted in one of Vincent's next letters. He had said, "Send me some

The idea of bringing Gauguin to Arles.

impressionists, but only those pictures that you yourself think the best" (letter 473). This was embarrassing for Vincent, for as he had planned to send some of his own work to Holland with Theo's next shipment, he was in the uneasy position of having to convince Tersteeg that he, too, was "a genuine impressionist of the Petit Boulevard."

For the first week of March the frost and snow remained, making it almost impossible to work outdoors. Yet Vincent succeeded in doing a second landscape with snow (JH 1360) and used the rest of the time painting still lifes. He could report with some satisfaction to Theo in the second week of March that up until now he had done *eight* studies, adding, "But this doesn't really count, because I haven't yet been able to work in any comfort or warmth" (letter 467). Two of the still lifes were small canvases of a flowering almond branch in a glass (JH 1361 and 1362), while a third, the most recent, was mentioned in letter 467: "I have just finished a study like the one Lucien Pissarro has of mine, but this time it is oranges" (this was JH 1363). Other things kept Vincent occupied as well. There was Theo's announcement that he had bought a Seurat, which made the enthusiastic Vincent dream that he might make an exchange with Seurat as soon as he sent Theo the works he had done thus far in Arles; there was the meeting with the young, intelligent painter Mourier Petersen, who used to come in the evening to keep him company; and there was especially the wealth of subjects in the landscape, now that spring had finally begun to arrive. His health was still not good—he was feverish and had no appetite—but the colorful surroundings made him feel as if he were in Japan, the country that for him was the measure of all things—and he realized that he had not even seen the Provence at its best.

After another week Vincent could write that he had finished *twelve* studies since his arrival in Arles (letter 469). The last three were a landscape with a rustic bridge and washing women (JH 1367), a road with trees near the station (JH 1366), and, as a highlight, the canvas he had brought home that same day: a sunny picture with a yellow drawbridge against a shining blue sky, also with washing women on the banks of the canal—a pendant of the landscape with the stone bridge, but infinitely more colorful (JH 1368).[100] Little could he foresee that this was to become one of his most popular paintings, although he seemed to realize that he had done something exceptional, since he chose to send it to Tersteeg. All this assured him that his long journey to the South had not been in vain. Thinking immediately of his less fortunate colleagues, he wrote, "For many reasons I wish I could found a retreat, where the poor cab horses of Paris—that is, you and several of our friends, the poor impressionists—could go out to pasture in case of exhaustion" (letter 469).

Most of the time it had been cloudy, windy and rainy, but the picture of the drawbridge with the washing women must have been done at a sunny moment. He started another picture of the bridge and took it home because of the bad weather, planning to finish it there the next day (18 March). Writing about it to Theo a few days later, however, he reported that he

A new painter-friend, Mourier Petersen.

Mid-March 1888: Vincent has completed twelve studies since his arrival.

[100] The bridge was named Le Pont de Langlois after the bridgekeeper; in his letters Vincent used the corrupted form, Pont de l'Anglais.

had "completely ruined" the painting (letter 471). He made a sketch of the picture in a letter to Emile Bernard written the same day and described it as, "sailors returning with their sweethearts to the town which profiles the strange silhouette of its drawbridge against an enormous yellow sun" (letter B 2). The fate of the picture is unknown; only a small fragment showing one of the sailors and his sweetheart has been preserved in a private collection. Vincent referred to this picture when he formulated the ideal that was later labelled "cloisonism": "I wanted to get colors into it like stained glass windows and a design with bold outlines" (letter 470).

Letter 470 contains interesting passages about literature, for despite his intense painting activity Vincent always found time for reading. The quotation he chose from Maupassant's *Pierre et Jean* is a confirmation of the endeavors that were more and more typical of his own work: the artist has the freedom "to exaggerate, to create a nature that is more beautiful, simpler, and more consoling." He also mentioned Maupassant's addition to Flaubert's words *Le talent est une longue patience*" (talent is a long patience): originality is a question of willpower and a keen sense of observation.

A short time later he wrote to his friend Bernard, "I am convinced that even if I were to work all my life, I should not be able to do one half of all that is characteristic in this town alone" (letter B 3). Yet he did not even begin, because another subject demanded all his attention: the flowering fruit trees.

The Flowering Fruit Trees

Although the weather was still not very accommodating, more and more fruit trees in and around Arles began to bloom. Looking at the task as a great challenge, Vincent attacked the flowering orchards, often working on several studies simultaneously. In a letter of 30 March to his sister Wil, for instance, he wrote that he was working on six fruit trees in bloom, despite the fact that working outside was not always very easy (letter W 3). In a letter to Theo he wrote that "every day is a good day now, not meaning the weather—on the contrary, there are three windy days to one that is quiet, but because of those orchards in bloom. The wind makes painting quite difficult— but I fasten my easel to pegs driven into the ground and work in spite of it, it is too beautiful" (letter 472). In a letter to Wil, he candidly explained one of the motives behind his activity: "I shall have to produce a number of things before next year, when the World's Fair [in Paris] will be held, because my friends will certainly not fail to have many interesting things on hand by then [too]."

In similar terms, he wrote that he was in a "frenzy of work," because he was planning to paint "a Provençal orchard of a monstrous gaiety" (letter 473). He said that nowadays one wants in art "something very rich and very gay" and mentioned to Wil a good example of such a "gay" painting: "What I brought home today would probably please you—it is a dug-up square of earth in an orchard with a fence of rushes and two peach trees in full bloom. Pink against a scintillating blue sky with white clouds, and in the sunshine."

67
Flowering Peartree, *painting from April 1888. JH 1394, F 405, 73 x 46 cm. Vincent van Gogh Foundation / National Museum Vincent van Gogh, Amsterdam*

He decided to set aside this canvas (JH 1379) for Jet Mauve, the widow of his former teacher Anton Mauve, who had died on 5 February 1880. He had planned to send her a picture for some time, and a coincidence finally triggered the decision. He told Theo: "At the moment I bring it home, I receive from our sister a Dutch notice, devoted to the memory of Mauve, with his portrait—the portrait very good, the text bad and meaningless, a beautiful etching. Yet, something inexplicable took hold of me and brought a lump to my throat, and I wrote on my picture: *Souvenir de Mauve, Vincent & Theo*, and if you agree, in this way we will send it to Mrs. Mauve from both of us" (letters 467 and 472). (Vincent later removed the words *& Theo* from the picture, probably at the request of Theo, who must have felt that he should leave the honor to Vincent, whose picture and whose idea it was.)

68
Orchard with Blossoming Plum Trees, *reed pen drawing from April 1888.*
Reed pen, heightened with white,
JH 1385, F 1414, 39.5 x 54 cm.
Vincent van Gogh Foundation / National Museum Vincent van Gogh, Amsterdam

The first three weeks of April Vincent spent almost completely on his studies of flowering fruit trees. At the end of that period, when the trees were losing their blossoms, he wrote that he had done ten orchard studies, not counting three small studies. He probably finished two more a little later, for in all, fifteen different studies of orchards in bloom—or of single trees—are known, dating from the spring of 1888. As the earliest one was mentioned in a letter of 24 March, all this work had been done in four weeks. And that was not all. During these weeks he did at least two drawings in black and white of the orchards. He made watercolors of two of the pictures which were meant for Holland (JH 1382 and 1384) in order to give Theo at least an idea of the paintings he had so often mentioned in his letters. He also made a copy in oils for Theo of the *Drawbridge with Carriage* (JH 1392), the picture Vincent found so worthwhile. And finally, as if this were not enough, he made a series of small pen drawings, of which the first was annotated with the date "mars 1888," but most of which must have been done in April.

Sketches in letters to Theo show that he imagined the orchard studies to be placed in groups of three, one of these

groups being the beautiful picture with the two pink peach trees (the pendant of the one destined for Jet Mauve) flanked by two large orchards in horizontal format. His comments make it clear that he had the distinct feeling of having entered a new path. In a letter to Bernard, for instance, he wrote: "I hit the canvas with irregular touches of the brush, which I leave as they are. Patches of thickly laid-on color, spots of canvas left uncovered, here or there portions that are left absolutely unfinished, repetitions, savageries; in short, I am inclined to think that the result is so disquieting and irritating as to make people who have preconceived ideas about technique not exactly happy" (letter B 3).

In spite of his abundant production, Vincent was inwardly unsatisfied. He felt that not all of these pictures were up to the high standard he used to demand from himself. On the contrary, he kept making a sharp distinction between the canvases he did daily, which he called "studies," and the few works that were of a much higher quality and might be called "pictures" (*tableaux*). It was during these weeks that he admitted to Theo, "Out of four canvases, perhaps one at the most makes a *picture*, like the one for Tersteeg or for [Mrs.] Mauve; but the studies, I hope, will come in handy for exchanges" (letter 474).

One of the results of Vincent's "frenzy of work" was that his small stock of paints and canvas was soon exhausted. When he received Theo's allowance around 1 April—this time reduced to the regular 50 francs—he spent almost the whole sum for paint and canvas (letter 473). Just a few days later he had to report that he was *sans le sou* (without a penny) and was obliged to ask Theo to send some paint (letter 475). It is true that this gradually became the normal procedure between the brothers, but earlier on in Arles Vincent had bought paint and canvas himself (this follows from the letters 464, 467, and 468), so that Theo cannot have read Vincent's request without some misgivings, the more so because this first "order" comprised more than a hundred tubes! It speaks for his liberality and for his confidence in his brother's work that Theo sent the entire order, although Vincent had written that less than half of it was urgently needed.

Vincent had said in an earlier letter, "If there should happen to be a month or a fortnight when you are hard pressed, let me know and I will immediately change to making drawings, which will cost us less." That situation occurred in the last week of April, when blossom time was almost over. Knowing that something was brewing at Boussod & Valadon, he did indeed start making a series of small pen-drawings, working with such drive that he was able to send Theo a dozen before the end of the month.

Vincent requests over one hundred tubes of paint!

69
Portrait of Theo van Gogh, sketch by Meyer de Haan from 1888. Vincent van Gogh Foundation / National Museum Vincent van Gogh, Amsterdam

Looking at Theo's life during the months that followed his brother's departure from Paris, one can get an idea of what this departure meant to him. In an unpublished letter of 24 February 1888 to his sister Wil, Theo described his feelings after looking back at the two years of their time together:

When he came here two years ago I had not expected that we would become so much attached to each other, for now that I am alone in the apartment there is a decided emptiness about me. If I can find someone I will take him in, but it is not easy to replace someone like Vincent. It is unbelievable how much he knows and what a sane view he has of the world. If he still has some years to live I am certain that he will make a name for himself. Through him I got to know many painters who regarded him very highly. He is one of the avant-garde for new ideas, that is to say, there is nothing new under the sun and so it would be better to say: for the regeneration of the old

ideas which through routine have been diluted and worn out. In addition he has such a big heart that he always tries to do something for others. It's a pity for those who cannot understand him or refuse to do so.

When he wrote Wil again on 14 March, there were more friendly words about Vincent. A rare comment about music stems from the fact that Wil had been taking piano lessons. "Although I know little about it I like hearing music, but the occasions to hear something good here are rare, unless one goes to the concerts. Still, I went with Vincent a few times to listen to a Wagner concert before he left, and we both liked it very much. It still seems strange that he has gone, he has lately meant so much to me. Soon the studio will be occupied again by a young Dutch painter, but he has by no means Vincent's talent, although he is not bad. At the end of the month an exhibition will be opened with three of Vincent's paintings on view. He does not attach much importance to this exhibition, but here where there are so many painters it is essential to become known, and an exhibition is, after all, the best thing for that."[101]

The painter who came to stay with Theo was Arnold Hendrik Koning. Vincent had come to know him in Paris, too; Koning was one of the painters he had persuaded to participate in the du Chalet exhibition. When he visited Holland in May 1888, Vincent wrote him a cordial farewell letter in which he said, "Well, old fellow, I know I shall often think of our meetings in Paris, and I do not doubt we shall hear from you as soon as you are back in Holland" (letter 498a). Koning's place was soon taken up by the Danish painter, Mourier Petersen, whom Vincent had met in Arles and whom he had "seen daily for several months" (letter 498). When he knew that Petersen was going to stay in Paris for some time on his way back to Holland, Vincent sent him to Theo with warm recommendations (although as a painter he considered him not more than a beginner). "Do you think it would work if he were to come and stay with you?" (letter 490). As Koning left a few days later, Vincent was able to write on 12 June that he was glad to hear that the plan had gone through, and although Theo was not quite pleased with Petersen, Vincent kept taking his side (letter 494). He wrote in July, for instance, "Have patience with Mourier a little longer; perhaps he is going through a crisis" (letter 507). He kept sending Petersen his regards in his letters to Theo, and as late as August he wrote a note to Petersen himself. After Petersen moved out, Theo probably stayed alone for some time. But as of 28 October he again had a housemate, the Dutch painter Meyer de Haan. Because J. J. Isaäcson—the friend with whom Meyer de Haan had come to Paris—came chatting every evening, Theo indeed had *two* guests (letter T 3).

Vincent's letters show that from a business standpoint Theo had no reason to complain, but his health was still far from good. Though the doctors had difficulty with the diagnosis, some of Vincent's letters contain enough details to give at least

Arnold Hendrik Koning, 1860-1945.
Jacob Meyer de Haan, 1852-1895.
J. J. Isaäcson, 1859-1942.

Theo's poor health and neurosis.

[101] The exhibition was the (second) Salon of the Société des Indépendants, founded in 1886. Two of the paintings which Theo sent to it were large landscapes of the hill of Montmartre; the third was *Romans Parisiens*, later equally well known.

268

a hint of what was wrong. In a long letter of the second half of May (letter 489), Vincent wrote that he was glad Theo had seen doctor Gruby. In contrast to Theo's family doctor Rivet, Gruby was an exceptionally progressive physician who promoted a kind of natural health cure in which good food and fresh air were advocated over medications. Vincent described Theo's symptoms as *hébétement* and *un sentiment de lassitude extrême* (stupor and a feeling of extreme weariness). Theo ascribed this to the medication that Rivet had given him—iodide of potassium[102]—but Vincent noted that he too had been *abruti* (stunned or exhausted) the winter before, to a degree that he could do nothing else but a little painting, even though he had not been using any iodide of potassium. Vincent thought it was the result of that *maladie de coeur* of which he was suffering himself—in another letter he called it *notre névrose* (our neurosis) (letter 481)—and he strongly recommended that Theo follow the advice of doctor Gruby, adding, "If only you could have one year of life in the country and with nature just now, it would make Gruby's cure much easier."

The theme was not discussed again in the next few letters, which might lead to the impression that, in any case, Theo's health did not deteriorate. Yet in a letter of the end of July Vincent warned, "Take good care of your health, above all take baths *if Gruby recommends it*, for in the four years by which I am older than you, you will see how necessary the relatively good health you are now in is for your work" (letter 514). The only hope of not breaking down, he said, was to follow "an up-to-date hygienic regimen," at least as much as he could stand. And he added, probably as a warning, "Because I for one do not do everything I ought to."

As far as business was concerned, the year had started favorably for Theo. Between February and April he bought several Monets, of which he sold one in April. Now that he had strengthened for Boussod & Valadon the ties with Monet, an even more important transaction followed. On 4 June Monet sold ten pictures to the firm, landscapes done in Antibes between February and May of that year, and Theo put them on show immediately at the gallery on boulevard Montmartre. Of course Vincent was delighted. "I congratulate you on having the Monet exhibition in your place" (letter 498), and "I am very sorry I can't see it" (letter 501), he wrote, and he also informed his friends Russell and Bernard of the big news (letter B 7). John Rewald, who checked the prices of the pictures, has shown how advantageous the transaction must have been for Boussod & Valadon as well as for Monet. Monet received an average of more than 1,000 francs for his paintings and half of the profit. Theo sold the first of the ten canvases on 12 June, making 3000 francs for it, and the rest during 1888 and the following year.[103]

All this will have particularly pleased Theo, because his superiors were not exactly happy about his dealings with the impressionists. In April he wrote about the situation to Vincent who, of course, was saddened, "For all these discussions with

Theo's success selling impressionist paintings.

[102] In those years iodide of potassium was a much used remedy against all kinds of complaints, such as the coughing which troubled Theo.

[103] John Rewald, "Theo van Gogh, Goupil and the Impressionists," *Gazette des Beaux-Arts* (1973).

269

the B.& V. people are rather an indication that impressionism hasn't taken on enough" (letter 479). The success with the Monets does not seem to have convinced *ces messieurs*, and in several of Vincent's letters from the following months an undertone of anxiety about Theo's position can be heard. They corresponded about the journeys that Theo was ordered—or at least urged—to make, which Vincent found very undesirable on account of Theo's health. A letter from September reveals for the first time that one of Theo's ailments was that he sometimes had pains in his legs—a bad omen considering what was to happen to him later. Vincent wrote, "It isn't cheery news that the pains in your leg have come back—Good Lord, you ought to be able to live in the South too, because I always think that what *we* need is sun and fine weather and a blue sky as the most efficient cure" (letter 543). Vincent did not necessarily think that going to London was such a bad idea—if he were younger, he would even be willing to accompany Theo—but New York . . . ! (letter 513).[104] Yet his anxiety about Theo's job is clearly shown by the conclusion of the letter, which urged patience: "In any case it is better if someday they say to you, 'Go to London,' than that they chuck you out, your services no longer being required."

On one business trip in May, Theo had to be in Holland and Belgium for a few weeks, and he understandably combined it with a visit to his mother. "I am very glad," Vincent wrote to him, "that you found our mother and our sister [Wil] in good health" (letter 480).[105] It was probably as a result of his trip that Theo had conceived the plan to invite his sisters Lies and Wil for a visit to Paris. In several letters Vincent wrote him how much he agreed with this plan, and when finally Wil had come alone (why Lies did not come is not revealed), he sent her a warm welcome. "Dear sister, I write you these few words in a hurry, as I don't want to postpone telling you how pleased I am that you are in Paris, and I suppose you are going to see a lot of things in the days to come" (letter W 6). Wil stayed until 2 or 3 September, and to Theo her visit certainly meant a very welcome distraction in his busy, yet monotonous existence.

[104] Boussod and Valadon probably wanted to intensify their business in New York, following the example of their competitor, Durand-Ruel, who had gone to New York in 1886 with 300 paintings and enjoyed some success there. Goupil had a branch in New York since 1848.

[105] A few months later, Theo traveled to Holland again, but now it was to attend the funeral of uncle Vincent, who had died on 28 July 1888 at Prinsenhage after a long illness.

A HOUSE OF HIS OWN

70
The Yellow House, *the apartment Vincent rented in Arles; watercolor, done after the canvas he had painted in September 1888. Chalk, pen, brown ink, watercolor, JH 1591, F 1413, 25.5 x 31.5 cm. Vincent van Gogh Foundation / National Museum Vincent van Gogh, Amsterdam*

For quite a while Vincent had been unsatisfied with his inn, the Restaurant Carrel; he was not getting the kind of food he thought was necessary for his recovery, and he had the feeling he was being cheated, because the owner pretended that he occupied more room in the hotel with his painting activity than the other clients. He started to look for another room (or rather two rooms, a bedroom and a room for working) and when he found something in the last week of April which suited him splendidly, his usual impetuosity made him cut the knot immediately. Referring to some drawings he had just sent Theo, he wrote: "You will find among them a hasty drawing on yellow paper, a lawn in the square as you come into the town, with a building at the back, rather like this [here he made a little sketch in the letter]. Well, today I have rented the right wing of this building, which contains four rooms, or rather two with two cabinets. It is painted yellow outside, whitewashed inside, in full sun. I have taken it for fifteen francs a month" (letter 480). This then was the celebrated "yellow house" which had such an important place in Vincent's life.

Vincent's mind was preoccupied in the next days and weeks by the house and the problems it caused. He was convinced that this time the choice of the house had been a lucky one. In his imagination he saw his paintings already displayed in this clear interior, in which the new, colorful art would stand out so much better against the whitewashed walls, the red tiles on the floor, the yellow front in the bright sun, and the greenery of the little park just outside the door. But to be able to enjoy it, he would have to furnish at least one room where he could sleep and be free of the innkeepers. He dared write to Theo, "If you approve, I shall furnish the bedroom, either hiring things or buying them for cash down," and, not awaiting Theo's reply, "I shall see about that today or tomorrow morning." He ended his letter saying, "If you could send me a hundred francs next time,

271

I could sleep at the studio this very week; I will write you what arrangement the furniture dealer is willing to make." Theo sent the hundred francs, but plans hadn't all gone as smoothly as Vincent had hoped; he informed Theo the next day: "Yesterday I went to the furniture dealer's to see if I could hire a bed, etc. Unfortunately they would *not* hire, and even refused to sell on a monthly installment basis. This is quite embarrassing" (letter 481).

Although Vincent had decided to move out of the Restaurant Carrel, it was not as easy to leave as he thought. While he had expected that he would have to pay forty francs upon leaving, the proprietor charged him over sixty-seven francs (letter 484). As the innkeeper refused to make an agreement with him or to let him take away his things, he had to pay the whole sum and then put the question before the magistrate. To his great disappointment he did not prevail before the magistrate. The innkeeper was reprimanded for keeping back the luggage, but Vincent got only twelve francs back instead of the twenty-seven he had counted on (letter 487). He had just enough money left to buy two chairs and a table and some things for making coffee and soup. This left him with only fifteen francs, but he now had the satisfaction of being able to call 2, Place Lamartine "home." He concluded philosophically, "In any case, I reckon that I have now paid my tribute to misfortune, and it is better that it comes at the beginning than at the end of the expedition (letter 485).[106]

Since Theo had not yet seen any of the work done during the first two months of Vincent's stay in Arles, in the first week of May 1888, Vincent prepared to send a package of twenty-six studies. He did not have enough money left to cover the shipping costs, but decided to dispatch the case anyhow, asking Theo to pay the seven francs that the transport would cost. He was not content with much of what he did, but he at least had the courage to write to Theo, "If you would put on one side the best things in what I have sent, and consider these pictures as a payment to be deducted from what I owe you, then, when the day comes when I'll have brought you in something like 10,000 francs in this way, I would feel happier" (letter 485). He mentioned three paintings for which he thought the price would go up later, the "pink orchard on coarse canvas, and the white orchard, lengthways, and the bridge" (JH 1387, 1378 and probably 1392) and advised Theo, "Take these three then for your own collection, and do not sell them, for they will each be worth 500 francs later on." Vincent obviously did not overestimate himself!

Another picture included in the group was the canvas dedicated to Tersteeg, *The Drawbridge* (JH 1368), though Vincent was uncertain whether the picture would be welcome. "If meanwhile you have come to the conclusion that Tersteeg would be offended by it, if in short I had better not cause him any annoyance, then keep it yourself and scrape off the dedication, and we can exchange it for something by one of the comrades" (letter 486). Theo agreed with this plan, for the painting, which is now in the Kröller-Müller museum in

Theo receives twenty-six studies from Vincent.

[106] The sentence: *"Seulement je compte bien avoir maintenant payé mon tribut au malheur, et mieux vaut que cela vienne au début qu'à la fin de l'expédition"* and two more were left out in the American edition of the *Complete Letters*.

Otterlo, was never in Tersteeg's possession and no longer shows a dedication.

For the moment, Vincent's worst worries were over. He took advantage of the beautiful weather and did some painting outside. He finished two new studies and sent Theo a few sketches of them. One was a very simple landscape, a green wheatfield with heavy trees along the roadway in the foreground (JH 1417). With the other one (JH 1416) he had been much more fortunate; it was again a real "coup de maître." It represented a meadow with bright yellow buttercups, some gray willow trees and the town of Arles in the background; but the surprise of the composition was that the foreground was filled by a row of violet-blue irises whose flowers and pointed green leaves supplied a beautiful contrast to the yellow flowers in the meadow. Vincent must have been particularly pleased with the picture, and wrote enthusiastically to Theo: "If the meadow does not get mowed, I'd like to do this study again, for the subject was very beautiful, and I had some trouble getting the composition right. A little town surrounded by fields all covered with yellow and purple flowers, you know, it would really be like a Japanese dream" (letter 487).

More landscapes.

71
Photograph of the Yellow House, which was destroyed by a bomb in 1944.

During the next week of May he again produced several important works. When he thanked Theo for sending him a hundred francs, he wrote that he had done another two studies, a drawbridge (JH 1421) and a (second) study of a farm at the side of a road (JH 1419). The *Drawbridge* was not a copy of the earlier ones; this time it was seen from the opposite side of the canal. There is a lady in black with a dark parasol on the bridge and there are two slim cypress trees as dark green notes on the left side of the picture. With its sensitive contrasts of the soft blue of the sky and the water on the one hand, and the warm yellow of the two banks of the canal on the other, the scene is a gem of quiet and harmony.

Vincent had tried his hand at much fiercer color contrasts when he wrote Theo again at the end of the third week in May (letter 489). The winds had probably been too strong to work outdoors (he told Emile Bernard that the two studies of a farm by the side of a roadway had been done "with the mistral raging") (letter B 5), and so he set himself to painting still lifes

Still lifes done at home.

273

at home, which is the first favorable result of having his own "studio" available. He reported to Theo that he had done two still lifes that week, one with a coffeepot (JH 1426) and one with a majolica pot with wild flowers (JH 1424) (letter 489). The two canvases have several elements in common—such as the yellow background, the three lemons and a cup-and-saucer—and must have been conceived as color studies, as Vincent's descriptions show. This is especially true for the one with the coffeepot, which is by far the more striking and more important of the two; it shows a table with a blue cover, set with a blue enamel coffeepot, a white and blue checkered milk jug, lemons and other objects. Vincent summarized the color scheme as "six different blues and four or five yellows and oranges" (letter 489), and in a simultaneous letter to Bernard as, "a variation of blues, livened up by a series of yellows that go as far as oranges" (letter B 5). He counted it among his best pieces; he made sketches of it in his letters to both Theo and Bernard (the latter with precise indications of the colors), and when sometime later he wrote with due pride about his large *Harvest Landscape* (JH 1440), he said that only the still life with the coffeepots and cups and plates could stand the comparison with it (letter 497).[107]

Before the end of this productive week, Vincent made a trip to the hills of Montmajour, about five kilometers northeast of Arles, where he had noticed the ruins of an old abbey on one of the first days after his arrival. On 19 May he sent Theo the drawings that had resulted from his excursion, explaining the subject in an accompanying letter. "These are views taken from a rocky hill, from which you see the country toward La Crau (a region producing very good wine), the town of Arles and the country toward Fontvieilles. The contrast between the wild and romantic foreground, and the distant perspective, wide and still, with horizontal lines disappearing into the chain of the Alpines, so famous for the great climbing feats of Tartarin P.C.A.,[108] and of the Alpines Club—this contrast is very striking. The two drawings that I am adding now will give you an idea of the ruin that crowns the rocks" (letter 490).

An excursion to Montmajour.

A Trip to the Coast

Hardly a week later, the indefatigable Vincent had planned another trip, "an excursion to Saintes-Maries in order to see the Mediterranean at last." The fact that he wanted to travel there is not surprising, because the famous Saintes-Maries-de-la-Mer, still the object of yearly pilgrimages by Gypsies of many countries, was not far from Arles and easy to reach by *diligence* (horse-drawn carriage). Yet the definite way in which he announced the trip must have surprised Theo. "Early tomorrow I start for Saintes-Maries on the Mediterranean; I shall stay there till Saturday evening. I am taking two canvases, but I am

107 The French text reads as follows: *"Il n'y a qu'une nature morte avec des cafetières et des tasses et assiettes en bleu et jaune qui se tienne à côté."* The erroneous translation in the American edition missed the point: "it is only a still life, with coffeepots and cups and plates in blue and yellow; it is something quite apart."

108 Abbreviation of "Président du Club des Alpines," the pompous title which Tartarin (of Daudet's humorous novels) used in Switzerland. The Alpines, a range of hills, are now called Alpilles.

rather afraid it will probably be too windy to paint. You go by *diligence*, it is fifty kilometers from here. You cross the Camargue, grass plains where there are herds of fighting bulls and also herds of little white horses, half wild and very beautiful. I am taking especially whatever I need for drawing. I must draw a great deal. . ." (letter 495). While the exact date of Vincent's departure cannot be deduced from the letters, it must have been in the last week of May.[109] He assembled what remained from the recently received hundred francs, his new supply of paints and his canvases—adding one to the two he had originally planned to take—and boarded the carriage for the five hour trip to Saintes-Maries.

72
Fishing Boats on the Beach, *reed pen drawing made by Vincent in June, 1888 before leaving Saintes-Maries-de-la-Mer. Pencil, reed pen, JH 1458, F 1428, 39.5 x 53.5 cm. Collection Dr. Peter Nathan, Zürich*

The village owes its name to the Saint Marys (Mary Magdalene, Mary Salome, mother of the apostles James the Greater and John the Evangelist, and Mary, sister of the Virgin). According to the legend, they had landed at this spot about the year 40 A.D. with their black servant Sarah, and were eventually buried here. Sarah became the patron saint of the Gypsies, who come here yearly at the end of May for a celebration; at that occasion her sculpture, which is kept in the crypt of the church, is solemnly carried into the sea. However, Vincent seems to have been interested in the town of Saintes-Maries simply because of its location on the Mediterranean; in his letters he never spends a word on the historic past of the village.

Soon after his arrival, he wrote to Theo describing the sea, the inhabitants of the village and a walk on the beach he had taken under a splendid starry sky (letter 499). The most important news the letter contains are two short passages about the work he had been able to do in Saintes-Maries. "I brought three canvases and have covered them—two marines, a view of the village, and then some drawings which I shall send you by post when I'll be back in Arles tomorrow," and a few lines down, "I am forced to leave my three painted studies here, for of course they are not dry enough to be submitted with safety to five hours' jolting in the carriage." This was no problem, though, because "[he expected] to come back here again."

[109] According to Ronald Pickvance in his catalogue *Van Gogh in Arles* (1984), it was on Wednesday 30 May.

73
*Landscape with Hut in the Camargue, reed
pen drawing from June 1888.
Pencil, pen, reed pen, brown ink, JH 1457,
F 1498, 34.5 x 25.5 cm.
Vincent van Gogh Foundation/National
Museum Vincent van Gogh, Amsterdam*

He wrote Bernard about his stay in Saintes-Maries, where there was undoubtedly more to see and more work to do than he had expected: "At last I have seen the Mediterranean, which you will probably cross sooner than I shall.[110] I spent a week at Saintes-Maries, and to get there I drove in a *diligence* through the Camargue with its vineyards, moors and flat fields like Holland. There, at Saintes-Maries, were girls who reminded one of Cimabue and Giotto—thin, straight, somewhat sad and mystic. On the perfectly flat, sandy beach little green, red, blue boats, so pretty in shape and color that they made one think of flowers. A single man is their whole crew; these boats hardly venture on the high sea. They are off when there is no wind, and make for the shore when there is too much of it" (letter B 6).

When he wrote this passage, he had already completed *Fishing Boats on the Beach* (JH 1460)—a work that later became one of his most popular paintings. He painted it in the studio, a surprising fact, but one which is known from his own description. He had seen the boats on the beach every morning, but as the fishermen put to sea early, he had not been able to

[110] Emile Bernard had to fulfill his military service in North Africa.

276

paint them. On the day of his departure, however, he did not want to miss the chance; he made a careful pen drawing very early in the morning as a preliminary study for a watercolor and for a large painting which he planned to complete upon his return to Arles. The drawing was a *tour de force*, and he wrote about it with due pride when he sent Theo the drawings. "The Japanese draw quickly, very quickly, like a lightning flash, because their nerves are finer, their feeling is simpler. I have only been here a few months, but tell me this—could I, in Paris, have done the drawing of the boats in an hour? Not even with the perspective frame; well, this is done without measuring, just by letting my pen go" (letter 500).

The rest of what Vincent produced during his short stay in Saintes-Maries is also impressive. In one week he completed three oil paintings and at least ten pen drawings. For those drawings he focused almost exclusively upon the little whitewashed cottages with their dark thatched roofs that were so typical of the region; they reminded him of the huts in the moors and peatfields of Drenthe. Two canvases were reserved for views of the Mediterranean, showing the curious little fishing boats after they had set off to sea. In one is a single boat and big waves in the foreground (JH 1452); in the other, a somewhat smaller canvas, are a number of small boats on a turbulent sea (JH 1453). Vincent must have been most impressed, however, by the view of the village as a whole with the mighty, fortified church in the center. For this scene he used the second large canvas, immortalizing the scene with the stern geometrical forms in soft and yet lively colors—Saintes-Maries glorified in an image that even after a century has lost nothing of its charm (JH 1447).

Back in Arles, Vincent was extremely active. The day of his return—or maybe the next—he mailed the drawings as promised, wrote Theo a letter to announce what he had done ("I am sending you by the same post the drawings of Saintes-Maries"), promised to write to Gauguin ("I think I shall write him today and send you the letter"), and started the painting of the boats on the beach (letter 500). He did not send all the drawings at the same time, but wrote, "I have three more drawings of cottages which I still need, and which will follow" (letter 500). In the next few days he did small painted studies after two of these drawings, one with three cottages (JH 1465) and one with a street and a large shrub in the foreground to the right (JH 1462).[111] Work became consuming; in his next letter to Theo he admitted that he had hardly found time to write to Gauguin because he had two canvases on the easel (letter 494). Yet he was already planning to profit a little more from the inspiration the excursion to the coast had given him, and although he had only just returned from the first trip, he wrote, "If you send me the next letter [meaning the letter with the weekly money that he would need] on Sunday *morning*, I shall probably hasten back to Saintes-Maries that day at one o'clock to spend the week there" (letter 494).[112]

Vincent's work in Saintes-Maries.

Return to Arles.

[111] The last mentioned study was auctioned at Christie's in New York in May 1981. It was announced that it had been sold for more than two million dollars, but later it was admitted that it had been "retained"; evidently the owner could not part with it even for two million dollars!

[112] The manuscript shows that he wrote "*que je refile à Saintes-Maries*"; the printed editions have "*que je file à Saintes-Maries*." Mrs. A. Karagheusian of New York drew

All kinds of circumstances prevented Vincent from realizing this plan, even though Theo had kindly sent the money by telegraph so that it would reach Vincent on that particular Sunday morning (10 June). Due to a mistake by the postman, he did not receive it until Monday, but, trying to avoid the impression that the delay was Theo's fault, Vincent wrote that the delay was not his reason for cancelling the trip (letter 496). He could have left on Monday too, as the carriage went every day, but had decided not to go because of the cost; the house had just been painted, for which he had to contribute ten francs, and, moreover, he had been obliged to buy a fairly large stock of canvases. This left only twenty of the original fifty francs on Tuesday morning, which meant that he would not be able to go the next week either. He was never to return to Saintes-Maries.

He was never to return to Saintes-Maries.

The "High Yellow Note"

It had become summery and quite hot in Arles, and here and there people had started harvesting. In his search for interesting subjects Vincent made the long trip on foot to Tarascon, which is ten miles north of Arles, but unfortunately there was such a blazing sun and so much dust that he came back empty-handed (letter 496). However, new trips to Montmajour and to the plain of La Crau to the south opened great possibilities. This time it was not so much the hill with the ruin of the abbey which fascinated him, but the glorious panorama of the sunny plain itself and the activity of the farmers, whom he could observe from a hill. He did a large preliminary study of the subject in ink and watercolor (JH 1438). Even then he seems not to have dared to start an oil painting before having made another, almost identical, drawing in watercolor (JH 1439). At that point he could write to Theo: "I am working on a new subject, green and yellow fields as far as the eye can reach. I have already drawn it twice, and I am starting it again as a painting. It is exactly like a Salomon Konink—you know, the pupil of Rembrandt who painted vast level plains" (letter 496). Vincent probably meant Philips, not Salomon, Koninck; in any case, one can feel in his description something of the emotion he must have felt when he knew that he finally had the courage to begin the assault on this magnificent landscape.

He also started the picture of a farm with haystacks (JH 1442), which he meant as a sort of pendant, but which afterward he felt could not equal the other landscape. Mentioning *The Harvest* (as he called painting JH 1440) in his next letter to Theo, he wrote, "I am working on a landscape with cornfields, which I think as well of as, say, the *White Orchard* [from April]; it is in the style of the two landscapes of the Butte Montmartre which were at the Indépendants, but I think it has more firmness and rather more style."

Vincent completes The Harvest *in a single day.*

my attention to this mistake in 1980, and it caused me to make a few changes in the chronology of the letters I had previously suggested.

74
Sun over Arles, reed pen drawing from the spring of 1888. Pencil, reed pen, brown ink, JH 1375, F 1506, 24.5 x 35.5 cm.
Fogg Art Museum, Harvard University, Cambridge, Massachusetts,
Bequest of Grenville L. Winthrop

It is hard to believe that a landscape like *The Harvest*, grandiose in its simplicity, yet masterfully detailed, could have been painted in a single day. Yet Vincent must be believed when, a month later, writing about the speed with which worked, he pointed to this painting as evidence that some of the paintings he completed most quickly were among his best. "Take the one I sent you the cartoon of, the *Harvest*, and the *Haystacks* [JH 1442] too. It is true that I had to retouch the *whole* to improve the technique a bit, and to make the touch harmonious, but in a single long sitting all the essential work was done, and I spare the canvas as much as possible when working at it again" (letter 507). It is evident that physically and mentally this must have demanded the utmost of his forces, and it is not surprising to read in the same letter, "But when I come home after a spell like that, I assure you my head is so tired that if that kind of work keeps recurring, as it has done since this harvest began, I become hopelessly absent-minded and incapable of doing heaps of ordinary things."

"After that," he concluded, "the only thing to bring ease and distraction is to sedate oneself by smoking heavily and drinking." He felt that this had undoubtedly laid the basis for his mental breakdown. In a letter written nine months later, when he was being treated in the hospital at Arles, he described what his doctor said about the causes of the illness. "Mr. Rey says that instead of eating enough at regular times, I kept myself going on coffee and alcohol. I admit all that, but all the same it is true that to attain the high yellow note that I reached last summer, I really had to be pretty well keyed up" (letter 581).

Vincent realized that a mental crisis was unavoidable. He did not write much about it, but at the end of July he made an allusion to it in a long letter to Theo in which he pondered over their role in the development of modern art. He knew that the problem was fatally connected with being an artist. "The more I am spent, ill, a broken pitcher, the more I become an artist, a creator, in this great revival of the arts of which we speak" (letter 514). At the same time, but in a much lighter vein, he wrote about it to Bernard. In a passage about the genius of artists like Delacroix, Daumier and Millet, he joked: "It is possible that these great geniuses are only madmen, and that one must be mad oneself to have boundless faith in them and a boundless admiration for them. If this is true, then I prefer my insanity to the sanity of the others" (letter B 13). To Bernard he

280

could also quip: "Oh! that beautiful midsummer sun here. It beats down on one's head, and I haven't the slightest doubt that it makes one crazy. But as I was so to begin with, I only enjoy it" (letter B 15).

Although Vincent sometimes wrote lightheartedly, the gravity of the situation should not be underestimated. In the letter to Theo, quoted above, he wrote: "Not only my pictures, but I myself have become haggard of late, almost like Hugo van der Goes in the picture by Emil Wauters.[113] Only, having got my whole beard carefully shaved off, I think that I am as much like the placid priest in the same picture as like the mad painter so intelligently portrayed therein" (letter 514). Three months later, after weeks of feverish activity, there was again a moment when Vincent was forced to write, "I am really falling asleep and I can't see anymore, my eyes are so tired" (letter 552). In a following letter, he again compared himself with Hugo van der Goes, feeling that he also lived on the edge of insanity. "I am again pretty nearly reduced to the madness of Hugo van der Goes in Emil Wauters' picture. And if it were not that I have a sort of double nature, that of a monk and that of a painter, I should have been reduced, and that long ago, completely and utterly, to the aforesaid condition" (letter 556).

76
Harvest Landscape; *watercolor study for one of Vincent's most famous paintings from Arles, 1888. Pen, watercolor, JH 1438, F 1484, 39.5 x 52.5 cm. Fogg Art Museum, Harvard University, Cambridge, Massachusetts, Bequest of Grenville L. Winthrop*

At the end of the short harvest time, the tension caused by Vincent's striving for what he called "the high yellow note" must have been immense. This was especially the case during the days after the *Harvest* and the *Haystacks near a Farm* (JH 1442) had been produced, in the middle of June. When the worst was over, he wrote to Theo, "I have had a week's hard, close work among the cornfields in the full sun." And in a letter to his friend Bernard he gave a striking description of his working speed: "I have seven studies of wheatfields, unfortunately all done very much against my will, all of them landscapes. Landscapes yellow—old gold—done quickly,

[113] In this picture the bearded fifteenth-century painter Hugo van der Goes, who had become insane, is represented while he is being exorcised by a priest.

quickly, quickly and in a hurry, just like the harvester who is silent under the blazing sun, intent only on his reaping" (letter B 9).

Immediately after mowing a wheatfield, the people of Arles started to sow the land again, and so Vincent was able to return to his favorite theme of the sower at the same time that he was doing harvest scenes. In a well-known canvas, *Sower with a Setting Sun* (JH 1470), the sower is at work against a background of unmown wheat. Evidently the painting had a special importance for Vincent; he made sketches of it in letters to his friends John Russell and Emile Bernard and he mentioned it many times in other letters.

Characteristically, when writing to Theo, he still called it the "sketch" of a sower. "On a plowed field, a big field with clods of violet earth—climbing toward the horizon, a sower in blue and white. On the horizon a field with short ripe wheat. Over it all a yellow sky with a yellow sun. You can tell from the simple mentioning of the tones that it is a composition in which *color* plays a very important part. And the sketch, such as it is—a size 25 canvas—torments me, making me wonder if I shouldn't attack it seriously and make a terrible picture of it. My Lord, how much should I like to!" (letter 501). The "terrible" painting was never made, but posterity appears to have been content with the "sketch." It was to be one of Van Gogh's most reproduced pictures.

Somewhat later, in July 1888, Vincent was inspired by the wealth of flowers in one of the private gardens in Arles. He wrote to Theo that he had made a drawing of the garden, adding, as in passing, "I also have two painted studies of it" (letter 512). There was one in a vertical and one in a horizontal format of the same motif, both "size 30 canvases"[114] (which means that the largest side of each is about 36 inches). In the letter to Theo he made a sketch of the vertical canvas, indicating the bands of different colored flowers; in a letter to Wil he described the horizontal painting in evocative words: "I have a study of a garden one meter wide, poppies and other red flowers surrounded by green in the foreground; then a bed of bluebells, a bed of yellow and orange marigolds, then white and yellow flowers, and last, in the background, pink and lilac; also dark violet scabiosas, red geraniums, and sunflowers; a fig tree, and oleander and a vine. And in the far distance black cypresses against low white houses with orange roofs—and a delicate green-blue streak of sky" (letter W 5). The description shows that these canvases, which were announced to Theo in such simple terms, represented a new phase in Vincent's oeuvre. They are among the warmest and most festive pictures of the Arles period; both are characterized by an almost abstract pattern of dots of color, seemingly carelessly strewn over the picture plane.

In May of 1888, Vincent had made a series of reed pen drawings of the hills of Montmajour and the plain of La Crau. One of the most important of these drawings, described to his friend Koning as "a view of meadows, a road with poplars, and in the far distance the town" (letter 498a), had been done in a large format; and when in July he was again wandering about

Vincent's favorite theme: the sower.

Flower gardens.

[114] A size 30 canvas was a standard format Vincent often used, measuring ca. 36" x 28".

282

in the region, he decided to make another five drawings in the same format. "When I have half a dozen I shall send them along," he informed Theo (letter 506). The panorama done in May (JH 1437) was an excellent drawing, but the five from July are equally impressive. A letter to Theo shows that he was quite satisfied with them (letter 509). He hoped that the art dealer Thomas, whom they both knew, would buy them, but with a self-assurance that was very unusual for him, he said that if Thomas would be willing to take the two drawings that Vincent found best, he could not have them for less than one hundred francs each. "Not everyone would have the patience to get himself devoured by mosquitos and to struggle against the nagging malice of the constant mistral, not to mention that I have spent whole days outside with a little bread and milk, since it was too far to go back to the town every once in a while" (letter 509).

The drawings of Montmajour and La Crau.

The two drawings that pleased Vincent most were *La Crau, Seen from Montmajour* (JH 1501), and a similar landscape in which one sees the Rhône and a little train far in the distance (JH 1502). To underline their particular significance, Vincent made annotations on them, something he seldom did. The texts are "*La Crau, vue prise à Montmajour,*" and "*La campagne du côté des bords du Rhône, vue de Montmajour.*" This makes the identification of the drawings easy, because in the accompanying letter Vincent used practically the same words: "In my opinion the two views of the Crau and of the country on the banks of the Rhône[115] are the best things I have done in pen and ink" (letter 509).

Considering the amazing number of paintings Vincent made during this time, it is difficult to imagine that he had time left for drawing. In these summer months the speed of his production was breathtaking. Despite the fact that in the middle of May he had sent Theo one shipment of all the pictures that were available at that moment, scarcely two months later, in the middle of July, he wrote that he was ready to send another thirty studies (letter 505). When Vincent finally sent the studies to Paris around the middle of August, the number had grown to thirty-six.[116]

Though the quantity was great, Vincent apologized for the quality of the pictures. Among them "there are many I am desperately dissatisfied with" (letter 524). He nevertheless sent them, "since at all events they will give you a vague idea of the very fine subjects there are in the country." Elaborating on his less successful pictures, he accidentally mentioned a study about which he had never before written in his letters. He described this study (JH 1491) as a *pochade*—a quick, rough sketch—that showed Vincent himself "laden with boxes, props and canvas, on the sunny road to Tarascon." It may indeed have been quite "sketchy," but it evokes the image of the artist wandering along the roads of summery Arles, week after week, month after month, on his way to paint the beautiful landscapes. He represented himself in the full sun, seen against the light, casting a heavy shadow on the road; behind him stood the golden wheat, still standing upright on the field,

[115] *La campagne du côté des bords du Rhône.*

[116] The printed editions have thirty-five, but the figure in the manuscript was thirty-six.

with a green meadow to the right providing the color contrast he so admired. He is flanked by two trees in full foliage; in the distance one distinguishes a violet row of hills and some cypresses, and the sky above is soft blue-green. It is not by chance that the canvas he carries under his arm is bright yellow; this canvas and the little figure of the walker, who is dressed in blue with a yellow straw hat, combine Vincent's favorite colors from the Arles period.

It may have been the figure in the picture—fascinating, yet rather clumsily rendered—to which Vincent objected most, making him "desperately dissatisfied" with the composition. When he did a series of drawings after paintings in August, one of the model paintings was this canvas. The drawing (JH 1531) corresponds exactly with the model; the fierce sun that casts the shadow in the painting is brought into the drawing, but the figure of the walker is omitted.[117]

Vincent did not exaggerate when he wrote about his dissatisfaction with some of his studies. He destroyed at least one himself, although in this case his motives were not only aesthetic. "I have scraped off a big painted study, an olive garden with a figure of Christ in blue and orange, and an angel in yellow. A red field, green and blue hills. Olive trees with violet and carmine trunks and green, gray and blue foliage. A citron-yellow sky. I scraped it off because I tell myself that one should not do figures of that importance without models" (letter 505). Even if one respects his motives, it would be fascinating to see this picture. The red field, the citron-yellow sky and the two figures in blue and orange and yellow, are reminiscent of paintings by Bernard and Gauguin—*Jacob's Wrestling with the Angel* of 1888 (with the blood-red ground) or the *Yellow Christ* of 1889—the first of which Vincent could not have seen, the second of which had not yet been painted. The painting he scraped off, like most of his other work, would have shown that at this moment he was no less progressive than his two colleagues in Pont-Aven.

Vincent is unhappy with his work and destroys one of his studies.

[117] The small painted study was destroyed by fire in 1944 together with the rest of the Kaiser Friedrich Museum in Magdeburg, and only color reproductions can give an idea of what it really looked like.

77
Portrait of Lieutenant Milliet, *one of Vincent's closest friends, 1888. Oil on canvas, JH 1588, F 473, 60 x 49 cm. National Museum Kröller-Müller, Otterlo, The Netherlands*

There must have been moments when Vincent felt quite lonely in Arles, but there was no hint of complaint in his letters until mid-July. "When I came here I had hoped that it would be possible to make some connections here; but up to the present I haven't made a centimeter of progress in the hearts of the people. And now Marseilles? I don't know, but that may very well be an illusion too. In any case, I have quite given up gambling much on it. So whole days pass without my speaking to anyone, except to ask for dinner or coffee. And it has been like that from the beginning" (letter 508). He qualified this statement by saying, "Up to now the loneliness had not worried me too much, because I was so much impressed by the stronger sun and its effect on nature."

It was not quite true that he had been lonely "from the beginning." In early March he had met the Danish painter Mourier Petersen and his American colleague Dodge McKnight, who had come to the village of Fontvieilles (just north of Arles) to paint. The three visited each other regularly to see each other's work. Vincent did not like McKnight very much ("... he is a dry sort of person and not very sympathetic either," he wrote in May), and so when Petersen left Arles for Paris in

June, Vincent probably was quite lonely (letter 482). The situation improved when the Belgian painter Eugène Boch visited McKnight. Boch (in his letters Vincent wrote *Bock*, undoubtedly because of the way the name was pronounced) became a friend, although he too, at least in the beginning, was cautious in his opinion of Vincent's work (probably under McKnight's influence). "Still a frosty silence about my work when they come," Vincent wrote in the last week of July (letter 512). Yet he immediately liked Eugène Boch. "He is a young man whose appearance I like very much, a face like a razor blade, green eyes, and a touch of distinction. Beside him, McKnight looks very common."

78
Portrait of Eugene Boch, *another of Vincent's friends. 1888, Oil on canvas, JH 1574, F 462, 60 x 45 cm.*
Museé d'Orsay, Paris

Vincent found another friend in June, whom he described to Bernard: "I am acquainted with a second lieutenant of the Zouaves here, called Milliet.[118] I give him drawing lessons—

[118] The Zouaves were infantry men, intended for service in North Africa. They were Europeans, although their uniforms had an Arab touch.

with my perspective frame—and he is beginning to make drawings; by God, I've seen worse" (letter B 7). In mid-July Vincent wrote to Theo : "I have come back from a day at Montmajour, and my friend the second lieutenant kept me company. We explored the garden together, and stole some excellent figs. If it had been bigger, it would have made me think of Zola's Paradou [the paradisiacal park from Zola's novel *La Faute de l'Abbé Mouret*], high reeds, vines, ivy, fig trees, olives, pomegranates with lusty flowers of the brightest orange, hundred-year-old cypresses, ash trees and willows, rock oaks, half ruined flights of steps, broken ogival windows, blocks of white rocks, covered with lichen, and scattered fragments of crumbling walls here and there among the garden" (letter 506). When he had painted a few studies in August, he said that they had been approved of as having "quite the modern touch" by "the young rival of good old general Boulanger, the very resplendent second lieutenant of Zouaves" (letter 552).

Shortly after the end of August, Milliet went on a holiday via Paris. Vincent asked him to take along a considerable number of his paintings, and informed Theo of their impending arrival: "I will let you know, or Milliet will send you a wire telling you by which train he will arrive on the 16th or 17th [of August]. He will then hand you over the painted studies, which will save us the cost of transport. He owes me that anyhow for my lessons" (letter 522). Everything went according to plan, and on 17 August, Milliet handed Theo a parcel with no less than thirty-six studies. In November, Milliet departed for Africa, but not before Vincent painted his portrait and presented him with a study to express his gratitude for what he had done.

Theo receives thirty-six studies.

Vincent may have had yet another reason for being grateful to Milliet. It was almost certainly thanks to him that he was able to write triumphantly in June: "I have a model at last" (letter 501). The model was one of the Zouaves of Milliet's regiment, and, as the letters do not mention any kind of payment, we may assume that the man had posed for nothing, but by order of the second lieutenant. It must have been exciting for Vincent finally to be able to to paint a portrait again—the first since he had painted the old woman on one of his first days in Arles. Although figure painting remained his ideal, he had never had enough money for models.

A portrait of a Zouave.

This time, the model was a particularly interesting type, especially because of the extremely picturesque uniform, corresponding to Vincent's needs of the moment: strong complementary colors, red and green, blue and yellow dominating. He wrote to Theo: "I have a model at last—a Zouave—a boy with a small face, a bull's neck, and the eye of a tiger; I began with one portrait and then did another one. The half-length I did of him was horribly harsh, in a blue uniform, the blue of enamel saucepans, with braids of a faded reddish-orange, and two yellow stars on his breast, an ordinary blue, and very hard to do. That bronze, feline head of his with the reddish cap, I placed him against a green door and the orange bricks of a wall. So it's a savage combination of incongruous tones, not easy to manage. The study I made of it seems to me very harsh, but then I'd like always to be working on vulgar, even loud portraits like this" (letter 501).

Vincent wrote another curiously ambivalent description of his own work in a letter to his younger colleague and friend, Emile Bernard. "I should make some sketches for you if I were not so beat after drawing and painting from a model, a Zouave, for three or four days. I am exhausted, but on the contrary, writing rests and distracts me. What I have dashed off is very ugly; a drawing of a seated Zouave, a painted sketch of him against a completely white wall, and finally his portrait against a green door and some orange bricks of a wall. It is hard and, well, ugly and damned hopeless [*mal foutu*]" (letter B 8).

It is easy to agree with Vincent's assessment of the first drawn sketch of the seated Zouave. The half-length portrait (JH 1486), however, was later admired for its force rather than rejected for its harsh color contrasts. The painting of the seated figure against a white wall (JH 1488) is one of his most impressive from the Arles period. It is an amazing achievement, striking in the originality of the composition; the bright red trousers occupy almost a quarter of the entire pictorial space.

An unusual fact is that Vincent again took up working on the picture some six weeks later, and only then seems to have considered it finished. "I have again been working on the figure of a Zouave seated on a bench against a white wall, which makes a fifth figure," he wrote in August (letter 519).[119] That he could call it the *fifth* figure can easily be explained; it is because in the meantime he had made portraits of a new friend, a young girl and a real "model." Of the model, he wrote to Theo at the end of July: "And now, if you know what a *mousmé* is (you will know when you have read Loti's *Madame Chrysanthème*), I have just painted one. It took me a whole week, I have not been able to do anything else, not having been very well either. That is what annoys me; if I had been well, I should have knocked off some landscapes between times, but I had to reserve my mental energy to do the mousmé well. A mousmé is a Japanese girl—Provençal in this case—12 to 14 years old. That makes two figures now, the Zouave and her" (letter 514).

The painting (JH 1519) shows the girl in a red and blue striped jacket and a blue skirt with orange dots, seated in a cane armchair, a branch of oleander in her hand—a striking image of awakening femininity with a touch of shyness and dignity. In a letter to Bernard, and in reference to the portrait, Vincent wrote about his artistic ideals. What he admired most in art, he wrote, were not the Primitives or the Japanese. Of course, they interested him enormously, but, "a complete thing, a perfection, renders the infinite tangible to us; and the enjoyment of a beautiful thing is like coitus, a moment of infinity." He found "calm perfection" in a Greek statue, a nude woman by Courbet or Degas, and in Vermeer, whose *Lady with a String of Pearls* he took as an example: "Do you know a painter, called Vermeer,[120] who has painted, among other things, a very beautiful Dutch lady, pregnant? The palette of

Another model: the mousmé.

[119] The American edition of the letters has: "I have worked on another portrait of the Zouave," etc., which gives the wrong impression that he was referring to a new version of the portrait. The original text is, "*J'ai encore travaillé à une figure de Zouave assis sur un banc contre un mur blanc.*"

[120] The question may now seem odd, but Vermeer's great fame dates from after 1866, when Thoré (W. Bürger) first called attention to his work.

288

this strange painter is blue, citron yellow, pearl gray, white. Certainly, there may be all the riches of a complete palette in his rare pictures, but the combination of citron yellow, pale blue and pearl gray is as characteristic of him as black, white, gray and pink are of Velázques" (letter B 12). Had Vincent tried to make "a complete thing" himself with the painting of the *mousmé*? His work was still far from the perfection of the Vermeer he described; as so often in his work, the hands of the model had been neglected, but qualities like the refinement in the tones of the face against the soft green of the background and in the joyous colors of the costume, not to speak of the delicate handling of the figure itself, have made this portrait one of the highlights in his oeuvre.

Along with the *mousmé*, Vincent also painted a portrait of a new friend—Joseph Roulin. He was a postman, or, as he called himself, an *entreposeur des postes* (head of a postal agency). When in late July he had started work on Roulin's portrait, he reported it to both Theo and his sister Wil. An amusing passage in the letter to Wil begins: "I am now engaged on a portrait of a postman in his dark blue uniform with yellow. A head somewhat like Socrates, hardly any nose at all, a high forehead, bald crown, little gray eyes, bright red chubby cheeks, a big pepper-and-salt beard, large ears. This man is an ardent republican and socialist, reasons well, and knows a lot of things. His wife was delivered of a child today, and he is consequently feeling as proud as a peacock, and is all aglow with satisfaction. In point of fact I greatly prefer painting a thing like this to doing pictures of flowers" (letter W 5).

When he was planning to make a picture of the baby, Vincent wrote to Wil again, providing an even more characteristic image of Roulin: "If I can get the father and mother to allow me to do a picture of it, I am going to paint a baby in a cradle one of these days. The father had refused to have it baptized—he is an ardent revolutionary—and when the family grumbled, possibly on account of the christening feast, he told them that the christening feast would take place nonetheless, and that he would baptize the child himself. Then he sang the Marseillaise at the top of his voice, after which he named the child Marcelle, after the daughter of *le brav' général Boulanger*, to the great indignation of this innocent baby's grandmother and some other members of the family" (letter W 6).

Vincent completed two portraits of Roulin in a row, one on 31 July—the day Marcelle was born—and one during the first days of August. The first was a half-length, showing Roulin with his left arm leaning on a table. The second—made, according to Vincent, because Roulin had kept himself too stiff when posing—shows only the head (letter B 14). This one (JH 1524) is a frontal, somewhat hieratic-looking portrait that expresses the man's amiable character. Vincent was so proud of having painted it "at a single sitting" that he mentioned the fact twice in his letters, once to Bernard and once to Theo, adding in the letter to his brother, "Well, that's what I'm good at, doing a fellow roughly in one sitting."

There is no doubt that the half-length painted on 31 July (JH 1523) is superior in every respect. The coloration alone makes it a very imposing picture–the clear blue of the uniform and the yellow buttons are splendidly balanced by the soft blue

79
Portrait of Joseph Roulin, *detail of the half-length portrait for which the postman posed in July 1888 (see color plate 8)*.
Oil on canvas, JH 1522, F 432, 81 x 65 cm.
Gift of Robert Treat Paine, 2nd Courtesy,
Museum of Fine Arts, Boston

of the background and the green of the table—but the superb composition contributes equally to the effect.

Though it could only be maintained by mail, Vincent's relationship with Emile Bernard meant more to him than the friendships he had formed in Arles with Petersen, Boch, Milliet and Roulin. Vincent and Bernard not only exchanged ideas, but during the summer of 1888 they also had a lively exchange of sketches. Bernard also sent Vincent poems. Several times he sent sonnets that sparked critical remarks from his older friend. When Bernard sent Vincent a sketch of a brothel scene with an accompanying poem on the back, an amusing error took place. Vincent immediately sent the sketch to Theo, recommending that he buy something from Bernard; but in a moment of distraction he addressed the letter to their old address, rue de Laval, instead of rue Lepic, with the result that "the post-office clerks, who returned the letter opened, had had the pleasure of edifying themselves by the contemplation of Bernard's brothel" (letter 503).

When Vincent received Bernard's drawing, he answered: "Your letter delighted me, the sketch is very, very interesting; many thanks for it. On my part I shall also send you a drawing one of these days—tonight I am too exhausted; my eyes are tired even if my brain is not." It took him only a few days to fulfill his promise. He sent Bernard a drawing in chalk and watercolor, which was a precise copy, but with a light green background, of the painted portrait of the Zouave, annotating it: *à mon cher copain Emile Bernard*. It is not surprising that Vincent chose to send the painting on which he was working when Bernard's sketch arrived. He even considered trading the portrait of the Zouave and told Bernard so in his next letter, though such an exchange never came about (letter B 9).

Vincent initiated another sort of exchange when he sent Bernard six drawings on 22 July (letter B 10). The six were small reed pen drawings, done after recently painted studies. He hoped that in return Bernard would send him sketches after his studies from Brittany. A few days later Vincent followed up with another nine drawings of the same kind, thereby proving, but without boasting about, the speed with which he produced these splendid drawings based on his own work (letter B 12). His initiative was successful; Bernard responded by sending ten of his sketches about a week later.

Even more important than these exchanges of drawings is the fact that Vincent expressed himself more openly in his letters to Bernard than in those to his brother. Some striking remarks, for instance, about his religious ideas—a subject he had not broached in his letters for a long time—are to be found in a letter to Bernard from the summer of 1888. In terms adopted from his own profession he described Christ as a great artist. "Christ alone—of all the philosophers, Magi, etc.—has affirmed, as a principal of certainty, eternal life, the infinity of time, the nothingness of death, the necessity and the *raison d'être* of serenity and devotion. He lived serenely, *as a greater artist than all other artists*, despising marble and clay as well as color, working in living flesh. That is to say, this matchless artist, hardly to be conceived by the obtuse instrument of our modern, nervous, stupefied brains, made neither statues nor pictures nor books; he loudly proclaimed that he made . . . *living men*, immortals. This is serious, especially because it is

80
Portrait of Madame Ginoux, *done by Vincent in November 1888.*
Oil on canvas, JH 1625, F 489, 93 x 74 cm.
Museé d'Orsay, Paris

290

the truth" (letter B 8). He went on to contrast Christ's teaching with scientific reasoning, which, because it dealt with the finite, could not yet answer certain questions. He believed that eventually science would arrive at conclusions similar to those of Christ. After all, he pointed out, hadn't science found that the earth was not flat? Science might then discover that life also was not flat, running simply from birth to death, but rather round and superior in expanse and capacity to the hemisphere. He ended his philosophical digression with a more realistic pronouncement. "However this may be, the fact is that we are painters in real life, and that the important thing is to blow with all our might as long as we have the breath to blow" (letter B 8).

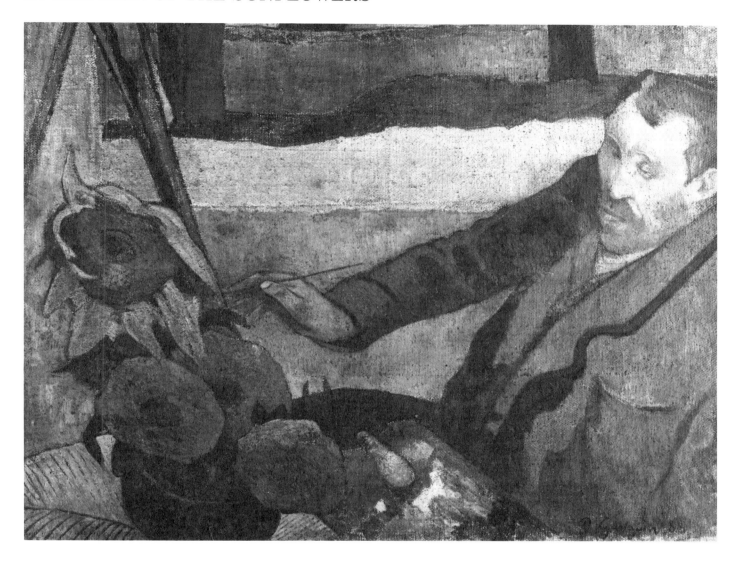

81
Portrait by Gauguin of Vincent painting sunflowers, probably done in November 1888, some three months after Vincent actually produced his famous flower still-lifes.
Vincent van Gogh Foundation / National Museum Vincent van Gogh, Amsterdam

The month of August 1888 was probably Vincent's happiest time in Arles, when he joyfully worked on the portraits of Roulin (payment for his sittings consisted of eating and drinking with Vincent). The famous paintings of the sunflowers which date from this month, with their wealth of citron yellow and golden yellow colors, are outward symbols of that happiness. He no longer complained about his health; on the contrary, he wrote that his stomach had so far recovered that he was able to live for three weeks out of four on ship's biscuits with milk and eggs. There was probably some exaggeration here, for he added in his next letter that he owed his restored health largely to "the people at the restaurant where I have my meals, which are extraordinary." In contrast to Paris, he said, "one really got something to eat for one's money here."When Theo sent a hundred instead of fifty francs in the second half of the month (as he had in the beginning of August), Vincent was

293

in an extravagant mood. He got up very early every day, saw to it that he had good meals, and was able to work hard and long without feeling himself weaken. In that same week he bought a black velvet jacket "of fairly good quality" for twenty francs and a new hat, having cautioned Theo beforehand that he was going to spend the hundred franc note in a single week. He added, almost triumphantly, "but at the end of this week I'll have my four pictures,"—referring to four pictures of sunflowers, on which he had worked "with the enthusiasm of a Marseillais eating bouillabaisse."

In the first week of August, Vincent must have been quite occupied making drawings after the pictures he still had in his studio. While he had barely finished the portraits of Roulin, he wrote, "I am working hard for Russell, I thought I would do him a series of drawings after my painted studies [as he had also done for his friend Bernard a little more than a week before]; I believe that he will look upon them kindly. . ." (letter 516).

Three series of drawings after painted studies.

Barely three days later he wrote that he had sent John Russell twelve drawings, and amazingly, they had been done with the same precision as the paintings he had sent to Bernard (letter 517). The drawings of the *mousmé* and the Zouave are miracles of graphic art, not inferior to the original paintings. Vincent must have felt that he could not deny his brother what he had given to his friends, for in his next letter he promised to send him similar sketches after painted studies (letter 518). Within a week about ten had been sent (letter 519).

Vincent also started work in his studio on paintings. On 11 August, he introduced the first of two important portraits (JH 1548) to Theo. "You are shortly to make the acquaintance of Master Patience Escalier, a sort of man with a hoe[121] formerly a cowherd of the Camargue, now a gardener at a house in La Crau. Today I'll send you the drawing I made after that painting as well as the drawing after the portrait of the postman Roulin" (letter 520). He realized that he had rendered the man in a highly unconventional manner and explained that he had worked as a true "colorist," starting with a realistic portrait, but using color arbitrarily. He imagined this peasant as "a terrible figure in the sea of fire of harvest time in the heart of the Midi"; hence the flashing orange colors of red-hot iron and the luminous tones of old gold in the shadows. He concluded: "Oh, my dear brother . . . the nice people will only see the exaggeration as a caricature. But what do we care? We have read *La Terre* and *Germinal*,[122] and when we are painting a peasant, we should like to show that our reading has more or less become a part of us" (letter 520).

Daring portraits.

If it is true that his contemporaries would view the head of this peasant as a caricature, one wonders what they would have said about the *other* portrait of Patience Escalier that Vincent painted two weeks later! In this painting (JH 1563), the peasant with his vivid green blouse is seen against an abstract orange-red background. The face is done in even

121 *Man with a Hoe* (*l'Homme à la houe*) is the title of a famous painting by Millet which Theo certainly knew.
122 Vincent followed Zola's work closely; *La Terre* had appeared in 1887, and he read *Germinal* immediately after it had come out in 1885.

294

heavier brushstrokes of red, brown and yellow. Much more than in the first portrait, the man seems to emerge from a "sea of fire," a background of which Vincent prudently said, "although it does not pretend to be the precise image of a red sunset, it may nevertheless give a suggestion of one" (letter 529). Rarely had he dared such fierce color contrasts, but the "terrible man" he saw in this old cowherd asked for such harsh treatment. He had again succeeded in producing an unforgettable portrait.

The highlight of Vincent's production in August 1888 was, however, his famous series of sunflowers. Seeing them in full bloom in the fields and in the gardens while he was working on studies must have inspired him to use them for a series of still lifes of cut flowers (as he had done a year earlier in Paris). In a letter to Bernard he wrote: "I am thinking of decorating my studio with half a dozen "Sunflowers," a decoration in which the harsh or broken chrome yellows will stand out on various backgrounds—blue, from palest Veronese green to *royal blue*, framed in thin strips of orange colored wood. Effects like those of stained-glass windows in a Gothic church. Ah! my dear comrades, let us crazy ones take delight in our eyesight in any case!" (letter B 15).

Scarcely after writing this letter he informed Theo of the result of his new activity: "I have three canvases going—first, three huge flowers in a green vase, with a light background, a size 15 canvas [JH 1559]; second, three flowers, one gone to seed, having lost its petals, and one a bud, against a royal-blue background, size 25 canvas [JH 1560]; third, twelve flowers and buds in a yellow vase, size 30 canvas [JH 1561]. The last one is therefore light on light, and hopefully will be the best" (letter 526). For a short time the task kept him completely busy. "If I carry out this idea there will be a dozen panels. So the whole thing will be a symphony in blue and yellow. I am working at it every morning from sunrise on, for the flowers fade so soon, and the thing is to do the whole in one rush" (letter 526).

After completing the picture with twelve flowers he immediately began to paint a variation of it; moreover he was to use these two big bouquets for later repetitions. It probably was not more than a day later when he wrote to Theo: "I am now on the fourth picture of sunflowers [JH 1562]. This fourth one is a bunch of fourteen flowers against a yellow background, like a still life of quinces and lemons I did some time ago" (letter 527).[123]

While he was here clearly experimenting with the effect of yellow on yellow in various nuances, the canvas with a light greenish blue background (JH 1559) was more in accordance with the idea of a "symphony in blue and yellow." In this picture he used a third complementary color by adding a dark red line around the vase and a dark red signature. The same color divides the table and the wall.

These studies of sunflowers were rendered in a far from conventional way. The splendid sunflowers from the Paris period, painted lying on a table (JH 1329-1331), were not conventional either, but they still showed the well-known image of a large disk, surrounded by a crown of bright yellow petals. In the new studies he expressed his interest in the

Decorating the yellow house with sunflowers, "a symphony in blue and yellow."

[123] Here he meant the canvas he had dedicated to Theo, JH 1339.

different stages of bloom, thereby producing a great variety of forms: fluffy balls and pointed stars, buds newly blooming, flowers standing proudly upright, and flowers half-withering and hanging. It was an image of life which Vincent did not try to embellish, just as he didn't embellish his potato-eating peasants. The difference is that this time everything was suffused with a golden light, making these pictures a hymn to joy.

A short time later Vincent expressed his happiness more literally in a similar still life. The picture shows branches of oleander in a jar instead of sunflowers, with two books lying in the foreground (JH 1566). On the yellow cover of one book he painted the title he had used three years earlier for his still life with a large Bible: *La joie de vivre*.

Yet this did not mean that he had no worries that summer. Materially, he found life "cruelly hard." He did not succeed in spending fewer than five or six francs a day, and even so he did not live well (letter 520). But he knew: "The only choice I have is between being a good painter and a bad one. I choose the first. But the needs of painting are like those of a wasteful mistress, you can do nothing without money, and you never have enough of it." Despite these hardships, he showed an amazing amount of optimism in the words with which he summarized his philosophy of life. "When you are well, you must be able to live on a piece of bread while you are working all day, and have enough strength left to smoke and drink your glass—that's necessary under the circumstances. And all the same to feel the stars and the infinite high and clear above you. Then life is almost enchanted after all. Ah! those who don't believe in this sun are real infidels" (letter 520).

September 1888 was an extremely important month as far as work was concerned. Among the numerous paintings he produced were several which may be considered among his masterpieces. If one counts only the pictures that are described, or at least mentioned, in the letters, he completed seventeen works. Among these are three portraits, four park-views, four other landscapes, and unusual pictures like *The Night Café*, *The Café Terrace*, *The Rhône under a Starry Sky*, and *The Yellow House*.

The first of the three portraits painted in September (JH 1574) represents Vincent's friend Eugène Boch. Vincent wrote that he wanted to make "the portrait of a poet," undoubtedly having in mind not a poet in the literal sense, but the painter Boch.[124] It is fascinating to read how accurately he had predicted what his painting would express:

> I want to put my appreciation, the love I have for him, into the picture. So I paint him as he is, as faithfully as I can, to begin with. But the picture is not yet finished at that point. To finish it I am now going to use my colors arbitrarily. I exaggerate the fairness of the hair; I even get to orange tones, to chromes and pale citron-yellow. Behind the head, instead of the banal wall of the ordinary room, I paint infinity, a plain background of the richest, most intense blue that I can contrive, and by this simple combination of the bright head against the rich blue background, I get a mysterious effect, like a star in the depths of an azure sky (letter 520).

The masterpieces of September 1888.

Three portraits.

124 Some time later he also called Paul Gauguin "a poet."

Three weeks later, Vincent and Boch spent the day together, and he could write to Theo: "Thanks to him I at last have a first sketch of that picture which I have dreamed of for so long—the poet. He posed for me. His fine head with that keen gaze stands out in my portrait against a starry sky of deep ultramarine; he wears a short yellow coat, a collar of unbleached linen, and a spotted tie. He gave me two sittings in one day."

It is a curious fact that he modestly called a painting that now is considered one of his most characteristic portraits "a first sketch." He appreciated it enough to hang it in his bedroom next to a portrait of Milliet; he wrote this himself in a letter to Boch, and one can also see it in the first version of a picture of the room (JH 1608). Yet it was literally meant as a first sketch. About a month later he made a new version, but he was not satisfied with it, and he showed again how much he objected to working without a model; in a letter addressed to Bernard he wrote, "I have mercilessly destroyed [a canvas] representing the Poet against a Starry Sky —in spite of the fact that the color was right—because the form had not been studied beforehand from the model, which is necessary in such cases" (letter B 19).

The second portrait he did during September was a self-portrait, and again he wanted to share with Theo several considerations in connection with it. When he described the paintings he did in the second week of September, he called this portrait (JH 1581) "the third picture of the week." He first mentioned it in a letter to Wil, the second part of which was written on 16 September. "I also made a new portrait of myself, as a study, in which I look like a Japanese" (letter W 7). This description is important because it suggests that at this time he more or less identified with the Japanese artists whom he so admired and emulated in his drawings, watercolors and paintings.

Vincent wrote Gauguin about the self-portrait, describing in detail the colors he had so deliberately chosen and stressing the peculiar character of the features, for Gauguin had also done a self-portrait which he described in a letter sent to Vincent by the end of September.[125] Vincent admired the way Gauguin had conceived the portrait as a symbol of the impressionist in general (letter 544a). Explaining the idea behind his own picture, he wrote: "I have a portrait all ash-colored, the ashen-gray color resulting from the mixing of emerald green with an orange hue. It is on a uniform pale emerald green background, with reddish brown clothes. But as I too wanted to exaggerate my personality, I had rather aimed at the character of a bronze, simple worshiper of the Eternal Buddha.[126] It has cost me a lot of trouble, yet I shall have to do it all over again if I want to succeed in expressing what I mean" (letter 544a). This splendid painting is one of the most impressive of the more than thirty self-portraits Vincent produced. Vincent appears serious and self-assured, and the "exaggeration" of his personality he had

82
Self-portrait with a Japanese look, dedicated to Paul Gauguin, 1888. Oil on canvas, JH 1581, F 476, 62 x 52 cm. Fogg Art Museum, Harvard University, Cambridge, Massachusetts Bequest of Grenville L. Winthrop

[125] Letter GAC 33 in Douglas Cooper's 1984 edition of Gauguin's letters, *Paul Gauguin: 45 lettres à Vincent, Théo et Jo van Gogh* (1984).
[126] For the idea of a Japanese "bronze" he may have been inspired by Loti's *Madame Chrysanthème* in which there was an illustration of a group of such bronzes (see the article by Tsukasa Kôdera, "Japan as primitive utopia: van Gogh's japonisme portraits" in *Simiolus*, 1984).

aimed at by giving himself the appearance of a Buddhist monk may well have contributed to its expressiveness. More than any of his other self-portraits, it conveys something of his enigmatic character which persists despite the hundreds of frank and revealing letters he wrote to his brother, sisters and friends.

Before he saw Gauguin's self-portrait, which must not have been until 7 or 8 October, he said that he knew in advance it would be far too important for the exchange of portraits he had proposed to Gauguin and Bernard (letter 535), though he said he would ask Theo to buy it. However, Vincent was not very enthusiastic about Gauguin's self-portrait once he actually saw it. Gauguin had added a small portrait of Emile Bernard in a corner of his own portrait and inscribed the painting with the words *Les Misérables*, the title of a novel by Victor Hugo. He had depicted himself as Jean Valjean, the shady character who is the hero of that novel, and had provided the two friends (and the impressionists in general) with a label with which Vincent could certainly not agree. He wrote that he disliked the "ill and tormented look" Gauguin had given his portrait; it gave "absolutely the impression of its representing a prisoner. . . . Not a shadow of gaiety" (letter 545).

The self-portrait which Bernard contributed, which in turn included a small portrait of Gauguin, was much more to Vincent's liking. Bernard, however, was not very happy with the painting Vincent sent in the exchange. He may have expected to receive a self-portrait of Vincent, as the original proposal had been an exchange of portraits. Vincent must have known this because when he sent the pictures meant for the exchange he wrote to Bernard, "Of course, if you should prefer another study in this batch to the *Men Unloading Sand*, you can erase the dedication if someone else will have it, and take the other one for yourself" (letter B 19). And this is what Bernard seems to have done, because the dedication has been scratched off.

The third portrait Vincent did in September 1888 was that of his friend, the second-lieutenant Milliet (JH 1588). Knowing that Milliet was to depart for North Africa soon after he returned from his holiday, he made an appointment with him to pose. When Milliet returned, though, his amorous adventures posed a problem. "Milliet is lucky," Vincent wrote, "he has as many Arlésiennes as he wants; but then, he cannot paint them, and if he were a painter, he would not get them" (letter 542). Vincent may have envied him a little, but he knew the cost that such a lifestyle would have upon his art. A few days later he was able to write, "I am working on Milliet's portrait, but he poses badly, or I may be at fault myself, which, however, I do not believe as I would really like to have some studies of him, because he is a good-looking boy, very casual and easy-going in his behavior, and he would suit me well for a picture of lovers" (letter 541a).

When the portrait of Milliet was finished Vincent hung it in his bedroom next to the one of his other friend, Eugène Boch. He did not think that it was "terribly harsh" as he had said of the portrait of the other Zouave, seated against a green door and an orange brick wall. This time, placing the figure against a plain green background had resulted in greater harmony while maintaining a lively effect. Moreover, in rendering the features of a self-assured man with a well-groomed, martial,

Gauguin inscribes his self-portrait "Les Misérables."

298

yet sympathetic appearance, Vincent succeeded in producing a highly characteristic portrait.

During September, Vincent was engaged in an unusual activity in addition to his work on these portraits. After his conflict with the people of the Restaurant Carrel in the spring of 1888, Vincent had found accommodations in a café called the Café de la Gare, owned (or managed) by Ginoux. The café was located on the Place Lamartine near the yellow house, but is not visible in the painting of that building. In August he wrote: "Today I am probably going to start on the interior of the café where I stay, by gaslight, in the evening. It is what they call here a *café de nuit* (they are fairly common here), staying open all night. Night prowlers can take refuge there when they have no money to pay for a lodging or are too tight to be taken in" (letter 518). It was the beginning of September before he actually painted the café, and then he wrote extensively about the adventure. It appears to have been an amusing event for his friends (including the landlord) as well as for himself, although at the same time he meant it to be an innocent kind of revenge. He explained in the letter to Theo written on 8 September: "Just as the worries do not come singly, neither do the joys. For just because I am always bowed under this difficulty of paying my landlord, I made up my mind to take it gaily. I swore at the said landlord, who after all is not a bad fellow, and told him that to revenge myself for paying so much money for nothing, I would paint his whole rotten joint as a way to repay myself. Then to the great joy of the landlord, the postman whom I had already painted, the visiting prowlers, and myself, for three nights running I sat up to paint, going to bed during the day" (letter 533).

Somewhat defiantly, he called the picture of *The Night Café* (JH 1575) "one of the ugliest I have done," undoubtedly referring to the intentionally drastic contrasts of reds and greens. Yet the importance the painting had for him is shown by the detailed description of it he sent to Theo. He even wanted to give him a visual impression immediately by making an elaborate sketch in color for him. "I am making a drawing of it in watercolor, which I'll send tomorrow to give you an idea of it" (letter 533). Together with the watercolor (JH 1576), Vincent's extensive comment must have given Theo a good idea of the picture that he, too, probably considered extremely "ugly" in spite of Vincent's explanation that he had tried "to express the terrible passions of humanity" with the use of red and green paint. "The room is blood red and dark yellow with a green billiard table in the middle; there are four citron yellow lamps with a glow of orange and green. Everywhere there is a clash and contrast of the most disparate reds and greens, in the figures of little sleeping hooligans, in the empty, dreary room, in violet and blue. The blood red and the yellow-green of the billiard table, for instance, contrast with the soft tender Louis XV green of the counter, on which there is a pink nosegay. The white clothes of the landlord, awake in a corner of that furnace, turns citron yellow, or pale luminous green" (letter 533).

The next day, Sunday 9 September, he wrote again to Theo in an attempt to explain even more clearly what his intentions had been. "In my picture of the *Night Café* I have tried to express the idea that the café is a place where one can ruin oneself, go mad, commit crimes. In short, I have tried to

Painting The Night Café.

express the powers of darkness in a low public-house, by using soft Louis XV green and emerald green, contrasting with yellow-greens and harsh blue-greens, and all this in an atmosphere of pale sulfur, like a devil's furnace. And yet, all this with an appearance of Japanese gaiety, and the good-naturedness of Tartarin."

Vincent's painting was a conscious deviation from reality, and he patiently explained: "Afterward, when I have carried these experiments even further, the *Sower* will always remain the first attempt in that style. The *Night Café* carries on the style of the *Sower*, as do the head of the old peasant and the one of the poet. . . . It is color not locally true from the point of view of *trompe-l'oeil* realism, but color suggesting some emotion of an ardent temperament" (letter 533).

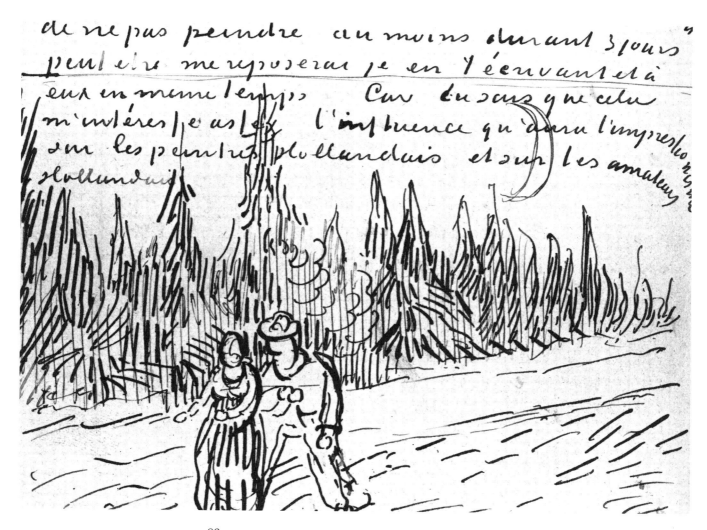

83
The Poet's Garden, *sketch in letter 556 from October 1888 after one of the paintings to honor Paul Gauguin (the painting is JH 1615).*
Vincent van Gogh Foundation / National Museum Vincent van Gogh, Amsterdam

In the month of September, Vincent worked at a group of landscape paintings intended as an homage to Paul Gauguin, who was coming to live with him in Arles. During the spring of 1888 Gauguin had been in serious financial difficulty in Brittany. He had written Vincent that he had gone there to paint and that the little money he had left was necessary for paying off debts; he expected to be penniless in a month. As usual Vincent felt compelled to do something; he asked Theo: "Would you risk taking his *Marine* for the firm? If that were possible, he would be safe for the moment." Unfortunately Theo was not in a position to do so. Gauguin then wrote Theo directly on 22 May, urgently asking for help because he had been living on credit at the Inn at Gloanec for three months and was becoming embarrassed. "Can you give me any hope?" he asked; "however little it is, it would give me some courage." Theo, who still supported Vincent with fifty francs weekly (and now and then a hundred), was willing to help Gauguin too and sent fifty francs. Vincent, who had rented a house in the

beginning of May, reacted immediately to Theo's gesture with a concrete proposal: let Gauguin come to Arles! There would be traveling expenses, and two beds (or mattresses) would have to be bought, but "the two of us will be able to live on the same money that I now spend on myself alone" (letter 493).

Gauguin agreed that living together might have some advantages, but he hid behind his illness, complaining to Vincent that intestinal pains worried him. It was the beginning of July before Theo was able to write that Gauguin had definitely accepted their proposal, but even then Gauguin kept delaying his departure; it was not before the last week of October that he finally arrived in Arles.

Vincent feverishly began to "decorate" the house for Gauguin's arrival, beginning a series of important landscape paintings inspired by the little public park in front of the yellow house. The subject of the first was very simple: "a corner of the public park with a weeping tree, grass, round clipped shrubs, and an oleander bush" (JH 1578). This canvas was the first of a series that was to become known under the title *The Poet's Garden*. He explained in a letter to Gauguin a short time later:

> I have expressly made a decoration for the room you will be staying in, a poet's garden; among the sketches Bernard has [and which Gauguin would therefore have seen] there is a first rough sketch of it, later simplified. The banal public garden contains plants and shrubs that make one dream of landscapes in which one likes to imagine the presence of Botticelli, Giotto, Petrarch, Dante and Boccaccio. In the decoration I have tried to disentangle the essential from what constitutes the immutable character of the country. And what I wanted was to paint the garden in such a way that one would think of Petrarch, the old poet from here (or rather from Avignon), and at the same time of the new poet living here—Paul Gauguin (letter 544a).

It comes as a surprise that Vincent had been thinking of Renaissance figures like Petrarch and Botticelli, but the explanation can be found in one of his letters. "Some time ago I read an article on Dante, Petrarch, Boccaccio, Giotto, and Botticelli; good Lord! it did make an impression on me reading the letters of those men" (letter 539).[127] He was struck by the thought that there was a link between Petrarch and himself. "Petrarch lived quite near here in Avignon, and I am seeing the same cypresses and oleanders."

A few days after he finished the first park landscape he wrote, "At the moment I am working on another square size 30 canvas, another garden, or rather a walk under plane trees, with the green turf and black clumps of pines" (letter 538). While the first park landscape with the greenish yellow sky and the bright green foreground was in accordance with Vincent's ideal of brilliant and gay colors, the new canvas (JH 1582) with sun-specks in the foreground, green and red dresses and pink parasols formed an even sunnier and still more colorful autumn symphony. In his next letter to Theo (written on the same day!) he wrote that he had finished still another land-

Gauguin comes to live with Vincent in Arles.

127 Evert van Uitert has researched what article Vincent could have read. It was an extensive study by Henri Cochin in the *Revue des Deux Mondes*, July-August 1888, called "Boccace d'après ses oeuvres et les témoignages contemporains" (see *Simiolus*, 1978-1979, p. 193).

scape and that more were soon to follow. His explanation was simple: "I have a terrible lucidity at moments these days when nature is so beautiful, I am not conscious of myself anymore, and the picture comes to me as in a dream" (letter 543).

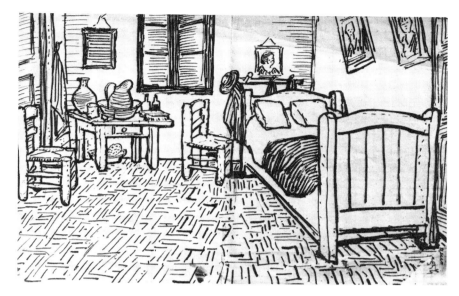

84
Sketch in letter 554 from October 1888, showing Theo what kind of painting Vincent had made of his bedroom. Vincent van Gogh Foundation/National Museum Vincent van Gogh, Amsterdam

This great speed at which he worked meant a serious drain on his finances and working materials, and it is not unexpected to read, ". . . my paints, my canvas and my purse are all completely exhausted," nor that he had come to the conclusion that henceforth he would have to to restrict himself to drawing until the new paints arrived. It is amusing to read (though far from amusing to poor Vincent himself), that while working in the public garden he found that he had run out of *green*. "The last picture of a garden, green of course, done with the last tubes of paint on the last canvas, is painted without green,[128] only a mixture of Prussian blue and chrome yellow."

In the next few weeks he continued to paint corners of the public park that faced the yellow house. In two of these park scenes a couple of lovers dominate the painting. The first of the paintings (JH 1601) is described in these words: "Now imagine an immense pine tree of greenish blue, spreading its branches horizontally over a bright green lawn, and sand splashed with light and shade. Two figures of lovers in the shade of the great tree: size 30 canvas. This very simple patch of garden is brightened by beds of orange geraniums in the distance under the black branches" (letter 552). Describing the second landscape (JH 1615), Vincent wrote: "Here is a very vague sketch of my last canvas, a row of cypresses against a pink sky with a crescent moon in pale citron yellow. A piece of waste land, sand and some thistles. Two lovers, the man in pale blue with a yellow hat, the woman with a pink bodice and a black skirt. That makes the fourth canvas of *The Poet's Garden*, which is the decoration for Gauguin's room" (letter 556).[129]

[128] Erroneously, the printed texts have "*dans vert*" instead of "*sans vert*" (in green instead of without green).
[129] For a more extensive study of the series of park scenes, see my article "The Poet's Garden" in *Vincent, Bulletin of the Rijksmuseum Vincent van Gogh*, vol. 3, nr. 1, 1974, pp. 22-32.

One landscape of a somewhat different type, painted before Gauguin's arrival, is also worth mentioning. This picture, known as *The Green Vineyard* (JH 1595), must have meant a lot to him. He mentioned it several times in the letters to his brother and his friends Bernard and Gauguin, possibly because it was the first time he ventured to paint a vineyard. It had not been as easy as the garden scenes. "Oh! my study of the vineyard, I have sweated blood over doing it, but, in any case, I have it, again a square size 30 canvas, and again meant for the decoration of the house" (letter 544). It is a remarkable painting, especially striking because of its almost abstract pattern of green, black and blue brush strokes and its dark blue sky, done in heavy impasto. It is certainly one of the most intriguing of the landscapes meant for the decoration of the yellow house.

"Oh! my study of the vineyard, I have sweated blood over doing it."

The Night and its Colors

While Vincent was still very much occupied with the idea of landscapes for Gauguin, he suddenly interrupted this work to do a completely different type of picture. His reasons for doing this are clearly and extensively described in a letter to his sister Wil. In the first part of the letter he wrote: "At present I absolutely want to paint a starry sky. It often seems to me that the night is still more richly colored than the day, having hues of the most intense violets, blues and greens." As was his habit, he immediately started to realize his artistic intention, and he was able to write to Wil a week later:

> It is already a few days since I started this letter, and now I will continue it. I was interrupted these days by my toiling on a new picture representing the outside of a café at night. On the terrace there are the tiny figures of people drinking. An enormous yellow lantern sheds its light on the terrace, the house front and the sidewalk, and even casts its brightness on the pavement of the street, which takes on a pinkish violet tone. The gable-topped fronts of the houses in a street stretching away under a blue sky spangled with stars are dark blue or violet and there is a green tree. Here you have a night picture without any black in it, done with nothing but beautiful blue and violet and green, and in these surroundings the lighted square acquires a pale sulfur and greenish yellow color. It amuses me enormously to paint the night right on the spot (letter W 7).

Once he had risked this effect, he went a step further by making the starry sky itself and its reflection in the water the subject of a new study. By the end of September he could write Theo: "Finally the starry sky, actually painted at night under a gas jet. The sky is greenish-blue, the water royal blue, the ground mauve. The town is blue and violet, the gaslight is yellow and reflections are russet-gold to greenish bronze. On the blue expanse of the sky the Great Bear sparkles green and pink, its discreet pallor contrasts with the harsh gold of the gas. Two colorful little figures of lovers in the foreground (letter 543)." It is an objective, unemotional description, and what it does not say (possibly because Vincent had hardly realized it himself) was that he had attempted an extremely daring experiment that had rarely been undertaken in the history of

painting. As he did in his *Café Terrace at Night* (JH 1580), he moved away from reality by rendering the stars—in an almost childish way—as big, aster-like flowers, although the stars of the Great Bear were carefully placed in the correct constellation (JH 1592). Remarkably enough, it was daring and naïve at the same time.

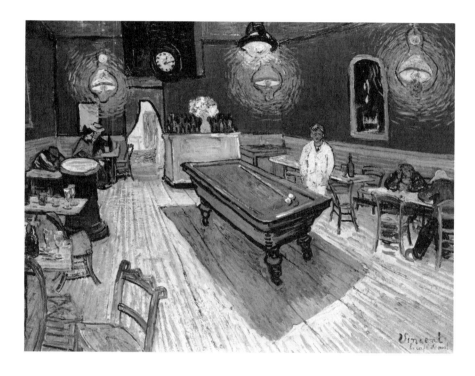

85
The Night Café, *painted in September 1888. Vincent lived at the Café de la Gare before he moved to the Yellow House. Oil on canvas, JH 1575, F 463, 70 x 89 cm. Yale University Art Gallery, New Haven, Connecticut*

Shortly before he made this *Starry Night* (JH 1592), Vincent painted a landscape which probably would have been called even more daring . . . if he had not destroyed it. He had scratched off a canvas with Christ in the garden of olives in July 1888, and a new attempt met with the same fate. "For the second time I have scraped off a study of Christ with the angel in the Garden of Olives. You see, I can see real olives here, but I cannot or rather I will no longer paint without models. But I have the thing in my head with the colors, a starry night, the figure of Christ in blue, all the strongest blues, and the angel broken citron-yellow. And every shade of violet, from blood-red purple to ashen, in the landscape" (letter 540). Less than a year later, he would address this subject again with even more impressive results.

When Vincent first announced the *Starry Night*, he also introduced a canvas with a less extraordinary character, but one that is more interesting from a biographical point of view. This is the well-known study of the yellow house (JH 1589). He was able to furnish his room and start using it as his home at last, and he wanted to share his triumphant mood with Theo, who up to now knew the house only from a very simple sketch in a letter. He enclosed a pen-drawing of the picture in his letter and promised to send a better drawing soon (letter 543), which he did, this time in watercolor (JH 1591). Here again, Vincent might be called a naïve painter, as the picture is purely illustrative and even childish in certain details (as in some of the figures and the little train with its wreath of smoke seen in the background). "[Enclosed is] a sketch of a size 30 canvas representing the house and its surroundings in sulphur-colored sunshine under a sky of pure cobalt. The subject is terribly hard! but that is just why I want to conquer it. Because it's terrific, these yellow houses in the sun, and the incomparable freshness of the blue" (letter 543). The painting of the yellow house does fulfill its anecdotal aim, and no description would have been able to leave to posterity such a lively image of the surroundings in which Vincent lived and worked for more than half a year at the zenith of his creativity.

Several pictures such as *The Viaduct* (JH 1603) and the *Trinquetaille Bridge* (JH 1604) depicting the immediate surroundings of the yellow house were done in the same few weeks of autumn. However fascinating these pictures may be, the one that has contributed more than most others to make Vincent's art popular all over the world is the painting of *Vincent's Bedroom* (JH 1608). He wrote about it to Theo in a short letter on 16 October, adding a large sketch of the new work. The often-quoted description is very precise, as usual, and contains valuable indications of Vincent's aspirations for the picture, as well. "This time it's just simply my bedroom, only here color is to do everything, giving by its simplification a grander style to things; it is to be suggestive here of *rest* or of sleep in general. In a word, the sight of the picture ought to rest the brain, or rather the imagination. The walls are pale violet. The floor is of red tiles. The wood of the bed and chairs is the yellow of fresh butter, the sheets and pillows very light greenish-citron. The coverlet scarlet. The window green. The toilet table orange, the basin blue. The doors lilac" (letter 554). Although he wrote that he wanted to continue work on the painting the next day, it must have been almost finished, as follows from the description. The next day, 17 October, in a postscript to his following letter, he was able to report, "I am adding a line to tell you that this afternoon I finished a canvas representing the bedroom" (letter 555). He also wrote extensively about the picture to Gauguin, again adding a detailed sketch (letter B 22). In this way the important work is one of the best documented of his whole production.

Few people will deny the charm of this simple, but extremely colorful canvas. Again, it is primarily an informative painting, although at the same time it was meant to be a composition of complementary colors; just like the picture of the exterior of the yellow house, it brings Vincent much closer to his audience, revealing something of the intimacy of his daily life in Arles.

86
Café Terrace at Night, *another night scene by Vincent from September 1888. Oil on canvas, JH 1580, F 467, 81 x 65.5 cm. State Museum Kröller-Müller, Otterlo, The Netherlands*

306

As there are two sketches of the bedroom, one of 16 and one of 17 October, and the finished painting, it is possible to check the changes Vincent made in what he did the first day. One of these changes is noteworthy. The first day he painted the portrait of a woman above the head of his bed; the next day he changed this to a picture of a landscape. What can the portrait of a woman, which he did not think appropriate for the final version of the painting, have meant to him? Half a year earlier he had written that the studio was in a far too conspicuous place for him to think it might tempt any woman; "a petticoat crisis," therefore, was not to be expected (letter 480). Vincent was not, however, dreaming of a female presence in his bedroom, all the same. Among the pictures he had done in his studio at the time there was only one portrait of a woman, and the composition of that piece, the position of the head and the general impression of it correspond exactly with the sketch in the letter to Theo; it was the picture of his mother, mentioned in a letter of a week earlier (JH 1600). He wrote that he was painting it after a photograph, because he was bored by the black-and-white of the photographic portrait (letter 546). For a true understanding of Vincent's personality it is interesting to know that he had hung the portrait of his mother over his bed, but also that, for a reason which can only be guessed at, he preferred to replace it by a landscape in the finished painting.

The painting of the bedroom had been inspired by a short, forced period of rest. The feverish activity of September and the first half of October had exhausted Vincent to such a degree that he informed Theo around 13 October that he had to give his eyes some rest; even writing became difficult (letter 552). In his next letter he wrote, "I have been and still am nearly half dead from the past week's work" (letter 553), but he had slept sixteen hours in a stretch, which had restored him considerably. That Vincent was "half dead" from work is far from surprising considering the substantial and incredible number of important paintings—the garden landscapes, the night scenes, the paintings of the yellow house and many others—which he completed in the Autumn of 1888.

Autumn 1888: Vincent paints at a feverish pace.

UNDER ONE ROOF WITH GAUGUIN

87
Self-portrait by Gauguin with a sketch of
Emile Bernard in a corner; received by
Vincent in the beginning of October 1888.

To Vincent, the most important event in October 1888 was the arrival of Paul Gauguin, who had finally decided to share the yellow house with him. Months of uncertainty had preceded, and it was not until 17 October that Vincent could inform Theo of the great news: that Gauguin had sent off his trunk and was going to arrive within a few days, around the 20th of the month (letter 555). In reality he arrived in Arles in the early morning of 23 August and Vincent immediately informed Theo by wire, confirming it with an extensive letter the following day. A new phase of his life had begun.

Paul Gauguin was forty when he came to Arles. He was taller and more robust than his younger friend, and he had already had many adventures behind him. For six years he had served in the navy as a sailor before he entered a stock brokerage in Paris. He did so well there that he was able to build up an extensive collection of paintings, works by Jongkind, Cézanne, Manet, Pissarro, and many others. In 1883 he gave up that career in order to devote himself exclusively to painting and sculpting. In the meantime he married a Danish woman, Mette Gad. They had five children, and as his paintings did not sell, he had to try to make a living for his family in another way. For some time he worked as an agent for a manufacturer of tarpaulins in Roubaix, living with his family in Copenhagen, but within half a year he fled the hostile circle of Mette's family and returned to Paris with his young son Paul, leaving the rest of the family behind. Gauguin's most recent adventure was a voyage to Panama and the island of Martinique in the French Antilles where he did a series of important paintings. He spent the summer of 1888 in Pont-Aven in Brittany, surrounded by a group of admiring young painters, including Charles Laval, Henri Moret and Emile Bernard. There was every reason for Vincent also to admire him; Gauguin had become a painter of importance; he had

participated in several group shows, being represented by no less than nineteen paintings in the last great impressionist exhibition in 1886, and at the end of 1887 and the beginning of 1888 some of his works had been on show in Theo van Gogh's gallery on the boulevard Montmartre. But Vincent also admired him as a human being. "He is very interesting as a man," was one of the first impressions he wrote to Theo (letter 557), and a few days later he repeated with even more stress, "Gauguin is astonishing as a man" (letter 558).

Ten or fifteen years later, Gauguin himself described his arrival in Arles when he formulated his recollections during his stay in the South Sea Islands. The fragments about the months he spent with Vincent in Arles that appear in his manuscript *Avant et après* have become quite famous and are often quoted as an addition to the little information available about the period. It is, however, a source that must be read with some reserve, because Gauguin describes events for which there were no other witnesses. It is well known from cases in which checking *was* possible that he did not always care about the exact truth. He was a stranger to objectivity; his writings are often colored by his attempts to represent himself as better or more important than he was, or to clear himself of real or imaginary accusations. The following account of his arrival in Arles, however, seems fairly accurate. He had arrived by night-train from Paris, and so he wrote:

> I arrived late at night and waited until daybreak in an all-night café. [This was certainly the Café de la Gare, owned by Ginoux.] The boss looked at me and exclaimed: "So you're his pal! I recognize you." A self-portrait that I had sent to Vincent is enough to explain the café manager's exclamation. Showing him my portrait, Vincent had explained that it showed a pal of his who would be coming shortly.
> Not too early and not too late, I went to wake Vincent. The day was spent in getting me settled in and a great deal of chatter, in strolling about so that I could admire the beauties of Arles and Arlésiennes, about whom, by the way, I could not get very enthusiastic.

Vincent had done everything to make living with his friend possible and agreeable. He had bought extra furniture for the yellow house. He had gas installed which cost him twenty-five francs, and he spent time and energy on what he called his "decoration": the paintings that were destined for Gauguin's room and the rest of the house, pictures such as the *Sunflowers* and the series *The Poet's Garden*. He had worked on these paintings with such fervor that in the middle of October he was completely exhausted, but he could proudly inform Theo that his decoration now consisted of fifteen large canvases, while he was planning to add at least another fifteen "to make a whole" (letter 553). He had also exhausted his finances, since he had spent too much money just to improve the decorations. "I was wild to see my pictures in frames, and I had ordered too many for my budget, in view of the fact that the month's rent and the charwoman also had to be paid" (letter 546). All other considerations had been set aside, and what this meant can be seen from the beginning of the same letter. "These four days I have lived mainly on twenty-three cups of coffee, with bread which I still have to pay for. . . . Do you know what I have left today for the week [it was only Monday], and that after four

days of strict fasting? Just six francs."[130] He did not make a secret of his reasons for doing all of this. "Well, yes, I am ashamed of it, but I am vain enough to want to make a certain impression on Gauguin with my work, so I cannot help wanting to do as much work as possible before he comes" (letter 544).

He felt he would not be able to escape Gauguin's influence, and though he did not object to that in itself ("his coming will alter my manner of painting and I shall gain by it, I believe"), he wanted to show what he was capable of doing himself before there could be any question of influence. In his second letter after Gauguin's arrival, he described the situation: "You will have my work, and in addition, a picture from him every month. And I shall do just as much work without having so much trouble and so many expenses. I always thought that the combination we have just made would be good policy. The house is getting on very well indeed, and is becoming not only comfortable but a real artists' house too. So have no fear for me, nor for yourself either" (letter 558).

Vincent was again experiencing a moment of reckless optimism, so characteristic of his changing moods. This time his euphoria was such that he preferred his paintings not to be sold, for with a curious twist of his mind he declared: "If you keep my pictures for yourself, either in Paris or here, I will be much happier to be able to say bluntly that you prefer to keep my work for yourself and not sell it, than that I should have to join in the scuffle for the money just now. Honestly. Besides, supposing that what I am doing is good, then we shall not lose anything in the money line, for it will mature quietly, like wine in the cellar" (letter 558).

The house becomes "a real artists' house."

Working Together Under Pressure

It is characteristic of Vincent's creative urge that on the day after Gauguin's arrival he had written, "I am in a hurry and must go out and set to work again on another size 30 canvas" (letter 557). Four days later he reported that he had done not only one, but two size 30 canvases. Gauguin had been productive too: "He is busy with a *Negress* and a large landscape of this region" (letter 558b). Thinking of Theo's new housemate Jacob Meyer de Haan and the latter's friend and pupil, J. J. Isaäcson, Vincent wrote:

What Gauguin tells us of the tropics seems marvelous to me. Surely the future of the great renaissance in painting lies there. Just ask your new Dutch friends whether they have ever thought of how interesting it would be if some Dutch painters were to found a colorist school in Java. If they heard Gauguin describe the tropical countries, it would certainly make them desire to do it directly. Not everybody is free and in circumstances that allow them to emigrate, but what things could be done there! I regret I am not ten or twenty years younger, then I would certainly go there. Now it is not very likely that I shall leave this coast, and the little yellow house here in Arles will remain an intermediate station between Africa, the Tropics, and the people of the North.

[130] Vincent must have thought this letter too embarrassing for Theo. He did not send it, but replaced it by another one, written in somewhat milder terms (letter 547).

Despite all this enthusiasm, living together started with some disappointments for both men. Although he wrote about it to Theo in mild terms, Vincent must have felt it as a heavy blow that Gauguin showed so little interest in the work with which he had expected to impress him. Six days passed after Gauguin's arrival and Vincent could still write no more than, "I do not yet know what Gauguin thinks of my decoration in general; I only know that there are already some studies which he really likes, like the sower, the sunflowers, and the bedroom." Gauguin's reservations about Vincent's work can be understood, as he saw himself in the role of master artist instructing pupil, not only toward his disciples in Pont-Aven, but also toward Vincent. In *Avant et après*, he declared in unmistakable terms:

> At the time I came to Arles, Vincent was up to his ears in the neo-impressionist school, and he was floundering a lot, which made him miserable; not that this school, like any other, was particularly bad, but it simply did not suit his impatient, independent nature. With all his yellow over purples, all this work with complementary colors, all done in a disorderly fashion, he merely succeeded in producing incomplete and monotonous, subdued harmonies. The sound of the bugle was lacking.
>
> I took it upon myself to enlighten him, an easy task for me since he was rich and fertile soil to work upon. Like all men of originality, marked with a personal stamp, Vincent was never afraid of the next man and never displayed any stubbornness. From that day on, Vincent made astonishing progress; he seemed to perceive everything that lay within him and from then on there was that series of sunflowers upon sunflowers in full sunlight.

Perhaps Gauguin really believed part of what he wrote; yet it is improbable that he would not have remembered that the *Sunflowers* had been painted *before* his arrival.

Gauguin's recollections reveal interesting details about life in the yellow house; in general outline they give a fair image of the first few weeks.

> To begin with, I was shocked by the utter disorder I found everywhere. The box of colors was hardly big enough to hold all the squeezed up tubes, never closed again, and despite all this mess, his canvases were aglow with brightness; his words also. Daudet, de Goncourt, the Bible, they all set this Dutchman's brain afire. In Arles, everything became Holland to him: the waterfront, the bridges, the boats, in fact the whole of the Midi. He even forgot how to write Dutch,[131] and as can be seen from the publication of his letters to his brother, he only wrote in French, and this admirably.... Despite all my efforts to unravel in his disorderly mind a logical reason in his critical opinions, I was not able to explain to myself all that was contradictory between his painting and his opinions. He, for instance, had an unlimited admiration for Meissonier and a deepfelt hatred for Ingres. He found Degas hopeless and Cézanne a phoney. The thought of Monticelli made him cry. What annoyed him was that he had to acknowledge in me a great intelligence, while I had a low forehead, a sign of stupidity.

[131] As Vincent's letters to his mother prove, this was completely untrue.

And amid all this a great tenderness, or rather an evangelic altruism. From the very first month I saw that our joint finances were becoming equally messy. What should I do? It was a delicate situation; the till was filled—modestly—by his brother, who worked in the Goupil firm; in my case, it was in exchange for paintings. It was necessary to talk it over, at the risk of offending his excessive susceptibility. So it was that with all kinds of precautions and a lot of coaxing, quite out of character for me, that I brought up the matter. I must admit that I succeeded much more easily than I had expected.

In the meantime it was November and autumn was progressing. Vincent started to concentrate on autumn colors, and when a week later he found time to write again (during the months with Gauguin his letters became more and more scarce), he had finished several new large landscapes. This time the inspiration was a lane at the south-easterly side of Arles, called les Alyscamps. Although the lane was known for its great number of Greco-Roman sarcophagi, he was not interested in the row of tombs, but rather with the imposing scene of heavy trees with their falling leaves. In a letter of about 10 November, he wrote to Theo: "I think you will like the falling leaves that I have done. It is some poplar trunks in lilac cut by the frame where the leaves begin. These tree trunks are lined like pillars along an avenue where there are rows of old Roman tombs of a blue lilac right and left. And the soil is covered with a thick carpet of orange and yellow leaves. And they are still falling like flakes of snow. And in the avenue, little black figures of lovers." His description stresses the composition, and rightly so; it is in fact the high vantage point from which he looked down upon the avenue, as well as the remarkable way the tree trunks cross the image, which distinguishes these two studies (JH 1620 and 1621) from everything he painted before. That he did not aim at a true representation of nature is verified by the unusual composition and his striking palette—the "lilac" tree trunks, which he painted a bright blue, were outlined in black.

The inspiration of les Alyscamps.

Paul Gauguin probably accompanied Vincent on these visits to the Alyscamps. He himself painted two studies of the subject, though they were very different and, in a way, even more "conventional." This makes it very unlikely that the composition of Vincent's first mentioned landscape should be ascribed to Gauguin's influence. The two painters soon went their own ways, but for some time they evidently liked to work on the same subjects. Gauguin amused himself by following Vincent's example in making a painting of the night-café, "but with figures seen in the brothels" (letter B 19a). This inspired Vincent to do a portrait of one of the persons in Gauguin's picture, Madame Ginoux.

Vincent and Gauguin in competition.

Gauguin's painting, which is now in the Pushkin Museum in Moscow, is indeed a remarkable counterpart to the one done by Vincent and differs from it profoundly with its quiet and dark flat colors. The main subject in the painting is Madame Ginoux, who is depicted as a large figure in the foreground, holding her head with her left hand, a siphon in front of her on the table. Gauguin had placed her in impressionistic fashion far out of the center and looking away from it.

Without disclosing the connection with this picture, which he did not even mention in his letter to Theo, Vincent wrote,

more or less triumphantly: "Then I have an Arlésienne at last, a figure (size 30) slashed on in an hour, background pale citron-yellow, the face gray, the clothes black, black, black unmixed Prussian blue. She is leaning on a green table and seated in an armchair of orange wood" (letter 559). Two portraits of Madame Ginoux are known in which the attitude of the figure and expression of the face are identical, but which differ in that there are books on the table in one (JH 1624) and gloves and a red parasol in the other (JH 1625). Both have found their way to museums of world renown: the first to the Metropolitan Museum in New York, and the other to the Louvre in Paris (now the Musée d'Orsay).

The incredibly short time in which Vincent finished the first portrait suggests that he was sitting next to Gauguin while he worked at it, either in the café itself or in the studio. The portraits of Madame Ginoux, however imposing the result, had not cost Vincent much time; his next work, on the contrary, was a complicated composition over which he must have "sweated blood"; it was the *Red Vineyard* (JH 1626). With its incredibly rich mosaic of colors, this painting is one of the most important works of this period, and Vincent himself liked it so much that he referred to it in several of his letters. He said for instance, "It seems to me that you might put this canvas beside some of Monticelli's landscapes" (letter 561). Again, Vincent and Gauguin had been inspired by the same subject. They had visited this Montmajour vineyard together in the beginning of November, but Gauguin, who according to Vincent had also been working on "women in a vineyard" around 11 November, was doing this "completely by heart" (letter 559), and had tried from the beginning to induce Vincent to follow his example. Curiously enough, his advice met with some success, although Vincent always argued that he saw as his artistic task the study of nature and the rendering of reality.

In a letter of a few weeks later he said, "Gauguin gives me the courage to work from imagination, and certainly things done from imagination take on a more mysterious character" (letter 562). To Wil he wrote, "He strongly encourages me to work often from pure imagination" (letter W 9). Even more explicitly, he wrote in November: "Gauguin, in spite of himself and in spite of me, has more or less proved to me that it is time I was varying my work a little. I am beginning to compose from memory, and all my studies will still be useful for that kind of work, recalling to me things I have seen" (letter 563).

For the time being, Vincent did not consider the pressure Gauguin was exercising upon him to be unwelcome, and continued to write about him admiringly. He wrote to Theo: "He is very interesting as a friend. I must tell you that he knows how to cook *perfectly*; I think I shall learn it from him, it is very convenient" (letter 561). Around the middle of November he wrote, "He is a very great artist and a very excellent friend" (letter 562); then around 25 November, "You cannot imagine how much it pleases me that you have painters staying with you, and that you are not living all alone in the apartment, just as it pleases me very much to have such good company as Gauguin's" (letter 558a); and a few days later, "It does me a tremendous amount of good to have such intelligent company as Gauguin's and to see him work" (letter 563)

Gauguin advises "working from imagination."

The force of Gauguin's influence is apparent when one realizes that, apart from a garden scene, Vincent painted only one landscape in the second half of November, and thereafter not a single one for months. Even this one landscape probably owed as much to the imagination as to nature. He announced it in a letter of about 21 November, and so there was a gap of approximately ten days between the *Red Vineyard* and this lone landscape. "This is a sketch of the latest canvas I am working on, another *Sower*. A citron-yellow disk for the sun. A green-yellow sky with pink clouds. The field violet, the sower and the tree Prussian blue. A size 30 canvas" (letter 558a). Even without the sketch it would not be difficult to recognize from this brief description the imposing *Sower with Setting Sun* of the Bührle collection in Zürich (JH 1627), of which there is a small replica in the Amsterdam Van Gogh museum. The sketch with its forceful ink lines is sufficient to indicate how completely new and daring the composition is: the almost black half figure of the sower in the left foreground, the threatening dark tree obliquely crossing the image, cut at the top and at the bottom by the frame, and the huge, unrealistic yellow sun forming an enormous halo behind the head of the sower. One wonders whether this could have been painted in the open; the perspective is as unreal as the colors of the field and the sky. It reminds one of a Japanese woodcut with its simple juxtaposition of flat patches of color. The effect is original and striking.

The results of Gauguin's suggestions were soon visible. The first two paintings Vincent made after the *Sower* were entirely "works of the imagination." One was a picture with three women in a garden (JH 1630), and the other a portrait of a woman in the costume of the Arles region who is shown reading in a room with books (JH 1632). He wrote about these pictures in two simultaneous letters of about the middle of November, one to Theo, the other to Wil. Curiously enough, it was only to Wil that he wrote extensively about these two recent canvases and their meanings; what he wrote about the picture of the women in the garden is particularly interesting.

Memory of the Garden at Etten: "Let us suppose that the two ladies out for a walk are you and our mother."

I have already told you that I did not like Mother's photograph. I have just finished painting, to put in my bedroom, a *Memory of the Garden at Etten*; here is a scratch of it. It is a rather large canvas. . . .

I know this is hardly what one might call a likeness, but for me it renders the poetic character and the style of the garden as I feel it. So, let us suppose that the two ladies out for a walk are you and our mother; let us even suppose that there is not the least vulgar or stupid resemblance—yet the deliberate choice of color, the somber violet with the blotch of citron yellow of the dahlias, suggests Mother's personality to me. The figure in the Scotch plaid with orange and green checks standing out against the somber green of the cypress, this contrast further accentuated by the red parasol—this gives me an idea of you, vaguely like a figure in Dickens's novels.[132]

I don't know whether you can understand that one can make a poem only by arranging colors, in the same way that one can say

[132] The last part of this sentence in the original and translated editions of the letters is slightly erroneous because of a mistake in the transcription; the manuscript has: "*me donne une idée de toi, vaguement une figure comme celles des romans de Dickens.*"

comforting things in music. In a similar manner the bizarre lines, purposely selected and multiplied, meandering all through the picture, may fail to give the garden a vulgar resemblance, but may present it to our minds as seen in a dream, depicting its character, and at the same time stranger than it is in reality (letter W 9).

What words cannot express is that through the incredible richness of color, this painting became one of the most "poetic" works Vincent ever produced. With a curious return to a sort of pointillistic technique, he had lent its colors a brilliance that had been missing for a long time. It is amazing that he could create a composition in 1888 that anticipated to such an extent a style that now is associated with terms like "art nouveau" and "Jugendstil."

Again, there is parallel between Vincent's work and Gauguin's. A picture of Gauguin's, called *Women of Arles*, very much resembles Vincent's *Memory of the Garden at Etten* and was painted at approximately the same time. It also shows two women in the left foreground, walking in a garden with a winding path, seen from a high vantage point so that the sky is not visible. The two painters must have worked at this subject in a sort of artistic competition. Mark Roskill, who studied the mutual influences of the two friends, wrote, "This canvas of Gauguin's may in fact have been painted either at exactly the same time as the Van Gogh or just a little later."[133] There can be no question that the original inspiration for the picture came from Vincent, for how could he have copied—with some alterations—a garden landscape by Gauguin and then write to his sister that he had painted a "memory of the garden at Etten" to hang in his bedroom? With his stiff and over-stylized painting and flat colors, Gauguin certainly did not surpass the striking composition and gem-like colors of his "pupil."

Gauguin's counterpart.

Regarding living arrangements, there were still no serious problems in November, nor even in the first half of December. Gauguin contributed to the common living expenses, and he even bought a chest of drawers and some linen for about a hundred francs, a sum that, according to Vincent, would be refunded the following year (letter 559). In the beginning of November, Theo wrote that he had sold two landscapes by Gauguin and that he could also sell a painting representing three dancing Breton girls on the condition that Gauguin change the hand of one of the children (letter T 3a). Theo sent the canvas to Arles, and Gauguin, who did not display any artistic pride, immediately did what was requested.

In the beginning of December Emile Bernard sent a marine painting in exchange for the canvases from Vincent. Charles Laval sent his self-portrait, which Vincent admired enormously and considered an important contribution to the series of self-portraits of artists he had assembled. It was probably after the receipt of this portrait that Vincent started to make a self-portrait for Laval (JH 1634, annotated *à l'ami Laval*). This in its turn may have caused Gauguin to paint a portrait of Vincent, who had initiated the exchange of portraits. Vincent mentioned Gauguin's portrait to Theo in a few unenthusiastic words: "He is working on a portrait of me which I do not count among his useless undertakings" (*que je ne compte pas dans ses*

Charles Laval, 1862-1894.

[133] *Van Gogh, Gauguin and the Impressionist Circle* (1970), p. 146.

316

entreprises sans issues) (letter 560). If what Gauguin said in his reminiscences is true, Vincent's caution is understandable. In *Avant et après*, Gauguin wrote, "I had the idea of making a portrait of him, showing him while painting the still life which he loved so much—sunflowers. And when the portrait was finished, he said to me, 'It is is certainly me, but me gone mad.' " Almost a year later Vincent returned to the subject of this portrait in a letter to Theo. "Have you seen that portrait that he did of me, painting some sunflowers? Afterward my face got much brighter, but it was really me, very tired and charged with electricity as I was then" (letter 605).

The letter in which Vincent first mentioned the portrait describes, "Our days pass in working, working all the time; in the evening we are dead beat and go off to the café, and after that, early to bed!" (letter 560). There was so much work to do, Vincent wrote, more than they could manage. It was in the early days of December, during which outwardly nothing pointed to discordance between the two men, that Vincent painted the canvas which later would set pens in motion: the picture of Gauguin's chair (JH 1636). Vincent himself contributed to the belief that the picture was connected with Gauguin's departure by what he wrote to the critic Albert Aurier—though it was one and one half years later: "A few days before we parted company, when my disease forced me to go into a lunatic asylum, I tried to paint 'his empty seat.' It is a study of his armchair of somber reddish brown wood, the seat of greenish straw, and in the absent one's place a lighted candle and modern novels" (letter 626a). Whatever unconscious symbolism psychoanalysts may attribute to the painting, it is of decisive importance that it is one of a pair; it is the counterpart of the canvas of Vincent's own rush chair (JH 1635). His first mention of it in a letter to Theo leaves no doubt that the two pictures were painted at the same time. "Meanwhile I can at all events tell you that the last two studies are odd enough. Size 30 canvases: a wooden rush-bottomed chair all yellow on red tiles against a wall (daytime). Then Gauguin's armchair, red and green night effect, walls and floor red and green again, on the seat two novels and a candle" (letter 563).

Gauguin's empty chair has often been connected with an engraving by Luke Fildes, titled *The Empty Chair* (a reference to the death of Charles Dickens), from the Christmas issue of *The Graphic*, 1870. It was an illustration that Vincent knew well and had mentioned in a letter to Theo much earlier (letter 352). Yet it is doubtful that he had thought of this print while working on the painting. Fildes's empty chair was the allegorical indication of someone's death, and when Vincent did this painting, the thought of Gauguin's death did not occur to him; the burning candle points to the contrary. Furthermore, if the picture had anything to do with the feared departure of Gauguin, it would be difficult to explain why Vincent also depicted his *own* chair—maybe even *first*, if any importance can be attached to the order in which he announced his latest pictures. Although he was to leave the yellow house himself a short time later, there cannot have been the slightest suspicion in his mind at the time that Gauguin would leave.

Whether or not there is a deeper symbolism in details like the pipe and tobacco pouch in one and the books and burning candle in the other, to Vincent the pictures had a very definite

The two empty chairs.

317

and simple meaning. To him they were studies for a daylight-effect and an evening-effect. He was very proud of the gaslight he had had installed to make the house more comfortable and more practical, as it enabled the artists to work during the evenings (and to read the modern novels lying on Gauguin's chair). As he was accustomed to depicting in pictures all the "conquests" he had made, it is not surprising that he also wanted to show the important gaslight. The two paintings also demonstrate his favorite contrasts of complementary colors: blue-yellow in the daylight painting, green-red in the other.

Finally, and most importantly, the pictures are metamorphic portraits of the inhabitants of the two rooms: the somewhat clumsy but solid and honest rush-bottomed chair was more than Vincent's chair, it was Vincent himself; the more luxurious and elegant armchair with its rounded lines was Gauguin, for whom Vincent had chosen the prettier room upstairs and had tried to make it "like the artistic boudoir of a woman" (letter 534). The paintings were indeed "odd," as Vincent had written, for who had ever tried to characterize people by depicting their chairs?

Opinions about these two pictures may differ, but one thing is certain: they were not done "by heart" or from the imagination as Gauguin had suggested. Vincent evidently concluded that painting from memory was much too foreign for him. He was so strongly convinced of it that he declared the picture of the garden with his mother and sister a failure, explaining that to be successful in works from the imagination one had to be in the habit of doing them. When he wrote this around the first week of December, he had already turned away from this method and had gone back to what he enjoyed most: "I have made portraits of *a whole family*, that of the postman whose head I had done previously—the man, his wife, the baby, the little boy, and the son of sixteen, all characters and very French, though they look like Russians" (letter 560).

It may seem astonishing that Vincent, who complained about the difficulty of getting models, had been able to make so many portraits. Stressing how comfortable he felt when making portraits, he declared, "I hope to get on with this and to get more careful posing, paid for by portraits" (letter 560). This explains why for almost all the members of the Roulin family there are at least two portraits—one was for Vincent and one was for the subject. There is a remarkable difference in quality between these works. Some are admirably done, like the two strikingly different portraits of the sixteen-year-old Armand (JH 1642 and 1643), but most are quite sketchy, and there are a few, such as the portraits of Mother Roulin with the baby (JH 1637 and 1638), that are more like rough sketches than finished paintings. The cause is not difficult to guess: Vincent's haste, and in some cases his stubborn, defiant haste. "You will lose nothing by waiting a little for my work, and we will calmly leave our dear comrades to despise my present canvases. Fortunately for me, I know better what I want than they do, and basically I am utterly indifferent to the criticism that I work too hurriedly" (letter 563). One painting was certainly not done quickly, the portrait of Roulin's wife that became famous under the title *La Berceuse* (JH 1655). Vincent mentioned it for the first time in a letter from January 1889, because fate would prevent him from finishing it completely in December 1888.

Turning back to making realistic portraits.

318

THE HOUSE OF CARDS COLLAPSES

88
Self-Portrait with Bandaged Ear,
January 1889.
Oil on canvas, JH 1658, F 529, 51 x 45 cm.
Private Collection

The work Gauguin produced in Arles must have given him great satisfaction. If one counts only the paintings he did in the last eight weeks of 1888 that are mentioned in his own letters or in those written by Vincent, there are at least sixteen works. This shows that he had not been idle, even if the number remains far below the more than thirty works made by Vincent during the same period. He had become, however, more and more tired of Arles and of life with Vincent. This is shown by at least four letters, two of his own and two of Vincent's. All four are of extreme importance to understanding the development of the situation. The first is a short note that Gauguin wrote to Theo.[134]

> Dear Mr. Van Gogh, I would appreciate it if you would send me part of the money for the canvases you have sold. Everything considered, I am obliged to return to Paris; Vincent and I simply cannot live together without trouble, due to the incompatibility of our characters, and we both need tranquility for our work. He is a man of remarkable intelligence whom I esteem very highly and whom I leave with regret, but I repeat, it is necessary. I much appreciate the

[134] The letter is dated "circa 12 December" in Douglas Cooper's edition.

thoughtfulness of your conduct with regard to me, and I hope you will excuse my decision.

He expressed the same feelings in letters to his friends Schuffenecker and Bernard. He had asked Schuffenecker to put him up when he returned to Paris, but the exact date of this request is not known. In his letter to Bernard he wrote: "In Arles, I feel completely disoriented, that's how small and petty I find everything, the landscape and the people. Generally speaking, there is not much we agree upon, especially in painting. He admires Daumier, Daubigny, Ziem, and the great Rousseau, all people whom I cannot tolerate. On the other hand he hates Ingres, Raphael, Degas, all of whom I admire. Merely to keep peace, I keep answering, 'Corporal, you are right.' He likes my paintings very much, but when I am working on them, he always finds something to criticize."[135]

Vincent himself wrote about vehement discussions for the first time in his long letter 564 (undoubtedly from late in December, but hard to date precisely). Even here the suggestion of tension is restricted to a single sentence: "Our discussions are *excessively electric*, sometimes we emerge from it with our heads as tired as a battery after the discharge."

"Our discussions are excessively electric, *sometimes we emerge from it with our heads as tired as a battery after the discharge."*

Vincent's other letter to Theo about the problems is much more important, but at the same time more enigmatic. This is the short letter in its entirety:

My dear Theo, Thank you very much for your letter, for the hundred-franc note enclosed and also for the fifty-franc money order. I think myself that Gauguin was a little out of sorts with the good town of Arles, the little yellow house where we work, and especially with me. As a matter of fact, there still would have been grave difficulties to overcome, for him as well as for me. But these difficulties are more within ourselves than outside. All in all, I think that either he will definitely go, or else definitely stay. I told him to think it over and make his calculations all over again before doing anything. Gauguin is very powerful, he is strongly creative, but just because of that he must have peace. Will he find it anywhere else if he does not find it here? I am waiting for him to make a decision with absolute serenity. A good handshake, Vincent (letter 565).

Vincent knew Gauguin was not happy in Arles and that he might leave, but he felt a change for the better was possible. The two men made an excursion together to the museum in Montpellier, and Vincent was especially impressed by the trip because he had not had a recent opportunity to see good paintings. He wrote almost exclusively about the works of art they had seen, but did not reveal anything about his companion's mood. Jo van Gogh-Bonger suggested 23 December as the date for letter 565 in her edition of the letters. 23 December was the day on which the tensions between the two men led to a dramatic climax, but the content of the letter does not seem to predict such a vehement explosion. Yet, for lack of more concrete indications, that date has been maintained in all articles and books on Van Gogh since the appearance of the 1914 edition. Professor Ronald Pickvance was the first author who suggested changing this date. In his exposition catalogue

[135] Maurice Malingue, *Lettres de Gauguin* (1946), nr. LXXVII.

of 1984, *Van Gogh in Arles,* he dated letter 565 "about 16 or 17 December," and placed it *before* letter 564. In this way it could be explained why the uncertainty which letter 565 displays is not found in letter 564.

89
Letter written by Joseph Roulin to Theo van Gogh to keep him informed about Vincent's condition.

Nevertheless, the order of the printed editions is preferable. Jo van Gogh-Bonger may have had a good reason for her date, for during those very days she was in Theo's company in Paris and must have followed the dramatic events. Apart from that, the unusual brevity of letter 565 is in itself a sign that something was wrong. Almost every sentence of the note betrays great tension, and instead of assigning it to an earlier date, the stress and uncertainty of which the note speaks may be ascribed to renewed and increased difficulties. In neither the letter in which Gauguin mentions the trip to Montpellier (GAC 12) nor in Vincent's report about the visit to the museum can one discern anything of a real "reconciliation"; on the contrary, it is precisely in letter 564 that Vincent mentioned the fact that their discussions were "excessively electric."

It will probably never be known exactly what happened between Vincent and Gauguin in the week following the trip to Montpellier, but there is an objective piece of information about

the catastrophe that took place at the end of that week. A weekly newspaper, *Le Forum Républicain*, contained a notice under the heading *Chronique Locale* on 30 December 1888, referring to an event that occurred on the previous Sunday, 23 December:

> Last Sunday night, at half past eleven, a certain Vincent Vangogh, painter, native of Holland, appeared at the *maison de tolérance* No. 1, asked for a girl called Rachel, and handed her . . . his ear, saying, "Keep this object carefully." Then he disappeared. The police, informed of these facts which could only be attributed to a poor madman, looked the next morning for this individual, whom they found in his bed, barely showing a sign of life. The unfortunate man was urgently admitted to the hospital.[136]

Vincent himself kept silent about the dramatic events of 23 December. He probably could not remember anything about them as a result of the mental shock he had experienced, and probably also because drinking had caused him to black out. Everything that is known about the events has come from Gauguin. For more than half a century, posterity had no available source other than the recollections Gauguin had written fifteen years after the event in *Avant et après*. These are the main passages from his recollections of the fatal day, recollections which, as we shall see, should be read with much reserve.

Gauguin's account of the events of 23 December 1888.

> My God, what a day! When evening came I ate a scant dinner and felt the need to go out alone for a stroll amid the scent of blossoming laurel. I had got almost to the other side of the Place Victor-Hugo when I heard a well-known little step behind me, quick and jerky. I turned around just as Vincent rushed at me with a razor in his hand. The look in my eyes at that moment must have been very powerful, for he stopped, lowered his head and ran back toward the house.
> Was I cowardly at that time? Ought I to have disarmed him and tried to calm him down? I have often questioned my conscience on this score but have nothing to reproach myself with. Let him who will cast stones at me.
> I went straight to a good hotel in Arles and, after inquiring what time it was, took a room and went to bed. I was so upset that I was unable to fall asleep until nearly three in the morning and woke up rather late, about half past seven.
> Reaching the square, I saw that a large crowd had gathered. Near our house were some gendarmes, and a little man in a bowler hat who was the chief of police.
> This is what had happened: Van Gogh went back to the house and immediately cut off his ear, very close to the head. It must have taken him time to staunch the flow of blood, for the next day a number of wet towels lay on the stone floor of the two ground-floor rooms. The blood had soiled both rooms and the little stairway which led up to our bedroom.

Gauguin then described how he was interrogated by the police and ended his account of the episode with these words:

[136] This document was first published by Henri Perruchot in his book *La vie de Van Gogh* (1955), p. 360.

In a near-whisper I said to the chief of police, "Sir, kindly wake this man up as carefully as possible, and if he asks for me, tell him I've left for Paris; the sight of me could be fatal to him." I must say that from that moment on, the chief of police was as polite as could be and wise enough to send for a doctor and a carriage.

As soon as he was awake, Vincent inquired after his comrade, asked for his pipe and tobacco, and even thought of asking for the box that was downstairs and contained our money. Doubtless, he suspected me—I who was already armed against all suffering! Vincent was taken to the hospital and there his mind immediately began to wander again.[137]

The most important detail of this account is the information that Vincent had intended to attack Gauguin with a razor. This is quite doubtful, however, since a much earlier account of what had happened, also by Gauguin, was made known in 1956 when John Rewald's *Post-Impressionism* was first published. In this book, Rewald cited an unpublished letter written by Emile Bernard to the art-critic Albert Aurier on 1 January 1889. Four days after Gauguin had returned to Paris, Bernard had looked him up to inquire about Vincent's condition in the hospital in Arles. With Gauguin's report fresh in his mind, he wrote to Aurier:

I am so sad that I need somebody who will listen to me and who can understand me. My best friend, my dear Vincent, is mad. Since I have found out, I am almost mad myself. . . . I rushed to see Gauguin who told me this: "The day before I left [Arles], Vincent ran after me—it was at night—and I turned around, for Vincent had been behaving strangely for some time and I was on my guard. He then said to me, 'You are taciturn, but I shall be likewise.' I went to sleep in a hotel and when I returned the entire population of Arles was in front of our house. It was then that the gendarmes arrested me, for the house was full of blood. This is what had happened: Vincent had gone back after I left, had taken a razor and had cut off his ear. He had then covered his head with a large beret and had gone to a brothel to give his ear to one of the inmates, telling her, 'Verily I say unto you, you will remember me.' "

As John Rewald states, the remarkable difference between the version of the incident reported in Gauguin's *Avant et après* and the version which he told Bernard almost immediately after the event, was that "in Bernard's report there is *no* mention of Van Gogh having tried to throw himself upon Gauguin with an open razor in his hand." According to the report Gauguin made to Bernard, Vincent had taken up the razor *after* returning to the house, in order to mutilate himself. And John Rewald concluded, "It may well be that Gauguin, writing his memoirs in 1903 (at a time when strange details of this incident had already been widely reported), chose to emphasize Van Gogh's aggressiveness so as to better justify his having abandoned a friend in a moment of crisis."[138]

Discrepancies in Gauguin's accounts.

[137] From Daniel Guérin's *The Writings of a Savage—Paul Gauguin* (1978), pp. 254-56.

[138] *Post-Impressionism* (1976), pp. 245-46. Bernard's unpublished letter was made available to John Rewald by Jacques Williame Chateauroux, a nephew of Aurier.

Although these new facts may change one's view of the situation, the sad reality remains that Vincent, in a moment of extreme excitement—and perhaps drunkenness—had acted in a manner which gave him the reputation of being a madman, not only in the *Forum Républicain* and with his friends Bernard and Gauguin, but for his whole future as an artist.

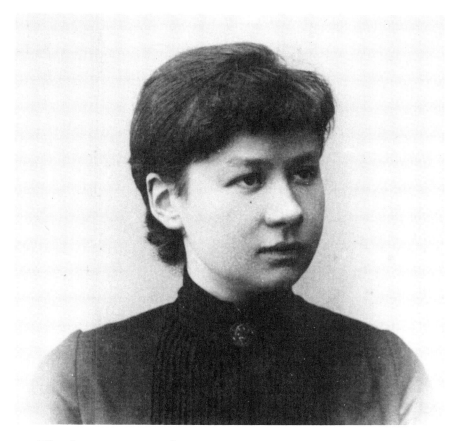

90
Johanna Bonger at the time of her engagement to Theo van Gogh.

Theo's response to the emotional months Vincent spent with Paul Gauguin can be found in some of his letters to Vincent beginning in October 1888. These letters have survived and were incorporated in the different editions of the *Complete Letters* since 1953. Passages of his unpublished letters to his mother and his sisters Lies and Willemien help to complete the picture. As mentioned earlier, in October 1888 Theo had been joined by a new roommate, Meyer de Haan. In his letter to Wil of December 1888 he called De Haan "a great painter," and he said of Isaäcson: " 'He doesn't have a penny and his life is therefore far from easy. I don't know how he would be able to make ends meet if he didn't have that good fellow De Haan. He is very busy painting portraits, especially in order to make some money for models. As far as their brains are concerned, both are very clever people, and therefore interesting company. As De Haan is physically weak, he stays at home most of the time, with the result that we get more people to come and have quite a pleasant life.' "

He wrote to Vincent about his roommate in equally friendly terms. "De Haan is coming this week, and he will stay with me for some time, which is very pleasant for me, for he will probably become the central figure of a group of young people here after a while" (letter T 2), and about De Haan's friend: "I haven't seen anything of Isaäcson's yet except his sketches, which are very well done and highly original" (letter T 1). Theo praised their "singular clarity of mind" and said that Isaäcson gave him the impression of being "a true scholar."

325

His letters show great concern for Vincent's health and financial problems. When Vincent had written that he was in danger of becoming insane (in letter 556 where he compared himself with the mad painter Hugo van der Goes), Theo immediately replied: "It was very distressing to me to learn that you are not feeling well. I suppose that you have worked too hard, and consequently have forgotten to take proper care of your body. I am glad that your letter arrived today, for otherwise I would have gone off to Brussels, in which case you would have had to wait at least two more days. What a financier you are! What causes me so much grief is that all this makes you so miserably hard up, because you cannot refrain from doing all kinds of things for others. I should greatly like to see you more egotistic, at least until your budget balances better" (letter T 2).

Vincent had asked him several times if he could sell something to a dealer named Georges Thomas (letters 547 and 556). Theo tried to do so, but was obliged to write: "You will understand that Thomas has given me the cold shoulder; you should have approached him yourself, and even then! Well, let's try to manage all the same; the others will come to us of their own accord" (letter T 2). When he had been able to sell a large painting by Gauguin, *Women of Brittany*, Theo sent 500 francs for it. This, however, made Vincent even more aware of the burden his unsold works must have been to Theo, and in his answer he once again agonized over the problem. "I myself realize the necessity of producing even to the extent of being mentally crushed and physically drained by it, just because after all I have no other means of ever getting back what we have spent. I cannot help it that my pictures do not sell. Nevertheless the time will come when people will see that they are worth more than the price of the paint and of my own living, very meager after all, that we put into them" (letter 557). Theo rarely gave a more convincing proof of his magnanimity and love for his brother than by settling this question "once and for all" in the reply he immediately sent:

Theo's magnanimity.

> I see from your letter that you are unwell, and that you are worrying a good deal. I want to tell you something once and for all. I look upon it as though the question of money and the sale of pictures and the whole financial side did not exist, or rather exists as a disease.
> As it is certain that the money question will not disappear before a formidable revolution or probably a series of revolutions has come about, it is necessary to treat it like small pox if one has caught it. That is to say, take the required precautions against accidents which may result, but don't bother your head about it. . . . You speak of money which you owe me, and which you want to give back to me. I won't hear of it. The condition I want you to arrive at is that you should never have any worries (letter T 3).

An important passage in this letter frankly proves how much Vincent's magnetic personality had meant to him in the past and even more in the future: "What you can do for me if you want to is to go on as in the past, and create an entourage of artists and friends for us, something which I am absolutely incapable of doing by my own self, and which *you* have been able to create more or less ever since you came to France."

326

Vincent replied that he had been living in a dreadful anxiety (*une atroce inquiétude*), fearing that he was forcing Theo to make an effort beyond his strength. He declared that he did not think he was ill, but might have fallen ill if his expenditure should have continued. He hoped now to breathe easily again since they would all profit from the sale of Gauguin's painting.

It is no wonder that Theo had a high opinion of Gauguin's talent as the sale of some of his pottery and of the picture of the *Women of Brittany* had proven that at least for *his* work, buyers could sometimes be found. That his admiration for Gauguin was great can best be shown by a letter he wrote to Wil on 6 December; in letters to Vincent he understandably avoided the subject. An interesting detail in the letter to Wil is that Gauguin had sent Theo some twenty pictures for the Goupil gallery, and other sources show that Theo had indeed exhibited them on boulevard Montmartre. "Do you remember the picture by Gauguin with the negresses that is hanging above the sofa? He has recently sent me for the gallery about twenty paintings which he had made in Brittany last year. If you can call the picture to mind you know what a strange poetry there is in it. Well, in the new pictures there is the same feeling, but as the subjects are more familiar, one can understand them more easily, and they are, if not more beautiful, in any case more enjoyable from the first moment."

Theo even compared him to Millet and Monet. "It is nature itself that speaks through his work, while with Monet one hears the maker of the paintings. Degas is enormously fond of Gauguin's work. So much so that he would like to go and visit him in Arles. '*Sont-ils heureux!*' [aren't they happy], he says, talking of Vincent and Gauguin, 'that is living.' I don't have to tell you what this means when it is said by the great Degas, who himself understands so well life in all its fullness." There is no doubt that Theo loved his brother dearly and did for him what he could, but even at the end of 1888, he was not yet as sure of his talent as of Gauguin's.

This was also demonstrated in a curious way by an incident between the two brothers. While Vincent had advised him to let his paintings "mature" a bit, Theo evidently decided that it was time to do something with them. He may have felt guilty exhibiting numerous paintings by Gauguin and none by Vincent. One might have expected that Vincent would be pleasantly surprised with Theo's very modest proposal to exhibit *one* of his paintings, but that was definitely not the case. He reacted in his usual, voluble, but decisive manner. "I am writing to reply to what you said about having a little canvas of mine of a pink peach tree framed, I think to place it with *ces messieurs* [Boussod and Valadon]. I don't want to leave any doubt as to what I think of that. First, if it is your wish to show there something of mine, good or bad, upon my honor, if it can in any way give you any pleasure now or later, you have absolute carte blanche. But if it is either to please me, or *for my own advantage*, then on the contrary I am of the opinion that it is absolutely unnecessary" (letter 563).

Vincent preferred that Theo return the canvases for which he had no room in his apartment. He also felt they might be useful when working from imagination, but primarily it was a question of pride.

Theo's high opinion of Gauguin.

You are with the Goupils, but I most certainly am not; after having worked with them for *six years*, we were mutually absolutely dissatisfied, they with me, and I with them. It's an old story, but all the same, that's how things were. So go your own way, but as a matter of business I think it is incompatible with my previous conduct to come back to them with a canvas as innocent as this little peach tree or something similar. *No*. If in a year or two I have enough for an exhibition of my own, say of thirty size 30 canvases or so, and if I said to them, "Will you do this exhibition for me?" Boussod would certainly send me about my business. As I know them, alas, rather too well, I think I shall not apply to them.

Of one thing Vincent was sure: "I don't want Boussod to ever have a chance to say: That little canvas isn't too bad for a young beginner" (letter 563). And so he quietly ended the discussion a few days later, saying: "Let's quietly postpone exhibiting until I have some thirty size 30 canvases. Then we are going to exhibit them in your apartment for our friends, and even then without exercising any pressure. And let's not do anything else" (letter 558a). It was another of his idealistic dreams, to which, as so often, he would never return.

As far as Theo was concerned, an event in December 1888 gave his life an important turn. In 1886 and 1887 he had planned to become engaged to Jo Bonger, as he had told his sister Lies. He had not had a chance yet, and in the last few months the possibility of marriage seemed even more remote since—for reasons unknown—there had been a falling out between him and his friend, André Bonger, who had married Anne van der Linden in April 1888. By the end of December, completely unexpectedly, everything turned for the best. It is characteristic that it was not shy Theo who took the first step, but energetic Jo Bonger. Theo's mother was the first to hear about the great news. On 21 December 1888 he gave her the following naïve report:

Theo's engagement to Jo Bonger.

> My dearest little mother, I recently wrote you, when I had met my friend De Haan, that I sometimes had the feeling as if something was being sent to me, but now it is something even more important. Imagine a few days ago I met Jo Bonger here; what was I to do? We stopped to talk to each other and she asked me if she might have a word with me. First she wanted to know if I thought that it was her fault that I was no longer on good terms with André. From one thing came the other, and gradually we became so familiar that I thought there would be no harm in looking upon her as my friend, and so she and her brother and I became good friends again. But, Mother, that was not possible, I loved her too much, and now, after we had seen much of each other the last few days, she has told me that she loves me too and that she wants to have me just as I am. In a way I am afraid that she is mistaken about me and that I will disappoint her, but oh! I am so happy, and I'll gladly try to understand her and make her happy, if I can . . . admit I do believe that she knew beforehand that I still loved her. And now, my dearest Mother, I must ask you to give her your loving Mother's heart too, and to help us both with your experience and your advice to become good people as is our duty. She can learn a lot from you and wants to, and from the bottom of our hearts we both wish to do what is good. It is impossible for me to leave here, otherwise I would have come with her to you and her

parents. Now I have to rely on a letter, but I hope to come to Holland the first days of January. I have written to her parents today too, and she encloses a word for you here.

His sister Lies, who no longer lived with her mother, received a separate letter, dated the day before Christmas. It gives an even better insight into the course of events:

Dearest Lies, You are one of the first whom I want to tell a very great piece of news which will cause a great change in my life and which makes me incredibly happy. The question is that I am engaged to Jo Bonger. When I write this down so simply, I still cannot imagine that it is true, such a short time after I had exclusively in my mind that it would be forever impossible. I can't tell you precisely how it came about as I really don't know myself anymore. She has been staying with her brother for the last four weeks and was on the point of leaving when I met her. We started to see more of each other, and I soon came to the conclusion that I loved her just as much as before.

He ended by saying that Jo was going to Amsterdam soon and that he also expected to go there in the first days of January to make the engagement public. This plan was indeed effectuated, albeit with a delay of a few days, but little did Theo suspect that on the same day he had written this to Lies, fate had a shock in store for him more terrible than he had ever experienced.

Exactly how and when Theo received the announcement of Vincent's self-inflicted wound is only known from Jo van Gogh-Bonger's *Memoir* to the *Complete Letters*. Although her report of the events was written much later, in 1913, it is of eminent importance, as she could consult authentic documents such as letters written to her by Theo, who went to Arles immediately after the drama and must have heard the details from the people in the hospital and from Gauguin. It is regrettable that she included in her report only a few short passages from Theo's letter, but they give at least some insight into events about which hardly any other sources are available. This is her summary of the dramatic happening:

Jo Bonger learns of the dramatic event in Arles.

The day before Christmas—Theo and I had just become engaged and intended to go to Holland together (I was staying in Paris with my brother A. Bonger, a friend of Theo's and Vincent's)—a telegram arrived from Gauguin which called Theo to Arles. On the evening of 23 December, Vincent had in a state of violent excitement, *un accès de fièvre chaude*,[139] cut off a piece of his ear and brought it as a gift to a woman in a brothel. A big tumult ensued. Roulin the postman had seen Vincent home[140]; the police had intervened, had found Vincent bleeding and unconscious in bed, and sent him to the hospital. There Theo found him in a severe crisis and stayed with him during the Christmas days. The doctor considered his condition very serious.

[139]"High fever combined with delirium"; this was probably the term used in the telegram.
[140] John Rewald was certainly right in doubting that Roulin would have seen Vincent home. How could he have left Vincent without calling a doctor? See *Post-Impressionism* (1978), note 47 of Chapter 5.

Jo also quoted from one of Theo's letters: " 'There were moments while I was with him when he was well; but very soon after he fell back into his worries about philosophy and theology. It was painfully sad to witness, for at times all his suffering overwhelmed him and he tried to weep but he could not; poor fighter and poor, poor sufferer; for the moment nobody can do anything to relieve his sorrow, and yet he feels deeply and strongly. If he might have found somebody to whom he could have disclosed his heart, it would perhaps never have gone thus far.' " Apart from the tragic character of the incident in itself (it was the first time that Vincent's latent mental illness had displayed itself in such a vehement form), to Theo it came at an extremely inconvenient moment. He must have left for Arles immediately—which means by the night train of 24 December—and therefore arrived on the morning of Christmas day.

Gauguin had already precipitately gone back to Paris on the 24th. This follows from his own recollections and also from Bernard's letter to Aurier. According to this letter, Gauguin had told Bernard that the incident had taken place "the day before I left"; in other words, he left on 24 December. Theo only stayed in Arles on the 25th (and not, as Jo van Gogh has written, "during the Christmas days"). He must have decided that there was nothing he could do. Before he returned to Paris, he had asked Joseph Roulin to keep him informed about Vincent's condition. The good Roulin faithfully did what was requested of him and Frédéric Salles, the Protestant minister at Arles, who had taken a deep interest in Vincent's tragic circumstances, did the same. As their letters have been preserved, the events of the following days can be closely followed. Roulin gave his first account on 26 December, the day after Theo's return, and it appears that he still considered a recovery unlikely.

Gauguin leaves Arles.

> Monsieur Gogh, I have been to see your brother Vincent. I promised to tell you what I thought of him. I am sorry to say I think he is lost. Not only is his mind affected, but he is very weak and down-hearted. He recognized me but did not show any pleasure at seeing me and did not inquire about any member of my family or anyone he knows. When I left him I told him that I would come back to see him; he replied that we would meet again in heaven, and from his manner I understood that he was praying. From what the concierge told me, I think that they are taking the necessary steps to have him placed in a mental hospital.
> Please accept, Monsieur, the greetings of him who calls himself the friend of your beloved brother. Roulin, Joseph.

In a postscript he had written: "My family sends greetings to M. Paul Gauguin."[141]

In his next letter, which was written on 28 December, the news was not much better:

> Monsieur Gogh, I should have liked to have had the honor of announcing an improvement in your brother's health. Unfortunately,

[141] I have published the French text of these letters in *Vincent, Bulletin of the Rijksmuseum Vincent van Gogh* (1970), nr. 1.

I can't. Yesterday, Thursday, my wife went to see him, and he hid his face when he saw her coming. When she spoke to him, he replied well enough, and talked to her about our little girl and asked if she was still as pretty as ever. Today, Friday, I went there but could not see him. The intern and the attendant told me that after my wife left, he had had a terrible attack; he passed a very bad night, and they had to put him in an isolated room. Since he has been locked in this room, he has taken no food and completely refused to talk. That is the exact state of your brother at present.

The intern has told me that the Doctor has postponed for a few days the decision to have him placed in a mental hospital at Aix. Please, Monsieur, accept my sincere greetings. Roulin, Joseph.

In the next few days, an unexpected and miraculous improvement in Vincent's condition took place. It was the Reverend Salles who first informed Theo of it. His letter confirms that Vincent had been placed in an isolated cell, and it gives a little more information about the possibility of his transfer to a mental institution, but he also tells how Vincent himself reacted to all this, and that is probably what Theo longed to know in the first place; the letter was dated 31 December, the eighth day of Vincent's stay in the hospital:

A miraculous improvement in Vincent's condition.

> Monsieur, I am writing to give you news of your brother. I have just seen him, and found him calm, in a state which revealed nothing abnormal. Unfortunately, as a result of the insane act which necessitated his admission to the hospital, and of his more than strange behávior there, the doctors have found it necessary to isolate him and lock him up in a separate room. It is their opinion that he should be transferred to a lunatic asylum and they have sent a report to this effect to the Mayor. This report will lead to an inquiry and the result will be sent to the Prefect, who will probably arrange for your brother's transfer to Marseilles or Aix.
>
> I wanted to warn you of what is going on with respect to your brother, something of which he himself seems to be fully aware. I repeat, I found him talking calmly and coherently. He is amazed and even indignant (which could be sufficient to start another attack) that he is kept shut up here, completely deprived of his liberty.

Theo must have been astonished when only two days later he received a letter from Vincent himself; on the back was a short note from an intern, Dr. Rey, which reveals how much he was concerned about the well-being of his patient. This is what Vincent wrote in this letter, dated 2 January 1889:

> So as to reassure you completely on my account, I write to you these few lines in the office of M. Rey, the intern, whom you have met yourself. I shall stay here at the hospital a few days more, then I think I can count on returning to the house very quietly.
>
> Now I beg only one thing of you, not to worry, because that would cause me a worry *too much*.
>
> Now let's talk about our friend Gauguin. Have I scared him? In short, why doesn't he give me any sign of life? He must have left with you. Besides, he felt the need to go back to Paris, and in Paris he will perhaps feel more at home than here. Tell Gauguin to write me, and that I am always thinking about him.
>
> A good handshake. I have read and reread your letter about your seeing the Bongers. It is splendid. As for me, I am content to stay

331

just as I am. Once more a good handshake for you and Gauguin (letter 567).

Dr. Rey had added the following note: "I add a few words to your brother's letter to reassure you in my turn on his account. I am happy to inform you that my predictions have been realized and that the over-excitement has been only temporary. I am firmly convinced that he will be himself again in few days. I made a point of his writing to you himself, so as to give you a better idea of his condition. I have made him come down to my office for a little chat. It will entertain me and will be good for him."

The sudden improvement in Vincent's condition must have surprised Roulin, for he sent Theo a telegram on 3 January, probably not knowing that the Reverend Salles had already written about it a few days earlier. He confirmed the telegram in a letter written the same day.

> Monsieur Gogh, I am happy to confirm the telegram I sent you today, in which I told you that my friend Vincent has completely recovered; he will leave the hospital one of these days to return to his house. Do not worry, he is better than before that unfortunate accident happened to him. At present he can move freely about the hospital; we walked for more than an hour in the courtyard; he is in a very healthy state of mind. I don't know how to explain the severe measures that were taken to keep him from seeing his best friends.

There was such a speedy recovery that the next day, 4 January, Vincent was permitted to leave the hospital, if only to go for a walk and have a look at his house. Either at home or in a café (probably the Café de la Gare), he wrote two short letters in pencil, one to Theo, and one to Gauguin[142]:

Vincent reassures his brother: "after all, no harm came to me."

> I hope that Gauguin will reassure you completely, and also a little about the painting business. I expect to start work again soon. The charwoman and my friend Roulin have taken care of the house, and have put everything in order. When I get out, I shall be able to go my own little way here again, and soon the fine weather will be coming and I shall again start on the orchards in bloom.
>
> My dear brother, I am so terribly distressed over your journey. I should have wished you had been spared that, for after all no harm came to me, and there was no reason why you should have gone to all this trouble [of coming to Arles].
>
> I cannot tell you how glad I am that you have made peace, and even more than that, with the Bongers. Tell this to André, and give him a cordial handshake from me.
>
> What would I have given for you to have seen Arles when it was fine; now you have seen the black side of it. However, be of good heart, address letters directly to me at Place Lamartine 2. I will send off to Gauguin the pictures of his that are still at the house as soon as he wishes. We owe him money that he spent on the furniture. A handshake, I must go back to the hospital now, but shall soon be out for good.
>
> Write a line for me to Mother, too, so that no one will be worried (letter 566).

[142] In the *Complete Letters* these two notes were erroneously dated 1 January instead of 4 January and therefore placed before letter 567 of 2 January.

In the letter to Gauguin, written on pages two and three of the letter to Theo, Vincent wrote:

Vincent reassures Gauguin of his friendship.

> My dear friend Gauguin, I profit from the opportunity of my first absence from the hospital to write you a few words of very deep and sincere friendship. I often thought of you in the hospital, even at the height of fever and comparative weakness.
> Tell me—was my brother Theo's journey really necessary, my friend? Now at least do reassure him completely, and please be confident yourself that after all no evil exists in this best of worlds in which everything is always for the best.
> Then I should like you to give my regards to good old Schuffenecker, to refrain, until after more mature reflection on both parts, from speaking evil of our poor little yellow house, and to remember me to the painters whom I saw in Paris. I wish you prosperity in Paris. With a good handshake, etc.
> Roulin has been truly kind to me, it was he who has the presence of mind to make me come out of that place before the others were convinced.

Roulin, too, hastened to inform Theo of the favorable developments, to which he himself had contributed so much. His good-heartedness and sensitivity are even more manifest in this letter of 4 January.

> Monsieur Gogh, I am truly happy today. I went to the hospital to get my friend Vincent and take him for a little fresh air. We went to the house, he was pleased to see his paintings again; we stayed four hours; he has completely recovered, it is really surprising. I am very sorry my first letters were so alarming, and beg your pardon for it. I am glad to say I have been mistaken in his lot. He only regrets all the trouble he has given you, and is sorry for the anxiety he has caused. Don't worry; I will do all I can to give him some distraction; one of these days he will leave the hospital and go back to his paintings. That is all he thinks of, he is as sweet as a lamb.
> The intern was rather uneasy about letting him go, so I told him that I would take it upon myself to accompany him and bring him back to the hospital. By the time you receive my letter, I shall be with him again to spend some hours together. The intern and Vincent have agreed to meet me tomorrow at the Café Ginoux so that he can show his paintings.

Reassured about Vincent's condition, Theo travels to Holland to announce his engagement.

This must have reassured Theo completely. He probably did not even wait until the letter of 7 January arrived, in which Vincent wrote him that he had definitely left the hospital, before undertaking the postponed journey to Holland. His presence there was, of course, urgently needed, as he had to take the necessary steps to make his engagement officially public. He also wanted to visit his mother with Jo, and knew they must call upon her parents.

In order to evaluate Vincent's reaction to the engagement justly, it must be decided whether the news had come to him as a surprise. Since 1886 he knew that Theo wished to marry Jo at some time or other, but he could not have known that the plans had now become concrete, as it seems very unlikely that Theo would have told Vincent in the state in which he had found him. He may, however, have hinted at it in the letter he

333

had written to the hospital, probably on 1 January. Vincent's reply makes it certain that he knew at least something: "I have read and reread your letter about your seeing the Bongers. It is perfect. As for me, I am content to stay just as I am" (probably meaning unmarried). It seems that Theo had wanted to spare Vincent the shock and cautiously prepared him for the great news. He did not reveal it to him until the day the official announcements were sent. Here are the first two paragraphs of Vincent's reply of 9 January:

> Even before receiving (this very morning) your kind letter, I have received this morning from your fiancée the official engagement announcement. So I have already sent her my sincere congratulations in reply, and herewith I repeat them to you.
> My fear that my indisposition might prevent you from making that very necessary journey which I had so much and so long hoped for, this fear having disappeared, I feel myself quite normal again (letter 570).

That Theo, like Vincent, had outgrown the influence of his religious upbringing is demonstrated by the fact that he did not wish to be married in a church. In a letter from his sister Lies of 16 March 1889 she begs him to reconsider that decision. In this letter she said that she wanted to address two issues. She advised him to take a maid, but that was not the most important matter. "The second question is that Mother is worrying, I must say: night and day, if you two don't marry in church. It is impossible to do it in the house of the Bonger family. Oh, please do it, or else it would cause such great sadness. If you want to do it without kneeling—that is sometimes done too, if you tell the minister." Yet, Theo did not give in, and on 18 April 1889,[143] the wedding between the thirty-one-year-old Theodorus van Gogh and the twenty-six-year-old Johanna Gezina Bonger took place in the Amsterdam town hall. Immediately after the wedding, the couple departed for Paris, where Theo had rented a new apartment, this time at 8, Cité Pigalle, a small side-street off the rue Pigalle.

When Vincent had received the announcement of Theo's engagement, he had sent only a few lines of congratulation. That it was not due to a lack of warmth becomes clear when, in a letter of a few weeks later, he explained that "banal" congratulations would certainly be considered superfluous; there could be no doubt about his happiness with the course of events. "Now the main thing is that your marriage should not be delayed. By getting married you will set Mother's mind at rest and make her happy, and it is after all almost a necessity in view of your position in society and in commerce. Will it be appreciated by the society to which you belong? Perhaps not, any more than the artists ever suspect that I have sometimes worked and suffered for the community. . . . So from me, your brother, you will not want banal congratulations and assurances that you are about to be transported straight into paradise" (letter 573).

Vincent did his best to express his warm feelings, despite his difficulties with congratulations. In the beginning of April

Vincent writes about Theo's engagement and marriage.

[143] Most books on Van Gogh write that Theo and Jo were married on 17 April 1889, but the certificate of marriage shows that they were married on 18 April.

334

he formulated his good wishes: "A few lines to wish you and your fiancée good luck these days. It is a sort of nervous tic of mine that on festive occasions I generally have difficulty in formulating good wishes, but you must not conclude from this that I wish you happiness less earnestly than anyone else, as you well know" (letter 583). A few days earlier he had already written to them about their marriage in even more eloquent terms. As Theo had said something about *le vrai Midi* (the real South), Vincent replied: "To you and your wife, on the occasion of your marriage, it is the happiness, the serenity, that I would invoke for you both, so that you would have that real Midi in your soul" (letter 582). And probably on the very day of the wedding he wrote, "I hope that all those things connected with a marriage have gone off to your liking. . . . I wish you and your wife much happiness from the bottom of my heart" (letter 584).

Vincent knew that this kind of happiness was not what fate had in store for him, but he found the strength to write: "I assure you that I am much calmer since I picture that you have a companion for good. Above all, do not imagine that I am unhappy!" (letter 586).

For Vincent, what lay ahead was work . . . and the struggle against his illness.

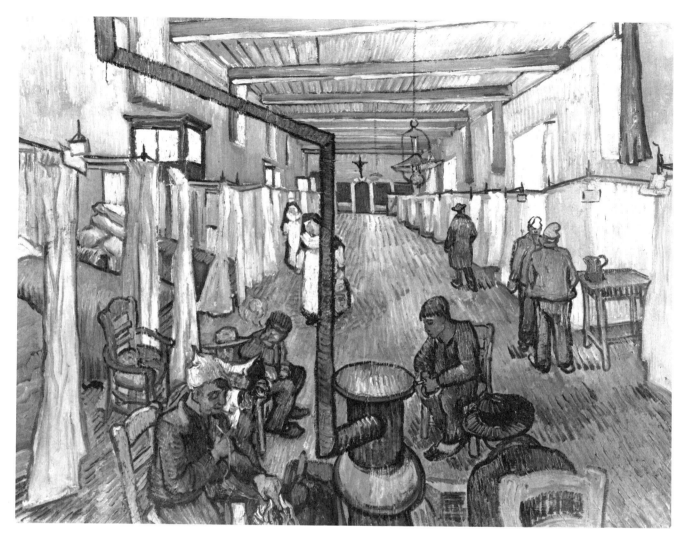

91
Dormitory in the Hospital at Arles, *painted by Vincent in April 1889, and reworked in October.*
Oil on canvas, JH 1686, F 646, 74 x 92 cm.
Oskar Reinhart Collection, Am Römerholz, Winterthur

When Vincent was allowed to leave the hospital on 7 January 1889, his usual optimism as well as his miraculously quick recovery gave him every reason to think that his illness was nothing but a passing disorder. He felt so well that he wanted to resume work immediately. "I now intend to do a portrait of M. Rey and possibly other portraits as soon as I am a little used to painting again," he wrote on the day he came home (letter 568). Later that day he wrote even more explicitly, "I am going to set to work again tomorrow; I shall begin by doing one or two still lifes so as to get back into the habit of painting" (letter 569). The portrait of Dr. Rey, a few still lifes and other important canvases were indeed painted in the following days.

At the same time he tried to minimize his illness. To Theo he wrote: "I do so regret that you had all that trouble for such a trifle; forgive me who am after all probably the primary cause

of it all. I did not foresee that it would have a consequence for you to be told of it" (letter 568). The same day he also wrote a letter to his mother and sister Wil, doing his utmost to represent his illness as transient.

> For a couple of weeks already I have firmly intended to write you a word or two to wish you a truly prosperous and happy New Year. Now I am pretty late in doing so. I think you will probably excuse me if I tell you that I happen to have been indisposed in December. But at the same time I can inform you that I have completely recovered, and am normally at work again Be so kind as to take good note of the fact that I am writing you these lines in case Theo has told you about my having been indisposed for a few days. I hope he understood of his own accord that it was not worth troubling to inform you of it (letter 569).

The well-meant note did not have the desired effect since his mother and Wil had already been completely informed. Theo (or maybe Jo) must have told them what had happened, and Wil had written to Roulin for more details.

For a whole month everything went well. If there were problems, they were mainly financial, for the letter with fifty francs that Vincent had expected around 10 January arrived on the 17th, causing him more than a week of "the most rigorous fast," as he explained in a long and rather bitter letter (letter 571). In any case, it did not prevent him from beginning to work as he had announced. "I have nevertheless started to work again, and I have already finished three studies in the *atelier*, besides the portrait of M. Rey, which I gave him as a keepsake."[144] This proves that the splendid portrait of Rey (JH 1659) was done between 8 and 16 January. There is less certainty about the three other studies. Two of them must have been the famous self-portraits with the bandaged ear (JH 1657 and 1658). In the first days after his return from the hospital, Vincent must have been greatly interested in the effect of the bulky bandage, and even more so in the effect his serious collapse had upon his features.[145] In both self-portraits, the expression is accordingly worried and probing; even in the seemingly more resigned one, where he quietly smokes his pipe, there is a deeply serious and even alarmed look in his eyes.

Why he never mentioned in his letters the self-portraits with the bandaged ear, which have such unique meaning, cannot be answered with certainty. He presumably considered them to be studies, done more for his own sake and having no value for Theo. Moreover, he possibly found it too alarming to mention the bandage because it brought to mind the fatal incident in December. In the long letter of 17 January he did mention a self-portrait, though without any description. At the end of that letter, Vincent said in passing, after mentioning the self-portrait he had done for Laval, "I have another new one for you too" (letter 570). This could refer to one of the self-portraits

Starting a new series of paintings.

[144] Dr. Rey seems to have disliked the portrait, although it was only sold in 1901. The stories vary as to what happened to the picture, but it seems very unlikely that it was used for years to close up a gap in the hen house! It is now in the Pushkin Museum, Moscow.

[145] After his long illness in Saint-Rémy, one of the first paintings he did was also a study of the effect the illness had had on his features (JH 1770).

338

with the bandaged ear, but he more likely had in mind the small self-portrait in the blue-gray blouse against a bluish green background (JH 1665), which is mentioned nowhere else in the correspondence. This canvas can be ascribed to the same period because he is shown with a clean-shaven face, just as in the portraits with the bandage. His beard had been shaved off during the treatment of the wound, but he would soon grow another.

Another canvas that was completed in the same early days of January 1889 is the still life of a table with objects relating to his illness (JH 1656). If the canvas is from this time, it would confirm that he had indeed started painting still lifes, as had been his intention. The still life is anecdotal, displaying the objects with which Vincent was surrounded during these difficult days. It is also symbolic, or allegorical, since the central place in the picture has been given to a plate with onions, either because of the healing power ascribed to them, or because their fresh green shoots represent the renewal of life. A book with the title *Annuaire de la Santé* (Yearbook of Health) represents the subject that preoccupied Vincent. Finally there is a letter that shows the words "à Monsieur Vincent van Gogh," which can be seen as an homage to Theo, whose regular messages were of such great consolation to Vincent.

A symbolic picture.

It is amazing that Vincent had the force and inspiration to finish at least another five important canvases in the few weeks before the end of January. In a letter of 23 January he gave a clear description of a still life that was a new variation on one of his favorite themes (JH 1664). "I have just finished a new canvas which has almost what you would call *chic*, a wicker basket with lemons and oranges, a little cypress branch and a pair of blue gloves. You have already seen some of these baskets of fruit of mine" (letter 573).

The second of the five canvases is the portrait of Roulin's wife, which he called *La Berceuse* (Woman Rocking a Cradle), and had almost finished before his illness (JH 1655). "I am working on the portrait of Roulin's wife, which I was doing before I was ill. In it I had ranged the reds from pink to orange, which in the yellow hues rose to citron-yellow, with light and somber greens. If I could finish it, it would make me happy, but I am afraid she will not want to pose with her husband away" (letter 573).[146] The description shows that in Vincent's eyes the picture was primarily a study in color contrasts. Besides being the portrait of a very good friend, it also had a more literary and symbolic connotation. This is shown in the letter he sent Gauguin on the same day.[147] While he wrote, "as an impressionistic color arrangement I have never come up with anything better" (showing a satisfaction with his own work that is very unusual in his letters), he also told him, "and I believe that if one would place the picture just as it is in a fishing vessel, even one of the Icelandic fishers, there would be some who would sense the *Berceuse* in it." He expanded this thought in his next letter to Theo: "About this picture I have just said to Gauguin that when he and I were talking about the fishermen

[146] Roulin had just been transferred to Marseilles.

[147] This letter had already been partly published by Jean de Rotonchamp in 1906 and 1925; a complete version is VP/GP in the edition of the Gauguin letters by Douglas Cooper.

of Iceland and of their mournful isolation, exposed to all dangers, alone on the sad sea—I have just said to Gauguin that following those intimate talks of ours, the idea came over me to paint a picture in such a way that sailors, who are at once children and martyrs, seeing it in the cabin of their Icelandic fishing boat, would feel the old sense of being rocked come over them and remember their old lullabies" (letter 574).

When he wrote this letter to Theo, he had been working hard on a second version of *La Berceuse*, and had also copied the two pictures of the *Sunflowers* from August 1888, which completed the group of five studies. He wrote to Theo: "During your visit I think you must have noticed the two size 30 canvases of the sunflowers in Gauguin's room. I have just put the finishing touches to absolutely identical replicas of them. I think I have already told you that besides these I have a canvas of a Berceuse, the very one I was working on when my illness interrupted me. I now have two of this one too" (letter 574). In his letter of 23 January he mentioned the reason for copying both *Sunflowers*: "Gauguin would be glad to have one, and I should like to please him with something that counts. So, if he wants one of these two canvases, all right, I will do one of them over again, whichever he likes" (letter 573).

Vincent had the curious idea of combining these pictures. "I picture to myself these canvases [of the *Berceuse*] between those of the sunflowers, which would form chandeliers or candelabra of the same size beside them, and so the whole would be composed of seven or nine canvases. (I should like to make another duplicate for Holland if I could get hold of the model again.)" He returned to this idea in a letter four months later, illustrating his words with a little sketch. "You also have to know that if you arrange them in this way, the *Berceuse* in the middle and the two canvases of sunflowers to the right and left, it makes a sort of triptych. And then the yellow and orange tones of the head will gain in brilliance by the proximity of the yellow wings. And then you will understand what I wrote you about it, that my idea had been to make a sort of decoration, for instance for the end of a ship's cabin" (letter 592).

From a triptych with a female form in the middle to religious art is only a step, and interpretation of the *Berceuse* gradually moves in that direction. Heinz Graetz in *The Symbolic Language of Vincent van Gogh* (1963) did not go further than to proclaim the *Berceuse* as a symbol of Vincent's "mother problem" which was here given "the central position" in his art just as in his life. The later interpretations of the painting as a religious icon go much too far, it seems. Vincent himself had clearly characterized Madame Roulin's portrait as the symbol of a *berceuse*, a woman rocking the cradle, whose image was meant to remind seamen of their wives or their mothers. The word triptych does not necessarily have religious connotations; Vincent liked to think of his flowering orchards also in the form of a triptych. Whatever the interpretation, it was generally recognized as one of his most forceful and most personal portraits. He himself was so pleased with it—though not for artistic reasons only—that he made no less than four replicas of it in a short time.

In these weeks of great artistic creativity, Vincent must have missed the company of Joseph Roulin, who had been transferred to Marseilles. How much he took his friend's move

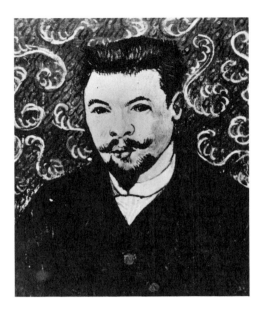

92
Portrait of Doctor Felix Rey, *Vincent's "interne" at the hospital in Arles; painted by Vincent in January 1889, immediately after he had begun working again. Oil on canvas, JH 1659, F 500, 64 x 53 cm. Pushkin Museum, Moscow*

La Berceuse *as a religious icon?*

340

to heart is evident from the tone of his letters. His first mention of the subject to Theo was more or less businesslike. "Roulin is about to leave, as early as the twenty-first. He is to be employed in Marseilles. The increase in pay is minimal, and he will be obliged to leave his wife and children for a time; they will not be able to follow him till much later, as the expenses of a whole family in Marseilles would be much heavier. It is a promotion for him, but that is a very, very poor consolation that the Government gives such an employee after so many years' work" (letter 571). But when he wrote again the day after Roulin's departure, his emotional tone showed how much that departure meant to him. "It was touching to see him this last day with his children, especially with the tiny one, when he made her laugh and bounce on his knee, and sang for her. His voice had a strangely pure and emotional quality in which I could hear at once a sweet and mournful lullaby and a kind of a faraway echo of the trumpet of revolutionary France. Yet he was not sad. On the contrary, he had put on his brand new uniform which he had received that very day, and every one joined in giving him a warm farewell celebration" (letter 573).

The friendship he felt for Roulin was as strong as it was because Vincent could see in Roulin the kind of laborer he himself was, and with even bigger worries. "His pay here was 135 francs a month; to bring up three children and live on it, himself and his wife! You can imagine what that has been," he wrote in letter 572. He also reported to Theo when Roulin had come to see him a week later during a short visit to his family: "I had just finished the replicas of my *Sunflowers*, and I showed him the two canvases of the *Berceuse* between the four bunches of flowers" (letter 575). Undoubtedly as a result of this visit he started a second replica of the *Berceuse* the same day. This was on 30 January, and for many weeks it was the only picture he did, apart from a third replica which he started in the first week of February. Sometime later, however, probably in April, the recollection of Roulin's friendship must have induced him to paint no fewer than three replicas of his portrait (JH 1673-1675), giving them a flowered background, similar to the one on the *Berceuse*.[148]

Vincent's confidence in his state of health, which was based on his speedy recovery and renewed energy, soon proved to have been premature. In the beginning of February 1889 he had a new mental collapse, so serious that the worst had to be feared for the future. This time it was the Reverend Salles who warned Theo, in a letter dated 7 February.

Vincent suffers another collapse.

Monsieur, Your brother whom we had believed cured and who had taken up his usual work once more, has recently again shown signs of mental distress. For three days he has believed that he is being poisoned and is everywhere seeing prisoners and poisoned people. The cleaning lady, who looks after him with devotion, noticing the more abnormal state he is in, has considered it her duty to report it—something that the neighbors have brought to the attention of the superintendent of police. He has put a watch over your brother and

[148] The replicas were *heads*, but, Roulin being away, the model Vincent used was the portrait of Roulin sitting at the table (JH 1522) done in August 1888, of which he copied the top part. The *head* he had done of Roulin in August was in Paris as part of the group that Milliet had taken to Theo. "The *big* portrait of the postman," however, Vincent kept, as he has clearly said in letter 525.

this afternoon had him taken to the hospital where he has been placed in a private cell. I have just seen him and got a very painful impression of the condition he is in. He hides himself in absolute silence, covers himself with his bedclothes and at times is weeping without uttering a single word. Today, according to the cleaning lady, he has refused all food; all of yesterday and this morning he has spoken little and his behavior has at times frightened the poor woman, who told me that while he was in this state she could not continue to look after him.

It was a short but serious relapse, which cannot have come to Theo completely unexpectedly, as deterioration in Vincent's condition could clearly be observed in his last letter. This letter, sent in early February, began with the words: "I should have liked to reply at once to your kind letter containing a hundred francs, but I was very tired just then and the doctor had given me strict orders to restrict myself to taking walks without doing any mental work; the result is that I didn't write you until today. As far as my work goes, the month hasn't been too bad on the whole, and work distracts me, or rather keeps me under control, so that I don't deny myself it" (letter 576). Another sign that something was wrong was that Vincent wrote more extensively about his illness than he had done in a long time. Considering that this was only a few days before his mind was again completely clouded, it is amazing that he was able to analyze his state of mind with such lucidity.

Vincent describes his state of mind with exceptional lucidity.

This so-called *good* town of Arles is such an odd place that it's with good reason that old Gauguin calls it "the dirtiest hole in the South." And if Rivet [Theo's doctor] saw the population, he would certainly be very upset at times, and say over and over again, "You are a sickly lot, all of you," just as he does of us; but if you catch the disease of this country, upon my word, afterward you cannot catch it again. By which I mean that I have no illusions about myself any more. I am feeling very, very well, and shall do everything the doctor says, but . . .
When I came out of the hospital with kind Roulin, I thought there had been nothing wrong with me, but only *afterward* I felt that I had been ill. What can we do? There are moments when I am twisted by enthusiasm or madness or prophecy, like a Greek oracle on his tripod.

Never before had he given such a telling description of the moments of exaltation which gave his mind that exceptional lucidity, and probably also—even if he did not say so—the creative power to produce the most remarkable paintings in such an amazingly short time. He might ironically console himself with the thought that he could not get the same illness twice, but realized only too well that his health could not be trusted. "The people from here who are ill like me are telling me the truth. You may be old or young, but there will always be moments when you lose your head."

When he wrote again on 17 February he had left the hospital, so this time the illness lasted ten days. "Today I have come home provisionally, I hope for good. I feel quite normal so often, and really I should think that what I am suffering from is only a disease peculiar to this region; I must wait here quietly till it is over, even if it would return again (and let's say

342

it won't)" (letter 577). Despite this real or feigned optimism, Vincent realized that he had to reckon with the unexpected, and it becomes clear that what he feared most was that decisions would be made without his knowledge. That is why he continued the letter with a strict warning, at the same time revealing how painfully his mind must have been torn by anxiety during these weeks. "But this is what I tell you and M. Rey once and for all. If sooner or later it would be desirable that I go to Aix [i.e. to the insane asylum in that town], as has already been suggested, I consent beforehand and I will submit to it. But in my quality as a painter and a workman it is not permissible for anyone, not even you or a doctor, to take such a step without warning me and consulting *me* about it; as up till now I have always kept a relative presence of mind in my work. I have a right to say (or at least to have an opinion on) whether it would be better to keep my studio here or to move to Aix altogether" (letter 507).

The next few days he walked a great deal to get some fresh air, and as a precautionary measure he slept and took his meals in the hospital. One day he received a visit from Madame Roulin, who was going to live temporarily with her mother in the country. He could show her the *Berceuse* and two replicas of it. "She had a good eye," he wrote to Theo, "and took the best,[149] only I am doing it again at the moment and I do not want it to be inferior" (letter 578).

Under Lock and Key

It was, alas, for not more than a week that Vincent could enjoy his regained freedom. This time the people from the neighborhood turned against him. As a result of their accusation that his abnormal conduct was a danger to their safety, he was again interned in the hospital, on the order of the head of police, completely against his will and while there was nothing wrong with his mind. A letter from the Reverend Salles written on 26 February immediately informed Theo of what had happened:

The Reverend Salles keeps Theo informed.

> Monsieur, Your poor brother has again been taken into the hospital. As you will undoubtedly have heard from him, he had returned to his home a few days ago. However, his behavior and the way he talked made me fear that the improvement which had taken place was only apparent. This fear which we all had, proved only too well-founded. A petition to the Mayor, signed by some thirty neighbors, draws his attention to the inconvenience caused by allowing this man his complete liberty and mentions facts to support this assertion. The superintendent of police, to whom the document was submitted, has immediately had your brother taken to the hospital with the express request not to let him leave the building. He has just left me to bring me up to date regarding the situation of your brother and to ask me to write to you.
>
> It is clear that a decision should be made. Is it your intention to have your brother come to you or to put him yourself into an institution of your own choice? Or do you prefer to leave it in the hands of the police? On this point we should have a categorical reply. Please do

149 The one she took was JH 1669.

not lose time in letting your intentions be known, either to myself or to the Mayor or to the superintendent of police. We will not act until your reply has been received and we will act according to your wishes.

Theo did not answer immediately; he did not make a decision either, but probably wished to know more details before he made up his mind. His letter (which is unknown) crossed another letter from the Reverend Salles, written on 1 March. The Reverend was able to send better news about Vincent, spoke of no abnormal conduct, and came to the definite conclusion that the internment was cruel and unjustified.

> Monsieur, I have just been to see your brother at the hospital and found him reasonably well. Everyone, the intern, the administrator and the board of management, is well disposed toward him and it has been decided that someone will go with him to his house in order that he may collect his brushes and paints so that he may find some distraction during his stay at the hospital. Nevertheless, the problem remains the same. The superintendent of police, who has the petition about which I have written to you and who has made inquiries in the district, remains convinced that suitable measures should be taken. Yet it seems to me, and this view is shared by M. Rey, that it would constitute an act of cruelty to permanently lock up a man who has done nobody any harm and who, as a result of a treatment based on kindness, can return to his normal state.

"It would constitute an act of cruelty to permanently lock up a man who has done nobody any harm and who, as a result of a treatment based on kindness, can return to his normal state."

The next day Reverend Salles received Theo's letter, which caused him to write again. His answer indicates that Theo had asked details about the petition. Mr. Salles made it clear that he found the accusations irrelevant; he justly pointed out, however, that the fact that Vincent had wounded himself had made his neighbors suspicious of Vincent's conduct.

> Unfortunately, the crazy act which necessitated his first hospitalization has resulted in a most unfavorable interpretation of the somewhat strange acts to which this unfortunate young man sometimes abandoned himself. In the case of another person they might not have been noticed, but with him they immediately assume a special importance.
> In spite of the conviction of the superintendent of police, and his decision to have your brother locked up, I hope that we will succeed in keeping him here. . . . As I told you yesterday, everyone in the hospital is well disposed toward him, and after all it should be the doctors and not the superintendent of police who ought to be the judges in a case like this.

A more carefully weighed consideration of the affair is hardly possible; the accusations were certainly exaggerated, and the neighbors had backed each other up. However, they did show that he had caused annoyance by touching or fondling neighboring women in a rather innocent way. The tragic irony is that these "somewhat strange acts to which this unfortunate young man sometimes abandoned himself"—as the Reverend Salles put it mildly—had practically nothing to do with the latent mental illness that more than once made Vincent's internment *truly* necessary.

Only one of Theo's letters from the tragic weeks of Vincent's internment has been preserved, permitting at least some insight into Theo's feelings toward his brother during this time. For weeks, Vincent had kept an absolute silence, but Theo's letter of 16 March 1889 finally prompted him to write a response. This is the beginning of the letter written by Theo, at a time when his own circumstances were in such complete contrast with those of his brother:

> My Dear Brother, I hear that you are not better yet, which causes me a great deal of grief. I so wish you could tell me how you are feeling, for there is nothing more distressing than this uncertainty, and if you could tell me how things are with you, I might be able to do something to give you solace. You have done so much for me that it is a great sorrow to me to know that precisely at the time when in all probability I am going to have days of happiness with my dear Jo, you are passing through days of misery. As she wanted to live my life as much as possible, she had imagined that you might have been a brother to her as you always have been to me. We hope from the bottom of our hearts that you will be able to regain your health completely and to resume your work within a short time.
>
> While arranging my new apartment it is such a pleasure for me to look at your pictures. They make the rooms so gay, and there is such a feeling of truth, of the true countryside in each one of them. It is really as you used to say now and then of certain pictures of other artists, that they give the impression of coming directly from the fields (letter T 4).

Vincent, who had not written since 22 February, must have decided that he could not leave such a cordial letter unanswered, and his letter proves that his silence had been deliberate, not the result of a mental breakdown. That the mental breakdown was over is confirmed by the Reverend Salles in a description he gave of Vincent's state of health, which Theo must have received a day before he got Vincent's own long letter. "I hasten to tell you that, much to my surprise, I found him entirely lucid and with a complete awareness of his condition. When I entered the hospital, the porter handed me a letter for him, which I recognized as coming from you. He thought that your brother might not be fit to read it. But I had scarcely entered his room when I noticed his remarkable improvement and did not hesitate to give the letter to him. He read it in my presence and even communicated to me the last part in which you speak of a friend, a painter like himself, who would want to come to Arles."

This letter gives the impression that a rather sudden improvement in Vincent's condition had taken place. Nevertheless it seems possible that Vincent had simply persevered in a stubborn silence all these weeks without having had a real crisis at all. Evidently not suspecting that Theo might have already heard the main facts, Vincent's letter, dated 19 March, started this way:

> My dear brother, I seemed to see so much brotherly anxiety in your kind letter that I think it my duty to break my silence. I write to you in the full possession of my faculties and not as a madman, but as the brother you know. This is the truth. A certain number of people here (there were more than eighty signatures) have addressed a

Vincent finally writes to Theo after a long silence.

345

petition to the Mayor (I think his name is M. Tardieu), describing me as a man not fit to be at liberty, or something like it. The superintendent of police or the Prefect then gave the order to have me locked up again.

Anyhow, here I am, shut up in a cell for days on end, under lock and key with keepers, without my guilt being proved or even open to proof. Needless to say, deep down in my soul I have much to reply to all that. Needless to say that I cannot be angry and that excusing myself would mean to accuse myself (letter 579).

People from his immediate surroundings must have told Vincent the reason for his internment. He clearly perceived the risk that he would be considered quite dangerous if he could not control his indignation. That is why he asked Theo not to attempt to "free him," but to let the doctors do what they thought best. Yet he could not refrain himself from declaring how terribly he was hurt. "You will understand what a staggering blow it was to find so many people here cowardly enough to join together against one man, and that man ill. Very well—so much for your guidance; as far as my mental state is concerned, I am greatly shaken, but I am regaining a sort of calm in spite of everything, so as not to get angry. Besides, humility becomes me after the experience of the repeated attacks. So I am being patient" (letter 579).

"A staggering blow."

It was difficult for Vincent to remain patient considering that he had nothing with which to occupy his time. Though the Reverend Salles had reported on 1 March that Vincent had been permitted his painting material, Vincent mentions nothing about painting. Vincent wrote that he wanted Theo to send him the canvases he had made earlier, but said, "all of them are under lock and key, guarded by police and guards" ("*garde-fous*"). He wasn't even allowed to smoke. "They pester me because of my smoking and drinking, but what's the use? With all their sobriety they only cause me fresh misery" and he worried that he could not answer a letter from Bernard. "It's a whole story to write a letter, there are as many formalities necessary now as if one were in prison."

Fortunately, the doctors gradually allowed Vincent more freedom, and the police did not interfere. When he answered a letter from Theo on 22 March, he still asked, "If you were to write, try to get them to give me the right to go out into the town" (letter 580). Yet his confinement was no longer overly strict; when Signac came to see him the next day (he was in Arles on his way to the South), Vincent accompanied him to the yellow house to show him his pictures. That his "imprisonment" was almost over is also shown by his announcement that Reverend Salles was busy finding him an apartment in another part of town (letter 580).

A clear and objective report about Vincent's state of health is contained in the letter Signac wrote to Theo immediately after he had visited Vincent in Arles.

A visit from Paul Signac.

I found your brother in perfect health, physically and mentally. Yesterday afternoon and again this morning we went out together. He took me along to see his pictures, many of which are very good, and all of which are very curious.

His courteous doctor, the intern Rey, is of the opinion that, if he should lead a very methodical life, eating and drinking normally and

346

at regular hours, there would be every chance that the terrible crises would not repeat themselves at all. He is quite willing to keep him all the time that would be necessary. He thinks that the expenses of his stay in the hospital will have to be defrayed by the municipality, since it was at the administration's demand that he be kept here.

At any rate, if he does not go back to Paris—which in Mr. Rey's opinion would be preferable—it would be necessary for him to move, as the neighborhood is hostile to him. This is also what your brother desires, for at the earliest possible date he wants to leave this hospital, where after all he must necessarily suffer under continual surveillance, which often must be of a petty nature (letter 581a).

Vincent's description of Signac's visit shows that he greatly enjoyed Signac's company, and it contains some amusing details (if one takes into account the still rather sad circumstances) about their difficulties in entering the yellow house. "I am writing to tell you that I have seen Signac, and it had done me quite a lot of good. He was so good and straightforward and simple when the difficulty of opening the door by force presented itself—the police had closed up the house and destroyed the lock. At first they did not let us have our way, but all the same we finally got in. I gave him a keepsake, a still life which had annoyed the good *gendarmes* of the town of Arles, because it represented two bloaters, which, as you know, people here call *gendarmes*" (letter 581). The picture that Signac was given remained in the Signac family; it is the still life of two fish on a plate, placed on Vincent's rush-bottomed chair (JH 1661). Evidently Vincent made more paintings in early 1889 than he mentioned in his letters. There is a pendant of the fish still life, and there are two still lifes representing crabs, which must all date from this period.

That he longed to resume work was a sign of his improving health. He asked Theo to send him some paints and a few days later went into town to buy some materials himself. The first subject he took up was *La Berceuse*—now for the fifth time. He again tried to diminish the importance of the canvas by saying—as he had done in a letter of the end of January—that it was "nothing but a chromo-lithograph from a bazaar," and that it had not even "the merit of being photographically correct." He explained his intentions, however: "I try to make a picture such as a sailor who could not paint would imagine to himself when he thinks of a woman ashore" (letter 582).

Once he had resumed work his thoughts went back to the time that lay behind. "How strange these last three months do seem to me. Sometimes moods of indescribable mental anguish, sometimes moments when the veil of time and fatality of circumstances seemed to be torn apart for an instant." And he told Theo that he had often thought of an old epitaph, written on an ancient tomb at nearby Carpentras—an epitaph which he had accidentally come across in an old newspaper: "Thebe, daughter of Thelhui, priestess of Osiris, who never complained of anyone." It corresponded exactly with the words he had written to Theo only a month ago: "To suffer without complaining is the one lesson that has to be learned in this life" (letter 579). It was an ideal he would have every reason to bear in mind in the time to come, and which he put into practice in an admirable way until the end of his life.

Vincent begins working again.

This courageous attitude was seriously put to the test in April when it became evident that Vincent could not stay in the hospital indefinitely. For a short time he had thought of renting a small apartment that belonged to Dr. Rey, but he soon felt that he was unable to start life again in a new studio and stay there alone, and there even was a moment when in desperation he earnestly considered joining the Foreign Legion, something to which Theo strongly objected. In consultation with the Reverend Salles, Dr. Rey and Theo, it was decided that Vincent should try to continue his work as a painter in a mental asylum. There was one in the nearby village of Saint-Rémy which seemed acceptable to all concerned.

Before going, Vincent sent all the paintings he still had in his studio to Paris, except half a dozen which were not yet dry; there were so many that he needed two cases, for he continued to work very hard even throughout his difficult times. Although he concentrated on spring scenes, his mood must often have been terribly somber. To his sister Wil he wrote at the end of April: "Every day I take the remedy which the incomparable Dickens prescribes against suicide. It consists of a glass of wine, a piece of bread with cheese and a pipe of tobacco. This is not complicated, you will tell me, and you will hardly be able to believe that this is the limit to which melancholy will take me; all the same, at some moments—oh dear me . . . (letter W 11). And around the same time he wrote to Theo in works that sounded like a farewell.

> I shake your hand in thought. I do not know if I shall write very, very often because not all my days are clear enough for me to write fairly logically. All your kindness to me seemed greater than ever to me today. I can't put it the way I feel it in words, but I assure you that this kindness has been pure gold, and if you do not see any results from it, my dear brother, don't fret about it; your own goodness abides. Only transfer this affection to your wife as much as possible. And if we correspond somewhat less, you will see that if she is what I think her, she will comfort you. That is what I hope (letter 585).

Vincent will continue to paint in the the mental asylum at Saint-Rémy.

Part IV

With Scorched Wings

93
Saint-Paul-de-Mausole, where Vincent was admitted in May 1889. Originally a medieval monastery, it is now an asylum for the mentally disturbed.

The year Vincent spent in the Saint-Paul-de-Mausole asylum at Saint-Rémy is one of the most tragic episodes of his life. It must have been terribly frustrating for this man who not only was such an extraordinary artist, but also an exceptionally good and gentle human being, to cope with such degrading surroundings. It was also a sad period because of several, sometimes prolonged spells of his own mental illness. In spite of this, it was a very productive time artistically, and physically the safety and rest in the institution must have done him much good.

To later observers, the move to the asylum opened the possibility of learning the opinions the doctors formed about Vincent as a patient. Details from the archives of the institution have been made known through a doctor by the name of Edgar Leroy. Leroy, who was interested in Vincent's medical history, later became director of Saint-Paul-de-Mausole himself and had access to the archives. He published his findings first in articles in a medical paper (*Aesculape*, 1926) and two years later in a book he wrote in collaboration with another doctor, Victor Doiteau, who had published articles on Van Gogh in the same year. Unfortunately, their book was published under the ominous and sensational title *La folie de Vincent van Gogh*, which implied that Vincent's illness was

351

insanity from the beginning. As a source of biographical details the book holds little value and medically it has been overtaken by countless later studies. Yet the actual facts related by Dr. Leroy are of invaluable significance for further research.

It is interesting to read here the opinion of the medical superintendent of the hospital at Arles, where Vincent had been treated for four months. The superintendent, a certain Dr. Urpar, had written a short report about the patient for his colleagues of Saint-Rémy, dated 7 May 1889, which described Vincent's state of health immediately before his departure for Saint-Rémy. It was probably brought to the asylum by the Reverend Salles when he accompanied Vincent on 8 May, and it is known only because it was copied in the register by Dr. Peyron, the director of the asylum. No other official reports about Vincent's illness in the hospital at Arles have been preserved. Dr. Doiteau and Dr. Leroy published this text and several others in their book, which even contains photographs of the relevant pages of the registers. Dr. Urpar's report is as follows:

The opinion of Dr. Urpar, medical superintendent of the hospital in Arles where Vincent had been treated for four months.

> I, the undersigned, medical superintendent of the hospital in Arles, declare that six months ago Van Gogh Vincent, 35 years old, was affected by a severe nervous attack, accompanied by complete mania and general mental derangement. At that time he cut off his ear. At this moment his state is much improved, but he nevertheless thought it useful to have himself treated in a mental institution.
>
> Arles 7 May 1889
> was signed
> Dr. Urpar
> copy conform, the superintendent
> Dr. Th. Peyron

Dr. Leroy warns the reader with the note: "Dr. Urpar will not have seen much of Vincent; his 'intern' Rey will have treated him." Indeed, Urpar's rather vague diagnostic certificate indicates that he can hardly have followed the development of the illness personally. Dr. Peyron wrote a much more accurate report in the column after having talked to Vincent. His statement, which must have been based mainly on what he had heard from Vincent, contains some surprising details.

Vincent is admitted to the Lunatic Asylum of Saint-Rémy.

> I, the undersigned, physician, director of the Lunatic Asylum of Saint-Rémy, declare that Vincent van Gogh, 36 years old, born in the Netherlands, and at present living in Arles (B. -du-R.), undergoing a treatment in the hospital of that town, has been affected by a severe nervous attack, accompanied by hallucinations of sight and hearing, which have led him to the act of mutilating himself by cutting off his ear. At present, he seems to have come back to reason, but he does not have the strength and courage to live in freedom and he has asked himself to be admitted to this house. In consequence of what preceded, I conclude that Mr. Van Gogh is subject to attacks of epilepsy, far distanced from each other, and that there is reason to subject him to a prolonged observation in the establishment.
>
> Saint-Rémy, 9 May 1889
> Signed: Doctor Th. Peyron

Somewhat lower in this column the so-called certificate of the *Quinzaine* (the "two-weeks" certificate) reads:

I, the undersigned, physician, Director of the Lunatic Asylum of Saint-Rémy, declare that Vincent van Gogh, aged 36, native of Holland, entered 8 May 1889, suffering from a severe nervous attack accompanied by hallucinations of the sight and the hearing, has experienced a noticeable improvement, but that there is reason to keep him in the establishment to continue his treatment.

Saint-Rémy, 25 May 1889
Signed: Doctor Th. Peyron

In order to understand Dr. Peyron's diagnosis of epilepsy—which can only have been based on information obtained from Vincent—it is necessary to take note of what he wrote in the register a year later when Vincent left the asylum. "He tells us that a sister of his mother was epileptic and that there were several known cases in his family. What had happened to this patient seemed to have only been the continuation of what had happened to several members of his family." Although no facts of this kind are known, it should not be concluded—knowing Vincent's character— that he had made up this story. In any case, it explains why in his letters he himself often described his illness as epilepsy.

When Vincent entered the asylum he must have been completely sane. Only a few days before he had made several masterly paintings, such as the landscapes with flowering fruit trees (JH 1681 and 1685) and the lane with chestnut trees (JH 1689) and he had written extensive, lucid letters to Theo until the last moment. In a letter written to Theo on 10 May, the Reverend Salles gave a clear confirmation on Vincent's state of mind. The letter concludes: "Our journey to Saint-Rémy took place under ideal circumstances. M. Vincent was perfectly calm and explained his case himself to the director, like a man who is fully conscious of his position. He stayed with me until I left and when I said goodbye, he warmly thanked me and appeared somewhat moved by the thought of the entirely new kind of life he was entering in that house. Let us hope that his stay will be truly beneficial for him and that soon he will be regarded as capable of resuming his complete freedom of movement. Mr. Peyron assured me that he will receive all the kindness and care which his condition demands."

The first letters that Vincent wrote from Saint-Rémy are also clearly the products of a completely undisturbed mind, but his condition cannot be viewed with optimism. When on 26 May Dr. Peyron wrote to Theo, who had requested information on his brother's condition, it was possible for him to speak of a slight improvement, but nonetheless his letter showed great concern. He spoke for instance of nightmares that had not been mentioned before:

In reply to your letter of the 23rd inst., I am pleased to tell you that since his entry into this house Mr. Vincent is completely calm, and he finds that this health is improving day by day. At first he was subject to painful nightmares which upset him, but he reports that these bad dreams tend to disappear and become less and less

The diagnosis: epilepsy.

"M. Vincent was perfectly calm and explained his case himself to the director, like a man who is fully conscious of his position."

intense, so that now he has a more peaceful and restoring sleep; he also eats with better appetite.

To sum up: since his arrival here there has been a slight improvement in his condition which makes me hope for a complete recovery. He spends the whole day drawing in the park here, but as I find him entirely tranquil, I have promised him to let him go out in order to find interesting sights outside this establishment.

You ask for my opinion regarding the probable development of his illness. I must tell you that for the time being I will not make any prognosis, but I fear that it may be serious as I have every reason to believe that the attack which he had was the result of a state of epilepsy and if this should be confirmed one should be concerned about the future.

In his first letter to Theo and Jo, Vincent wrote about his new surroundings with some signs of optimism, but on the whole his impression of the institution could not have been very satisfied. Although he had only been there a few days he had started two canvases. "I am working on two pictures— some violet irises and a lilac bush, two subjects taken from the garden," he wrote to Theo,[150] and to Jo he wrote kindly about the way he could work in the midst of the other patients. "When I am working in the garden, they all come up to look, and I assure you they have the discretion and manners to leave me alone—more than the good people of the town of Arles, for instance" (letter 591). Less reassuring is the resignation that permeates the following important sentence from the letter to Jo: "It is rather queer perhaps that as a result of this terrible attack there is hardly any very definite desire or hope left in my mind, and I wonder if this is the way one thinks when, with the passions lessened, one descends the hill instead of climbing."

The first pictures from Saint-Rémy.

Misfortune's Companions

The confrontation with the patients of the institution must have been very depressing, but it is curious proof of his adaptability and his generally optimistic attitude that Vincent immediately saw the good side of the situation. In his short note to Theo he wrote: "I wanted to tell you that I think I have done well to come here; first of all, by seeing the *reality* of the life of the various madmen and lunatics in this menagerie, I am losing the vague dread, the fear of the thing. And little by little I can come to look upon madness as a disease like any other. Then the change of surroundings does me good, I think" (letter 591). In slightly different words he repeated this conviction in the part of the letter written to Jo. "Although there are some seriously ill patients here, the fear and horror of madness that I used to have has already lessened a great deal." Some weeks later on 22 May he stated again in a long letter to Theo, "I *assure* you that I am quite all right here and that for the time being I see no reason at all for going to a boarding house in or

[150] It says something of the state of mind of this voluntary patient that he started here with two masterpieces. *The Lilac Bush* (JH 1692) found its way to the Hermitage museum in Leningrad, and *Irises* (JH 1691) became even more famous. When it was sold at Sotheby's, New York, in November 1987 for almost $54 million, it became the most expensive painting ever sold at an auction.

near Paris," and, "All joking aside, the *fear* of madness is leaving to a great extent, as I see at close quarters those who are affected by it in the same way as I may very easily be in the future" (letter 592).

94
Sun over Walled Wheat Field, *the view from Vincent's room; reed pen drawing from May 1889. Black chalk, pen, brown ink, heightened with white, JH 1706, F 1728, 47.5 x 56 cm. National Museum Kröller-Müller, Otterlo, The Netherlands*

Nevertheless, what he saw around him must have been shocking. In the first letter after his arrival, he wrote incidentally to Jo, "Though here you continually hear terrible cries and howls like beasts in a menagerie, in spite of that people get to know each other very well and help each other when their attacks come on" (letter 591). In the letter to Theo of two weeks later one can read similar details. "I am again—speaking of my condition—so grateful for another thing. I gather from others that during their attacks they have also heard strange sounds and voices as I did, and that in their eyes, too, things seemed to be changing. And that lessens the horror that I retained at first of the attack I have had, and which, when it comes on you unawares, cannot but frighten you beyond measure. Once you know that it is part of the disease, you take it like anything else. If I had not seen other lunatics close up, I should not have been able to free myself from dwelling on it constantly." It is only in this letter that he reveals how terrible his condition must have been during the crises in the hospital in Arles. "There is someone here who has been shouting and talking like me *all the time* for a fortnight; he thinks he hears voices and words in the echoes of the corridors, probably because the nerves of the ear are diseased and too sensitive, and in my case it was my sight as well as my hearing, which according to what Rey told me one day is usual in the beginning of epilepsy. Well, the shock was such that it sickened me even to move, and nothing would have pleased me better than never to have woken up again."

355

Dr. Leroy's quotations provide much information about the people who were Vincent's *compagnons d'infortune* (misfortune's companions), as Vincent called them (letter 622). To begin with, there were only about ten patients in the *quartiers des Messieurs* (the gentlemen's quarters). Vincent himself had written about one of the patients: "I can sometimes chat with one of them who can only answer in incoherent sounds, because he is not afraid of me." Dr. Leroy wrote that this referred to a demented man of twenty-three who, according to the register, could indeed only produce inarticulate sounds. A second patient, who suffered from severe persecution mania and hallucinations of hearing, was a lawyer who seems to have become insane while working on his examinations. He pretended to be persecuted by the secret police and by the famous actor, Mounet-Sully, who continuously insulted him. One patient was in constant fear of being poisoned or murdered. He shouted all the time and wore his clothes in a "ridiculous" manner; he was very noisy, made terrible scenes and broke furniture and mirrors. Two others were also suffering from maniacal excitement. A patient who had arrived on 27 May, shortly after Vincent, was described by the latter in the following words: "A new man arrived, who is so worked up that he smashes everything and shouts day and night. He wildly tears his shirts too, and up till now, though he is in a bath *all day* long, he is hardly getting any quieter; he destroys his bed and everything else in his room, upsets his food, etc. It is very sad to see, but they are patient here and will pull him through in the end" (letter 593). In an earlier letter he had already written: "As these poor souls do absolutely nothing (not a book, nothing to distract them but a game of balls and a game of checkers) they have no other daily distraction than to stuff themselves with chick peas, beans, lentils, and other groceries in fixed quantities and at regular hours. As the digestion of these commodities offers certain difficulties, they fill their days in a way as inoffensive as it is cheap" (letter 592).

His description of the common hall is typical of his realistic approach and his decision to take his environment for what it was; some of Vincent's black humor even appears in the following: "The room where we stay on wet days is like a third-class waiting room of the station in a sleeping village, the more so as there are some distinguished lunatics who always wear a hat, spectacles, a cane, and a traveling cloak, almost like at a watering place, and they represent the passengers" (letter 592). His description of the furnishing of his bedroom (he had been given a second room to use as a studio) further displays his good-humored and resigned nature. "I have a little room with a greenish-gray wallpaper and two curtains of sea-green with a design of very pale roses, brightened by slight touches of blood-red. These curtains, probably the relics of some rich and ruined deceased, are very pretty in design. A worn armchair probably comes from the same source; it is upholstered with tapestry, dotted like a Diaz or a Monticelli with brown, red, pink, white, cream, black, forget-me-not blue and bottle green. Through the iron-barred window I see a square wheatfield in an enclosure, a perspective *à la* Van Goyen, above which I see the morning sun rising in all its glory (letter 592)."

Vincent always omitted the grim detail of the barred windows in his paintings. There does, however, exist a sketch

"*Through the iron-barred window I see a square wheatfield in an enclosure, a perspective à la Van Goyen, above which I see the morning sun rising in all its glory.*"

356

in which he had twice outlined the window with the forbidding iron bars as if he wanted to familiarize himself with his lack of freedom (JH 1704). Much later, in September, when he finished the sunny study of the reaper in the yellow wheatfield (JH 1773), he remarked with a kind of astonishment, "I find it queer that I saw it like this from between the iron bars of a cell" (letter 604).

The personnel of the asylum included a number of nuns. Their superior was Mrs. Deschanel, "Soeur Epiphane." According to Dr. Leroy, the mother-superior, who was still active at the monastery in the 1920's, had a clear memory of Vincent. "She was the only one," he says, "that foresaw his talent. She had even planned to ask him for a painting to decorate the common room of the nuns, but her companions had strongly opposed." Soeur Epiphane presumably told this to Dr. Leroy around 1926 when Vincent was already a famous painter, but it seems highly improbable that she would have recognized his talent in 1889.[151]

The director, Dr. Peyron.

Vincent revealed as little about the male personnel of the asylum as about the nuns. A warden is sometimes mentioned in passing. A little more is known about the head-warden whose portrait Vincent painted in September. The director, Dr. Peyron, with whom Vincent had the most important contacts, was mentioned more often. In one of the earlier letters he was described as "a little gouty man, several years a widower, with very black spectacles." Vincent added the rather matter-of-fact observation, "As the institution is rather dull, the man seems to get no great amusement out of his job, and besides he has enough to live on" (letter 593). When Vincent was to look back on the time he spent in the asylum, his opinion of Dr. Peyron was more harsh. "Certainly my last attack, which was terrible, was in large measure due to the influence of the other patients, and then prison life was crushing me, and old Peyron didn't pay the slightest attention to it, leaving me to vegetate with the rest, all deeply tainted" (letter 648). Yet, some letters also show that he was not entirely ungrateful to Dr. Peyron and did not hold a grudge against him. He told his mother: "We had words over it [he wanted to leave the institution], but we separated on good terms, and he has asked Theo for news of me. I liked him very much, and in turn he differentiated between me and his other patients in my favor" (letter 639).

In the beginning of his stay in Saint-Rémy, Vincent was not so discontented. In his long letter of 22 May, when he had been there about two weeks, he wrote, "I have a bath twice a week now, and stay in it for two hours; my stomach is infinitely better than it was two years ago; as far as I know, I just have to go on" (letter 592). He remarked two weeks later, "It's almost a whole month since I came here; not once have I had the slightest desire to be elsewhere, only the wish to work is getting a tiny bit stronger" (letter 593). With the words "to be

[151] Just as improbable is M. E. Tralbaut's romantic fantasy about Vincent and Soeur Epiphane, who in his 1969 biography, *Van Gogh le mal aimé*, reproduced Vincent's copy of the *Pietà* by Delacroix (JH 1775) with the caption: "Vincent has lent the figure of Christ his own likeness and the Mater Dolorosa that of Mme Deschanel . . . whom he wanted to honour in this way." There is not a single indication that Vincent had a special reason to be grateful to the mother-superior, and there is no question of any likeness with the photograph of Mme Deschanel (also reproduced in his book); Vincent had copied the face of the Madonna faithfully from the print after the painting by Delacroix that he had in front of him.

elsewhere" he certainly meant Paris. About Theo's living there he wrote: "It is a pity that you are always condemned to stay in Paris and that you never see the country except the immediate surroundings of Paris. I think it is not more unfortunate for me to be in the company I am in than for you to have always to do with the inevitable Goupil & Co. From this point of view we are pretty much even. For in your case you can only carry out your ideas partially. However, once we get used to these annoyances, it becomes second nature" (letter 592).

Vincent's optimism and good nature sustained him. He knew that only rest and stability in his life might cure him. "My health is all right, considering. I am happier here with my work than I could be outside. By staying here a good long time, I shall have learned regular habits and in the long run the result will be more order in my life and less susceptibility" (letter 594).

He knew that for the moment he lacked the courage to live outside the monastery. "I went once, still accompanied, to the village. The mere sight of people and things had such an effect on me that I thought I was going to faint and I fell very ill." An experience like this must have made him wonder about the mystery of everything that had happened to him, and his conclusion was far from encouraging. "It is queer that every time I try to reason with myself to get a clear idea of things, why I came here and that after all it is only an accident like any other, a terrible dismay and horror seizes me and prevents me from thinking. It is true that this is tending to diminish slightly, but it also seems to me to prove that there is quite definitely something or other deranged in my brain; my being afraid of nothing and unable to remember things is staggering" (letter 594).

It must have been an extra strain on him during these critical weeks that Theo and Jo did not at least give him the consolation of their letters. When Theo had written a short note on 8 May in connection with Vincent's departure for Saint-Rémy—"Two words in haste . . ." was the opening phrase—he waited until 21 May to write a second letter, and then until 16 June to write a third one. "It's a very long time since I ought to have written you a letter, but I have not been able to formulate my thoughts," was his apology. No wonder that Vincent, who always replied immediately after having received a letter, had already complained around 9 June, "Above all, write me soon, because your letter is very slow in coming; I hope you are all well" (letter 594). He did not hear from Jo either, despite the kind letter he had sent her in reply to the letter she wrote together with Theo on 8 May. She waited until 5 July to write again, when she wanted to be the first to tell him the important news that she was expecting a baby.

Content to remain in the monastery.

FIRST PAINTINGS

95
Wheat Field with Cypresses, *1889. Black chalk, pen, reed pen, brown ink,*
JH 1757, F 1538, 47 x 62 cm.
Vincent van Gogh Foundation / National Museum Vincent van Gogh, Amsterdam

Vincent's production at Saint-Rémy started propitiously, but slowly, considering his normal tempo. By the third week of May 1889 he had only completed "four canvases of 30, and three or four drawings." After the two canvases he had done in the first days after his arrival—the irises and a lilac bush—he continued painting in the park of the asylum. In his letter of 22 May he mentioned an important picture (JH 1693) and included a little sketch of "thick tree trunks covered with ivy, the ground covered with ivy and periwinkle." As there was a stone bench and a bush of pale roses in the shadow between the trees he described it as one of those "eternal nests of greenery for lovers." The last of the four canvases shows the garden and gives a glimpse of the building (JH 1698), a picture that is remarkably harmonious of color and composition. The drawings probably included the large sepia drawing of the fountain in the garden of the asylum (JH 1705) that has often been reproduced as a fine example of Vincent's draftsmanship.

His tempo soon increased considerably, and it is an amazing and inexplicable fact that Vincent's arrival at Saint-Rémy resulted in such an outburst of creativity in spite of the gloomy circumstances. Before mid-July—in about ten weeks—he worked on thirty-one paintings and some forty drawings in total. It is thus clear that Vincent had not given in to the life of idleness for which he pitied the other patients. More important than the number of works he had accomplished in those weeks is their quality, which can only be described as admirable. Dr. Peyron had given Vincent permission to work outside the asylum garden, as confirmed by Vincent's own letter of around 7 June in which he thanked Theo for the canvas and colors that he had sent. "I was very glad of them, for I was feeling a little low after working. Also from then on I have been working in the neighborhood for several days" (letter 594).[152] He continued, saying that he had worked on two canvases with views from the hills. One was the landscape that he saw from the window of his bedroom. "In the foreground a field of wheat, hurled to the ground by a storm, surrounded by a wall, and beyond the gray foliage of a few olive trees, some huts and the hills. Then at the top of the canvas a great white and gray cloud floating in the azure sky. It is a landscape of extreme simplicity—also of coloring." This is such a clear description that it is not difficult to identify the painting as JH 1723. Curiously enough, the canvas is not as simple as Vincent thought. The enormous cloud above the mountains lends it the strong emotional value that was to become typical of many of the paintings of the Saint-Rémy period.

The other landscape on which he was working around 9 June can also be identified easily. In a letter to his sister Wil, Vincent described it as "a field of wheat turning yellow, surrounded by blackberry bushes and green shrubs" (letter W 12). He also mentioned a little house at the end of the field and a tall dark cypress. This painting (JH 1725), which owes the liveliness of its composition to the high wheat in the foreground, makes a friendlier and more harmonious impression, heightened by the tender color combination of light green, soft yellow and light blue. Only a short time later, Vincent made two variations of this painting with the cypress tree placed not in the middle but at the extreme right hand side of the canvas (JH 1755 and 1756). They are almost identical and it would be difficult to say which is the original and which is the replica. They are still well balanced and harmonious pictures, but the turbulent skies distinguish them clearly from the earlier one.

Even more surprising are the two works that were announced in a letter from 17 or 18 June. "Finally I have a landscape with olive trees and also a new study of a starry sky" (letter 595). Behind this short sentence, two important new developments are hidden. First, it must have been his unspoken wish to make studies with olive trees, and they were indeed to become one of his main subjects of this period; he did at least fifteen pictures of olive orchards in the course of the coming half year. It is certainly not far-fetched to see in this

Thirty-one paintings and some forty drawings in ten weeks.

Working on studies with olive trees.

[152] According to several books on Van Gogh, he was always accompanied by a warden, but this seems highly improbable; there are no indications of it in any of the letters. Dr. Peyron did, however, send someone with Vincent when he went to Arles once.

theme, as many authors have, an expression of his mental state during this period. The strange forms that characterize these trees with their twisted branches must have unconsciously appealed to him by the similarity with his tormented mind. One early commentator, Meyer Schapiro, described one of these landscapes, *Olive Trees in a Mountain Landscape* (JH 1740), as follows: "Van Gogh's passionateness fills the entire landscape—ground , trees, mountains, clouds—with a tumultuous heaving motion. It is more powerful and imaginative than anything in later expressionist art, which proceeded from a similar, emotionally charged vision of nature." [153]

The other canvas, which was announced in such modest terms in the letter to Theo of 17 or 18 June, was of an even more sensational character. It was the painting *The Starry Night* (JH 1731), which was to become one of Vincent's most famous works. Not only does it occupy an exceptional place in the whole of Van Gogh's oeuvre, but it is considered to be one of the most important works in all of modern painting. Not without reason is it counted among the highlights of the collection of the Museum of Modern Art in New York. Meyer Schapiro described the landscape with olive trees and a white cloud as "more powerful and imaginative than anything in later Expressionist art," but this painting went even farther in its breach with Realism. In his book Schapiro characterized *The Starry Night* in terms that leave no doubt of the significance he attached to this work; he called it "one of the rare visionary pictures inspired by a religious mood." [154]

Vincent spoke of the work as "a new study of a starry sky" (letter 595) because a year earlier he had done a night-scene on the banks of the Rhône in Arles (JH 1592). Even there the stars show an unusual brilliance, but it is nothing compared to the eleven enormous lights with which he filled the sky in his new painting, nothing compared to the still brighter radiance on the right side of the canvas where sun and moon seem to have fused into one celestial body, nothing compared to the two masses of cloud that interlock and seem to turn around each other in a dynamic movement above the landscape. Stylistically, Vincent had never before gone so far in a fantastic and expressionist direction as in this picture, not even in the Arles period. It is startling to realize that nature in Saint-Rémy and the shocking change in his lifestyle had effected these results hardly six weeks after his arrival. The painting is without doubt the expression of an exalted mood, just as the one of the starry night in Arles from the previous September. Vincent wrote that the Arles *Starry Night* resulted "from having a terrible need of—shall I say the word?—of religion" (letter 543), but it is doubtful that he would have used that expression for the recent painting. He just mentioned it to his brother in a few words and did not even try to give any explanation, leaving that task to later commentators.[155]

Painting The Starry Night.

[153] *Vincent van Gogh* (1950), p. 108.

[154] *Ibid.*, p. 100.

[155] Heinz Graetz, for example, devoted an entire chapter of his book *The Symbolic Language of Vincent van Gogh* (1963) to this painting, pp. 197-213. A far more important and better documented study of the painting was done by professor Albert Boime in 1984: "Van Gogh's Starry Night: a History of Matter and a Matter of History," *Art Magazine*, pp. 85-103.

96
Cypresses with Two Women in the
Foreground, *1890. Black chalk, reed pen,
JH 1887, F 1525a, 31 x 23 cm.
National Museum Kröller-Müller, Otterlo,
The Netherlands*

He did realize, however, that the style of his works at this
time led him further and further away from impressionism.
Without having seen their recent work, he felt that his friends
in Brittany were doing something similar, and he was
compelled to explain to Theo: "Though I have not seen either
Gauguin's or Bernard's latest canvases, I am fairly well
convinced that these studies I've spoken of are parallel in
feeling. When you have looked at these two for some time, and
that of the ivy as well, it will perhaps give you some idea,
better than words could, of the things that Gauguin and
Bernard and I sometimes used to talk about, and which we've
thought about a good deal; it is not a return to romantic or
religious ideas, no. Nevertheless, by going the way of Delacroix,
more than is apparent, by color and a more spontaneous kind of
drawing, one could better express the purer nature of the
countryside compared with the suburbs and cabarets of Paris"
(letter 595).

Around 25 June, when he had been in Saint-Rémy for only
seven weeks, he could write to Theo, "We have had some
glorious days and I have set even more canvases going, so that
there are twelve size 30 canvases in prospect" (letter 596).

362

When one realizes that most of these paintings are now considered his masterpieces, twelve large canvases meant an extraordinary achievement, and he did not even mention the studies of a smaller format he had done in the meantime, nor the numerous drawings and sketches of the past weeks. Of the wheatfield he saw from his window alone he made a whole series of sketches in pencil, and there are also six or seven charming watercolors of trees and flowering bushes which most probably belong to the same first weeks of his stay in the asylum.

He was, of course, burning with desire to show this work to Theo, and he began to send him drawings as soon as he could. Around 17 June he sent the first roll of drawings, including "hasty sketches of the garden," probably the previously-mentioned drawings in pencil and watercolors; in late June or early July he wrote, "In order to give you an idea of what I am doing, I am sending you a dozen drawings today, all from canvases I am working on" (letter 597).[156] This last indication is important, since the canvases that were done in the first six or seven weeks in Saint-Rémy can be identified with more certainty. There are indeed ten large format drawings known (they are all ca 47 x 62 cm, something that Vincent called "a whole sheet"), including the *Wheatfield with Cypress*, *Landscape with Olive Trees*, and *The Starry Night*.

Several of these paintings and the corresponding drawings are less emotionally charged than canvases such as *The Starry Night*, but they are no less attractive or less typical of the very personal style he had developed. Many of them show his preoccupation with cypress trees, as is apparent in his 25 June letter: "The cypresses are always occupying my thoughts; I should like to make something of them like the canvases of the sunflowers, because it astonishes me that they have not yet been done as I see them. It is as beautiful in line and proportion as an Egyptian obelisk. And the green has a quality of such distinction. It is a splash of black in a sunny landscape, but it is one of the most interesting black notes, and the most difficult to hit off right that I can imagine" (letter 596).

In several of his paintings the cypresses are the dominating element. In two of them they fill almost the entire canvas (JH 1746 and 1748), and in two others the dark form of the cypresses is contrasted in a masterly way with the yellow-green of the wheat in the foreground (JH 1725 and 1755). It is also a group of cypresses that he used as a strong vertical accent against the turbulent sky of *The Starry Night*. This group of paintings must have had a great emotional value for Vincent. He even kept one for himself (JH 1748) for almost a year and then presented it to the critic Albert Aurier, who had written an important and laudatory article about him.

A canvas that was to take an exceptional place in his oeuvre was mentioned for the first time in the same letter in which Vincent digressed on the cypresses. It was one of the paintings representing the wheatfield that Vincent could see from his bedroom window, and it shows the little figure of a reaper (JH 1753; the corresponding drawing is JH 1754). "I have a wheatfield, very yellow and very light, perhaps the lightest

June 1889: Theo receives the new drawings.

The cypresses, a subject typical of the Saint-Rémy period.

156"A dozen" was probably meant as a rough indication, for in a later letter he repeated to Theo that he had sent "ten or so" (letter 603).

canvas I have yet done" (letter 596). Enumerating the studies on which he was working in his following letter, Vincent gave a few more details. "The latest one I've started is the *Wheatfield*, in which there is a little reaper and a big sun. The canvas is all yellow except for the wall and the background of violet-tinted hills" (letter 597). What he really had in mind when he painted it, he only revealed much later, in September when he worked on this canvas again and had the feeling that he finally had succeeded; it was one of the few occasions that Vincent said something about the symbolic value of his work:

> I am struggling with a canvas begun some days before my indisposition, a *Reaper*; the study is all yellow, terribly thickly painted, but the subject was fine and simple. For I saw in this reaper—a vague figure fighting like a devil in the midst of the heat to get to the end of his task—I saw in him the image of death, in the sense that humanity might be the wheat he is reaping. So it is, if you like, the opposite of the *Sower*, that painting I tried to do before. But there's nothing sad in this death, it goes its way in broad daylight with a sun flooding everything with a light of pure gold. . . .
> It is an image of death as the great book of nature speaks of it—but what I have sought is the "almost smiling." Except for a line of violet hills, it is all yellow, a pale fair yellow (letter 604).

His attachment to the theme is clear. In September he repeated the same subject in a somewhat different color scheme (JH 1773), as well as in a smaller replica for his mother and sister Wil. It haunted him even as late as November; when the canvas had been in Paris for some time, he could not refrain from asking his friend Bernard: "Have you seen a study of mine with a little reaper, a yellow wheatfield and a yellow sun? It isn't *it* yet, however, I have attacked that devilish problem of the yellows in it again" (letter B 21). The canvas with the wheatfield and the reaper may have been an example of what he meant with the term *une peinture plus consolante* (a more consoling kind of painting). It was a term that Vincent used more than once and that, significantly, also cropped up in the letter that immediately preceded the first mention of this painting. Musing about life in Paris he wrote: "We try to prove that something very different exists as well. Gauguin, Bernard and I may not live to see it, and will not conquer, but neither shall we be conquered; perhaps we do not exist for the one thing nor for the other, but to give consolation or to prepare the way for a painting that will give even greater consolation" (letter 595).

His surroundings at the asylum probably intensified his need of a "more consoling" sort of *reading*. It is therefore not accidentally that he asked Theo in this same letter to send him an edition of the collected works of Shakespeare. He knew of an edition that was very cheap and yet complete, the *Dick's shilling Shakespeare*, and in modesty he added, "In any case I do not want one that costs more than three francs." Theo complied with his request only a few days later, and in his letter of thanks Vincent reported that he had started with the series of the Kings which he had not formerly read. "It will help me not to forget the little English I know, but above all it is so great," he wrote. He also excitedly wrote to his sister Wil that he was engrossed in the Shakespeare that Theo had sent him.

The reaper is "the image of death," the sower's opposite.

Reading Shakespeare.

364

"Did you ever read *King Lear*? But never mind, I think I am not going to urge you to read such dramatic books, seeing that I myself, after reading them for some time, feel obliged to go out and look at a blade of grass, the branch of a fir tree, an ear of wheat, in order to calm down" (letter W 13). Vincent sometimes thought of his own life and of the lives of so many other workers in his profession "with a feeling of stupefaction," and felt that his enormous exertions would do little to fill the emptiness of his life in the future. He further wrote to Wil, to whom he let himself digress into gloomy contemplations: "All that is in front of us, after the years that, relatively speaking, we lost—is poverty, sickness, old age, madness, and always: exile."

In the meantime, Vincent went on with unabated energy. In the first few weeks of July he succeeded in making three more large canvases and probably several smaller ones. The large canvases were a repetition of the wheatfield behind the asylum (JH 1761), a variation of the ivy-covered trees in the garden (JH 1762), and a mountain landscape (JH 1766). The most curious, although certainly not the most attractive of the three, is the wheatfield, in which the moon rather than the sun rises above the hills. It was done in a new, experimental style, forms being indicated by small, regularly placed patches of color. The garden scene shows a similar mosaic of little squares of color, but here the new stylistic experiment resulted in a much more harmonious painting. The most imposing of the three studies is unquestionably the somber, agitated landscape in which the mountains show still stranger forms than before.

Although it was inspired by reality, there was a very special reason for Vincent to paint the mountain range that he could see from his window. In the course of June, his sisters Lies and Wil had sent him a book by the Swiss novelist Edouard Rod, which he had read without much enthusiasm. "It isn't bad," he wrote, "but the title *Le sens de la vie* is really a little too pretentious for the book, it seems to me" (letter 596). Yet reading it had caused him to make a picture of a particular motif from the story. He sent the picture to Theo in September, commenting: "They will tell you that mountains are not like that and that there are black outlines of a finger's width. But after all it seemed to me it did express the passage in Rod's book—one of the very rare passages of his in which I found something good—about a desolate country of somber mountains, in which one noticed some dark goatherds' huts and blooming sunflowers" (letter 607). The dark huts and the sunflowers depicted near the lower edge of the painting are hardly noticeable; but the huge, threatening mountain range expresses with overwhelming force *le sens de la vie*, the sense of life, as he saw it at this point of time.

Theo's Reactions

Toward the end of June 1889, Vincent informed Theo: "I still have some canvases in Arles which were not dry when I left. I very much want to go and get them one of these days in order to send them to you; there are about half a dozen" (letter 597). Less than two weeks later he wrote that he had carried out his plan, accompanied by an attendant from the asylum,

July 1889: landscape painting is in full swing.

and that he would send him the canvases he had brought from Arles the next day.

As some letters from Theo to Vincent from these months have been preserved, it is possible to get a fairly good idea of his opinion of Vincent's recent work. In several letters he had written with much appreciation but with some apprehension about Vincent's achievements, even before he had received the shipment that contained not only the last canvases from Arles, but also some of the more extreme paintings from Saint-Rémy, such as the new *Starry Night* (JH 1731). In his letter of 21 May he went into great detail about the large group of works that Vincent had sent him before his departure for Saint-Rémy. It was the first written appraisal of this kind from Theo that is known.

The paintings that Theo liked.

> Some days ago I got your consignment, which is very important; there are superb things in it. Everything arrived in good condition and without any damage. The cradle, the portrait of Roulin, the little sower with the tree, the baby, the starry night, the sunflowers and the chair with the pipe and tobacco pouch are the ones I prefer so far. The first two are very curious. Certainly there is none of the beauty in them which is taught officially, but they have something so striking and so near the truth. Who can tell whether we are more in the right than the common people who buy illustrations with glaring colors? Or rather, isn't the charm they see in them just as sensational as looking at pictures in museums is to more pretentious people? There is in your canvases a vigor which one certainly does not find in the chromos.[157] In the course of time the paint will become very beautiful, and they will undoubtedly be appreciated some day. When we see that the Pissarros, the Gauguins, the Renoirs, the Guillaumins do not sell, one ought to be almost glad of not having the public's favor, seeing that those who have it now will not have it forever, and it is quite possible that times will change very shortly (letter T 9).

Vincent was quite content with this reaction and he was not offended at the comparison with "illustrations with glaring colors"; on the contrary, he clearly agreed. "What you say about the *Berceuse* pleases me; it is very true that the common people, who are content with chromos and melt when they hear a barrel organ, are in some vague way right, and perhaps more sincere than certain men of the world who visit the Salons" (letter 592).

There was also something in his brother's paintings which Theo did not understand and which slightly alarmed him. In his following letter, dated 16 June, he tried to formulate that feeling. "Your last pictures have given me much food for thought on the state of your mind at the time you did them. In all of them there is a vigor in the colors which you have not achieved before—this in itself constitutes a rare quality—but you have gone further than that, and if there are people who seek for the symbolic by torturing the form, I find this in many of your canvases, where the expression of your thoughts on nature and living creatures shows how strongly you are attached to them. But how your brain must have labored, and

The paintings that Theo failed to understand.

[157] Chromos are cheap color illustrations.

366

how you have risked everything to the limit, where vertigo is inevitable" (letter T 10).

It was well meant, and Theo, who was not a great letter writer, expressed himself this time quite eloquently when he warned Vincent not to venture into regions that might be dangerous. "Therefore, my dear brother, when you tell me that you are working again, from one point of view I rejoice, for by this you avoid lapsing into the state of mind to which many of the poor wretches in the establishment where you are staying succumb, but it also worries me a little to think about it, for you ought not to venture into the mysterious regions which it seems one may skim cautiously but not penetrate with impunity before you recover completely." That he tried to guide Vincent back to the harmless region of simple, realistic subjects was certainly well-meant, but it did not show much artistic and psychological discernment. "Don't take more trouble than necessary, for if you do nothing more than simply tell the story of what you see, there will be enough quality in it to make your pictures last."

In his answer Vincent tried to reassure Theo, but he insightfully indicated that the heights to which his development led him were not entirely dependent on his free will. "Do not fear that I should ever of my own will rush to dizzy heights. Unfortunately we are subject to the circumstances and the maladies of our time, whether we like it or not. But with the number of precautions I am now taking, I am not likely to relapse, and I hope that the attacks will not come back" (letter 586).

It was probably Theo's enthusiasm for several of the pictures from the consignment of early May that caused him to ask Vincent whether he wanted to participate once more in an exhibition (in March 1888 he had taken part in an exhibition of the Independents with three paintings and some drawings). Vincent seemed uninterested and did not reply immediately, but in early June he wrote, "As for the exhibition of the independents, it's all the same to me, just act as if I weren't there" (letter 593). What Vincent meant was that Theo didn't have to consult with him. He added however, "So as not to seem indifferent, and not to exhibit anything too mad, perhaps the *Starry Night* [meaning the one from Arles] and the landscape with yellow vegetation [a park view from Arles], which was in the walnut frame." Theo took care of the rest, but it follows from a letter he wrote in September that instead of the park view he had chosen the irises from Saint-Rémy, a picture he particularly admired (letter T 16).

In the spring of 1889 Vincent had almost been represented at an exhibition that in later days would be considered a very important one, the Volpini exhibition. This show was organized by a small number of painters as a protesting gesture in a café on the grounds of the World Fair 1889, where they had no chance of being admitted. The initiator was Gauguin's friend Emile Schuffenecker, who discovered the Grand Café des Arts as a site for their exhibition and who persuaded the owner, the Italian Volpini, to let them use it. When Vincent read a notice about this affair in the press, he thought that Theo might have been referring to this show in his letter. "I have seen the announcement for a coming exhibition of impressionists, Gauguin, Bernard, Anquetin and other names. So I am inclined

"Venturing into mysterious regions."

The Volpini exhibition.

367

to think that a new sect has again been formed, no less infallible than those already existing. Was that the exhibition you spoke of? What a tempest in a teacup" (letter 594).

Theo's reply shows that in the meantime, without consulting Vincent, he had decided against Vincent's participation. "As you know, there is an exhibition at a café at the Exposition where Gauguin and some others (Schuffenecker) are exhibiting pictures. At first I said you would show some things too, but they assumed an air of being such tremendous fellows that it really became a bad thing to participate. . . . It gave one somewhat the impression of going to the World's Fair by the back stairs" (letter T 10).

At first, Vincent did not seem to disagree; moreover, he had his own motive for not wishing to participate. "I think you were right not to show any pictures of mine at the exhibition that Gauguin and the others had. My not being recovered is reason enough for my keeping out of it without giving them offense" (letter 595). On the other hand, it is clear that he did not want to disparage his friends. For people like Gauguin and Bernard, who had real merit, who were young and vigorous and had to live and hack out their way, it would be impossible, he said, "to turn all their canvases to the wall until it should please people to admit them into something, into the official stew." Even if he did not say it in so many words, he was actually sorry not to have participated with the rebellious little group. Some time later, when he had received the catalogue of the exhibition, he could not refrain from saying that they had been right to organize a show of their own.

97
Johanna van Gogh-Bonger shortly after her marriage.

The day before Vincent departed for Arles to retrieve the canvases he had left behind, he received a letter from Paris containing an important announcement from Jo. For the first time she wrote to Vincent in French, knowing that he preferred this. "I'll start by telling you a great piece of news, which has occupied our thoughts very much lately—next winter, toward February probably, we hope to have a baby, a pretty little boy—whom we are going to call Vincent, if you will kindly be his godfather. Of course I know we must not count on it too much, and that it may well be a little girl, but Theo and I cannot help imagining that the baby will be a boy" (letter T 11). She was concerned, however, because neither Theo nor she was in very good health, and she feared they might have a weak child.

Vincent's reply, written immediately after the receipt of this letter, could not have been kinder. He wrote extensively about

the great news and at the end of his letter he devoted a long paragraph to Theo's health.

> Jo's letter told me a great piece of news this morning. I congratulate you and am very glad to hear it. I was touched by your thought when you said that neither of you being in such good health, as seems desirable on such occasions, you felt a kind of doubt, and in any case you had a feeling of pity for the child who is to come passed through your heart.
>
> In this case, has the child been less loved, even before its birth, than the child of very healthy parents, whose first movement must have been such a joy? Certainly not. We know life so little that it is hardly in our power to distinguish right from wrong, just from unjust, and it has still to be proved that one is unfortunate because one suffers. Remember that Roulin's child came to them smiling and very healthy when the parents were in a desperate plight ...
>
> Altogether I think it is all going very well, and once more, while sharing with all my heart all possible uneasiness about Theo's health, with me the hope predominates that in his case a more or less sickly condition is only the result of nature's efforts to right herself (letter 599).

Vincent protested to their naming the baby after him, but it was a mild protest that did not cause the parents to change their plans. Furthermore, he never repeated his objection, at least not before it was too late. This was what he said about it in the same letter of 6 July: "As for being a godfather to a son of yours—to begin with it may be a daughter, and also, under the circumstances I would rather wait until I am away from here. Moreover, Mother would certainly rather set her heart on its being called after our father. I for one would think that more appropriate under the circumstances."

Vincent's reaction.

His warm reaction to the great news becomes still more evident by the fact that he wrote *a second* letter about it *on the same day*. This fact has been overlooked because that letter was erroneously placed in the various editions of the *Complete Letters*; it should have followed letter 599 immediately instead of being placed after 602. There were two reasons for sending a second letter on the same day; he had written a letter to Gauguin, which he wanted to send via Theo as usual, and he wanted to write something to Theo personally (letter 599 was addressed to both his brother and sister-in-law), as he hadn't heard from Theo since the letter of 16 June. To Theo he wrote:

> And you, old man, how are things going? Write me a few lines one of these days, for I think that the emotions which must seize the future father of a family, the emotions which our good father so liked to talk about, in your case as in his, must be great and fine. For the moment you seem to have difficulty in expressing them in the medley of the petty vexations of Paris. After all, realities of this kind must be like a good mistral, not very caressing, but purifying. I assure you it is a great pleasure to me too, and will contribute much to relieving me of my mental fatigue and, perhaps, of my indifference. After all, it is something to get back one's interest in life, when I think I am about to pass into the state of an uncle to this boy planned by your wife. I find it very funny that she feels so sure it is a boy, but that remains to be seen. Anyway, meanwhile the only thing I can do is plod a little at my pictures.

If Theo was worried about Vincent's state of mind—as he had shown when he wrote about the daring individualism of his latest paintings—it would soon become evident that his anxiety had not been unfounded. When Vincent wrote again, not more than a few days later, it was to inform Theo of his trip to Arles, which had taken place on Sunday 7 July, and of his consignment of paintings. He did not forget to refer once more to Jo's pregnancy in the warmest terms. "I expect you will be greatly absorbed by the thought of the child who is to come; I am very glad it is so. I expect that in time it will give you a good deal of inner tranquility" (letter 600). "Write me a line soon," was the last sentence. After this there was silence.

Ill Again

When Theo wrote on 16 July to thank Vincent for his latest letter and the drawings, apologizing that he hadn't done so earlier because of the overwhelming heat and his extreme tiredness, he did not receive a reply (letter T 13). It was only after he had written a second time, on 29 July, and had wired to Dr. Peyron for information around the middle of August, that what he had feared was confirmed: Vincent had suffered a breakdown around the middle of July. One can only wonder why Dr. Peyron had not warned Theo earlier. What Peyron had written to Theo is unknown, for this letter has not survived.[158]

It is certain, however, that Vincent was again the victim of hallucinations and nightmares. On 14 August Theo wrote—curiously enough in Dutch, something he had not done for a long time: "I thought it so strange not to get a letter from you that I telegraphed in order to learn if you were well. Dr. Peyron answered me in a letter that you have been ill for some days, but that you are already recovering a bit. Poor fellow, how dearly I should like to know what to do to put a stop to those *cauchemars* [nightmares]." Theo must have heard about the *cauchemars* from Dr. Peyron, but more details came from Vincent himself, and they were not encouraging. The first time Vincent was able to write to Theo after his crisis was in a letter that must be dated 22 August.[159] It was written in black crayon and begins: "I thank Jo very much for having written, and knowing that you want me to drop you a line, I must let you know that it is very difficult for me to write; my head is so disordered. So I am taking advantage of an interval. Doctor Peyron is very kind to me and very patient. You can imagine that I am terribly distressed because the attacks have come back, when I was already beginning to hope that they would not return. It would perhaps be a good thing if you wrote a few words to Dr. Peyron to tell him that working on my pictures is almost a necessity for my recovery, for these days without anything to do and without being able to go to the room they had allotted me to do my paintings, are almost unbearable" (letter 601).

[158] Earlier and later letters from Peyron to Theo are published in *Vincent*, vol. 1, nr. 2 (1971).

[159] This follows from a letter from Theo to Wil; see *Vincent*, vol. 3, nr. 2 (1974).

What he wrote about his state of mind was so depressing that part of it had been eliminated from the printed editions of the letters. The following is the text of the original manuscript: "For many days *my mind has been absolutely wandering*, as in Arles, quite as much, if not worse, and presumably the attacks will come back again in the future; it is *abominable*. For four days I have not been able to eat because of a swollen throat. I hope it is not complaining too much if I tell you these details, but I do it to show you that I am not in a condition to go to Paris or to Pont-Aven, unless it were to Charenton.[160] It seems that I pick up *des saletés* [dirt] and eat it, although my memories of those bad moments are vague, and it seems to me that there is something shady in this story; they always have I don't know what kind of prejudice against us painters."

This time the crisis lasted longer than the previous ones, and caused Vincent great concern. "I no longer see any possibility of having courage or hope, but after all, it wasn't just yesterday that we found that this job of ours wasn't a cheerful one." As to the cause of the illness, one can only speculate; only Vincent himself could reveal the facts surrounding what had happened. "This new attack, my dear brother, came on me in the fields, on a windy day, when I was busy painting. I will send you the canvas that I have finished in spite of everything."[161]

Charles Mauron, a distinguished psychoanalyst, was probably the first to forward the theory that Vincent's crises in Arles and Saint-Rémy roughly coincided with the receipt of letters announcing Theo's engagement, his marriage, Jo's pregnancy, and the birth of the child. He did this in an impressive study, "Notes sur la structure de l'inconscient chez Vincent van Gogh."[162] It was a theory that was eagerly adopted by many later authors, often formulated in less cautious terms than Mauron's. The most concise, and the fairest, rendering of his ideas may be his own summary in his 1976 book. "The equation that begins to form [in Vincent's mind] is: Theo's marriage = end of the symbiosis of the brothers = withdrawal of the money and the love = death of Vincent. This is a classic trauma at the birth of a brother."[163] In a somewhat different wording in the same book: "With a series of exact quotations one can show that during the decisive period of spring 1889 in Vincent's subconscious an equation begins to form and to structure his whole emotional life. This equation is the following: 'You marry, therefore I retire.' This is expressed in a very conscious manner, but the deeper meaning is: 'You marry, therefore I die.' "[164]

It is difficult, however, to endorse completely everything Charles Mauron believes to have found, if only because the *factual* circumstances of Vincent's life in many cases do not correspond to what Mauron imagined them to be. He wrote for

Dr. Charles Mauron's theory.

[160] Charenton was an insane asylum. Vincent's remark that he would not be able to come to Paris may also need some explanation. It is his reaction to the letter of 14 August in which Theo had written, "Remember our little guest room if you should ever think it might do you some good to be among people" (letter T 14).

[161] It was the rather small canvas *Entrance to a Quarry* (JH 1802).

[162] *Psyché*, nrs. 75-78 (January-April 1953).

[163] *Van Gogh. Etudes psychocritiques* (1976), p. 74.

[164] *Ibid.*, p. 108.

instance: *"La crise psychique du 24 décembre a eu lieu le jour même des fiançailles de Theo."* ("The psychological crisis of 24 December took place the same day as Theo's engagement")[165] That the tragedy connected with Vincent's ear occurred on 23 December and not on 24 December as Mauron says may seem irrelevant, but more importantly, at that moment Vincent had certainly not yet received Theo's announcement of his engagement. It was not something Vincent would have left unmentioned in the letter he wrote to Theo that day (letter 565), and it is even more probable that Theo had not written about it to Vincent *at all*. On 24 December he wrote about the big news to his sister Lies "as one of the first," while he was still waiting for permission from his mother and Jo's parents. Moreover, the news could hardly have been a great shock to Vincent as he had already known about Theo's plans to marry Jo Bonger for more than two years. If Theo's marriage plans were perceived by Vincent—consciously or subconsciously—as a threat to himself, then that threat must have been felt already for a long time.

As far as Jo's letter about her pregnancy is concerned, it may be assumed that it made a deep impression on Vincent. The thought that the coming event would make it more difficult for Theo to spend as much attention—and money—on him as before may certainly have caused him great anxiety. Yet, there are at least two reasons why it is difficult to see this as the principal reason for Vincent's crisis of mid-July. First, there is the unfeigned joy revealed in his reactions to the announcement of the future happy event; *consciously* at any rate there were no negative feelings at that moment. Secondly, the surprise or the shock, again, cannot have been very great. From the very first moment that Theo and Jo were married three months before, it was a matter of course to reckon with the possibility of a pregnancy.

If one looks for a direct cause for the crisis, there are much more important factors. Since the fatal happenings of December 1888, six months had passed in which Vincent had been in a very unstable condition, first in Arles, then in Saint-Rémy. It was a condition of which he was painfully aware, as in Arles his equilibrium had been so ominously disturbed several times. More recently, new tensions had thrown him into a very pessimistic mood; his letter to Wil about his outlook on the future leaves no doubt about that. The excitement resulting from the announcement of Jo's pregnancy—provided one wants to count it at all—cannot have been the only cause, and certainly not the most important cause of Vincent's mental breakdown in July 1889. Something that must have led much more directly to the crisis was Vincent's trip to Arles on 7 July, including a meeting with the Ginoux (or more specifically, with Madame Ginoux).[166]

After his trip to Arles, all creative work that had been done in Saint-Rémy had come to an end, and thus also what might

The real causes of the crisis.

[165] *Ibid.,* p. 107.

[166] Dr. Peyron did not hesitate to ascribe the crisis to the trip to Arles. "He told me," Theo said in a letter, "that, seeing that your trip to Arles provoked a crisis, it is necessary to ascertain, before you go to live elsewhere, whether you can bear a change" (letter T 18). When Vincent returned to Arles again in November 1889, it is clear that he was aware of the danger, writing: "We will wait a little first to see if this journey will provoke another attack. I almost dare to hope it won't" (letter 614).

be called the first phase of his oeuvre in Saint-Rémy. While he stayed at the monastery, his illness was to strike again a few more times, once at Christmas, when he was unable to work for a week, once more around 23 January 1890, when he was again ill for a week, and finally one month later, when a long period of illness started that was to last until the end of April 1890. The result of these ensuing illnesses was that only the second phase of Vincent's activity at Saint-Rémy, from September until December 1889, was as productive as the first had been.

98
Enclosed Field with Plowman, *sketch in letter 602 after the first painting Vincent did*
following his recovery at the end of August 1889.
Vincent van Gogh Foundation / National Museum Vincent van Gogh, Amsterdam

In this second phase of Vincent's stay in Saint-Rémy the dominant theme in his letters was his growing desire to return to the North—meaning Paris and its surroundings, and not the Netherlands. He wrote about his state of health with a moderate kind of optimism, even if he was aware of the fact that "a more violent attack might forever destroy my power to paint" (letter 605). "These last weeks I have been, as far as my health is concerned, quite good" (to his mother, 19 September, letter 606); "I feel quite normal now, and do not remember those bad days at all" (28 September, letter 608); "I am feeling well just now; I think Mr. Peyron is right when he says that I am not strictly speaking mad [something Peyron *had* said to Theo], for my mind is absolutely normal in the intervals, and even more so than before" (about 8 October, letter 610); "Fortunately those abominable nightmares have stopped tormenting me" (early November, letter 613); "I hope you are well; for myself I have nothing to complain of, I am absolutely normal, so to speak" (7 December, letter 618).

Perhaps it was because of this state of mind that life at the asylum became more and more unbearable; the loneliness in

itself must have been terrible. Although he declared in September that he hadn't been outdoors for two months, he could not bring himself to go downstairs to the communal rooms in the building. The will to recover, he wrote, made him eat like two now, work hard, and limit his relations with the other patients for fear of a relapse (letter 605). Because of this, his longing for his friends must have become even stronger. He admitted that he had "a terrible desire" to see his friends and the countryside in the North again, in spite of the enthusiasm with which he had come to the South, where he had begun to like people and things; he even spoke of *des attaches un peu trop fortes* (ties which are perhaps too strong).

He admitted that Dr. Peyron was good with him, allowing him many liberties, but added, "He is not the absolute master here—far from it." The Mother Superior and the nuns also asserted their influence at Saint-Rémy. When he compared his second crisis with his first, he had the impression that this time the attack had an external rather than an internal cause, and he wondered whether the stay in the hospital in Arles—where the nurses were also nuns—and in this "old monastery" could not have been worsened by them. "What annoys me is constantly seeing these good women who believe in the Virgin of Lourdes, and make up things like that; and to think that I am a prisoner under an administration of that sort, which willingly fosters these sickly religious aberrations, whereas the right thing would be to cure them. So I say again, better to go, if not to prison, at least into the army" (letter 605). When he returned to this point in a later letter, he explained in still clearer terms that it was the religious atmosphere that made him desire to leave. "I am astonished that with the modern ideas that I have, and being so ardent an admirer of Zola and de Goncourt and caring for things of art as I do, that I have attacks such as a superstitious man might have and that I get perverted and frightful ideas about religion such as never came into my head in the North" (letter 607).

Aversion to the religious atmosphere of the asylum.

Therefore, if ever it should be necessary for him to enter an insane asylum—Theo had suggested this in a letter of 18 September (letter T 17)—Vincent insisted that it be a secular institution (letter 607). He assured Theo, however, that he felt calm and confident enough to wait and see whether a new attack would come in the winter. It was not yet time for formal measures "as if it were a lost cause," he said, and at the end of this letter he concluded, "If there would be a fit of religious exaltation again, then no mercy, I would like to leave *at once*, without giving reasons." For the time being, nothing happened. Dr. Peyron, who had found it advisable for Vincent to stay somewhat longer, discussed it with Theo when he was in Paris in the beginning of October. Theo told Vincent about the conversation: "He says for the present you are absolutely healthy, and if it weren't for the fact that it is such a short time since you had that crisis, he would already have encouraged you to leave the establishment more often. He told me that, seeing that your trip to Arles provoked a crisis, it is necessary to ascertain, before you go to live elsewhere, whether you can bear a change. If you can stand these tests, he sees no objection to your leaving them" (letter T 18).

Dr. Peyron's opinion.

In the meantime, other plans had developed. Vincent asked Theo if he could possibly live with the painter Camille Pissarro,

who had recently lost his mother and was having trouble with his eyesight. Vincent was thinking not of his own interests, but rather of Pissarro's. "If you would pay him the same as here, he will find it worth his while, for I do not need much—just work" (letter 605). Theo had to answer, after speaking to Pissarro, that it was impractical; however, Pissarro had suggested that Vincent might find a place to live in Auvers-sur-Oise, a village North of Paris where he knew a doctor who did some painting in his spare moments, having been in contact with all the impressionists painters (letter T 18). Theo did not mention his name, but he was referring to Dr. Paul-Ferdinand Gachet, whom Vincent would indeed come to know very well.

There was soon an occasion to test Vincent as Dr. Peyron had suggested. In the beginning of October Vincent had written that he wanted to repeat the trip to Arles. In spite of Dr. Peyron's warnings, Theo was confident that it would do no harm, and in his following letter he sent 150 francs "for Mr. Peyron and for your traveling expenses to Arles" (letter T 19).[167] When Vincent handed the money to Peyron, the doctor made no objection to his going (letter 611). For some reason Vincent did not go immediately, but in a letter of 17 November he wrote:

Vincent's second trip to Arles, mid-November 1889.

> Now I must tell you that I have been to Arles and that I have seen Mr. Salles, who handed me the rest of the money you had sent him and the remainder of what I had given him, that is seventy-two francs. Nevertheless, now only about twenty francs remain in hand for Mr. Peyron, since I bought a stock of paints there and paid for the room where the furniture is, etc. I stayed there for two days, not yet knowing what to do in the future; it is a good thing to show yourself there from time to time, so that the same story doesn't start among people again. At present no one has any antipathy toward me, as far as I can see; on the contrary, they were very friendly and even *fêted* me. And if I stayed in this country, I should have a chance to acclimatize myself little by little, which is hardly easy for strangers and would have its use when painting here. But we will wait a little first to see if this journey will provoke another attack; I almost dare to hope it won't (letter 614).

There seem to have been no harmful consequences from the trip, and although a new attack followed near Christmas, it could hardly have been connected with this journey made in early November. Medically and psychologically, the explanation for Vincent's breakdowns does not become any easier.

Renewed Activity

The mysterious character of Vincent's illness made it possible for him to awaken, almost overnight, from a state of confusion and apathy to renewed activity and an astonishing lucidity that enabled him to show himself and others, in clear and well-written letters, that he was perfectly aware of what he was doing. It must have been around 1 September 1889 (about one and one half weeks after he had shown the first sign of life during his illness), that he wrote Theo a letter of seven pages

[167] Dr. Peyron had asked that some extra expenses be settled.

(letter 602). This letter's tone and content show that he had made a surprising recovery, which was confirmed by a short note Dr. Peyron wrote on the back of the last page. "Dear Sir: I add a few words to your brother's letter to inform you that he has quite recovered from his crisis, that he has completely regained his lucidity of mind, and that he has resumed painting just as he used to do. His thoughts of suicide have disappeared, only disturbing dreams remain, but they tend to disappear too, and their intensity is less great. His appetite has returned, and he has resumed his usual mode of life." The note, although optimistic about Vincent's recovery, again shows that the mental disturbance had been accompanied by suicidal tendencies, an ominous bit of information.

Vincent's own letter is most surprising in that it shows an extraordinary sketch of a landscape he had painted (it seems symbolic that it was a landscape with a rising sun). "Yesterday I began to work a little again—on a thing that I see from my window—a field of yellow stubbles that they are plowing, the contrast of the violet-tinted plowed earth with the stripes of yellow stubble, background of hills" (letter 602). Only black-and-white reproductions are available, as the present owner of the painting (JH 1768) is unknown, but there is no doubt that the canvas, made immediately after a serious breakdown, is as good as the landscapes Vincent did before the illness. Philosophizing about his state of mind at this time, Vincent wrote: "Work distracts me infinitely better than anything else, and if I could once really throw myself into it with all my energy, possibly that would be the best remedy. The impossibility of getting models, however, and a lot of other things prevent me from doing it. Altogether I must try to take things a little more passively and have patience" (letter 602). He wondered whether or not it had been wise to go to Saint-Rémy. "I think very often of the other fellows in Brittany, who are certainly busy doing better work than I do. If it were possible for me to start again with the experience I have now, I would not try to find it in the South. Were I free and independent, I should nevertheless have kept my enthusiasm, because there are some beautiful things to be done here. The vineyards, for instance, and the fields of olives. *If* I had the confidence in the management of this place, nothing would be better and simpler than to bring all my furniture here to the hospital and go quietly on."

When he wrote again a few days later, his decision was firm. One of the reasons for it was his intuition, which would prove well-founded, that he would have a new crisis around Christmas. "I will go on working very hard and then we shall see if the attack returns about Christmas, and that over, I can see nothing to stop my telling the management here to go to blazes, and returning to the North for a longer or shorter time. To leave now, when I judge a new attack next winter probable, that is to say in three months, would perhaps be too risky" (letter 604). His feelings toward the asylum had changed dramatically since he first arrived, and he no longer felt the same respect for the institution as he had in the beginning. "I'm of the opinion that one must not spare the feelings of the people of this establishment any more than of the proprietor of a hotel. We have rented a room from them for so long, and they get well paid for what they give, and that is all there is to it. Not to mention that they would perhaps like nothing better

A landscape with a rising sun.

378

than for the thing to become chronic, and we should be culpably stupid to give in to that. They inquire a great deal too much to my liking about what not only I but also you earn, and so on. So give them the go-by—without quarreling" (letter 604).

Letter 604 is one of the most important from these months, not only because Vincent vividly described the paintings he was working on (several of which are masterpieces), but also because he regained interest in other questions. He must have re-read some of Theo's letters because he mentioned subjects about which Theo had written in a letter of 16 July (letter T 12). There was, for instance, the question of storing Vincent's numerous paintings—a problem that would continue to cause serious difficulties. It is interesting to know what Theo had written in July because it shows how intimately the paint dealer Tanguy was involved in the Van Gogh brothers' life and work. It is here that one reads for the first time that Tanguy regularly exhibited Vincent's paintings in his little shop. "As from the 15th onward I no longer have the apartment in the rue Lepic at my disposal,[168] and as it is impossible to store all the canvases at home, I have rented a little room in père Tangui's[169] house, where I have put quite a few of them. I have chosen those which are to be taken from the stretchers, and the other canvases can be put on them. Père Tangui has been very helpful, and it will be easy to let him have new things all the time, which he will be able to show. You can well imagine how enthusiastic he is about the things with expressive colors, like the vine, the night effect,[170] etc. I wish you could hear him sometimes" (letter T 12). Vincent called it "a very good measure" (later he would think quite differently), provided Theo was not paying too much for it (letter 604).

Theo had written in July that Vincent's work was beginning to attract the attention of much wider circles than the small group of the Indépendants. Vincent was invited to participate in the yearly exhibition of the Brussels group "Les XX" (thus called because the group was limited to twenty artists). The active center of the group, a lawyer from Brussels named Octave Maus, had sent the invitation. Theo wrote the following about him: "The latter is the secretary of the 'XX' at Brussels. He came to ask me whether you would be willing to send in work for their next exhibition. There is plenty of time for it, but he did not not know whether he could come to Paris before the event. I told him that I did not suppose you would have any objections. He was going to invite Bernard too. In general people like the night effect and the sunflowers. I have put one of the sunflower pieces in our dining room against the mantelpiece. It has the effect of a piece of cloth with satin and gold embroidery; it is magnificent" (letter T 12). Vincent's answer was characteristically modest. "It is curious that Maus had the idea of inviting little Bernard and me for the next exhibition of the Vingtistes. I should very much like to exhibit there, though I feel my inferiority beside so many of the Belgians, who have tremendous talent . . . but I should do my best to do something good this autumn" (letter 604).

99
Vincent's studio at the asylum, probably done in October 1889. Black chalk, gouache, JH 1807, F 1528, 61.5 x 47 cm. Vincent van Gogh Foundation / National Museum Vincent van Gogh, Amsterdam

[168] Theo had moved to 8, Cité Pigalle when he married in April, but he had kept the old apartment.
[169] Theo invariably wrote Tangui instead of Tanguy.
[170] By "the night effect" Theo meant *The Starry Night* from Arles (JH 1592).

This stimulus to go on working at full speed was hardly necessary, for Vincent felt that continuous painting would keep him healthy, a point he returned to three or four times in this letter. On the one side he was optimistic, writing, "My strength is returning from day to day, and I feel that I already have almost too much," and, "Now my brain is working in an orderly fashion, and I feel perfectly normal." On the other hand he felt that a relapse was not impossible, and therefore he wrote ominous things like: "I am working in my room at full speed, it does me good and drives away, I think, these abnormal ideas"; or, "my dear brother—it is always in between my work that I write to you—I am working like one actually possessed, more than ever I am in a dumb fury of work"; or, "I am struggling with all my energy to master my work, thinking that if I succeed, that will be the best lightning-conductor for my illness" (letter 604). The high standards he maintained for himself are once more confirmed toward the end of the letter. "After another year of work I shall perhaps attain command of myself from the artistic point of view. And that is always a thing worth seeking. But for that I must have some luck." It is distressing to think that he would not live to see that year end.

Vincent's worries about the future did not prevent him from thinking of his mother, whose birthday on 10 September was nearing, and he decided to make for her as a present a copy after either the mower in the wheatfield, or another painting. He asked Theo to send him canvas as soon as possible, as he wanted to make still more small versions for his sisters. "Of course I shall work at this with as much pleasure as for the Vingtistes, and with more calm; since I have the strength, you may be sure that I am going to try to polish off some work."

He had already started to "polish off some work"; in letter 604 he describes his astonishing production in the few days since his illness. His first work had been the *Enclosed Field with Plowman* (JH 1768). At the same time he must have worked on a self-portrait, the one with the palette (JH 1770), as the description makes it easy to identify: "I was thin and pale as a ghost. It is dark violet-blue and the head whitish with yellow hair, so it is a color study." He made a second self-portrait, "for want of another model—because it is more than time I did a little figure work." This time the description is brief: "a three-quarters one on a light background,"[171] but there can be no doubt that he meant the famous self-portrait with the flaming background (JH 1772).

At the beginning of letter 604 Vincent mentioned that he had copied the painting of his bedroom. Theo had returned the study Vincent made in Arles, which had been damaged by moisture in the yellow house, and asked him to copy it. Vincent had done this, advising Theo to have it recanvased since the study was "certainly one of the best." The new painting (JH 1771) can be distinguished from the earlier one (JH 1608) only in a few details, such as the portraits on the wall.

This was not the only early study that Vincent had taken up again. "Work is going pretty well—I am struggling with a canvas begun some days before my indisposition, a reaper; the

100
The vestibule of the asylum, watercolor, done at the same time as the studio, 1889. Black chalk, gouache, JH 1806, F 1530, 61.5 x 47 cm. Vincent van Gogh Foundation / National Museum Vincent van Gogh, Amsterdam

171 The translation of this passage in the English edition of the letters is erroneous; it speaks of a "three quarter length" portrait. In French, *un portrait de trois quarts* means a three-quarter profile.

study is all yellow, terribly thickly painted, but the subject was fine and simple." The result of his new effort was painting JH 1773, which differs from the original canvas with the reaper (JH 1753) only in coloration; this time Vincent made the color of the wall and the hills somewhat deeper and the sky yellow-green instead of yellow, allowing the yellow sun—placed higher in the sky—to stand out more clearly against the green.

The last painting that Vincent started while still working on the *Reaper* was again a portrait. "Yesterday I began the portrait of the head attendant, and perhaps I shall do his wife too, for he is married and lives in a little house a few steps away from the establishment. A very interesting face; there is a fine etching by Legros, representing an old Spanish grandee; if you remember it, that will give you an idea of the type" (letter 604). The splendid portrait of the head attendant, whose name was Trabuc,[172] has been identified. It is a replica that Vincent made for Theo a few days later (JH 1774); the original, given to Trabuc, seems to have been lost.

In this one letter, therefore, he announced the following list of finished paintings: the self-portrait with the palette, the self-portrait with a light background, the repetition of the bedroom, the repetition of the wheatfield with reaper, and the portrait of Trabuc. With the landscape with the plowman, mentioned in his first letter after his illness, this accounts for six canvases painted in less than two weeks! This seems incredible, but the dates of the letters allow for no other conclusion. When Theo wrote his first letter after Vincent's illness, he dated it 5 September 1889. Vincent had not received this letter when he wrote letter 604; therefore, this letter must be of 5, perhaps 6 September at the latest. Theo did mention Vincent's letter 602 when he wrote: "The view from your window—which you give a sketch of—must be very fine." As letter 602 contains the words, "Yesterday I began work a little again," it indicates the beginning of Vincent's new activity. Letter 602 must have been written *several* days after the letter written in black crayon, dated 22 August, in which Vincent confessed that it was difficult for him to write (letter 601). It is, of course, impossible to say how much time Vincent needed to recover enough from this state of half-illness to paint a skillful picture such as the landscape with the plowman, or to write a perfectly lucid letter, such as the one in which he sketched that painting. Yet, even if we allow only four days for recovery, there remains no more than ten or eleven days for the production of the six paintings listed above—a group that includes some of his most renowned masterpieces. It was a perplexing achievement.

Vincent paints six canvases in less than two weeks!

Making Copies

Vincent was certainly right when he declared that painting was the best "lightning-conductor" for his illness (letter 604), for he was lost in his work with indescribable passion from September to December 1889. This is clear when one surveys what he accomplished during this second phase of his stay in

[172] In the Van Gogh literature the man has always been called "Trabu." Ronald Pickvance learned that the name should be spelled "Trabuc," and gave details about Trabuc and his wife in his catalogue *Van Gogh in Saint-Rémy and Auvers* (1987), p. 128.

Saint-Rémy, in which he completed some sixty paintings (among them quite a few smaller ones, it is true) and some thirty drawings.[173]

Portraits remained his ideal, but the difficulty in getting models in the asylum made it impossible to satisfy his desire for this kind of work. He did make portraits of the head attendant, Trabuc and his wife, each painted in two copies (JH 1774 and 1777). On stylistic grounds the splendid portrait of a farmer or gardener (JH 1779) can probably be added to the small group of portraits—the vigorously striped blouse, the frontal pose and spirited expression are strongly reminiscent of Trabuc's portrait, but Vincent does not mention it in any of his letters. Vincent did mention the portrait of one of the patients which he made more than a month later (JH 1832). He wrote to his mother, "It is curious that after one has been with them for some time and gotten used to them, one does not think of them as being mad anymore" (letter 612). These paintings, however, were not the only work Vincent would do in the fall.

What distinguishes Vincent's production of autumn 1889 from the previous one was that he now made a series of copies after the works of other painters. The main reason for this was that he was confined to his rooms and could not produce only self-portraits and window views. He was also prompted by a simple coincidence. A lithograph of Delacroix's *Pietà*, Vincent wrote, had fallen into some oil, and was ruined. "I was very distressed—therefore in the meantime I have been busy painting it, and you will see it someday" (letter 605). A letter to Wil shows that he wanted to hang it in his own room, though "I don't especially like to see my own paintings in my bedroom." And as he appeared to be quite content with the outcome, he immediately made a second, much smaller copy for her, "in order to give you an idea of what Delacroix is" (letter W 14). In the letter to Theo he also mentioned the smaller copy: "I made a copy of it on a size 5 or 6 canvas; I hope it has feeling" (letter 605).[174]

He soon began copying Jean-François Millet, his second great idol, of whom Theo had sent him a series of engravings entitled *Les Travaux des Champs* (the labors of the farmer). Less than two weeks after having copied the *Pietà* he told Theo, "I now have seven copies out of the ten of Millet's *Travaux des Champs*. I can assure you that making copies interests me enormously, and it means that I shall not lose sight of the figure, even though I have no models at the moment" (letter 607).

As so often when Vincent was obsessed with a new idea, he approached it with great energy and developed an extensive working program. Other models he wanted to copy were Millet's sower and diggers and his *Quatre Heures de la Journée* (the Hours of the Day), and another work by Delacroix, *The Good Samaritan*. He copied this whole group in the following months as Theo sent him engravings or photographs of the works. Several of the copies, such as *Les Travaux des Champs*, were canvases with small formats; others, such as the series

101
Sower after Millet, *painting from November 1889. Oil on canvas, JH 1836, F 689, 64 x 55 cm. State Museum Kröller-Müller, Otterlo, The Netherlands*

[173] The Hammachers must have had the wrong impression of this period when they wrote in *Van Gogh: A Documentary Biography* (1982), "He was at this time working long hours and slowly," p. 199.

[174] The large copy is JH 1775; the smaller one JH 1776.

Quatre Heures de la Journée, were quite large, but all were important studies of *color*, and as such they were more than copies, because Vincent had worked from black and white models. He was clearly aware of the fact that his copies could be seen as independent creations, and it is worthwhile to read his explicit affirmations about them to Theo:

> You will be astonished at the effect *Les Travaux des Champs* takes on in color; it is a very intimate series of his. I am going to try to tell you what I am seeking in it and why it seems good to me to copy them. We painters are always asked to *compose* ourselves and to *be nothing but composers*. So be it, but in music it isn't like that, and if some person or other plays Beethoven, he adds his personal interpretation; in music and especially in singing, the *interpretation* of a composer is something, and it is not a hard and fast rule that only the composer should play his own composition.
>
> Very well, and I, mostly because I am ill at present, I am trying to do something to console myself, for my own pleasure. I let the black and white Delacroix or Millet or something made after their work pose for me as a subject. And then I improvise color on it, not, you understand, altogether myself, but searching for memories of *their* pictures—but the memory, the vague consonance of colors which are at least right in feeling—that is my own interpretation. Many people do not copy, many others do—I for one started on it accidentally, and I find that it teaches me things, and above all it sometimes gives me consolation (letter 607).

102
Plow and Harrow after Millet, *painting from January 1890. Oil on canvas, JH 1882, F 632, 72 x 92 cm. Vincent van Gogh Foundation / National Museum Vincent van Gogh, Amsterdam*

As only eighteen paintings of the last four months were copies after other painters (he sometimes made repetitions of his own works), his own "compositions" still form the vast majority. As long as Theo supplied him with colors and canvas, he profited from the autumn effects by painting one landscape after the other. Theo did not always succeed in keeping up with his tempo, and when that happened production stagnated for some time. Vincent complained for instance around 21 November that he was at the end of his canvas. The new

consignment—ten meters of canvas—did not arrive before 7 December, and as a result he could not make even one painting in more than two weeks; a whole series of drawings in pencil of the trees in the park of the institution (JH 1809-1831) probably date to this period.

His subjects were mostly views of the park and its surroundings, for he never tired of the autumn colors that abounded. Owed to that predilection are impressive landscapes, such as a corner of the asylum and the garden with a heavy, partly sawed-off tree (JH 1849), or just the trunks and the upper branches of some pine-trees against a warm yellow sky with a setting sun, which in a way is a still more imposing picture (JH 1843). Many paintings of the park are striking because of their forcefully contrasting, even joyous colors, such as the painting that was probably done for Dr. Peyron in which a man in dark clothes is standing near the entrance (JH 1840) or the variant of this subject (JH 1799). He must have had such paintings in mind when he wrote: "I also have two views of the park and the asylum, where this place looks very pleasing. I tried to reconstruct the thing as it might have been, simplifying and accentuating the haughty, unchanging character of the pines and cedar clumps against the blue" (letter 610).

It must have been his inner unrest and insecurity that sometimes forced him to choose grim and inharmonious forms in nature, such as the entrance to the quarry, which he had painted once before in July when he was overcome by dizziness (JH 1802). Sometimes the picture is so confusing through the tangle of strange colors and forms that one hardly recognizes the subject; the painting of a brook in a ravine (JH 1803) is a case in point. The rocky path alongside a brook in the mountains which he painted twice (JH 1804 and 1871), resulted in an equally colorful, but quite unusual picture. Gauguin admired it when he saw it at Theo's place and was prepared to exchange it for any painting of Vincent's choice. He wrote about it to Vincent in a letter of April 1890,[175] in which he identified the picture by means of a little sketch. "The one I am talking about is a mountain landscape. Two very small travelers who are climbing there appear to be in search of the unknown. There is in it an emotion *à la* Delacroix with a very expressive color. Here and there red notes looking like lights, the whole in a violet note. It is beautiful and grandiose. I have talked about it for a long time with Aurier, Bernard and many others. They all compliment you."

There is much more harmony in the paintings of olive orchards, in spite of the strange forms of the trees and branches. They were a favorite theme that Vincent, after the first experiments before his illness, had taken up again with a vengeance. In these four months he made some eleven variations of it. Vincent's digressions on his motives for returning to the subject are worth reading, not only because they provide insight into his ideas about religious and aesthetic problems, but also because they show how far he had moved away from the ideas of his neo-impressionist and symbolist friends onto his own, lonely path. It began with a letter from Theo, who wrote enthusiastically about a wood sculpture he had received from Gauguin. In forwarding a letter from

The autumn colors.

Olive orchards once again become a favorite theme.

[175] Letter GAC 40 in Douglas Cooper's edition.

384

Gauguin, who had described his painting of Christ in the garden of olives, Theo wrote that Emile Bernard, whose work he had recently seen, had also depicted this subject. "A violet Christ with red hair and a yellow angel. It is very difficult to understand, and the search for style often lends the figures a ridiculous quality, but perhaps something good will come of it."

As he often did, Vincent at first agreed with Theo, but then went on, completely developing his own ideas. "If I continue, I certainly agree with you that it is perhaps better to attack things with simplicity than to seek after abstractions" (letter 614). As an example he mentioned the Christ in the garden of olives by Gauguin. He did not object to Gauguin depicting himself as Christ—for the painting was in fact a self-portrait; he did, however, loathe Bernard's picture.

Vincent prefers the realistic to the symbolic.

> And then, as for Bernard's picture, he promises me a photograph of it. I don't know, but I fear that his biblical compositions will make me long for something different. Lately I have seen women picking and gathering olives, but as I had no chance of getting a model, I have done nothing with it. However, it is not the moment to ask me to admire our friend Gauguin's composition, and our friend Bernard has probably never seen an olive tree. He is avoiding getting the least idea of the possible, or of the reality of things, and that is not the way to synthetize [Gauguin and his followers called themselves the "synthetist" group]—no, I have never gotten mixed up in their biblical interpretations. . . .
>
> If I stay here, I shall not try to paint Christ in the garden of olives, but the picking of the olives as you still see it, and further giving the figures in it the right proportions, perhaps that would make people think of it (letter 614).

He must have set out to do it immediately, because within a few days he told Theo that he had completed five paintings of olive orchards, and on size 30 canvases. In announcing their completion, he did not conceal his dislike of the recent work of his friends. "The thing is that this month I have been working in the olive groves, because their Christs in the garden, with nothing really observed, have gotten on my nerves. . . . Well, to shake that off, morning and evening these bright cold days, but with a very fine, clear sun, I have been rummaging about in the orchards, and the result is five size 30 canvases, which along with the three studies of orchards that you have, at least constitute a first attack of the problem" (letter 615).

When he finally received Bernard's photographs of Christ in the garden of olives and other paintings, he attacked him directly in a response letter. While Vincent always wrote to Bernard in a very outspoken way, his artistic ideals of the moment made him exceptionally critical.

Critical of Bernard's works.

> Thanks for your letter and especially for the photographs, which give me an idea of your work. For that matter, my brother wrote to me about it the other day and told me he liked the harmony of the colors and a certain nobility in many of the figures very much.
>
> Now look here, I am too much charmed by the landscape in the *Adoration of the Magi* to venture to criticize, but it is nevertheless too much of an impossibility to imagine a confinement like that, right on the road, the mother starting to pray instead of giving suck; then

385

there are these fat ecclesiastical frogs kneeling down as though in a fit of epilepsy, God knows how and why!

No, I can't think such a thing sound, but personally, *if* I am capable of spiritual ecstasy, I adore Truth, the possible, and therefore I bow down before that study by Millet—powerful enough to make you tremble—of peasants carrying home to the farm a calf which has been born in the fields. Now this, my friend, all people have felt from France to America; and after that you are going to revive medieval tapestries for us? Now honestly, is this a sincere conviction? No! you can do better than that, and you know you must seek after the possible, the logical, the true, even if you should have to forget the Parisian things à la Baudelaire a little. How much do I prefer Daumier to that gentleman! (letter B 21)

Although the second part of the letter may have been friendly, it is not surprising that there seem to have been no more letters from Vincent to Emile Bernard; for Bernard this had meant the end of the correspondence with Vincent.

In the five olive gardens that Vincent painted in reaction to Bernard's work (JH 1853-1857), he indeed avoided all literary or symbolic effects. His only aim was to express the special character of these trees with their old twisted trunks and their strange angular branches, twisting in all directions. He had sought after diversity in the color combinations, because apart from being variations of a particular form in nature these paintings were primarily color studies. In his letter to Bernard he described them accordingly in these words: "At present I am working among the olive trees, seeking after the various effects of a gray sky against a yellow soil, with a green-black note in the foliage; another time the soil and the foliage all of a violet hue against a yellow sky; then again a red-ocher soil and a pinkish green sky." He probably did not realize how far from reality he had moved with his strong color-contrasts (as for instance in the canvas with the yellow sky where the sun, surrounded by a dark yellow circle, stands out against clear blue mountains), nor how stylized his painting was, in which forms are suggested by heavy, isolated brush-strokes in strongly contrasting colors.

Olive gardens as color studies.

Vincent retained his interest in the subject of the olive trees for a long time. As late as the middle of December he wrote Theo that he was working on a landscape of women picking olives. He even did it in three variations, and added that he was also reproducing the picture for his mother and sister (JH 1868-1870). He had convinced himself that it was necessary to go on working without ever stopping. "It is the little job *of every day* which alone will ripen in the long run and allow one to do something truer and more complete." In other words, "We *must* work as much and with as few pretensions as a peasant if we want to last. . . . If you work diligently from nature without saying to yourself beforehand—'I want to to do this or that,' if you work as if you were making a pair of shoes, without artistic preoccupations, you will not always do well, but the days you least expect it, you find a subject which holds its own with the work of those who have gone before" (letter 615).

IN THE EYES OF THEO AND OTHERS

Theo reacted to Vincent's letter with some kind words, revealing admiration for Vincent's work: "I fully agree with you when you say in your last letter that you want to work like a cobbler; surely this will not prevent you from turning out canvases that will hold their own beside those of the masters." More and more signs of appreciation began to appear in the letters he wrote concerning the paintings Vincent continued to send. "I received your last consignment, which was in perfect condition, and which I think extremely beautiful" (letter T 13). "I like the wheatfield and the mountains enormously; they are very beautiful in design. In the wheatfield there is that unshakeable something which nature has, even in her fiercest aspects" (letter T 18). "Among the pictures there are some in which the harmony is sought in less glaring tones than you generally use; for all that there is a great deal of air in them" (letter T 21). "I received the package containing your wheatfield and the two *Bedrooms*. I particularly like the last one, which is like a bouquet of flowers in its coloring. It has a very great intensity of colors. The wheatfield has perhaps more poetry in it; it is like a memory of something one had once seen" (letter T 22). "I received your new batch last night; it is very remarkable. Do you know, one of the things I liked most is that *Evening* after Millet. Copied in such a way, it is no longer a copy. There is tone in it, and it is so full of air. It is really very successful" (letter T 24).

The fact that Theo preferred the copy after Millet is noteworthy. In May 1890 he again singled out the *copies* for praise when he had received a numerous group of paintings. "The copies after Millet are perhaps the best things you have done yet, and induce me to believe that on the day you turn to painting compositions of figures, we may look forward to great surprises" (letter T 33). It is evident that Theo had little understanding for the daring new experiments Vincent undertook, nor for those of Gauguin and his group. In June 1890 he had even tried to persuade Vincent to limit himself to simple, realistic subjects. There is an echo of Vincent's reaction to this in a letter of September, when he sarcastically wrote, "You are right a thousand times over—I must not think of all that—I must make things, even if it's only studies of cabbages and salad, to get calm, and after getting calm, then—whatever I am capable of" (letter 605).

Theo betrayed his aesthetic preferences when, having received a number of drawings from Arles and Saint-Rémy, he wrote: "I thank you for your letters and the fine drawings you sent me. The hospital at Arles is very remarkable, the butterfly and the branch of eglantine are very beautiful too; simple in color and very beautifully drawn. The last drawings give the impression of having been made in a fury, and are a bit further removed from nature" (letter T 12). The latter sentence probably refers to the drawings of *The Starry Night* and the *Olive Trees in a Mountain Landscape*. He added, "I shall understand them better when I have seen one of these subjects in painting." He must have been disappointed when he did (Vincent sent them at the end of September), for his reaction was less than positive. "It seems to me that you are stronger when you paint true things like that [meaning *Irises*], or like

103
Sketch of Theo van Gogh by his friend J.J. Isaäcson.
Vincent van Gogh Foundation / National Museum Vincent van Gogh, Amsterdam

the Stagecoach of Tarascon, or the head of a child, or the underbrush with the ivy in perpendicular format. The form is so well defined, and the whole is full of color. I feel your preoccupations in your new canvases, like the village in the moonlight [*The Starry Night*], or the mountains, but I think that the search for style is harmful to the true sentiment of things" (letter T 19).

This was partly in answer to the comments Vincent had written when sending his paintings. He must have expected that Theo would have difficulty understanding them and had tried to prepare him a little for the shock. "The Olives with a white cloud and a background of mountains, as well as the Moonrise and the night effect, are exaggerations from the point of view of arrangement, their lines are warped as in old wood-engravings.... It is only where the lines are precise and deliberate that the picture begins, even if it would be exaggerated" (letter 607).

Vincent's ideas about his paintings must have been based on his discussions about the subject with his friends, especially Gauguin. "That is more or less what Gauguin and Bernard feel; they do not ask the correct shape of a tree, but they do insist that one must be able to say if the shape is round or square—honestly, they are right, exasperated as they are by certain people's photographic and empty perfection. They will not ask the correct tone of the mountains, but they will say, By God, the mountains were blue, weren't they? Then chuck on some blue and don't go telling me that it was a blue rather like this or that; it was blue, wasn't it? Good—make them blue and that's enough!" (letter 607). These comments echo the lesson that Sérusier brought from Pont-Aven, often quoted in the literature about post-impressionism: "How do you see that tree (Gauguin had asked him somewhere in the Bois d'Amour), is it green? Put on green then, the most beautiful green of your palette; and that shadow, does it seem blue? Don't be afraid to paint it as blue as possible."

Theo did not have much appreciation for that side of Gauguin's development, but at least he thought he understood it a little. "In the last consignment of Gauguin's there is the same preoccupation as in your things, but with him there are many more reminiscences of the Japanese, the Egyptians, etc." But he sighed, "As far as I am concerned I prefer a Breton woman of the countryside to a Breton woman with the gestures of a Japanese woman, but art knows no bounds, and so one is allowed to do what one thinks one ought to do" (letter T 19).

Vincent patiently attempted to explain his views. "I do not quite know if you will like what I am doing now. For in spite of what you said in your last letter, that the search for style is often harmful to other qualities, the fact is that I feel strongly inclined to seek style, if you like, but by that I mean a more virile, more deliberate drawing. I can't help it if it makes me resemble Bernard or Gauguin more. But I am inclined to think that in the end you will come to like it" (letter 613).

Admired by Isaäcson

A man who had a much more unconditional admiration for Vincent's work than Theo was J. J. Isaäcson, a young painter

"Certain people's photographic and empty perfection."

(born in 1859) who had come to Paris with his friend Meyer de Haan in the hope of being able to work there for an extended period of time. Isaäcson wrote articles about art in an Amsterdam weekly, *De Portefeuille*, and as he had come to know Vincent's work well in Theo's house where Meyer de Haan lived since October 1888, it was only natural that he wanted to write about it at some point. In the beginning of October 1889 he had expressed the wish to do so, but Vincent's modesty and lack of self-assurance showed itself in a curious but very characteristic way. "It surprises me very much that Mr. Isaäcson wants to write an article on my studies. I would much prefer to persuade him to wait, his article would lose absolutely nothing by it, and with yet another year of work, I could—I hope—put before him some more characteristic things, with more decisive drawing, and more expert knowledge of the Provençal South" (letter 609). When he wrote again to Theo, he enclosed a letter to Isaäcson asking for this delay.

It may have surprised Vincent to hear that Isaäcson wanted to write about him, but he must have been still more surprised when he saw how Isaäcson had already introduced him to the public in Holland. Theo had sent Vincent some issues of *De Portefeuille* with articles by Isaäcson, and although Vincent showed some appreciation (he guessed the author "to be a sorrowful creature, restless, with a rare tenderness"), he could not refrain from saying, "No need to tell you that I think what he says of me in a note extremely exaggerated, and that's another reason why I should prefer him to say nothing about me."

Isaäcson had written about Vincent in the issue of 17 August 1889 in glowing terms. It is a curious manifestation of Theo's cool and matter-of-fact character that he had not written a word about it to Vincent, for wasn't the article the first printed piece—coming from abroad at that—in which so much admiration was expressed for his brother's work? Writing about the Dutch artists at the World Fair in Paris Isaäcson had asked, "Who is there to interpret in forms and colors the terrific life, the life of the 19th century that is finally becoming conscious of its own greatness?," and he had answered himself, "I know of one, a lonely pioneer; he is struggling alone in the deep night; his name, Vincent, is for posterity." In the note, to which Vincent objected in particular, Isaäcson said, "About that remarkable hero—he is a Dutchman—I hope to be able to write later." As a result of Vincent's pressure Isaäcson did not carry out his intention, but even these few words were a clear sign that for Vincent the tide was turning.

That the tide was turning was also manifested by the interest the Vingtistes in Brussels had shown for his work. Theo had transmitted the invitation to Vincent in July, but a more official one came in November in a letter from Octave Maus himself, likewise forwarded by Theo. Vincent's answer speaks for his growing self-confidence, as he proposed to Maus to exhibit no less than six large paintings. "It is with pleasure that I accept your invitation to exhibit with the Vingtistes. This is the list of canvases intended for you: 1. *Sunflowers*; 2. *Sunflowers*; 3. *Ivy*; 4. *Orchard in Bloom* (Arles); 5. *Wheatfield at Sunrise* (Saint-Rémy); 6. *The Red Vineyard* (Montmajour). All these canvases are size 30. I am perhaps exceeding the four meters of space, but as I believe that the six altogether, thus

"His name, Vincent, is for posterity."

389

selected, will present a somewhat varied color effect, perhaps you will find a way to place them. Accept, Sir, the assurance of all my sympathy for the Vingtistes" (letter 614b).

Preparing for the exhibition of the Vingtistes.

It is interesting to see that Vincent wanted to show not only the earlier paintings such as the *Sunflowers*, which according to Theo had already attracted the attention of Théo van Rysselberghe, one of the most important members of the group of the Vingtistes, but also one of his latest works. *The Wheatfield at Sunrise* (JH 1862) was a canvas he was still working on, as he had written Theo only a few days earlier (letter 614): "It shows the sun rising over a field of young wheat; lines fleeting away, furrows rising up high into the picture toward the wall of the asylum, and a row of lilac hills." It is not difficult to guess why Vincent wanted to add this picture to the group; it was an excellent example of his latest working-method, in which all the planes and forms of the subject are filled with conspicuous, unconnected squares of vigorous color.[176] It somewhat endangered his being on time with his consignment, as he continued to work on it for quite a long time and it would take some time to dry, but in the middle of December he was finally able to send it. On 3 January 1890, Theo could report that the pictures were ready in time for the exhibition (Tanguy had framed them) and that he was going to send them to Brussels (letter T 23).

Aurier's Praise

"Les isolés, Vincent van Gogh."

A short time later, at the end of January 1890, a long article on Vincent's work appeared in the first issue of a new periodical devoted to art and literature, the *Mercure de France*. Apart from the few prophetic sentences by J. J. Isaäcson in *De Portefeuille*, it was the first article ever to appear on Vincent van Gogh. Curiously enough, although Theo had evidently seen the article, "Les isolés, Vincent van Gogh"—as follows from a letter of 29 January from Jo (letter T 26)—there was not a word of comment, not a single sign of satisfaction or joy in Theo's own letter of 31 January (letter 625); again and again he appears to lack warmth and sympathy at important moments.

The author of the article was G.-Albert Aurier, a young artist who in a short time had become the spokesman of the symbolist movement, a group of writers and poets who handled language in the same experimental way as the contemporary painters did with the depiction of reality. Aurier's prose is difficult to read and almost impossible to translate adequately: "*sous des ciels tantôt taillés dans l'éblouissement des saphirs ou des turquoises, tantôt pétris de je ne sais quels soufres infernaux, chauds, délétères et aveuglants; sous des ciels pareils à des coulées de métaux et de cristaux, en fusion; où parfois, s'étalent, irradiés, de torrides disques solaires. . . .*" ("under skies, now hewn in the dazzle of sapphires or turquoises, now moulded from I don't know what kind of infernal sulphur, hot, deleterious and blinding; under skies like flows of molten metal and crystal; where sometimes torrid solar disks spread their

[176] The present whereabouts of the painting are unknown, but there is a good color reproduction of it in Meyer Schapiro's *Vincent van Gogh*. In May 1985 it was sold at an auction of Sotheby's, New York, for the record price of $9.9 million.

radiation. . . ."), and so it goes on, an endless sentence of hundreds of words. Most readers of the new *Mercure de France* will soon have given up trying to find logic and coherence in this symbolistic jargon. In this respect Vincent was not very lucky with his first interpreter, and yet—even the reader that had just hastily glanced through the text, looking for some cue sentences, must have deduced that with this totally unknown Dutchman, Vincent van Gogh, a great and surprising talent had come to light. To quote a few paragraphs:

> Such is, without exaggeration, even if one might think so, the impression that the retina receives from the first glance at the strange, intensive, and feverish works of Vincent van Gogh, that compatriot and not unworthy descendant of the old Dutch masters.
>
> I think that in the case of Vincent van Gogh, in spite of the sometimes disconcerting strangeness of his works, it is difficult to contest (if one wants to be impartial and use one's eyes) the naive truthfulness of his art, the ingenuity of his vision.
>
> What particularizes his entire oeuvre, is the excess, the excessive strength, the excessive nervousness, the violence of expression.
>
> Indeed, Vincent van Gogh is not only a great painter, delighted with his art, his palette and with nature, he is also a dreamer, an exalted believer, a devourer of beautiful utopian concepts, living on ideas and dreams.

It is hard to estimate the influence of an article of this kind, but it more or less has set the tone for much that has been written about Van Gogh after his death. People might reject his work—as they did in the first ten or twenty years—but he could not be neglected as one of the numerous insignificant, second-rate artists of his time.

Vincent's own reaction was curious. No doubt it moved him deeply that finally someone had shown complete understanding of his talent and had been willing to write about it in such glowing terms. He asked Theo if it would not be a good thing to send a copy of the article to H. G. Tersteeg, "or rather," he said on second thought, "to C. M." (letter 626). He certainly expected that it might impress people who had never shown any interest in his work. He also mentioned the art dealer Alexander Reid, revealing some sense of business: "It seems to me that we ought to take advantage of it to dispose of something in Scotland, either now or later." Paul Gauguin was also on his mind, but if he asked Theo to show him the article, it was certainly not because he wanted to boast; on the contrary, "I am going to copy my reply to M. Aurier to send to him, and you must make him read the article in the *Mercure*, for really I think they ought to say things like that of Gauguin, and of me only very secondarily" (letter 626).

He showed the same reservations when he wrote to his mother and Wil, but it was only toward his mother that he did not conceal his satisfaction with the article. "I was rather surprised at the article they wrote about me. Isaäcson wanted to do one some time ago, and I asked him not to. I was sorry when I read it, because it is so exaggerated. The problem is different—what sustains me in my work is the very feeling that there are several others doing the same thing I am, so why an article on me and not those six or seven others, etc.? But I must admit that afterward, when my surprise had passed off a little,

"Really I think they ought to say things like that of Gauguin, and of me only very secondarily."

391

I felt at times very much cheered by it" (letter 627). Under the immediate impression of the article, he had already written similar thoughts to Theo two weeks earlier. "I was extremely surprised at the article on my pictures which you sent me. I needn't tell you that I hope to go on thinking that I do not paint like that, but I do see in it how I ought to paint. For the article is very right in that it indicates the gap to be filled, and I think the author really intended to guide not only me, but the other impressionists as well, and even partly wanted to make the breach at the right place" (letter 625).

Equally characteristic is the passage in his next letter to Theo, showing that Aurier's article had reinforced his awareness that his strength lay in a way of painting that one might call "expressionistic," while on the other hand reality was what he loved most: "Aurier's article would encourage me if I dared to let myself go, and venture even further, dropping reality and making a kind of music with color, like some Monticellis. But it is so dear to me, this truth, this *trying to make true things*, and I think that after all I would still rather be a shoemaker than a musician in colors. In any case, trying to remain true is perhaps a remedy in fighting the disease which still continues to disquiet me" (letter 626).

Most important is what Vincent wrote to Aurier himself. The letter may have been somewhat colored by his ineradicable feelings of inferiority, which can also be sensed in his reactions to Theo and Wil; yet it is a remarkable example of self-analysis, carefully worded, and as characteristic of his artistic ideas as of his character. It was about a week after receiving the article— on about 2 February—that he wrote Aurier what he thought of it, with great modesty and yet with self-assurance, with much appreciation, but in essence clearly rejecting Aurier's analysis:

> Many thanks for your article in the *Mercure de France*, which greatly surprised me. I like it very much as a work of art in itself; in my opinion your words produce color. In short, I rediscover my canvases in your article, but better than they are, richer, more full of meaning. However, I feel uneasy in my mind when I reflect that what you say is due to others rather than to myself. For example, Monticelli in particular. Saying as you do, "As far as I know, he is the only painter to perceive the chromatism of things with such intensity, with such a metallic, gemlike luster," be so kind as to go and see a certain bouquet by Monticelli at my brother's—a bouquet in white, forget-me-not blue and orange—then you will feel what I want to say. . . .
> And further, I owe much to Paul Gauguin, with whom I worked in Arles for some months, and whom I already knew in Paris, for that matter. . . .
> Therefore, you will perhaps perceive that your article would have been fairer, and consequently more powerful, I think, if, when discussing the question of the future "painting of the tropics" and of colors, you had done justice to Gauguin and Monticelli before speaking of me. For the part which is allotted to me, or will be allotted to me, will remain, I assure you, very secondary (letter 626a).[177]

[177] It is surprising that Vincent also defended painters of much less importance, such as E. Quost and G. Jeannin, although it speaks for the sincerity of his admiration for some of his colleagues. He wrote of these others: "Suppose that the two pictures of sunflowers, which are now at the Vingtistes' exhibition, have certain qualities of color, and that they also express an idea symbolizing 'gratitude.' Is this different from so

He was aware that his strength lay in a way of painting that one might call "expressionistic," while reality was what he loved most.

All in all, there is no question that Vincent, in spite of his reservations, was grateful to Aurier for the attention he had devoted to his work, as is clearly shown by the fact that he promised Aurier one of his studies of cypresses. The study he sent was one of the canvases of June 1889 (JH 1748), which he had originally kept for himself, and Vincent enlivened it somewhat by adding two female figures. In speaking of the cypresses, he admitted to Aurier a phenomenon that is significant with respect to his emotional state and consequently the causes of his illness: "Until now I have not been able to do them as I feel them; the emotions that grip me in front of nature can cause me to lose consciousness, and then follows a fortnight during which I cannot work."

many flower pieces, more skilfully painted, and which are not yet sufficiently appreciated, such as the *Hollyhocks* and the *Yellow Irises* by père Quost? The magnificent bouquets of peonies which Jeannin produces so abundantly?"

104
Old Man with His Head in his Hands,
detail of the painting which Vincent did in
1890 after his own lithograph called At
Eternity's Gate. *Oil on canvas, JH 1967,*
F 702, 81 x 65 cm.
National Museum Kröller-Müller, Otterlo,
The Netherlands

In late 1889 there had been alarming news about Vincent's state of health. Around 20 December he had written to his mother and sister Wil (letters 619 and W 18),[178] but only a few days later the illness struck again. The letter to Wil shows that it wasn't completely unexpected. "It is exactly a year ago that I had that attack; I have no reason to complain much, as things are going better with me at the moment, but it is to be feared that it will come back from time to time" (letter W 18). That his illness *did* come back is shown by a letter he had written around New Year's Eve to Joseph Ginoux and his wife. "My dear friends, Mr. and Mrs. Ginoux, I do not know whether you remember—I think it rather strange that it is nearly a year since Mrs. Ginoux was taken ill at the same time as myself; and now the same thing happened again, as this year again I had a rather bad attack for several days; however it passed off very quickly; it took me less than a week. So, my dear friends, as now and then we suffer together, this makes me think of

[178] In the printed editions letter W 18 is erroneously dated January 1890; it should precede letter W 17.

what Mrs. Ginoux said: 'When you are friends, you are friends for a long time . . .' " (letter 622a).

Dr. Peyron had notified Theo of Vincent's relapse, but even before Theo had been able to react, Vincent wrote to his brother himself to give him some reassurance. In this important document, which he must have written in the first days of January 1890, Vincent reveals his attitude towards his illness. He began the letter, however, expressing his concern about *Theo*. "First of all I wish you and Jo a happy New Year and regret that I have perhaps, but quite unwillingly, caused you worry, because M. Peyron must have informed you that my mind has once more been deranged" (letter 620). What had happened was an exact repetition of what had taken place in July. "Odd that I had been working perfectly calmly on some canvases that you will soon see, and that suddenly, without any reason, the mental derangement seized me again." He did not let it depress him, though, as there was still much to do. "I am going to set to work again as soon as M. Peyron permits it; if he does not permit it, then I shall be through with this place. It is that which keeps me comparatively well balanced, and I have a lot of new ideas for new pictures."

Vincent expresses concern about Theo.

Vincent returned to work with great energy immediately after the attack. The first thing he did was send Theo a number of important pictures of the last few months, eleven in all, mostly olive orchards. Theo had advised him on 3 January to make more *drawings*, writing, "If you know that it is dangerous for you to have colors near you, why don't you clear them away for a time, and make drawings?" (letter T 23). Vincent replied immediately that he did not see the possible danger of using colors. "It is perfectly true that last year the attack returned several times—but then it was also precisely by working that my normal condition came back little by little" (letter 622).

This evidently persuaded Theo, and he ordered Tasset to send Vincent colors and canvas again, replying—perhaps having been reassured a little too easily: "When I wrote you last time I did so under the impression I received from Dr. Peyron's first letter. I am very glad to hear that things are not so bad as this letter made me believe, and he himself wrote me once more to tell me that things had turned out quite differently from the way he had expected at first. In his first letter he made it understood that it was dangerous for you to go on painting, as the colors were poison to you, but he went a little too far, which might have been due to his having relied on unverified rumors, as he himself was ill at the time" (letter T 24). In reality, Doctor Peyron's warning had not been unfounded. His final report shows that during his crisis Vincent had tried to poison himself by swallowing paint. Whether danger would have been prevented by putting away all his colors is another matter. It would certainly not have made Vincent any happier.

Because of the wintry weather it was impossible for Vincent to work outside, and so he filled his time making copies after Millet, one after the other. In November he had done *La Veillée* (The Evening) from the fourfold series *Les Heures de la Journée*; and by the middle of January he had finished the other three, *Fin de la Journée*, *La Matinée*, and *La Sieste* (The End of the Day, Morning, and Rest at Noon, JH 1835, 1880, and 1881). He then made copies after Millet's *Plow and Harrow*

A *new series of copies.*

(JH 1882) and *The First Steps* (JH 1883), all of them on size 30 canvases, so that he now had six big canvases after Millet. He also mentioned that he intended to copy *The Drinkers* by Daumier and *The Prison* by Régamey, but it was not before the beginning of February that he reported having finished these last two copies, *The Prison* by Gustave Doré having replaced the print after Régamey (letter 626).

The month of January had not left time to do much more, because Vincent had again planned to make a trip to Arles. In his letter of 4 January 1890 he also announced it to Theo. "I should very much like to go to Arles again, not immediately, but toward the end of February for instance, first of all to see my friends again, which always revives me, and then to test whether I am capable of risking the journey to Paris" (letter 622). The desire to see his friends seems to have been so great that he did not wait until the end of February, but undertook the trip in January, probably on the 20th.

At first it seemed that the trip had turned out well. Immediately after his return Vincent wrote a long letter to his sister Wil, because he had heard that she had arrived in Paris with a cold (she was going to help Jo, whose confinement was expected soon). That letter started with the words: "The other day I saw some patients suffering from influenza, and I am curious to know whether you have had it too, which I am inclined to think. I saw one sick woman who had a rather disquieting nervous complication and difficulties with the change of life" (letter W 19). Although he was concerned about Mrs. Ginoux—because it was she to whom he was referring—nothing in the letter suggests tension, and Theo, who must have read the letter to his sister, started the one he wrote to Vincent on 22 January with the words, "I am pleased to hear that you are feeling better, and that the trip to Arles was accomplished without bad consequences" (letter T 25).

Unfortunately a distressing letter arrived from Dr. Peyron dated 29 January—he had not exactly hastened to write—which revealed a different situation. "I am writing to you on behalf of Mr. Vincent, who is the victim of another attack. I therefore confirm receipt of the registered letter you sent him and of a roll of papers sent by normal mail. Mr. Vincent was getting on very well and was completely himself when last week he desired to go to Arles to see some people, and two days after he made the journey the attack took place. At present he is unable to do any work at all and only replies incoherently to any question put to him. I trust that this will pass again as it had done before."

The crisis lasted a week, but in the middle of January Vincent still felt so insecure that he thought of continuing his work in another establishment, writing Theo about an asylum in Montevergues and adding, "Now even leaving Montevergues out of it, if I return to Holland, aren't there institutions at home where one can work, and where it is not expensive and which we have a right to take advantage of?" (letter 623). Theo replied untactfully, "There is Gheel in Belgium, but I don't know what one must do to get admitted there." Had he forgotten how terribly hurt Vincent had been when their father had threatened him with the possibility of Gheel?

A trip to Arles.

397

A Child is Born

Vincent did not have much time get upset about Theo's remark, as there were more important thoughts requiring his attention. Late in the evening of Wednesday 29 January, Jo van Gogh-Bonger wrote a letter to Vincent, knowing that childbirth was near, but not that Vincent was ill; Doctor Peyron's note of the same day had not yet reached the couple. She wrote in Dutch, maybe because this time her feelings were too intimate to express them in a foreign language. The beginning of her tender and cordial letter reads:

> Ever since Christmas it has been my intention, day after day, to write to you—there is even a half-finished letter to you in my writing case—and even now, if I should not make haste to write you this letter, you might already have gotten the news that your little namesake had arrived. Before that moment, however, I want to say good night to you. It is precisely midnight—the doctor has gone to sleep for a while, for tonight he prefers to stay in the house—Theo, Mother and Wil are sitting around the table with me, awaiting future events—it is such a strange feeling—over and over again that question: will the baby be here by tomorrow morning? I cannot write much, but I do dearly want to have a chat with you—Theo brought along the article from the *Mercure* this morning, and after we read it, Wil and I talked about it for a long time—I am eager for your next letter, which Theo is anxiously awaiting too—shall I read it? So far all has gone well—I must try to be of good heart (letter T 26).

On Friday 31 January, as soon as he had received this letter, Vincent answered in terms that leave no doubts about the warmth of his feelings; exceptionally, he wrote in Dutch too. "It moves me so that you write to me and are so calm and master of yourself in one of your difficult nights. How I am longing to get the news that you have come safely through, and that your child is living. How happy Theo will be, and a new sun will rise inside him when he sees you recovering. Forgive me that I warn you that in my opinion recovery takes a long time and is no easier than being ill. Our parents knew this too, and following them in this respect might almost seem our duty. Well, I myself am also thinking of you people these days. I am feeling better, but have again had a few days like the others, when I did not know exactly what was going on, and was upset. But you see that quietness is coming back" (letter 624). Vincent did not completely avoid the painful subject of his illness, but merely touched on it with a few tactfully chosen words. Yet at the end of the letter there is one short sentence that is telling: "I do not write more as I am not yet quite calm."

Two days later there was again a letter from Paris, this time from Theo who had finally received Dr. Peyron's note. "My poor brother, I am infinitely sorry that things do not go with you as they ought to. Fortunately it did not last long the last times, and we hope most ardently that you will recover quickly this time too." (At that moment he had not yet read Vincent's letter to Jo.) The main topic of his short letter was of course news of Jo's childbirth, which had taken place on that same day, 31 January. "She has brought into the world a beautiful boy, who cries a good deal, but who looks healthy." He ended with the cordial words: "How happy I should be if after some

Vincent's namesake is born.

398

time, when Jo has recovered, you could come to see her and our little fellow. As we told you at the time, we are going to name him after you and I make the wish that he will be able to be as persevering and as courageous as you."

So much has been written about Vincent's subconscious feelings towards the new-born, that the heart-felt words with which Vincent reacted to Theo's message should be stressed. The beginning of the letter he sent to Paris on 2 February reads: "Today I received good news that you are at last a father, that the most critical time is over for Jo, and finally that the little boy is well. That has done me more good and given me more pleasure than I can put into words. Bravo—and how pleased Mother is going to be. The day before yesterday I received a fairly long and very contented letter from her too. Anyhow, here it is, the thing I have so much desired for such a long time. No need to tell you that I have often thought of you these days, and it touched me very much that Jo had the kindness to write to me the very night before" (letter 625).

In a letter to his mother around 20 February he briefly mentioned the question of the baby's name, a problem that was still on his mind. "I imagine that, like me, your thoughts are much with Jo and Theo. How glad I was when the news came that it had ended well, it was a good thing that Wil had stayed on. I should have greatly preferred him to call the boy after Father, of whom I have been thinking so much these days, instead of after me; but seeing it has now been done, I started right away to make a picture for him, to hang in their bedroom, big branches of white almond blossom against a blue sky" (letter 627). To Wil he formulated it in almost the same words. "As I write to his grandmother, these days I started to paint for him a big sky-blue canvas with blossoming branches standing out against it" (letter W 20). He also added a line, "It is possible that I shall see him soon—at least I hope so— toward the end of March."

The idea that he would have a chance of being in Paris and meeting his little nephew so soon comes as a complete surprise, but an explanation can be found in Vincent's letter to his mother, in which mention is made of an equally surprising fact: "Yesterday Theo informed me that they had sold one of my pictures at Brussels for 400 francs."[179] Curiously enough, Vincent did not seem overjoyed by this success, in spite of the fact that it was the first time—and according to many writers, also the last time—that one of his paintings was sold during his lifetime. "Compared with other prices, also those in Holland, this is little, but therefore I try to be *productive* to be able to go on making reasonable prices. And if we have to try to earn our bread with our hands, I have to make up for pretty considerable expenses" (letter 627). What it meant to him, however, becomes clear when he went on to say, "Now I am strongly inclined to take advantage of my good luck in selling this picture by going to Paris to visit Theo." It follows from a letter to Wil (letter W 20) that he had allowed himself about a month to prepare for his departure from Saint-Rémy—which he saw as definitive.

One of Vincent's paintings is sold!

[179] There is no known letter from Theo that contains this message, but he probably sent Vincent a telegram. The painting was *The Red Vineyard* (JH 1626); it was bought at the exhibition of Les XX by Anna Boch, Eugène Boch's sister and a painter herself.

As for the theory that Vincent's crises coincided roughly with the times he received the announcements of Theo's marriage and the birth of the child, it is again not supported by the facts. The last crisis did not occur immediately *after* Vincent had heard of Jo's childbirth, but immediately *before*. It is true that Vincent knew about it even before he had received the letter with the good news; the arrival in Paris of his sister was a sign that childbirth was near, and Jo herself had written in her letter of July that the baby was expected toward February (letter T 11). The thought of the future under these new circumstances may have caused him some concern in spite of the real joy his brother's happiness gave him, but even if that is true, there is no reason to connect the crises *with particular moments* between July 1889 and January 1890, as there was nothing unexpected in those events.

On the other hand, it is difficult to deny the connection between these crises and Vincent's trips to Arles. Just as in July 1889, the last attack in January 1890 occurred almost immediately after such a trip. If, however, there is such a connection, the cause doesn't seem to have been the bustle of Arles (which according to Vincent had almost made him faint in May or June 1889 (letter 594)), but rather seeing Mrs. Ginoux again. Vincent had not taken a trip to Arles prior to the crisis of Christmas 1889, but he feared that the attack of a year earlier would repeat itself at that time. He was also obsessed by the thought that a year before, Mrs. Ginoux had been ill exactly at the same time as he, something he had never mentioned before. His first thoughts after his re-convalescence were about her and it was when they had seen each other again after three weeks that he collapsed again.

A striking symptom of his preoccupation with her can be found in a letter of 2 February, when in the midst of a digression about the painting of sunflowers and cypresses, he suddenly interrupted himself with the words, "Here I stop"— and then goes on—"I am a little worried about a friend who appears to be still ill, and whom I should like to go and see; it is the one whose portrait I did in yellow and black,[180] and she had changed so much. It is nervous attacks and complications of a premature change of life, in short very painful. Last time she looked like an old grandfather. I had promised to return within a fortnight and was taken ill again myself" (letter 625).

Looking ahead, it was less than three weeks later that he started work on another portrait of her, the *Portrait of an Arlésienne*, as he called it in letters to Theo and Wil. Gauguin had painted Mrs. Ginoux in 1888 as the main figure of his version of the *Night Café*. As a preliminary study, he had first done a portrait of her in pencil, and it was this drawing that Vincent—who had evidently gotten it from Gauguin—used as a model. Just how obsessed he was with her and her portrait becomes clear when one sees that he painted no less than five versions of the new study, one after the other, differing only slightly in expression and coloring. Working at Mrs. Ginoux's portrait had been so emotional that even he ascribed to it the long illness that followed shortly later. It was not something he told Theo, but he mentioned it in a letter to Gauguin, who had

Vincent's trips to Arles and his crises.

His preoccupation with Madame Ginoux.

180 The painting "in yellow and black" was the one he had done of Marie Ginoux in November 1888, either JH 1624 or JH 1625.

400

expressed a favorable opinion about the portrait that was based on his drawing. "For my part I paid for doing it with a month of illness" (letter 643).

Fate was not to be favorably inclined towards Vincent. As he had told Theo in his letter of 2 February, the thought of the sick Mrs. Ginoux left him no peace, and he planned to pay her another visit (letter 625). In his letter to Wil, which should be dated around 20 February, he said in very definite terms, "Tomorrow or the day after I shall try to make the trip to Arles again as a kind of trial, in order to see if I can stand the strain of traveling and of ordinary life without a return of the attacks" (letter W 20).

It was a dangerous experiment. Only a few days later Theo received a short note from Dr. Peyron, dated 24 February 1890, describing the sad result. "I again confirm receiving the registered letter addressed to Mr. Vincent. He had another attack, which prevents him from writing to you and which took place after a trip to Arles. I note that the attacks are becoming more frequent and take place quite suddenly after every journey he undertakes away from this house. I do not believe he gives himself over to any excess when he is at liberty, for I have always known him sober and reserved. However, I am forced to recognize the fact that each time he undertakes a little journey he becomes ill. It will only be for a few days and he will regain his sanity as before." Some important details were added in a short postscript: "I have had to send two men with a carriage to fetch him from Arles, and it is not known where he spent the night from Saturday to Sunday. He had taken with him a painting of an Arlésienne, but it has not been found."

It can be deduced with certainty that Vincent had planned to present Mrs. Ginoux with one of the five copies he had made of her portrait. It is equally certain that he had not been able to hand it over to her, and even that he had not seen the Ginoux couple at all, otherwise Dr. Peyron would not have said that the portrait had not been found. This is confirmed by the few words that Vincent devoted to the event in the farewell letter he sent the Ginoux's two months later. "I greatly regret I fell ill on the day I came to Arles to say goodbye to you all" (letter 634a). He wrote this on 12 or 13 May, and there was to be no further opportunity to go to Arles again.

A dangerous experiment.

A Drinking Problem?

Dr. Peyron's statement, "I have always known him sober and reserved," is very important, for it raises the question that has been discussed endlessly in books and articles about Van Gogh: Did Vincent have a drinking problem? Wilfried Niels Arnold, professor of biochemistry at the University of Kansas City, recently revived the theory that his mental illness was the result of an addiction to absinthe. Professor Arnold evidently found his "discovery" important enough to publish it in two medical and scientific journals within a year.[181] No

[181] In *JAMA, Journal of the American Medical Association* (November 1988) under the title "Vincent van Gogh and the Thujone Connection" and *Scientific American* (June 1989) under the title "Absinthe."

wonder that thereupon the story about Vincent's so-called mental ruin by the use of absinthe found its way, sometimes in sensational form, into newspapers in different countries, from renowned daily papers in the United States such as the *Los Angeles Times* (November 30, 1988) to popular weeklies with very large editions as *Der Spiegel* in Germany.

In *Scientific American* professor Arnold wrote, "There is good evidence to indicate that van Gogh was addicted to absinthe, that his psychosis was exacerbated by thujone" (a chemical that is the toxic principle of absinthe), and, "in his fondness for absinthe van Gogh was by no means alone." In *JAMA* he was a little more cautious, but still wrote, "It is clear that van Gogh started drinking heavily after his arrival in Paris in 1886," and, "there are numerous anecdotes along these lines from relatives and friends." He speaks here of Vincent's "proclivity for absinthe" which, he says, is often underestimated, and he ends this article by saying that thujone was "the slow poison that probably shortened van Gogh's life."

The reality is that there is *no evidence at all* "that van Gogh was addicted to absinthe" and that there is *not a single anecdote* "along these lines" either from relatives or friends. The fact that Toulouse-Lautrec did a portrait of Vincent with a glass of absinthe in front of him (though not "partaking of a glass" as it is put in the article), or that Vincent himself did a still life with a glass of absinthe and a carafe, does not prove anything; these paintings are simply in line with the preferences of the impressionist painters, and although it is highly probable that he had an occasional glass of absinthe with his friends while in Paris, it is not very scholarly to conclude that he "was addicted to absinthe" or even that he had a "fondness for absinthe"—something that nobody could tell.

No evidence exists.

As for the anecdotes, only one mentions the word absinthe, but it has nothing to do with Vincent's stay in Paris. Florent Fels, who published a book on Vincent in 1928, tells that Signac had written him: "Never did he give me the impression of being a madman. Though he hardly ate anything, what he drank was always too much. Returning after spending the whole day in the blazing sun, in the torrid heat, and having no real home in the town, he would take his seat on the terrace of a café. And the absinthes and brandies would follow each other in quick succession." Vincent admitted that in the midsummer days in Arles, when he had spent long days painting with intense concentration in the terrible heat, the only thing that could comfort and distract him was drinking a good glass (*buvant un bon coup*) or heavy smoking (letter 507). Again, this is far from saying that he was "addicted to absinthe"—a drink, by the way, that Vincent never mentioned. Signac's words have often been quoted, but the Van Gogh literature seems to ignore that they are based on hearsay and not on something he witnessed himself, for in the summer of 1888 he was not in Arles but in Paris. What he wrote to Florent Fels may have been a free version of Vincent's own words, read in his letters (which had come out many years before 1928), or of what Vincent may have told him during his visit to Arles in March 1889.

Paul Signac's recollections.

Signac's visit to Arles is the subject of an anecdote in another biography, *Vincent van Gogh*, by Gustave Coquiot (1923), to which Signac contributed. It has been repeated in many books and is also quoted in professor Arnold's article in

JAMA. Signac's account of the visit ends with these words: "Throughout the day he spoke to me of painting, literature, socialism. In the evening he was a little tired. There had been a terrific spell of mistral, and this may have enervated him. He wanted to drink about a quart of essence of turpentine from the bottle that was standing on the table. It was high time to return to the asylum."[182] Professor Arnold's comment is: "The attempt has usually been regarded as demented but there is a chemical connection. Turpentine is extracted from sapwood of firs, pines and other conifers." It contains pinene and other terpenes which are also found in absinthe, he explains, and so even this anecdote is used to support the absinthe theory.

To rate the story at its true value two things must be kept in mind. First, the translation. It is true that the French original is a little ambiguous—"*Il voulait boire à même un litre de térébenthine qui se trouvait sur la table de la chambre*"—but the translation has made it worse. It is clear that it was not Vincent's idea to drink "a liter of turpentine." "*Boire à même la bouteille*" means "drink straight from the bottle," so what was meant here is that there was a liter bottle of turpentine on the table and that Vincent had made a gesture to drink "straight from the bottle"—something, it is hoped, Signac prevented him from doing.

Another unreliable anecdote.

But a second, and far more important question must be asked, namely whether the anecdote, told more than thirty years after the fact, is at all reliable. That Signac (or Coquiot) partly made it up becomes clear when one reads that during his visit, which took place on 23 and 24 March 1889, Vincent "had the famous bandage on, and the fur cap." The drama with the ear had happened three months earlier, and not "several days earlier" (*quelques jours auparavant*), and it is inconceivable that nearly three months after he had left the hospital Vincent would still have worn the bandage around a wound that would have healed a long time before; instead, Signac must have seen one of the two paintings where Vincent wore the bandage. What makes the whole story very suspect is that it is in complete contrast to what Signac had reported to Theo immediately after the visit—probably on request—on Sunday 24 March. Not more than two sentences need to be quoted: "I found your brother in perfect health, physically and mentally," and, "Summarizing, I assure you that I found him in a condition of perfect health and sanity" (*dans l'état le plus parfait de santé et de raison*). Is it possible that he had deliberately wanted to mislead his friend Theo van Gogh?!

What, then, can be said with certainty about Vincent's drinking problem, if that expression can be used when referring to two isolated and brief periods of his life? In September 1888, when he referred back to his move to Arles in a letter to Theo, he said that at the time he was "very distressed" (*bien, bien navré*) and "almost an alcoholic" (*presqu' alcoolique*), adding "*à force de me monter le cou*," which is difficult to translate (and therefore was left out in the American edition of the letters) but which must have meant "trying to keep myself going" (letter 544). Much earlier, in May, he had already told Theo: "If my stomach has become terribly weak, it's a trouble I picked up there [in Paris] and most likely due to the bad wine, of which I

[182] I quote from the translation of the *Complete Letters*, letter 590a.

drank too much. The wine is just as bad here, but I drink very little of it" (letter 480). Once he entered the hospital in Arles, there was no question of drinking, and so he could write in June 1889 about his "almost half a year now of absolute frugality in eating, drinking and smoking" (letter 595). During the remainder of his stay at the asylum in Saint-Rémy (until May 1890) there was no question of drinking either, although after his illness in the summer of 1889 Dr. Peyron had allowed him a little wine. Finally, according to the recollections of the inn-keeper's daughter, Adeline Ravoux (discussed later in this book), Vincent "never used alcohol" in the last few months of his life, May-July 1890.

Vincent himself realized that at the height of the summer of 1888 he sometimes drank too much, which explains why he could write to his friends Ginoux and his wife in June 1890, "It is a certain fact that I have done better work than before since I stopped drinking, and that is so much gained" (letter 640a). But Dr. Peyron, after observing Vincent for months, came to the conclusion that Vincent had not given himself over to any excess outside the asylum. Even during the three hot summer months of 1888 Vincent had been able to produce almost sixty paintings, an average of two every three days, of which many are now considered masterpieces. He himself gave the best answer to the question whether or not he was addicted to alcohol, when he said in defense of the admired painter Monticelli (also called "such a drinker"), "I'd like to see a drunkard in front of a canvas . . ."

"I'd like to see a drunkard in front of a canvas."

A Long Illness

Vincent's undertaking to go to Arles again in February 1890 had resulted in a crisis that was worse than all the preceding ones—and this time it was certainly not due to one of the events in *Theo*'s life. Despite Dr. Peyron's optimistic words about the prospect for recovery, Vincent was far from being his old self again after "a few days." Although he was capable of writing Theo a short letter after nearly three weeks, his illness had not come to an end, not by a long way. This time it lasted a full two months before Vincent had completely come to his senses and could resume work with his usual energy.

The first words he was able to write after his collapse were as follows[183]: "Today I wanted to read the letters which had come for me, but I was not yet clear-headed enough to be able to understand them. However, I am trying to answer you at once, and I hope that this will disappear in a few days. Above all I hope that you, your wife and child are well. Don't worry about me, even if this should last a bit longer, and write the same thing to those at home and give them my kindest regards" (letter 628). What Vincent did not write was that between the painting of the almond-blossom and the attack he had made a trip to Arles, the danger of which he so terribly underestimated. Theo knew about the trip, but in his answer to Vincent's letter he made no allusion to it. In his short letter of

[183] In the printed editions of the letters this note is erroneously dated "April" (in the Dutch edition, "half April"). The letter must have been written around the middle of March, because Theo's letter of 19 March (letter T 29) was meant as an answer.

19 March he restricted himself to a wish for a quick recovery, and a few sentences about Vincent's work, probably not wishing to influence his condition unfavorably and to bring him some distraction and stimulating news. There *was* good news. On 19 March the exhibition of the Indépendants had opened in Paris and gradually so much more weight was given to this progressive group that even Carnot, the president of the Republic, had been present at the exhibition.

Vincent was represented by no less than ten paintings, chosen by Theo, who had *carte blanche* because of Vincent's illness. In February Vincent had written, "As to the Impressionists' show in March, I hope to send you a few more paintings, which are drying at the moment; if they do not arrive in time, you could make a selection from the ones that are at père Tanguy's" (letter 626)

The opening was a success, and Theo related to Vincent: "I was there with Jo; your pictures are very well placed and make a good effect. Many people came to me and asked me to send their compliments. Gauguin said that your pictures were the highlight of the exhibition" (letter T 29). Theo had more good news: Gauguin had proposed an exchange of one of his paintings for one of Vincent's; Bernard and Aurier intended to come to see his latest pictures; there was a letter from Aurier, which Theo forwarded to him; and finally there was a message from Octave Maus, who wanted to let him know how glad he was of Vincent's participation in the show of the Vingtistes, where his work had met with "many lively artistic sympathies." The letter concluded: "If only you could see your little namesake you would feel happier. Try to find out from Dr. Peyron whether he sees any danger in your coming to Paris as soon as you have recovered from this crisis."

Although Vincent had expressed the hope that he could write again "tomorrow or the next day" (letter 628), there were no more letters from him, and for the time being Theo and Jo did not write either. Yet, faithful to the old Dutch custom, they could not let Vincent's birthday pass unnoticed, and so two letters with good wishes were sent to Saint-Rémy at the same time on 29 March (letters T 30 and T 31). Instead of an answer written by Vincent there came a short note from Dr. Peyron, dated 1 April, that left no doubt as to the seriousness of the situation. "I regret to inform you that Mr. Vincent has not yet regained his full clarity of mind and that for the time being he is unable to reply to your letters. This attack takes more time to wear off than the previous ones. At times one is inclined to believe that he is coming to himself; he explains the feelings he is experiencing, but a few hours later a change takes place, the patient once more becomes despondent and suspicious and replies no more to the questions put to him. I am confident that he will regain his sanity as before, but it is taking much longer this time. As soon as he feels capable to write he will let you hear from him."

Something that distinguished this long period of illness from others was the remarkable fact that Vincent had moments of comparative lucidity, such as when he wrote the letter in mid-March (letter 628). Now and then he even made drawings and paintings. He wrote about his paintings in the first letter he sent Theo after his illness. "While I was ill I nevertheless did some little canvases from memory which you will see later,

March 1890: Vincent is ill, but his work is a success in Paris.

memories from the North" (letter 629). He also told his mother and sister, and even in more detail. "I continued painting even when my illness was at its height, among other things a memory of Brabant, hovels with moss-covered roofs and beech hedges on an autumn evening with a stormy sky, the sun setting amid ruddy clouds. Also a turnip field with women gathering green stuff in the snow" (letter 629a).

The turnip field with women in the snow (JH 1923) is the largest of the paintings described here; the other canvases indicated as "memories of the North" or "of Brabant" were the small pictures of farmers' cottages at sunset, painted in exactly the same style (JH 1919-1921). They show the same tormented skies with multi-colored tattered clouds. Some of the moss-covered cottages that form the main subject of the small paintings appear in the painting of the two women. In all four there is a strange kind of insecurity in the drawing of forms, which can only be ascribed to Vincent's state of mind at that moment.

Memories of the North.

It has often been debated whether or not Vincent's illness influenced his work. While in the beginning observers maintained that his extremely personal style showed signs of mental instability (even Cézanne was supposed to have declared, when he saw Vincent's paintings at Tanguy's, "Really, yours is the work of a madman!"[184]), in later years any connection between his art and his illness has often been bluntly denied. The majority of Vincent's work seems to have been produced in periods of great lucidity, but that done during the two months in which Vincent was subject to such serious illness show the results of his unstable state. The clearness and mastery that characterize the paintings made just before the illness—paintings such as the amazingly beautiful and tender canvas with the blossoming almond-branches or the portraits of Mrs. Ginoux—have disappeared during the breakdown. The "memories of Brabant" seem to have been painted with a trembling hand; the women are strangely deformed and the cottages with their sagging roofs look like roughly kneaded clay-figures. *Two Diggers* after Millet (JH 1922), a small canvas that unquestionably belongs to the same little group of paintings done during this period of illness, shows the same deformations as the two women in the snow and lacks the sureness and the poetic force of the other copies after Millet that Vincent had made only a few weeks earlier, copies such as *The First Steps* or *The Hours of the Day.*

Most of the *drawings* he made at this point could also be called "memories of Brabant." They show the same cottages with thatched roofs as in the paintings, covered with snow. What especially lends a mentally "disturbed" appearance to these drawings are the human figures, shown here in pairs or groups, walking, digging, etc. Most of them are lanky and pitiful figures; when in some of the drawings a sower is depicted in a landscape with deep long furrows (clearly a repetition of the walled-in field behind the asylum), the figure can be described in the terms which Vincent seems to have used to describe his portrait to Gauguin: it is certainly a sower, but a sower gone mad.

[184] Related by Emile Bernard in his article on Julien Tanguy in *Mercure de France* (1908), p. 607.

Several of the sheets belonging to this sad period have been compulsively filled to the border with very small figures, something that also seems to be characteristic of a disturbed mind. Some drawings of "memories of Brabant" should be mentioned in particular, namely those that were clearly inspired by the painting *The Potato-Eaters*. There is one sketch that completely corresponds to that composition (JH 1958), but there are others that show related subjects, such as two or three farmers eating at a table. Vincent remembered the composition of the *Potato-Eaters* in such detail because he had already done the last version of that painting "from memory"; he may also have kept a copy of the lithograph which showed the composition in reverse.

Such was his preoccupation with his native country that he asked Theo in his first letter after his illness to return some of his old drawings. "Please send me what you can find of figure-studies among my old drawings. I am thinking of doing the picture *Peasants Eating, Lamplight Effect*, over again. That canvas must be quite black now, perhaps I could do it again altogether from memory. Send me especially the *Women Gleaning* and the *Diggers* if you still have some of them. Then, if you like, I will do the *Old Tower of Nuenen* again and *The Cottage*. I think that if you still have them, I could make something better of them now from memory" (letter 629). He also asked his mother and Wil in a letter if they happened to have some of his "old studies and drawings." "Even if they are not good in themselves, they may serve to refresh my memory and be the subject for new work, but I do not want those you have hanging on the walls, for instance. I should prefer sketches of peasant figures" (letter 629a).

Of all these plans nothing ever materialized, but they show how strongly during these two months of illness his mind was preoccupied with images from the past—not from a remote past, however, but from the Nuenen months, five or six years earlier. Yet one picture is reminiscent of the years spent in The Hague. This is the powerful painting of an old man sitting by the fire, holding his hands before his eyes in a desperate gesture (JH 1967). It is the exact copy of the drawing of November 1882, titled *At Eternity's Gate*, for which Vincent's favorite model, the "orphan man" with white whiskers, had posed, but the image had gained immensely by the addition of color: the light blue of the clothing against the dark yellow of the simple wicker chair and the light tints of the boarded floor and the whitewashed wall. Without losing any of the sad expressiveness of the figure, Vincent used as his main color the soft, yet clear blue in which he had clothed all the people in Millet's series, *The Labors of the Farmer*, indifferent to the fact that originally the "orphan man" was most certainly dressed in black.[185] As a model for the colorful "orphan man" he probably used the lithograph after his drawing, of which he may have had a copy in his portfolio, unless Theo had returned the original drawing. It is difficult to say when exactly this copy was made, as it is not mentioned in the letters, but one thing is certain: in no way is the painting influenced by the mental

[185] He wrote to Theo in September 1889, "You will be surprised at the effect *Les Travaux des Champs* takes on in color" (letter 607). He again had "improvised color" on the black and white of his own drawing, and again it gave him "consolation" to do that.

407

breakdown of March and April 1890, for it shows the refinement of color and the sureness of drawing of Vincent's finest works.

After receiving a reply only from Dr. Peyron to his letter of 29 March, Theo tried again on 23 April: "Your silence proves to us that you are still suffering, and I want you to know, my dear brother, that Jo and I suffer too because we know that you have not yet recovered" (letter T 32). Again he tried to cheer him up with good news about his success at the exhibition of the Indépendants. To Vincent, the most surprising piece of news may have been the fact that "Monet said that your pictures were the best of all in the exhibition," but it will also have given him much pleasure to read what Theo wrote about Serret, the painter in whose opinion he had shown so much confidence at the time of the *Potato-Eaters*: "Serret came to our house to see the other pictures, and he was enraptured. He said that if he had no style of his own in which he could still express some things, he would change his course and try what you are trying to do" (letter T 32). The former master wishing to take up the part of pupil; the tables had turned completely!

This time Theo did not wait long for a reply, and again it was a birthday that acted as a catalyst. It must have been on 29 April that Vincent felt capable of writing: "Until now I have not been able to write to you, but being a bit better just now, I must not delay wishing you a happy year, since it's your birthday, you, your wife, and child. At the same time I beg you to accept the various pictures I am sending you with my thanks for all the kindness you have shown me, for without you I should be very unhappy" (letter 629). Vincent was not quite himself again and he was certainly not very cheerful, but it is clear that in any case his lucidity had come back completely. "What am I to say about these last two months? Things didn't go well at all. I am sadder and more wretched than I can say, and I do not know at all where I have got to. . . . Mr. Peyron being away, I have not yet read my letters, but I know that some have come. He has been good enough to keep you posted on the situation, I do not know myself what to do or what to think, but I greatly wish to leave this house. That will not surprise you, I need not tell you more. Letters from home have come too, but I have not yet had the courage to read them, I feel so melancholy."

He must have been worrying about Aurier's article, as he still felt compelled to write about it now, two months later. "Please ask Mr. Aurier not to write any more articles on my painting, insist upon it that, to begin with, he is mistaken about me, and secondly, that I am too overwhelmed with grief to be able to face publicity. Making pictures distracts me, but if I hear them spoken of, it pains me more than he knows" (letter 629). He seems to have been so preoccupied with these thoughts that he could not refrain from talking about it in the letter he wrote to his mother and Wil on the same day. In the postscript he said, "As soon as I heard that my work was having some success, and read the article in question, I feared at once that I should be punished for it; this is how things nearly always go in a painter's life; success is about the worst thing that can happen" (letter 629a).

Vincent writes again at the end of August 1890.

FAREWELL TO SAINT-REMY

105
*The Raising of Lazarus, after part of an
etching by Rembrandt; painting from May
1890. Oil on canvas,
JH 1972, F 677, 48.5 x 63 cm.
Vincent van Gogh Foundation / National
Museum Vincent van Gogh, Amsterdam*

In his first letter after his illness of March and April 1890 Vincent spoke of "leaving this house" in Saint-Rémy (letter 629). He now carried through with great determination, and while he continued to paint he made the necessary preparations to leave as soon as possible. Some vague remarks in Theo's letters about a short stay with him in Paris (they are to be found in Theo's letters of 19 and 29 March) must have given Vincent the feeling that Theo had taken the initiative, and he wrote on 2 May, "Now you propose, and I accept, a return to the North" (letter 630). He had prepared the doctor for his leave: "I have talked to Mr. Peyron about the situation and I told him it was almost impossible for me to endure my lot here, and that not knowing with any clearness what line to take, I thought it preferable to return to the North." And he concluded: "If you agree and if you mention a date on which you expect me in Paris, I will have myself accompanied part of the way, either to Tarascon, or to Lyons, by someone from here. Then you could wait for me or get someone to wait for me at the station in Paris."

Theo replied immediately. He did not refuse, but declined all responsibility.

> And now what is most important in your second letter [Vincent had written two on the same day] is your telling me of your intention to come here. I am very happy that you feel strong enough to attempt a change, and I *approve absolutely* of your coming as soon as possible, but you say that you want me to fix the date of your coming. I will not venture to make a decision, for, after taking Dr. Peyron's advice, only you can bear the responsibility. Your trip to Arles was definitely disastrous; is it certain that traveling will do you no harm this time? If I were in your place I should only act in conformity with Dr. Peyron's views, and in any case as soon as you have decided to come here, it will be absolutely necessary for you to get somebody to accompany you during the *whole journey* (letter T 33).

Despite Theo's opinions, Vincent had already made his decision and the reply he sent the following day, 4 May, showed firm determination:

> Look here, I shall be very simple and as practical as possible in my reply. First, I reject categorically what you say about it being necessary to have me accompanied all the way. Once on the train I run no more risk; I am not one of those who are dangerous—even supposing an attack comes on—aren't there other passengers in the coach, and don't they know at every station what to do in such a case?
> You make yourself uneasy about this, and it weighs on me so much that it would completely discourage me.
> I have just said the same thing to Mr. Peyron, and I pointed out to him that such attacks as I have just had, were always followed by three or four months of complete quiet. I want to take advantage of this period to move—I want to move in any case, my wish to leave here is now imperative (letter 631).

He reminded Theo that six months ago he had already written that, if another breakdown should occur, he did not want to stay under the same roof.[186] He thought that a week or two at the most should be enough to prepare for moving, and he asked his brother to write to Dr. Peyron to let him go. "Mr. Peyron speaks vaguely so as to escape responsibility, he says, but we shall never see the end of it this way, never, the thing will drag on and on, and we shall end by getting angry with each other. As for me, I can't go on, I am at the end of my patience, my dear brother, I can't stand it any longer—I must make a change, even a desperate one" (letter 631).

He was no less resolute about a traveling companion. "I have tried to be patient, up till now I have done no one any harm; is it fair to have me accompanied like a dangerous beast? NO thank you, I protest." This made Theo give up his resistance. When he wrote again on 10 May, he sounded resigned. "Many thanks for your two letters; I am happy that you continue to feel better, and it would give me a great deal of pleasure if you could undertake the journey without danger. . . . If you think it so annoying to travel in the company of one of the people of the establishment, my God, you must take the risk, although I must say that I am not like you, and that if I were you I should do it to avoid all the misery that would be brought about by the recurrence of a crisis, for instance if at some unknown railway station you should fall into the hands of people you don't know, and of whom one cannot tell how they would treat you" (letter T 34).

In spite of his objections Theo enclosed in this letter 150 francs for the travel expenses and wrote to Dr. Peyron to let Vincent go according to his wishes ("provided there should not be an absolute danger"); he also said that he had ordered the paint dealers Tanguy and Tasset to send Vincent paints and canvas.

"I must make a change, even a desperate one."

186 It is amazing what Vincent was able to remember from earlier letters. He had indeed written that he did not want to stay in Saint-Rémy if he had another attack in a letter from the beginning of September 1889 (letter 604).

410

To Vincent it was the signal to make the last preparations for his departure. "The day of my departure depends on when I'm packed and have finished my canvases; I am working on the latter with such enthusiasm that packing seems to me more difficult than painting" (letter 633). Tuesday 13 May 1890 was the last day he mailed a letter to Theo from Saint-Rémy, expressing the hope that he could undertake the journey on Friday or Saturday at the latest in order to spend Sunday with his brother (letter 634). It was not without some feelings of melancholy that he left Saint-Rémy: "This morning, when I had been to the station[187] to send off my trunk, I looked at the country again after the rain, quite fresh and full of flowers— what things I could still have done!"

An Outburst of Creativity

Between the time when he first regained his lucidity at the end of April and his departure from Saint-Rémy, Vincent had painted one masterly picture after the other in quick succession, for along with a clear mind his creativity had returned with a vengeance as it had the previous September. His first letters after his breakdown, written on 29 April, made it clear that he had already resumed painting, working in the garden in Saint-Rémy. In the letter to his mother and Wil he wrote, "These last few days I have been working on the picture of a lawn in full sun with yellow dandelions" (letter 629a). On 3 May he had finished four paintings, including a second one of the same lawn and two copies after other painters.

For a good understanding of these last two paintings it is necessary to look at the preceding correspondence. On 2 May Vincent finally read the letters that had arrived for him during his illness, and he noticed with great pleasure that Theo had added a number of etchings. He wrote that he was especially grateful for an etching by Rembrandt, representing the *Raising of Lazarus*. The same day he made a painting that was inspired by the etching, showing only the central part of it (JH 1972). His letter of the following day,[188] 3 May, includes a sketch of what he had done. The picture, on which he may have worked on for some time during that day, was finished. This is what he wrote about it: "On the back of this page I have scribbled a sketch after a painting I have done of the three figures which are in the background of the etching of Lazarus: the dead man and his two sisters. The cave and the corpse are violet— yellow—white. The woman who takes the piece of cloth away from the face of the resurrected man has a green dress and orange hair, the other has black hair and a gown of striped green and pink. In the background a countryside of blue hills, a yellow sunrise. Thus the combination of colors should suggest the same thing as the chiaroscuro of the etching" (letter 632).

The finished painting is sketchily done, but it is most impressive, and it is amazing how quickly Vincent's mind and hand must have worked to react in this masterly way to the Rembrandt etching he had received. Not only did he have to

The Raising of Lazarus.

[187] The halfway station at Saint-Rémy that Vincent refers to no longer exists.
[188] In the printed editions of the letters the order of 631 and 632 is wrong. Letter 632 should be dated 3 May; letter 631 should be dated 4 May 1890.

411

improvise the colors, but he also managed to change it into a completely new composition. The etching contains many more figures and shows Christ as the main figure, rising high up in the foreground. It has been said that in Vincent's painting Christ has been replaced by the sun as Vincent's "pagan deity," but that seems to be an over-simplification. Vincent had a deep respect for the figure of Christ, and it is that respect rather than a "pagan" consideration that induced him to copy only the center of the etching and to avoid painting a figure which he held in such great esteem. In July and September of the previous year he had painted a Christ with an angel in the garden of olives, and both times he had scraped off the study; "one should not do figures of that importance without models" (see letters 505 and 540).

In his description of the painting, however, he spoke of a *rising* sun, and that suggests that he may have attached a symbolic meaning to this picture of the resurrection. It seems only natural to assume that he connected the painting with his own situation. Such a connection is further indicated by the fact that the models for the two sisters of Lazarus were in fact the two women who at that moment meant the most to him: the red-haired Mrs. Roulin and the black-haired Mrs. Ginoux. Though he did not mention their names, there can be no doubt about his models. "If I should still have at my disposal the model who posed for *La Berceuse*, and the other one whose portrait after Gauguin's drawing you have just received, I would certainly try to carry it out in a large size, this canvas, as the personalities are the characters of my dreams" (letter 632).

On 4 May, the day after his description of the *Raising of Lazarus*, Vincent did not announce new work, but he did confirm that he now had two paintings of the lawn in the park (JH 1970 and 1975), and was already thinking with joyful anticipation of everything he was going to do in the surroundings of Paris. "My work is going well, I have done two canvases of the fresh grass in the park, one of which is extremely simple; here is a hasty sketch of it. The trunk of a pine violet-pink and then the grass with white flowers and dandelions, a little rose tree and other tree trunks in the background right on the top of the canvas. Over there [meaning in Paris] I shall be in the open air a lot—I am sure that the longing for work will devour me and make me insensible to everything else, and cheerful. And I shall let things slide, not thoughtlessly, but without lapsing into regret for things that might have been" (letter 631).

Theo waited to send his reply until Saturday 10 May, and Vincent did not write either that week. He had not, however, been idle. When he wrote again on 11 or 12 May, he announced three new canvases (and they were paintings of extraordinary beauty), though this was not all that he had finished in the meantime. "At present all goes well, the whole horrible attack has disappeared like a thunderstorm and I am working with a calm and steady enthusiasm to give a few last strokes of the brush here" (letter 633). He had worked during the week on still lifes of flowers—something that was in accordance with his serene and optimistic mood, even if he put some stress on the color contrasts in one of them. "I am doing a canvas of roses with a light green background and two canvases representing big bunches of violet irises, one lot against a pink background

The paintings of the park.

412

in which the effect is soft and harmonious because of the combination of greens, pinks, violets. On the other hand, the violet bunch (ranging from carmine to pure Prussian blue) stands out against a startling citron background, with other yellow tones in the vase and the stand on which it rests, so it is an effect of tremendously disparate complementaries, which strengthen each other by their juxtaposition" (see JH 1976-1978). Hardly a day later, probably 13 May, he announced yet another still life. "I have just finished another canvas of pink roses against a yellow-green background in a green vase" (letter 634).

As he was planning to leave Saint-Rémy within a few days, he knew that he would not be able to take these new paintings with him, and he wrote to Theo, "These canvases might take a whole month to dry, but the attendant here will undertake to send them off after my departure" (letter 633). After more than a month, the canvases left behind in Saint-Rémy were forwarded to Vincent, and he gave an enumeration of them in a letter to Theo. He referred to three subjects which had not been mentioned previously, but which must also have belonged to the very last work he had done in Saint-Rémy. He certainly was not exaggerating when he wrote to his sister from Auvers, "And those last days in Saint-Rémy I still worked as in a frenzy. Great bunches of flowers, violet irises, big bouquets of roses, landscapes" (letter W 21). A passage in a letter from June identifies those paintings. "The paintings from there have now arrived; the irises are quite dry and I hope you will see something in them, and there are also roses, a wheatfield, a little canvas with mountains, and finally a cypress with a star" (letter 644).

The painting that was simply indicated as "a wheatfield" may have been the large landscape *Field with Green Wheat* (JH 1980) as it shows remarkable similarities with the painting *Road with Cypress and Star* (JH 1982) which can be identified more easily. This picture is described in a letter to Gauguin which even contains a sketch, done from memory before the paintings had arrived. "I still have from down there a cypress with a star, a last attempt; a night sky with a moon without radiance, the slender crescent barely emerging from the opaque shadow cast by the earth—one star with an exaggerated brilliance, if you like, a soft brilliance of pink and green in the ultramarine sky, across which some clouds are hurrying. Below, a road bordered with tall yellow canes, behind these the blue Alpines, an old inn with yellow lighted windows, and a very tall cypress, very straight, very somber. On the road, a yellow cart with a white horse in harness, and two late wayfarers" (letter 643). It is the perfect description of a painting whose expressionistic style is more reminiscent of the equally emotional picture *Starry Night* from June 1889 than of the harmonious flower still lifes he had also done in May 1890, and it shows in what extremely contrasting ways Vincent expressed himself as an artist in the same short period. Seen as the final picture of the eventful and troubled year in Saint-Rémy, it is certainly much more characteristic than the flower pieces, however perfect these may be as examples of Vincent's mature art.

Another of the paintings which had arrived from Saint-Rémy was described as "a little canvas with mountains." This is

The last Saint-Rémy painting: Road with Cypress and Star.

more difficult to identify, but there is every reason to believe that this was the curious picture mostly referred to as *The Evening Walk* (JH 1981). It is in the same expressionistic vein as *Road with Cypress and Star*. Although the star is missing in the small canvas, there are again the cypresses and the crescent moon and the blue range of hills in the distance. There is a great temptation to attach a symbolic meaning to the picture and to see in the figure with the red hair and red beard, being led out of the country of the olives, a self-portrayal.

A survey of the canvases which Vincent had finished between the end of April and his departure for Paris on 16 May, therefore in little more than two weeks, looks like this:

> *Field of Grass with Dandelions and Tree Trunks* (JH 1970)
> *Field of Grass with Flowers and Butterflies* (JH 1975)
> *The Raising of Lazarus* (JH 1972)
> *The Good Samaritan* (JH 1974)
> *Vase with Pink Roses* (JH 1976)
> *Vase with Violet Irises against a Yellow Background* (1977)
> *Vase with Violet Irises against a Pink Background* (JH 1978)
> *Vase with Pink Roses* (JH 1979)
> *Field with Green Wheat* (JH 1980)
> *Couple Walking in a Mountainous Landscape* (JH 1981)
> *Road with Cypress and Star* (JH 1982)
> *Old Man with his Head in his Hands* (JH 1967)—provided this picture was also done in May 1890.

Considering the short period in which they were made, not only the number of these paintings but also their superior quality is astounding.

On 16 May, Dr. Peyron made an extensive final notation in one of his registers about the patient who was leaving the institution. Once more he described the character of the patient's mental illness, using practically the same words as a year before. The end of his annotation is of greater interest; here he outlined in a few words the history of Vincent's stay in the asylum—including some distressing details:

Dr. Peyron's conclusion.

> The patient, who was calm most of the time, has experienced during his stay in the institution several attacks with a duration of a fortnight to a month; during these attacks the patient is a victim of terrible anxieties, and he has repeatedly tried to poison himself, either by swallowing the colors which he used in painting, or by drinking the petrol he had surreptitiously taken from the attendant who was filling the lamps. The last attack he has suffered, took place after he made a trip to Arles and lasted some two months. In between the attacks the patient is completely calm and lucid; he then abandons himself with passion to his painting.
>
> Today he asks for the permission to leave in order to move to the North of France, hoping that the climate there will be better for him.

Dr. Peyron noted as the date of departure 16 May 1890, and he stated the reason for Vincent's departure in one word: *Guérison* (recovered).

Arrival in Paris

Just as Vincent had expected, his journey to Paris passed without difficulties. When he arrived there in the early morning of 17 May 1890, he was met at the station by Theo. Jo, who had awaited them at home, spoke from personal experience when she wrote: "From the Cité Pigalle [where they had settled in April 1889] to the Gare de Lyons [the train station] is a long distance. It seemed an eternity before they arrived, and I was beginning to be afraid that something had happened when at last I saw an open carriage enter the Cité. Two merry faces nodded at me, two hands waved—a moment later Vincent stood before me." Luckily she described the impression her as yet unknown brother-in-law made upon her, for there is no other eye-witness account of Vincent's looks at that time, and those few lines certainly belong to the most personal and most striking of her Memoir:

> I had expected a sick person, but here was a sturdy, broad-shouldered man, with a healthy color, a smile on his face, and a very resolute appearance; of all the self-portraits, the one before the easel is most like him at that period. Apparently there had again come the sudden puzzling change in his condition that the Reverend Mr. Salles had already observed to his great surprise at Arles. "He seems perfectly well; he looks much stronger than Theo," was my first thought.
>
> Then Theo drew him into the room where the cradle stood of the little boy that had been named after Vincent. Silently the two brothers looked at the quietly sleeping baby—both had tears in their eyes. Then Vincent turned to me and said smiling, pointing to the simple crocheted cover on the cradle: "Do not cover him too much with lace, little sister."

Unfortunately, she devoted only a few sentences to the three days he spent with them in Paris:

> He stayed with us three days and was lively and cheerful all the time. Saint-Rémy was not mentioned. He went out by himself to buy olives, which he used to eat every day and which he insisted we should try too. The first morning he was up very early and was standing in his shirt sleeves looking at his pictures, of which our apartment was full. The walls were covered with them—in the bedroom, the orchards in bloom; in the dining room over the mantelpiece, the *Potato-Eaters*; in the living room (salon was too solemn a name for that cozy little room), the great landscape from Arles and the *Night View on the Rhône*. Besides, to the great despair of our *femme de ménage*, there were under the bed, under the sofa, under the cupboards in the little spare room, huge piles of unframed canvases; they were now spread out on the ground and studied with great attention. We also had many visitors, but Vincent soon perceived that the bustle of Paris did him no good, and he longed to get to work again.

Yet there are signs that not everything went so smoothly as the description seems to suggest. There are indications of friction in one of the first letters that Vincent wrote after his departure from Paris for Auvers—a letter that in the different editions has erroneously been put at the end of Vincent's stay

415

in Auvers, but should be dated 23 May—the fourth day after his departure from Paris (letter 648).[189] Vincent began the letter complaining that he had not heard anything from Theo and Jo. He realized that no financial arrangements had been made before his departure for Auvers and he did not know how to pay for his living there. Two days earlier he had warned them, "If you can send me some money toward the end of the week—what I have will last me till then, but I haven't any for a longer time" (letter 636).

He now wrote: "I think it strange that I do not in the least know under what conditions I left—if it is at 150 francs a month paid in three installments, as before. Theo fixed nothing, and so I left in confusion" (letter 648). And in the last part of the letter he repeated, not without bitterness—though this sentence is left out of the printed editions of the letters—"It makes me a little sad that I have to insist that you send me at least part of my monthly allowance from the start."

The letter makes it clear that the atmosphere in Paris had been tense. "Considering things as they are," Vincent wrote, "honestly—I think that Theo, Jo and the little one are a little on edge and worn out—and besides, I myself am also far from having reached any kind of tranquility." No wonder he asked, "Would there be a way of seeing each other again more calmly?," and that he ended his letter with the line, "I wish there were a possibility of seeing each other again soon with more collected minds" (*à têtes plus reposées*) (letter 648).

A tense atmosphere.

One of the things that had caused the unpleasantness must have been the manner in which Theo had cared for the collection of paintings. As related before, Theo had stored some of Vincent's pictures in a little room at Tanguy's. During his stay in Paris Vincent had gone to Tanguy's to have a look at his work and the condition in which it was kept there had seriously shocked him. Returning to this question he now said: "I can get a lodging, three small rooms at 150 a year. That, if I find nothing better—and I hope to find something better—is in any case preferable to the bedbug-infested hole at Tanguy's, and besides, I should find shelter for myself and could retouch the paintings that need it. In that way the pictures would be less ruined, and by keeping them in good condition, there would be a greater chance of getting some profit out of them" (letter 648).

[189] Letter 648 was written on 23 May and should have been placed between letters 636 and 637, and not with the letters written in the middle of July. The error has had the result that in many books about Van Gogh the interpretation of Vincent's feelings toward Gachet is completely wrong. With respect to the date, the first sentence of the letter is a clear indication: "Under ordinary circumstances I should certainly have hoped for a line from you *these first few days*." Jo van Gogh-Bonger must have felt that there was something wrong with her dating of the letter; knowing that the baby was not three months old in July, she changed Vincent's words *"l'enfant n'ayant que 3 mois"* to *"l'enfant n'ayant que 6 mois."*

AUVERS-SUR-OISE AS A REFUGE

106
Houses at the Village of Auvers-sur-Oise, *watercolor from May 1890. Pencil, washed, blue watercolor, JH 1986, F 1640, 45 x 54.5 cm.*
Vincent van Gogh Foundation/National Museum Vincent van Gogh, Amsterdam

Vincent left Paris for Auvers-sur-Oise on 20 May 1890. The main reason Camille Pissarro had suggested the small village as a temporary home was the fact that Dr. Gachet lived here, but it was also because of its quiet, pastoral situation on the river Oise that Auvers had a certain reputation among painters. Pissarro himself had worked here in the seventies, while he was living in the neighboring village of Pontoise. Charles Daubigny had possessed a villa with a large garden in Auvers from 1861 until his death in 1878, and Cézanne and other painters whom Vincent admired had also worked here.

Not surprisingly, Vincent felt at home immediately. The day after he arrived he wrote to Theo and Jo, "Auvers is very beautiful, among other things a lot of old thatched roofs, which are getting rare. . . . It is the real country, characteristic and picturesque" (letter 635). The next day he painted a study of one of these houses with thatched roofs, "with a field of peas in flower in the foreground and some wheat, behind it the hills"

(JH 1984), and he repeated, "Auvers is decidedly very beautiful" (letter 636). With great enthusiasm he started depicting these cottages and other motifs from the village. On the third day of his stay he was already able to report, "I am very well these days, I am working hard, have four painted studies and two drawings" (letter 648). He was especially fascinated by spring motifs, and he announced two new works within two more days: "a study of pink chestnuts and one of white chestnuts," two very expertly painted pictures of the trees in the village (letter 637).

Early in his stay Vincent made the acquaintance of the doctor who had been so warmly recommended to him, but his first impressions were disappointing. "I have seen Dr. Gachet, who gives me the impressions of being rather eccentric, but his experience as a doctor must keep him balanced enough to combat the nervous trouble from which he certainly seems to be suffering at least as seriously as I" (letter 635). Yet he also wrote: "His house is full of old things, black, black, black, except for the impressionist paintings I mentioned [Pissarro's and Cézanne's]. Although he's a strange little fellow, the impression I got of him is not unfavorable. When he spoke of Belgium and the old painters [Gachet was born in Rijsel, in the north of France], his grief-hardened face grew smiling again, and I really think that I shall go on being friends with him and that I shall do his portrait" (letter 635).

Paul-Ferdinand Gachet (1828-1909) was certainly even more eccentric than Vincent could have guessed when he first met him. As a physician he was interested in methods considered extremely modern for those days. In the book *La folie de Vincent van Gogh,* one of the two authors, Dr. Victor Doiteau, who had also written extensively about Gachet in the medical journal *Aesculape,* sums up his opinion of Gachet as follows: "In medicine he was a renewer, as he was in art. He practiced homeopathic theories and was one of the first to use electricity in the treatment of illnesses."[190] He still had a practice in Paris a few days a week, but the rest of the time he spent in his large villa in Auvers-sur-Oise, where he also painted and made etchings, which he printed on his own press.

It worried Vincent that Gachet was neurotic as well as eccentric, as he suspected during their first meeting, and a few days later he said so in plain words. "I think we must not count on Dr. Gachet *at all.* First of all, he is more sick than I am, I think, or shall we say just as much, so that's that. Now when one blind man leads another blind man, don't they both fall into the ditch?" (letter 648). This opinion, however, was based upon first impressions, for Vincent had not found the doctor at home when he went to see him the next day. The next Sunday, 25 May, they met again, and this meeting made Vincent change his mind almost completely. To Theo he wrote: "Today I saw Dr. Gachet again, and I am going to paint at his house on Tuesday morning; then I shall dine with him, and afterward he will come to see my work. He seems very reasonable, but he is as discouraged about his job as a doctor as I am about my painting. Then I told him that I would gladly swap jobs with

Meeting Dr. Gachet.

190 *La folie de Vincent van Gogh* (1928), p. 83. See also "La curieuse figure de Dr. Gachet," *Aesculape* (August 1923-January 1924).

him. Anyway, I am ready to believe that I shall end up being friends with him" (letter 637).

It was fortunate for Vincent that he could paint at Gachet's house, which he seems to have done regularly in the next two months, because at the inn of Gustave Ravoux, where he had settled in, he had only a very small room with a dormer-window on the third floor, with little room to work. On the day of his arrival, Dr. Gachet had "piloted" him to a better inn, but the six francs a day they charged there Vincent considered too much for him—understandably, considering that his allowance was 150 francs a month (letter 635). Ravoux had taken him in for three and one half francs a day, and in the letters from Auvers he never complains about his lodgings. Yet it is probably the result of his restricted housing that practically all the paintings he did in Auvers are landscapes; the exceptions are a few portraits which he could do at the homes of the sitters. There was a sudden end to the long series of copies after prints, which in Saint-Rémy he had completed in his room.

Vincent finds a room at Ravoux's inn.

At Work at Dr. Gachet's

A week went by in which his contacts with Dr. Gachet gave Vincent a better understanding of his host. After numerous discussions about art, they discovered common sympathies. "He happens to have known Brias of Montpellier and has the same idea of him that I have, that there you have someone significant in the history of modern art." And so he could now wholeheartedly say, "we are great friends already." There was a side of his friendship with Gachet that he found unpleasant. The doctor evidently was not exactly frugal, despite his preference for modern healing methods. When Vincent reported to Theo Gachet's opinion that Theo and Jo (who had to feed the weak baby) should eat well, it must have been with horror that he added, "he talks of taking two liters of beer etc., in those quantities." Vincent was also not pleased with dining at Gachet's. "But till now, though it is pleasant to do a picture there, it is rather a burden for me to dine and lunch there, for the excellent man takes the trouble of having four- and five-course dinners prepared, which is as dreadful for him as for me—for he certainly hasn't a strong digestion."

Except for this small inconvenience, however, the arrangement with Gachet had many advantages for Vincent. In the last week of May he had already painted two studies at Gachet's place. The first was a canvas he probably had done in Gachet's garden on the agreed Tuesday, 27 May; it was described as "an aloe with marigolds and cypresses" (JH 1999). The other was done the following Sunday, and this was a picture with white roses, vines and a white figure in it (JH 2005). It showed a corner of the garden, and the white figure represents Gachet's twenty-one-year-old daughter Marguerite. Vincent simply gave both pictures to his host.

After he worked at Gachet's on the following Tuesday, he could report a much more important development. "I am working at his portrait, the head with a white cap, very fair, very light, the hands also a light flesh tint, a blue frock coat and a cobalt blue background; he is leaning on a red table, on

which there are yellow books and a foxglove plant with purple flowers.[191] It is in the same sentiment as the self-portrait I took with me when I left for this place. Monsieur Gachet is absolutely fanatical about that portrait and wants me to do one of him exactly like it, if I can, something which I should like myself" (letter 638). In the letter he made a little sketch of Gachet's portrait, but even without that sketch it would not have been difficult to identify the picture; it was the portrait in which one sees two books with yellow covers, the titles clearly legible: *Manette Salomon* and *Germinie Lacerteux* (JH 2007).[192]

107
Portrait of Dr. Gachet. *Etching, JH 2028, F 1664.*
Vincent van Gogh Foundation / National Museum Vincent van Gogh, Amsterdam

When Vincent wrote to Wil a few days later, he described the picture again, giving even more details and clearly stating, "What impassions me most—much, much more than all the rest of my *métier*—is the portrait, the modern portrait" (letter W 22). He had every reason to mention the portrait of Gachet as an example, for even much later generations experience it not only as a psychologically striking, but also as a very unconventional and "modern" portrait.

> I seek it in color, and surely I am not the only one to seek it in this direction. I *should like*—mind you, far be it from me to say that I shall be able to do it, although this is what I am aiming at—I should like to paint portraits which would appear after a century to the

[191] According to the doctors Doiteau and Leroy, the branch of foxglove is symbolic of Gachet's special interest in heart diseases (p. 87).
[192] Two novels by the brothers de Goncourt, probably displayed here as a token of the interest the painter and sitter had in common.

people living then as apparitions. So I do not endeavor to achieve this by a photographic resemblance, but by means of our impassioned expressions, using our knowledge of and our modern taste for color as a means of arriving at the expression and the intensification of the character. So the portrait of Dr. Gachet shows you a face the color of an overheated brick, and scorched by the sun, with reddish hair and a white cap, a landscape of blue hills in the background; his clothes are ultramarine—this brings out the face and makes it paler, notwithstanding the fact that it is brick-colored. His hands, the hands of an obstetrician, are paler than the face. Before him, lying on a red garden table, are yellow novels and a foxglove flower of a somber purple hue.

From his letter to Wil it also becomes clear which self-portrait Vincent meant when he wrote to Theo that Dr. Gachet wanted the same sort of portrait. "My self-portrait is almost alike, but the blue is a fine blue of the midi and the clothes are a light lilac."[193] This can only refer to the self-portrait on a light background, done in September 1889 (JH 1772), which he had sent to Paris. From there he had taken it with him to Auvers with a few other examples of his work. What the two portraits have in common is the tense facial expression and the way in which they are set against the blue hues of the background and clothing.

A portrait of Madame Ginoux also roused Dr. Gachet's enthusiasm, as Vincent had reported to Theo. "When he comes to see the studies, he always comes back to these two studies, and he accepts them completely, but completely, just as they are" (letter 638). He now also told Wil about it. "My friend Dr. Gachet is *decidedly enthusiastic* about the latter portrait of an Arlésienne, of which I also have a copy for myself" (letter W 22). Vincent had already told Wil that Theo and Jo had "a new portrait of an Arlésienne" in their apartment, and it reveals something of his feelings for Madame Ginoux that he had kept a copy for himself and even taken it with him to Auvers. It follows from the description he gives of the portrait which elements of it he used for Gachet's portrait. "The portrait of the Arlésienne has a colorless and dull flesh tint, the eyes are calm and very simple, a black dress, the background pink, and with her elbow she is leaning on a green table with green books." Compositional elements borrowed from this portrait for the one of Dr. Gachet were the table-top with two books and the pose of the figure with the head leaning on one hand.

Vincent wrote to Theo, "I hope to send you a portrait of him soon" (letter 638), and in a few days he made a second portrait of Gachet—almost a replica of the first, but without the books and with a branch of foxglove lying on the table rather than in a glass. It is obvious that this picture (JH 2014) was meant to be Theo's copy, but Gachet must have been allowed to choose between the two and preferred the second one, for this is the version that was in his possession and was presented to the Louvre after his death; the portrait with the books must have gone to Theo after Vincent's death.

[193] This last important sentence was in French: "*Mon portrait à moi est presqu'aussi ainsi, mais le bleu est un bleu fin du midi et le vêtement est lilas clair*" (the word *mais* was left out in the printed versions). The translation in the *Complete Letters* is far from the mark.

Vincent's productivity was so exceptional, and the fascination that the surroundings had for him so great, that he had completed a large and extremely important canvas even before he had started on the second portrait of Dr. Gachet. Curiously enough, he did not even mention this painting, one of the main works of the Auvers period, in his letters to Theo, but he did talk about it in the letter to Wil, dated 4 or 5 June. After having enumerated the pictures he had done at Dr. Gachet's house, he continued: "Apart from these I have a larger picture of the village church—an effect in which the building appears violet-hued against a sky of a simple deep blue color, pure cobalt; the stained-glass windows appear as ultramarine blotches, the roof is violet and partly orange. In the foreground some green plants in bloom, and sand with the pink glow of sunshine on it" (letter W 22). This description of the painting clearly stresses that, as so often, Vincent had wanted above all to make a study in color contrasts. This does not prevent the *Church in Auvers* (JH 2006) from also making an overwhelming impression by its subject and composition, for the medieval village church which surprisingly fills almost the entire picture is recreated into an imposing, enigmatic presence, an "apparition," as Vincent wanted his portraits to be. With the first portrait of Dr. Gachet, it has the deep and radiant blue in common, and also the short divided brush strokes. In the portrait they are especially prominent in the background; in the painting of the village church they are equally conspicuous in the foreground. However different in subject, the two paintings, done so shortly one after the other, are clearly related stylistically.

The church in Auvers.

A Quiet Lodger

Apart from the fragmentary information about Vincent's life in Auvers which the letters reveal, an article containing the reminiscences of a contemporary gives a fairly good impression of it. Ravoux's daughter, Adeline Carrié-Ravoux, wrote what she remembered of Vincent's stay at her father's inn.[194] Although written sixty years later, this lively memoir is an important document that gives quite reliable information. Although she was only thirteen in 1890 (Vincent took her for sixteen), her memories were supported by much that her father told her, as there had always been much discussion in the family about their remarkable and unforgettable lodger, Vincent.

Adeline Carrié-Ravoux's memories of Vincent.

> He was a man of good build, the shoulder lightly bent to the side of his wounded ear, the eye very brilliant. He was gentle and calm, but of a character that was little communicative. When one spoke to him, he always answered with an agreeable smile. He spoke French correctly, though sometimes looking for words. . . . When I heard much later he had been interned in a lunatic asylum in the Midi, I was much surprised, as he had always appeared calm and sweet to

[194] At the request of Louis Anfray, who for some time published a periodical called *Les Cahiers de Vincent van Gogh*, Adeline Carrié-Ravoux contributed her recollections to that journal under the title "Les souvenirs d'Adeline Ravoux" (1956).

me. He was highly regarded in our family. We called him informally "Monsieur Vincent." He never mixed with the clients of the café.

He took his meals with our two other lodgers, who were Tommy Hirschig (Tom, as we called him informally) and Martinez de Valdivielse. Tommy Hirschig was a Dutch painter, of twenty-three or twenty-four, it seemed to me, who arrived at our place after Van Gogh. . . .

Martinez de Valdivielse was a Spanish etcher who was exiled from his country because of his Carliste sympathies. He received large subsidies from his family. Martinez had his house in Auvers and only took his meals at our place. He was a tall, handsome man with a long brown, graying beard and a profile as from a medal. He was lively and nervous and used to pace up and down the house. He could express himself very well in French and liked to talk to Father, whom he held in high esteem. The first time he noticed a painting by Van Gogh he shouted with his usual ardor, "Who is the pig who has made that?" Vincent, who was standing behind his easel, answered with his ordinary composure, "It's me, Monsieur." That's how they made each other's acquaintance. . . .

The question of religion was never touched in our house. We have never seen Vincent van Gogh in church or visiting a priest. I did not know of Protestants in Auvers. Besides, Vincent did not frequent anybody in the village as far as I know. He did not speak much with us. Father, who had settled down in Auvers only a few months before Vincent's arrival, was forty-two at that period. He was not capable of holding an artistic conversation and only talked with him about material questions.

On the other hand, Vincent had become very much attached to my little sister Germaine (she is now Madame Guilloux and lives with me). She was a baby then, two years old. Every evening, after the meal, he took her on his knees, he drew for her on a slate the Sandman: a horse-drawn carriage in which the sandman was standing, throwing handfuls of sand around. After which the little girl used to kiss everybody good night and go upstairs to sleep.

It is with this picture in mind that one must imagine Vincent during his stay in Auvers: a quiet, reticent, but friendly and sensitive man, who led an extremely regular life, completely absorbed by his work. It is this regularity which enabled him to do the amazing amount of work known from this period.

When Vincent received another letter from Theo in the first days of June, it brought good news. Dr. Gachet appeared to have expressed a favorable opinion about Vincent's state of health. "Dr. Gachet came to see me yesterday, but unfortunately there were customers, which prevented me from talking with him very much, but at any rate he told me that he thought you had recovered, and that he did not see any reason for a return of what you had" (letter T 36). Vincent invited Theo and Jo to visit on the following Sunday. Theo asked Vincent to tell Dr. Gachet that they would gladly come, but that they should like to be home again in the evening if the weather would not permit Jo to come with the baby; Theo himself would accept the invitation, in any case. Theo also announced that Vincent would soon get the colors for which he had asked as well as a copy of the drawing models by Bargue (the sixty sheets with nudes) which Vincent had said he "absolutely" wanted to copy once more. The visit took place, and the descriptions of it give a good impression of the

Drawing the Sandman for the two-year-old Germaine Ravoux.

somewhat strange, but friendly and inspiring, atmosphere in which Vincent spent so many hours of the last few months of his life.

108
The inn at Auvers and the inn-keeper Arthur Gustave Ravoux with his family, circa 1890.

To Theo and Jo he wrote only, "Sunday has left me a very pleasant memory; in this way we feel that we are not so far from one another, and I hope that we shall often see each other again" (letter 640). In a letter to his mother, however, he gave more particulars. "Last Sunday Theo, his wife and their child were here, and we had lunch at Dr. Gachet's. There my little namesake made the acquaintance of the animal world for the first time, for at that house there are eight cats, eight dogs, besides chickens, rabbits, ducks, pigeons, etc., in great numbers. But he did not understand much of it all, I think. But he was looking well, and so were Theo and Jo. For me it is a very reassuring feeling to be living so much nearer to them. You too will probably be seeing them soon" (letter 641a).

When many years later Jo wrote her memories of this exceptional day for her Memoir, she stressed the harmonious atmosphere of their time together, not adding, however, how different it was from the days they had spent together in Paris, and from the one last meeting with him that was still to come.

> Vincent came to meet us at the train, and he brought a bird's nest as a plaything for his little nephew and namesake. He insisted upon carrying the baby himself and had no rest until he had shown him all the animals in the ward, till a too-loudly-crowing cock made the baby

"The day was so peacefully quiet, so happy, that nobody would have suspected how tragically our happiness was to be destroyed for always a few weeks later."

424

red in the face with fear and made him cry. Vincent kept shouting laughingly, 'The cock crows *cocorico*,' and was very proud that he had introduced his little namesake to the animal world. We lunched in the open air, and afterward took a long walk; the day was so peacefully quiet, so happy, that nobody would have suspected how tragically our happiness was to be destroyed for always a few weeks later.

109
The still-existing building in later years.

Productive Weeks

Vincent's daily life had become routine: up at five o'clock, drawing and painting the whole day, writing letters in the evening, off to bed at nine o'clock—and the following weeks in Auvers did not bring much change to that pattern. There has been some doubt whether Vincent could really have produced the seventy to eighty painted studies mentioned in the catalogs in the short period he was in Auvers (not more than seventy days!). It cannot be said with certainty that they all date from the Auvers period, or that they are all authentic, but even the

number of works that are surely authentic—because they show the characteristics of Vincent's hand and are described, or at least mentioned, in his letters—is amazingly great. He never tried to give an exhaustive survey of his studies; some are mentioned only in the letters to Theo, and some only in the letters to Wil, but to take the four weeks from the beginning of June until the beginning of July 1890 as an example, there are at least fifteen paintings that can easily be identified because they are mentioned in these two groups of letters.

When Vincent wrote to Wil in the second week of June, he mentioned three new landscapes: "a large landscape, showing fields as far as one can see" with "on the horizon a line of blue hills along which a train is passing, leaving behind an immense trail of white smoke," "another landscape with vines and meadows in the foreground," and finally, "one with nothing but a green field of wheat, stretching away to a white country house" (letter W 23). Writing to Theo a few days later, on 14 June, he mentioned two of those three, and one new study; "at the moment I am working on a field of poppies in alfalfa" (letter 641). This was a large and important painting (JH 2027), a size 30 canvas, as was the landscape with the train in the distance (JH 2019). When he wrote to Theo again on 17 June, he had already attacked two new studies: "one with a bunch of wild plants, thistles, ears of wheat, and leaves of different kinds of color," the other "a white house among the trees with a night sky and an orange light in the window" (letter 642). For the first time he mentioned that he had already been painting in the garden around Daubigny's house. "I am planning to make a more important canvas of Daubigny's house and garden, of which I already have a little study." He followed through with his plan; there are even two variations of that painting.

Vincent's creativity and his courage to enter new fields at this moment are shown by his surprising interest in a technique that he had never tried before: etchings. Dr. Gachet not only painted, but was also able to print his own etchings. As if it were a thought that had suddenly crossed his mind, Vincent unexpectedly wrote in his letter of 17 June, "I hope to make a few etchings of subjects of the Midi, say six, because I can print them without cost at Monsieur Gachet's, who is ready to print them for nothing if I make them."[195] As so often before, especially in earlier years, his imagination ran wild and he dreamed of doing a whole book of etchings, which would form a kind of continuation of Auguste Lauzet's book on Monticelli with lithographs after Monticelli's paintings.[196] He even thought of involving Gauguin in the enterprise. "Gauguin will probably engrave some of his canvases in conjunction with me. His picture that you have, for instance, and for the rest, the Martinique things especially. Monsieur Gachet will print these plates for us too. Of course he will be at liberty to print copies for himself too. He is coming to see my canvases in Paris someday and then we could choose some of them for engraving."

Vincent tries his hand at etching.

[195] The translation of the American edition has a serious error here, which is especially unfortunate because the question of Vincent's etchings is a problematic one already; instead of "I hope to make a few etchings" it has "I hope *he does* some etchings," etc.

[196] Paul Gauguin: *Adolphe Monticelli* (1890), with lithographs by A. M. Lauzet.

It is typical that Vincent immediately suited the action to the word; he made an etching, had it printed, and sent copies to both Theo and Gauguin. All this can only have taken a few days, for Theo gave a reaction in his letter of 23 June. "And now I must tell you something about your etching. It is really an etching done by a painter. There is no refinement of process, but it is a drawing on metal. I like that drawing very much— Boch likes it too. It's funny that Dr. Gachet has that printing press; the etchers are forever complaining that they have to go to a printer to get proofs" (letter T 38). Despite this favorable reaction, Vincent seems to have restricted himself to this one attempt.

110
Field with Stacks of Wheat, *one of Van Gogh's last paintings, July 1890.*
Oil on canvas, JH 2125, F 771, 50.5 x 101 cm.
Collection Mrs. Charles Beatty, London

In the meantime Vincent had not stopped painting. From the draft of a letter to Gauguin which was later found among his papers (published in the *Complete Letters* as letter 643), it is known that he was even attempting a new inspiration. Adding a few explanatory sketches he wrote:

Look, here is an idea that might suit you, I am trying to do some studies of wheat, like this—but I don't succeed in drawing it— nothing but green-blue ears of wheat, long leaves like green ribbons, pink by reflection of the light, ears that are just turning yellow, bordered by the pale pink of the dusty bloom—a pink bindweed at the bottom twisted round a stem. Against this, a very vivid yet tranquil background, I would like to paint portraits. You have greens of a different quality, but of the same value, so as to form a whole of green tones, which by its vibration will make you think of the gentle rustle of the ears swaying in the breeze; it is not at all easy as a color scheme.

One of the studies described above in such carefully chosen words—clearly the words of a painter talking to a painter—is the lovely canvas that shows an almost abstract play of waving lines and refined colors (JH 2034). Luckily, the draft of the letter to Gauguin has been preserved, because it contains not only a commentary on a painting, but also because it gives good insight into the thoughts that particularly occupied Vincent's mind at that moment: true painter's problems, problems of color and composition more than anything else.

The portraits of Adeline Ravoux.

The idea of making portraits against a background of wheat was indeed realized, but not before other subjects kept Vincent busy. In an important letter he wrote to Theo on 24 or 25 June, Vincent described the studies he had done in the last few days. "This week I did a portrait of a girl of about sixteen, in blue against a blue background, the daughter of the people with whom I am staying. I gave her this portrait, but I have made a variant of it for you, a size 15 canvas" (letter 644). This, of course, was Ravoux's daughter Adeline, who gave the story of this portrait more detail in her 1956 article in *Les Cahiers de Vincent van Gogh.* "One day he asked me, 'Would you like me to make your portrait?' As he seemed eager to do it, I accepted, and he asked my parents for their consent. I was thirteen then, but looked more like sixteen. One afternoon he made my portrait, in one session. While I was posing, Vincent never spoke to me, he didn't stop smoking his pipe. He found that I had been very good and complimented me for not having moved.'"

Adeline was not very enthusiastic about the portrait, and neither were her parents, so it is not surprising that, according to her, her father had no difficulty in parting with it when in 1905—they had moved to a café in Meulan near Versailles in the meantime—an American painter, Harry Harronson, showed an interest in it. Gustave Ravoux possessed two paintings by Van Gogh; the other was the picture of the little town hall of Auvers with flags and garlands, which Adeline had seen him paint on their narrow terrace on 14 July. Harry Harronson was in the company of three friends at the time, something which gave Ravoux an idea for the price he should ask. "Give me ten francs each," he said—and in this way two paintings of Van Gogh were sold for forty francs as late as 1905.[197]

In the same letter in which he wrote about Adeline's portrait, Vincent mentioned still more new canvases. He had started to experiment with a new oblong format with which he seems to have been very pleased. "Then I have a canvas 40 inches long and only 20 inches high, of wheatfields, and one which is a pendant to it, of undergrowth, lilac poplar trunks and at their foot, grass with flowers, pink, yellow, white, and various greens" (letter 644). As Vincent painted at least five wheatfields in this format, it would be difficult to say which canvas he meant here if he had not made a sketch of it in his next letters (645 and 646). It is a picture that is much different from the later landscapes, because it conveys a gay impression with its blue sky, its yellow, green, and blue-green fields and the number of poppies in the foreground (JH 2038). The second

[197] One of the two copies of Adeline's portrait was sold in 1988 at Christie's, New York for $12.5 million.

428

painting (JH 2041) also makes a joyous impression as a result of the colorfulness of the ground, which is completely covered with flowers, but at the same time the long row of violet, bare tree trunks and the elongated figures of the walking couple beneath them give quite an unrealistic appearance to the painting. He also arrived at a strong color effect in the third of the canvases in this elongated format: a view at sunset of the large country estate which was commonly called *Château d'Auvers*. The effect that especially draws attention here is the brilliant yellow of the evening sky, done with heavy brushstrokes (JH 2040).

In the last days of June, Vincent again devoted himself to a portrait, and he did not hesitate to use the same format, which, in a vertical variation, seemed also to satisfy him. "Yesterday and the day before I painted Mademoiselle Gachet's portrait, which I hope you will see soon; the dress is pink, the wall in the background green with orange spots, the carpet green with red spots, the piano dark violet; it is 40 inches high by 20 inches wide" (letter 645).

Coincidentally, Toulouse-Lautrec had also done a portrait of a lady at the piano at practically the same time, and it is no surprise that Vincent, when he saw it a week later at the Salon des Indépendants in Paris,[198] wrote to Theo, "Lautrec's picture, portrait of a lady-musician, is amazing, I saw it with emotion" (letter 649). The two pictures have indeed the same composition; the model is shown from the same angle. For the rest, the comparison ends abruptly! Compared to Lautrec's portrait, where the open space above and to the side of the figure is filled completely with realistic details—a music-stand and wall-decoration—Vincent's picture is much freer and more modern (JH 2048). The white dress of Marguerite Gachet is executed with long waving brushstrokes, which give the figure a touch of art nouveau; the orange dots of the background and the short brownish-green stripes of the red carpet add to this effect. Finally there is the strange feature of the bird's-eye perspective in which the bottom half of the painting has been observed; the result is that the floor seems to be a continuation of the vertical wall, and the figure seems to float in an abstract space.

Though he still gave his figures a more-or-less abstract background—abstract insofar as he now used the motif of the ears of wheat about which he had written to Gauguin a few weeks before—Vincent's next portraits did not move as far from reality. One of the two canvases was clearly described in a letter to Theo of 1 July (letter 646): ". . . the figure of a peasant girl, big yellow hat with a knot of sky-blue ribbons, very red face, coarse blue blouse with orange dots, background of ears of wheat" (JH 2053). He also used the motif in a smaller picture of the same girl, this time standing in a white dress (JH 2055). He seems to have enjoyed using the stippling effect; instead of orange on blue, the dots are now white on white.

Another portrait in a vertical variation.

[198] Unless the Salon had already been closed as Theo had written in his letter of 30 June; in that case, Vincent must have seen it either at Lautrec's or in his brother's apartment.

429

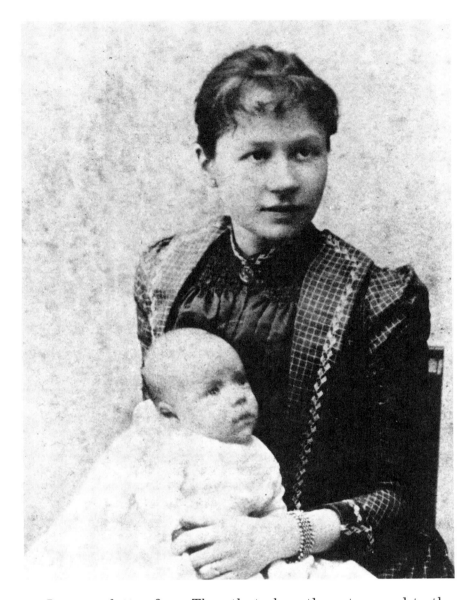

111
Johanna van Gogh-Bonger, with her baby
Vincent Willem van Gogh, photographed in
1890.

It was a letter from Theo that abruptly put an end to the relative quiet in which Vincent was working and to the quite cheerful mood that seems to characterize his recent paintings of June 1890. This letter (T 39) is more important than any of Theo's previous ones, because it gives unexpected insight into his personality, revealing how disturbed he was, and explaining much of what was to happen in the following weeks. It is not only the longest of all his letters that have been published, it is also a letter in which, as a result of his despondent mood, he let himself ramble, much more than he had in his earlier short and rather business-like notes. Even the first words, *"Mon très cher frère Vincent,"* a phrase he had never used before (he usually used a simple *"Mon cher Vincent"*), betray the emotional state of mind in which this letter of 25 June had been written. The primary reason for that state of mind was the fact that his baby boy was seriously ill, but writing about the child's illness made Theo also come forward with the other worries that preoccupied him.

431

To understand Vincent's reaction to the baby's illness, it should be remembered that he had expected from the beginning that life in Paris would be bad for his health, so that he had insisted several times that Theo and Jo should come to Auvers for a rest. On 23 May, for instance, he had written, "I always foresee that the child will suffer later on for being brought up in the city" (letter 648). A few days later he continued in the same vein, "How I wish that you, Jo and the little one would take a rest in the country instead of the customary journey to Holland" (letter 637). On 3 June this was followed by: "I often think of you, Jo and the little one, and I noticed that the children here in the healthy open air look well. And yet even here it is difficult enough to bring them up, therefore it must be all the more terrible at times to keep them safe and sound in Paris on a fourth floor" (letter 638).

His warnings proved to be well-founded. The first sentence of Theo's letter was alarming. "We have gone through a period of the greatest anxiety; our dear little boy has been very ill, but fortunately the doctor, who was uneasy himself, told Jo, 'You are not going to lose the child because of this.'" Theo wrote that they ascribed the illness to the fact that the milk in Paris was "downright poison." The child was a little better, because they gave him ass's milk, and Jo had been admirable, he said, but she was worn out. "In general she is having a hard time of it." Even in her sleep he heard her moaning, and could do nothing to help her.

Worries about the baby's illness

After this somber introduction he poured out his heart about other problems. Vincent had again become the elder, admired brother; it was from him that Theo now expected advice and support. There was uncertainty about the apartment, and there was uncertainty about his position at Boussod & Valadon's.

. . . and about Theo's position.

> We don't know what we should do; there are several questions. Should we take another apartment—you know, on the first floor of the same house? Should we go to Auvers, to Holland, or not? Should I live without worries for the morrow, when I work all day long and even then don't succeed in protecting that good Jo from worries over money matters, because those rats Boussod and Valadon are treating me as though I had just entered their business and are keeping me on a short allowance? Should I, when I don't count the pennies, don't make extras and am short of money—should I tell them how matters stand, and if they still dare to refuse [to do anything], finally say, "Gentlemen, I am going to take the plunge, and establish myself as a private dealer?" (letter T 39).

While writing, he seems to have come to the conclusion that this was what he ought to do, and in an emotional and somewhat confused sentence he wrote that it wouldn't help even if his mother, Jo, Vincent or himself would tighten their belts a little more; the only possibility for Vincent and himself was to live as poor devils (*en pauvres bougres*), who, it is true, would have nothing to eat, but would keep up courage and would live sustained by their mutual love and their mutual esteem. There followed the question which must have been for Vincent a very serious dilemma, for he was not the man to take this kind of thing lightly: "What do you think, old fellow?" Theo

432

probably did not realize that he put a heavy burden upon his brother's shoulders with this question, for he continued:

> Don't bother your head about me or about us, old fellow, but remember that what gives me the greatest pleasure is the knowledge that you are in good health and that you are busy with your work, which is admirable. You have too much ardor as it is, and we have to be ready for the battle all through life without eating the oats of charity they give to old horses in the mansions of the great. We shall draw the plow until our strength foresakes us, and we shall still look with admiration at the sun or the moon, according to the hour. We like this better than being put into an armchair and rubbing our legs like the old merchant at Auvers.

An emotional letter to Vincent.

After this unexpected effusion, he indulged in reminiscences of a common past, developing an eloquence unknown in any of his former letters.

> Look here, old boy, watch your health as much as you can, and I shall do the same, for we have too much in our heads to forget the daisies and the lumps of earth freshly cast up by the plow; neither do we forget the branches of the shrubs germinating in spring, nor the bare branches of the trees shivering in winter, nor the limpid blue of the serene skies, nor the big clouds of autumn, nor the uniformly gray sky in winter, nor the sun rising over our aunt's garden, nor the red sun going down into the sea at Scheveningen, nor the moon and stars of a fine night in summer or winter—no, come what may, this is our profession.

The following lines, which are no less emotionally charged, betray Theo's feeling of impotence. One can certainly say that Vincent was often underestimating his own capabilities; Theo, on the other hand, reveals here that he was suffering under even more serious personal problems, problems he thought he could only solve with the help of Jo.

> No, I have, and hope from the bottom of my heart that you too will someday have, a wife to whom you will be able to say these things; and as for me whose mouth is so often closed, and whose head is so often empty, it is through her that the germs, which in all probability come from afar but which were picked up by our beloved father and mother, perhaps will grow so that at least I may become a man, and who knows whether my son, if he can stay alive and if I can help him—who knows whether he will not grow up to be somebody. As for you, you have found your way, old brother, your carriage is already steady and strong, and as for me, I am beginning to see my way, thanks to my dear wife. Take it easy, you, and hold your horses a little, so that there be no accident, and as far as I am concerned, an occasional lash of the whip would do me no harm (letter T 39).

Vincent must have been deeply shocked. Though he could not resist giving the usual information about his latest canvases and even made three sketches of them in his letter, his answer was almost completely devoted to the health of the child. His first thought had been to hasten to Paris. "I have just received the letter in which you say that the child is ill; I should greatly like to come and see you, and what holds me back is the thought that I should be even more powerless in the

present state of anxiety. But I feel how exhausting it must be and I wish I could help you a little bit" (letter 646). It is only natural that he repeated his idea that it would be better for the child to be in Auvers than anywhere else. "The people at the inn here used to live in Paris, where they were constantly unwell, parents and children; here they never have anything wrong with them, especially the youngest one, who was two months old when he came here, and then the mother had difficulty nursing him, whereas here everything came right almost at once. On the other hand, you work all day, and at present you probably hardly sleep. I honestly believe that Jo would have twice as much milk here, and that if she would come here, you would be able to do without cows, donkeys and other quadrupeds."

About the important question of Theo's possibly leaving Boussod & Valadon, Vincent was curiously short and somewhat evasive, but it is obvious the prospect worried him enormously. In contrast to what he had written seven years earlier in Drenthe, when he almost begged Theo to give up his position with the firm, he now wrote:

Vincent's answer.

> What do you want me to say about the future, which perhaps, perhaps, will be without the Boussods? That will be as it will be, you have not spared yourself trouble for them, you have served them with exemplary loyalty at all times. I myself am trying to do as well as I can, but I will not conceal from you that I hardly dare count on always having the necessary good health. And if my illness returns, you would have to forgive me. I still love art and life very much, but as for ever having a wife of my own, I have no great faith in that. I rather fear that toward, say my fortieth . . . or rather say nothing, I declare that I know nothing, absolutely nothing as to what turn this may yet take.

A few days later there was an opportunity to exchange views about the problems in person. In his letter of 30 June, Theo invited Vincent to visit him in Paris, albeit with much reservation. "Now listen, as soon as Jo is a little stronger and the little one entirely recovered, you must come and stay with us for a day or two, at least on Sunday and some days after" (letter T 39). When he answered Vincent's letter on 5 July,[199] he repeated the invitation. "There is no reason why you should put off your visit . . . therefore come on Sunday by the first train. . . . You will stay with us as long as you like" (letter T 40). Theo also had good news to report about the baby. "After some days of suffering he is beginning to be merry again and is not crying so much. This is due to the good ass's milk we are giving him now. The animals come to the door, and in the morning he gets warm milk, always from the same animal. After that there remains enough for two portions which he gets alternately with his mother's milk, which is coming abundantly at present. At the moment he is looking very well. It is necessary for him to take ass's milk for at least two weeks."

It is somewhat surprising that Theo also wrote, "You are going to advise us with regard to our new apartment." Obviously the decision to move had been made without waiting

[199] 5 July was a Saturday. If the date on Theo's letter was not a mistake, it must be assumed that a letter from Paris could reach Auvers the same day.

434

for Vincent's opinion about it: "Dries and Annie [Bonger] will probably take the ground floor, and they will have a little garden, which we will, of course, make good use of. If the two women can hit it off, it promises well."

Days of Worry and Anxiety

On Sunday 6 July Vincent went to Paris to visit Theo, but there is no doubt that the visit left a crushing impression on him. Jo van Gogh-Bonger told about it in her Memoir: "Vincent visited us once more in Paris. We were exhausted by a serious illness of the baby; Theo was again considering the old plan of leaving Goupil and setting up in business for himself; Vincent was not satisfied with the place where the pictures were kept, which caused us to discuss our removal to a larger apartment— so those were days of much worry and anxiety."

"Days of much worry and anxiety" may also have meant the time preceding Vincent's visit, for it is improbable that Vincent stayed more than one day. The question of "the place where pictures were kept" was something about which they had corresponded in May, and it is not surprising that they should have discussed the subject again now. Many old friends came to see the now somewhat-famous Vincent, such as Aurier, Toulouse-Lautrec and others. It became too much for Vincent and he hurried back to Auvers.

Yet it was not only the number of visitors that made Vincent hurry back to Auvers overtired and overstrained. The talks with Theo and Jo had a stormy and—at least in Vincent's case—desperate character. This is the only possible conclusion to be deduced from the letter he addressed to them upon his return to Auvers. "My impression is that since we are all rather stupefied and besides a little overwrought, it matters relatively little to insist on having any very clear definition of the position we are in. You rather surprise me by seeming to wish to force the situation *while there are disagreements between you.* Can I do anything about it—*perhaps not—but have I done anything wrong*, or, finally, can I do anything that you would like me to do? However that may be, a good handshake in thought, and in spite of everything it gave me great pleasure to see you all again. Be very sure of that" (letter 647).[200]

To this emotional little note, Jo responded with a letter which must have seemed very reassuring. The text might have given a better insight into the problems that had been discussed in Paris, but unfortunately the letter has not been included in the group of forty-one by Theo and Jo that have been published. Yet even the first lines of Vincent's reaction show that Jo's letter must have been of the utmost importance. "Jo's letter was really like a gospel to me, a deliverance from the agony which had been caused by the hours I had shared with you, hours which were a bit too difficult and trying for us all" (letter 649). The rest of his letter makes it obvious that most of their discussions concentrated on the possibility of Theo giving up his position at Boussod & Valadon. But this was not the only danger that threatened the peace and quiet in Theo's

Vincent's visit to Paris on 6 July and its consequences.

[200] This translation was made after the manuscript. Jo van Gogh-Bonger left out two quite important passages for the printed edition of the letters, here in italics.

family. Vincent himself admitted that he had felt his existence to be in danger, and he did not conceal from them that even Jo's reassuring words had not been able to assuage his anxiety. In a letter which would be one of the last he would send to Theo and Jo, he wrote:

> It is no slight thing when we feel that our daily bread is in danger, no slight thing when for other reasons we feel that our existence is fragile. Back here I also felt very sad and continued to feel the storm which threatens you weighing on me. What can we do about it—you see, I generally try to be fairly cheerful, but my life is also threatened at the very root, my steps are wavering too. I feared—not altogether, but yet a little—that being dependent on you, you felt me to be a burden [*je vous étais redoutable*], but Jo's letter proves to me clearly that you understand that for my part I am as much in toil and trouble as you are (letter 649).

The somber mood in which he had returned from Paris is evident in the description of the work he had begun before he received Jo's letter. "There—once back here I set to work again—though the brush almost slipped from my fingers—and knowing exactly what I wanted, I have painted three more big canvases since. They are vast fields of wheat under troubled skies, and I didn't mind trying to express extreme sadness and loneliness" (the subject of the third was Daubigny's garden). Although among Vincent's pictures from Auvers there are several wheatfields, it is not difficult to identify with certainty the two Vincent meant (JH 2099 and 2102); there are sketches of them in his next letter to Theo and almost identical descriptions. Vincent intended to express sadness and loneliness, but he still believed these wheatfields displayed the positive side of his surroundings. "I hope you will see them soon—for I hope to bring them to you in Paris as soon as possible, since I almost think that these canvases will convey to you what I cannot say in words: the health and restorative forces that I see in the country." He continued to stress their visiting him, even though Theo and Jo had decided, in spite of all Vincent's recommendations, to spend their holidays in Holland and not in Auvers. This, too, must have been one of the topics they discussed in Paris, and although he must have been disappointed, Vincent now wrote, "I hope with all my heart that the intended journey will give you a little distraction."

The date of the journey is revealed in Theo's letter of 14 July (letter T 41). "Today we are finishing the packing of our trunks to start for Leyden tomorrow morning. From there I shall go to Mesdag on Wednesday to speak with him about [a] Corot, and after that to Antwerp with a picture by Diaz." From the Memoir to the *Complete Letters* it is known that Theo was back in Paris for a short time and intended to return for a longer vacation in Holland where he had left Jo and the child. In the same letter he reacted to what Vincent had written a week earlier, in his turn trying to reassure him. "We are very glad to learn that you are feeling less dispirited on account of the unsettled business questions than when you were here. Really, the danger is not as serious as you thought. If only we can all continue in good health, which will permit us to undertake what is growing little by little into a necessity in our minds, all will go well."

"My life is threatened at the very root."

Theo and Jo travel to Holland.

436

The letter could not have given Vincent much consolation, for it did not say whether Theo hoped to stay with Boussod & Valadon or preferred to leave and make a new start as an independent art dealer. From the talks with his brother in Paris, Vincent must have known about the ultimatum Theo had given his employers. He had asked them for a decision within eight days regarding his demand for better conditions. The news, or lack of news, which Theo's letter contained, was disappointing. "Although the eight days are past now, [they] have not said a word about what they intend to do with me" (letter T 41). The only thing Vincent could do was to wait for further information and to devote himself to his painting.

During these few weeks in July he must have finished several new pictures. Though they are difficult to identify, it is certain that he continued painting the wheatfields that gave him the consolation of their soft colors and endless expanses, for between 10 and 14 July he wrote to his mother: "I am completely absorbed in the immense plain of wheatfields against the hills, boundless as a sea, delicate yellow, delicate soft green, the delicate violet of a dug-up and weeded piece of soil, checkered at regular intervals with the green of flowering potato plants, everything under a sky of delicate blue, white, pink, violet tones. I am in a mood of almost too much calmness, in the mood to paint this" (letter 650).

Despite Vincent's apparent calm, it can be assumed that one of the works of these last five weeks was the famous canvas of the *Wheatfield under Threatening Skies with Crows* (JH 2117), which points to a completely different mood, somber and hopeless. There is, however, nothing in Vincent's letters about such emotional moments, and neither this painting nor any other of the wheatfields under such dark, stormy skies is mentioned. In the three weeks following his reply to Jo's letter (written around 9 July), there is only one letter to Theo (651; 652 is an unfinished draft of 651), and one letter to his mother and Wil (650). Theo and Jo were in Holland, and Vincent waited until he had received Theo's letter of about 23 July to write in return.[201]

Vincent's Last Letter

From Vincent's relatively long silence, Theo may have guessed something of his brother's mood. This is also suggested by Jo van Gogh-Bonger's reminiscences from these weeks in her Memoir. " 'If only [Vincent] is not getting melancholy and a new crisis is to be expected, everything has gone so well lately,' Theo wrote to me on 20 July, after he had taken the baby and me to Holland and had returned to Paris for a short time, until he also could take a vacation." Theo's comment on Vincent's state of mind can only be viewed as incredibly naïve. Hadn't he written only ten days earlier that he had tried to express in his pictures extreme sadness and loneliness? There was no need to ask whether a new crisis was to be expected; there was already a crisis, though not the kind Theo had meant. It is difficult to tell from his letters what had been going through Vincent's mind during these weeks. Although he had written to his

Absorbed in the calmness of the wheatfields?

201 Unfortunately this letter from Theo has not been preserved.

mother about a mood of almost too much calmness, this seems to have been meant to reassure her at the moment she was expecting Theo's and Jo's visit. He may also have been trying to make himself believe in that mood. Therefore it is of the utmost importance to see what he wrote to Theo around 24 July (letter 651; the draft of this letter, published as 652, ended in the middle of the definitive text, and was found in Vincent's pocket after his death).

> Thanks for your letter of today and the fifty francs note it contained. There are a lot of things I might write you about, but to begin with the desire to do so has so much left me, and then I feel the uselessness of it.
>
> I hope that you will have found those worthy gentlemen (*ces messieurs*) well disposed to you.
>
> As to the peace in your household, I am equally convinced of the possibility of conserving it, as of the storms that threaten it. I prefer not to forget the little French I know and I certainly can't see the usefulness of stressing the wrong or the right on both sides in eventual discussions. Only it wouldn't interest me. Here things go fast—Dries, you and me, are we not a little more convinced, don't we feel it a little better than the ladies? Good for them—but, after all, to discuss things quietly, we don't even count on it anymore.
>
> As far as I am concerned, I apply myself to my canvases with all my mind. I try to do as well as certain painters whom I have greatly loved and admired (letter 651).

The rest of the letter is of less importance and may easily be summarized in a few sentences. There is first the pessimistic thought that since Vincent was back in the North, painters seemed to be more and more in a desperate plight, but that the time to convince them of the utility of collaboration had passed; if some dealers might combine on behalf of the impressionists, the combination would certainly be short-lived. Vincent forwarded an order for paints from his young Dutch colleague Hirschig, who was another boarder at Ravoux's inn, and added an order for himself. He stated that his order had been reduced to the barest minimum, a detail which shows his awareness of the uncertainty of Theo's position. He ended the letter with a description of one of his last paintings, the *Garden of Daubigny*, illustrating the letter with large sketches of this and three other paintings.

In her Memoir, Jo van Gogh-Bonger wrote about Theo's thoughts regarding this letter: "On 25 July he wrote to me, 'I have a letter from Vincent, which I again found quite incomprehensible. When will there finally come a happy time for him? And he is so thoroughly good.'" Curiously enough, Vincent's letter does not seem to be incomprehensible at all. One might ask why he should suddenly return to such old themes as the coordination of painters or the importance of art dealers for the well-being of the impressionists, but these topics were probably reactions to something which Theo himself had discussed in his (unpublished) letter written around 23 July. Vincent's reference to "the little French that I know" may seem strange at first, but is not difficult to explain either. Vincent most certainly meant that he did not want to take sides in discussions that were held in Dutch between Theo, Jo, Andries and Annie. The "ladies" seem to have had a different opinion

"There are a lot of things I might write you about, but to begin with the desire to do so has so much left me, and then I feel the uselessness of it."

438

than the men. It is impossible to say what exactly they differed on, but in any case, Vincent was not interested in interfering.

In the draft of the letter, Vincent spoke in different terms of the main point of disagreement between Theo and Jo. "That you reassured me about the state of peace in your household was hardly worth the trouble, I believe, having seen the weal and woe of it for myself. And besides, I so much agree that rearing a child on a fourth floor is a hell of a job for you as well as for Jo" (letter 652). It follows from all this, first, that this passage too had been inspired by the text of the letter he had just received, in which Theo had clearly tried to convince him that the disagreements between himself and Jo were not serious, and second, that the main difference was the question of the apartment. Vincent's response was that he knew all about their problems. He assured them that he was convinced that the peace in their household could be conserved, but he felt that certain storms could threaten it. This too must have been a danger that worried Vincent a great deal.

Anxiety about the future was another of Vincent's worries. Although *seventeen* days had passed since Theo made his ultimatum, there seems to have been nothing about the development in the letter Vincent received. Vincent hoped, he wrote, that Theo had found Boussod and Valadon well disposed toward him on his return to Paris, granting him better conditions so he could continue working for the firm. This, evidently, was what Vincent wanted. There is no doubt that he was still quite afraid that their daily bread was in danger.

It is strange that with respect to this important question Theo kept Vincent in the dark—strange and deplorable, because it may have influenced the dramatic turn things would soon take. Theo *had* made a decision about his job, the decision that Vincent hoped for. This information is only known from a previously unpublished letter which Theo wrote to his mother and Wil on 22 July, the same day, or perhaps the day before, he wrote to Vincent.

Vincent remains anxious about Theo's (and his own) future.

> Since I am back here I haven't written to you, because I was waiting a solution from the side of the gentlemen. On the road and coming here I clearly realized that it was a very dangerous thing recklessly to give up my position in order to enter an uncertain future; I did have some hope of finding the money to start a private business, but was far from certain about it. I had to think about it so much that I became almost desperate that I had let things go so far and that perhaps very soon I was going to be without a penny of income. So yesterday morning I again talked with the gentlemen, and I discovered that in spite of everything they are quite well disposed toward me. I said that when I had first spoken to them, I may have trusted too much on my good luck and not enough realized how mighty the firm was, but that on second thought I had come to the conclusion that it was wiser for me to stay, and that even if they found I did not deserve a raise in salary, I would try to make the best of it and make ends meet. [202]

Theo left Vincent in a state of almost unbearable suspense, a state Vincent described more clearly in the unfinished letter he

[202]This kind of attitude certainly did not help to increase the respect Boussod and Valadon had for their employee.

left than in the one he wrote and finally sent to Theo. Looking at the earlier text, it is apparent that Vincent saw the situation as a crisis (*"un moment de crise relative"*); he even used the word *"débâcle."* His main reason for writing was to assure Theo of his love and esteem, as if he wanted to offer his support at a decisive moment—not knowing that the decision had already been made. Vincent stressed the role Theo had played in the production of his paintings. He had told him this many times, but he now expressed it with an earnestness as never before.

Why he left all this out when he rewrote the letter is a mystery. Perhaps he was afraid that it would sound too much like a farewell letter, which in a sense it was. It may also be that it was contrary to his usual modesty to repeat a sentence in which there could be sensed even the slightest feeling of self-complacency, namely when he wrote about "certain canvases, which will retain their calm even in catastrophe" (a striking explanation for the lasting value and dignity of his most important work).[203] The main passages of the draft (letter 652) contain the characteristics of a spontaneous outcry. "As things go well,[204] which is what matters most, why should I say more about things of less importance? My word, before we have a chance to talk business more collectedly, it will probably be a long time. That is the only thing I can say at the moment, and I haven't hidden from you that I was appalled to realize that. But that is really all. The other painters, whatever they think, instinctively keep themselves at a distance from discussions about the actual trade. And yes, truly, we can only let our pictures speak" (letter 652).

What follow are the often-quoted passages about Theo's role in the world of art dealing, which make it apparent that his position was foremost in Vincent's mind.

> But yet, my dear brother, there is this that I have always told you—and I repeat it once more with all the earnestness which results from a mind assiduously fixed on trying to do as well as possible—I tell you again that I shall always consider you to be something else than a simple dealer in Corots, that through my mediation you have your part in the actual production of certain canvases, which will retain their calm even in catastrophe.
>
> For this is what we have got to, and this is all or at least the main thing that I can have to tell you at a moment of comparative crisis. At a moment when things are strained between dealers in pictures of dead artists and living artists.
>
> Well, my own work, I am risking my life for it and my reason has half foundered because of it—right—but you are not among the dealers in men as far as I know and can still choose your side; I think you are really acting with humanity, but what can we do?

"Truly, we can only let our pictures speak."

203 In the original: *"certaines toiles qui même dans la débâcle gardent leur calme."*

204 The French text *"Puisque cela va bien,"* does not make it clear what it refers to; it may mean "as the baby is doing well now," or even "as I am well."

112
Vincent van Gogh on his deathbed, drawing by Dr. Paul Gachet.

Was there nothing in the last few weeks that might have predicted the violent end to Vincent's life? Several books about Vincent have related an incident that could have been such a bad omen, but it is questionable whether the source of the story is trustworthy. The story originated in the book by Dr. V. Doiteau, *La folie de Vincent van Gogh* (1928), and all

441

subsequent embellished or moderated versions were derived from the following passage of Doiteau's highly sensational text: "Dr. Gachet believed for a long time that the return of the crisis was very probable, for one day, under the influence of a sudden criminal impulse, Vincent had almost killed him. This is what had led to it: Dr. Gachet had among the paintings that covered his walls a canvas by Guillaumin, which represented a woman, naked to the waist, stretched out on a divan and with a small, oval Japanese fan in her hand. Vincent had a great admiration for this canvas, *which was not framed.*" Vincent also mentioned the picture, showing that it had made a certain impression on him. In the beginning of June he wrote, "Gachet had a Guillaumin, a nude woman on a bed, which I think very fine; he also has a very old self-portrait by Guillaumin, very different from ours, dark but interesting" (letter 638). Dr. Doiteau continued:

> Noting this [that the canvas was unframed], he flew into a violent rage, burst out into insults, and demanded that a frame be ordered at the carpenter's in Auvers without delay. When he came back a few days later, he found the painting in the same state. He showed a terrible irritation and suddenly he put his hand in one of his pockets. Dr. Gachet understood that it was to seize a revolver. He did not lose his head: just like Gauguin in Arles, when Vincent had threatened him with a razor, he looked at him with a domineering glance, which stopped him at once. Overpowered, Vincent took his hand from his pocket, empty, went to the door and went out with a contrite air. The next day he came back to the doctor's place. He did not talk about his gesture of the preceding day. He certainly had absolutely no recollection of this painful adventure.

A sensational incident as reported by Victor Doiteau.

At least one of the authors who has related the incident, John Rewald, has commented on the conduct not of Vincent, but of Dr. Gachet. "It seems utterly inconceivable," he said, "that Dr. Gachet would not have tried to disarm the painter and should have left a pistol in his friend's possession."[205] M. E. Tralbaut, who included the story in his biography of 1969, used practically the same terms as Doiteau and reinforced the effect of the story with the following words: "Paul Gachet, Jr. and his sister Marguerite, who were then respectively seventeen and nineteen, have told us more than once that they had been present at this scene, standing there as if rooted to the ground. They had experienced minutes of terrible anxiety they were never to forget. Nobody would have expected such an outburst for such a futile reason."[206]

It should be noted that Dr. Doiteau, who was the first to publish the incident, did not owe the material for his book to Dr. Gachet, who had died in 1909, but to Paul Gachet, Jr. He, however, was not a man in whom unrestricted confidence should be given. It is true that he and his sister generously donated to the Louvre the paintings Vincent had given to their father or had left him after his death. However, he was a strange character, who for unknown reasons had surrounded his important collection of Van Gogh paintings with the greatest secrecy. Photos of them were not available to anyone,

Doiteau's source: Paul Gachet, Jr.

[205] *Post-Impressionism* (1978), Chapter VIII, note 26.
[206] *Van Gogh le mal-aimé* (1969), p. 327.

442

not even to J.-B. de la Faille for his oeuvre catalogue of 1928 or the second edition of 1939. Even Tralbaut, who was on good terms with him, once wrote of the younger Paul Gachet: "It was especially under the pretext that he was the only person in the world to have known Vincent van Gogh personally and intimately, as he suggested, that he lent himself an importance which sometimes bordered not only on eccentricity, but even on deceit," and "At all cost he wanted to play a role that was more or less equal to that of his father. In his turn he behaved like a great eccentric."[207]

It is odd, to say the least, that this knowledge did not prevent Tralbaut from ending his story with the words, "In any case it is a fact that a few days later Vincent pointed a pistol at himself and died of the wound he had inflicted upon himself." Curiously, Paul Gachet, Jr. himself, who seems to have been somewhat alarmed by the effect of his disclosure to Dr. Doiteau, in later years tried partially to recant his statement. When in 1956 he published a book about his father and one of his father's friends under the title *Deux amis des impressionnistes*, he gave a somewhat different version of the incident regarding the Guillaumin painting, saying that Vincent may have been upset, but that only afterward, after the suicide, had Dr. Gachet considered the possibility that Vincent might have had a pistol in his pocket. People had later represented as a certainty, he said, what had only been a hypothesis of his father; some had even pretended that Dr. Gachet had seen the pistol in the mirror, and more of such things.[208] This story cannot be reconciled with Tralbaut's version about Gachet's children who, in his words, had watched the scene "rooted to the ground," convinced they would never see their father again.

As for the veracity of the incident, it is true that Vincent could be short-tempered at times, and it is certainly possible that a trifle such as an important picture being left unframed could have upset him terribly, but Dr. Gachet never wrote anything about it and in Vincent's letters there is not a trace of bitterness toward Gachet. The two had become good friends despite Vincent's initial reservations about Gachet. In his description of the incident Dr. Doiteau made a reference to Gauguin, who was said to have restrained Vincent with his glance when he felt threatened with a razor. The irony of history is that the only two cases in which Vincent is said to have threatened someone else with a weapon have been related to us by witnesses whose credibility is extremely doubtful, one of whom had even partly renounced his earlier testimony.

Vincent's "last" letter was probably sent on Thursday 24 July, as according to the Memoir, Theo had written to Jo on the 25th: "I have a letter from Vincent, which I again found quite incomprehensible." After this letter, Vincent waited two more days, days in which the storms in his soul evidently still raged. On Sunday 27 July the dramatic climax took place. Adeline Ravoux, the only eye-witness, later wrote this extensive account of the end of Vincent's tragic life.

The dramatic climax: 27 July.

[207] *Van Goghiana IV*, pp. 80-82.
[208] Paul Gachet Jr., *Deux amis des impressionnistes* (1956), p. 114.

That Sunday he had gone out immediately after breakfast, which was unusual. At dusk he had not yet returned, which surprised us very much, for as he was extremely correct in his contacts with us, he always arrived at the regular hours of the meals. We were all sitting on the terrace of the café, which only happened on Sundays after the hustle of a day that was more exhausting than the weekdays. When we saw Vincent arriving, the night had fallen, it must have been around nine o'clock. Vincent walked bent down a little, holding his hands on his belly and exaggerating his habit of holding one shoulder higher than the other. Mother asked him, "Monsieur Vincent, we were worried, we are glad to see you come home; has anything unfortunate happened to you?"

He answered with a painful voice, "No, but I . . ." He did not finish the sentence, went across the café to the staircase and went up to his room. I was witness to that scene.

Vincent had made such a strange impression upon us that Father stood up and went to the staircase to listen if something unusual was happening. He thought he heard someone groaning, went quickly upstairs, and found Vincent on his bed, crouched like a hunting-dog, his knees up to his chin, and moaning heavily. "What is the matter?" asked Father, "Are you ill?" Thereupon Vincent lifted up his shirt and showed a small wound in the region of the heart. Father cried out, "Poor fellow, what have you done?"

"I wanted to kill myself," Van Gogh replied. . . .

Next morning, two gendarmes of the brigade of Méry, who had probably been alarmed by the gossip of the public, appeared at our house. One of them, called Rigaumon, questioned Father in an unpleasant tone, "Is it here that there has been a suicide?" Father asked him to watch his manners and then invited him to come upstairs to see the dying man. He went first into the room, explained to Vincent that in a case like this the French law prescribed an investigation for which the gendarmes had come. They came in, and, still in the same tone, Rigaumon questioned Vincent, "Is it you who has tried to commit suicide?"

"Yes, I think so," replied Vincent in his usual soft way.

"You know that you don't have the right to do so."

In the same quiet tone Van Gogh said: "Gendarme, my body is mine and I am free to do with it what I want. Accuse nobody, it is I who wanted to commit suicide. "

Father then asked the gendarmes rather sharply not to insist any further.

From early morning on, Father had been busy trying to warn Theo, Vincent's brother. As the wounded man was unconscious, he could not give precise information. (The burst of energy he had had when the gendarmes had come to see him had very much tired him out.) But as he knew that Vincent's brother was a sales assistant at the picture gallery Boussod-Valadon, boulevard Montmartre, in Paris, Father sent a telegram to that address as soon as the post office was open.

Adeline Ravoux's narrative of 1956 is quoted at some length because it is the most detailed report about the events of 27 through 29 July 1890. The evident affection for Vincent it shows creates a sympathetic and credible impression. Nevertheless, it should be read with some reserve. There are indications that it is not completely in accordance with reality, despite the assuredness with which she wrote.

Some of the oldest information about Vincent's death is contained in Jo van Gogh-Bonger's Memoir, about which Adeline Carrié-Ravoux probably did not know when she put her reminiscences on paper in 1953 (the French edition of the Memoir had not yet appeared). Although only in fragments, some authentic documents are quoted in the Memoir that are of the utmost importance.

After having stated that Vincent shot himself "on the evening of 27 July," Jo continued: "Dr. Gachet wrote that same evening to Theo: 'With the greatest regret I must disturb your repose. Yet I think it my duty to write to you immediately. At nine o'clock of today, Sunday, I was sent for by your brother Vincent, who wanted to see me at once. I went there and found him very ill. He has wounded himself. . . . As I did not know your address and he refused to give it to me, this note will reach you through Goupil.'[209] The letter did not reach Theo until the next morning and he immediately started for Auvers."

Theo warned by a letter from Dr. Gachet.

This proves that Theo had not been warned by a telegram from Ravoux, though it is possible that Ravoux himself sent a telegram in the morning of 28 July, just to be on the safe side. This, however, is not probable, as he knew about Gachet's letter, which had been brought to Paris by Tommy Hirschig. There can be no doubt about this, because it is told by Jo van Gogh-Bonger in her Memoir with a literal quotation from a letter she had received from her husband: "This morning a Dutch painter who also lives in Auvers brought me a letter from Dr. Gachet that contained bad news about Vincent and asked me to come. Leaving everything, I went and found him somewhat better than I expected. I will not go into details, they are too sad, but you must know, dearest, that his life may be in danger"

The account of the doctors Doiteau and Leroy.

From parts of Adeline Ravoux's story which have not been quoted here, it becomes clear that the Ravoux family rather disliked Dr. Gachet, and, consciously or unconsciously, Adeline seems to have tried to reduce his role in the event to the smallest possible proportions. She certainly was wrong when she said that the village doctor, Dr. Mazery, had been absent from the scene. In the letter that Theo wrote to his mother after Vincent's death, he said: "Dr. Gachet and the other doctor were exemplary and have looked well after him." In their book *La folie de Vincent van Gogh* (1928), the doctors Victor Doiteau and Edgar Leroy gave an extensive description of Vincent's last few days, in which they also reported as a fact that *both* Dr. Gachet and Dr. Mazery had been at Vincent's bedside on 27 July. Here are the most important passages of their version of the events:

> Someone sent for the doctor of Auvers, Dr. Mazery. Vincent asked for Dr. Gachet, who, when he had been warned, came hastily, accompanied by his son Paul. . . . In the flickering light of a candle he immediately started to examine the wound. . . . When Doctor Gachet had finished his examination and replaced the bandages, he withdrew to another room with Dr. Mazery to consult with him about the treatment that had to be followed. They decided to delay any

[209] Too much importance has often been given to the fact that Vincent did not want to give Theo's address. Out of politeness, Gachet explained why he sent his note to Theo's office address, but it did not reach him any later for that reason. Tommy Hirschig, who delivered the message, certainly could not have reached Paris the previous night.

action as there were no serious symptoms and as it was impossible to remove the bullet. When Dr. Gachet entered the room again, Vincent was very calm, his face did not show any pain. He asked if he was allowed to smoke. Dr. Gachet agreed. He then asked to get the pipe from the pocket of the blue plumber's blouse which he always wore and which was put near the bed. Dr. Gachet looked for the pipe and having found it, he stuffed it for him, lit it and put it in his mouth, whereupon Vincent started smoking silently.

Dr. Doiteau, who had written the biographical part of *La folie de Vincent van Gogh*, based on his conversations with Paul Gachet Jr. According to him, Gachet had left his seventeen-year-old son Paul with Vincent to warn him if anything serious should happen after he himself had left. This part of the story, again, must be read with reserve. It seems doubtful that the younger Gachet would have been one of the few who had been sitting up with Vincent during the night; Theo van Gogh said nothing of the kind, and Adeline Ravoux strongly denied it. It seems highly improbable that Gachet should have left this boy all night with the wounded man while Ravoux or one of his lodgers could have warned him if it were necessary.

It has often been assumed that Vincent's life could have been saved by timely action, but the few details that have become known about his last moments make it certain that he himself would not have wished that. According to Jo van Gogh-Bonger's Memoir, Theo had written to her on 28 July: " 'He was glad that I came and we are together all the time. . . . Poor fellow, very little happiness fell to his share, and no illusions are left him. The burden grows too heavy at times, he feels so alone. He often asks after you and the baby, and said that you could not have imagined there was so much sorrow in life. Oh! if we could only give him some new courage to live. Don't get too anxious; his condition has been just as hopeless as before, but his strong constitution deceived the doctor.' " And when that hope had proved idle, he wrote to Jo, "One of his last words was, 'I wished I could pass away like this.' " Theo also wrote his sister Elisabeth that Vincent was determined to die, and Emile Bernard wrote that when Dr. Gachet had told him that he still hoped he could save his life, Vincent had said: "Then it has to be done all over again" (*c'est à refaire alors*).

He was buried on 30 July in Auvers, at the little village cemetery behind the large medieval church. Fortunately a detailed account of the events, written the next day, has been preserved. This is the moving account that Emile Bernard, who was only twenty-two at the time, gave of the burial of his great friend in a long letter to the critic Albert Aurier[210]:

Theo's account of Vincent's last moments.

The burial.

> Wednesday 30 July I arrived in Auvers about ten o'clock. Theodore van Gogh, his brother, was present with Dr. Gachet; Tanguy also. Charles Laval came with me. The coffin was already closed. I arrived too late to see him again, the man who had left me four years ago so full of hopes of all kinds. The innkeeper told us all the details of the accident, the impudent visit of the gendarmes, who even came to his bedside to blame him for an act for which he alone was responsible, etc. . . .

[210] Published in *Arts-Documents* (February 1953).

446

On the walls of the room where the body lay all his last canvases were nailed, forming a sort of halo around him, and rendering his death all the more painful to the artists who were present by the splendor of the genius which radiated from them. On the coffin a simple white linen, masses of flowers, the sunflowers which he loved so much, yellow dahlias, yellow flowers everywhere. It was his favorite color, as you will remember, a symbol of the light he dreamt in hearts as well as in paintings. His easel, his folding stool and his brushes were placed on the ground before the coffin. Many people arrived, especially artists, among whom I recognized Lucien Pissarro and Lauzel, the others I don't know; there also came people from the neighborhood who had known him a little or seen him once or twice, and who liked him, because he was so good, so human. There we are gathered, in the greatest silence, around the coffin which hides a friend. I look at the studies: a very beautiful and sad one, done after Delacroix with the Madonna and Jesus, convicts making their round under high prison walls, a canvas after Doré, a terribly cruel symbol of his end. Hadn't his life been that prison with walls, so high, so high . . . and those people, going round incessantly in that cave, weren't they the poor artists, the poor damned souls walking under Destiny's whip . . . ?

At three o'clock the body was raised. Friends carry it to the hearse. In the assembly some people cry. Theodore van Gogh, who adored his brother, who had always supported him in his struggle for art and independence, did not stop sobbing painfully. . . .

Outside there was a terribly hot sun; we climbed the hills of Auvers, talking of him, of the bold push he has given to art, of the great projects he always had, of the good he has done to all of us.

We arrive at the cemetery, a little new cemetery, dotted with new tombstones. It is on the hill overlooking the harvest fields, under the great blue sky which he would still have loved . . . perhaps.

Then he is lowered into the grave. Who could not have cried at that moment; this day was so much made for him that one could not help thinking that it could still have made him happy. . . .

Dr. Gachet . . . wanted to say a few words devoted to Vincent's life, but he too is crying so much that he can only utter a muddled farewell . . . (which is the most beautiful). He was an honest man, he said, and a great artist. He had only two goals, humanity and art. It is the art, which he cherished above everything, that will make him live on. . . .

Then we returned. Theodore van Gogh is broken by grief.

THEO'S COLLAPSE

"Theodore van Gogh is broken by grief," Emile Bernard wrote. Theo's health was frail, and this shock must have been indescribably heavy. Convinced though he was of Vincent's gratitude for all Theo had done on his behalf, one can suppose that Theo asked himself many times whether he couldn't have prevented his brother's act of despair and, if this had been impossible, whether his own circumstances—the storms that threatened his marriage, the fact that he now had a child to care for, his shaky position at Boussod & Valadon—may not have been the principal cause of Vincent's decision to end his life. Wasn't it evident that he no longer wanted to be a burden to Theo and Jo? Theo's first reaction to the death of his beloved brother was contained in a letter to his mother, whom he had immediately informed of what had happened with a telegram. He also wrote to Jo, who was in Holland at the time, but the letter to her has not been preserved.[211] A short passage from the letter to his mother was quoted in the Memoir to the *Complete Letters*. The complete text from this important document, dated Paris, 1 August 1890, reads:

> One cannot write how sad one is, nor find solace in pouring out one's heart. May I come to you soon? I still have to make all sorts of arrangements here, but if it is possible I would like to leave here on Sunday morning to be with you in the evening. It is a grief that will weigh on me for a long time and will certainly not leave my thoughts as long as I live, but if one should want to say anything about it, it is that he himself has found the rest he so much longed for. If he could have seen how people behaved toward me when he had left us and the sympathy of so many for himself, he would at this moment not have wanted to die.
>
> Today I received your letter and the one from Wil, and I thank you both. I can better tell you everything than write. Dr. Gachet and the other doctor were exemplary and have looked after him well, but they realized from the first moment that there was nothing one could do. Vincent said, "I would like to go like this," and half an hour later he had his wish. Life weighed so heavily upon him, but as happens so often everyone is now full of praise, also for his talent. Maybe it was fortunate that Jo was not here, it would have been such a shock for her. May she also come once I am there? Later we will go to Amsterdam for a couple of days. Oh, Mother, I so much long to be with you. I suppose you will have written to Lies. I can't do it at this time. Tomorrow I will only know for certain whether I can leave, and if I cannot come I will let you know. Oh, Mother, he was so very much my own brother.[212]

"Oh, Mother, he was so very much my own brother."

Theo did manage to write a letter to his sister Elisabeth a short time later, on 5 August, and again mentioned a few details about the tragic event. This letter, even more than the letter to his mother, conveys something of the emotion with which he witnessed his brother's last moments, and it is therefore worth quoting in its entirety—assuming the text that Elisabeth published in her book of 1910 was complete.

[211] At least not published. In her Memoir to the *Complete Letters*, Jo van Gogh-Bonger quotes a few sentences from this letter.

[212] This letter was earlier published in *Vincent*, vol. 3, nr. 2 (1974).

To say we must be grateful that he rests—I still hesitate to do so. Maybe I should call it one of the great cruelties of life on this earth and maybe we should count him among the martyrs who died with a smile on their face.

He did not wish to stay alive and his mind was so calm because he had always fought for his convictions, convictions that he had measured against the best and noblest of his predecessors. His love for his father, for the gospel, for the poor and the unhappy, for the great men of literature and painting, is enough proof for that. In the last letter which he wrote me and which dates from some four days before his death, it says, "I try to do as well as certain painters whom I have greatly loved and admired." People should realize that he was a great artist, something which often coincides with being a great human being. In the course of time this will surely be acknowledged, and many will regret his early death. He himself wanted to die; when I sat at his bedside and said that we would try to get him better and that we hoped that he would then be spared this kind of despair, he said, "*La tristesse durera toujours*" (The sadness will last forever). I understood what he wanted to say with those words.

A few moments later he felt suffocated and within one minute he closed his eyes. A great rest came over him from which he did not come to life again.

As he had promised his mother, Theo went to Leiden a short time later to spend some time with her and Wil. He stayed a few days with Jo at the house of the Bonger family, and on 18 August they returned to Paris. Unpublished letters to his mother and Wil show that during the following weeks they were very much taken up by the interest shown for Vincent's work. Dr. Gachet paid them a visit and several artists came in the evenings to look at the great number of paintings that filled the apartment. Among the artists were Camille Pissarro (who immediately proposed an exchange of one of the paintings for one of his own) and Serret. The well-known art dealer Durand-Ruel came as well, as Theo had asked him for permission to organize an exhibition of Vincent's work.

According to one of Theo's letters, they had friends for dinner no less than three times in the first week of September. One of them was Albert Aurier, who had published the important article in the *Mercure de France* in January. In a letter of 8 September, Theo wrote to his mother, "He thinks he can write a history of Vincent and promised to come often to browse through his letters."[213] Aurier would certainly have done this, but death took him prematurely too; he died in 1892, at the age of twenty-seven.

Theo was obsessed by the thought that he had to do all he could to make Vincent's work known. As Durand-Ruel appeared unwilling to lend one of his rooms for an exhibition, Theo asked Emile Bernard for help. In mid-September Theo moved to a larger apartment at the same address, and the paintings that were still in Tanguy's attic were transferred here. No wonder he wrote to his mother on 16 September, "We are still in a terrible mess and don't know where we are going to put all these things." He hoped that Bernard could help him

Visitors fill Theo's apartment to admire Vincent's work.

[213] Theo's letter to Albert Aurier of 27 August 1890 in which he suggests that he write a biography is included in the *Complete Letters* as T 55.

450

hang the paintings in the apartment so that visitors could get the best impression of Vincent's work, writing him: "I have not been able to arrange them in a way that one gets a good survey of his oeuvre. When I saw in Auvers [at the funeral] how clever you are in organizing such a thing, I had already gotten the idea of asking you for your help if ever an exhibition would have to be put together. As Durand-Ruel definitely refuses to exhibit the work, the only thing I can do is to hang as many as possible in our apartment in order to show it to anyone who mentions the desire to get better acquainted with my brother's work. In short, would you be so kind as to give me a hand in solving this problem?" (letter T 56).

Bernard himself told the rest of the story in his introduction to the 1911 publication of Vincent's letters to him. In a passage from this introduction he relates: "I replied to this letter affirmatively and on Saturday I made my way to Theodore. The hanging was soon done; he relied completely on me. When it was all done, the apartment looked like a row of museum rooms, for there was not a little space on the walls that I had left unoccupied. . . . Once everything was ready, I tried to mask the houses on the other side of the street so as to create more intimacy in the exhibition space that was devoted to the memory of a friend, and I changed the windowpanes into a sort of stained glass window by painting on it *The Sower*, *The Shepherd*, *The Haystacks*—a pastoral scene that summarized Vincent's love for the countryside."

Bernard organizes an exhibition at the apartment.

Theo was very pleased with Bernard's work, but he was not to enjoy it long, for soon after he took ill. In his introduction of 1911, Emile Bernard summed up the tragic events in a few words: "Alas, this memorial [the improvised exhibition] had not been erected for long. We had hardly finished it when Theodore, heartbroken over his brother's suicide, lost his reason and collapsed; he was paralyzed. The most assiduous care was given to him, but in vain. He was taken to Holland, where he died six months later."

Here for the first time was anything published about Theo's paralysis and insanity. More particulars became known when Maurice Joyant, who for a short time had been Theo's successor at the boulevard Montmartre branch of Goupil's, published a book in 1926 about Henri de Toulouse-Lautrec. In a passage devoted to the struggle that went on in Paris around the movements of impressionism and symbolism, he wrote:

Theo's tragedy.

One day in September 1890, the manager of the Goupil firm at the boulevard Montmartre, Theodore van Gogh, abruptly had an attack of paralysis, certainly due to the emotions caused by the tragic end of his brother Vincent, who had committed suicide in July. As a result of his disappearance, the Goupil firm was in great trouble, and M. Boussod, the head of that gallery, where I was trying to get employed, told me this: "Our manager, Van Gogh, a madman of sorts, like his brother the painter, is in a mental asylum. You go and replace him, do as you please. He has accumulated appalling things by modern painters which are the shame of the firm. As a matter of fact there are also a few Corots, Rousseaus, Daubignys, but we have taken away that stock from there; as you are inexperienced they would not be of any use to you. You will also find a certain number of canvases by a landscape painter, Claude Monet, who is beginning to sell a little in America, but he makes too many. We have a contract

451

to buy his whole production and he is busy to encumber us with his landscapes, always the same as to the subject. All the rest are horrors; try to manage and don't ask us for anything, otherwise we'll close the shop."[214]

Theo wanted to rent the Café du Tambourin in order to use it for a society of painters, something that had always been Vincent's dream. But soon he became violent, it seems he wanted to attack his wife and child, and had to be interned. As soon as he was able to travel, his wife took him to Holland.

The crisis did not come unexpectedly. Theo had felt miserable for a long time. The last few weeks his coughing bothered him especially, and he sought a treatment for it by consulting a Dr. Van der Maaten. In a birthday letter to his mother of 8 September he wrote: "Jo is getting stronger and looks well. Luckily her toothache is over. As far as I am concerned, I am getting better too. Every day I take the drops that Dr. Van der Maaten has prescribed; I sleep better and the coughing has almost stopped. The lovely weather helps a lot. So we have every reason to be content." A little more than a week later, on 16 September, he wrote to his mother in the same vein, but now he admitted that there was more to be worried about than the coughing. "I cough much less, probably as a result of the drops, but it is rather in my head. I think it is the nerves that I feel so miserable and that the least work with my brains is causing me so much trouble." A few days earlier he had consulted Dr. Gachet. In a long letter to him of 12 September, these ominous words appear: "The question is that my health is far from good; I have a feeling that my head is spinning and whatever I write gives me a feeling of dizziness. It's again the nerves that have got the upper hand."[215]

Unpublished letters from Theo foretell the crisis.

It soon became evident that the remedy—the drops prescribed by Dr. Van der Maaten—was worse than the ailment. An unpublished letter he wrote to Wil on 27 September leaves no doubt about that and must have made her fear the worst.

Hallucinations and nightmares.

Fortunately I did some good business these last days and also sold [a] Pissarro, [a] Guillaumin and [a] Degas. That gives one courage. I had become so sick by the drops of that Dr. that I would have become insane. They helped to stun me during the night and prevented me from coughing, but they gave me hallucinations and nightmares night and day to the extent that I would have jumped out of the window or would have killed myself in one way or another if I should not have stopped taking them. I was literally crazy. When I stopped with them the coughing came back with a vengeance, and this led to a heavy cold and hoarseness and luckily terrible sneezing which cleared my head a little. Everyone said to me, go to your bed and take care, but that was impossible as I was working on important business which has now succeeded with a profit for the firm of 10,000 francs—and a promise of more business. So you can imagine that I hated to stay at home and was very glad when Dr. Leon Simon (whom I had consulted at the advice and with an introduction from Dr. Gachet) told me, "If you would stay home it would be good for your coughing, but your nervousness would come back." No need to tell you that I listened to him, and I now feel much better.

[214] *Henri de Toulouse-Lautrec*, p. 118.

[215] Published by Paul Gachet Jr. in *Deux amis des impressionnistes* (1956).

452

His feeling better was pure imagination. At Jo's request, André Bonger wrote to Dr. Gachet on Friday 10 October[216]:

André Bonger asks Dr. Gachet for help.

> Since yesterday my brother-in-law Van Gogh has been in such a state of over-excitement that we are seriously worried. If it would be possible, we would be most grateful for you to come and see him, pretending that you are paying him an impromptu visit. Everything irritates him and gets him beside himself. The over-excitement is caused by a difference of opinion with his employers, as a result of which he wants to establish himself on his own without further waiting. The memory of his brother haunts him to such a degree that he resents everybody who does not agree with his ideas. My sister is exhausted and does not know what to do. I hope it will be possible for you to come; if not, send me a word of advice, please.

It must have been on one of those critical days that Theo sent Gauguin a telegram that clearly bears witness to his insanity. In his 1930 book on Gauguin, A. Alexandre exclaims: "Poor Gauguin! At the most unexpected moment he must have imagined that fortune was awaiting him. He was handed a telegram saying, 'Departure to tropics assured, money follows, Theo, Director.' He asked himself whether Theo van Gogh had become mad, or whether it might be a mystification in a very bad taste (something which seemed the most likely)."[217]

The available documents don't give the impression that Gachet had come that Saturday, but he did come on one of the following days as the symptoms became rapidly worse. Already on Sunday 12 October Theo had to be brought to a Paris hospital, the Maison Dubois, and Jo again asked for help from Dr. Gachet, now with a hastily penciled note: "Monsieur Gachet, My husband is very ill at the Maison Dubois. Please come see him if you can."[218] Gachet must have just managed to see him there, as Theo stayed in the Maison Dubois no more than two days. On Tuesday 14 October he was transferred to the clinic of Dr. Blanche in Passy (near Paris).[219]

Theo brought to a hospital on 12 October.

Some details about this episode are found in an unpublished letter written by André Bonger to his parents on 16 October.[220] In it he tells that Tersteeg had arrived from Holland the preceding day and that he had exchanged ideas about Theo with the old Mr. Boussod, because on top of all this misery there was also the problem that Theo had given notice at the firm. Fortunately this conversation had given no reason for concern. "He had said that for them there naturally was no question of accepting Theo's resignation and that in any case he

[216] Also published in *Deux amis des impressionnistes*.

[217] In *Paul Gauguin, sa vie et le sens de son oeuvre* (1930), the French text was, "*Départ assuré pour les tropiques; argent suit, Théo, Directeur*" (quoted also by John Rewald in *Post-Impressionism*, chapter VIII, note 55). Unfortunately, Alexandre did not mention the source of the information.

[218] She also informed the physician and author Frederik van Eeden, who was to become one of the friends of the family when she lived in Holland; it is certain that he traveled to Paris in those critical days, but that is all that is known about his visit to Jo.

[219] This is what Paul Gachet, Jr. said in his article "Les médecins de Théodore et de Vincent van Gogh," *Aesculape* (1957). The psychiatrist who was the head of the clinic at that time was Antoine Emile Blanche, son of the founder.

[220] In the archives of the Vincent van Gogh museum in Amsterdam, here translated from the manuscript.

453

would remain their *gérant* [manager] till the end of the year. There was no question either for them to be annoyed with Theo; the last few days they had clearly noticed that he was not well, and they had appeased him as well as they could."

As to the financial situation, Bonger wrote that there was nothing to worry about as Theo still had enough to claim from the firm. He also related that Tersteeg had gone to the clinic with Dr. Gachet.

> The doctor has not allowed them to talk with Theo, but they saw him in the garden, where he had been since ten o'clock in the morning. This proves that his physical condition has much improved. The doctor had called the situation very serious, but had not given a positive opinion. As to Dr. Blanche, he has seen him only after their visit, so we cannot hear his opinion before this afternoon. Tersteeg left already yesterday evening. This afternoon Net [as Bonger called his sister] and Wil have again gone to see him. Wil is terribly sad but calm and positive. Net cannot agree with what has been done, and all the time she wants something else because she thinks she knows Theo best and knows what he needs. I don't have to tell you how absurd the things are that she wants. It was impossible to act otherwise than we did, and she ought to accept that for the time being. . . . If his condition allows it, the best thing to do will certainly be to take him to Holland as soon as possible and to place him in an institution. . . . As far as I am concerned, I believe that there is extremely little hope. Rivet [Theo and Vincent's doctor in Paris] said that his case is far worse than Vincent's, and that there is not a spark of hope.

Bonger's words about his disagreement with his sister make it practically certain that Theo was interned in a clinic at his insistence. There is no doubt that it was necessary.

Painful details of what had happened in the preceding days later became known (though in the beginning only in restricted circles) when in 1940 a letter from Camille Pissarro to his son Lucien was published in the French medical journal *Aesculape*.[221] Pissarro, frightened by rumors about Theo van Gogh being ill and leaving the firm, had gone to make inquiries at Boussod & Valadon's. As a result he told his son:

Camille Pissarro's account.

> I return from my discussion at Boussod & Valadon's. Everything goes well, the sale had been recognized as valid. Mr. Boussod, Jr. has told me [however] that we should not count on further sales, as nobody can replace the poor Van Gogh who, as far as I am told, did not want to hear of other paintings than ours; he stubbornly kept believing in the impressionists only; it is a very great loss for all of us. . . .
> It seems that Van Gogh was ill before his madness, he had a retention of urine; eight days already he did not urinate; apart from that there were his worries, his sorrows, and a violent discussion with his employers about a painting by Decamps. As a result he has, in a moment of exasperation, taken his leave from the Boussods, and all at once he has become mad, he wanted to rent the Tambourin in order to found an association of painters. He then became violent; he who loved his wife and his son so dearly, he wanted to kill them. In

[221] It was published in an article by Dr. Victor Doiteau, "A quel mal succomba Théodore van Gogh." The letter was later included in the edition of Pissarro's letters to his son Lucien edited by John Rewald (1950). In translating it here the *Aesculape* version was followed.

short, one had to take him to the clinic of Dr. Blanche. The retention seems to have ended, but for the rest he is very bad.

Although the letter was written by a layman, Dr. Doiteau felt that he could easily deduce from it that "the symptoms described in this letter of 18 October are so precise and characteristic that the diagnosis is completely clear. Evidently there was an *anurie calculeuse* [a calculus anuria], complicated by a *urémie délirante* [a delirium caused by the blood being poisoned by the urea]." To many this may sound as if he had just put into medical terms what Pissarro said in simpler words in his letter, but there are some conclusions in the rest of Dr. Doiteau's article that are more interesting. In his opinion, Theo had already shown signs—his state of exhaustion, the pale color of the face and his chronic bronchitis—of a chronic inflammation of the kidneys. Regardless of whether this opinion was shared by his colleagues, the publication of Pissarro's letter must be appreciated, because until then nothing specific was known about Theo's sudden collapse.

However sudden, Theo's collapse cannot have come completely as a surprise to the people who knew him well. In 1883 Vincent had advised him: "Beware of your nerves—try all means to keep your mind at rest. If it is possible, go and consult a doctor every day" (letter 332). In 1886, André Bonger wrote twice to his parents about Theo's health; in June he wrote, "He keeps looking terribly bad; he literally has no face left," and in December he reported, "He has serious nervous complaints, so bad that he could not move." In 1888, Vincent stated that he and Theo shared the same constitution: "We must acknowledge that we belong to the number of those who suffer from a neurosis which already has its roots in the past" (*une névrose qui vient déjà de loin*) (letter 481). In another letter he called the two of them "the happy possessors of disordered hearts" (*de coeurs dérangés*) and described Theo's complaint as "a feeling of extreme lassitude" (letter 489). In the same year he inquired several times about Theo's leg pains, his *douleurs sciatiques* (letters 550 and 554). Theo himself wrote in July 1889, "As for me, I look like a corpse, but I went to see Rivet, who gave me all sorts of drugs, which at least do me enough good to put a stop to the cough, which was killing me" (letter T 13).

Little is known about the further development of Theo's illness. He stayed in Dr. Blanche's clinic until about 18 November. On 20 November André Bonger wrote to his parents: "This morning we received your letter with the good news about the arrival of Theo and of Net and the little Vincent. A load was lifted off our mind that everything went well." Theo was interned in the Willem Arntsz clinic in Den Dolder near Utrecht, where he died after two months on 25 January 1891. The only available information about his stay in the Dutch clinic is a detail told by Dr. G. Kraus, at that time a professor of psychiatry at Groningen University, who had access to documents from the clinic's archives. In a lecture published by the Kröller-Müller Foundation in 1954,[222] these words were devoted to Theo's illness and death: "The doctor, who treated him with great devotion, tried in vain to get his

Earlier symptoms of Theo's bad health.

[222] Dr. G. Kraus, *De verhouding van Theo en Vincent van Gogh* (1954), pp. 38-39.

attention by reading to him an article in the *Handelsblad* about Vincent. The only interest he had was for the name Vincent. He died, thirty-three years old, on 25 January 1891, half a year after Vincent. In the 'history of the illness' it says in the column 'cause of the disease: chronic illness, excessive exertion and sorrow,' and the doctor annotated this with, 'He had a life full of emotions, worries, and exertion.' "

Finally, a few words about Theo's widow. In his 1911 introduction to Vincent's letters, Emile Bernard had already stated the essential:

Jo van Gogh-Bonger back in Holland.

> In her haste to take her husband to Holland, Mrs. Van Gogh had been obliged to leave her apartment in a state of neglect. She soon asked that the paintings be sent to her. I took it upon myself to watch over the packing. By a sentimental scruple that is easy to understand, she did not want to return to France, to Paris, to the place where the cruel tragedy had taken place. She retired to Bussum, near Amsterdam, and opened a boarding house there. "It is a beautiful house," she wrote me, "and we'll have a roomier place, the baby, the paintings, and myself, than in our apartment in the Cité, where we were yet so well installed and where I have spent the happiest days of my life. Therefore you don't have to fear that the paintings will be put in an attic or a cupboard; the whole house will be decorated with them."

Even more interesting details were published by Theo's grandson, Johan van Gogh, in his contribution to the magnificent book about the Amsterdam museum, published in 1987 under the title *The Rijksmuseum Vincent van Gogh*, edited by Evert van Uitert. In this important article, called "The History of the Collection," he states: "After Theo's death the influential Dutch artist and critic, Jan Veth, made a valuation of the paintings and drawings in Theo's collection. His appraisal included the following items: 1 Breitner: Dfl. 40; 2 Lautrecs: Dfl. 150; 3 Gauguins: Dfl. 300; 200 paintings by Vincent van Gogh: Dfl. 2,000; 1 portfolio of drawings by Vincent van Gogh: Dfl. 1,000." With such an appraisal it is no wonder that, as Johan van Gogh assures, "she found not the slightest appreciation for Vincent's work, either from her family or Theo's." The article continues: "Theo's death left Jo van Gogh-Bonger to care for a child not yet a year old, and she decided to move back to Holland. Fortunately she did not listen to her brother Andries (Dries) when he advised her to throw out the entire Van Gogh collection, although who could have blamed her if she had? . . .Over the years she sold a number of Vincent's paintings and drawings—it was not for nothing that she had been married to an art dealer. It is admittedly unfortunate that these works left the collection, but on the other hand they did help to spread the artist's fame."

That is indeed what matters most, and this chapter can be closed only by repeating what was said in the introduction: Jo van Gogh-Bonger may not have been the first to take up the pen to write about Vincent and Theo van Gogh, but she is owed a great debt of gratitude for the tremendous efforts she spent in organizing exhibitions of Vincent's work and publishing his letters to make the world aware of one brother's talent and of the other's sacrifices to keep the flame of his talent burning.

113
The graves of Vincent and Theo van Gogh at Auvers-sur-Oise.

It is tempting to look for parallels in mythology when one realizes how cruelly fate pursued the Van Gogh family. Little could Theodorus van Gogh and his wife Anna Cornelia Carbentus have suspected what unhappiness lay in store for their children. Four out of six would meet a tragic end, while one daughter, who led a seemingly normal and happy life, kept a secret that must have weighed heavily upon her conscience.

It is difficult to imagine how terribly Mother Van Gogh must have suffered, first under the sudden loss of her husband in 1885, and then under the tragic circumstances in which one after the other of her children were involved. Time after time, her somewhat naïve religious faith was tested seriously.

It began with Elisabeth Huberta. For her, fate struck within a year of her father's death. Elisabeth—called Lies in the family—lived in Soesterberg where she had a position with the family of a lawyer, J. Ph. Th. du Quesne van Bruchem, working as a nursemaid during his wife's serious illness. But in 1885 she became pregnant, and the next year gave birth to a girl whom she called Hubertina Normance. To conceal her disgrace, Mr. du Quesne took Elisabeth to a village in

Normandy where her child was born on 3 August 1886. The rest of her long life, Hubertina Normance remained in France, where she died in needy circumstances in 1969. What sadness it must have meant to Elisabeth that for many years she had to keep the existence of this child a secret to the world as well as to her own family (with the possible exception of her mother). Fortunately, she had at least the consolation that finally, five years later, when his wife died, du Quesne married her on 17 December 1891, and she was able to raise a family.

The deaths of Vincent and Theo, one shortly after the other, and under such tragic circumstances, were not the end of the disasters that struck the Van Gogh family. The youngest brother, Cornelis Vincent, went to South Africa in 1889 to build a future for himself. He worked for the railways, married in February 1898, and settled down in Pretoria. This may have given his mother new hope for his happiness, although it must have been difficult for her to see her only remaining son move to another part of the world, but Cor's marriage was not a success. His twenty-year-old wife, Anne Catherine Fuchs, left him within the course of the same year. A few months after the war between the South African Republics and England began, Cor enlisted as a volunteer on the side of the Transvaal army. He died on 12 April 1900 near the village of Brandfort. On his death certificate it says that "he lost his life as the result of an accident during his illness (fever)," but in an official register from after the war the information is more precise: "suicide during fever / According RC" (Red Cross).[223]

Perhaps the most tragic fate of all the Van Gogh siblings came to the youngest daughter, Wilhelmina Jacoba, with whom Vincent exchanged so many beautiful and interesting letters. She lived with her mother for many years, but finally moved from Leiden to The Hague. In October 1902 she began to show signs of insanity (she was forty-one). She was committed to an asylum in The Hague and was sent in December to the Protestant Mental Home *Veldwijk* at Ermelo. She had only one wish—to die—but her suffering continued until 17 May 1941— thirty-nine long years before the Furies released the last of the Van Gogh siblings.

Although the lives of Vincent and Theo van Gogh also ended in tragedy, for them at least there was the satisfaction that they left an oeuvre whose importance Vincent certainly realized, despite his ineradicable lack of self-confidence, and which Theo also learned to appreciate over the course of time. Their lives ran parallel to the end, and even if they had not belonged to the same family, they would have been brothers in any case, Vincent believed, because in so many respects they were *companions in fate* (letter 603). The legacy they have left to the world was a common creation, for Vincent called himself no more than the intermediary through which it had come into being, and only moments before his death he repeated with deep earnestness that Theo had played a vital role in the production of paintings which "even in catastrophe will retain their calm."

[223] These details about Cor's marriage and death were published for the first time by Colonel Dr. Jan Ploeger in an article, "Cornelis Vincent van Gogh in Transvaal" (in *Lantern: Journal for Knowledge, Art and Culture*, December 1981, pp. 51-59).

Biographical Chronology

1853 Vincent Willem van Gogh is born in Zundert, in the south of Holland, on 30 March.

1857 Theodorus van Gogh (Theo) is born on 1 May.

1869 Vincent begins work as an apprentice at Goupil & Co., art dealers in The Hague.

1871 The Reverend Theodorus van Gogh is appointed to Helvoirt.

1873 Theo begins work at Goupil & Co., first in Brussels, then in The Hague.
Vincent is transferred to Goupil's London office.

1875 Vincent is transferred to Goupil's main branch in Paris. The Reverend Theodorus van Gogh is appointed to Etten.

1876 Vincent is dismissed from Goupil & Co. in April. He travels to England and works as a teacher and assistant preacher in Ramsgate and Isleworth.
Theo is seriously ill from September to November and recovers at his parents' in Etten.

1877 Vincent returns to Holland. He works in a bookstore in Dordrecht for four months. In May he moves to Amsterdam to prepare himself for the study of theology.

1878 Vincent enrolls in a course for evangelists in Brussels.
Theo is employed by Goupil's at their stand at the World's Fair in Paris.

1880 Theo is employed at the Paris branch of Goupil's on a permanent basis.

1881 Vincent lives with his parents in Etten from April until December and falls in love with his cousin Kee Vos.

1882 The Reverend Theodorus van Gogh is appointed to Nuenen.
Theo visits Vincent in The Hague in August.

1882-83 Vincent moves to The Hague and lives with his model Sien Hoornik and her children.

1883 Vincent works in Drenthe from September to December.
Theo considers leaving Goupil's.

1883-84 Theo has a mistress, named Marie.

1883-85 Vincent lives in Nuenen, first with his parents and then alone.

1884 Vincent has a love affair with Margot Begemann. Serious controversies arise between the brothers.

1885 Father van Gogh dies suddenly on 26 March. Vincent moves to Antwerp.

1886 Vincent works at the Antwerp Academy of Fine Arts for almost two months, then leaves for Paris.
Theo has another mistress called "S" but plans to marry Johanna Bonger.

1886-88 Vincent lives with his brother in Paris. He works in Cormon's studio for a few months. He meets Emile Bernard, Paul Gauguin and many other painters.

1887 Vincent organizes an exhibition in a restaurant on the Avenue de Clichy.

1888 Vincent leaves for Arles in February. Gauguin joins Vincent in October.
Theo and Jo become engaged in December. Vincent cuts off part of his ear and is sent to the hospital in Arles.

1889 Theo marries Johanna Bonger on 18 April. Vincent enters an insane asylum in Saint-Rémy on 8 May.

1890 Vincent Willem, the only child of Theo and Johanna, is born on 31 January.
In May Vincent moves to Auvers-sur-Oise. Vincent shoots himself on 27 July and dies on 29 July at the age of thirty-seven.
Theo arranges an exhibition of Vincent's works at his apartment in September. He becomes mentally ill in October, and Jo takes him back to Holland.

1891 On 25 January Theo dies in an asylum in Den Dolder near Utrecht at the age of thirty-four.

Concordance of Numbers

The heading *JH* in the columns below is a partial listing of the illustration numbers published in *The Complete Van Gogh*, by Jan Hulsker (Harry N. Abrams and Phaidon, 1980). In many books on Vincent van Gogh, illustrations are indicated by *F* numbers which refer to the *catalogue raisonné* by J. B. de la Faille, (Meulenhoff International, Amsterdam) third edition 1970. Dr. Hulsker's 1980 catalog has taken de la Faille's numbering system and updated it chronologically, based on Van Gogh's letters and more recent research. The result is a more logical and practical system beginning with Van Gogh's earliest sketches drawn in Etten in 1881 (JH 1- 89) and ending with the canvases made shortly before his death in July 1890 (JH 2064-2125).

JH	F	JH	F	JH	F	JH	F
7	845	356	1067	1018	1369v	1366	398
11	849	368	1032	1080	1364e	1367	396
14	876	390	1037	1089	208a	1368	397
15	850	406	1095	1090	181	1371	400
34	863	424	1104	1093	244	1378	403
61	851	425	1098	1097	1390	1379	394
63	897	461	1129	1099	231	1382	1480
66	854	467	1240a	1100	265	1384	1469
76	880	475	1343	1101	261	1385	1414
81	1	504	38	1102	262	1387	553
84	870	505	39	1108	222	1392	571
90	910a	511	1144	1121	253	1394	405
95	946v	513	41	1124	255	1416	409
99	910	516	43	1175	266	1417	408
107	983	517	42	1176	229	1421	570
108	984	522	122	1177	230	1424	600
111	918	525	125	1198	178v	1426	410
116	921	538	53	1202	263	1432	1448
122	915	666	1168	1206	369	1440	412
125	923	689	167	1208	370	1447	416
129	929	734	78	1210	296	1452	415
130	929a	737	1661	1211	295	1453	417
140	936	764	82	1242	341	1460	413
141	898	770	1230	1244	346	1462	420
142	933	772	84	1245	350	1465	419
143	935	777	83	1248	356	1470	422
144	937	782	388	1249	345	1477	545
145	932	785	86	1250	343	1486	423
146	941	832	1269	1269	293	1488	424
147	942	911	1319v	1270	354	1491	448
150	939	921	59	1280	1402	1501	1420
153	944	925	51	1283	1400	1502	1424
156	943	946	117	1284	1401	1519	431
182	8	959	45	1286	1410	1522	432
197	951	962	44	1332	359	1524	433
216	1062	967	1350v	1337	382	1531	1502a
221	1064	968	1350a	1339	383	1548	443
222	970	969	1350b	1340	378	1559	453
256	1658	970	260	1351	363	1560	459
259	1655	971	205	1352	364	1561	456
268	1662	972	206	1353	344	1562	454
278	1001	981	1357	1355	381	1563	444
281	1002	999	212	1356	522	1574	462
299	1007	1002	1693h	1358	391	1575	463
300	1685	1004	1160v	1360	290	1576	1463
301	1008	1005	1160	1361	392	1578	468
316	1018	1015	1368	1362	393	1580	467
336	1024	1017	1369	1363	395	1581	476

JH	F	JH	F	JH	F
1582	470	1762	746	2014	754
1588	473	1766	622	2027	636
1589	464	1767	635	2028	1664
1591	1413	1768	625	2034	767
1592	474	1770	626	2035	768
1595	475	1771	484	2037	769
1600	477	1772	627	2038	775
1601	479	1773	618	2040	770
1603	480	1774	629	2041	773
1604	481	1775	630	2048	772
1608	482	1776	757	2053	774
1615	485	1779	531	2099	782
1620	486	1802	744	2102	781
1621	487	1803	645	2117	779
1624	488	1804	662		
1625	489	1807	1528		
1626	495	1809	1579		
1627	450	1831	1566		
1630	496	1832	703		
1632	497	1840	653		
1635	498	1843	652		
1636	499	1849	660		
1637	490	1853	587		
1638	491	1854	586		
1642	492	1855	708		
1643	493	1856	710		
1655	504	1857	707		
1656	604	1862	737		
1657	527	1867	1729		
1658	529	1868	654		
1659	500	1869	655		
1661	510	1870	656		
1664	502	1871	661		
1665	525	1882	632		
1673	439	1884	667		
1674	435	1885	669		
1675	436	1886	670		
1681	514	1891	671		
1685	516	1919	673		
1686	646	1920	674		
1689	517	1921	675		
1690	520	1922	694		
1691	608	1923	695		
1692	579	1958	1594v		
1693	609	1967	702		
1698	734	1970	676		
1704	1605v	1972	677		
1706	1728	1974	633		
1723	611	1975	672		
1725	719	1976	681		
1731	612	1977	678		
1740	712	1978	680		
1746	613	1979	682		
1748	620	1980	807		
1753	617	1981	704		
1754	1546	1982	683		
1755	615	1986	1640		
1756	712	1999	755		
1757	1538	2005	756		
1761	735	2006	789		

Bibliography

Letters

Brieven aan zijn broeder. Edited by Jo van Gogh-Bonger. 3 vols. Amsterdam, 1914.

Verzamelde brieven van Vincent van Gogh. Edited by V. W. van Gogh. Reprinted forewords and introduction by J. van Gogh-Bonger. 4 vols. Amsterdam and Antwerp, 1952-54 (and later editions).

The Complete Letters of Vincent Van Gogh. Edited and with memoir by J. van Gogh-Bonger. Introduction by V. W. van Gogh. 3 vols. Greenwich, Conn., 1958. (Translation of last mentioned title.)

Letters of Vincent van Gogh 1886-1890: A Facsimile Edition. Preface by Jean Leymarie. Introduction by V. W. van Gogh. 2 vols. London and Amsterdam, 1977.

Oeuvres Catalogues

Faille, J.-B. de la. *The Works of Vincent van Gogh: His Paintings and Drawings.* 3rd. edition. Amsterdam, New York, 1970.

Hulsker, Jan. *Van Gogh en zijn weg.* Amsterdam, 1978. Recent edition 1989.

Hulsker, Jan. *The Complete Van Gogh.* New York, 1980, 1985. (English edition of last mentioned work.)

Other Catalogues

Vincent van Gogh. Exhib. cat. Hayward Gallery, London. Compiled by Alan Bowness. 1968.

Anthon van Rappard, his life and all his works. Exhib. cat. Rijksmuseum Vincent van Gogh, Amsterdam. Text by J. W. Brouwer, J. L. Siesling and J. Vis. 1974.

English Influences on Vincent van Gogh. Exhib. cat. University of Nottingham and other places. Text by Ronald Pickvance. 1974.

Vincent van Gogh in zijn Hollandse jaren. Exhib. cat. Rijksmuseum Vincent van Gogh, Amsterdam. Text by Griselda Pollock. 1980-81.

278 works in the collection of the Rijksmuseum Kröller-Müller. Otterlo, 1983.

Van Gogh in Arles. Exhib. cat. The Metropolitan Museum of Art, New York. Text by Ronald Pickvance. 1984.

Van Gogh from Dutch Collections: Religion - Humanity - Nature. Exhib. cat. The National Museum of Art, Osaka. Text by Tsukasa Kôdera. 1986.

Concise catalogue of the works of Vincent van Gogh and others in the Rijksmuseum Vincent van Gogh. Text by M. Berendsen-Albert and H. van Crimpen. Amsterdam, 1987.

Van Gogh in Brabant. Exhib. cat. Noordbrabants Museum, 's-Hertogenbosch. Text by Evert van Uitert. 1987.

Van Gogh in Saint-Rémy and Auvers. Exhib. cat. The Metropolitan Museum of Art, New York. Text by Ronald Pickvance. 1987.

Van Gogh à Paris. Exhib. cat Musée d'Orsay, Paris. Text by Bogomila Welsh-Ovcharov. 1988.

Van Gogh and Millet. Exhib. cat. Rijksmuseum Vincent van Gogh, Amsterdam. Text by L. van Tilborgh, S. van Heugten and P. Conisbee. 1988.

Books and Articles

Alexandre, A. *Paul Gauguin, sa vie et le sens de son oeuvre.* Paris, 1920.

Arnold, Wilfried N. "Vincent van Gogh and the Thujone Connection." *JAMA* (25 November 1988), pp. 3042-44.

Arnold, Wilfried N. "Absinthe." *Scientific American* (June 1989), pp. 112-17.

Aurier, G.-Albert. "Les isolés, Vincent van Gogh." *Mercure de France* (January 1890).

Badt, Kurt. *Die Farbenlehre Van Goghs.* Cologne, 1961.

Bernard, Emile. *Lettres de Vincent van Gogh à Emile Bernard.* Paris, 1911.

Bernard, Emile. "Vincent van Gogh." *Les Hommes d'Aujourd'hui*, nr. 390 (1890).

Bernard. Emile. "Extraits de lettres à Emile Bernard." *Mercure de France* (April 1893).

Bernard, Emile. "Notes sur l'école de Pont-Aven." *Mercure de France* (December 1903), pp. 675-82.

Bernard, Emile. "Julien Tanguy." *Mercure de France* (December 1908), pp. 600-616.

Bernard, Emile. "Emile Bernard et Vincent van Gogh." *Arts-Documents*, nr. 17 (1952).

Boime, Albert. "Van Gogh's Starry Night: A History of Matter and a Matter of History." *Arts Magazine* (December 1984), pp. 86-103.

Carrié-Ravoux, Adeline. "Les Souvenirs d'Adeline Ravoux sur le séjour de Vincent van Gogh à Auvers-sur-Oise." *Les cahiers de Vincent van Gogh*, no. I (1956), pp. 7-17.

Charensol, Georges, ed. *Correspondence complète de Vincent van Gogh*. Paris, 1960.

Chetham, C. *The Role of Vincent van Gogh's Copies in the Development of His Art*. New York and London, 1976.

Clébert, Jean-Paul, and Pierre Richard. *La Provence de van Gogh*. Aix-en-Provence, 1981.

Cooper, Douglas, ed. *Paul Gauguin: 45 lettres à Vincent, Théo et Jo van Gogh*. The Hague, 1984.

Coquiot, Gustave. *Les Indépendants*. 4th ed. Paris, 1920.

Coquiot, Gustave. *Vincent van Gogh*. Paris, 1923.

Doiteau, Victor. "La curieuse figure du Dr. Gachet." *Aesculape* (August 1923-January 1924).

Doiteau, Victor. "A quel mal succomba Théodore van Gogh." *Aesculape*, vol. 30, nr. 1 (1940), pp. 76-87.

Doiteau, Victor, and Edgar Leroy. *La folie de Vincent van Gogh*. Paris, 1928.

Dujardin, Edouard. "Aux XX aux Indépendants—LeCloisonnisme." La Revue Indépendante (March 1888).

Eerenbeemt, H. F. J. M. van den. "Van Gogh in Tilburg." *Brabantia* (November 1971).

Erpel, F. *Die Selbstbildnisse Vincent van Goghs*. Berlin, 1963.

Fels, Florent. *Utrillo*. Paris, 1923.

Fels, Florent. *Vincent van Gogh*. Paris, 1928.

Fénéon, F. "Le Néo-Impressionnisme." *L'Art moderne* (May 1887).

Florisoone, Michel. *Van Gogh*. Paris, 1937.

Forrester, Viviane. *Van Gogh ou l'enterrement dans les blés*. Paris, 1983.

Gachet, Paul. *Deux amis des Impressionnistes: le docteur Gachet et Murer*. Paris, 1956.

Gachet, Paul, Jr. "Les médiecins de Théodore et de Vincent van Gogh." *Aesculape*, vol. 40 (1957).

Gauguin, Paul. *Avant et après*. Facsimile edition of the manuscript of 1903, Leipzig, 1918. Regular edition, Paris, 1923.

Graetz, H. R. *The Symbolic Language of Vincent van Gogh*. New York, 1963.

Gruyter, Jos. de. *De Haagse School*. Vols. I-II. Rotterdam, 1969.

Guérin, Daniel. *The Writings of a Savage—Paul Gauguin*. New York, 1978.

Hammacher, A. M. *Genius and Disaster: The Ten Creative Years of Vincent van Gogh*. New York, 1969.

Hammacher, A. M., and R. Hammacher. *Van Gogh: A Documentary Biography*. London, 1982.

Hartrick, A. S. *A Painter's Pilgrimage through Fifty Years*. Cambridge, 1939.

Isaäcson, J. J. "Letters from Paris." *De Portefeuille* (17 August 1889).

Johnson, W. Branch. *Welwyn, By and Large*. Welwyn, 1967.

Joyant, Maurice. *Henri de Toulouse-Lautrec, 1864-1901*. 2 vols. Paris, 1926.

Kôdera, Tsukasa. "Japan as primitive utopia: van Gogh's japonisme portraits." *Simiolus*, nr. 3/4 (1984).

Kraus, Gerard. *De verhouding van Theo en Vincent van Gogh*. Amsterdam, 1954.

Lauzet, Auguste. *Adolphe Monticelli*. Paris, 1890.

Leymarie, Jean. *Qui était Van Gogh?* Genève, 1968.

Lubin, Albert. *Stranger on the Earth: A Psychological Study of Vincent van Gogh*. New York, 1972.

Lutjeharms, W. "De Vlaamse Opleidingsschool." *Historische Studies* of the *Vereniging voor de Geschiedenis van het Belgisch Protestantisme*, nr. 6. (1978).

Malingue, Maurice. *Lettres de Gauguin*. Paris, 1946.

Mauron, Charles. *Van Gogh. Etudes psychocritiques*. Paris, 1976.

Mauron, Charles. "Notes sur la structure de l'inconscient chez Vincent van Gogh." *Psyché* (January-April 1953).

Mothe, Alain. *Vincent van Gogh à Auvers-sur-Oise*. Paris, 1987.

Nagera, Humberto. *Vincent van Gogh: A Psychological Study*. Foreword by Anna Freud. New York, 1967.

Pabst, Fieke, ed. *Vincent van Gogh's Poetry Albums*. *Cahier Vincent*, vol. 1 (1988).

Perruchot, Henri. *La vie de Van Gogh*. Paris, 1955.

Piérard, Louis. *La vie tragique de Vincent van Gogh*. Paris, 1924.

Piérard, Louis. "Van Gogh au pays noir." *Mercure de France* (July 1913).

Piérard, Louis. "Van Gogh à Auvers." *Les Marges* (January-May 1914).

Pissarro, Camille. *Lettres à son fils Lucien*. Edited by J. Rewald. Paris, 1950.

Ploeger, Jan. "Cornelis Vincent van Gogh in Transvaal." *Lantern: Journal for Knowledge, Art and Culture* (December 1981), pp. 51-59.

du Quesne-van Gogh, Elisabeth Huberta. *Persoonlijke herinneringen aangaande een kunstenaar*. Baarn, Netherlands, 1910. English edition: *Personal Recollections of Vincent van Gogh*. Translated by Katherine S. Dreier. Boston, 1913.

Rewald, John. *Post-Impressionism from Van Gogh to Gauguin*. 3d ed. New York, 1978.

Rewald, John. "Theo van Gogh, Goupil and the Impressionists." *Gazette des Beaux-Arts* (January-February 1973), pp. 1-108.

Roskill, Mark. W. *Van Gogh, Gauguin and the Impressionist Circle*. Greenwich, Conn., 1970.

Sanders, Piet. "Genealogie Van Gogh." *Genealogisch Tijdschrift voor Midden- en West-Brabant*, vol. 5, nr. 4 (1981).

Schapiro, Meyer. *Vincent van Gogh*. New York, 1950.

Secrétan-Rollier, Pierre. *Van Gogh chez les gueules noires: l'homme de l'espoir*. Lausanne, 1977.

Sheon, A. "Monticelli and van Gogh." *Apollo* (June 1967), pp. 444-48.

Stokvis, Benno J. *Nasporingen omtrent Vincent van Gogh in Brabant*. Amsterdam, 1926.

Stokvis, Benno J. "Nieuwe nasporingen omtrent Vincent van Gogh in Brabant." *Opgang* (January 1927).

Szymanska, Anna. *Unbekannte Jugendzeichnungen Vincent van Goghs und das Schaffen des Künstlers in den Jahren 1870-1880*. Berlin, 1968.

Tralbaut, Marc Edo. *Van Gogh le mal aimé*. Lausanne, 1969.

Tralbaut, Marc Edo. "Van Gogh's Japonisme." *Mededelingen van de gemeente 's-Gravenhage*, vol. IX, nr. 1-2 (1954), pp. 6-40.

Tralbaut, Marc Edo. "Een en ander over Margot Begemann." *Van Goghiana IX* (1974), pp. 73-84.

Uitert, Evert van. *Vincent van Gogh in Creative Competition, Four Essays from Simiolus*. Zutphen, 1983.

Uitert, Evert van, ed. *The Rijksmuseum Vincent van Gogh*. 1987.

Vincent: Bulletin of the Rijksmuseum Vincent van Gogh, Amsterdam, vols. I-IV (1970-1976).

Visser, W. J. A. "Vincent van Gogh en 's-Gravenhage." *Jaarboek Die Haghe* (1973), pp. 1-125.

Vollard, Ambroise. *Souvenirs d'un marchand de tableaux*. Paris, 1937. Published first in English as *Recollections of a Picture Dealer*, 1936.

Welsh-Ovcharov, Bogomila M. *Vincent van Gogh: His Paris Period, 1886-1888*. Utrecht and The Hague, 1976.

Wilkie, Ken. *Het Dossier Van Gogh*. Baarn, 1978. English edition: *The Van Gogh Assignment*. New York/London, 1978.

Wolk, Johannes van der. *De Schetsboeken van Vincent van Gogh*. Amsterdam, 1986.

Index